Rubens

RUBENS

A Portrait

Paul Oppenheimer

First Cooper Square Press edition 2002

This Cooper Square Press hardcover edition of *Rubens* is an unabridged republication of the edition first published in London, England in 1999, with the addition of forty textual emendations. It is reprinted by arrangement with Duckworth Publishers and the author.

Published by Cooper Square Press
A Member of the Rowman & Littlefield Publishing Group
200 Park Avenue South, Suite 1109
New York, New York 10003-1503
www.coopersquarepress.com

Distributed by National Book Network

Library of Congress Control Number: 2002101574

ISBN 0-8154-1209-6 (cloth : alk. paper)

☉™ The paper used in this publication meets the minimum requirements of American National Standard for Information Sciences—Permanence of Paper for Printed Library Materials, ANSI/NISO Z39.48–1992.
Manufactured in the United States of America.

Contents

II. The Idea of Absolute Beauty

III. Beauty Human and Superhuman

IV. Kings, Queens, Ministers and the Angelic

V. Rubens and Sensuality

VI. Apotheosis: Beauty and Physics

Other books by Paul Oppenheimer

Before a Battle and Other Poems
Till Eulenspiegel: His Adventures (translation)
Beyond the Furies: new poems
The Birth of the Modern Mind: Self, Consciousness and the Invention of the Sonnet
Evil and the Demonic: A New Theory of Monstrous Behaviour
Infinite Desire: A Guide to Modern Guilt
Blood Memoir, or The First Three Days of Creation (fiction)
The Flame Charts, new poems

Preface

This biography traces Rubens' quest for an understanding of beauty. It is not an essay in art history (nor does any artist live a life of art history), though it naturally focuses on his art, the work of his predecessors and contemporaries and the age in which he lived. It sets out to offer a portrait.

A number of discoveries, not cited as such, but which will be apparent to the specialist, together with new points of view about his career, are introduced throughout. Areas of controversy, and there are many, are considered in the end-notes.

While self-contained, this book also complements my previous *Evil and the Demonic: A New Theory of Monstrous Behaviour*. It follows as well out of my other inquiries into various sources of modern thought, *The Birth of the Modern Mind: Self, Consciousness and the Invention of the Sonnet*, and *Till Eulenspiegel, His Adventures*, with its theory of language (an idea most fully set out in the introduction to the Routledge edition).

Some of the political, military and religious history described may seem at first only to lead into interesting byways, but as will become clear, it is essential to illuminating Rubens' life and to revealing how he came to paint as he did. This is because his life forms a story, doing so not in the usual sense that most people seek to endow their experiences with direction and meaning but in the unique one that he sought to give the same depth and background to his life as to his paintings. Great artist that he was, still his life was his most splendid creation, and extraordinary for that intelligible mystery about it alone.

Somewhat more attention is given over to his earlier years than his later ones, when he produced his finest masterpieces and spent an exciting time as a diplomat. Research and reflection have led me to believe that the imbalance is appropriate. After the stage was set during his first three decades, and setting it was anything but easy, his thrilling achievements seemed to follow on his own and others' expectations, though not without bitter struggles. Part of Rubens' precocity lay in his seeing while very young that the path to making his amazing art would

initially, and for social, religious and political reasons, be tortuous. A less courageous man might have given up. A less gifted one might have lapsed into impetuosity. Rubens seems early to have developed the sheer pluck that, as he himself noted with disarming frankness, showed him the way.

I am grateful to Robin Baird-Smith, who offered me invaluable support and guidance on this project from the start, and to my editor, Martin Rynja, who has made many essential suggestions. My gratitude is also boundless to Francesca Simpson Pedler and Andras Hamori (of Princeton University), who read the manuscript in whole or part and spotted how it might be improved. Others to whom I am likewise happily indebted for enthusiasm, ideas and research are Rose Sawkins, Barry Wallenstein, Jack Barschi, Katharine Jones, Peter Evans, Harry Rolnick, Robert Harding, Burt and Mary Hasen, Anthony Rudolf, Wolfgang Karrer (of the University of Osnabrück), Peggy Abraham, Gloria Williams (of the Norton Simon Museum), Barbara Thompson (of the Courtauld Institute Galleries), Judy Sproxton, Nora De Poorter (of the Rubenianum in Antwerp), Deanna Cross (of the Metropolitan Museum of Art), Ruth Dar (of University College London Library), Margret and Ekkart Klinge, Isabel de Azcaráte (of the Marlborough Gallery, Madrid) and Elena Lappin. To my colleagues in the English Department of the City College of New York, and especially to Saul Brody, Pat Laurence and Leon Guilhamet, I offer my thanks for much needed encouragement, as I do to Joshua Wilner and Martin Tamny for their assistance in obtaining a Rifkind-Eisner Award from the Simon H. Rifkind Center for the Humanities and Arts, which made possible a good deal of my research. I wish to acknowledge as well the assistance and insights of my colleagues in the Department of German at University College London, particularly those of Timothy McFarland and Adrian Stevens, and of the staffs at the Siegerlandmuseum im Oberen Schloss (Siegen), the Rubenianum (Antwerp), the Rubens Gesellschaft (Cologne), the British Library, the City College Library, University College London Library, the libraries of Columbia University and the New York Public Library. My son Ben served as collaborator throughout, not only by providing photographs of Rubens' *David slaying Goliath* but also by helping me to clarify some points of scientific history. My daughter Julie helped in a similar way with observations on film. I am, finally, grateful to the splendid work of many Rubens scholars, whose contributions, I trust, are appropriately recognized in the notes.

P.O.
London and New York
1999, 2002

Illustrations

Colour Plates (between pages 116 and 117)

Figures (between pages 276 and 277)

Introduction

It is vain to try to analyse how Rubens achieved this impression of 'gay vitality'.

E. H. Gombrich on *Head of a Child* (drawing, possibly of Rubens' daughter Clara Serena, 1616)[1]

When Peter Paul Rubens died in 1640 at the age of 62, he was unquestionably the most popular artist in the world. Flocks of his over 3,000 paintings adorned the courts of Europe.[2] Dozens of his portraits flooded and brightened the great houses of the aristocracy. His altarpieces and other depictions of aspects of the Christian drama thrilled congregations in a necklace of churches and cathedrals encircling a personal aesthetic empire that swept from his native Antwerp through Prague, Rome, Paris, Madrid, London and back again. His natural gifts were everywhere esteemed. His 'gay vitality' was universally admired. His brush commanded the very highest prices, and he himself was regarded by many as the finest painter since Michelangelo, and by quite a few as his equal if not superior.

All this rapture is long since faded. Rubens' reputation today lies, if not in ruins, at least in a shambles. His women are seen as absurdly fat, his peasants vulgar, his devotional paintings insincere, his still lifes full of repellent animal corpses, his method of production (which often involved turning over the main work to assistants) deceptive, his fascination with Greek and Roman myths banal, his obsession with human flesh nauseating and his gay vitality superficial. Though major museums the world over still display his canvases, and though his paintings still rank among the most expensive, the reason probably has more to do with a fossilized tradition among purchasers, plus a desire not to be caught napping should interest reawaken, than with any sincere modern enthusiasm.

Rubens, in other words, is profoundly unfashionable. This is especially true among recent crops of art historians, whose obligatory salute to him as one of the Old Masters often looks awkward rather than smart, and often smacks of sniffy disapproval. Eric Newton typically carps that 'he has every sort of equipment for scaling the heavens – except a pair of wings. And yet he persists in trying to fly. Rubens was in fact the perfect

1

worldling, a good churchman, a devoted husband and father, a successful politician, an excellent businessman, an indefatigable worker. Perhaps if he had been a social failure, if he had known a little more suffering, he might have been one of the dozen artists to whom it was permitted to reveal a new world. As it was, he is merely the Prince of Painters.'[3]

Such remarks, which are not merely typical but faddish in their sneering at sophisticated worldliness and their prescriptions of social failure and a bit more suffering for the sake of even better art, are actually charitable by comparison with Yves Bonnefoy's dismissal of Rubens' art as 'the rather vain projection of an illusory triumph',[4] or Herbert Read's twitting that 'with Rubens we may safely venture on the question of the banal in art. "Too much of a good thing" is merely another way of saying "boredom", and most people, if pressed, would admit to being bored with Rubens.' While conceding that Rubens had 'a sense of glory', Read argues that he lacked 'idealism' and 'self-criticism': 'He painted as other men fenced, or fought, or made business.'[5] Picasso niggles that 'he's gifted, but he has used his gifts to make nasty things, a nothing. It's journalism, historical film.'[6] The influential Clement Greenberg allots Rubens grudging and cryptic praise: 'Modernism has not lowered ... the standing of Leonardo, Raphael, Titian, Rubens, Rembrandt or Watteau. What Modernism has made clear is that, though the past did appreciate masters like these justly, it often gave wrong or irrelevant reasons for doing so.'[7] The queer self-contradiction here implies that the past did not appreciate these painters quite so justly after all, and what Greenberg seems really to have in mind is that Rubens *et al* are to be congratulated solely on having anticipated some of the giddier extravagances of modernist art. 'Modernism,' adds Greenberg, 'has never meant anything like a break with the past,' but he obviously means a queer past as well, one viewed through a skewing if not skewering modernist lens.

Rubens' biographers, with few exceptions, have complemented many of his critics in the oddity of their attitudes toward his life and work. This is to say that they have often contented themselves with tones of dullish reverential praise, while practically toppling over one another in their eagerness to rephrase limp truisms about him as the grandest artist of the Baroque period, croon about the mystery of his gifts and agree on his general inscrutability as a man. No less than sixteen biographies in various languages have appeared since his death, with the earliest in 1677 based on a French translation of reminiscences of his life by his nephew, who knew him and cherished him and whose adoring paean remains valuable for its anecdotes.[8] Of the three most recent, in English, French and German respectively, in 1987, 1990 and 1996, by Christopher White, Marie-Anne Lescourret and Otto von Simson, White's monumental and superb volume is essential to anyone who hopes to learn how Rubens developed as an artist, though it refrains from offering any muscular account of the political and social vitality of his age,

Lescourret's for its heroic insistence on his appreciation of sexy women, even fat sexy women, while quibbling absurdly that when Rubens painted Christian subjects, such as Christ's baptism or the Day of Judgement, he did so automatically, submissively and without religious conviction, and the late Otto von Simson's for its combining a sagacious elucidation of Rubens' methods and intentions with an old-fashioned eulogy to his bloodless grandeur.[9]

Beyond these efforts, the tones of hushed piety adopted by most scholars (often to be distinguished from the biographers) investigating Rubens' *oeuvre* have also done little to reinvigorate his glamour and sagging renown – the modern viewer's intuition of a noisy snapping off of the past when it comes to Rubens – even if the investigations have proved important. Brilliant scholars such as Julius Held have cleared up knotty questions about which paintings Rubens actually painted and which drawings may be attributed to him.[10] The labours of other conscientious if generally humourless rummagers in the archives have led as well, and most recently, to posh Rubens exhibitions accompanied by delectable if criminally costly catalogues that have rocketed high into the museum heavens over the past eight years, only to blaze forth and vanish, in Antwerp, New York, Boston, London and Paris.

As a result it seems clear that despite bushels of notable modern struggles to shift public and professional taste, Rubens persists in being miserably out of sync with it where he was once the glass and spectacle of several ages. The interesting, indeed compelling question is why. To be sure, this question itself would be of no consequence except for the apprehension of the marvellous produced by his work. Whether Rubens is fashionable or not, his ability to astound, to startle the soul into melody, to excite the human mind and heart with unimagined but plausible and exquisite possibilities, remains inescapable (even Eric Newton allows him the phrase 'Prince of Painters'). The mass boredom cited by Herbert Read, moreover, is itself bizarre: one senses, if one feels it, a roguish paradox rendering it intriguingly different from any usual experiences of boredom: an ecstatic irritation, a gagged ecstasy. One readily guesses that there is probably something wrong with a great many people's way of looking at Rubens' work and at the man himself, that crucial knowledge that might set right the topsyturvydom has gone missing or been scanted, or that if only what is already known were seen in a broader, more voluptuous light – perhaps especially the lucid illumination of his own day – the problem of his bracing isolated splendour could be made clear, and could swiftly dissolve, with the facts falling into their proper places. Rubens might cease to appear as he now does, as a type of irrelevant magnificence, and be understood as a man, an artist and – what one might reasonably expect him to be – an invaluable asset to our millennial richness of opportunity.

The book that follows proposes to tackle this vaunted Rubens puzzle,

and a good deal more. The challenge of the puzzle itself is easily under-stood. Rubens appears uninteresting to large numbers of people except as a technician because they have no idea how he and his contemporaries thought about painting, art, politics, war, science, colour, love, hate, liter-ature and lots else. His thinking and that of his friends, colleagues, compatriots and enemies is of the essence here, and they reflected on all these matters in their own unusual ways. Indeed the premise of what follows is that works of art and people generally cannot be understood unless their assumptions about reality are also understood.

Reality here means the universe on its physical, mental and spiritual levels. Prior to Rubens' day these were neatly wedded. They were delin-eated by surviving elements of the ancient Ptolemaic System, which described the known solar system, or universe from their point of view, coupled with medieval Christian theology, though both now came under a withering set of attacks. The attacks were as dramatic as they were devastating. They emanated from scientists such as Copernicus, Kepler and Galileo (whom Rubens knew, painted and respected[11]) as well as from often contemptuous Reformation revisionists of Church doctrines such as Martin Luther. They led into smash-ups and reformulations of consciousness and religious feelings as well as of entire nations and soci-eties, and helped to create the unrecognized conflicts of Rubens' soul and the political and social anarchy, frequently set arumble by violence, that he experienced. They contributed while he was alive to the flowering of nationalism as a novel and world-shaping phenomenon. They furrowed English, French, Dutch and Flemish fields for the democracy that was later to take root and flourish. They also stimulated chessboard-smooth gambits by philosophers such as Descartes to reassert the harmony of the formerly united physical, mental and spiritual and thus defy a breakneck popular current running in the other direction.[12] These gambits were thrown down before audiences even as most informed people were being persuaded of the fracturing of experience – and as they felt themselves plunged into soul-stabbing dreads, with the dreads themselves inducing princely investments in sumptuous art and atrocious wars and enduring in horrific as well as hopeful forms for hundreds of years, or straight into modern times.

To ignore these achievements, eruptions and decisive changes in ways of thinking is to remain baffled about why Rubens painted as he did, or lived as munificently and adventurously as he did, or dressed as he often did in his elegant, slightly foppish laces, frills, doublets and black felt hats, or enjoyed having the Roman historian Tacitus read out to him in Latin as he painted, or even about why the ordinary Flemish housewife in his home city of Antwerp insisted on scouring her already clean stoop every morning. It is therefore to miss two of the most lucent facts essen-tial to comprehending the flamboyant genius of his painting. The first, somewhat surprisingly, is that he is no apologist for kings, queens,

4

princes and aristocrats at all but an unusual and new type of democrat. The quintessence of Rubenism is democracy. As will be seen, his drawings and paintings illustrate this feature of his mind and astute hand and the rest of his life confirms it. The second is that, unlike most artists, he is passionately curious not merely about beautiful things but – and this is crucial – about beauty itself. He believes that he knows what beauty is because he has investigated it by asking a number of appropriate questions and has little patience with the seductive ease of relativism: he is convinced that he has actually solved the problem of beauty, of what the word must ultimately mean, and his exemplary solution, which is not simply his own but a universal one, manifests itself in his every brush stroke and in virtually all else he does, whether in his painting or in the rest of his astonishingly diverse life. This is in no sense an extravagant claim. It is also not meant to imply that his cornucopian existence lacks the usual humbling accidents, miseries, bumblings, messes and foolishnesses that innoculate most souls against a facile and vacuous optimism.

Rubens' attitude toward beauty, however, accounts almost entirely, and this fact is one of the chief propositions in what is to come, for the continuing modern griping about him, along with the brittle, stewed admiration: it is deeply unacceptable today, and especially among art critics and other art professionals, to admit that the problem of beauty has been solved by anyone, or that it even exists. In the relativist-minded age in which we live, such problems (the problem of evil is another) are not supposed to exist or be solvable. They are considered fictions. Fragmentation is all the rage. Confusion is praised as the loftiest form of consciousness. Ambiguity and meaninglessness are esteemed as realism. Materialism is truth. Despair is merely the result of childhood maladjustment. The physical universe is no more than the sum of its parts. The human mind is a mere electrical machine destitute of essential mystery. Personality, and for that matter sense and sensibility, are merely social inventions.

Rubens' life and art sabotage these trendy persuasions with heaps of evidence, and as a result any biography of him, set alight by his idea of beauty as well as the central beliefs of his age, is bound to seem provocative, and explosive of modern superstitions, no matter how unobtrusive its aims.

If this biography is also awash in his day's odours, yowls, burrs of cooking fat, alleys banked with rotting soldierly corpses and bristly rubbings of soft pig snouts, as well as its parades, ornate speeches and rosy palaces, its tulips and sun-spanked bedsheets, its arrogant, flirtatious and opportunistic women as well as its pious and loyal ones, its sanguinary boar and stag hunts, its admixture of sewage-waftings and salt sea-air, its naval and land battles, its music, theatre and poetry, of his own and other cultures, its costumes and conspicuously thickened cosmetics, its squabbles and friendships, between him and other

painters, its sniping among politicians and its feverish universal terror of the loss of rooted faith – and this in everything, with the nightmare of it galumphing like a shadowy vulture across the Delft-blue sky of northern Europe and blotting out various traditions of human trust – then this portrait of the artist may seem to modern readers too ripe with sensations, too lush with conflicts and ecstasies, precisely like one of his own large canvases.

Such an impression, though, if it emerges, will only be the result of another of our exasperations, of our being too long fed on abstractions. Rubens, an empiricist to his fingertips, rejoiced in an abstract-empirical balance. Any realistic portrait of him should seek to recreate it. It should match his empiricism as an artist and thinker against his aesthetic and spiritual values as a man of seventeenth-century Spanish-ruled Antwerp. This can best be managed, I believe, by adopting a fresh method: of presenting his life in terms of his early-arrived-at concept of beauty itself.

This concept, to be described in the first part, dealing with his childhood and early manhood, and presenting it as he discovered it himself, depended on seeing beauty, along with the universe, not as a thing but as a process. Action, and not stasis, was and is all. Action was ripeness. For him, reality moved. The universe always pranced. It seemed to him actually to flaunt its galactic smears of light. Even its repose was a tambourine of stars and planets, a musical drum of silver tappings. Its plain sublimity was an angelic hibiscus of wings that flapped in feathery strokes toward a spot of eternity.

As a result, the human soul, unlike nature, could flow backwards as well as forwards. It rode on memory, but that was not all. Its essence could sweep itself off into soul-dramas lost except in the pith of the species, long perished except in the nerve-scrolled many dimensions of its long history, vigorous and fluent still, and as ancient as dimension itself. These dramas survived in Christian spiritual beliefs, Ptolemaic science, which was a genuine science despite its differences from modern science,[13] and ancient literature, along with theatrical paintings of a specific type. They allowed the mind to conceive of eternity as a fact and to depict it as truth.

How captivating and vital seems his concept of beauty as compared with the dry, motionless ones invented by nearly all subsequent thinkers about it, and yet (as I hope to show) how close to modern scientific ones. Walter Pater (1839-94), who remains preeminent and seminal among modern aestheticians, for example, intones that 'beauty, like all other qualities presented to human experience, is relative', and that 'to define beauty, not in the most abstract but in the most concrete terms possible, to find not its universal formula, but the formula which expresses most adequately this or that special manifestation of it, is the aim of the true student of aesthetics',[14] thus rather lazily assuming that any universal formula cannot be found, and fudging the challenge of the problem –

which is to move beyond fossilizing subjectivity, to avoid confusing the fashions of the moment with universal realities. Pater was influenced by the Scottish empiricist philosopher David Hume (1711-76), who believed that 'to seek the real beauty, or real deformity, is as fruitless an inquiry, as to pretend to ascertain the real sweet or real bitter',[15] a notion that similarly mixes up what is personal, 'the real sweet or real bitter', about which everyone may disagree, with the possibility that aesthetic experiences may have little or nothing to do with what is private. This possibility is ignored as well by George Santayana (1863-1952), who advances the smoggy idea that beauty is not merely personal and relative but also gloomily moral: it 'is a pledge of the possible conformity between the soul and nature, and consequently a ground of faith in the supremacy of the good'.[16] Santayana is apparently innocent of the frequent scramblings of beauty with immorality, as in the more orgiastic poems of Baudelaire. He likewise fails to notice that beauty often cosies up to evil rather than goodness, and that a ghastly blend of the two is probably the true source of the problem of evil.

Against this befuddled nonsense – against the idea of beauty as a relativistic vortex – it may at once be asserted that for Rubens beauty was a process of growth into form. The process is always imperfect and always afflicted with powerful elements of disorder. What is crucial, however, is the fact that beauty is this process only. When a particular form is perfectly attained, or almost, the result is mere prettiness. It also appears that Rubens regarded as beautiful those experiences that seem to lift one out of all contexts. For seconds, and often longer, the world, which is too much with us, falls away. The universe itself, even if it is the universe that one is contemplating, drops astern, as does one's sense of mortality. One luxuriates and relaxes in freedom and bliss. Angels gather in the nearby trees, and even the shabby trees of winter, and fluffed-out dreams make fabulous one's mind. The sense of harmony that accompanies the beautiful springs directly from this intense isolation, from the elimination of contexts, which is not lonely. It may occur while looking at a flower, or a woman's face, or the lineaments of a corpse, or a dead fox.

For Rubens, the experience of beauty thus knew no proper bounds or limits. Garbage, cockroaches and mould could appear beautiful if one found oneself leaping free of context, of one's consciousness of one's own mortality, when viewing them – a prospect admittedly not available to those who do not want it. This experience could only occur because beauty is a peculiar arrangement of energy, in which the contents and subject make no difference – and in this sense (though, as will be seen, precisely) it resembles Einstein's famous equation $E=mc^2$, in which energy is defined as equalling the mass of a thing, anything at all, times the square of a constant (the speed of light).[17] It is the ever-active, everincomplete, yet universal symmetry of the Einsteinian reality – in Blake's phrase, its fearful symmetry – that creates his equation's

universal yet objective aesthetic appeal. Beauty is in this way a special and energetic arrangement of light for the painter, where for the musician it is one of sound, and for the writer one of words, but words understood as fields of energy rather than as mere symbols. Nor is this characteristic arrangement of light to be found only in painting. It also occurs in the natural world, or wherever light gleams, glitters, angles and vanishes. It appears nearly everywhere as well in the artificial worlds of human culture and civilization. Putting on makeup, for instance, is a manner of arranging the play of light across hair, eyes, teeth, cheeks and lips.

The goal of this rather unconventional biography, therefore, is to uncover, as by drawing aside a veil, if that can ultimately be managed, how Rubens' approach to beauty matured for him and rapidly became the cosseting, imaginative custodian of his art. It is to investigate how his ideas were stewarded by his education, his love-life and the rest of his life, including many of his other beliefs, his age and the people whom he knew, doing so in the light of several new discoveries and family letters which here appear in English for the first time. To this I must add a note of self-caution, to wit, that in my view, but surely not only in my view, there are two great perils in attempting biography. One is poor selection of the materials, or worse, no selection at all. The second is that the author will manufacture only a pale, irrelevant and flattering version of himself. These perils come to the same thing, an imbecile compression of someone else's life-spirit, one reducing his adventures in the world to tasteless puppeteering. Probably in dread of sliding over either precipice, I have long despaired of attempting to deal with Rubens at all, with his full intelligence and craft, his courage, grace, mildish pomposity, tact, gentleness and shrewd whimsicality. It has always seemed essential to me that the secret of his 'gay vitality', as Gombrich accurately puts it, should be revealed in the process, and that if this cannot be done, if Rubens himself cannot somehow be coaxed into revealing it, any efforts of mine would hardly be worth the candle.

I do not pretend to have solved this problem, only to have become, perhaps recklessly, impatient with it. Devotion, research and study have reached the point of expression, and the Baroque personalities of the past, chief among them Rubens' own, with their self-mocking eccentricities, passions, imagination and convictions, seem eager at this point to present themselves, or so I wish to believe.

I

Rubens and the Question of Beauty

1. The True Opposites of Evil and the Demonic: Prelude

The opposite of evil and the demonic is not goodness. It is beauty and the angelic. The reason is that aesthetics must precede all else. In a sense aesthetics precede God, or God is impossible without them.

Aesthetics here means not merely the study of beauty but beauty itself in its various forms: the types of harmony, the manifestations, if they exist, of divine love. In a universe based on physical laws, these come first. They precede humanity and humanity's worries: politics, disease, hunger, disorder, unfairness, war and even goodness. The idea of justice, in the sense of restored harmony, seems to come first as well.

Goodness trots along later, often as a suspect animal. It is not stabled in, as is beauty. It cannot be adulterated as beauty can, or as the angelic may be, with Lucifer's transformation into Satan. It may be lost, but it cannot be defiled. It cannot be corrupted, only sacrificed. It cannot be guaranteed, only hoped for. It may come naturally to some, but most learn it, often at a painful cost. Goodness – honesty, compassion, pity, love, altruism, empathy, loyalty, even-temperedness, merriment – may prove practical indeed on many occasions, but it is an apparently artificial contribution to human life, even if, as many continue to believe, it is God-inspired. Certainly it is by no means as apparently essential to setting up civilizations as killing, conceit, politeness and bribery.

This is as it should be because while goodness is precious, and a source of safety, joy, happiness, stability and self-assurance, it seldom produces wild flashes of lightning in the human soul. Unfortunately these appear to be caused by evil, the demonic, beauty and the angelic, with the latter reaching into a spirituality beyond mere goodness – and all of them sometimes intermingled with one another. Madness, it may be said, arouses curiosity as mere sanity never does. It seems an escape from the conditions of existence. The idea that an evil person might not be mad but sane, if thoroughly different in outlook, provokes even greater curiosity, as well as dread. Such a person – a Nero, say, or a Stalin – seems to revel in special advantages over everyone else, in unique opportunities for escape. A sane and clever saint, by contrast, rapidly dwindles into a figure of ridicule, contempt, adoration or boredom.

9

The risk of devoting one's life to beauty may be evil. Because a great many guess at this, even if they do not consciously think that the pursuit of beauty may involve such a risk, the true artist's devotion stimulates wariness. Often it invites hostility. Of course there have existed, and presently exist, many artists, no doubt the vast majority, whose mettle-some careers are absent this devotion. It seems reserved for the very greatest: Michelangelo, Da Vinci, a few others, and certainly Rubens. In their work, as in Mozart's music or Shakespeare's poetry, or Dante's, one is aware of the rich dimensions of life and the universe, and these displayed to their utmost. No possibility is resisted. No question is left unasked. No subject is taboo, even goodness, even dullness. The technical abilities of these artists, and their training, reading, nerve, humility and independence of spirit, which prove equal to the burden of their devotion, match it in integrity as well.

2. The Artist Meets the Prince

To meet Rubens, you stroll across the Thames bridge linking Windsor and Eton, above the dozens of scuffling swans, geese and mallards mewing bread from the tourists, and head up to the galleries in the castle. Outside: the gold-lettered restaurants, the gateau-stuffed tea rooms, the gaggles of polite Americans and slangy Germans escorted by the inevitably brisk guide ('Here we take a short-cut'; 'Yes, Henry the Eighth did have a son'; 'There was no need for a moat, which would have meant diverting the river'), and the sweet July afternoon and regular creakings of transatlantic and Europe-bound jets overhead. Inside: the snuggish King's Dressing Room where one of Rubens' most famous self-portraits, hanging among paintings by Rembrandt and Van Dyck, and one that he did himself of Van Dyck, loops you back through the centuries, past the long dead emperors and archdukes, past the pretty and waxy duchesses and queens, to reveal him alive and alone amid ghosts, supernaturally quiet, looking at and through and past you, and with a trace of bottled mischief.

You are in another world here, groping for knowledge, feelings, connections. This is probably how to begin to know him, though, as he wanted to be known, through this particular self-portrait (86 x 62.5 cm.; plate I) done in 1623 for the then-prince Charles, who was to become king in 1625 and who had not yet met him but admired him and virtually begged him for it.

His face is astonishing for its insolent frankness, kindness and confidence. His squishy, black felt hat slopes rakishly across his gleaming forehead. Its tassel seems less a decoration than a jolly banneret of success. The same might be said of his obsolete collar in lavish Antwerp lace, and the gold chain about his neck, probably a gift of the Archduke Albert and his wife Isabella,[18] rulers of the Spanish Netherlands, and his

black cape with its hint of clerical, cosmopolitan mystery. His tender brown eyes are witty if evasive. His slightly ruddy hair, goatee and sprigged moustache, touched with silver, seem flourishes of independence. Amazingly, there is no clue to his occupation, or that he has any.

To seventeenth-century royalty, straight across Europe, all this no doubt seemed inappropriate, daring and attractive. Insolence amounted to a declaration either of genius or stupidity. It assumed a formidable risk. It flung a poisoned gauntlet in any royal face. Either one in fact had genius, or the sort of divine spirit and gifts which alone might allow one to ignore decisive class differences and meet a prince on equal terms – and the prince agreed – or one invited jeering dismissal. Rubens, at the age of forty five and approaching the peak of his renown, is fearless. He reveals none of the minor painter's fawning hesitation, which is the more remarkable for the son of a disgraced lawyer, who spent his first ten years in seedy exile with his family in a small town in Germany and in Cologne.

He never wanted to paint this portrait, and did so only when Charles repeatedly asked for it and because he respected the prince as a collector of fine art, and his own art. 'The Prince of Wales,' he wrote to Palamède de Fabri, Sieur de Valavez, the brother of Nicolas-Claude Fabri de Peiresc, one of his closest friends, in 1625, 'is the most sophisticated lover [amateur] of paintings among the world's princes. He owns something by me already, and through the English agent in residence in Brussels asked me for my portrait with such insistence that I found it impossible to turn him down. While it seemed to me inappropriate to send my portrait to so high-ranking a prince, he overcame my modesty.'[19]

The result is a masterpiece of self-revelation. His modesty, or nice reserve, which emphasizes the naturalness of his confidence rather than belying it, shows in the absence of arrogance, of exaggeration, or of the cobra edges of egotism. You sense, as did so many who knew him, the mystery of a flowing, luminous personality that so completely accepts itself as to inspire trust.

The gleaming, naked brush strokes also let you deduce qualities not obvious here but which bustle in the relatively few other self-portraits that he did during his lifetime. The entire man can be inferred. Unpretentious, tall, broad-shouldered and easy of gait, with the expansive, long-fingered hands of the musician and a sensual, attentive mouth, he seems at once the aristocrat and the manual labourer, or even an interesting peasant got up in an expensive costume, his cape and hat, that paradoxically becomes him. In character, you realize too, he is no foot-pounder or table-thumper.[20] He might clasp his hands as he leans forward a bit over a table, or back from it, and listen, reasoning candidly if alerting someone to impending danger or error, but doing so with delicacy and clarity. He might smile indulgently. At the same time, you would perhaps notice in his smile, as others did, if a trace uncomfortably, his keen sense of the absurd, one peculiar result of his fascination with

history, his own and the world's and the lovely, tortured history of his native Antwerp and Brabant.

Like Charles, who a few years later cultivated his friendship in person and negotiated with him as king to politician, when Rubens arrived at Greenwich as the peace emissary of the King of Spain as well as the Spanish Netherlands, working now as a diplomat-artist – his diplomatic career was for years as important to him, and as lively, as his artistic – you cannot quite pin him down. Like the sea, he seems constantly to be changing while remaining thoroughly himself. His tides of moods and passions are constrained by invisible, charmed and often menacing currents.

Some of these currents are not hard to spot. In 1623, Europe bristled under the grim lights of the Thirty Years War, from the guns of warships and privateers in the English Channel and the Mediterranean to Antwerp's River Schelde, blockaded by Dutch frigates, to the terrified villages and cities of northern and central Germany, to Prague farther east, and into France, Spain, Italy and Sweden, where vast armies gathered, preened themselves and filled out with fresh troops in preparation for the continuous cruel battles to come over the next two and a half decades. The Twelve Years Truce between Spain and the United Provinces of Holland and Zeeland to the north of Antwerp had ended in 1621, and Spanish armies, commanded by generals eager to retake them for Spain and above all to squash the heretical Protestantism that they found sickening, had immediately swept forward into districts that were eventually to defeat their worst efforts in a series of humiliating battles and become the Dutch Republic.[21] That lay in the future. In the meantime, fierce military currents twisted about Antwerp's suburbs, leaving the populations of nearby towns and villages distraught and cowed.

Several months before Rubens painted this very picture in fact, in 1622, the Genoese general Ambrogio Spinola, military commandant of the Spanish Netherlands, whom Rubens at first distrusted, then came to admire for his astuteness and refinement, and later to paint, in 1625, in a magnificent shrine of a portrait showing him in gilt and black dress-armour, his red-plumed helmet placed judiciously to one side on a table,[22] had crossed the border with a powerful army into the United Provinces and laid siege to the fortress-town of Bergen op Zoom. He was not unopposed. The Protestant German commanders Mansfeld and Christian, riding at the head of armies equally well equipped, set out to meet him and relieve the siege. They ploughed through Metz and Verdun into the Spanish Netherlands, just below Antwerp, and moved past it. Pillaging as they went, they left in their wake a swath of torched farms, hamlets and villages through which plague and starvation spread horribly and quickly.[23]

This was a time of emotionally extravagant currents too, among them romance and epic heroism, and the military grandee often seemed to

possess superhuman courage. Only twenty-three-years-old, one of the German commanders, Christian, the duke of Brunswick-Wolfenbüttel, was severely wounded while leading his men in five murderous charges against the Spanish before reaching Bergen and joining up with Mansfeld. Christian's arm had to be amputated. He ordered the job done by his field-surgeon to the accompaniment of a crescendo of trumpets, and had a celebratory coin struck to honour the occasion, on which appeared the defiant motto *'Altera restat'* (My other one remains intact).[24]

Nearby battlefields, you begin to realize, loom across Rubens' eyes in this self-portrait as much as his confidence, scepticism and amity. Spilled blood flares, if implicitly, buried in subtle blends of colours, along with terrible glowing wounds. Lances flash behind his irises. As his face grows more familiar, you recognize that if he is the world's most famous painter of princes and glorious nudes, he is also its most devoted painter of monsters and fiends. Within each of them, princes, nudes, monsters and fiends alike, shimmers an unexpressed yearning. It is not the same as the yearning of other painters, even other great ones, and seems to expose itself in his unusual handling of light. Where Michelangelo's colours merge easily with light, and Rembrandt's often shrug it off into flakes of dark, and Van Dyck's lap up its gloss and sheen, Rubens' burn with the many types of it, brazenly, coolly, softly, strenuously, ambitiously.

He is, you find yourself admitting, probably the most deliberate painter of the invincible penetrations of light – illumination inserts itself seamlessly everywhere, so that there is no real dark, no absolute, lethal blackness – and on returning to this picture and viewing it again, and several times, you catch yourself relishing his handling of light as a phenomenon both revealing and somehow extra, and wondering what it means. Its gleams nestle slyly in his black felt hat and cape.

The light does not seem unnatural, you realize, though unobtrusively it suggests the supernatural, that a mysterious, divine and even satanic dimension may lie beyond the physical. In this fact, as each of his thousands of other paintings also makes clear, and as you come to acknowledge as you get to know him even better, lay both his challenge and conflict. These had to do with depicting the dimension of the supernatural, or discovering it anew, and doing so in a world that was propelling itself into becoming unrelievedly and shiningly fleshly, rebellious and violent. The invisible dimension of human beings, the something extra about them (as F. Scott Fitzgerald says of style in writing), of the vile as well as the virtuous and average, and of other creatures too, needed to be sought out, and introduced with fluency into his art, and this according to its own unaccountable naturalness. It had to be presented as viewers themselves experienced it. Michelangelo had already shown one way to manage the trick of this, in his paintings on the ceiling and walls of the Sistine Chapel, if without perhaps suffering

Rubens' early doubts and pains over method: Michelangelo's Christian beliefs seemed firmer, their truths more unquestioned and unassailed, as were those of the Italy in which he lived, despite its decadence.

Since Michelangelo's death in 1564, however, an ungovernable menace had been developing. An unhinging, especially of religious beliefs, was universally in progress. Ancient premises of Christianity, as well as of Christian government and society, no longer seemed clear to everyone, or self-evident. A Christian or at least a spiritual revival was what the age demanded, and its most gifted and conscientious thinkers in every possible way sought to provide it – along with quacks, con-men, rogues, charlatans, fear-mongers, outlaws, murderers and other opportunists, who had their own ideas about the uses of any Christian rebirth. At the very least, however, a new type of art was vitally necessary.

All this is also implicit in Rubens' expression. A key to it lies in precisely his intriguing omission of any reference to his occupation. If he is an artist, diplomat, spy, husband, father, lover and businessman, he consciously enjoys himself as a man who merely engages in art, diplomacy, spying, marriage, fathering, loving and business. Each of his self-portraits insists on his unremarked humanity. Each presents him, significantly, as a thoughtful, sensual man of the world.[25] His 'beloved profession' of art may count more with him than his diplomatic activities and hasty spying – surely it does – but evidence of that is lacking here. Nor, as a number of art historians have argued, has he eliminated all clues to his life as a painter simply because he is anxious to appear before Charles as a gentleman.[26] A deeper yearning than one for social status and princely acceptance pervades his view of himself.

The contrast with Rembrandt, his nearly exact contemporary could thus not be greater. Rembrandt's psychologically exploratory self-portraits, often showing him a bit dishevelled and with paint brushes fizzing about, broker him as an artist. The man is equivalent to the artist, no more, or perhaps that is enough, or in his case a sufficient blessing.[27]

The candle-bright face of Rubens, however, leaning forward from a dark wall against a distant azure sky, emerges as altogether independent of such announcements, deliberately so, as a personality enthusiastic about playing and living many roles on the vast stage of a world that he regarded as a theatre. The part of diplomat is as shot through with interest for him, and even spiritual implications, as that of the artist.

Even this self-portrait bowed to political expediency. As relations between England and Spain became at first unsettled, with Charles' abandonment of his courtship of the Infanta Maria of Spain, then threatening, and then dangerous with the war that simmered between the two countries in 1623, spluttering along though it was not to erupt in any serious way until 1625, Rubens' decision to send his self-portrait to Charles was rescinded. For years it hung in the artist's grand house on

the Wapper canal in Antwerp, admired by visitors and continually copied.

It was finally sent in 1628.[28] Rubens seems to have dispatched his long-deferred personal introduction to the now-King of England just before meeting him in 1629, on his peace mission to London. His mission was to last for nearly a year. It resulted in his finest diplomatic success, as well as in several other paintings, and a commission for one of his most astonishing masterpieces, a set of nine large canvases celebrating the union of Scotland and England, which to this day adorns the ceiling of the Banqueting House of Whitehall Palace, not far from Trafalgar Square and opposite the Horse Guards' Parade as you head down Whitehall toward the Thames, some thirty smooth miles below Windsor.

The fact that this is such a complex self-portrait, therefore, with its own complex history, forces it into evoking the dramas of his life, and perhaps for this reason you feel free to surmise without presumption that he is gazing not simply at Charles but into memories, into who he is and where he comes from, even before his birth in Germany in 1577. His ambiguous expression seems rooted in the bitter events of his age, about which he cared with unceasing passion – the European-wide war that refused to end, the mass murders, also without end, the burnings of cities, the shootings of women, dissenters, Churchmen and children, and the mothers and fathers famished and reduced to eating dogs in the streets; and the palaces furnished with his paintings recruited by triumphant, shrewd kings, and the prince who would become a king; and his quest, always realized and yet waiting to be realized better, with worse horrors to come, about which he perhaps also speculates and guesses in this painting, for the revelation of an indomitable supernatural dimension to existence, with its implication of absolute beauty. It was apparently only absolute beauty that could matter in these circumstances, acting as a saviour, and it was to be found, as he believed, in love, prayer and art.

3. The Landscape of the Portrait

Heading on foot from Germany or France into the Low Countries, which were mere provinces of the Spanish half of the Hapsburg Empire and hence the private property of King Philip II of Spain in the mid-sixteenth century, you would first have noticed the hundreds and then thousands of others who were heading there too, along a vast web of intricate roads that spread north like a skein of nerves into dozens of towns, villages and cities.

In good weather, and especially during the summer, when the poor had no need to feel ashamed of their thinnish clothes, you would have joined soldiers for hire, journeymen, vagabonds, farmers taking vegetables to market, itinerant professors, actors, musicians, beggars, peddlers, hucksters, students, artists hungry for commissions, Reformist preachers,

prostitutes, apprentices, hunters with pelts to sell, prospective sailors making for the major northern ports at Antwerp and Amsterdam, quack-pill sellers, the occasional nobleman on a horse, the even rarer noble lady in a gilt coach (travelling with chaperones, perhaps with her mother), magicians, astrologers, witches, escaped prisoners of all sorts, mendicant friars, the royal post-coach from Rome or Paris or Madrid (bound for Antwerp or Brussels), the swifter government messenger on a horse – flashing at a life-and-death gallop alongside the crowd and on the edge of the road to his next relay point – and plumed and powdered officials gazing apprehensively at the faces around them through the windows of their tilting carriages.[29]

Antwerp especially, even more than its neighbouring city of Mechelen, or Malines, and more than Amsterdam, had been well protected through the 1550s under the rule of Philip's father, Charles V, who had himself been born in Ghent, and now smelled pleasantly of money. It was reputedly the richest city in Europe.[30] While this was not strictly true, because Venice, with its larger population of 168,000 in 1563, and its longer established merchant fleets trading with half the great ports of the planet, was certainly as rich, Antwerp to many looked far more promising for the future.[31] Its burgeoning trade lay with London, Scandinavia, Cadiz and the recent Spanish conquests in the New World, in cloth, glass, gold, precious stones and silver. Over the previous fifty years it had become a magnet for the clever and adventurous, and was even called the Venice of the north, despite its proverbial mists and winter cold and its 'greyest of grey rivers', the Schelde.[32]

Financially prominent since the 1490s, the city had since been fairly thoroughly reconstructed by its glass manufacture, its thread, print, iconic statuary, ceramics, the paint of its famous artists and modernistic swappings of money in low-interest lending operations run by bankers drafted into its new Beurs, or Exchange, built in 1531. By 1512 the Italians had introduced methods of glazing.[33] Their example inspired a rapid expansion of the previously smallish pottery industry. They also set up ateliers for glass production. By 1549 one alone of these was turning out 11,000 mirrors per year.[34] Large factories for fustian were likewise an Italian import. The Spanish brought in leather manufacture, working with local as well as Cordova hides unloaded by the crateful along the city's pleated mile of piers. The very winds of the English Channel seemed to blow in wool for the new Flemish tapestries, while gales off the North Sea and Atlantic disgorged copper, coffee, pipe tobacco, sugar and spices.

By 1550 Antwerp's 90,000-plus people lived on 212 streets knotted into a twisty ganglion at the waterfront and streaming outward into the shape of a flat half-moon pasted against the Schelde and skirted by thick walls.[35] Away from the shipping centre and past the many bridges over its numerous broad canals and the narrow Wapper canal, which were

later to be filled in to accommodate additional housing for the arriving refugees and workers, many of the streets broadened out into an embroidery of trees, linden, willows and chestnut. Along the grander carriage lanes and avenues the crimson brick houses of the wealthy, four storeys high with stepped Gothic facades, sat cheek-by-jowl on triangular plots that yielded to lavish gardens. In spring, summer and fall these gardens, formally arranged in surviving medieval style as a series of squares, shone with constellations of roses, clematis and late-blooming asters.

The population delighted in an equally massive consumption of books and beer. Astonished Spanish visitors in 1549 took note of an average daily beer habit of three pints per adult, whatever his or her wealth, along with a literacy rate among people of all classes so high that it was rare to find anyone who could not read.[36] Drunken feasts, they reported, were frequent at the houses of both rich and poor. They began in the early afternoon and lasted straight through the night. If many of the guests became too immobilized in their cups to rise from their chairs, they urinated on the floor. Again, both rich and poor, well bred and ill bred alike, indulged in this (as it seemed) un-Spanish practice, including large numbers who had been educated in Latin and Greek poetry, philosophy, music and Christian piety at one of Antwerp's 150 schools.[37]

The combination of expanding business and industry with a traditional spirit of religious and political tolerance attractive to dissenters of all sorts produced severe overcrowding throughout the slatternly districts along the waterfront, where sailors, carpenters, chandlers, blacksmiths and shoemakers trundled among smokers pubs, cheap inns, gambling dens and whorehouses for both men and women. Rents were steep, as were the narrow staircases of most homes, 200 écus per month for the low earners, who jammed into lightless rooms, sharing beds and a drop-toilet or outhouse, 500 for the better off.[38]

Greed, open hearths and vermin encouraged repeated spewings forth of the plague and city-threatening fires. Between 1480 and 1551, the dreaded 'sweating sickness' raised its ghostly skeleton, as it was depicted by painters, five devastating times. Further epidemic outbreaks carrying off thousands of the Christian faithful, who marched in unavailing mass prayer-processions through the streets and were escorted by gloomy drums and ecclesiastics, ravaged all districts repeatedly over the next hundred years, or throughout Rubens' lifetime. By contrast, the ravenings of major fires, furious as they were, seemed constrained. In 1441 the considerable Wolstraat area burned to the ground, as did the houses on Hoogstraat in 1443. In 1503, after a new series of conflagrations, the city magistrates ordered tubs of water to be placed before every door. In 1551, according to local records, this protective measure did not prevent thirty or more buildings on the street at the Great Market from going up in flames.[39]

It was no wonder that few people of gentle birth ate out. To enter a

tavern or inn was often to enter a brawl. As elsewhere in much of Europe, one stooped over one's ale and beef amid wrenched haunches, scrambled fists, shirts being ripped from chests, kneeings, knockings, whippings, knifings, shootings, garottings, quiet poisonings, elbowings, shouts, corner fuckings, belches and ill humour. Calling the police was out of the question as there were no police, only mercenary soldiers rarely employable in restoring order.

If toughness was required to survive the belligerent deportment of one's neighbours, vigour was often essential to survive the meal. While the food was often fresh and good, it was also assailed and inhabited. In warm seasons one competed as one ate with squadrons of beetles, flies and gnats. In winter, when vegetables were scarce, maggots appeared melodramatically in the meat. People were accustomed to this animation. Apart from the Netherlands and a few wiped-down German, Italian, English and Spanish palaces, but clearly among the dingier waterfront streets of Antwerp, sanitation was viewed as wasteful. To wash the body was pointlessly and recklessly to remove its protective coating of aromatic dirt. To wash the dishes was to sacrifice uneaten food. It could profitably be saved for the next meal. Vermin were accepted, if not enjoyed, as part of a life that was replete with far more unpleasant irritations. In any case, no one knew that mosquitoes, rats, mice and flies carried diseases. No one thought of the ubiquitous cockroach as anything other than an unpaid scullery maid, clearing away the spilled crumbs and staging a madcap dance.

A universal passion for gambling matched the passion for absolute cleanliness of those who lived away from the docks, and whose fiercely scrubbed stoops, fresh-pressed linens and fine laces, as intricate in their many indigenous designs as they were forever whitened by dyes and soaps, were already a legend.[40] Betting on almost everything, as well as public lotteries, often sponsored by the government at Brussels, attracted so many people that imperial permits to prevent cheating were issued as early as 1524.[41] Albrecht Dürer, who lived with his wife off and on at Jobst Plankfelt's modest inn at the corner of Wolstraat and Minderbrudersrui for over nine months, from the summer of 1520 to 1521, and whose fame led him to be repeatedly and ceremoniously invited out and feted by the Burgomeister, the painters' guild, the Portuguese consul and other *splendidi*, describes unending defeats at cards (he seems almost never to have won) and complains that despite the rapid sales of his portraits, 'I have suffered loss in the Netherlands.'[42] Others placed bets on even chancier possibilities: ship arrivals from the West Indies, the date of Charles V's next visit to the Low Countries, a truce between the king and the Protestant rebels against the Inquisition, the sex of unborn children, the death-dates of political figures yet alive, and exchange rates and business affairs of every type.[43]

Parades involving much of the population were frequent and magnifi-

cent. Dürer, whose diary from this period usually reads like a ledger of winnings, losses, opportunities to sketch the odd interesting face and the profits from his paintings, drawings and woodcuts, waxes rhapsodic over one of them, held on a Sunday in late August, 1520, to commemorate the assumption of Mary, the mother of Christ. It lasted over two hours, passing below a window at Plankfelt's inn, from which he watched it. Like many visitors, he was impressed less by its official orderliness and sophistication than by the city's publicly displayed good taste, general high spirits and the money it could spend without stint on religion and whatever else appealed to its fancy:

> The whole town of every craft and rank was assembled, each dressed in his best according to his rank. And all ranks and guilds had their signs, by which they might be known. In the intervals great costly pole-candles were borne, and their long old Frankish trumpets of silver. There were also in the German fashion many pipers and drummers. All the instruments were loudly and noisily blown and beaten.... I saw the Procession pass along the street, the people being arranged in rows, each man some distance from his neighbour, but the rows close one behind another. There were the Goldsmiths, the Painters, the Masons, the Broderers, the Sculptors, the Joiners, the Carpenters, the Sailors, the Fishermen, the Butchers, the Leatherers, the Clothmakers, the Bakers, the Tailors, the Cordwainers – indeed workmen of all kinds, and many craftsmen and dealers who work for their livelihood. Likewise the shopkeepers and merchants and their assistants of all kinds were there. And after these came the shooters with guns, bows and crossbows and the horsemen and foot-soldiers also. Then followed the watch of the Lords Magistrates. Then came a fine troop all in red, nobly and splendidly clad. Before them, however, went all the religious Orders and the members of some Foundations very devoutly, all in their different robes.... A very large company of widows also took part in this procession. They support themselves with their own hands and observe a special rule [or daily routine of work and prayer]. They were all dressed from head to foot in white linen garments, made expressly for the occasion, very sorrowful to see.... Last of all came the Chapter of Our Lady's Church with all their clergy, scholars and treasurers. Twenty persons bore the image of the Virgin Mary with the Lord Jesus, adorned in the costliest manner, to the honour of the Lord God.... In this Procession very many delightful things were shown, most splendidly got up. Waggons were drawn with masques upon ships and other structures. Behind them came the company of the Prophets in their order and scenes from the New Testament, such as the Annunciation, the Three Holy Kings riding on great camels and on other rare beasts, very well arranged; and also how Our Lady fled to Egypt – very devout.... At the end came a great Dragon which St Margaret and her

19

maidens led by a girdle; and she was especially beautiful. Behind her came St George with his squire, a very goodly knight in armour. In this host also rode boys and maidens most finely and splendidly dressed in the costumes of many lands, representing various saints.[44]

Such processions were quasi-moral affairs. They buttressed a novel urban pride. They nourished longings and jittery respect. Their unabashed mix of decadence and religion, along with theatrical opulence, also appealed to the Italian merchant-historian Ludovico Guicciardini (1521-89), who settled in Antwerp and made his fortune there. In the 1560s he saw the compact, wealthy city as 'marvellously well furnished both out of [its] own country and out of foreign countries, of all kinds of victuals and dainties, both for the necessary use of man, and ... for wantonness'.[45] He savoured its open hedonism and gaiety: 'At all hours one sees weddings, feasting, dancing and recreations. On all street corners one hears the sound of musical instruments, singing and general rejoicing.'[46]

Lording it over the city, and on sunny days pointing the needle of its shadow across the rumple of piers and well-paved streets while sweeping heavenwards into a delightful Brabant Gothic grace, stretched the three-tiered north spire of Our Lady's Cathedral (Onze-Lieve Vrouwekathedraal), which was begun in 1420 and completed in 1519 according to a design by Herman de Waghemakere, and which for three centuries remained the loftiest spire in the Netherlands.[47] In surviving woodcuts it upstages even more exquisite secular buildings devoted to politics and commerce, as if the energies of the population were slowly pulling apart, licorice-like, into rivalries: the italianate Town Hall (Stadhuis), by Cornelis Floris (whose name is the likely source of 'florid'), finished in pink marble in 1561; the Butchers' Hall (Vleeshuis), another design of Herman de Waghemakere, in 1503, with its layered bands of tawny sandstone and brick in what was tartly called 'streaky bacon style';[48] the Hof van Liere, built for the Burgomeister Arnold van Liere in 1515-20 and praised by Dürer for its beauty; the mansion of the financier Jacob Fugger in the alcove known as the Steenhouwersrest, with, again according to Dürer, its 'noteworthy tower, broad and high, and with a beautiful garden';[49] and dozens more trim structures, many giving onto lush courtyards hemmed with serene Gothic columns; and smaller yet spacious and superb churches.

The contemporary woodcuts hardly hint at the city's brittle and ancient bargain with the sea, or that it dominated the new-found prosperity with as much decisiveness as any king. From time immemorial, Antwerp had matured under an absolutist Faustian pact concluded with vicious devils of tides, winds, punishing storms and sudden obliterations. For centuries before the arrival of Julius Caesar's invading armies, and

through a millennium and a half after his Roman troops marched out of the nearby forests, gaped in amazement at the toughness and civilization of the Flemish and retreated southward again, the sea had reluctantly let itself be squeezed by intricate labours from swamps, bogs and fens and penned behind a network of dykes. Everywhere the sodden, soupy land, wrung from fickle currents that threatened to flood back in and sometimes did, was rescued by human struggle, stone by stone, until Antwerp and the surrounding countryside could emerge and indeed stand out as a single vast work of art themselves, built in gritty defiance of natural forces.

The sea-pact required constant inspections and repairs. It was a bizarre gift in that it asked everyone somehow to yield his or her body and soul to art, with urban life itself dependent on a genuine awareness of craft and aesthetics. Aesthetic passions among the Antwerpers and throughout the Netherlands were thus never a simple game or a merely decorative expression of personal or spiritual conflict, as often elsewhere. Their importance was born of danger. It was no wonder, perhaps, that by the mid-sixteenth century the city could boast an already long tradition of sculptors, masons, architects and painters, or that if by 1560 its butchers guild registered seventy-eight members, and its bakers 169, its number of professional artists, who had served their apprenticeships and earned their designation as masters from the painters guild, stood at an amazing 300.[50]

4. Publishers, the Word and Censorship

In the meantime, black ink was winning it international renown. By mid-century, printing and book publishing, already over one hundred years old, were considered a liberal art.[51] Straight across Europe, they commanded an enthusiasm out of all proportion to the number of copies of individual books actually sold, an attention that presaged revolutionary changes.

In part this was due to the hoary Judeo-Christian worship of the word, whether spoken, written or printed. Language led back to God. It embodied the miracle of creation. The Book of Genesis and The Gospel according to St John, which even the illiterate had heard read to them in services and masses before the invention of moveable type, and which the great majority in Antwerp began to read to themselves afterwards, revealed in their first phrases the divine powers of speech. Genesis described how God had uttered the physical universe into existence ('Let there be light', 'Let there be a firmament in the midst of the waters'), while The Gospel according to St John proclaimed the splendour of language in syllables that every religious Christian – and nearly every Christian felt it only realistic to be religious, as religion seemed to explain the harmony of everything under the sun, and the moon too –

took as literal fact: 'In the beginning was the Word, and the Word was with God, and the Word was God.' To be uninterested in words was to be exhausted with life.

Few were. Among the crowds of immigrants pouring into the city in 1549 was a young, well educated but by no means scholarly fellow from a village near Tours, Christophe Plantin (1520-89), who had begun his printers apprenticeship in Caën, married and moved north in search of opportunities.[52] He soon set himself up as a master (or qualified) printer and gained citizenship.

The city was a flourishing publishing centre, with streams of books, tracts, pamphlets and broadsides issuing yearly from a printers and publishers district located around the Friday Market (Vrijdagmarkt). Competition was keen, and not simply for the local reading audience but for the larger European one, with books routinely shipped off to customers in England, France, Italy and Spain, where equally competitive houses, such as Macé in Paris, at which Plantin had completed his apprenticeship, vied with one another for essential financing and readers while often bucking and struggling under the smothering imperial hand of censorship.[53]

Dread of the censor, of book-seizures and book-burnings, led publishers everywhere to glance frequently over their shoulders, and Plantin himself may have moved to the city in part because every publisher's life under Henri II of France had become increasingly dangerous. On occasion life in Antwerp, despite its atmosphere of tolerance, proved little better. As recently as 1545 Jacob van Liesveldt, an Antwerp-born publisher, had been beheaded for putting out a Bible with notes arguing that Christ alone, and not the Church, was the way to salvation. His wife, who insisted on continuing his work, was likewise beheaded in 1546, three years before Plantin arrived.[54]

At first he suppressed his publishing ambitions, perhaps because he was short of necessary funds, certainly because in those early days he could not have known that he might score a resounding, three-centuries-enduring success, becoming one of the most important publishers on the Continent. He and his wife started out by selling books, prints, hats, gloves and scarves in a small shop also set up as a book-bindery and a place where, as a sideline, leather and wooden jewellery boxes were given him by his well-connected customers for decoration and finishing. It was only after one fearful night when he was assaulted and stabbed in the shoulder by a street gang while walking across the Meir Bridge to deliver one of his expensively embossed leather cases to Gabriel de Çayes, the secretary to Philip II, that he turned to printing, and a bit later to book publishing. His attackers, mistaking him for a guitar player on whom they were out to revenge themselves for some reason, almost killed him.[55] In any event, they left him temporarily crippled and unable to work with leather-carving knives and gilding tools. Typesetting suddenly seemed an easier affair, as did operating a printing press, perhaps especially as both

required his own more sophisticated knowledge and intelligence. Both also, as he well knew, could bring in more money.

There is no doubt that Plantin was attracted to publishing as much by a desire to make money as by his love of books. In this he differed not a whit from a great many other publishers or even the better artists of his day (Dürer himself, in recommending the career of the artist, ranked earning lavish sums as among its chief attractions[56]). In the wealthy climate of Antwerp, candid materialism combined sensibly with idealism. So did working for the supportive yet print-suspicious government of the King of Spain, even when, as in Plantin's case, this included quilting up lists of prohibited books.[57]

In 1555 Plantin issued his first book under his own royally granted patent, the small *Institution d'une Fille de Noble Maison*, which contained a proper enough code of manners and behaviour for girls of noble birth, a subtle beginning for a new publisher who himself had five daughters. He followed this up with a Spanish translation, the *Flores de l'anneo Seneca*.[58] The popularity of these first two and numbers of other books that he soon began to bring out, along with his fast-selling calendars and almanacs, rapidly convinced him that he was onto a good thing. As early as 1549 in fact, six years before embarking on his grandish publishing venture, he had written to Pope Gregory XIII that his decision to come to Antwerp 'above all other towns' was due to his realizing that 'for me no other town in the world could offer me more facilities for carrying on the trade I intended to begin. Antwerp can easily be reached; various nations meet on its market; there too can be found the raw materials indispensable for the practice of one's trade; craftsmen for all trades can easily be found and instructed in a short time; moreover I saw to the satisfaction of my faith, that this town and the whole country, shone above all neighbouring peoples, by their great love for the Catholic religion, under the sceptre of a king, Catholic by name and fact; finally it is in this country that the famous university of Louvain flourishes, where chairs are taken by professors whose collaboration I hope to obtain to the greater benefit of the public'.[59]

The benefit soon must have exceeded his wildest dreams. Guicciardini, whose *Description of All the Low Countries* Plantin also published in 1567, by which time he had become chief printer for the king, or prototypographer, fairly gushed over De Gulden Passer (The Golden Compasses), the 'magnificent printing house established next to the shop' that Plantin's extraordinary range of popular as well as scholarly and ornate books had quickly created: 'Such an establishment has never been seen, nor is yet seen in the whole of Europe, with more presses, with more type of various kinds, with more prints and other instruments, appertaining to so excellent an art; with more capable and competent printer's assistants, earning higher wages by working, correcting and revising in all languages, strange as well as familiar, none excepted,

which are used throughout the whole of Christendom.'[60] By the late 1560's, indeed, Plantin had become the employer of fifty-five workers, most of whom spoke and wrote French, Flemish, Spanish, Italian and German, the languages that he himself knew, along with Hebrew, ancient Greek and Latin, which as the international tongue of all educated Europeans, was taken for granted with everyone. A broad group of scholars in several fields, including philosophy, regularly published their books and acted as consultants with the now forty-seven-year-old Antwerp immigrant, whose publishing house was to become a second home for Rubens' artistic career.[61]

His books were striking for their quantity and quality, for the profits reaped by many of them and for the use they had begun to make of the city's rich artistic talents. They challenged other publishers, raising standards and prices.

The sheer vastness of Plantin's production – twenty thick, often wonderfully illustrated volumes per year on subjects ranging from theology through botany, history and cartography, plus multiple slender books of poetry and fiction – was astonishing, especially if one considered the tangled manual labour involved from start to finish.[62] Typesetting took place on one side of the composing room, as it was called even then, printing on the other. In large establishments such as his, where sixteen presses were kept cranking away by 1574, as many as twelve men darted among each other, performing their specialized tasks.[63] The operation began at the type racks, their slots crammed with crisp steel letters, often in the new Roman design and gleaming like silver nuggets, that awaited the setter's deft fingers. These were extracted, one after the other, slapped into palmed words, tamped beside wood slugs among other words into page-sized frames on a table and forced firm with more bits of wood before accepting the pressman's lash of ink at the press and their final plush intimacy with paper or parchment.

Work went quickly, and though proofs were continuously taken and corrected by the author and professional proof-readers, mistakes cropped up. The costliest books could provoke embarrassments. Plantin began to fine his typesetters for errors. He also enforced a policy of minimal conversation. Religious disputes were banned altogether. Strikers faced sacking (in Venice and Strassburg printers had struck successfully for higher wages, an example that he did not wish to see repeated).[64] Notwithstanding Guicciardini's claim that his workers were well paid, compositors actually earned a rather low 142 florins a year, pressmen 100, or far less than a live-in carpenter, who made 250, and this for working days that began at five in the morning and ran through till sunset. With rare exceptions, authors were paid in copies, usually twelve. They sometimes financed their own publications.[65]

Plantin's personal earnings were more extravagant. Though his average print runs rarely exceeded 1,250 copies (his edition of the

Pentateuch went as high as 3,900, and his Virgil 2,500), by 1557 he was able to offer 1,500 books for sale at the important Frankfurt Fair, together with masses of copper prints and engravings.[66] The growing market for fine copies of works by famous artists had in fact never seen anything like the numbers of beautifully reproduced paintings that he now began to sell both at Frankfurt and on the broad European market. His book prices were low, as were paper and labour costs, with his octavo *Virgil*, for example, selling at five sous, his quarto edition of Horace at 25 sous and his *Humanae Salutis Monumenta* by Arías Montanus, with 72 plates, at three florins (an approximate modern value would allow for ten florins to the pound and six to the dollar).[67] Annual sales brought in between 5,000 and 15,000 florins. Exceptions also abounded. A single sale to a retailer in London in 1568, for instance, yielded 4,400 florins.[68]

Contending with the Inquisition and its accompanying book-burnings likewise at first proved no obstacle. Plantin remained a fairly devout Catholic at a time in Europe when many were switching to Calvinism, Anabaptism or other forms of Protestantism, and even more veering back and forth between the Church and sectarian rebellions against it, as often out of honest religious confusion as an opportunistic desire to snuggle under the protection of wavering kings, dukes and princes and so keep a step ahead of the executioner.

Religious convictions had become as important to survival as the nearby dykes. Attitudes toward the Mass, Christ's body, the role of the priest and reading new vernacular translations of the Bible in private were matters of life and death. Charles V had brought the Inquisition to the Spanish Netherlands in 1522.[69] He reorganized it along more gruesomely efficient lines in 1546. As a result, the early decades of the Reformation saw at least 2,000 Netherlanders executed for disagreeing with established Catholic dogma.[70] With his edict of May 25, 1521, Charles also instituted book censorship across the Netherlands and Germany. The edict proclaimed that all books must be approved by imperial censors prior to publication. Despite stringent penalties, including heavy fines, the stipulation that booksellers could not open their packages of books except in the presence of censors, the denunciation of all violators as traitors to the king, and then brandings of offenders with hot irons, pokings out of eyes, choppings off of hands and, in 1550, mandated executions of disobedient publishers throughout the empire, Charles' decree and later harsher ones were often ignored.[71] Bannings increased sales. Curiosity led to smuggling. Religious defiance actually lifted prices and profits. Spanish authoritarianism induced the birth and secret nurturing of new principles of freedom of the press.

For the time being Plantin made gestures of compliance with all royal decrees, while allowing his apparently natural tolerance considerable leeway. By 1550 he was a member of an important Protestant group, La Famille de la Charité, though whether his membership was more than a

gesture is questionable.[72] He certainly risked imperial wrath by publishing the Protestant *Spiegel der Gherechtigkeit* (Mirror of Justice), doing so, however, without his official imprint. At the same time he turned official publisher in the Netherlands of the papal *Index*, the constantly revised list of prohibited books which all book sellers and publishers were required to display on their premises.[73] Like many publishers, in other words, he ducked and dodged. He managed to look and be so politically reliable that Philip II had no trouble confirming his good standing by promising him a fabulous investment of 21,000 florins for his polyglot Bible, published after tortuous delays and accusations of sacrilege in 1568, in Hebrew, Greek and Latin.[74]

This book was Plantin's masterpiece. It was one of the great publishing achievements of the century. Edited by the renowned scholar Bênoit Arías Montanus, Philip's own appointee, who worked with scholars from Louvain's Theological Faculty, it also threatened Plantin for a time with the morbid thrill of bankruptcy, as the king never kept his promise of payment.[75]

5. Musicians and the Flemish Renaissance

If Plantin and other publishers were dispatching provocative influences into the world from their wealthy, walled city in the north, the world itself was rummaging through the city's baggy musical and artistic life and finding much there that it imitated and wanted to buy.

Bells and oils especially were gaining it admiration. By the 1550s Antwerp rang, tinkled, gonged and chimed as did no other city of northern Europe, and not London either, with only the small and great bells of Venice, far to the south, half-matching it in percussive beauty.[76] Bells in Antwerp were everywhere, and they pealed at all times of the day and night, in the cupola of the new Beurs to announce the start of the morning's trading or the arrival in port of overdue ships, in the churches to mark the hours, quarter hours and half hours, usually to the accompaniment of folk tunes and religious music, at the schools, at the new town hall, at the entrance to the port itself and occasionally at the Steen, or old castle on the Schelde near the Bakers Tower, to proclaim the arrival of a Spanish dignitary or general or as a warning against attack or floods.[77]

Floods and a commercial need to know the time before the existence of watches, and even of pendulum clocks, had provided the impetus a few centuries earlier for the wonderful encouragement of bell-making all across the vast plains of the Netherlands. Europe elsewhere had known nothing like it. By the 1480s Antwerp maintained what may have been the world's first carillon.[78] The Renaissance can be said to have arrived there and in other Netherlands cities, such as Ghent, Bruges and Amsterdam, as a result of this innovation that was to prove so crucial to the history of music, plus two other small-seeming developments which,

along with the unceasing economic expansion (by the 1550s trade on the Beurs amounted to ten million florins per day[79]) and book publishing, enticed the native genius of dozens of musicians, artists and poets down avenues of achievement hitherto only imagined and barely explored: the invention, oddly enough, of turpentine, which altered the nature of painting in oils, and the import from Italy of an insignificant looking poetic form, that of the sonnet, which had been dreamed up at the court of the emperor Frederick II of Hohenstaufen in the thirteenth century. Both turned out to be immensely influential.

If new lenses pilot new perceptions, each of these acted as a strong one. All three inventions in fact – that of the carillon, of turpentine and of the sonnet – fitted almost at once into a new aesthetic telescope through which human behaviour and possibilities could be seen far more closely and revealingly than before.

The carillon itself was born out of a condition and an innovation peculiar to the Netherlands: their ancient history of political freedoms, which amounted to a limited form of democracy, and the substitution of keyboards for hand-pulled ropes and hammers in the ringing of bells.[80] The invention of these large, many-toned contraptions, turning secular towers and churches into sounding boxes, or into the world's largest musical instruments, actually heralded a time one hundred years hence when instrumental music would emerge as an expressive form in its own right apart from singing, thus paving the way for counterpoint, for the music of Bach and for modern chamber and symphonic orchestras.[81]

The novel political freedoms of the Netherlands, mostly tolerated by Charles V till his abdication in 1555 and then progressively hacked to pieces by his son Philip II, had always invited the Flemish to fiddle about with bells in original ways. Public meetings ever since Roman times had required a bell to summon the local aristocracy and the few rich merchants qualified to vote on local issues.[82] These meetings took place in or near the market square. The privilege of owning or building the tower that housed the single bronze bell was granted by the elected rulers of towns and cities, and even during the Middle Ages and Renaissance was asserted as proof of citizenship beyond priestly control. A nearby church bell was assigned to notify everybody of curfew, nones, other times for prayer and eventually the hours of the day, but the Church in the Netherlands, as opposed to other parts of Europe, never exercised control over the prominent civic bell or its multiplying successors.[83]

The breakthrough into fabricating carillons resulted from the desire for more accurate and reliable clocks, the invention of pendulum clocks, which were run by weights, allowing bells to be synchronized with time-telling, and in the fifteenth century the adoption of what was called the *voorslag*. The *voorslag* was conceived because people often failed to notice when the hourly chiming began and so counted the hours incorrectly. A bit of chiming ahead of the hour (or *voorslagen*, which means a

striking before) might alert them.[84] This chiming was at first managed with a couple of tuned bells hung beside the grander time-bell. People immediately enjoyed what seemed a remarkable improvement on merely ringing the hours, and also the melodies and complicated arrangements of tones according to the diatonic scale that resulted from experimenting with the addition of more bells. When sets of *vorslaag* bells were hung in the church steeples, and often in the civic towers, and a keyboard, consisting of slats of wood placed next to each other and roped to the clappers, was fitted below all the new bells, brilliant carillons began to flood urban Flemish life with a rich instrumental sound, a tintinnabulation that would indirectly influence Rubens' painting.

By this time too Antwerp had become musically vibrant in other ways. The street musicians who entertained Guicciardini probably bought their oboes, teneure-pipes, velt-trumpets, drums and lutes from local instrument makers.[85] The city had blossomed into one of the Continent's centres of instrument manufacture. In 1557 ten producers of clavecins alone, the cheeky, tinkly successor of the clavichord, were accepted into full membership in the all-inclusive Saint Lucas Guild of artists.[86] This meant that their instruments were shielded from cheap imitations by their own patented seal. It guaranteed them steady sales. Jan Pietersz Sweelinck, the most esteemed organist of the mid-sixteenth century, bought one of them, taking it with him on musical tours of Austria and Germany, as did the city of Amsterdam, for two hundred florins.[87] Other Antwerp makers of instruments were busy too, chasing out organs, harpsichords, virginals, spinets, lots of the still-in-demand clavichords and violas da gamba, or all the major instruments in use in Europe at that time. Many of them were sold abroad.

Antwerp rang, sang and painted, even as it gambled, studied, made money hand over fist and saw its native Flemish expanding into a language rich enough in vocabulary and subtle enough in grammar to accommodate highly sensitive poetry. Something of the city's musical flavour can be grasped from the sheer size of Our Lady's Cathedral, in which several masses with their singing could comfortably be held at once. Plantin published five collections of the choir music of Corneille Verdonck (1563-1625), the cathedral's choir master, three of which had lyrics in Latin, French and Italian.[88] The German composer and music publisher Tielman Susato made Antwerp his home from 1529 until his death in 1561.[89] He brought out more than fifty volumes of song books for voice and instruments by various composers including himself, on which he made a steady profit.

6. Painters and the Discovery of Natural Lighting

In this musical, publishing and financial arena Flemish painting also began to flourish in fresh ways. For nearly a millennium educated

I. Rubens and the Question of Beauty

Europeans had argued that paintings ought to be evaluated less according to the skills of their artists than their faithfulness to biblical stories. At the very least, any painting that aspired to truth ought to include biblical symbols, such as crosses, wafers, churches, acts of blazing martyrdom, scenes of gray contrition, moments of piety and above all recognizable Christian hints of damnation and salvation. This way of evaluating art applied as much to portraits as to dramatic painting. If God was a Word, the art of words, and especially of divinely inspired biblical words, was the primary art.[90] Music ranked second because everyone thought that God's angels chanted biblical hosannas to each other as they whisked among the nine spheres of the Ptolemaic universe, spinning its planetary and starry hoops with splendid clocklike regularity. Angelic singing, plus the sounds of the spheres as they whipped through the invisible ether blowing between them, produced, it was believed, a celestial music whose uniqueness lay in the fact that only the deeply devout could hear it. Painting slipped in as a close third art, often after sculpture. Artists and philosophers routinely disagreed about which might best represent the essential truth of words, or the ultimate nature of reality.

Jan van Eyck (1385/90-1441) began to introduce a hitherto unknown luminosity into oil painting shortly after the chiming mechanism for bells was brought into church steeples in Ghent, though before the invention of the carillon. He did so by using turpentine.[91] The most important Renaissance art historian, Giorgio Vasari, whom his ironic friend Michelangelo praised for bringing the dead back to life in his *Lives of the Artists* (Michelangelo was less enthusiastic about Vasari's accomplishments as an artist), thought that Van Eyck had actually discovered how to distil the resin of pine trees to do so, producing pinene, whose high boiling point and clarity rendered it an ideal solvent for pigments.[92] The likelihood of this is very small.

What is certain is that the sudden widespread use of turpentine, probably starting with Van Eyck, transformed the art of painting. Working in oils had been fairly old hat, though few artists fancied it. They were unable to get beyond making a lumpy impasto, or mix of pigment and oils, that left the texture of their paint uneven and hopelessly out of control, if not hysterical, from the viewpoint of its cluttery distribution of light.[93] The use of turpentine, however, at once allowed successive glazes to be laid on top of each other with savoury smoothness. It thus immediately permitted painters to experiment at will with the varying impressions of light in the world. They quickly began to rival if not to exceed sculptors in their moulding of light's sheer and soft angles, of its depths and cool subtleties.

The result was the new Flemish signature in painting, with its brocades of precise and fainty details, its candid-camera-like portrayals of domestic and commercial scenes, its flesh-solid, realistic renderings of

the human body and its naturalistic landscapes. Lambert Lombard, the sixteenth-century architect and Flemish painter who worked mostly in Liege, complained in a letter to Vasari of April 27, 1565, that Netherlands artists before 1400 presented 'clumsy' figures 'very disagreeable to the eye, for they were neither thin nor fat nor had they any good style'.[94] The awkwardnesses melted away as Van Eyck presented his audiences with astonishing novelties, such as the apostles of his Ghent altarpiece, whose beards and heads reveal scores of individual hairs gleaming in the sun, or whose vistas of distant cathedrals and bridges seem coaxed into full three-dimensionality by gentling lights and shadows, and as his contemporary, Roger van der Weyden (1400-1464), unveiled light-shaped limbs, faces and castles exposed by the lens of what Lombard regarded as a new 'excellence in colouring'.[95]

Painting everywhere from this time forth in fact began to be characterized by, among other things, its development of natural lighting. This new fascination streamed off in various and often fashionable directions, according to the temperaments of competing artists, their training, religious beliefs and the desires of the rich religious orders or nobility hiring them for specific jobs. What was of importance, though, and this far more than has generally been recognized, is that painting now rapidly became a European-wide laboratory for the exploration of the nature of light itself. Depictions of light as shooting earthwards in unbending rays, which had figured among the conventional stage props of medieval artists, and which everybody thought of as representing the true and straight reasoning or miraculous *ratio* of God's mind, were suddenly complemented by new types of paintings in which light was shown as moving in snaky lines, curlicues, dot-and-dash streaks and leaps. A major empirical investigation of the properties of light was underway, though no one could foresee where it might lead, and it was matched by an equally significant investigation into self-consciousness. This was an only-to-be-expected transition, as the more sensitive a painter's ability to handle the spring, shiver and sweep of emotion across the human face, the more telling must be his exposure of human frustration, fantasy and conflict.

Joachim Patinir (d. 1524), who was registered as a master in Antwerp by 1515, ranks as among the first to devote much of his career to landscape painting as a light-exploring genre in its own right.[96] His modestly sized altarpiece *The Patience of Saint Jerome*, painted in 1518-20 for a church in south Germany and now in New York's Metropolitan Museum, serves up rather predictable episodes from Christian history, but dwarfed as never before by panoramic vistas of planetary-sprawling distances. The figures of Saint Anne with the Virgin and Child, and that of Saint Sebald, fleshed out in custardy grisaille on the wings of a tryptich, seem virtually shunted aside by Patinir's unusual centrepiece. This glimmers with scenes showing the baptism of Christ and the temptation of Saint Anthony, but pitched as trivial and almost minute against a landscape so

broad as to show the curvature of the Earth.[97] In the foreground, disputing with the Earth's curvature in a newfangled flexing power, loom blueish cliffs, an expanse of sea that is broadcast between low blue mountains and a fortified town. From on high God can be seen dumping a pailful of gold light in a traditional straight-rayed shower on a group of enraptured peasants who sit listening to John the Baptist amid a grove of trees. They seem as much enthralled by the landscape and its freshets of light as by any divine message. The landscape itself seems a new way of estimating the power of divinity.

As may be imagined, the originality of such scenes was captivating, the ambition to duplicate them contagious. By mid-century ticklish trade-offs were in progress between Italian and Netherlands painters. While it had by now become fashionable for northern painters to travel to Italy to soak up the happiest methods of the genius of the Italian Renaissance, the new landscape art from the north, frequently imported, became equally fashionable at various wealthy Italian courts and among several popes.[98]

The reactions to it were not always favourable. Michelangelo saw little sense in landscape art for its own sake, perhaps because its meaning, or focus on Christian ideas of truth, was obscure. It seemed frivolous. Francisco de Hollanda, a Portuguese artist, reported that he remarked in a conversation with Vittoria Colona in 1538, 'In Flanders they paint very green fields, shaded by trees, and rivers and bridges, which they call landscapes and in which they put many little figures here and there; such paintings may make a good effect on certain eyes but there is neither reason nor art in them; they lack symmetry and proportion, and no regard has been paid to selection and grandeur; there is no body in such painting and no strength.... The artists try to depict perfectly so many things that they fail to succeed in perfecting any.'[99] His worry was that the venerable Christian quest for beauty, as expressed by symmetry and proportion, and for the beautiful truth of divine Reason, was being sacrificed to what he chided as mere 'good effect', or a sort of dissipation among curiosities.

Despite such reservations, the curiosities themselves struck large numbers of viewers as wonders. They represented a new pursuit of beauty. Carel van Mander (1548-1606), an early Flemish art historian, artist and the teacher of Frans Hals, echoed popular and aristocratic feelings when he wrote somewhat later, in 1604, that Roger van der Weyden had succeeded not only in the new landscapes but also in an 'enlightened' modelling of light itself.[100] This enabled him to limn 'the inner desires and emotions of his subjects, whether sorrow, anger, or gladness' – or the precise hues of their possible self-consciousness.

7. Light and Mannerism

Another shift in fashion occurred as well. Whatever the achievements of Van Eyck, Patinir and Van der Weyden, it seems clear that their vigor-

ously planted roots nourished the sprouting of the bizarre Flemish scions of Mannerism in the late 1520s.[101] This extraordinary movement came about almost entirely through the desire of many northern painters to collect *curiosa*. It was mobilised by a new wish to assemble in painting and engraving the naturally and unnaturally fantastic. The Dutch and Flemish dyke-bound imagination, it seemed, had rapidly been prodded into a hunt for everything that natural lighting might illuminate.

To be sure, Mannerism had several other sources. Even bad weather, whose vitality is never to be sneered at (and the mid-sixteenth century saw a freakish string of bitter and stormy winters[102]) may have contributed to this novel obsession with complete freedom from old constraints. The Italian influence also swept all before it, the southern-born passion, which rapidly caught on in the north, for mimicking the 'manner' of Michelangelo and Da Vinci, and then for reaching beyond it, creating in oils and ink what Plato had called 'a dream for those who are awake'.[103] Delicious, myopic and strange, the art of the Mannerists, repulsive to some, salacious to others, extravagant to all, and most often merely puzzling, burst across audiences in Antwerp and other Netherlands cities happy to be dazzled and entertained, in spite of Michelangelo's privately expressed annoyance with the whole thing, by the 'good effect' of the mercurial acrobatic possibilities of light and line. Turpentine began to act as a distorting if liberating lens within the north's aesthetic telescope, and this some sixty years before the invention of actual telescopes, which also took place in the Netherlands, and whose mind-altering magnifications Galileo would eventually train on the stars.

Federico Zuccari's *Idea of the Painters, Sculptors, and Architects*, published in Turin in 1607, provides a brisk fillip of Mannerist attitudes, though he had in mind more the Mannerism of his fellow Italian artists than that of the most daring and influential Flemish ones, such as Cornelis Floris (1506/10-1564), who designed Antwerp's Town Hall, his brother Frans (1516-70), Cornelis Coort (1533-1578) and Bartholomaeus Spranger (1546-1611). Zuccari rejoiced in the fact, as he saw it, that

whatever the human mind, fancy, or whim may invent in any art is necessary and delightful ... and affords great help, improvement and perfection to all the painter's works as well as to those of the other arts and the practical sciences. It devises new inventions and caprices ... to be executed in stucco, stone, marble, bronze, iron, gold, silver, wood, ebony, ivory, and other natural or artificial materials, or stimulated with colours, and for ornaments pertaining to any other art whatsoever, such as fountains, gardens, loggie, halls, temples, palaces, theatres, stage scenery, decorations for festivals, war engines, and anything else, such as grotesques, harpies, festoons, scrolls, almanacs, spheres, mathematical forms, a thousand kinds of contrivances, machines, mills, ciphers, clocks, chimeras, and what not. All these things enrich our art and are very ornamental.[104]

Zuccari was most captivated by the show-business or decorative aspects of Mannerism. He relished its unbounded freedom, or uninhibited poetic license.

From another point of view, though, Mannerism, even at its best, simply proposed a triumph of details and trivia over common sense. An army of pygmy citizens overwhelmed visiting giants, as in Swift's Lilliput. This held true of ideas too. They seemed stifled by a slew of smotherings.

Henrick Goltzius' copper engraving of the *Farnese Hercules*, for instance, finished on his return from Italy to Haarlem in about 1592 and based on a Roman copy of a Greek statue dug up in the Baths of Caracalla in the 1540s, shows the godly Greek strongman as an animated nightmare (the Latin caption reads, 'I, the terror of the earth, Hercules'[105]). As he leans against a pillar, resting after the eleventh of his twelve labours, his gargantuan torso seems to explode like a frightening disease into one's eyes as one notices the two tiny noblemen at his feet, gazing up at him. At the same time, and paradoxically, Hercules' physical power itself, and his very immanence as a demi-god, seem to shrink into piddling wisps. This is managed through something else that one cannot avoid, the brutalizing sight of his dozens of majestic, furrowing, plummy and grisly muscles. They puff and billow up his neck, trunk, shoulders and arms. They dominate and even bludgeon his body. They reveal him not as muscle-bound but muscle-flayed, as in some eerie *in vitro* autopsy. The gracefulness of his posture, Goltzius' brief nod in the direction of naturalism, seems an irrelevance. He looms with his back to the viewer as a gruesome, satisfying testament to morbid, imprisoned strength.

This type of artistic enthusiasm, together with a complementary affection for elaborately twisted limbs, for delirium and for physical cruelty, reminiscent far more of the torments of Dante's *Inferno* than of ordinary life, soon abounded in Mannerist Dutch and Flemish engravings. It was perhaps thankfully absent in the work of other major artists: Quentin Massys (born *c*.1466), Antonis Mor (1519-1575) and Pieter Bruegel the Elder (1520-69).

8. Massys, Mor, Bruegel and the New Tradition

Massys, who like most of the painters living in Antwerp immigrated from elsewhere (probably Louvain, though he was registered as an Antwerp master by 1491), started out as a blacksmith. One story about him has it that he discovered his artistic abilities when asked to colour in religious woodcuts while bedridden with a serious illness just before his twenty-first birthday. Another has him turning to painting for love. His girlfriend loathed his blacksmith's filthy hands. His rival was a painter, and Massys began to paint only to woo and win her. Van Mander,

accepting both stories, believed that he became a master through 'his love, his interest in nature and his knowledge'.[106] This knowledge extended into copies of work by Da Vinci, which influenced the delicacy of his naturalism.

What influenced him domestically, however, at a time when Antwerp was just beginning to establish a tradition in painting, was the opulent life of the gentleman. It might be made more opulent if one became a successful painter. Lucrative commissions from religious organizations, such as the Fraternity of St Anne, for which he painted a Louvain altarpiece in 1507, now in the Brussels Museum, allowed him to convert his gift for depicting clean, ascetic and introspective saints, along with making sensitive secular portraits, into two splendid homes. These were bruited about as city showcases even as he lived in them.[107] Dürer visited him at the first, ironically called The Ape, in 1520.[108] The second, the perhaps more ironic St Quentin, which he built himself in Schutterhofstraat on property inherited from the family of his second wife and where he resided with many of his fourteen children, boasted an Italian-style frieze peppered with satirical baboons and grotesques. Putti *en grisaille* fluttered across its walls. A cast-iron statue of St Quentin, Massys' patron saint, stood over the entrance. The sweetness of the painter's gold shadows, as in his famous *A Money Changer and his Wife* (1519?), now in the Louvre, was translated by his mid-forties into the solid coin of social and financial success.

Massys' art reveals a sensual sort of piety, not at all startling in someone who prospered in a city full of light-exploring artists. A friend of Erasmus, the brilliant humanist author of *In Praise of Folly* (1509), whose portrait he painted in 1517, as well as of Joachim Patinir, with whom he sometimes collaborated on large paintings, Massys also cultivated the aloof society of Carthusian monks, with their passion for scrupulous reenactments of biblical scenes.[109] In 1530 he died of the plague at their monastery on the outskirts of Antwerp.

His life and art seem to have unfurled a standard for dozens of later painters, including Rubens, while his manner of living set an example of luxury, achievement and satisfaction. His style sifted into countless new masterpieces. His effortless mixture of saintly sacrifices, through painting after painting, with scenes of everyday drama, acceptance and struggle, challenged imitation and improvement.

As you begin to taste the flavour and reinhabit the atmosphere of those experimental decades in painting, you realize that nearly the same can be said of Mor and Bruegel. In each, perhaps because of their instructional trips to Italy, the quest for new ways to plumb the nature of light took on fresh and amazing forms.

Mor was also one of the first of a number of northern painters to dabble in politics. The use of turpentine and the investigation of light had led into novel chances for social influence. As a brilliant portraitist

regularly employed by the monarchs of Spain, Portugal and England, he found that he might express himself at the highest levels on the dangerous questions of his day, such as the Inquisition, as well as on oak panels and canvas. Where others could count on a rendezvous with the executioner's axe for butting in, he might say what he pleased with an impunity guaranteed by his gifts as an artist. Tact and bravery allowed him quietly, if vainly, to urge Philip II to soften the deadly impact of the growing Christian slaughter by Spanish troops in the Netherlands.[110]

In fact the position of the portrait artist, as in rare cases of the writer, was suddenly and briefly developing along lines unique in European history. A canny artist might on occasion come to occupy a more important if temporary seat at the centre of his local culture, and even of European culture generally, than was conceivable a century and a half earlier, at the close of the Middle Ages. This was because he seemed to represent so much, religious values and insights, for instance, and scientific as well as intellectual sophistication. The best medieval artists, who had just begun to be recognized as more than mere craftsmen, had held themselves largely obedient to the dictates of their aristocratic rulers and religious orthodoxy. They might have chafed a bit, letting personal eccentricities seep out here and there into their work, but mostly they toed the line, especially in art and politics.

Van Mander describes Mor's hearty, near back-slapping relationship with Philip, aware of the freakishness of it, and of the peril for any artist from the provinces (Mor was born in Utrecht, and gained admission to the Antwerp guild of painters only toward the end of his life, probably because he was on the road so much, winning at one point a knighthood in England) in baiting the scratchy Spanish Lion, as Philip was called.[111] A precedent for Mor's daring, though, can be spotted in the career of Lucas Cranach (1472-1553). The versatile German artist not only set up a near factory-like atelier in Wittenberg, where his dozens of pupils and apprentices helped him to channel his unending flow of commissions into his finished paintings, as Massys was to do later on, and made money enough to buy up two adjacent houses for himself and his family, but also capped his genuine political interests by getting himself elected Burgomeister of the city in 1542.[112] An anonymous woodcut shows the ageing Cranach in his mayor's office, his hair cropped short, his beard brushed out into a pompous, huge stalactite. He leans forward across his desk while swaddled in the requisite fur mantle of the city patrician. Nonetheless, he holds his paint brushes in one hand. His colour-daubed palette waits beside him. His eyes have kept their dreamy vigour. Only his expression seems a trifle puzzled, though full of slyness, tenacity and amusement.

By contrast, a sublime indifference to politics and social causes washes through the quartz transparency of the landscapes of Pieter Bruegel the

Elder. Glassine rivers and streams almost always bisect his valleys bedded between scissory cliffs, on which perch elfin monasteries and far-off cities that unravel into an optimistic, ash-white sky. His jesting serenity, a confection of nature's power and the natural inevitabilities reigning over human affairs, feels like a birth of cherubs. Light sweats and bubbles from inside soil, stones, trees, people and houses. All phenomena seem illuminated from within as well as without. The very earth is unstained and unaffected by malice, curses, disputes and hints of violence. An unperturbed lassitude, dropping from natural forces, freezes hot, cold and mild experience into a sort of Never Never Land of permanent peace and domestic January warmth.

His famous *The Flight into Egypt* (1563, now at the Courtauld Institute in London) features many of these traits of his style. Little moves. A stork, caught in flight over an inlet, is pent eternally in a private sector of air, mummified freedom and stopped wind. Mary, draped over an ass led by Joseph, on a hillock in the foreground, pauses motionless on the verge of their descent into a darkened vale. Only the miraculous light, drifting voluptuously across undulating miles of terrain, seems to stir, and this with a limitless heavenly caress.

Bruegel apparently picked up his conception of light on his trek across Switzerland into Italy in 1553.[113] The Alps influenced him far more than Italian painting. Unlike his Flemish contemporaries, who shipped or walked off to Italy for the sake of inspiration and artistic techniques, he paid less attention to Renaissance giants than to gigantic snowscapes. He 'swallowed up all the mountains and cliffs', says Van Mander, 'and on coming home, spat them out on his canvas and panels'.[114] In Antwerp he had already joined the painters guild, in 1551. He spent much of his life roaming the countryside and mingling with the peasants – he may have been a peasant himself – sopping up their manners, as Van Mander puts it, 'in eating, drinking, dancing, jumping, making love and engaging in various drolleries, all of which he knew how to copy in colour very comically and skillfully'.[115]

He had little enthusiasm for tremendous dramas. He was generally unconcerned with history. His pictures almost never present heroic clashes, victories or defeats. Mythical characters failed to excite him. Instead he concentrated on the relatively small, often patched against an enormity of mountains and rivers. He became the world's premier genius of small choices. These he amassed in scores of paintings, capturing them as would a brilliant still-photographer – the instant of seduction, of tasting, of changing a dance step, of kicking a dog, of lighting a pipe, of returning from the hunt, of stealing eggs from a bird's nest – as if happy to seal forever in oils those details of the human comedy that light had always revealed to ordinary people, but which paint had never before been able to fix with such perfect accuracy.

9. Poetry and Painting

The painter Frans Floris, who also enjoyed a reputation as a poet, may have been the first to introduce the sonnet into the Low Countries.[116] It is likely that he brought the form back with him from Italy, where he lived from 1541 to 1547.

Lucas de Heere, also a painter and one of Floris' apprentices, published the first sonnet in Flemish in 1565, 'Den hof en boomgaerd der poeisen' (The garden and orchard of poetry).[117] He seems to have learned about this revolutionary way of writing from his artist-teacher in Antwerp, where it was unthinkable, as it was throughout the rest of Europe in those days, for a painter to be uninterested in poetry and often, like Michelangelo, not to be a poet oneself.

The sonnet was revolutionary in that it was the first poetic form since the fall of the Roman empire intended for silent reading, meditation and reading aloud to oneself or before small groups. It was the first modern poetic type designed not for music or singing, as was the case with all other lyric forms of the Middle Ages (and as a great many people are still apt to assume today about the sonnet itself), but for describing and resolving the problems of self-consciousness, or of the self in conflict.[118]

Invented in around 1230 by Giacomo da Lentino, a *notaro*, or lawyer, at the court of the polyglot emperor-general Frederick II of Hohenstaufen, who had waged war on the pope and been excommunicated three times, the little form had acted as a lever for shifting fashions in literature and ideas, assisting mightily if discreetly in promoting the Italian Renaissance.

All this became possible because of Giacomo's deliberate introduction of a new element, an unbalancing split, into the form that he devised. Its octet, or eight introductory lines, posing a problem of some sort, most often in love, glided unexpectedly into a sestet, or final six lines. These resolved the problem. On the other hand, the unimportant-looking innovation of the sestet produced a dramatic and fascinating quandary for poets and composers alike. It altered the quatrain structure of a form that in its early versions was a single poetic stanza.[119] No other medieval lyrics had contained stanzaic and thematic divisions, and the upshot was that medieval composers, working according to their usual *cantus firmus* approach for setting lyrics to music, which required stanzas to keep their structures and themes unchanging and repetitious, found the new form unwieldy and impossible to deal with. Medieval music could not be composed for sonnets. Apparently none was.[120] In fact the earliest musical settings for the form that was to inspire profound changes in literary fashions, sparking the brush-fire of a new type of literature that was itself meant to be read in private and silence, or at most before audiences of a few interested people, date from over two hundred years after its invention, in the 1470s.[121] By then, though, music and composers had

themselves become a good deal more individualistic, flexible and self-conscious according to modern fashions.

Changing fashions are the issue here, as in much of the rest of Antwerp's intellectual, artistic, financial and religious life. Struggles from darkness into light, and back and forth, and these amid arguments, bickerings, dissent and acceptance, marked the day.

Self-consciousness, for instance, often squeezed out of the frustrated ramming together of mutually hostile passions – 'I love her, I hate her'; 'I crave food, I loathe food' – must naturally have had a history as old as Adam and Eve's guilty nakedness before God in the Garden of Eden. It reached back to Cain's unabashed perception of himself as the first murderer, or in Christian history, the decision of Saul of Tarsus to change his name to Paul and to go forth as a Christian evangelist after an incandescent vision of Christ blinded him with the light of salvation on the road to Damascus. It flooded the poetry of Catullus and Virgil. It embittered the soliloquies of Seneca. It converted the erstwhile roué St Augustine. Its power loomed over the early thirteenth-century epic poems *Parzival*, by Wolfram von Eschenbach, and *Tristan*, by Gottfried von Strassburg.[122] It complicated a few of the courtly love poems of the French *troubadours* and *trouvères*. Certainly it ransacked many a smug life in the sixteenth century, many a soul aching for a passionate yet rational expression of its deepest conflicts – as it may now, though not enough of them, it seems, to foster a broad, enduring human reconciliation.

What was different with the sonnet, however, and what may have led it into promoting a new fashion in self-conscious literature, if not also in painting, was its built-in resolution, its conciliation through reason of all sorts of self-conscious struggles. The harmonic requirements of the rhymed, small form enforced a quiet relief. An emotional problem could find solace in the light of aesthetics. Logic and metrics produced momentary peace. As a result, the experience of reading a good sonnet must from the first have seemed akin to entering a beautiful church or a marvellously proportioned room (comparisons actually advanced a few centuries later by Goethe and Wordsworth in sonnets of their own[123]), and the evidence shows that Giacomo da Lentino may have based his design of the poem on Plato's conception of the three-dimensional architecture, or ratios, of the plan of heaven and the human soul.[124] These ratios, at any rate, were the same as those adopted by Michelangelo in his design of the Vatican, and regarded as 'harmonic' or sublime by the Venetian architect Andrea Palladio (1508-80). They were the ratios as well of the inaudible music of the heavens. The sonnet reproduced in its divided metrical stillness the celestial music that only the devout could hear but that everyone longed to hear. Its construction seemed to sketch the shape and music of the heavens and the individual soul on paper and in words, and so rendered superfluous any human musical accompaniment.

In Renaissance Italy, the form achieved swift popularity. It influenced Dante, who not only wrote many superb sonnets himself but also produced in his *Divine Comedy* (*c.* 1307-1321) the world's first epic poem intended for silent or small-group readings. Dante's epic offered up the self-conscious, doubting struggles over his Christian faith of an ordinary man, surely a persona of the poet himself, through Hell and Purgatory toward a radiant vision of the divine.[125] By well over three centuries later, when the form's original silent intentions had been forgotten, sonneteering had fanned out as a challenge and virtual initiation rite among poets in France, Germany and Spain. Its resolving powers, or plot, had proved irresistible.

Its appeal was scarcely less among painters. Michelangelo wrote sonnets, as did many Renaissance artists who were his contemporaries and successors, including Benvenuto Cellini, Jacopo Pontormo and Il Bronzino (Agnolo di Cosimo di Mariano). The exploration of the nature of light and self-consciousness in art seemed now to run in tandem with the exploration of self-conscious lights in poetry, and soon among the wide rivers of literature. Both, to be sure, swept out of the unquestioned Judeo-Christian belief in the universe as a story.

10. History and Painting

The connection between story, or history, or *istoria*, and art had been insisted on as early as the late fifteenth century by the Genoese-born architect and painter Leon Battista Alberti (1404-72), himself a poet and musician.[126] His *De re aedificatoria*, arranged into ten illustrated volumes and published after his death, in 1485, stimulated the already powerful fascination among Italian Renaissance painters with ancient Roman architecture.[127] In his *Della pittura* (1435) he also wrote that 'every painter should make himself familiar with poets, rhetoricians and others expert in letters, because they will supply new inventions [or story ideas], or at least assist in beautifully assembling the *istoria* through which a painter will surely acquire a good deal of praise and renown in his painting'.[128]

Alberti's notion was in fact hardly new. Poetry and rhetoric had been interchangeable terms during the Middle Ages. Rhetoric was the loftiest peak of the medieval *trivium*, or system of education, along with *grammatica* (the study of Latin, chiefly Church Latin) and *dialecta* (the study of philosophy).[129] In Antwerp, as everywhere else in the Netherlands, the unique rise in late medieval times of local 'rhetoricians' (rederijkers), who formed 'Chambers of Rhetoric', or professional and amateur literary guilds, mostly devoted to poetry and verse drama, but soon exerting some social and political influence, brought poets, musicians, artists and town officials together for debates, recitations, performances and clubby drinking. By the early sixteenth century, Antwerp alone had three

Chambers of Rhetoric. The most respected, The Gillyflowers (De Violieren), had long since become part of the painters guild of St Luke, which itself started off as an association of goldsmiths, enamelers, glassmakers, embroiderers and painters in 1382, and was formally chartered in 1442.[130] Guicciardini reports that by the mid-sixteenth century the vast majority of St Luke's members were artists.[131]

The marriage of poetry and painting also seemed to be sponsored by the classics. Apart from the Bible with its wealth of divine stories, all 'master' artists, along with educated people generally, read Ovid. His *Metamorphoses* had survived the early clerical incinerations of ancient authors. In the High Middle Ages (1160-c.1500), however, the urbane Roman poet was chiefly enjoyed for his stories and style. The pagan content of his work seemed unthreatening rather than seductive. Even his *Ars amatoria*, with its frank descriptions of sex, had seemed harmless enough to priests of the twelfth century, when confidence in a Christianity triumphant led to an easing of strictures against classical poetry (or what could still be found of it).[132] Throughout the Middle Ages as well, Horace was read by the better educated and all professional artists, and also chiefly for his Latin style. To this should be added the bewildering fact that as with Roman historians such as Tacitus and Livy, both poets were admired in an almost complete ignorance of their pagan world. This lack of knowledge sanctioned a universal assumption that Romans of thirteen centuries earlier had looked, dressed, spoken and acted like Renaissance Italians and Netherlanders. Painters often depicted them as they did their contemporaries. Nor was this anachronistic mix-up limited to Italy and the Netherlands. Christopher Marlowe, Shakespeare and Ben Jonson, when writing for the Elizabethan theatre some forty years later, saw nothing wrong with bluffing out ancient Romans as thinking and speaking like men and women of Renaissance England.

In his *Ars poetica*, the first-century-BC-poet Horace, a favourite of Augustus, had argued for the supple kinship of poetry and painting: '*ut pictura poesis*' (as is painting, so is poetry).[133] What he had in mind was their similar commitment to story telling through images. This idea was promoted by Sir Philip Sidney in his 'Apologie for Poetrie' (c.1593; published 1595), in which he described the images of poems as 'speaking pictures'.[134] He infused his 'Astrophel and Stella' (1591), one of the first sonnet sequences in English, with many *concetti*, or complex images dependent on long, detailed comparisons.

Horace also held that poetry and painting shared a special freedom of 'poetic license': 'To painters and poets there has always been allowed an equal license of attempting whatever they like.'[135] In mid-sixteenth-century Antwerp it became conventional for artists to sketch or paint allegorical figures of poetry and painting ranged together as close friends.

I. Rubens and the Question of Beauty

Not all Netherlands poets shared this sophistication. Most mid-to-late-century literature of the Low Countries was hardly as refined as the painting, and few poems, or for that matter few works in prose, can be said to escape dullness. On occasion, as with Cornelis Pieterzoon Hooft (1547-1626), a politician as well as author from Amsterdam, the reader is treated to a magnificent rusty eloquence.[136] An ancient Roman historian, a sort of stuffed Tacitus, seems to be discoursing on ghastly modern events with an irrelevant gusto and shrivelled wit. Much of the poetry of the forties through the eighties, just after Rubens' birth, including many sonnets, has a creaky feel. It smells acridly of the fish market or too sweetly of the garden or laundry. Often, as with the poetry of Anna Bijns, it is convulsed by a bumpy pugnacity or spasms of spite.

Bijns was the most popular Catholic lyric poet of mid-century Antwerp. Her arch-enemy, and one whose assumed lascivious corruption she constantly denounces, was Luther. Her *Refereinen ... meer suers dan soets* (Refrains ... more sour than sweet), published in the late 1520s, mingles bitter satire with moving piety: 'Is God met mij, wie sal mij schaden?' (If God is with me, who can hurt me?).[137] To the modern ear, her undoubted sensitivity and gift for lyric terseness – she was called the Sappho of Brabant – seem repeatedly mangled by religious vehemence and a rejection of ideas: 'What is the use of studying many books?/What is the use of acquiring many goods/Or of following in the skies/The course of the stars and planets?'[138]

On the other hand, the most refined and ambitious and eventually the most famous of the Antwerp poets was Jan van der Noot, who spent years abroad in religious exile as a Protestant, in France, where he met Ronsard, and England, where he got to know the young Edmund Spenser, who translated him into English. Van der Noot, despite defects of egotism (he constantly proclaims his own immortality, and the immortality of anyone he chooses to write about, a classical convention borrowed from Ovid and Horace and later picked up by Shakespeare in his sonnets), plus excessive moralising, especially after his return to Catholicism and Antwerp, belongs to the new wave of vernacular poets and sonneteers.[139] In his poetry Flemish grows more elastic and sinewy. For the first time in any language apart from Latin, a poet aspires unabashedly to becoming what Spenser called 'the monarch of all sciences', or branches of knowledge.

11. Sizes and Theatres

It is often assumed that in previous ages everything was a good deal smaller, even the people. In the sixteenth and seventeenth centuries in the Low Countries and Europe generally, people were indeed on average a bit shorter, but with notable exceptions, such as the Swedish King Gustavus Adolphus (1594-1632), who stood over six feet seven inches.[140]

41

In most cases the assumption of previous miniaturization is unjustified. Christian and Turkish fleets routinely embarked over two hundred and sometimes as many as four hundred ships for single naval battles. Armies could count on upwards of 300,000 men, plus camp followers, many of them wives and whores, who numbered in the tens of thousands. Military engagements by land forces frequently involved between twenty and forty thousand men. A well stocked fortress, such as that at Veere in the Netherlands in 1571, could muster 2,000 bronze naval cannon, along with a larger number of less valued but devastatingly effective iron ones.[141]

Commercial shipping, as at Antwerp through three quarters of the sixteenth century, when 2,500 vessels shuttled up the broad river Schelde into the sprawling port and down again every week, was impressive by any standards.[142] If the beds, especially in middle-class homes and those of the aristocracy, were shorter, the reason was not the smallness of the sleepers but health: people wrongly believed that it was better for the circulation to spend the unconscious part of their lives in ancient Roman style, reclining on a heap of pillows. Cattle were enormous, or at least as large as modern cows and bulls. An entire genre of cattle painting developed in the Netherlands toward the end of the sixteenth century as prosperous farmers hired artists to record the increasing monstrousness of their livestock, including horses, sheep and swine.

From a modern point of view, populations were minuscule. That of the Netherlands in 1598 was three million, about the same as in England and Wales, while Germany's eighteen million, not yet or for centuries to come organized into any form of country or nation, dwarfed but hardly intimidated Spain's six million, at least until 1600, when ten percent of the Spanish people died of bubonic plague.[143]

What loomed larger during the sixteenth and seventeenth centuries in Europe than it does now was disease, especially epidemic disease. So fierce, widespread and frequent were the outbreaks of tuberculosis, typhus, syphilis and plague from the fourteenth century onwards that commanders of well defended but besieged towns and cities, unable to defeat their enemies, commonly waited a few weeks or months for bacteria and viruses to do the job for them. If disease could not win them victories, starvation might do the trick.

Political displays were larger than they are now, in the sense that they often involved virtually the whole of an urban population. They reflected an increasingly fashionable belief not simply in politics as theatre but in the Earth itself as a smaller theatre imitating the larger one of the divine universe itself. Politics ought therefore to be a show, or *trionfi*, as the Italians (after the Romans) termed royal entrances into cities, even a sort of Roman comedy *à la* Plautus or Terence, full of dancing, poetry, clowns, music, ornament, paintings and glittering demonstrations of eternal power. Renaissance political displays thus differed from the pomp and

circumstance of medieval rulers, which centred more or less exclusively about naked military might and knightly skills.[144] In fact Frederick II of Hohenstaufen, at whose medieval-Renaissance court the sonnet was invented, was one of the first of the European rulers, in the thirteenth century, to go modern in this way. The 'flashing comet', as Frederick was known to his contemporaries, made his royal progresses through his Italian domains accompanied by court jesters, a menagerie of exotic animals, an imported harem of tambourine-beating women and German knights fitted out in the latest, shiniest parade armour.[145] He regarded himself as a second Augustus, born to recreate the grandeur that was Rome, with its exhilarating ancient union of power and art, and in his own Christian day their demonstration, always together, of the absolute power of God through the absolute power and creative genius of his earthly representative, the emperor himself.

In 1540, Charles V of Spain was more old-fashioned, if not deliberately insulting to what by then was a customary way for a king to meet his subjects. Fifteen years before he abdicated at the age of fifty five, yielding his Netherlands provinces to his son Philip and retiring into a monastic routine of meditation and prayer, he returned to Ghent, the city of his birth, with a massive army, crushing edicts and a frightening panoply of tyranny that helped to incite the Flemish-Dutch rebellion.

The occasion was Ghent's refusal to finance his war to destroy Turkish imperial forces forever expanding and probing along the North African coast of the Mediterranean (he had scored a serious victory by seizing Tunis from them in 1535) and posing a potential threat to Spain itself through the Moslem city of Grenada. Charles retaliated for Ghent's insubordination, though its Flemish residents saw their behaviour as a natural assertion of their traditional independent rights, among them the right to abstain from financing foreign wars, by riding north to Paris, and then on into Ghent itself, at the head of 60,000 men. He was accompanied by his Queen Regent, Margaret of Austria, and a crowd of splendidly dressed and befurred cardinals, bishops and archbishops, wearing their posh sables and ermines to show off their elegant *hauteur* and to scare everybody and because it was a wintry February 14.[146]

His entrance into the city made up for its weakness in modern Renaissance theatricality with major doses of age-tested murderousness. Nineteen men, whom he judged to be leaders of the resistance, were executed. Prominent officials were forced, on pain of death, and yoked together like oxen, to kneel before him and to swear allegiance to the Spanish crown while begging his pardon. This he deigned to grant only after the Queen Regent, in a carefully rehearsed moment of smarmy compassion, begged him for it herself. Meanwhile, his troops, including thousands of cavalry, were posted at every street corner. Ghent's ancient rights, called Freedoms, were annulled. Heavy fines were imposed on its prosperous mercantile population of nearly 200,000. Property and profits

were confiscated. Most humiliating of all, the city's famous municipal bell, the old bronze Roland, on which were inscribed the rousing words 'When I toll there is fire; when I ring there is victory in the land', was ordered removed.

Popular hatred bristled fruitlessly against kingly contempt, but Charles' crude power-flaunting scarcely resembled Renaissance political displays elsewhere. It amounted to a near declaration of war on his own subjects. Up and down Italy, by contrast, the Borgias and Medicis in their heyday often combined military exhibitions of their power – the sword raised slightly in its scabbard, enough to reveal a sparkle of menace – with the sort of suave urban theatre that everyone could enjoy, or at least gape at in amazed happiness.

Lucrezia Borgia's marriage to Alfonso d'Este in Rome in late December, 1501, for instance, bustled its gem-studded exuberance through a week of public horse-racing, bullfights and races between prostitutes, wild boars and even Jews, with a good deal of cheating by fops in the pay of Lucrezia's brother, Cesare, to make sure that his favourites came in first.[147] Painted wooden arches in ancient Roman style decorated the major streets. Two months earlier as well, on October 30, Cesare had staged a more private stag party at the apostolic palace, in the grand Sala Reale, to celebrate Lucrezia's already concluded wedding by proxy to Alfonso. Fifty prostitutes or courtesans were brought in. Lucrezia and Pope Alexander VI, their father, were invited. After dinner, the prostitutes danced with servants and guests, stripped and crawled about on hands and knees in a soon-to-become-notorious competitive hunt for chestnuts cast rolling across the floor. A sexual potency contest followed, with prizes of doublets, shoes and hats showered on the men whom the prostitutes found able to last longest with them. Everybody watched, to make sure that no one faked his performance.[148]

All this, however, was as nothing compared to Cesare's carnival entrance into Rome to celebrate the Jubilee or holy year of 1500 and his military success through much of Italy. Starting in the mid-fifteenth century, Jubilees, a fairly recent practice borrowed from the ancient Jewish idea of a time of special privileges in Israel, were held at twenty-five-year intervals (the Jewish version, mentioned in Leviticus XXV, specified fifty-year intervals), and marked by a vast influx of pilgrims (usually over more than twelve months), liberal papal indulgences and heavy-handed appeals for money to finance crusades and other Church expenses.

Cesare entered Rome at the Porta del Populo as the new Julius Caesar. He rode in isolated satisfaction at the back of a long procession led by waggons full of the spoils of war carefully sheeted in black, heralds decked out either in the French fleur-de-lis or the Borgia bull emblem, Swiss pikemen, hundreds of mounted cavalrymen and his personal bodyguard, also numbering in the hundreds, with 'Caesar' stitched in silver across

their doublets.[149] His languid progress to the Vatican through the arch-spanned streets, accompanied by his father the pope, at just the moment when the city thronged with 200,000 pilgrims who had mostly walked to Rome for the Jubilee from various parts of Italy and countries to the north and west, or come by boat, and who stopped to applaud or admire or stare at the wickedly colourful costumes and uniforms (he himself wore the strictest black), coincided with the ringing of all the city's church bells and cannon-fire salutes from the Sant'Angelo fortress. Banners billowing from special poles along the route proclaimed his victories to the ignorant.

12. Political Festivals, Masques and the Bliss of Illusion

The sheer extravagance of these displays affirmed everyone's belief in the universe as a work of art, or macrocosm, with the Earth and its peoples billeted in it as a microcosm that mirrored the divine drama of history. A dizzy height was reached with the entrance into Venice in 1574 of the soon-to-be-crowned French king, Henri III, the third son of Catherine de'Medici. Henri had merely stopped off on his way back to France from Poland, where in 1573 the royal electors had also chosen him as their king.[150]

The Venetian Republic thirsted for French military protection. The pale, pious and sensual young king, who at twenty three mingled the human contradictions of his era, wanted to be amused and flattered. The death of his brother, Charles IX, had left a risky vacuum in Venetian-French relations. It might be filled by an extraordinary reception.

The best artists were summoned, among them Palladio, Tintoretto, Veronese and Antonio Aliense. All the major guilds, including the silk-weavers, goldsmiths, mercers, mirror-makers, swordsmiths and shipwrights, spent mightily on preparations.[151] Classical and Renaissance authorities on *trionfi* were consulted, especially perhaps Petrarch. Few doubted the authority of the poet seen by so many as divinely inspired.

The Florentine poet and scholar Francesco Petrarca (1304-74) had been crowned poet laureate by the senate of Rome on Easter Sunday, 1341. He had personally contributed to the Renaissance revival of classical ideas by discovering a number of Cicero's lost speeches and letters, along with bits of Quintilian, and helped to establish the style of modern royal entrances into cities by describing Scipio Africanus' Roman triumph in his epic *Africa* and, in his poem *I Trionfi*, triumphal processions of Love, Chastity, Death, Fame, Time and Divinity (or Eternity).[152]

Petrarch's theme was to show how desire can be transformed into virtue by divine Reason or knowledge. Savage instincts might be redeemed. Eros might thus become love of God, sexual inexperience devout restraint, mortality the gateway to Heaven, ambition humility,

indolence ethical acts and prayer itself a glimpse of the everlasting. In the stormy atmosphere of Italian anarchy and violence from the fourteenth through the sixteenth centuries, with so much blood flowing so democratically from innocent and criminal veins alike, Petrarch's versions of these Christian ideas seemed a sublime relief, both refreshing and inspiring. They also coincided with the selfish interests of brilliant and ever watchful local rulers, such as Cesare Borgia and Lorenzo de'Medici, and their increasing absolutism. In fact Petrarcan allegory seemed to prop up the growing absolutism of monarchs straight across Europe and in England, along with the newish, dynamic notion of the divine right of kings. Partly as a result, his *Trionfi* and his moving sonnets to Laura easily ran through dozens of printed editions, including ingenious pocket-sized ones complete with illustrative woodcuts, rhyming dictionaries and eloquent commentaries by the famous Cardinal-scholar Pietro Bembo (1470-1547). These little books might be consulted by the traveller or pilgrim on the road, as well as the artist or architect in his studio.[153]

Perhaps working from Petrarch's allegories as well as descriptions of Roman triumphs in Livy, Palladio designed a towering triumphal arch for Henri's entrance, modelled after that in Rome of the emperor Septimus Severus, conqueror of Byzantium in 199 and of northern Britain in 208. He also swiped accents for it from the colossal ruins of several ancient thermal baths. The arch was sited on the shore of the Lido before a splendid loggia, which he prepared as an unusual complement to it. The loggia equalled the arch in height. It was buttressed on one side by twelve huge Corinthian columns. Both structures were decorated by Veronese and Tintoretto with carved and painted heraldic emblems, heroic figures from classical myths and personifications of Henri's Catholic Faith vanquishing the Huguenot Heresy.[154]

Palladio's loggia also served as an *ad hoc* temple. It boxed in an altar framed by statues of the four demi-gods of Victory and a painting of Christ by Tintoretto. As a stage set all these elements formed an enchanted place. They congratulated kingly power. It was among them, therefore, on the second day of Henri's visit, that the Patriarch of Venice welcomed him. He was accompanied by the Doge and Venetian officialdom, along with a crowd of guildsmen and their wives, who travelled to the Lido in a fleet of one thousand adorned gondolas. Henri himself, standing in a beribboned galley crewed by four hundred oarsmen, slipped across the Bacino di San Marco from the palace of Bartolommeo Capello on the island of Murano, where he had spent the night.[155] He and the Patriarch retired into the loggia for prayer. The solemn fantasy of Palladio's arch and temple seemed admirably suited to his necessary reserve. He had arrived in Venice both distressed and happy, and embroidered in expensive mourning for his recently dead royal brother.

I. Rubens and the Question of Beauty

On the previous day a parade of gondolas had established a majestic tone for this moment. The next eight days embellished it with entertainments: banquets for five-hundred people, concerts of choirs with stringed orchestras, royal visits to bankers and the famous glass-works, mock naval battles, regattas, balls, opportunities for the king to sneak off in disguise for private shopping and to drop in on a noted courtesan or two and, as icing on the cake, at the Doge's palace a grand masque, or the sort of royal musical play that had become trendy at Italian courts over the past century and whose Humanist-influenced lavishness was already spreading to courts throughout Europe.[156] This palatial drama, staged just before Henri's departure for Ferrara and Mantua on his way back to France, where sixteen years later his odd career of transsexual dissipation led to his being stabbed to death by a crazed monk,[157] proclaimed even more than the other public exhibitions his importance to the city itself.

The reason lay in Venetian ambitions and also in the fact that performances of court masques had become vital to Renaissance ideas of theatre. Masques combined allegory with dreams, myth, music, dance, poetry, folly and royal flattery. By implication, their artificiality (and Venice itself became a type of court masque during Henri's visit) admonished, praised and reassured everyone with visions of the mystery of God and earthly stability.[158] They stimulated artistic innovation and, among their designers, mechanical inventiveness. In masques, politics, religion, the classics and science were duffed into dazzling amusements that were also a universal explanation.

From their earliest beginnings in the fourteenth century, court masques had thus abounded in what are today called special effects. By contrast, theatrical naturalism seemed a deception. It poorly reiterated only what people could see and hear all day long. It ignored the meanings of things. It focused on human shabbiness and cunning unlit by imagination. It neglected the spiritual dimensions of life and events, their hidden celestial vigour, in which God's creative purpose, as in Euclidian geometry, might be identified.

Court-hired painters competed to contribute to masques, as did poets, musicians and choreographers. They argued over how to present heavenly and hellish landscapes, scenes showing the Elysian Fields, revolving models of the universe, hell mouths leading into an Underworld accessible to a spectral ferry captained by Charon, singers impersonating Mercury as he descended with Cupid from tinted clouds, magical tournaments in which courageous knights and their king, who might play himself at a performance, emerged victorious, a new ballet to garnish their victory and at the end salvos of starry fireworks. In August, 1572, for example, these very ingredients, in some respects like those arranged for Henri, came together in the 'magnificence', or masque, *Le Paradis d'Amour*, staged in the Louvre's Salle de Bourbon to celebrate the

Protestant-Catholic wedding of Henri of Navarre and Marguerite de Valois.[159]

The revival of classical Roman drama was also an important catalyst in the invention of these festivals. The idea that 'all the world's a stage', an intriguing theme of many of Shakespeare's plays toward the end of the sixteenth century, had actually caught on as a fashionable belief much earlier. This was not simply because of the popularity of royal entrances into cities but also because it was officially promoted. A pivotal moment had been the staging of Seneca's *Hyppolytus* at the Palazzo della Cancelleria in Rome in 1486. Seneca's Roman play was directed by Cardinal Raffaello Riario, the cousin of Pope Julius II and nephew of Sixtus IV, and himself a wealthy connoisseur of classical theatre (as well as the financial backer of the construction of the new palace).[160] The renewal of Italian comedy, starting in about 1500, can be traced to this performance, as can the transference of Roman theatrical ideas into royal celebrations and masques throughout Italy and elsewhere over the following century. In 1494, for instance, audiences in Antwerp were able to attend a classical Roman play in Flemish for the first time.[161]

Behind Renaissance theatrical politics, in other words, and inflating its propaganda, can be seen several powerful convictions. The first was that theatrical illusion, as long as it paired up with Church doctrine and familiar medieval astronomy, amounted to a revelation of reality, or the actual methods of the mind of God. The second was that special effects, if spangled with mythical details, historical facts and supernatural stories, revealed God's grace. Illusion and artificiality were talismans. Power, even divine power, was understood as sweeping out of both. What to the Mannerists seemed merely ornamental, or bizarre and sumptuous trickery, seemed to the royal political world, and to many ordinary people, essential.

To be sure, such entertainments did not satisfy everyone, and herein lay the seeds of a great, centuries-long dispute over the nature of the real. It continues into our own day.

13. Two Weddings and the Signs of Revolution

The Leipzig wedding of William of Orange and Anna von Saxon in 1561, in the same year as the Antwerp wedding of Jan Rubens and Maria Pypelinckx, mingled magnificence, princely ambitiousness, absurdity and misery. Set against the bloodthirsty practices of the second phase of the Inquisition that was about to be loosed on the Netherlands, it burst as a gorgeous masque-like bonfire before macabre darkness. A decade and a half later, when William's marriage was dissolved, with Anna banished as an ignominious adulteress to Dresden to die amid scandalous poverty, madness and neglect, the darkness had become a vast Netherlands torture chamber. The Rubens family fled it, as did William,

seeking safety not far from his provincial estates in northern Germany. Neither Jan nor Maria Rubens found it there, however, or they lost it, only scarcely to recover it again, while barely, desperately managing to survive.

Both weddings shine even now, however, and brightly, though with the lives of the four participants soon to be violently tangled together, as background lights on the painful struggles to come. They cast mixed beams over their futures. Without their knowing it, because their marriages acted as a beautiful if grotesque preparation for unanticipated terrors, these weddings shaped part of Europe's future. They augured broad conflicts in Catholic-Reformation society and art throughout the Continent.

In the case of William and Anna Europe had never seen anything more wondrous. Not the least of its wondrous aspects was that it took place at all. William the Silent, called the Silent because of his initial unwillingness to tell anyone of Philip II's secret plan to unleash the mass murder of the Inquisition on Protestant heretics in the Low Countries,[162] was the descendant of a long line of German, Flemish and French aristocratic families. At the age of eleven, he inherited sufficient properties and rights in the southern Netherlands, as his German districts were then termed, as well as in France and Brabant, to make him spectacularly rich, at least on paper. He was a devout Catholic, in fact so sincere in his orthodoxy that he soon found himself unable to stomach the shattering impact of the Inquisition altogether, and converted to Calvinism and rebellion. At the time of his wedding to Anna, however, when he was twenty eight, his Catholic beliefs remained intact. Anna herself was a Lutheran.

Their religious differences would not have prevented their marriage. The pope had so far refrained from excommunicating Lutherans as heretics, and in the 1560s and 70s, intermarriages between Protestants and Catholics continued to take place fairly often, especially among the largish group of noble families rather more interested in money and power than religion, and willing to overlook their disagreements over prayer, confession, papal authority and sin.[163] Sometimes, as with the marriage of Henri of Navarre and Marguerite de Valois, their purpose was political-religious reconciliation. It often failed. Four days after the staging of *Le Paradis d'Amour*, on August 17, 1572, setting a seal on Henri and Marguerite's wedding, the Huguenot Admiral Gaspard II de Coligny, who had been specially invited to it by Charles IX, was wounded in an assassination attempt by someone firing at him from a house that belonged to the Catholic Duke de Guise. Fearing Protestant retaliation, and nervous about the stability of his government, Charles panicked. He authorized the infamous St Bartholomew's Day massacre ('I agree with this plan,' he said, 'providing that not one single Huguenot is left alive in France to reprove me for it'[164]). Over the next three days, at least five

thousand Huguenots were murdered in Paris, with many thousands more slaughtered across the country.[165] Charles himself joined in the carnage, using his arquebus to fire off rounds at presumed heretics from the windows of the Louvre.

William and Anna's families were divided less by religion than by personal animosities, though there was a real worry, which William did everything he could to allay, that after their wedding he would refuse to allow her to worship in the style to which she had been accustomed. An even bigger worry, though this time on the Spanish-Netherlands side, centred on William's possibly placing himself under the influence of German factions and noblemen fiercely hostile to the Spanish monarchy and Philip II. Anna's father, Maurice of Saxony, had been regarded by Charles V as a traitor. Her grandfather, the landgrave of Hesse, detested the whole of Philip's Hapsburg dynasty.[166]

William's charm and stubbornness, the very qualities that were shortly to serve him well as the leader of the first modern revolution against royal absolutism, and indeed against Spain itself, won the day. Despite repeated exhortations to abandon the match by Philip and Antoine Perrenot, Lord of Granvelle, the chief enforcer of Philip's policies in the Netherlands and Archbishop of Mechelen, and vitriolic German denunciations of him as a social and money-grubbing opportunist (William had been left one million florins in debt on the death of his father in 1559, most of which was conveniently owed to Anna's grandfather, while her own dowry amounted to 250,000 florins, which would come in handy), he refused to budge.[167] His persistence was the more remarkable in that, as nearly everyone on both sides agreed, Anna was both staggeringly ugly and temperamentally unpleasant, if not insane. Her own enthusiasm over the proposed marriage, expressed in letters after she met him and was apparently swept off her feet during his visit to Dresden for some ten days in 1560, did little to assuage the general anxiety.[168]

None of these problems impeded the brilliance of the wedding itself on August 24, 1561, a rather more cheerful St Bartholomew's Day than the blood-splattered one to come in 1572. Anna's grandfather refused to attend but seemed to withdraw his objections, and Philip forbade the participation of the Netherlands nobility while sending a single emissary.

Thousands of others showed up, including electors, the king of Denmark, the kings and queens of several other countries and principalities and nearly the whole of the German aristocracy. William arrived from his ancestral home at Breda via Antwerp with his ennobled younger brothers and one thousand cavalry. He was met outside the gates of Leipzig by Augustus of Saxony, the Lutheran Elector and Anna's uncle, who commanded four thousand horsemen of his own and escorted him into the city.

Two weddings now in effect took place, one in the grand stateroom of

the city hall to appease the Lutheran prejudice against church cere-
monies, the other the next day at the church of St Nicolas to mollify the
Catholic piety of the bridegroom. In fact the second of these was merely
a benediction presented for what was called 'der hochzeitliche Ehrentag'
(the day in honour of the wedding). The St Nicolas church, which had
been consecrated by Martin Luther himself, was poshly draped with
tapestries, however, and in the nave a full orchestra awaited the young
couple, ready to perform several motets written for the occasion. William
and Anna arrived early in the morning, shepherded by a dozen of Anna's
German counts (she was after all the richest heiress in the land) wearing
gold wreaths on their heads and carrying lighted torches. The aristo-
cratic pair were piloted through the crowds packing the streets by a band
of fifes, drums and trumpets.[169]

Over the following three days, music, feasts for the flocks of guests
and nearly two-hundred tournament bouts between Europe's most
skilful knights bolstered each other in mesmeric succession. By candle
light, after the swank dinners, which offered up as many as twenty-five
courses, the daily clashes of shields and lances in the tournaments gave
way to the bustle of gowns and dancing. During the carnivalesque after-
noons, giant, clumsy-looking acrobats, imported from Prague and
Moscow, performed intricate stunts on horses. For one competition,
scores of knights disguised themselves as Turks, jesters, hunters, monks
and peasants, each sashaying his horse into a ring before the glittering
spectators to the tune of music appropriate to his costume. William
himself had brought a company of mummers, who showed off a type of
entertainment better known to audiences in the Netherlands than in
Germany. Dressed in a fantastic array of gold- and pearl-decorated
doublets, hose and belled caps, they apparently delighted everyone with
their newish style of 'masquerades'.[170]

If an abundance of eye-witness reports remains of William's wedding,
none at all has survived of Jan and Maria Rubens' more modest one a few
months later. On the other hand, a bit is known about it, and a good deal
more can be guessed. As both came from Antwerp, and from well-heeled
Catholic families, it is likely that they accepted what had become the
usual rather magnificent customs of the town for these affairs. Their
marriage feast, for example, while no doubt lacking in the mountains of
gold-leafed plates and silverware prominent at Leipzig's city hall for
William and Anna, and minus as well their dozens of well-mannered page
boys clad in silk, though the Rubens would have had their own domestic
servants plus others recruited for the occasion, probably also ran into
twenty-five or even fifty courses.[171] Everybody's wedding feast seems to
have been gargantuan in Antwerp at the time, and even peasants were
expected to provide an ocean of delicacies for friends and neighbours who
drank and stuffed themselves into the early hours of the next day and
merry, noisy oblivion. The Antwerp fashion in dining, as in the

ponderous chests, chairs and bureaus furnishing most bourgeois houses, streamed into excess. Plumpness, though not obesity, meant prosperity. Generosity with food, and eating it if you were offered it, argued intelligence and refinement.

Carriages – up to fourteen for people as comfortably off as the Rubens, with the lead ones drawn by teams of six horses apiece – were probably hired to take the couple to the elegant Gothic St Jacob's Church (completed in 1491), not far from the Meir thoroughfare and Wapper canal and the crowded St Jacob's market, and three streets over from the corner of Wolstraat and Minderbrudersrui, where Dürer had lived in 1521, for the ceremony on November 29 (a Saturday).[172] Lawyers such as Jan Rubens, with connections to the city government, were normally assigned an escort of halberdiers as well.

The house to which he and his wife most likely returned after their wedding would have been strewn with greenery and flowers. All the walls of the reception rooms were probably covered with mirrors, any that could be scooped up from other rooms – another local custom – and festooned with heraldic insignia. Given the universal passion for the excessive, even the vulgarly excessive, in decoration as well as eating, the ceilings probably shimmered in wreaths and hordes of dangling wax cupids. If, as is likely with the Rubens, their house had a garden, a temple of green branches would have been erected in its midst, over an allegorical flaming heart set between two burning candles; either that, or the temple would have held a small statue of Venus rising from a circle of candles. Both were meant to create a temporary garden of religious and sensual love.

In the largest reception room of the house, if they followed local practice, the bride and groom would have taken their places on two chairs converted into mock thrones with bits of coloured paper, and soon after their arrival but well before the feast, received their guests, who would have brought their presents, ranging from tables and finely carved benches, which had to be lugged in on the spot, to pots, pans and dishes.

The feast itself was an oddly solemn business. It was probably enlivened a bit with music from three or more players on the clavicin, lute and viola da gamba, amid a great crowd that, at least at the start, behaved with decent restraint. A specially composed poem would have been read out – this was a particularly esteemed custom honoured in the poorest houses – most likely in Latin, though poems in French, Greek, Italian and even Arabic were acceptable as long as the tone was pompous enough to seem learned and dignified.[173] The poem would have been effusively flattering to the bride and groom in the stilted style popular then (irony was out of the question), and written on parchment decorated with heraldic designs, to be kept as a memento.

As at Leipzig, though again on a far smaller scale, the Rubens' cele-

brations probably extended over several days. Guests would have returned for a 'repeat wedding party' to polish off the leftover food. New guests would have arrived. The musicians probably came back as well.

All this was usual. In Antwerp as in other parts of Europe, it clearly set out to mimic a number of the elements of royal weddings: the triumphal procession, the mixture of the classical with the contemporary, and the blending of Christian rituals with gifts, music, art and frivolity. Couples such as the Rubens would also have understood that after their marriage they might be flirtatious but not promiscuous, willing (and in the Netherlands allowed) to kiss in public but not licentious. Few people seem to have been prudish.[174] In most cases they were devout, frank and loyal.

At the same time one cannot help realizing that many of the wedding pictures from this era exude a strange stiffness, like that of the bridal pairs in silvery Victorian daguerreotypes. The atmosphere suggests a lost world. Antonis Mor's over-flattering portrait of Anna von Saxon, for instance, made shortly after her marriage, straightens her long nose and spine (she had a small hump over one shoulder), and supplies her with a sympathetic, interested glance that no one else seems to have noticed. It also endows her with a bright, unreal rigidity, as of a bewitched marionette. As one considers these images, one may find it crucial to recall that they were intended as formal certificates of a singular type of wedding and marriage, now largely vanished. They have nothing to do with candid photographs of modern weddings, or their brides, or grooms, or merriment or even, except by implication, love. Instead they matriculate before one's eyes as webs, placid, geometric, delicate, aloof and respectful, in which the husband and wife, or the bride or groom individually, appear caught in an official universe of human trust and cosmic machinery. Beyond the social ceremony of marriage, everyone felt, lay a ceremonial universe. It was essential, much more so to the very survival of the married couple than it is for many now, that the strands of these webs not be broken.

14. Family History

From the viewpoint of understanding particularly original and imaginative people, what if anything is the use of knowing anything about their parents? The question seems foolish. It is broadly assumed not only that the child is father to the man, but also that the mother and father are parents to the child. Yet especially in the case of strikingly powerful and inventive minds, is this necessarily true?

Is it not all too easy, and in the end unrevealing, to assume connections where none or few may exist? Aside from a smattering of facts that may be interesting in themselves, may not a knowledge of the parents actually interfere with seeing the independence and unique choices made by

their unusual children? May these facts not obscure their special person-
alities? Or may they sometimes reveal them more starkly?

On Jan Rubens' side of the family, an Arnold Rubbens is mentioned in
the city records as early as 1396 in connection with the sale of a parcel of
land.[175] He came from a family of well-off tradespeople, possibly tanners.
While information about other direct ancestors of Jan and Maria is
cursory and even murky, a sufficient amount exists to reveal consistent
values transmitted through several generations.

In 1499, one Peter Rubens, a descendant of Arnold Rubbens, living in
a townhouse called The Old Star (De Oude Ster) on Appelstraat, not far
from the Great Market near the centre of Antwerp, married Marguerite
van Looveren.[176] Peter Rubens ran a thriving specialty grocery shop. This
meant that he sold spices imported from the New World and even Asia,
herbs, sweets, finely spiced breads, aromatic wines, pastries, honey, anise
sugar, marzipan, perfumes and makeup (most likely rouge). It also
implies that as the chance presented itself, he worked with doctors,
recommending and selling medicinal drugs: vermifuge (to combat
worms, a common problem), digestible oils, healing plants and possibly
the ineffectual 'cordials' of the sort concocted by Chaucer's physician
against the plague, and desperately sought out during epidemics. Until
1499, no distinction was made between spice-dealers, druggists and qual-
ified apothecaries (apothecaryssen), and Peter Rubens apparently
operated as all three.[177] His wife was the daughter of Jan van Looveren,
an innkeeper with some pretensions to noble descent (he had a coat of
arms). In 1515 his inn, called On the Rhine (In den Rhijn), was incorpo-
rated into Antwerp's first Beurs, an indication of his rising
prominence.[178]

Peter Rubens died in 1527. The eldest of his five children,
Bartholomeus, twenty seven at the time, now found himself responsible
for the education of his under-age brother and three sisters. He also
inherited the family business. Unlike his father, he was an actually regis-
tered apothecary by 1531, a fact suggestive of his greater ambitiousness,
though he may not have taken the strict new training under the royal
ordinances of 1510 and 1517, according to which apothecaries had to face
a board of medical examiners for their licenses.[179] Public success and
profits rather than professional attainments may have sufficed for him.

In 1529, he married Barbara Arents, also known as Spierinck, who
came from a family of Antwerp officials and lawyers. She was the
daughter of Lambert Arent (also known as Spierinck) and Catherine
Bisschot.[180] A moving and informative dyptich, probably painted by Jacob
Claesz van Utrecht and now on display in the living room of the Rubens
House in Antwerp, commemorates the wedding of these two young and
fairly well educated people, who a year later became the parents of Jan
Rubens.

In their diminutive, sleek portraits, the family history becomes more

vivid, though neither of their faces contains a clue to their all too brief time together or to the adventurous, wavering personality of their son. Bartholomeus, wearing a black beret over his ruddy hair and clasping the hem of his fur-edged coat in one hand, as though he were out in a wintry breeze when he is sitting down in a cosy room, pushes himself forward self-consciously at a small table. His primness goes a bit flat as one realizes that in his other hand he holds a disc of gambage, a symbol of his druggist's trade and a strong laxative. His tentative brown eyes ignore it and gaze off into a wholesome middle distance.

In the second portrait, his wife's wistful beauty, her fashionably abased look (has she lost some great dream or merely a house key? – her expression seems enticing and suspicious), fits in with his practicality. She wears a severe white wimple, as was customary, a black cloak and a rich burgundy dress. In one hand, as also per the convention of the time, she holds a rosary, in the other a couple of violets to symbolize her devotion and humility.

This natty yet stoic pair has been inserted into traditional Gothic frames by the artist, presumably to stress their conservatism at a time of religious uncertainty, and beneath foliage borrowed from Bartholomeus' family crest. Its figurative leaves may hark back to his mother Marguerite's family, whose name, van Looveren, means 'of leaves'.[181] The families' joined coats of arms appear on the back of Barbara's portrait. The gold lion of Brabant and the black one of Flanders, in hers, nuzzle against his own leafy emblem, under the year when (most likely) Van Utrecht painted the couple, 1530.

Jan Rubens was born on March 13 of that year.[182] Nothing is known of his early childhood. By 1539, though, or when he was about eight years old, his father Bartholomeus was dead. His mother Barbara had remarried, and with curious constancy selected a second druggist-husband, Jan de Landmetere, whose spouse had also recently died.

Her elder brother, Jan Arents, or Spierlinck, became Jan Rubens' tutor, probably teaching him much of the Latin at which he became so proficient, and quite likely awakening his interest in law and civic administration. His mother's new husband, who allowed him to keep his family name, was equally generous in supporting him some years later, perhaps by the customary age of fifteen, when he attended the University of Louvain (Leuven).[183] De Landmetere must certainly have spotted in his step-son the intelligence and flair for principled compromise remarked on by all who knew him.

The transition to student life threw Jan Rubens into the religious, intellectual and emotional hurly-burly of his age. It also marked the start of his nomadic existence, a dramatic, enforced wandering, in which eventually Antwerp would become more alien to him than foreign lands, and foreign lands no home to him either.

The city of Louvain, on the river Dijle, a tributary of the Schelde, not

far from Antwerp and below Mechelen, was a centre both of Catholic power and more tolerant Christian Humanism. Its university was a beehive of disputes over what Christians ought to think and how to attract and nurture believers. The narrow streets, teeming with students, booksellers and professors from all over Europe, as well as more disreputable hangers-on (quack-pill sellers apparently did a brisk, shifty trade), ran past the Pauscollege, first set up at the former home of a noted alumnus, Pope Adrian VI (1522-23), who had served as tutor to Charles V, to Namsestraat and the oldest of the university's colleges, the Holy Ghost (Heilige Geest), established in 1442.[184]

The city's atmosphere was electric with liberal notions of press freedoms, scholarly experimentation and icy counter-reactions. Erasmus, a former resident who spent his waning years in exile in Basle, had edited Thomas More's Latin *Utopia* for publication there in 1516. His ambition that students would learn the classics in Greek, Latin and Hebrew had inspired his friend, Hieronymus Busleyden, to found Louvain's famed Collegium Trilingue.[185] The influence of its educational methods was widespread, promoting a similar innovation in teaching the classics and the establishment of the College de France in Paris in 1529, as well as parallel educational reforms in other countries. More frighteningly, in 1521 Louvain was the site of an early *auto-da-fé*. This was ordered by Charles V, long before any of these ghastly spectacles of religious execution took place in Spain.[186] In addition, the reorganization of the Church in the Netherlands, whose purpose was precisely to facilitate the operations of the Inquisitors, became the work of Franciscus Sonnius (1507-76), a professor of theology at the university from 1543 on, or when Jan Rubens would have been a student there. Under Sonnius' shrewd plan, clerical power was snatched out of local hands, with outsiders appointed to the highest Church posts in their place. Greater efficiency was quickly achieved in arresting and burning heretics.[187]

Jan Rubens may have picked up his never-to-be-surrendered evasiveness toward religion among the theological scrapping and battles in and around the famous university. Throughout his life he exhibited an atypical and even opportunistic scepticism toward all branches of Christianity, though not toward its basic principles, and toward all claims to spiritual superiority of one sect or branch over another. At this time, too, he probably decided on his career in law and politics. This he pursued abroad. He had realized that no matter how competent the instruction in the Netherlands, his best bet from the viewpoint of fulfilling his ambitions lay in indirections finding directions out, or through Italy. The cachet of Italian training was as yet unmatched. The ancient-modern magnetism of Rome as the nexus of Christendom remained irresistible. Like so many of his contemporaries in the arts and other professions, he headed south, in 1550, to Padua, to Rome itself and later to Provence, 'to cultivate his mind', as one of his descendants

observed, 'and strengthen his judgement'.[188] He stayed away for seven years.

The result, when he returned to Antwerp in 1557, was not merely the prestige of his doctorate in civil and canon law, awarded him at Rome in 1554, but also a smoothly flourishing private practice and access to the loftiest, patrician levels of Antwerp society. In 1562, not many months after his marriage to Maria Pypelinckx, he was elected a city Alderman.[189]

This impressive advancement by the age of thirty one was both allowable and unusual. To appreciate its speed, and the quasi-meritocracy in Antwerp that encouraged it, one may reflect that in mid-sixteenth-century England nearly nothing like it could have happened. Seats in Parliament were the hoarded property of landowners, almost invariably from the peerage. The right to vote was restricted. If in Antwerp in 1562 it was acceptable that the son of a druggist and pill-maker should assume an elective position on the city's highest governing body, it may be remembered that popular elections to the US Senate began under an American Constitutional amendment only in 1913, and that the first working-class person entered the British Cabinet only in 1905.[190]

Jan Rubens' position was nonetheless delicate, a bit like that of Antwerp itself. It could not be sustained. Since 1558, or shortly after his return from Italy, rumours had swarmed about him that he might be an Anabaptist. These he denied. They persisted.[191] A nastiness was brewing, for him and for the city, whose nightmarish risk, gathering among strong undercurrents of religious hatred, had only been made clearer by the glorious *Landjewel* held in 1561, the city's last before the coming disaster. *Landjewelen* (country jubilies) were guild celebrations, plumped out and potentially explosive with plays, including farces (kluchtspelen) and morality plays (sinnespelen) such as the widely famous *Everyman* (*Elckerlijc*) by the Carthusian monk Petrus Dorlandus van Diest (*c.* 1500), with recitations, a parade, music and lots of drinking.[192] They were organized in towns and cities all over the Low Countries at irregular intervals. In Antwerp, the tradition reached back to 1495, but in August of 1561, the year of the Rubens' wedding, the city spent more than ever before, 100,000 florins, on a sprawling display that already looked to many like the swan-song of its threatened sang-froid.[193] Jan Rubens would soon acquire his Alderman's seat, and Antwerp even greater wealth, but only for a falsely bright interval, after which the religious poison began to bubble up in the rankest way.

Permission for the festival from the royal authorities in Brussels was granted only after a good deal of pressure from the guilds. The Spanish government, under Philip II's half-sister, Margaret of Parma (1522-86), had long since grown suspicious of Antwerp's tolerance of the expression and publication of seditious opinions. When the *Landjewel* in fact went ahead, arranged by the most important of the Chambers of Rhetoric, De

Violieren, with other chambers joining in 'merely for the honour' of participating, it proved peaceful enough, though its unprecedented grandness had about it an odour of overblown exuberance.

Lod Torf, in a contemporary account, remarks that previous *Landjewelen* paled into insignificance by comparison with this one, recalling that

> ... the Chambers (including the three from Antwerp, of which the most illustrious, De Violieren, sponsored the festival, while the two others chimed in merely for the honour without worrying about the cost) ... were announced by masses of trumpeters accompanied by standard-bearers, and a total of 1,400 brilliant knights ahead of hundreds of foot-soldiers. In addition, Chambers from other cities brought along twenty-three stage-waggons for performances and 196 travelling waggons as well, on which were sitting even more guild members with banners and flaming torches. And were one to visualize the different riders, all in the same silk, velvet and taffeta costumes, trimmed with glittering gold and silver, then one would indeed imagine a Procession that would have gone far to honour either a kaiser or a king.[194]

Torf adds that the Procession itself lasted from noon till dusk. It was so long that by the time the first marchers reached and filled the square of the Great Market in front of the new Town Hall its tail snaked straight back to the port, many streets away, where others were still waiting to start out.[195] The day was bright and warm. It may be assumed that Jan Rubens and his fiancée Maria Pypelinckx were there. As well known citizens (she came from a family of prosperous merchants), they would have participated. Certainly they were present for the parties everywhere that ran through the night.

15. The Menace of the Reformation

The violence did not begin at once. In fact, to judge from the immediate popularity of Luther's books and pamphlets, the world seemed to have been waiting for his message.

On the other hand, it hardly greeted his denunciations of clerical corruption with glee. Cornelius Grapheus, Antwerp's municipal secretary, had rhapsodised over the new freedom of 'letters' and the 'rebirth of the Gospel of Christ' in 1521, only to find himself recanting under Inquisitorial pressure from Brussels in 1522, sacked from his job and stripped of his property.[196]

Enthusiasm for the Reformers' movement waxed and waned. If it flared up swiftly in Italy, it vanished there almost as fast. In France, initial rejoicing fumbled into enfeebled rejection. Everywhere Church and state opposition assumed vital roles in its rise and fall, as did a prior history of dissent in some areas, such as Flanders and Brabant. In

I. Rubens and the Question of Beauty

Germany and the Netherlands, the long-established publishing industry, with its quick distribution of books and broadsides, became pivotal to its acceptance, which nonetheless always hovered between applause and sabotage.[197] Peasants rebelling against ferociously exploitative landgraves in Germany embraced Luther's ideas, though he himself condemned them for rebelling. Intellectuals such as Erasmus often soured on him after praising him. Humanists erroneously believed that his criticisms of the pope implied support of their new scholarship. When they discovered their mistake, they lapsed into silence. A few, among them Erasmus, launched attacks on his apparent indifference to political and intellectual freedom.[198]

Bafflement abounded. In grasping the effects of the momentous upheaval caused by the Lutheran mass movement, and its important influence on the Rubens family over at least two generations, those of Jan and Maria Rubens and their children, it is crucial to realize that much of what looks like trading in one sort of Christianity for another, and even religious hypocrisy from a modern point of view, was actually part of a tortured struggle to weather torrential assaults on society itself. Often it was a mix of the religious confusion of the time with adaptations to worsening economic conditions. The conditions seemed as much the cause as the result of the confusion. Among people such as Jan Rubens, who abandoned Catholicism for a while (and whose father may have abandoned it before him) and later returned to it, as among many who did not return to it, purity of motive often melted into convenience. Vacillation frequently reflected spiritual malaise. The questions of what and how to paint, for instance, and how to think about art altogether, as well as everything else in life, down to its minutiae, resurfaced nervously in a world whose details were always understood as emblematic of the universal Christian drama. Clashes between Reformists and the Church opened a twilight zone of sunset pain in millions of souls. Only fanatics found simple solutions to these intense difficulties. On occasion, it was impossible to distinguish the fanatic from the philosopher.

Luther himself, along with William Tyndale the century's most gifted translator and one of its finest writers and scholars, seemed a welter of mulish contradictions. Nauseated by the big papal business in profit-making indulgences, which he had seen at first hand on his visit to Rome in 1510-11, infuriated with the luxuriant lives of many Italian and German priests, appalled by the equally contemptuous luxuriance of the ruling nobles in Germany and elsewhere (such as France and the southern Netherlands), while many of their subjects languished in the sleaziest poverty – all of which inspired his call for a return to 'true' and unvarnished Christianity – he still rejected any connection between Christianity and elementary human rights.[199] Politics and religion, he argued in pamphlet after pamphlet, had nothing to do with each other.

Decent housing and fair pay were irrelevant to the Christian cause. The true Christian was 'a martyr on earth'.[200]

'I am opposed,' he wrote in *A Sincere Admonition* (1522), 'to those who rise in insurrection, no matter how just their cause.'[201] He was terrified of 'making Christian liberty an utterly carnal thing', persuaded that 'a worldly kingdom cannot stand unless there is an inequality of persons, so that some are free, some bound, some lords, some subjects'.[202] In *Against the Robbing and Murdering Peasants* (1525), scribbled in eloquent haste at the height of the peasant revolts in Swabia, Franconia and Thuringia and running into a popular twenty-one editions, he urged 'everyone who can [to] smite, slay and stab [the peasants], secretly and openly, remembering that nothing can be more poisonous, hurtful or devilish than a rebel. It is just as when one must kill a mad dog: if you do not strike him, he will strike you, and a whole land with you'.[203]

Catholic and Protestant princes alike responded to this invitation, which reflected common and ancient anxieties about peasants and the belief that they were not merely members of a lower class but also biological inferiors. Dispatching well trained armies against their crudely armed gangs, which committed atrocities of their own, the German aristocracy not only obliterated their amateurish uprisings throughout its various duchies but murdered between seventy and one hundred thousand people who were trying to improve their lives under the banner of Christianity.[204]

The shock of this was unexpectedly great. In part it was a human reaction, in part a measure of evolving Renaissance attitudes toward members of the lower classes. If the slaughter stirred sympathy, the sympathy soon led to vague ameliorations of peasant misery. In Brandenburg at least, but in other parts of Germany as well, peasants gained bite-sized concessions, such as the right to fence in their farmland to protect it from poachers and to loose dogs on it to guard it from foxes and wolves.[205] The sympathy also splintered the Reformists' movement. Those hungering for some swift response found themselves immersed in fresh, slippery squabbles over the application of theology to social problems. In the wake of broad revulsion, Protestant sects multiplied across Germany, Switzerland and the Low Countries. Luther himself pleaded for mercy. Doctrinal differences were tutored by bloodshed, which provoked strains and irreconcilable splits.

Divisions also splayed between Catholics and Reformists. If Lucas Cranach, Luther's lifelong friend in Wittenberg, where he had first posted his Church indictments, continued to swear allegiance to his most extreme positions, Anna Bijns in Antwerp raved at him in her influential poetry as a homicidal agent of the devil, who promised war and starvation.[206] Like many Catholics, she found it barbaric that according to Luther's teachings even 'carpenters [and] masons have become our

theologians', and that ordinary people with no knowledge of Latin might assume that they had better insights into God's will than trained priests and scholars.[207]

It was nonetheless clear that most 'lutherans' at least from the 1520s through 40s had no desire to renounce Catholicism. Especially in Antwerp, with its vast financial resources and its tradition of brooking a variety of beliefs as long as its markets remained unthreatened, they saw their studies of Luther as mere supplements to normal parish services. They dismissed the prohibitions against biblical translations as an aberration, while the idea of a dramatic wrenching away from Rome scarcely occurred to them. It scarcely occurred to their Catholic opponents. Many Catholics themselves saw the measures taken to frighten and punish the Reformists as incomprehensibly harsh. Before 1530, at any rate, there existed no separatist congregations in Antwerp or elsewhere in the Netherlands.[208]

An omen of Antwerp's grim future lay in the fact that the mass violence, when it finally broke out in August, 1566, started with an assault on art. To thoughtful witnesses, a number of whom at once took themselves off to quieter spots in England, France and Germany, this meant that they ought to expect in their own city no mere uprising of lower-class people concerned with alleviating their poverty, which remained a factor after several arid summers and reduced harvests leading to bread shortages, and bread riots in Ghent, or with vengeance on the Flemish landed classes, but a revolt by some of the best educated people in Europe against Catholic civilization itself. They might also expect ghastly responses. A dangerous rabble of Samsons suddenly seemed to be tugging at the columns of the ancient temple. The loyalists inside it, unlike the biblical Philistines, might easily succeed in stopping them.

By this time Antwerp's magistrates had enlisted Jan Rubens as a negotiator and investigator whose job was to prevent religious disturbances altogether.[209] He assumed this thankless task at least one year before the onset of the violence – or iconoclasm, as it came to be called, because at first it seemed aimed exclusively at religious paintings, statues, vestments, reliquaries, altars, baptismal fonts and church buildings. His role was immediately paradoxical. A satirical pamphlet sneered at him as the city's 'most learned Calvinist'.[210] The accusation of hypocrisy, which seemed accurate enough, did not prevent him from interrogating other suspected Calvinists such as Christopher Fabricus and Oliver Bockius in July, 1564, both of whom were later executed.[211] There is no evidence that he sought their deaths, as there is none that he supported the iconoclasm. There are signs that after it subsided he tried to blunt Spanish wrath toward Antwerp and the other cities in which it had occurred. He failed at this, as he failed in his conscientious efforts to mitigate the cruel Spanish reprisals. Indeed, within two years

he realized that he was becoming a marked man and an outlaw, precisely because of his role as peace-maker, and that his best option was to flee the country.

16. The Profanation of Art

Part of his problem, as for all peace-makers at this crucial turning point – and unusual as this may seem to the modern temperament – was that once it started, the iconoclasm actually looked to many Catholics and Reformists more alarming than mass murder (the irony was that it claimed no lives at all,[212] but again, to think solely in terms of lives is to think along modern and not sixteenth-century lines).

Probably its most frightening aspect was its unpremeditated, expanding and for weeks uncontrollable mass hypnosis. Though only relatively few participated in the pillaging and smashings-up, a dozen in one town, a couple of thousand in the next, about one hundred in Antwerp itself, nearly nobody did anything to stop the dour and drab, if often fiery and roving, sacrilegious bands of mostly Calvinist preachers (predikanten) and their poorly paid lackeys: unemployed workers, whores, adolescent boys and groups of Calvinist refugees come back from exile abroad. Outside the major churches, huge crowds looked on, transfixed by terror, incredulity, dazed helplessness and morbid satisfaction, as magnificent altarpieces, illuminated Bibles, censers, chalices, carved choirs, pews, gilt crosses and hundreds of superb statues and portraits were dragged into the streets, trampled on, torn, mangled and burned or melted down.[213] No one had ever seen anything quite this appalling. Its brazenness seemed a horror even to its numerous sympathizers. If, as everyone believed, all the Earth was a stage, or a microcosmic theatre of the universe, these bizarre desecrations comprised a feral attack on one image of that theatre, or at least on its supporting Church. The iconoclasm appeared a hideous overture to a liberating or enslaving apocalypse, no one knew which. Scattered outbursts of icon-breaking had occurred over the previous decades, but none resembled the zigzaggy conflagration that now swept the southern and northern provinces of the Low Countries from August 20, 1566, into the early autumn.

Official resistance collapsed. In some towns the hired burgher or citizens guards (schutters) refused to lift a finger to defend the property, as they saw it, of 'church, pope and monks'. In others, they took part in the burning and vandalising.[214] In Antwerp, where the assault began just after vespers, with the eviscerating of the Cathedral of Our Lady, and where hundreds of pious trophies and paintings were destroyed by the jeering mob, the city magistrates, with Jan Rubens most likely among them, at first tried to intercede and then fell back in quarrelsome disarray. Over a two-day period, some thirty churches within the city

walls fell to the flamy eruption. About four hundred did so over the next few days in Flanders alone.[215]

Lamentations over the loss to the human spirit of much of its most wonderful art, coupled with increased outrage, but this time pointing at the presumed ignorance of the Reformists, echoed at Spanish courts from Brussels to Madrid, as they continue to echo over the centuries. Nearly all the great altarpieces of the Low Countries were sacrificed at one horrid blow – and for what?, it was asked – for the sake of a useless gesture of resistance to new and loathed Spanish authoritarianism, to the intensifying Inquisition under Philip II and to suppressions of the Calvinists themselves, with their stripped-down, puritanical moralising and their contempt for poshly decked-out churches.

As is often the case with unsubtle emotional reactions, however, the justifiable anger misted over and even today muddles fair-mindedness, in this case a simpler and more apt understanding of the motives of the art-wreckers. In particular it prevents the so-called iconoclasm from being seen on its own terms, apart from social defiance: as the world's most violent instance of mass art criticism, as a blast aimed quite rationally at a singular type of artistic representation. Once the anger is excepted, it may be admitted that the weeks of wrath poured out on churchly art have been to some extent mislabelled and misconstrued.

Some of the objects destroyed, for instance, such as chasubles, gilt lamps, lush copes and chandeliers, no doubt sparked resentment for their sheer opulence. Others, such as stained-glass windows, paintings and statues, were destroyed not because they were icons but because they were not obviously icons, or because they were no longer perceived as such. Instead they were understood quite correctly as specimens of the new, brilliantly naturalistic art.

The differences between the two, between iconography and naturalism, which may also seem peculiar to modern eyes, were decisive, revealing and important. In fact the principles of naturalism could not easily be associated with icons. The reason was that while icons' other-worldly colours and outlines might be suggestive of specific religious figures – of Mary, the mother of Christ, for example – true icons never so much represented appearances as incorporated miraculous powers. Icons were like divine wands. They could heal. They could soothe. They could relieve melancholy. They could elate by seeming to cure, as might an anodyne or medicine. They could respond to prayer. They were alive with ghostly glory.[216]

During the fifteenth and sixteenth centuries, however, a shift had been in progress among Christian artists, from producing sacred figures and paintings whose rigid formulas were thought to possess miraculous powers, to making statues and paintings whose naturalism depicted religious dramas (and which therefore required historical research for the sake of accuracy). The art destroyed by the 'iconoclasm', or a good deal

of it, was transitional between the miracle-capable, as people thought of it, or the iconic, and the historically ambitious work of the best Renaissance artists. Its vulnerability resulted from its having ceded its miraculous vitality. The better the art from a naturalistic point of view, the more likely it was to provoke disgust among tradition-minded purists. To the mostly Calvinist 'iconoclasts', it appeared false, powerless and offensive. An alienated Church seemed to them to be developing in their midst, with alienated, a-religious and fearful intentions, as revealed in its alienated art. It must be driven out.

This was no doubt why Jan Rubens' peace mission was doomed from the start. Each side in the debacle over Christian art was convinced of the chasteness of its cause. Under orders from Philip II, Margaret of Parma demanded of the Antwerp magistrates an account of their behaviour during the image-breaking. Jan Rubens collaborated on an official description of it. This turned out to be a recitation of the city government's queasiness in the face of the rampaging Protestants. With uneasy reluctance, it was submitted to the Brussels court almost a year and a half later, on January 8, 1568.[217] By then fresh riots and acts of rebellion against Spanish rule in Antwerp and across the Netherlands, accompanied by Margaret's own forced acceptance of the right of Protestants to worship in churches of their own (part of the iconoclasts' goal was to denude the Catholic churches so that they might use them for their own very different services), had embittered relations nearly to the point of armed conflict. Indeed, at Philip's court in Madrid, the decision was taken to deploy an army and the utmost ferocity against the threat of Protestant heresy.[218]

A novel type of violence was now about to be loosed on the world. It was a creature of its times, and of its often gifted if self-righteous personalities. It mixed executions with religion, publicity, ceremony and a theatre of terror on a scale never before seen. Its purpose was not military or police victory but human cleansing and eradication, leading eventually to wholesale slaughter. Its hope was no political conquest but sacred affirmation and social purification. Its costumes, uniforms, troops, insignia and edicts were understood not as mere symbols but as divine realities granted earthly expressions, in much the same fashion as, in reverse, the art burned by the 'iconoclasts' was perceived as a devilish corruption. The wrecked art had after all been blessed by the degraded fingers of priests and cardinals, and defiled, as many believed, by unchristian fiendishness.

In this ominous situation, God's Reason was interpreted everywhere as unreasonable and rigid. Compromise meant defeat and, worse, disgrace. The day after the 'iconoclasm', among Antwerp's disordered streets piled with broken glass, torn canvases, ashes and painted wooden arms that had been raised to beseech God's mercy, many realized that a great struggle had begun over the quality of the miraculous and human

nature itself. The ruthlessness attendant on this struggle, and its ensuing violence, would last for eighty years. They would change world history.

17. Philip II and the Revolt in the Netherlands

It is not clear that the acquaintances of historical figures understand them best. If passing time erases intimate details, it may also reveal the essences of secretive personalities, as when a gold miner drains off brackish water and leaves a couple of nuggets gleaming dully but unmistakably in the sun.

Philip II (1527-98) was the type of person who sees only one side of a question. If he could not see even that, as often happened, he said nothing. He also did nothing. Several of his acquaintances have attributed his reticence to prudence or hesitation.[219] It seems more likely to have been due to intellectual and emotional simplicity.

This is not to suggest that he lacked intelligence or emotions. On the contrary, he concentrated his adequate mind with steely narrowness on religion, war, money and public monuments. If he was confused, he listened. If he was criticised, he blushed. Throughout his life, he retained a belief in his own gentleness. This was managed by avoiding introspection and waving off information about the thousands of murders resulting from his instructions. He had always been a religious fanatic, or the sort of ideologue who confuses clarity of passions with clarity of ideas. Usually the two are opposites: emotional clarity is a signal of mental intransigence. Philip seems to have been ignorant of this possibility.

In fact he was a perfectionist. Most of his working days were devoted to reading and signing documents concerning the pettiest matters across his enormous empire. As he signed them, his empire shrank. It repeatedly went bankrupt. Society and industry stagnated. Micro-management became self-defeating. It lacked both analysis and the perspective of self-examination.

Philip's constant immersion in trivia also showed up in other ways. Some of them were exciting and useful to posterity, others irrational. He became an ardent collector, of art, books and manuscripts, as well as of 7,000 iconic bones, ten saints' bodies, 144 saints' heads, 306 saints' arms, teeth, toenails and legs (all encased in silver) and four wives.[220] These he ultimately enshrined in several of the more than 1,200 rooms of his memorial palace, the Escorial, built between 1568 and 1584 at a cost in today's money of $200,000,000 or so, thereby keeping a promise he had made to Saint Laurence at the battle of San Quentin on August 10, 1557, that in gratitude for his victory over the French he would erect the most elaborate church-building ever seen.[221] Much like the king himself, this huge, square edifice, stacked across a plain between mountains thirty

miles north of Madrid, has always incited extreme reactions. If Theophile Gautier saw it in 1843 as 'this desert of granite, this monkish necropolis', with 'little crushed-looking windows, looking like the cells of a hive',[222] and the American historian John Milton Hay in 1871 found its 'blank walls and that severe facade' lacking in 'any trace of human sympathy' ('I know of nothing so simple and so imposing as this royal chapel [rising three-hundred feet from black and white pavement], built purely for the glory of God and with no thought of mercy or consolation for human infirmity'[223]), and the friar Francisco de los Santos in 1650 rejoiced in it as the 'wonder of the world', with its masses of jasper, and its cascades of marble staircases,[224] Alexandre Dumas in 1846 seemed to find in it a sketch of the king's gloomy-defiant, medieval-Renaissance character:

> Approaching it, one realizes the insignificance of man in the face of its gigantic bulk. ... It is like nothing but itself, created by a man who bent his epoch to his will, a reverie fashioned in stone, conceived during the sleepless hours of a king on whose realms the sun never set. No one could call it beautiful. It evokes not admiration, but terror. Even Philip himself must have shuddered when his architect handed him the thousand keys of this monument conjured up by his inflexible spirit.[225]

His inflexible spirit was even better captured, together with his wobbly rage, by Antonis Mor in a portrait done in 1557, when he was thirty (and which today hangs in the Escorial's library, though the building itself was later to assume an enormous importance for Rubens).

Mor's painting has many attractions, but the strongest impression produced by it of his subject's character is that of a man who is trying to hide his dread that he is not up to the job of being king. A sloped face, with a straight nose, his hardiest feature, a weak chin, oblique blue eyes, whose expression seems flimsily arrogant, thin sideburns, a slip of a goatee and weak, Epicurean lips, sits on a head obviously too large for its body. The mismatch between head and body is disturbing. His body is a slackness, a lopped reed. He stands, looking past the viewer, in an attitude of mock challenge, in gold and black parade armour (Mor painted him just after the success of his 50,000-man army at San Quentin, which he supervised from some twenty-five miles away, or at a safe distance[226]), one hand on his sword hilt, the other grasping a sceptre symbolic of royal power. The effect of this curious pose is to thrust his arms into a pair of parentheses enclosing his body, as if he regarded himself as a foolish thing that did not count, that ought to be tossed onto a rubbish heap.

Mor's frankness in painting him so revealingly is astonishing, as is Philip's laxness in letting him do it. One might argue that his posture suggests humility. What seems more reasonable, and is indeed a feeling hard to avoid, is that it shows a bland self-innocence, of which Mor was aware. Philip perhaps thought of himself as presenting the world with much tougher, kinder stuff than he had on tap. The truth seems more

perilous: a fierce, bleak self-loathing that is masked by shyness that is freckled with aggression: omens of secrecy, conspiracy and a sumptuous disdain for human life.

On the other hand, there is no question that he loved his empire, good books, fine painting, his fourth wife Anna, the daughter of Emperor Maximilian II, his eldest son, Don Carlos, by his second wife, the Infanta Maria of Portugal, who died in 1546, tournaments, hunting and lovely women, at least one of whom, Eufrasia de Guzmán, became his mistress.[227] At the same time, his austere domestic life at his palace in Madrid resembled his foreign difficulties, which were self-induced, and the barbarism that he practised in his northern provinces.

Don Carlos heartily hated his father, suspected him of plotting his assassination, slept with pistols under his pillows and kept two loaded arquebuses in a nearby closet.[228] At the age of twenty three, he was arrested by his father, who also feared assassination, but at his son's hands. Some weeks later, Don Carlos was either strangled on Philip's orders or committed suicide.

Don Carlos himself, despite his veneration by Schiller as a tragic hero and potential liberator of the Netherlands, had a volatile and peculiar personality that makes veneration tricky. Once, because a few drops of water fell on his head from the balcony of a house, he ordered it burned to the ground and its occupants killed (the order was not carried out). When his pet snake bit him, he bit off its head. While a student at the University of Alcalá, he hurled a woman with whom he was angry against a wall, doing so with such force that he thrust himself down a staircase and suffered a concussion. On being allowed to take out his father's favourite horse, he spurred it so cruelly that it collapsed and bled to death. A nobleman who failed to answer his summons quickly enough was almost thrown through a window. When a shoemaker produced boots too tight for him, he had them cut apart, cooked into a stew and served up to the man, who was happy to eat them because he feared the worse penalty of execution. On hearing that the Duke of Alva had been appointed commander in the Netherlands, the prince, who had wanted the post for himself (and who had been promised it, until his father decided that he was untrustworthy), attacked the Duke with a dagger. The two men fought wildly, tumbling to the floor and rolling about snarling.[229]

In features he seems to have been a blow-up of the king, a type of Baroque Philip, large of head, nervous, pleasure-seeking and cunning, though with a yellowy, darkish complexion, twisted legs and a small hump above his shoulders. His expression alternated between towering leers and frivolous grins. His father probably considered him mad. The intricate, poisonous relations between most members of the royal household, however, which frequently turned solicitousness into revulsion – Philip regarded his third wife, Mary, the queen of England and prede-

cessor of Elizabeth I, with ill-disguised contempt (he spent only fourteen months with her in London, though he was grateful for her money) – make it difficult to distinguish in the case of Don Carlos between mere psychopathology and jealous evil.

In this gruelling, strained atmosphere, which was not without its brilliant lights, even if they often seemed lights in a fog thickening across a darkling plain, Philip presided over his world, and the world of millions of others. Within it, he received reports about the uprising against his rule in the Netherlands, listened to his advisers, tried to batter together a consensus on policy among the members of his council of State and eventually made his decisions, or let matters slide into *de facto* decisions because he found it more tactful to do nothing, and accept no responsibility for what happened.

As far as the Low Countries were concerned, it seems clear that he viewed them with distaste for their grit and rebelliousness, admiration for their industry, literacy and art and envy for their wealth, which he needed for imperial purposes. He found it embarrassing that only the Plantin publishing house in Anwerp, and not one in Madrid or elsewhere in Spain, had the expertise to do justice to his grand polyglot Bible, brought out in 1568, and that he was forced to send his own librarian-scholar, Bênoit Arías Montanus, to Anwerp to act as Plantin's consultant.[230] He found it galling, on the heels of the iconoclasm, that the Inquisition and his other suppressive policies had so far inspired only increased resistance, and that a formidable army, led by Ferdinand Alvarez de Tolédo, the Duke of Alva (1508-82), had to be sent north to put the rebels and heretics in their place.[231]

Still, the Netherlands could be handled. In solving his political problems, Philip always proved as astute an evaluator of the uses of sadists as of artists, however the quality of empathy might elude him. In Alva, who came from an old family of Spanish grandees, and who had shown himself to be a reliable strategist in a fistful of battles, including that at San Quentin, which he had won for his king with a series of cut-and-thrust sallies that left over 5,000 French dead in the field, as against a Spanish loss of less than three hundred, he found just the sort of uninhibited, unhesitating slasher that the Netherlands dilemma seemed to require.[232] Philip's father, Charles V, had early warned him of Alva's megalomania while praising his soldiering as 'the best that we have at present in these realms': 'You are younger than he: take care that he does not dominate you. Be careful not to let him or other grandees get a firm footing in government.'[233] Philip heeded this advice while embracing the sour bloodthirstiness of the taller, older military man with his forked, limp beard. Charles had underestimated his son's desire to match and exceed his own impressive conquests.

He had also not understood Philip's intolerance, which was to develop into majestic proportions. In 1548 Charles had invited him on a tour of

his imperial domains. This took him through Italy, Austria, Germany and up to Brussels, where on April 1, 1549, the emperor greeted the son whom he had not seen for six years with a magnificent welcoming parade, witnessed by 50,000 people.[234] Philip next spent six months travelling through each of the seventeen dyke-wrapped provinces and being affirmed by his father in them as king-to-be. It was a time of carefree fun and games for him, sugared with flirtations and jousts, alongside William of Orange, for instance, who was not yet an enemy and who shared his own appreciation of chivalric poetry. The fact remains, however, that the local Flemish and Dutch populations felt no real affection for him, in part because, unlike his father, he spoke neither Flemish, nor its Dutch variant, nor French, nor any language but Spanish.[235] A second visit to Brussels, this time as king, after Charles' death in 1558, scarcely tempered the general wintriness of his reception.

Even his lavish royal buying spree in Brussels, his last, because he was never to come back, seemed cast under a pall. On his uncomfortable but costly voyage home from Flushing, in August, 1559, he was borne amid the hems and folds of a colourful fleet across the North Sea through the English Channel, and then into the Atlantic, by adroit winds and hearty gales, and soon by tempestuous gales. As his cumbersome collection of ships headed for its landing at Laredo on September 8, the waves and storms turned so rough that fifteen ships of the ninety sank beneath looming crests, taking with them a good many of his purchases, including tapestries and 15,000 capons. Hooft, in his history, reports that to lighten the cargo it became necessary to throw overboard a good many masterpieces of Flemish fabric and, as he archly notes, 'to enrobe the roaring waves with silks'.[236]

Philip's indulgence in luxuriant waste was immediately followed by a more spectacular one in human depravity. He had arrived too late to witness Spain's first *auto-da-fé* involving executions on May 21 in Valladolid. He was early enough to observe and relish the second at the same city on October 8. These two morbid, pompous displays heralded three generations of religious cruelty, of a scuppering of people hitherto unmatched for its calculation and arrogance. With the ceremonial participation of the Bishop of Çuenca, as well as the king's sister, his son, a host of government officials and thousands of citizen-witnesses, thirteen prominent heretics were burned to death. When one of them, the nobleman Carlos de Sessa, asked him how he could authorize these executions, he is reported to have said, 'I would bring the wood to burn my own son, if he were as evil as you.'[237]

18. The Flight into Germany

As a direct consequence of Alva's murderous polices, Jan Rubens and his family fled to Cologne in December, 1568.[238] William of Orange and his

wife, correctly anticipating what Alva might do, had absconded over a year earlier, in May, 1567, to William's ancestral estates in Dillenburg and Siegen.[239]

Alva had marched north from Spain, conducting a superbly costumed force of 10,000 Castilian soldiers, plus their wives and the usual prostitute camp-followers, over the 'Spanish road', which ran through Italy and the Alpine passes and avoided apprehensive, mistrustful France. His professional regiments were to form the core of an eventual 60,000-strong army, along with 12,000 cavalry, to be hired in Luxemburg or neighbouring Franche-Comté.[240]

Fully fledged out with these troops, he arrived in Brussels on August 22, 1567. Though sixty years old and ailing, he wasted no time. Against a background of the rival recruitment of mercenaries by some of the Flemish Calvinist nobles planning on open insurrection, spreading waves of Protestant sympathy surging through Antwerp and rumours that William was busy in Germany trying to form a league among Reformist princes to assist him in invading the Low Countries, the new military governor at once set up his Council of Troubles. The purpose of this unprecedented institution was to concentrate judicial powers throughout the provinces, including the power to stage arbitrary arrests, trials and sentencings of anyone at all, in his own hands as virtual dictator.[241]

Humiliated by Alva's sudden assumption of total power, Margaret resigned. She left for Italy on December 30. Not the least of her problems was her horror at being associated with the Duke's arrest on September 8 of the leading Netherlands noblemen Counts Lamoral Egmont and Philippe de Montmorency Hornes, each of whom, as members of the celebrated knightly Order of the Golden Fleece (Philip was himself a member), enjoyed vast prestige throughout the provinces. Hornes had returned from Germany at her invitation. Egmont had remained in Brussels, also at her invitation, to help further peace negotiations with the dissenters. Both would be publicly executed by Alva's Council of Troubles some nine months later, on his express orders, in a theatrical beheading scene that would outrage the noble classes from London to Prague ('I am thoroughly pleased and satisfied with everything you are doing,' Philip wrote to him on September 9, before he knew of their arrest, but approving of his methods[242]). The Council itself soon became known as the 'Council of Blood'.[243]

If Alva's protestations are to be believed, he repeatedly suffered pinches of regret over the campaign of killings on which he now embarked ('I have always loved and esteemed [them] as my own brothers,' he wrote to Philip about Egmont and Hornes after he had them executed[244]), though there is no evidence that this appropriate passion was ever translated into remorse, or shame, or guilt, or that it affected his slaughterous behaviour in the slightest. Regret, it seems, was merely an armband to be worn on special occasions, as when addressing

his king. Sorrow was a form of politeness. Alva was an early representative of a new breed of careerist that began to proliferate in European capitals at this time, as again fashions in leaders changed, to whom edicts were more important than lives, and who valued ideology over pity.

Clues to his personality are still to be found in William Key's portrait (1568, now in the Collection of the Duke of Alva in Madrid) showing his coffee-coloured eyes, peculiar neck and cauliflower-white complexion, symptomatic of the gout which he bravely endured through his years in the Netherlands. In Key's painting, his broad eyes are displayed as exceptionally wide apart, staring and school-teacherish, while his neck, albeit hidden among the metallic pleats of his tournament armour, is not only thick but exceptionally long, shimmying his head to a strange height above his shoulders, as if it were unhappily moored to his body. His disdain of the general run of humanity was indeed matched by a soaring piety.[245]

His managerial abilities were commendable. While William assembled his fragile resources at his two small castles in Dillenburg and Siegen – a few thousand men to start with, plus some two-score knights, aides and their families from among the one-hundred-fifty people who had fled with him into Germany, hardly a force from which to expect a revolt to be launched against the arrayed military power of the king of Spain – Alva coolly devoted his energies to awakening terror and enforcing loyalty to the crown.[246]

Heretics were pronounced traitors. They came under an automatic death sentence. Oaths of allegiance were required of all officials. Most magistrates were removed from office. Alva replaced them with Spaniards, or men of Spanish descent. The property of roughly 9,000 people, Catholics and Protestants alike, was confiscated.[247] Because disloyalty to Philip might be presumed to be festering throughout the population, as many Catholics as Protestants were abruptly thrown into prison, drowned, beheaded, garotted (with the notorious Spanish invention of an iron collar tightened by a screw) and shot. Books, that most subversive enemy of authoritarianism, were everywhere seized in a series of raids on publishers and book shops. At Tournai alone, on June 16, 1569, five-hundred suspect volumes were swept off the sellers' shelves and consigned to the public flames.[248]

During the first two years of Alva's rule, his Council of Troubles ordered the arrests, prosecutions and trials *in absentia* of at least 12,000 people. Over one thousand of them were sentenced to death and executed.[249] At the same time, Baron Floris de Montmorency Montigny, a member of the Golden Fleece, who had gone to Madrid to plead for mercy and to try to conduct peace negotiations with Philip directly, was placed under house arrest (he was later strangled in secret, no doubt at Philip's bidding, in October, 1570[250]). More ominously, Antwerp's Burgomeister, Anton van Straelen, was executed on Alva's orders at Vilvorde on

September 24, 1568.[251] By late 1568, Jan Rubens himself had appeared on Alva's list of suspected traitors. A pamphlet denounced him, this time as a confirmed Calvinist, and after eight years' service in his Alderman's post, he was refused reelection. He submitted a brief in his own defence, denying any wrongdoing, whether political or religious. He also at once made arrangements to resettle his family abroad, sending his wife and children away into Germany while he stayed behind to secure a testimonial from Antwerp's City Council.[252] This affirmed his honour and asked that he be well received wherever he went.

A hideous fear began to eel across the Netherlands, compounded by the universal dread of execution. It is reliably described by Marnix van St Aldegonde, a close friend of William of Orange, in his *Libellus supplex Imperatoriae Maiestati* (published in English by John Daye in 1571 as *A Defence and true Declaration of the things lately done in the lowe Countrey whereby may easily be seen to whom all the beginning and cause of the late troubles and calamities is to be imputed* [those imputed are Cardinal Granvelle, Alva's predecessor, Alva himself and Philip II]). Marnix's purpose in writing his *Defence* was to enlist financial and military support for William's rebellion from sympathetic German princes, to whom it was presented as a petition on October 26, 1570. He speaks, for instance, of Alva's freighting the gallows with hundreds whose only crime was to have listened to Protestant sermons, and adds that 'he destroyed many with the sword, he burnt many alive with a small fire, he beheaded many before their causes were pleaded. Many he spoilt of their goods and possessions, poisoned to death with the filthy stink of continual prison.... He cut out many of their tongues (whom he put to death afterwards), lest they should testify of so great injustice. He burnt many of their tongues with a hot pair of tongs, and to some he tied their lips together through with an iron, sharp on both sides. Others having their mouths most beastly set awry with terror and anguish, the matter and blood dropping down together, he cruelly drew to most pitiful slaughter.'[253]

As often with atrocities, individual cases best suggest their arbitrary cruelty: 'In the town of Maastricht he put a father to death because he had for one night lodged in his house his own son, which had been for a space absent before. And likewise he murdered another well known citizen, because he gave the sixth part of a bz. of corn unto a poor widow, burdened with the keeping of four children, whose husband was before put to death for religion's sake.'[254]

Alva's loyalty oaths produced their own excruciations. The conflicts kindled by them among religious people of all sorts are typified by the story of Dirk Willemzoon, an Anabaptist, whose 'offence' was to have associated with other Anabaptists. He was arrested and condemned to death, as was universal with everyone who professed Protestantism, but he escaped. With an officer in hot pursuit, he fled across a frozen lake. He

made it to the other side, but the officer fell through the thin ice and seemed about to drown. Willemzoon, who took his Christian charity seriously, raced back at great risk to his own life and hauled him out. The officer at that point would gladly have let Willemzoon's case drop, but the Burgomeister of Asperen saw their situation differently. He reminded the officer of his oath to arrest all Reformists and condemned men, and threatened him with death. Willemzoon was thereupon arrested by the man he had saved, and on May 16, 1569, burned at the stake.[255]

Such tales, multiplied by their thousands to indicate how the army of lights swizzling through the Low Countries moulted into arsonous lights of death, only reveal an intensification of prior terrors. A modern evaluation may also reach back to allow glimpses of their overtures. The story of Francis Junius offers one among many that might be cited. A brilliant twenty-year-old French Huguenot preacher on the run from the Inquisitorial police, he possessed boundless insolent courage. At Breda in 1565, he delivered a sermon in support of the Reformed Church in a room just over the marketplace where several Protestants were going up in flames. The light cast by their burning bodies shimmered through the windows as he spoke, before fleeing to other towns to carry on his work with a zeal for life that equalled Alva's eagerness in murdering heretics.[256]

19. Refuge in Cologne

At first, Cologne seemed a relief. Beyond the surrealist death-lights flickering across the Low Countries, there had fallen over their northern cities and fens a cold, sturdy beam of hatred. Already much of the population had surrendered to previously unknown disciplines of betrayal and rebellion. These were still restrained by practicalities, apprehension and self-interest, but only because they had not yet focused on a goal. Antwerp, whose port remained crowded each day with hundreds of ships, but whose prosperity seemed precarious as its population was increasingly threatened, suddenly looked far less auspicious than the German, church-masted city of 40,000 on the Rhine, with its two-hundred steeples, broad squares, profitable cattle and agricultural markets and its tradition of extending hospitality to immigrants.[257] On arriving there, Jan Rubens had no idea that he would never return to Brabant.

Some forty-eight years earlier, in 1520, on his way to Antwerp, Albrecht Dürer had bought one of Luther's pamphlets in the city, and one attacking him, the *Condemnation of Luther*. He had purchased 'a little skull' (ein kleiner Schädel) for two white pennies.[258] He paid two more pennies to the cathedral caretaker to view Master Stephan's altarpiece, the *Adoration of the Magi*. In the evening, he had gone out drinking with his travelling companions. On All Saints' Day (November 4), he attended a dance and banquet in Charles V's 'dancing house', noting that 'it was

splendidly done'.[259] He visited other churches. There he saw various relics and bought another skull, a little ivory one. He thoroughly enjoyed himself.

Some forty years hence, in 1608, the English prankster-traveller Thomas Coryat, whose dalliances with Italian courtesans are probably made up but whose descriptions of towns and cities in Italy, Germany and the Netherlands are apparently trustworthy, found Cologne ('where the Netherlands begins') 'delectable'.[260] The city seemed smallish to him, so that he needed only 'a four-hour walk to make a compass of it',[261] and was situated, as he enthusiastically observed, on 'a pleasant and fruitful plain hard by the Rhine, which washes its walls', with 'many houses four storeys high, some of stone, others of timber', and 'a vast number of turrets in them'.[262] He surmised that it had more churches than Venice.

In between, the city had shifted from acceptance of Luther's Reformists into a strictly Catholic revival. This was fostered by the Jesuits, who first settled there in 1544. Coryat himself acknowledged that Cologne lay 'under a Roman Bishop',[263] aware that as a Hapsburg imperial city amid a sea of Protestants it had for seventy years by then been officially Catholic, with its inhabitants harbouring intense suspicions of non-church-goers, Calvinists and other Reformists. Like many other German cities, it had witnessed its own iconoclastic outburst, in 1536.[264] Crucifixes had been torn from their altars and broken. Their naturalistic Christ figures had been decapitated. As later in the Netherlands, the idea was to ridicule the doctrine of the Real Presence, or the belief that Christ was miraculously present in the Eucharist.

Jan Rubens at once fell afoul of Cologne's intolerance of Calvinists, but he had not come unprepared. For one thing, his usual scepticism about religion and religious conflicts left him with no serious qualms about reverting to Catholicism. For another, he found as if awaiting him profitable opportunities admirably suited to a lawyer with his qualifications among the hundreds of other Flemish refugees who had immigrated to the city. Their property, like his own and his wife Maria's, had been 'sequestered' by the Spanish authorities. There existed a faint hope of reclaiming it, or of doing so in the future, and his ability to conduct a correspondence in five languages – Latin, Italian, French, German and his native Flemish – attracted clients. In no time, he had established himself in society, with messengers from the city council calling him by the false but noble-sounding title of Herr von Rubens.[265] He and his wife lived at first in a house on Weinstrasse, along with their two sons and two daughters, Jan-Baptist (born in 1562), Blandina (born in 1564), Clara (born in 1565) and Hendrik (born in 1567).[266]

Among the clients drawn to him was Anna von Saxon, whose emerging wildness, arrogance, alcoholism, desolation and need of money precipitated a catastrophe, though one with important consequences for the history of politics and Rubens' art. Anna had always been unhappy with

William of Orange in Breda. Her infatuation with him had faded. The glory of her wedding was forgotten. Her husband's public support of anti-Spanish Calvinists, his immersion in seditious and revolutionary schemes, his absences, his brooding, his continuing coldness toward her (had he, after all, only married her for her money?), bored her and roused her to a rebellion of her own. The Landgrave William of Hesse, her uncle and partisan, defended her degraded reputation by arguing that anything unpleasant about her behaviour must be her husband's fault. By thoughtlessly plying her with books full of 'diverting tales of love' instead of 'good Christian' ones, and exposing her to a lot of immoral Netherlands dancing and parties, he had turned 'a virtuous woman, who was young and who like other people knew nothing of human flesh and blood, into a dissolute consort'.[267] About her dissoluteness there could be little doubt. She had discreetly taken a couple of lovers. She liked a hefty glass or two of wine in the morning, followed by a few more big ones in the afternoon. These led into fits of delirium, accompanied by the most vulgar language. She had a habit of throwing her food at her servants. She whipped them and threatened their lives. She often required physical restraint in the midst of her maniacal swearing, shouting, stamping and furniture breaking.[268]

She had also experienced the deaths of two of her children, a daughter born in 1562, who died almost immediately, and a son, born in 1564, who died two years later. Another daughter, also named Anna, born in 1563, had survived. Anna herself was pregnant when she and William fled to Dillenburg. Her son Maurits was born there on December 11, 1567.[269]

She quickly came to hate her isolated life at William's ancestral castle, pent up among his disapproving relatives. She seems to have nurtured in herself an even greater ambition for pleasure, along with an irresistible sense of neglect. These passions required money, great swags of it, but her dowry had been eaten up by Spanish property seizures and her husband's military needs: the soldiers for his planned invasion came expensive. When William set out across Germany to raise troops and funds for his Netherlands cause, she relocated to Cologne. On October 20, 1568, she moved, or sprawled, into the house of Johann Mohr, the royal 'penny-master', or accountant, along with her two children and sixty servants.[270] There she rapidly spent all her money. By May, 1570, she was purse-proud and lawyer-hungry, avid for compensation from the Spanish for her confiscated property, and seeking support from her family in Saxony, or from anyone who would lend an ear.[271]

What happened next resembled less a love affair than a joyless frisking into darkness and a hurtling through a tunnel into several dank prisons. Even allowing for the rigid class distinctions of those days, it is hard to believe that a man of Jan Rubens' sophistication was bewitched by the prospect of making love to a princess, and especially not a princess who habitually became drunk and violent, and this the more so as he knew

that the crime of adultery, whether with a princess or not, was punishable by death. It would be easy to chide him for the weaknesses that may figure into the personality of almost anyone – curiosity, ambition and lust – but perhaps the worst that can be said of him is that he was incapable of rudeness. He also seems to have been driven by fear, a dread like that of Joseph faced with the seductive blandishments of Potiphar's wife in the Book of Genesis: that Anna might denounce him as a rapist to her husband if he rejected her advances. At any rate, while a good deal about his relations with her is known, the revealing moments, which surely existed, can only be guessed at: the tentative glances traded as he read out to her broadsheet reports on Netherlands politics, the casual touchings, the abashed lookings away, the efforts at secrecy in the presence of her ladies-in-waiting, a manoeuvre that could not work.

When Anna travelled to Kassel, seeking assistance from her royal relatives, Jan Rubens went with her as her legal adviser. He did the same when she went on to Strassebersbach, a village between Marburg and Siegen. There, after dining together on June 15, 1570 (this by his own account, which survives), they became lovers.[272] Again, one may speculate on the fear that accompanied and tormented their passions. It echoes through his recollections of that night and those to come: 'We became more intimate and for the first time went to bed together. She said, "Be careful not to rumple the bed."'[273] They snatched at other hasty rendezvous, in Ebersbach, Frankfurt, Cologne itself and Siegburg, or fourteen in all.

Their downfall was abrupt and miserable. In August 1570, when these perilous trysts were at their height, Anna moved back to Siegen. With the sort of self-indulgent, coolish irony of which she was capable, she left her two children in the care of Maria and Jan Rubens (Maria to date knew nothing of her husband's fiddlings about with the princess), at the same time turning over to them her patrician mansion, The Rinkenhof, where they resided for a time in a precarious splendour ministered by two butlers and two maids.

By March, 1571, Anna was pregnant. Her constant, imploring letters to Jan Rubens – he seemed to have grown abruptly unresponsive – along with her increasingly obvious condition, sounded the alarm for William's brother, Count Johann of Nassau, who ordered his arrest. Rubens was seized on March 15 while riding to Siegen to see her. He was thrown into the dungeon-prison at William's Dillenburg castle and, once confronted with what everybody was thinking anyway, led into making a complete confession.

In the legal-religious idiom of that age, and there seems to be little doubt that he subscribed to it despite his reservations about various branches of Christianity, he spoke up for the sake of 'his soul's holiness',[274] but Anna understandably spurned the very idea of honesty. She denied everything, denounced her husband for having framed her,

accused him of 'fouling his own nest'[275] and let forth with a stupendous barrage of expletives. Only when shown her lover's letter admitting their love affair did she break down: 'Rubens, Rubens, how could your tongue have turned so liberal as to publicize my shame and yours! I would never have believed it! I would like to think, and convince myself, that somehow this was therefore the will of God!'[276] One senses a painful, fatalistic struggle in her ferocious rebuke.

20. Disappearance and Compassion

The fortunes of Jan Rubens, his family and Anna von Saxon plummeted in tandem with those of Antwerp itself. Extracted from his life, so to speak, he simply disappeared. For two weeks Maria had no idea where he was. At that point, however, her relationship with him, and his with her, suddenly came to exhibit an integrity that proved influential on the life of their as yet unborn painter-son.

On March 28, Maria received a long letter from her husband, detailing his relationship with Anna and begging forgiveness. He described himself as unworthy of Maria. He insisted on the horror of his guilt. He offered her his coming execution as an atonement. From his point of view, the future presented a dispiriting simplicity: either death by beheading as an adulterer under German law, or a more honourable death by the sword under William's royal prerogative.[277] He requested the latter, if only because it would exonerate his family from the public stigma fastening automatically on adulterers, or people considered beneath contempt not so much for their sexual treachery – a more modern attitude – as for their betrayal of an oath taken 'in the sight of God'. In sixteenth-century societies that regarded reality itself, including sacred reality, as a Word, and in which as a result oath-keeping was understood as the supreme virtue (no matter that, as today, oaths were often trashed or ignored), the oath-breaker seemed a paradigm of corruption.

Maria's letter in response to the news of his plight assured him, remarkably and generously, of her forgiveness. He wrote to her again, protesting his unworthiness. Her second letter, written between twelve and one in the morning of April 1 – what brooding, what frantic ecstasy by candle light must have guided her as she scratched away at the thickish sheets of paper in The Rinkenhof – reflects even more clearly the passionate religious convictions of their time, as well as her undaunted love for him, her fears for her children, her practicality, her humility and her sense of helplessness:

Beloved Husband (Lieve ende seer beminde man),
I received your letter on April 1, and well understand that you are anxious to hear from me. I had already guessed as much, and in fact on the same day as you wrote your letter, March 28, had already sent you a long letter

by a reliable messenger.... I hope you have received it, and are now feeling calm and certain about the pardon that you beg of me: I offer it to you, now and always, as often as you ask it of me, on the sole condition that you love me as before. I ask of you no other compensation than our same love once again, because if I have that, then everything else will follow. I am so happy to have news of you because to be separated in this way throws my heart into eternal turmoil and continuous longing. I have drawn up a request to see you ... may the Lord grant it the success that I wish for it. I am only afraid that it presents neither skill nor cleverness. I simply expressed my wish as best I could, because – Heaven forbid! – I haven't told a single soul, not even our friends, about your situation, as it ought to be kept quiet about on our side. So I sought no help in doing it, but took my own counsel as best I could. And the thing is easily enough said as long as the Lord grants us his mercy, and these lords are moved with compassion for us, for which reason we must and should beg that He will do so: the little children ask after you two or three times a day, that the Lord may restore you to us....

Beloved Husband,
I was just writing the above letter when our messenger came in and brought me a letter from you that makes me very happy because I can see from it that you believe in my pardon ... I never imagined that you would think me capable of showing any great harshness, which I also have not done. How could I be so crude as to punish you still further in your own great need and distress, from which I would gladly rescue you with my life, if that were possible. And even if this were not the case – so that where before there was a long-lasting love there were now suddenly a great hate, one that refused to allow me to forgive a small offence, in comparison to the many great offences for which I have to ask the heavenly Father for forgiveness every day: even then I would forgive all those who have offended me.... You can rest assured that I have quite forgiven you; if only God saw the solution to your problem in that, we would soon be happy indeed. But along these lines your letter scarcely makes me happy. I cannot read it, and my heart breaks, because you describe yourself as having lost your courage and speak as if you ought to die on the spot. All this upsets me so that I hardly know what I am writing. It sounds as if I am supposed to desire your death because you desire me to be made satisfied by it. How oppressive it is to me to hear this. I practically lose all patience over it. If compassion no longer exists, where am I to turn? Where am I to find refuge? I want to cry it down from Heaven with an endless voice and tears. I only hope that the Lord will listen to me and send it into the hearts of these lords, so that they take pity on us and have sympathy for me; because otherwise one thing is certain, that they will be killing me as much as you – because I shall die of heartbreak. I could not so much as hear the report of your death without my heart stopping on the spot.... Oh, we are wanting no legal rights, only mercy, mercy, and if that is not to be found, what is there for us to do? Oh, merciful, heavenly Father, may You stand beside us. Surely You do not seek the death of the sinner, only that he may live and mend his ways! Oh, make more quiet the hearts of these lords, whom we have so angered, with the spirit of your mercy, so that we may soon be released from this great agony and grief,

for it goes on and on. Oh, Lord, strengthen our belief, for if it were as large as a mustardseed we could move mountains, as we could so much the better beg for one human life. I fear and hope, yet my hope is stronger than my fear, and that alone for the grace and goodness of God's will and that of these good lords.... And so I consign myself to God, because I cannot write any more. And beg you not to see the worst always before you and to take heart; the worst comes on us soon enough, because to be thinking always about death, and to be afraid, is worse than death itself. So put it out of your heart.... I shall plead for you with these lords as best I can: so will our children, who greet you warmly and long so much to see you, as do I, God knows! Written during the night of 1 April between twelve and one. – And stop writing 'unworthy husband', because all is forgiven (en schrijft toch nu niet meer: unweerdighen man, want tis toch vergeven). Your loyal wife, Marie Ruebbens[278]

The passionate richness and intelligence of her personality here shine forth even more clearly as one realizes that her letter has a double purpose: to give confidence to her husband, who might, for all she knew, be undergoing physical torture, and to move the hearts of Johann of Nassau and William, who would certainly read it themselves before allowing him to do so.

21. Release and the Tragedy of Anna von Saxon

Her efforts bore fruit, but not without strain and sacrifice, no less of her own freedom and that of her children than his. Her numerous petitions to Johann of Nassau, to his wife, to William of Orange, to his mother Juliana and even to Anna von Saxon at first went unanswered, and when she travelled to Dillenburg herself to meet Johann she was refused permission to see Jan. If she returned to Cologne empty-handed, however, at least she guessed that for some reason he might not be executed immediately, that her sincerity had made an impression and that her communications with him could continue.

Letters now flew back and forth between them. Nor was Jan Rubens tortured, or so it appears. He waited in his dungeon cell, lit at best by an oil lamp. He was not discouraged from writing to his wife, and liberally provided with ink and paper.

In fact what continues to echo through their letters is neither heroism, nor superhuman devotion, but a brilliant ordinariness, the sort of love that paralyses hardship, the stout, thrifty, rather unimaginative, amiable love known to devoted married couples, and that often imparts balance to their children. No doubt this is the love best suited to meet catastrophes. It is evident in Jan Rubens' letters to his wife, especially one of his first (written on July 17, 1571), in which he still anticipates his execution:

> ... I also want you to write to your parents [who were still in Antwerp] and my friends, when judgement is passed in my case, that if it must be

that I am suddenly taken into another country, that you greet them warmly and ask them to forgive me for having brought this shame upon them. I advise you to stay on in Cologne for a few months after my death, so that no one may say that you were driven out by my shame.

Perhaps you will wish to defend me against the lies, as I fear, that will be told about me. (Indeed it will be argued that I made an attempt on the life of William of Orange.) ... I also advise you to sell our silver, carpets and clothes, as well as my books, especially those dealing with theology, law and the Greek classics: if my assets and life are now to be taken, and your parents are in [financial] danger, still there will be enough left over for you and the children to live on. The best thing is to convert everything of value into cash, and to live off the interest. The children are still small, and I do not wish them to go on to advanced studies.[279]

As the months passed, with the threat of his death receding somewhat, though he could never be sure, he suspected the reason, that his case had become an embarrassment to William of Orange and his Netherlands cause.[280] He now began to write to Maria on another subject. His fascination with religion, and his doubts about the competing claims of priests and Protestant ministers, flooded the neat, thoughtful paragraphs that he produced and that are starkly devoid of self-pity:

You write that you often miss listening to sermons. My dearly beloved, you are right to search for God, but you must know that not everything is determined by sermons; honest prayers are sent up to God from all sorts of places, if they are sent in the proper spirit of truth.... You've got Luther's pamphlets, Bullinger's sermons, Erasmus' paraphrases and so many other good books, from which preachers get what they give us. One cannot accept all spiritual points of view, and it is not essential that a young widow with small children, living in a foreign country, wander about, just for that reason, seeking out any old refuge. I have listened to many a pure and profound preacher in Cologne. You could go do so too, provided that you commit yourself to a specific church (one must do that first). You ought not to act like those who set the entire well-being of their souls on masses, and who think that if they have heard or seen them, they are safe and that they have done something admirable; on the other hand, that is how many betray themselves these days, and sermons decline in their minds into superstition, as in another way do masses.... I hope that you won't think of me as equivocating, or that I think little of sermons and all religious practices; I consider them important and necessary as food for the soul – and without them the church could not go on and we could not live; but I am only hesitant over something that one can do without for a while, as I must have patience and do without you, and for a long time now be cut off from all churches and all religious services everywhere – a thing that I hope will not lead to my damnation, and I counsel myself with my prayers, with books and with humility; help yourself with the books I have named, and with holy scripture: in them you will find enough support and teaching, comfort and exhortation....[281]

As he penned these moving sentences, he was aware, as Maria had

been from the start, that the question of his future had turned into a political football, with William doubtful whether to punish him with death, yet anxious to avoid publicity about Anna, and aware that gossips were already at work everywhere because of his own prominence.

In fact the extreme punishment for adultery was not lightly to be exacted in Jan Rubens' case, and especially not by William, who had no desire to appear to treat a likeable former Alderman of Antwerp harshly at the very moment when he was seeking to liberate Flemish citizens from Spanish harshness. The truth too is that he secretly rejoiced in what had happened. He was happy enough to be rid of Anna, somehow, anyhow. She had proved to be nothing but trouble.[282] Off recruiting and organizing, as well as losing skirmishes and early battles to the unrelenting Duke of Alva in the first of the Dutch Revolt's military campaigns, he had not seen his wife for over two years. His frosty, meticulous brother Johann, always an astute guardian of his royal reputation in Germany, might best handle what for him had become a tricky unpleasantness.

An agreement was reached, worked out by Johann and Anna von Saxon's princely uncle, Augustus. The result was that fully two years later, on Pentecost, 1573, Jan Rubens was released from his Dillenburg prison, not into freedom but only into a nasty form of house-arrest which lasted for most of the rest of his life. His original suggestion that his family might live off the interest on the money obtained from selling their books, clothes and other possessions was tacitly accepted, but with a macabre twist. Maria was instructed to provide Johann with a 6,000-thaler deposit, in fact bail money, part of which she borrowed from her family in Antwerp (a friend, Reymont Ringott, a relative of hers and an apothecary in the manner of Jan Rubens' father and step-father, was sent off to Antwerp to get it), part from selling off most of their property in Cologne.[283] This meant breaking up her household, but if she wished to live with her husband, as she did, she had to break it up anyway. In fact she was required to undergo a type of imprisonment herself. A condition of Jan Rubens' release was that he live only on land belonging to Johann and William, and specifically, of all places, in Siegen. There he could be watched. There any possible embarrassment could be avoided. There, if he chose to violate any of the terms of these detailed arrangements, which included his making himself available to present himself on any summons from Johann, he could (as was also provided) be executed at once and without a public hearing.[284]

Meanwhile Anna's case, as the darkness descended, was disposed of with equal discretion but greater cruelty, against a background that was passionate, ruthless and far worse than merely humiliating. Confined at first to rooms at the Nassaus' upper, or hilltop, castle in Siegen, she was later shifted into a royal lodge in nearby Diez, where on August 22, 1571, she gave birth to her daughter by Jan Rubens, Christine von Diez (as she

was christened, because William refused to recognize her), who was at once taken from her and brought up by Anna's family in Dresden (Christine von Diez later married Johann Wilhelm Bernkott, also called Welschenengst; she died in 1638 at Langendernbach; her descendants survive to this day).[285] In 1575, negotiations between Johann of Nassau and Anna von Saxon's family led to Anna's being released into her family's custody. Their treatment of her proved fatal. She was kept in a series of solitary confinements at Beilstein, Zeitz and at the electoral palace at Dresden. Later she was relegated to a more isolated, terrible punishment at the secluded royal castle in Meissen.

Her final conditions, according to the ideas of rough justice of the day, were appalling. Nor did they prevent William of Orange from divorcing her in 1575. Indeed, by this time William had fallen in love. As early as 1572, on a fund-raising visit to Heidelberg, he had met the beautiful, intelligent Princess Charlotte de Bourbon. The daughter of the Duc de Montpensier, who was a devout Catholic and one of France's staunchest supporters of the Spanish suppression of the Netherlands, she had been sent at an early age and against her will into the convent at Jouärrs. There she had done well, rising to become an abbess – only and abruptly to scandalize the world by revealing her Reformist sympathies, renouncing her vows and fleeing to Germany.[286] William's marriage to her on June 12, 1575, in a quiet ceremony at Dort, without any of the lavishness that had marked his wedding to Anna in 1561, attracted the sarcastic wrath of Anna's uncle, Augustus ('the Prince has too many heirs already, and ought to wish that he had neither wife nor children'[287]), and just about everybody else. On this occasion, however, his stubborn insistence on the rightness of what he was doing coincided with good judgement: he and Charlotte were happy, and remained so with each other throughout his lifetime.

Anna declined into unrelieved madness. Her last room on earth was a small, sealed affair, with a slit of an opening just big enough to receive trays of food and hours of daily preaching about her sins from a minister charged with lecturing to her. Barely surviving for a while amid her own excrement, she sank into bouts of shrieking, rage and incoherence. She died on December 18, 1577. Her cell had to be chopped open to extract her body.[288]

The situation of the Rubens family was only moderately better. For a time they squatted in a single room vacated for them on the orders of Johann of Nassau at the house of the local magistrate of Brambach, just outside the Siegen town walls, where Jan Rubens could be constantly kept under observation.[289] Their four children were permitted to return to Maria's parents in Antwerp. Maria alone was allowed to work. She was granted an acre or so of land near the town walls, converting it into a survival-garden for vegetables and spices with seeds sent to her from the Netherlands.[290] Less than a year later she and Jan moved into a small

house in Siegen, rented with money sent by her family. Two children were born to them there, Philip, on April 27, 1574, and Peter Paul, on June 28, 1577.[291]

22. Birth and the Months at Siegen

It is neither melodrama nor exaggeration to say that Peter Paul Rubens was born into his family's and country's worst hour. At the beginning he had no country at all, only several alien houses, within which his family enjoyed a skeletal subsistence. His father, no longer a respected exile, had become a pariah, ostracized by his society, scorned by any neighbours, denied the opportunity to provide for his wife and children, prohibited even from entering churches and spied on as he took lonely walks in the nearby forest.[292]

On the other hand, European societies themselves had by now been launched among drizzly changes. Politics, religion and culture were dipping into fresh currents. A new temperament, a new sea-weather of the time, was unfolding. If so far it had neither name nor shape, its influence could be sensed. It spawned strange wars and meaningless truces. It unsettled the arts and sciences with unholy questions. Its spectral impertinence challenged explorers cruising rivers on the other side of the planet, in the New World. It beset the hearts of rulers in the Old World with anxieties that no one could have anticipated. Civilization seemed to be swept by novelties.

Elizabeth, on the throne of England, dithered over sending military assistance to the Netherlands rebellion. How potent – how useful to her – would William's struggle against Philip II turn out to be? Was he himself a saviour, promising relief from Spanish military ambitions, or a menace to established monarchies?[293]

In the year of Rubens' birth, William Shakespeare, still living in Stratford, and thirteen years old, was busy studying his 'small Latin and lesse Greeke'. What, though, could honestly be praised about English literature in the decade before it became truly Elizabethan? Was its recent dullness an omen of morbidity or a signal of secret vitality? Had its precocious, spring-like magic died with Chaucer and Langland almost two centuries earlier, or was it maturing incognito, as a shadowy wriggle of buds unspottable in a pause and shifting?

New forms of lawlessness, mostly taking the form of religious rebellions, and also straight across the Continent, were revitalizing imperial egotism, which itself loomed against fresh agricultural prosperity: excellent vegetables and beef available throughout the north, amazing potatoes from the Andes valleys (and Peruvian silver) streaming into the south. Montaigne (1533-92), in his essay 'On Cannibals', reflected with a candour shocking to his readers on the comparative barbarism of Europeans and Brazilians (when a couple of the latter were brought over

from 'the new world that we have lately discovered') that they had 'no knowledge of letters; no use for slaves; neither wealth nor poverty; no contracts; no successions; no partitions; no occupation but that of idleness; only a general respect of parents; no clothing; no agriculture; no metals; no use of wine or corn. The very words denoting falsehood, treachery, dissimulation avarice, envy, detraction, pardon, unheard of'[294] – lines that, subtly lifted from John Florio's translation, were to reappear almost word for word some thirty-four years later in Shakespeare's *The Tempest* as a description of a desolate yet appealing utopia. Christianity, Montaigne observed, was a religion no more natural to the uncorrupted natives of the Americas than their cannibalism to his fellow Europeans, or people who engaged in far worse atrocities.[295]

No considerations of atrocities prevented masses of the Dutch and Flemish from refusing to rebel against their Spanish king. Their loyalty, though slackening in the face of Spanish cruelty, remained enthralled by ancient reverential feelings.

Their reasons had not changed since the Middle Ages. To don the royal mantle, to wear the crown, to become king or emperor, as to wear the mitre, clasp the ruby-encrusted cross to one's breast and assume the papal purple – all these, and especially during this new heyday of the divine right of kings, meant far more to most people than grappling after secular or spiritual power. They amounted to conjuring with ultimate hopes and dreads. The often foolish ordinary man became a totem. His foibles might literally stink – Charles V's public flatulence, say, which foreign visitors had remarked on with unease, or his conniving, viciousness, thieving, treachery and whoring, along with the dour fanaticism of his son Philip II – but costume, palace and title altered him.[296] If God could be made flesh, flesh, whatever its corrupt frailties, might be made holy. This possibility remained the premise which millions cherished, including the most savage king, emperor and pope himself. The wildest dreams, as well as the basest terrors of life, were awakened by the sight of the pompous ruler, and vast numbers of his subjects confused him with celestial energies.

The secluded town of Siegen paid scant heed to these dubious dilemmas. Squirrelled away in a broad, primeval forest known as the Westerwald, it was a two-thousand-year-old, former Celtic mining centre built on a hill of iron. Even its name was Celtic, and had nothing to do with the German word 'Sieg', meaning 'victory'. It meant 'running water', and referred to a nearby river.[297]

For twenty centuries miners had shaved off the iron hill's skin of slate for the ore beneath it. The slate itself, once trimmed, was used to shingle the roofs of houses and their outside walls, colouring the whole modest place, as it coiled about the flanks of its mount of metal, along with its dozens of smelting furnaces, in a smoky elegance that looked like the coat of a silver fox.

I. Rubens and the Question of Beauty

Its upper castle, an ancient one, with a cobblestone courtyard and several storeys of spacious rooms joined by corkscrew staircases and fretted with ramparts that overlooked a woodsy valley, perched on what in Celtic days had been innumerable potential swords and lance-heads, and during the Middle Ages, Renaissance and sixteenth century thousands of potential shields, cannons, mortars, cannon balls, bullets, arquebuses, shackles, chains and oven doors. Siegen's wrought-iron oven doors had acquired a fame all their own. The chink of the pick-axe, the blaze of the flame-spitting forge, promoted solid craft and interesting art. Siegen's 2' x 4' iron plates (Ofenplaten), and the larger chimney guards (Kaminplaten), with the best examples based on sketches by Philip Soldan of Frankenberg-Hessen, featured biblical scenes in bas-relief: the sacrifice of Isaac, the adoration of the magi, Cain killing Abel, Jesus among the Samaritans and the Resurrection.[298] Everyone with an oven and a chimney – and all but the poorest had both – cooked and kept warm in winter beside tempered, metal pictures of God's Judeo-Christian power, often in houses full of other religious pictures and icons.

Just below the castle, Siegen's population of 20,000 resided in a warren of narrow houses crammed along intricate, sloping streets (its modern population of 110,000 overflows its medieval walls into a larger city that includes a traffic-free shopping centre). The Rubens family may have lived at 37 Untere Metzgerstrasse, a three-minute walk down from the castle gate, though the authenticity of the address is debatable.[299] Their sixteenth-century house, if it is the right one, was a four-storey, toothpick-shaped affair, slate-shingled, and is today privately owned. An inscription has been carved into one of its outer wall-timbers: 'In this house, on the 28th of June, 1577, Peter Paul Rubens first came into the world' ('He in dam Huss es Peter Paul Rübens vam Hearnsä am 28. Juni 1577 ob de Welt komme').

Rubens' birth-date is less debatable. Probably he was named after Saints Peter and Paul (and his own great-grandfather?), whose feast day falls on June 29, and given his double name because he was born on what then became the day of his baptism, or the feast day.[300] No birth or baptismal record exists. Given the Lutheran influence of the Nassaus in Siegen, he may even have been baptized a Lutheran, despite the fact that his life-long commitment to Catholicism, and later on that of his father, who again reentered the Church, are clear enough.[301]

What is clearest is that though Anna von Saxon had played a major role in his father's imprisonment, once dead she guaranteed his release, not into complete freedom but into more of it than he had known for the previous six years. In fact the news of her death liberated everyone involved in her downfall.

As usual, money helped. Anna's love affair with him had originally been sparked by her need of money. His release from prison had been purchased with a family loan to the princes Johann and William.

Following her death, which eliminated her as a problem, the Rubens found themselves free to do as they pleased, on two conditions exactly reversing the earlier ones: they could live more or less where they liked, as long as they avoided any land belonging to William, and they had to sign over half their loan, or 3,000 of their original 6,000 thalers, to Johann.[302] This meant that they could neither stay on in Siegen, their confinement-home, nor return to Antwerp, which remained under William's jurisdiction. Accordingly, they accepted the bargain offered them, and in 1578, shortly after Anna's death, moved back to Cologne.

A curious, morbid yet strangely prophetic event also occurred in that year, on December 20, 1577, or two days after the death of Anna von Saxon. Far to the south in Venice, the Doge's palace caught fire. Its Great Council Chamber, made gorgeous with historical 'eye-witness' paintings, as they were called, and full of anecdotal depictions of Venetian military triumphs, by Giovanni and Gentile Bellini, as well as portraits by Titian, Veronese, Carpaccio and Veronese, burned to the ground. At that precise moment a fierce outbreak of the plague began to subside. Over the previous two years, it had claimed more than 50,000 lives, including Titian's.[303] The winding down of the plague and the ruination of the Council art led to the commissioning of new paintings for a new chamber. These repeated the themes and conflicts of the paintings that had been lost, but their tone announced a difference. Veronese, Tintoretto, Palma Giovanni, Aliense, Francesco Bassano, Domenico Tintoretto and other artists painted startlingly depersonalised allegories of the familiar historic Venetian battles.[304] On the one hand, they reflected new political struggles against hero-worship in the ruling circles of the city itself. On the other, they amounted to approval of the ideas of allegory and sensuality of the developing Catholic Counter-Reformation, which itself had begun to alter several cultures across Europe.

23. Beginnings in Cologne

No one will ever know when or where Rubens dipped his first brush or pen, at the start of a career that would repaint and redesign much of the universe and the human soul. It is a sublime moment to consider. One of the pleasures of history and biography is that their art makes it possible to do so.

Life in Cologne the second time round for the Rubens family was nothing like what it had been in 1570, before Jan Rubens' arrest, and again because of money, or this time the lack of it. Prosperity had slithered into penury, health into physical weakness. Though he had lost none of his charm, tact, spirit and intelligence, his prison-ordeal and humiliation had taken their toll. By the age of 48, he had turned grey and become sickly. Even worse, at the beginning he was not allowed to practice law or

earn a living (he was also still compelled to present himself to Johann of Nassau if summoned[305]).

The family lived in a house on Breitestrasse and then in one on Sternengasse, a stumpy *cul-de-sac* not far from the Catholic Church of Saint Peter and within its parish.[306] No hint of this house remains, and Sternengasse today, not far from the Rhine, sports a modernistic art gallery doing picture restorations and a Deutsche Telecom building. In the 1570s, it was close to several other churches and markets selling meat and vegetables.

It is unclear when the Rubens began attending masses at St Peter's, on Leonhard-Tietz-Strasse (these days you have to cross busy Neu-Köllner-Strasse to get to it). The largish church stands in a drowsy majesty, restored after a series of air raids during World War II. What is known is that by 1583 at the latest the family (with their other children returned from Antwerp to be with their parents) had once more become Catholic.[307] The two boys, Philip and Peter Paul, were not immediately permitted to enrol in the parish school, run by Jesuits, though they did so later. St Peter's nonetheless may have been the church at which Rubens himself first regularly attended services, perhaps daily, as did most members of the parish.

It is useful, on visiting the church, to imagine its probably deep impact on him, and in attempting to understand the growth of his mind to see it again, across these hundreds of years, as it must have been, illuminated by the sun through its stained-glass windows in the mornings and afternoons, and then, at sunset, as its vast, long hall turned into a marbly forest in which its gold- and cherry-coloured trunks of stone mingled with the insinuating dark. By candle light one always understood the dark as nearby in those days, aware of its various types, wrinklings and probings amid the imperfect gloom. Electricity had not erased its mystery, or flattened into smoothness that other scruffy mystery of the graves under the carved stone slabs of the floor.

One would also have heard a good deal of music, most likely by Bernhard Schmidt, the organist of the Strassburg cathedral, who in 1577 published two books of his own compositions that were widely played throughout Germany.[308] As one prayed, sacred music would have flooded the saintly figures of the old altarpiece and the church's other paintings with life, while the chants and blessings in Latin stirred the terrible, rescuing image of the cross into its own animation. It is thus interesting to note that probably none of Rubens' earliest exposures to painting, which would have been church painting, took place in silence. The tones of the organ, the rhythmic voice of the priest as he recited the stations of the cross, the choir singing a canticle, the crowd of worshippers repeating it – all these altered his first apprehensions of the painted nativity and crucifixion. Music too may have provided its own training in the crucial artist's disciplines of restraint for the sake of clarity, of repetition for the

enhancement of effect and – given his family's miserable crisis – of harmony for the sake of distinction-making between hysteria, love and beauty.

After the service, one wandered out into a daily scuffling of horses, carts, numerous armed men, legates from abroad rushing to present themselves at the Stadthaus, fashionable and various not-so-prim ladies, other school children, nuns and ubiquitous pigs forever scrounging among the rubbish heaps piled for collection at the intersections of the streets.

It may also have been at the church school that Rubens encountered a little book of biblical texts in Latin and German published by Thomas Guarin in Basel in 1576, and used for the copying-instruction then in vogue among teachers and pupils across the German-speaking countries. Guarin's book was illustrated with sensitive woodcuts by Tobias Stimmer.[309] Stimmer's woodcut accompanying the story of Hagar, among others, seems to have caught his eye. He copied it in pen and ink. He may at that time, or somewhat later, have decided that he could 'improve' on it.[310] At any rate, the story itself, with its themes of an ageing wife, adultery, sexual jealousy and exile, seems to offer clues to some of his passions then, when he would have been nine or ten years old. In Genesis 16, one learns that Hagar, the Egyptian handmaid to Abraham's wife Sarah, was made pregnant by him at Sarah's urging because it was assumed that she was too old to have children. Stimmer's woodcut shows her, furious despite herself that her husband has had sex with her servant and that she is with child, driving Hagar out of their house into exile in the desert. Abraham, ever accepting of his wife's moods, looks on. Hagar was to become the mother of Ishmael, whose name implies 'outcast', and of whom it was said (by God): 'He shall be a wild ass of a man: his hand shall be against every man, and every man's hand against him; and he shall dwell in the face of all his brethren.'

Rubens' earliest education, or self-initiation, into the essentials of art may have continued at home. No one knows whether he first copied a number of the woodcuts in Hans Holbein's *Totentanz* (Dance of Death) while growing up Cologne, or some years later, after his family had arranged to move back to Antwerp, where he definitely made copies of them.[311] It is sensible to assume (because he later said so) that in his boyhood he knew of Holbein's admirable woodcuts depicting the futility of human vanity in the face of death.[312] It is also likely that he had seen, and in his Cologne days may have copied, one or more woodcuts from the universally read German *Schwankbuch* (jest-book) *An Amusing Reading of Till Eulenspiegel*.

Holbein's *Totentanz*, published in French and Latin in Lyon in 1538, and running through many editions in several languages after his death in 1543, belongs to the venerable tradition of *ars moriendi* books, which since medieval times had been showing people how to live rather than

die, as the phrase incongruously suggests. What now seems morbid looked agreeable to many toward the end of the sixteenth century: death was the gateway leading into a choice of next worlds, either delicious or tormenting. If no one could avoid death, anyone might at least escape a horrible afterlife by renouncing the vainglory of pomp, arrogance, power, miserliness and the merciless quest of never-satisfied lust. Holbein had illustrated this Christian philosophy in a series of fifty-one small wood-cuts, accompanied, as in the case of Stimmer's book, by biblical excerpts and modern French quatrains glossing them. Rubens seems to have made as many as forty-six copies of these, of which forty two survive in an early sketchbook.[313] While it remains problematic whether any of his earliest-surviving sketches either from Stimmer's or Holbein's woodcuts dates from his time in Cologne, the use of Stimmer's book in schools, and the broad appeal of Holbein's, which had equal pedagogic value, hint that he had begun to find his *métier* as an artist at a precociously young age, or sooner than has often been assumed.

As a boy, he may also have been influenced by the famous Till Eulenspiegel adventures, at least one of whose woodcut illustrations he may have copied (though no trace of it survives). Again, the circumstan-tial evidence seems compelling. Eulenspiegel, who remains enormously popular in Germany to this day, and chiefly (if inappropriately) among children, is a ferocious, often ethical jester and rogue. In the original High German versions of his tales, published in Strassburg in 1510, he wanders about Germany, France, Poland and Italy, playing sadistic prac-tical jokes on a succession of unpleasant employers, townspeople, hypocritical priests, professors, thieves and innkeepers.[314] He quickly became a beloved German folk-hero. By the 1580s his ninety-five frequently scatalogical exploits, compiled by an anonymous author who may have been Hermann Bothe, had been widely translated, even into Flemish. In the Flemish adaptation his character is changed. He ceases to be an 'outsider', merely regaling audiences with buffoonery, mockery, scepticism and defiance (qualities that continue to inspire twentieth-century artists and composers such as Richard Strauss, with his *Till Eulenspiegel's Merry Pranks*), and proclaims himself a friend of Flemish and Dutch freedom. He sets about sabotaging the Inquisition and the Spanish king.[315]

Virtually all Germans knew the Eulenspiegel stories. It is unlikely that an educated Flemish refugee family residing in Cologne would not have read his adventures, naturally enough (considering the family's origins) in the Flemish version. The woodcut accompanying his twenty-sixth tale may particularly have captivated Rubens. This presents the rogue-jester lying in a cart packed with earth that is pulled by two horses heading along a rutted lane toward a far-off castle. A farmer stands to one side, lashing the horses on with a whip.[316] A similar cart figures in sketches made by Rubens decades later, and in several of his paintings,

where it shows up as drawn by a couple of horses at a corresponding if reversed angle, and also hustling along a country road (figs 1 and 3).[317] Significantly, many of the woodcuts in this book were made by Hans Baldung-Grien, the most brilliant of Albrecht Dürer's apprentices, and other, unidentified artists.[318] It has long been established that Rubens early developed an enthusiasm for the work of north-German book illustrators.[319] His passion for their work perhaps began here, with the tales of Till Eulenspiegel and his exposure to Stimmer's and Holbein's woodcuts.

The themes of the Eulenspiegel stories, their deflation of egotism and ridicule of most occupations – all solidly caught up in the twenty-sixth tale – may easily have intrigued him as well.[320] His father or one of his older brothers perhaps discussed them. The circumstantial evidence here is also persuasive. Eulenspiegel is not simply a rogue but a type of linguistic philosopher. He is enthralled by the differences between the slangy, garbled ways in which most people speak, as opposed to what they really mean. His method is to search out ingenious chances to humiliate human linguistic pretensions by taking people at their word, or literally, and with disastrous, absurd results.[321]

The twenty-sixth tale, much like the Hagar story, centres on an idea of banishment. It has to do with getting the better of an irate nobleman. Ordered out of the nobleman's district on pain of execution and because of his reputation for mischief-making, Eulenspiegel retaliates by buying some 'land' of his own, or a cartful of earth from a land-owning farmer and having himself trundled across the nobleman's forbidden territory in a tumbrel pulled by two horses. When the nobleman confronts him with having violated his edict, Eulenspiegel points out that he is merely 'sitting in [his own] land'. He is ordered to get out again anyway – this nobleman seems unable to take a joke – but Eulenspiegel has exacted his rather petty revenge, and drives off in a halo of brittle triumph.

Rubens' childhood, it may be seen, offered him a batter of aesthetic opportunities. If church paintings dished up creamy and threatening splendours, music and book illustrations supplied artistic instruction. Stimmer, Holbein and Eulenspiegel may even have led him as a gifted beginner into grasping the techniques of perspective and foreshortening, into the power of the single-stroke line (and the uses of its varying thicknesses), into the treatment of landscape in relation to foreground figures and into seizing the dramatic moment so as to convey a story – with each of these confirming the universal idea of art as theatre. Religious services, church architecture and his exposure to three languages – Flemish at home, German in the street and Latin at school and church (though Rubens' and his brother Philip's earliest Latin tutoring was probably provided by his father before, at a later date, he was allowed to return to work again[322]) – may have reinforced his first perception of the world as a stage. Made-up actors moved about on it, from one scene to

the next, in a drama with the strongest cosmic as well as social implications. The world may easily have seemed clear and sensible, despite domestic strains.

24. 'The Common Calamity'

'For the sake of our children,' Jan Rubens wrote to Johann of Nassau on September 24, 1582, 'to educate and nurture them, we have spent beyond our means, hoping that our parents would allow us something, though now the common calamity [the Spanish decimation of Antwerp] has stripped them bare.'[323]

His letter was a plea for mercy, and as during most of the shabby Anna von Saxon business, the questions were money and freedom. Out of the blue, Johann had once more ordered Jan to report to him in Siegen, on November 1, and there to submit to some new judgement to be passed on his case.[324] With unfilmed realism, Jan understood this as extortion. His letter was followed up by Maria's brisk offer to secure his complete liberty in return for ready cash. Her offer was accepted. More money was handed over. The result was that by January 10, 1583, he was remitted of all charges. After twelve years of disgrace, imprisonment, house arrest and ostracism, he was finally allowed to resume his law practice. Perversely, however, for as long as William lived he was still denied permission to return to Antwerp.[325]

His exoneration had come none too soon. The family's plight was desperate. To help her children survive, Maria had set herself up as a boarding-house manager in their house on Breitestrasse, taking in paying guests. Even after his pardon, Jan found it necessary to work night and day, accepting one case after another, not least because the city of Cologne itself required Reformists to pay for a new residence permit. While he met this last demand and also re-entered the Church, the financial strains, which affected his health, never diminished.[326]

Home life was apparently happy. What is striking about the Rubens through each of their difficulties is their capacity to establish an atmosphere of kindness. Maria's pardon proved as genuine as his own devotion. Resourcefulness led them into avoiding lethal errors with each other and outsiders. Piety nurtured resilience. It mollified fears. It seems to have helped them through the horror of the deaths of their son Bartholomaus, who was born in Cologne in 1581 and died there at the age of two, in 1583, and of their second-born son, Hendrik, who also died in 1583, at the age of sixteen.[327] The deaths of two children in rapid succession imply as the cause an epidemic disease, probably bubonic plague.

Even during this unfortunate time, Jan Rubens' isolation from society at large had begun to relax. Heady political developments were afoot in the city, and various noblemen, who had admired his abilities in the past, wished to consult him.

Their invitations had actually started to arrive a few years earlier. In the spring and summer of 1579 Cologne rang with the sound of alien armour, a baleful melody if muted by felt and cloth and accompanied by the creak of hundreds of saddles and the clip of scores of battle horses. Fresh from a string of defeats and victories in the Low Countries, the warring princes of Spain and the Netherlands, with dozens of their knights, lawyers and ministers, plus legates and secretaries dispatched by the pope himself, streamed into the neutral German city in a frustrated quest of peace. Churches murmured in Spanish, Italian and Flemish. Taverns and inns were crammed. Few imagined that the exhausted armies just to the north, steeped with demoralisation amid their bloodletting, would secure more than a pretence of a cease-fire while preparations for renewed warfare moved ahead in secret.[328]

A vast official group jangled through a diplomatic circus of suspicion. Its members bickered endlessly over the seating and sites of their conferences. Jan Rubens proposed acting as an adviser to William's staff, and while his participation was not openly accepted, it is clear that he was once again welcome on the highest political levels. Marnix van Aldegonde, the prince's closest confidant, wrote to him, soliciting his ideas.[329] On August 13, 1580, when these peace talks abruptly collapsed because of new Spanish battle successes, the Prince of Croy, later to become the fourth Duke of Aerschot and at the time a reluctant supporter of the Netherlands rebellion, invited him to his wedding in Aachen.[330] There is no evidence that he went, but their friendship, confirmed by the invitation, whispers of his possible discreet sharing in banned Calvinist services in Cologne, which the prince himself attended, slipping off at night to clandestine houses.

Interestingly, by July 22, 1581, Jan Rubens had switched sides, and in a letter of that date began advocating the views of the prince's father, the Duke of Aerschot and a Spanish-supporting Catholic, urging the Duke's son to recant and to realign himself with Philip II for the sake of peace: peace, it appears, was always uppermost in his mind. On March 13, 1583, the prince replied with touchy impatience, 'I can assure you that no one in the world desires peace more than I ... to restore this poor, devastated country [the Netherlands] to its former prosperity and glory, sparing no effort to do so.But instead of treating with us to that end, the King of Spain repeatedly seeks to subjugate us to his barbaric and tyrannical government whose memory is still fresh with us. For my part, I intend to bear every hardship in the world, even to my last drop of blood, in our defence.'[331] Six months later he also switched sides. As commanding officer in Bruges, he tried to surrender the city to the Spanish. In 1584, he succeeded.[332]

It can thus be assumed that political and military conflicts early intruded into the lives of the Rubens children. A certain amount of evidence, never satisfactorily confirmed, also hints that Jan-Baptist, the

family's oldest son and fifteen years Rubens' senior, may himself have been a painter. He is described as one in a document of 1583, when he was living at his parents' house in Breitestrasse. Another document, of 1586, reveals him as setting out for Italy, as did many northern painters, presumably to study Italian art. Little more is known of him, though as late as 1611, some ten or eleven years after his death at the age of about 37, he is cited as an artist in a letter of the Council of Nuremberg.[333] These glimmerings of his nearly invisible career may be enough to discern a beneficial influence on his younger brother. Certainly artistic ambitions were no stranger to the family. From the beginning, it seems fair to say, Rubens' life was suffused both with art and politics, and this despite the fact that by the time he was ten his parents had been away from Antwerp for twenty years. Even at a distance, the whirlpool power of war twisting through the Low Countries, like the magnetism of art itself, pervaded his childhood. The 'common calamity' of Antwerp, as his father had put it, fabled the air. He approached his adolescence amid familial hopes of return, prohibitions against it and his father's contradictory example of self-betrayal and success.

As a boy he was probably also beguiled by his father's descriptions of Italy and Italian painters, his account of his legal studies, his love of Greek and Roman literature, his absorption in international politics, his hard-earned scepticism of princes, lords, courts and kings, his years in prison, his suffering there (perhaps without a full revelation of the reason, though Flemish parents appear to have been frank with their children in most matters) and his devotion to humane compromise – in short, his prompting of his sons to become men of the world.

25. The Ongoing Violence

Chivalry hovered as a ghost over the crimson battlefields and bloodied cities to the north. By 1587, the Netherlands revolt, in progress for almost two decades, had hounded old standards of honour and gallantry into hiding. They seemed obsolete. New versions of them were emerging, but the Middle Ages, with their altruistic lip-service paid to chivalric ideals, no matter how often rubbished in actual combat, were dead. The aims of the war on both sides overshadowed with sanctimony all fantasies of the civilized conduct of violent disputes. Everyone everywhere seemed fair game. Neither piety, nor rank, nor sex, nor age, nor obedience counted amid the ruthless solipsism of modern conquest. Priests, noblemen, farmers, women, babies and children fell beneath the universal axes, arrows and bullets as casually as halberdiers, knights and infantry. The country was moulting into a killing field. Foreign troops poured in and out. Native troops united for the sake of the rebellion, only to desert and retreat into their villages. City governments provided money for one side or the other, then withdrew it.[334] Not even a Don

Quixote could have deluded himself into finding romantic glory amid this incessant tilting at windmills, this charging at foreign military giants who turned out to be unimaginative, often arrogant and sometimes pious men tyrannised by nightmares of spiritual superiority and sleazy profits.

A few realized that the idea of war itself was changing. Even fewer found themselves prepared to accept its new implications for religion and society. Talk of democracy, when it took place, produced as much contempt as friendly curiosity, with the added snag that nobody had ever seen popular government in action on a large scale.[335]

What did Rubens know of these alterations as he grew up in Cologne? It is a reasonable guess that he knew a great deal, if only because of his family's interests, his own intelligence and the fact that the world itself, or all educated people and in the end just about everybody, spoke of them all the time. Broadsheet accounts of battles, assassinations and acts of daring-do circulated in the streets. Gossip and war speculation sat down with many families at breakfast, lunch and dinner. Tales of bloodshed, fear and hope, leavened with strictures against sin and exhortations to Christian virtues, tempered even children's games.[336] In such circumstances it is easy to imagine that Rubens' mind was early tossed back and forth between violent extremes, and this so often, and amid such extravagant examples of decay and beauty, of anarchy and repression, of torment and pampering, that he may, as seems to have been the case, have been prompted into an unusual alertness to the outside world. He may also, and this seems to have been the case too, have been led into finding the idea of balance, especially the sort of emotional balance that may develop in those who find themselves caught up among the great passions of others, attractive as a plateau. Certainly no sensitive person could long remain unaffected by the acting out of the terrible hatreds swarming over the battle-theatre of the dyke-swathed northern plains just a few miles away.

26. The Slaughter at Mons and Mechelen

The massacre of the Huguenots in France in August of 1572, for instance, five years before his birth and several days after the staging of the court masque *Le Paradis d'Amour* in Paris, was one of several turning points in the rebellion, and remained a hot subject of discussion as he was growing up. At the time, the Duke of Alva was laying siege to the insurrectionist city of Mons, midway between Tournai and Namur and southeast of Brussels. Relying on a formidable army of horse and foot, and with tacit French connivance, William of Orange's brother, Louis, managed to keep up a fervid resistance from behind the city walls.[337] On the heels of the massacre across France itself, however, and when the French suddenly withdrew their support, any relief of those trapped inside became impossible. The betrayal by Charles IX in Paris

allowed Alva's troops to move in with alacrity. It also allowed the commission of unexpected atrocities.

Many Orangist volunteers, who chose not to slip away after the enforced surrender (as did Louis), were rounded up and killed, despite a pact, agreed to by the Spanish commander, stipulating that they would be spared. Their slaughter, and that of thousands of innocent civilians, formed one of the grimmest chapters of the revolt, sending shivers through all seventeen Spanish-ruled provinces.[338]

Often the killings of these unarmed citizens, as in the past, were ordered for the pettiest offences. Blaise Bouzet, a shoemaker, was hanged for begging at Protestant meetings and eating a soup laced with meat (instead of fish) on a Friday. The father of one volunteer was hanged for failing to prevent his son from joining the rebels.[339]

The bodies of the hanged were left dangling on rows of scaffolds that lined the roads. Baron Philip Noicarmes of St Aldegond, a Netherlands nobleman loyal to Philip and appointed by Alva to take charge of the carnage, revealed his true motives, which had nothing to do with religion, when he arranged the transfer of the property of those executed to him personally. With greed as the motive, any pretext sufficed for execution. The rich François de Glarge, Seigneur d'Elesmes, earned the hangman's attention by forgetting to take the sacrament on Easter.[340]

Local and Spanish noblemen working with Noicarmes, and eager for profit themselves, soon began to complain that they were not reaping the spoils of victory promised them, although they had dirtied their hands, as they wrote, by murdering many of their closest 'relatives and friends'.[341] Noicarmes ignored their objections, and indeed extended his seizures of property, making himself a wealthy man. The executions at Mons continued for eleven months, or till August, 1573.[342] Their grisliness extinguished the lights of defiance in masses of people elsewhere, and put an almost complete end to the rebellion in the southern Netherlands. It suggested to some that the whole country might eventually be pacified by formal division.

Renewed oaths of allegiance to Alva and Philip were accepted by the victorious Spanish, but the not-so-distant city of Mechelen was nonetheless selected as their sacrificial lamb. Its punishment would serve as a warning example to everyone. This important and prosperous place was thoroughly looted after its besieged urban guards had run away. Thousands were murdered. Churches of every description and belonging to all types of Christians were sacked. Protestants and Catholics together were slaughtered. Hundreds of Protestant and Catholic women were raped. Scores of them were afterwards tortured and killed. Children were left to starve in the streets.[343] Here too was enacted a newish, vicious concept of war, applicable only to civilian populations: atrocity as educational theatre. Its lessons, predictably horrific, have never been forgotten. To this day, Mechelen, which lies some thirty miles from

Antwerp and twenty or so from Waterloo, has not quite regained its previous prominence. It remains a small if charming town, but a mere phantom of the boasting place of commerce that it was several centuries ago.

27. The Spanish Mutiny

Massive conflicts now erupted in the minds and hearts of many of Europe's potentates, all of whom watched with anxiety as year after year the rebellion ebbed and flowed in the Low Countries. In England Elizabeth sympathized with the Reformers but as an absolute monarch continued to worry about their threat to kings and queens.[344] Similar emotions, but prodded by opposite hopes, drove the ever-vacillating French king to sign a specious treaty with the Huguenots, the Peace of Monsieur, on May 14, 1576, even as his hope of picking up the southern provinces of the Netherlands for himself led him to renew his offers of support to William of Orange.[345]

German electors and princes shilly-shallied in their enthusiasm for the Low Countries' usurpation of Spanish rule. Many ordinary people in Germany, as in the southern Netherlands (in Cologne and even in Siegen), had lately found it repulsive that the Protestants of both countries were using religious differences as an excuse for stealing Church property and the estates of Catholics. Their antipathy produced a resurgence of Catholic converts and added fire to the expanding Counter-Reformation.[346] The conviction of injustice of one side became the sense of outrage of the other. Decades later, during the Thirty Years War, such refined questions as those of purity of motive would be forgotten. They would be replaced by an unadorned quest for power among virtually everyone, even those with deep religious convictions. In the meantime, Lutheran-Calvinist rivalry among the nobility, coupled with the freshets of Catholicism among the German lower classes and peasants, meant that German assistance to the Netherlands could scarcely be anticipated.[347]

It was at this point that relief came from an unexpected quarter, the Spanish themselves. Though not without its grotesque aspects, the loathing it inspired was to promote liberation and union across portions of the Netherlands.

At Zierckenzee, a mutiny broke out among the several thousand Spanish troops who had seized it. Efforts to calm them by their courageous commander, Mondragon, who faced down their howling, menacing mob in the streets, came to nothing. His reminders of their duty to their king, their past conquests and their impressive reputation throughout the world met with jeers and derision. For nine years, they argued, they had done the grubbier tasks of the empire – killing, maiming, robbing and burning, as well as providing riches to their generals and officers.

They were poor themselves. They were hungry. Their uniforms were in tatters. Worst of all, they no longer trusted the empty promises of pay emanating from Brussels and Madrid.[348]

They went on a rampage. It was at first a restrained rampage, because they were disciplined Spanish veterans, but it was still a rampage. Moving out of Zierckenzee, where the relative poverty of the captured citizens failed to slake their appetite, they roamed the country, laying unsuccessful siege to one town after another, testing their garrisons, hunting for the right opportunity to strike and seize whatever they could.[349]

Brussels soon trembled before their threat, and the Flemish demands became universal that the mutineers be declared outlaws and expelled or killed. In the popular mind all Spanish troops came to be associated with the marauding rebels, and their commanders, even those who opposed them, with predation. The pressure for royal intervention mounted to such an extent that on July 26 and again on August 2 Philip took the remarkable step of issuing two edicts denouncing them and in effect condemning some of his best soldiers as criminals.[350] While this was by no means the first mutiny among Spanish forces – others had taken place in 1573, 1574 and 1575 – it was the most consequential in stimulating support for the rebellion.[351]

By mid-July the defiant regiments had snatched up the wealthy town of Aalst in Flanders, with its one-hundred parishes and elaborate fortifications. Here they settled in, led by their *eletto*, or irregularly chosen commander-in-chief, and began to issue threatening edicts of their own, demanding money and provisions. They were joined by opportunistic German regiments under Frugger, Frondsberger and Polwiller. Nor was this all. The expectation gained ground every day across the country, fed by Catholics and Protestants alike, that Antwerp itself, garrisoned by Sancho d'Avilla with a powerful force, would be turned over to them. D'Avilla was known to be sympathetic to their grievances, and his collaboration might mean the loss of the commercial and financial heart of the Netherlands, with its vast reserves of merchandise, gold, silver, precious gems and shipping.[352]

Horror piled on outrage as by September the rebellion reached into most of the Spanish army. With the support of German mercenaries, other mutineers quickly assumed control of the huge Citadel at Antwerp, built some years earlier by the Duke of Alva. D'Avilla indeed ceded it to them, along with fortresses at Utrecht, Valenciennnes, Columber and Viane. Brussels alone remained secure, if only for the moment. The arrests, tortures and murders of Catholics and Protestants everywhere had switched with headlong speed into virtual war-making by a criminal army on the country itself.

Resistance, however, was itself baffled by the unstoppable revival of Catholicism in the fifteen southern provinces and by mistrust between

Catholics and Protestants. The traditionally stronger hold on the south of the aristocracy, most of whom were Catholic, stiffened Catholic attitudes. Detestation of Spanish and other foreign soldiers on their soil thus prompted but did not at first induce religious adversaries to combine against the lurching terror.[353]

Despite the common menace, therefore, and agreement that military steps needed to be taken to combat it, efforts by William to forge a union of all seventeen provinces encountered repeated rejection, with many people believing – so firm was their wariness of any government by now – that an official body of their own might also betray them to the Spanish. The result was that probably at William's instigation, and certainly with the aim of immobilizing Spanish authority, a daring operation took place on September 15, 1576, in which the State Council at Brussels, the chief agency of Spanish rule in the Netherlands, was placed under arrest. The young Seigneur de Heze, a nobleman supporting William, broke into the Council Chamber with five-hundred armed troops, prying the bolted palace doors off their hinges to do so. Though the president of the Council, the Duke of Aerschot, the father of the Prince of Croy and Jan Rubens' friend, was himself not taken – he had been warned and stayed at home, pretending to be ill – the rest were confined under house arrest or imprisoned at the Brood-Huys, the very place where Egmont and Horn had been kept before Alva ordered their beheading.[354]

It was a sign of the bizarre anarchy sweeping through the provinces that William now called the first meeting of a new national congress at Ghent, whose fortress was held by the Spanish. With Mondragon, the commander who had confronted the mutineers, off in Zeeland, his wife assumed command and sent for assistance to the mutinous Spanish army. The leaders of the mutiny, however, had long since lost all eagerness for defending Spain's hegemony in the Netherlands, or even for aiding their compatriots. They retired to Aalst.[355] In Ghent, then, a Spanish-occupied fortress was besieged by a mélange of regiments from the two northern provinces and the fifteen mostly Catholic southern ones, under William's direction but amid bickering, mistrust and petulant threats to withdraw from their tetchy alliance. Disputes arose over Protestant hymn-singing, which irked the southern Catholics, who also feared clashes with the Protestants. These were settled, and the congress began to meet as their cannon, trained on the citadel, roared out a daily barrage clamouring for Spanish surrender.[356]

28. The Role of Don Juan

Throughout this period, Philip's policy never wavered: to destroy Protestantism. The dispatch to the Netherlands of his illegitimate half-brother, Don Juan, where he was to take charge of Spanish interests,

represented merely the latest slippery flash of the royal smile, behind whose warmth the same wolfish purpose was pursued as before.

Alva's recall to Spain had been arranged in 1573, amid accusations of self-defeating cruelty. He had routinely disregarded the accepted 'law of war', according to which a town should not be looted and its inhabitants randomly slaughtered if it surrendered before those besieging it began their artillery bombardment. After the surrender of Haarlem in 1573, he had ordered the execution of 2,000 citizens, no doubt in reprisal for having lost close to 10,000 of his own soldiers in taking it.[357] In August of that year he wrote to Philip that he could not 'refrain from beseeching Your Majesty ... to disabuse yourself of the notion that anything will ever be accomplished in these provinces by the use of clemency'.[358] He advised his successor, Don Luis de Requesens, that 'these troubles must be ended by force of arms without the use of pardon, mildness, negotiations or talks until everything has been flattened'.[359] Requesens himself, as the new governor-general, confronted hopeless conditions of bankruptcy at the financial centre of Antwerp ('I cannot find a single penny here [to pay his troops], nor can I see how the king could send money here, even if he had it in abundance'[360]). He died in office, thoroughly frustrated, on March 5, 1576.

Don Juan's immediate assignment was to lure the ever-nervous Catholic majority of fifteen southern provinces away from the Protestant-dominated northern ones. This would be managed with promises of pardon for their having defied the Spanish king, and if successful, would rip apart the tentative union forged by William at Ghent. The familiar acts of treachery and plundering of Dutch and Flemish towns might then follow with ease. William never doubted the nice cloak of cunning in which this plan was wrapped, advising the traditional (and to this date powerless) Netherlands governing council, or States General, about princes on November 30, 1576: 'Nature teaches them to reach their goal by fraud when violence is unhelpful. Like little children, they whistle to the birds they wish to catch. They always offer up plenty of promises and pretences.'[361]

In choosing his new commander Philip seemed to have done well. Don Juan was an egotistical, ambitious soldier of thirty-one, admirably adaptable to royal make-work. From beginning to end, his life mingled romance, disguise, courage, misunderstandings and adventures. Until he was eight, he was disguised even from himself. The son of Charles V and his expensive, histrionic mistress, Barbara Blomberg, he was raised knowing nothing of his royal connections by Luis Quixada, a member of Charles' entourage, and his wife, Magdalen Ulloa, who kept him away from all public and royal contacts at the king's Villa Garcia.[362] Informed of his identity by Philip during a surprise meeting on horseback in a forest, he seems at first to have been thrilled, then humbled, then grateful, then smitten with jealousy and paranoia. Trained as a soldier to

serve the king, who nursed his own doubts about his dashing half-brother, he soon proved his worth in battle. He contributed brilliantly, so the legend went, to defeating the Turks in the great naval contest, involving some 430 ships on both sides, at Lepanto in 1571. For this triumph he received, and prized all his life, taking them everywhere, a set of heroic tapestries.[363]

Not atypical of his idea of justice was his treatment of the Venetian general Bragadino. Bragadino was a mercenary of the Turks, and when Don Juan had earlier put down the Moorish rebellion in Famagusto, which he was leading, the Spanish prince not only took him prisoner but had him killed, skinned, stuffed and sent off to Constantinople suspended from the yardarm of a frigate. An accompanying message described him as a present to the sultan, and a final payment of all the mortgages and other debts owing him.[364]

29. The Spanish Fury

Don Juan arrived at an inopportune moment in Luxemburg on November 3, 1576, on his way to assume command in Brussels.[365] In Antwerp, where mutinous army units held the Citadel, preparations were in full swing for a catastrophe that was to determine its new, black destiny, a murderous assault on the population itself, in an episode that would colour and shape much of Rubens' life.

It would be incorrect to describe the motives of the Spanish and other foreign troops that participated in what happened as purely material-istic. The so-called 'Tenth Penny' tax, imposed by Philip to raise money for his war against the Turks, and lifted by Alva, had aroused animosity. The decision in 1563 by the English to shift their shipments of wool and cloth from Antwerp to Emden, depriving thousands of workers of their jobs in Flemish factories, had contributed to Antwerp's financial decline (Elizabeth suspended the decision in 1565, but English trade was later shifted to Hamburg, with the same result).[366] It is nonetheless clear that the Netherlands rebellion, and the Spanish response to it, were driven chiefly by religious differences. Certainly class struggle played no deci-sive role in the increasingly mutual hatred that spurred the fighting. Money remained crucial to hiring soldiers, but even this was hardly essential, a fact confirmed as both sides showed themselves willing to hurl themselves into poverty, and to sacrifice thousands of lives, for no useful economic purpose, while religious disputes appeared always as potent as poison.

Antwerp's ruling council had some inkling of what was to come. The city's magistrates authorised pitiful defensive preparations, letting the States General send in 5,000 infantry and 1,200 mounted knights, mostly Germans and unreliable Walloons who were themselves unsympathetic to the residents, on November 2-3, and mobilising all able-bodied men,

women and children, or some 12,000 people, to dig a protective trench around the Citadel in extreme haste and under emergency conditions. By Saturday, November 3, the trench was as ready as they could make it. On its street side, it was backed by a crude rampart between six and sixteen feet high, and made up of overturned waggons, piles of earth, bales of cotton and odds and ends of timber. Construction became hazardous as cannon atop the looming fortress, one of the strongest in Europe and crammed to capacity with thousands of hostile soldiers and cavalry, showered the frightened labourers with crackling volleys.[367] Nor were matters helped by the arrival on Sunday morning (November 4) of between two and three thousand of the mutinous soldiers from Aalst. They had marched twenty-four miles through most of the night to join up with Sancho d'Avilla, and raced through one of the fortress gates opened to admit them, hungry for battle.[368]

The fighting began almost at once, in a palpable mist sifting in from the plains. Over five-thousand seasoned Spanish troops, accompanied by six-hundred horsemen dressed in steel, all well armed and shouting 'España, España! á sangre, á carne, á fuego, á sacco!' (Spain, Spain! blood, flesh, fire, sack!), poured spectre-like and fearsome out of the fortress, crashing across the shallow trench and through gaps in the flimsy breastwork. The Walloons fled, in some cases joining the enemy. The German cavalry, stationed some distance off, stood firm. They put up a fierce though useless resistance, which was swiftly broken by the river-raging Spanish onslaught, as did thousands of the citizens, including many women, who found themselves trapped among their own defences, the city walls, and bottled up in the narrow streets. Ghastly slaughters erupted at the Beurs, where traders massed and fought back but were sliced to pieces in its elegant courtyard, in the square before Our Lady's Cathedral and around the superb Town Hall, which was set ablaze as the Burgomeister, Van der Meere, and other magistrates fought and were slain in the street behind it.[369]

Many residents, after initially joining the fray, retreated into their houses. There the invading soldiers, bent on rapine and battering in the doors, hunted them down, first forcing them to haul out their valuables for looting, and then raping wives, mothers and daughters, often before chopping off their arms, while husbands, fathers, brothers and sons were beaten into watching, and before whole families themselves were slashed to death or set afire amid their furniture, in their kitchens, hallways and bedrooms – all this as the gangs of mutineers cheered horribly outside in the streets.[370]

For eight days, from November 4-11, the terror proceeded without letup. It swept from one district to the next and back again. Close to one thousand houses, among them the city's most exquisite, were set afire and burned to the ground. Over eight-thousand people were murdered, with many shot and others drowned in the Schelde or the canals, or

trampled by horses. Mad people, left demented by what they had seen, wandered among the glowing ruins.[371]

Early November thus presented to the revulsion of Europe itself the funereal violence of the great metropolis, of days and nights when Antwerp's canals and the Schelde swam in the yellow shadows of the buildings flaming beside them, and when, as was reported, the river itself carried echoes of the screams of the dying out to ships at sea, miles away, together with afternoons whose weather rained cinders, exploded limbs and blood, along with the aroma for weeks afterwards of decayed flesh and smoke mixing among the salty, ripening breezes.

30. Don Juan's Misjudgements

Who could doubt that this episode marked the end of an age? Or that, even if strong elements of the age now passing were to carry over into the future, a new age would slowly and painfully be born?

With the departure of the murderous Spanish army some six months later, the Citadel, nerve-centre of the decimation of the city, was placed under the command of the Duke of Aerschot, the Catholic leader whose depth of religious feeling and refinement made an odd contrast to his hatred of William's religious toleration.[372]

Don Juan, meanwhile, who described himself as offended by what soon came to be called the Spanish Fury, and which must be judged one of the worst atrocities of the century, recovered some of his reputation by expressing sympathy for those killed and arranging a stately theatrical entrance into Brussels on May 1, 1577, or just two months before Rubens' birth.[373] Dozens of triumphal arches, designed and painted by local artists and intended to evoke, as usual, the grandeur of imperial Roman triumphs, lined his progress through the crowded streets. He wore a brocaded green cloak and rode on horseback between the Bishop of Liege and the papal nuncio.

As minstrels sang specially composed ballads recounting his victories, virgins (specially selected, from the city's leading families) decked him with wreaths and crowned him with laurels. Tens of thousands of people watched from the rooftops and windows. Painted banners, snapping smartly in the wind, named and saluted in bright colours his battles and courage. Flowers cascaded from the balconies of the houses. The rhetoric clubs reenacted familiar scenes from his astonishing life. His most splendid public day, which began with a benediction in a church, ended with a massive outdoor banquet to which hundreds were invited. The new commander of the Citadel stood in attendance throughout, dressed as magnificently as the Spanish prince himself, in a pink cape embroidered with gems and gold.[374]

The more extravagant the public theatre, however, the fiercer the policy. Don Juan's private purpose through all his activities in the Low

Countries was to effect a Spanish pacification of the rebellion so that he might move ahead with a larger project: war against England. While visiting the Louvre on his way to Luxemburg, he had glimpsed Mary, Queen of Scots. He at once fell in love with her, giving vent to a barrage of love letters. If only the Netherlands troubles were settled, he might concentrate his prodigal energies on winning her hand, overcoming English resistance with Spanish ships and troops, rescuing her, marrying her and securing new dominions for the Spanish crown across the English Channel.[375] War spiced by love and money seemed more appealing to him than these seventeen muddy provinces of northern Europe. In his letters he described them as a 'Babylon of disgust', and 'a hell', full of 'drunkards', 'wineskins' and 'scoundrels'.[376]

A more important snag was that he had now become governor of the Netherlands in name only. Real power by this time resided in William and the States General, to his most intense frustration.[377] So debilitating was his bafflement that, according to his friends, he shortly began to suffer several 'fevers' and to 'wither away'.[378] On the other hand, this strange decline seemed only appropriate to his fiery, easily bored personality. While clever, he was incapable of calm. Eager for glory, he was contemptuous of the struggles of ordinary people. Dramatic gestures brought him solace, as the tedious negotiations of political life exhausted his patience. Such a typhoonish nature, it may be surmised, could quickly fall victim to the machinations of steadier, subtler ones. Precisely this now occurred.

His chief problem was that he misunderstood his adversaries. Amazingly, after over ten years of Dutch and Flemish resistance to Spanish rule, William appeared to him as a merely materialistic, power-hungry prince, as a man much like himself. William simply wanted money and obedience. He was an opportunist, taking advantage of the financial weakness of Spain and the corruption of the Church.[379] The idea that the prince of Orange might actually mean what he said, especially about political freedoms in the Low Countries and religious toleration, seems not to have crossed his mind. In this he exactly resembled Philip's cabinet and advisers in Spain, who had also not had his advantage of meeting William recently and visiting among the rebellious Hollanders.

Beyond these issues, and like most members of the Madrid government, he also misconstrued the religious rebellion. He regarded Protestantism as a crazed superstition. It had taken hold of the minds of the misguided and ignorant. Better education, more decisive leadership and above all brute force would restore the Reformers to sanity and right-mindedness. The irrationality of this view never occurred to him, to wit, that those espousing Church reform and their allies in the Dutch rebellion, including many Catholics, were among the best educated people in Europe, with literacy rates on average far higher than those of his own country, with a culture equally accomplished and with talents for

manufacture, commerce and the arts, especially those of publishing and painting, that made wonderful impressions on those who came to know them.

All these factors, which were personal, conduced to the pointlessness of the few attempts by Don Juan and William to reconcile their interests. Don Juan wanted peace for the sake of disunity and domination, William war for the sake of union and freedom.

31. Artists and the War

It would be a mistake to imagine that amidst the ongoing revolt and civilian slaughter Flemish artists remained inactive. In fact, whether because of the violence, or in spite of it, or mysteriously both, they seemed to accelerate their efforts. Nearly thirty years later, in 1604, Carel van Mander observed of the relations between art and war in a passage that remains applicable through all these decades: 'Reckless and destructive Mars is terrifying our country with thundering batteries that raise even the grey hairs of Time. It is surprising, in spite of this, that artists can continue their work in the art of painting.'[380] He went on to say that 'art requires peace and prosperity',[381] but here he was wrong, and art could manage without them.

Pieter Bruegel the Elder, whose two famous sons hardly knew their father because he died in their infancy with the result that they became important painters in their own right only by studying his techniques, worked in Brussels and Antwerp through the first few years of Alva's rule, or during some of the worst outrages of the Inquisition.[382] His *Peasant Wedding* (1568) reflects none of its dread, as does none of his other canvases.[383] *Peasant Wedding* shows a party of sprawling, cheerful gluttons feasting on improvised tables in a barn after the village nuptials. A couple of smartly clad farm workers, no doubt hired for the event, are busy lugging in a trayful of pies for dessert. No one seems to care about the outside world, and certainly not about its wars and politics. The painting also presents what looks like a clear violation of Alva's edict aimed specifically at the rebellious population, that no more than fifteen people could assemble anywhere, even for a wedding party. Without a hint of official objections, well over thirty are assembled in a picture that is probably a faithful record of an actual feast.

This is not to say that the spasms and noise of war did not enter his paintings, only that they did so seldom and with irrelevance, as from a soothing distance. If he himself was a practical joker who liked to scare his friends by imitating the sounds of goblins and ghosts,[384] he seems to have had little desire to challenge local authority with depictions of its barbarism. His *Slaughter of the Innocents* (c. 1564, in two versions, one in Vienna, one at Hampton Court) is suggestive of his attitude toward art and the growing lawlessness. It shifts the biblical story of the mass

murder of children ordered by Herod into a snowbound Flemish town (in the Hampton Court version), turning an ancient biblical tale into a type of modern journalism. On the other hand, the knights in armour conducting their ferocious raid cannot be Spanish, as no Spanish troops were stationed in Flanders between 1560 and 1567.[385]

The fact that he did not flee the violence at the very time when Jan and Maria Rubens were moving to Cologne to escape it, and to save their lives, implies at the end of his own short life (he died some seven years before the Spanish Fury) his lack of involvement in the great political events of his day, and possibly his scepticism of rebels and Spanish alike. He perhaps agreed with his famous friend, Abraham Ortelius (1527-98), the Flemish geographer and author of the first modern atlas, the *Theatri orbis terrarum*, issued in 1570 and later brought out in a series of popular editions by several publishers, including Christophe Plantin. Ortelius wrote to him derisively of 'Catholic evil, Protestant fever and Huguenot dysentery', noting that 'sins are committed within and without', or on both sides.[386]

The truth was simply that there existed no tradition among Flemish artists or artists in other countries for depicting the cruelties of war as an indictment of the political fanaticism of existing governments. As in the case of the more cowardly writers facing proscription by imperial Spanish censorship, this lack was no doubt due in part to the fear of arrest and execution. It also meshed with hesitations washing through the population at large, and with the interests of the royal and loyalist patrons who paid for the best artists' work and who would hardly have condoned paintings insulting enough to match the acts of military depravity insinuating themselves across the Netherlands.

Squeamishness, in other words, was not the issue. Few of the Flemish or Dutch painters had any qualms about laying open the grimiest aspects of daily life, if they felt so inclined, or grand, sensual and hellish scenes either, as long as they had to do with battles made in Heaven rather than atrocities manufactured by earthly princes, whose allegorical meanings, considering the hideousness of the conflict now afoot, might be ambiguous. The Mannerist Frans Floris, for instance, who died one year after Bruegel, had no compunction about painting a terrifying *Fall of Lucifer* full of 'a weird mingling and falling of the nude bodies of various demons',[387] or a *Victory* celebrating Philip II's arrival in Antwerp in 1549 that showed 'a group of prisoners bound and lying on the ground',[388] but these and the rest of his paintings that have survived are only free of all prohibitions save the one that was rarely discussed: that against political independence combined with criticism.

To say that this concept was little esteemed among painters, or only now and then assumed its modern stroppiness, usually against the stiffest exhibitions of disapproval, would also be to miss the point. At the height of the revolt, and even among those most committed to it (in the

beginning these included William himself), few people thought of renouncing Philip as their king. Atrocities were attributed to the corrupt policies of his commanders and advisers, and only seldom to him. The Spanish might be despised for what was done in their name, but Spain, in the person of her monarch, almost not at all, or not yet.

Exceptions to this general artistic reserve were Joos van Winghen (1542-1603), whose allegory *Horrified Belgium* was painted after he fled Brussels for Frankfurt,[389] and Hans Snellinck (1549-1638), who, according to Mander, was 'good at painting ... battle scenes. He paints realistically the smoke of cannon, and the soldiers enveloped by it and partly visible',[390] though again without any but implied commiseration with the often suffering combatants.

Most artists, especially the established portrait painters, simply stuck to their last. For Frans Floris this meant as much drinking as painting. 'When I work, I am living; when I indulge in pleasure, I am dying,' he announced after coming home late one night from a drinking bout and picking up his brushes for a stint in his studio.[391] In his bedroom, beautifully decorated with gold-embossed leather hangings, his apprentices helped him off with his shoes and stockings, once doing so after he had spent the evening toasting sixty times, or one full stein per toast, each of the thirty members of Antwerp's clothiers guild. He remained to the end 'a great painter and a great drunkard', whose bibulousness did not interfere with his becoming a friend of William of Orange and the Counts Egmont and Horn, or his plunging himself and his embittered wife into debt after making vast amounts of money through sales of his work.[392] Revelry, and no doubt lack of time, because he loved his cups as much as his brushes, seem to have eliminated any worries about politics and war.

Other less dissipated artists embraced his indifference or remained Spanish loyalists. Otto van Veen, whose father Cornelis was Burgomeister of Leyden, where he was born in 1558 (he lived long into the next century, dying at Brussels in 1629), was a fine portraitist who repeatedly turned down invitations to become a court painter in Brussels, Paris and Madrid. A Humanist with a literary bent and an enthusiasm for the Greek and Roman classics, he preferred staying in Brabant among his friends, though he devoted much of his career to painting Spanish and Hapsburg royalty and Spanish military grandees.[393] Tobias Verhaecht, who was born at Antwerp in 1561 (and who was also long-lived, dying in Amsterdam in 1631), excelled at landscapes, which may have diverted any political passions.[394] Adam van Noort, himself the son of a painter, who was born at Antwerp in 1562 (and died there in 1641), is merely described by Van Mander as 'a good painter of figures'.[395] William Key, the well known painter of the Duke of Alva, reacted more personally to the Spanish military onslaught. While finishing his portrait of the duke, he overheard him confirming the death sentences of Egmont and Horn to a member of his 'Council of Blood'. He

became ill on the spot, and actually died on the day of their execution.[396] More typical, though, was the career as a landscapist of Joos de Momper, who was born in Anwerp in 1564 and lived there till his death in 1635, producing during his over seventy years an *oeuvre* unruffled and untouched both by war and the question of atrocities.[397]

Still, it is clear that little of this situation among artists was as quiescent as it now seems. A strange grey space was unbuckling in the souls of men and women, whether they were artists or not. The siege of minds matched the siege of towns and cities. The slaughter of the innocent produced a grim sophistication. The absence of contemporary battles in Flemish painting only attested to the mesmerism of armies everywhere.

From another point of view, the iconoclastic outbursts of the 1560s and earlier had left a vacancy of art on the walls of hundreds of sacred buildings. Their uses became question marks. Believers were vanishing or taking over the naked apses and naves for spiritual practices incompatible with the art of the past. Catholic churches awaited restoration, and a possible opulence that no one could imagine. The same might have been said of the noble houses and mansions in the south, where Blake's as yet undescribed 'hapless soldier's sigh/[Ran] in blood down palace walls', and where an unguessed new art was already wondered about.

While no one understood precisely, as thousands of refugees from Antwerp moved north into Holland or further south into Germany, that the seventeen provinces would be split apart by the revolt, a division between southern and northern painters, involving a tendency to paint in different ways, seemed in the air. The violence of war, a harsh complement to many artists' earlier explorations of light and self-consciousness, had begun to extend a perverse invitation.

32. The death of Don Juan

What followed in 1578, the pathetic, ugly but hardly tragic death of Spain's foremost soldier, the absurd end of the bastard half-brother of Spanish royalty, needs to be recounted if only because it sheds light on the flavour, squabbles, attitudes and values of the period in which Rubens was passing his childhood. The awkward end of the Spanish grandee also casts a candid shot of light into the theatrical minds of the Spanish king and some of his confederates.

The dying first: Don Juan died in a pigeon coop. This was in September at his military base near Namur, a pretty town with its lordly dark fortress clapped firmly on a hilltop, from which the victor of the Battle of Lepanto had originally sought to launch his conquest of the Netherlands. The pigeon coop, a farmer's wooden hut, had been cleared of pigeons and scrubbed out. One of the heroic tapestries to which he remained so attached as a reward for his Lepanto triumph, along with some scattered-about Turkish chairs that he had earlier managed to

salvage when he had been forced to flee Mechelen at the sudden approach of William's troops, hung around the walls above his thick-blanketed cot. The weather was stifling. Outside, his tough, little army, together with its baggage, horses, prostitutes and wives, awaited his orders. It verged on mutiny. It had not been paid. Plague had struck among the soldiers, and over 1,200 of them languished in military hospitals. The emaciation of Spanish glory was appalling at that moment, and unrelieved.[398]

Over the previous weeks, the ever-busy prince had sent off dozens of letters to his half-brother in Madrid, pleading for assistance. None arrived. He lay tossing in delirium for several days and immured in a suspicious, kingly silence. Then he awoke and dictated his last testament, in which he appointed Alexander of Parma, his nephew, to succeed him with Philip's blessing. Alexander, recently arrived from Glemboux, where he had won a victory over the rebels for his uncle-commander, witnessed his death.[399]

After he died, apprehensions immediately arose that he had been poisoned. Many, aware of the rumours of an alleged (and nonexistent) plot against Philip, in which he had been implicated, seemed convinced that the king had ordered his death. Of this there was no evidence, but a type of autopsy was performed, mingled with the embalming practices usual for royalty. This revealed nothing but the severe desiccation of his internal organs consistent with the plague rampant in the camp itself: on examination, his heart appeared to crumble to dust. Nonetheless, two Englishmen were arrested as spies and executed on an unproved charge of assassination.[400]

An elaborate funeral was staged near Namur. His officers from the Low Countries, Spain and Germany argued with acerbic tastelessness over who should assume the place of honour. They finally agreed to share the ceremonies through relay stages for his corpse, which was borne on a scaffold into the town for interment, amid muffled rolls of drums and richly clad in his knightly armour and heaps of gems, and wearing his medallion of the Order of the Golden Fleece.

Six months later a more peculiar ceremony took place. The prince had expressed a wish to be buried in the Escorial. Philip was amenable to this but had no interest in spending the money necessary to transport his body in an official way across France, where at great expense a cortege outfitted with troops and a military musical ensemble would have to pause to conduct memorial concerts in every town and city. Accordingly, the corpse was exhumed, sliced into three sections, which were wrapped in bags, and secretly hustled by three cavalrymen over several days to the palace. There it was reassembled, the pieces expertly knitted together by wires. Made to stand upright in his armour with his own tall staff of war, so that 'he looked alive', and arranged once more in his Golden Fleece medallion and covered with precious stones, he faced his half-brother, the king, for the last time before being consigned to a marble sarcophagus

beside his father, Charles V.[401] Philip was reportedly moved by this grotesque sight, but the resemblance between their last meeting and similarly grotesque interviews with corpses and skeletons in Elizabethan plays such as Tourneur's *The Revenger's Tragedy* (first printed 1611, though it was probably first put on years earlier) suggests that some of the more gruesome scenes of the new Elizabethan drama had recent historical reports as their source, and argues for their haunting accuracy.

33. Alexander of Parma and the Great Betrayal

At the same time, the headstrong cleverness of Don Juan's successor told against the rebellion almost at once. In Alexander the king seemed to have found a commander, governor and politician whose eagerness for battlefield heroics matched his concentration on repairing Spain's reputation among the people he was supposed to rule. His achievements in the latter area were confined to the Flemish- and Walloon-inhabited provinces of the south, but they were to endure through Rubens' lifetime and for centuries. They are evident now.

So far, or since the death of Charles V, the Spanish Netherlands, as Philip still regarded all seventeen provinces, had seen four governors: Margaret, Philip's sister, who ruled with Cardinal Granvelle; Alva; Requesens; and Don Juan. In Alexander, the son of Margaret, they ran into someone who seemed an exaggeration of his predecessors' virtues and a diminishment of their myopic vices.

Alexander (1543-92) had been the true hero of the Battle of Lepanto, for which his uncle had soaked up most of the credit. He had slipped his Genoese galley alongside the treasury ship of the Turkish fleet, bombarded her, boarded her alone as none of his soldiers would follow him, and with a double-bladed broadsword slashed a path among the enemy sailors until he found Mustapha Bey, the commander, whom he decapitated. Taking over the ship, he likewise captured a second sent to rescue it.[402] The wealth that he brought home was stupendous, as was the jealousy that he provoked among his rival commanders, to his unimpressed satisfaction.

It was perhaps his experience of this jealousy, though, that prepared him to put to sly use the envy of William of Orange flashing sourly among the ranks of the nobles of the southern Low Countries. There were many aristocrats – the Montignys, the Le Mottes, the Meluns, the Egmonts, the Aerschots and the Havres, whose families had in the past won victories for their people – who yearned for peace with Spain only to humiliate William. Among them, his national ambitions remained as despised as misunderstood, with his idealism still seen as profiteering. A diplomatic, ruthless generalissimo, Alexander was devoid of Don Juan's menacing charm. This endeared him to nobles vainer than he, and eager for wealth themselves.

His purpose was also aided by the resurfacing of a by-now general bigotry. A period of relative peace, in which the Spanish seemed to be losing their grip, with the death of Don Juan, and in which Antwerp, following the Spanish Fury, had turned into the centre of Protestant rebelliousness in the south, allowed old winds of intolerance to fan flames of religious hatred. In town after town Catholics and Protestants revived their mutual persecutions. Reformers, some thirty thousand of whom had fled to England, returned to find their welcome sailing into discrimination and assaults.[403] This threatening social atmosphere glided into a military disintegration. De-mobbed mercenaries wandered everywhere. As in the middle of the century, the roads were crowded, but now with violent thieves and murderers determined to strip the already stripped land of whatever they could seize. Some were native ex-soldiers from disbanded units of the States armies. Most were mercenary Spaniards, Burgundians, Germans, Walloons, Scotch, English and Italians.[404]

34. The Theatrical Soldier

In the midst of this anarchy Alexander developed a strategy of his own, even as the Hollanders and Zeelanders in the north pressed ahead in their quest for freedom and union among themselves. He used a new treaty signed by the two united provinces and the Duke of Anjou, Francis Hercules, the brother of Henri III of France and their elected alternative sovereign (from 1581 to 1584), as an excuse for reintroducing foreign mercenaries into the southern Walloon areas.[405] Troops assembled by their thousands at his behest, mostly Italians and Spanish. At the same time, in the summer of 1582, when Rubens was a boy of five, he seized a number of valuable cities with the soldiers that he already had on tap.

The most important was Audenaarde, on the Schelde, where his grandmother, Margaret van Geest, had been born. The celebrated story of his dining while conducting the siege of that city, and of his refusing to allow the slaughter of several of his guests during the meal to interrupt his enjoyment of it, reveals much about the age, his bravery and suavity and the reasons for his remarkable success with men and battles.

The contemporary historians Bor and Strada report that he habitually commanded his men personally at the battlefront, leading them by rushing ahead and choosing the weapons of the ordinary soldier, the mattock and spear, over the horse, pistol and sword that were his by right.[406] Often he took his meals at the outermost points of his military advances, in full view of his Dutch and Flemish enemies, taunting them by exposing himself in full-dress uniform.

On the day in question he was busy helping to set up a battery of artillery close to the city wall and aimed at an already bombarded weak spot. He refused to withdraw at dinner time, and insisted on eating out

in the open, under the muskets rattling in his direction from the parapets. A tablecloth was laid over several drumheads, and food was served to him and his staff, along with the noblemen Aremburg, Montigny, Richbourg and La Motte.

The dinner commenced with the decapitation of a Walloon officer sitting beside him. A cannon ball removed the officer's head as he raised his fork, and a chunk of his skull clicked into the eye of another guest, who departed the table in some alarm. Two more guests, a German captain and a prosecuting attorney, were dismantled by a second cannon ball. Their brains, along with a quantity of their blood, exuded themselves over the plates and food. The remaining guests now rose to leave. Alexander frowned. He continued to eat, and calmly ordered the corpses removed and a clean tablecloth spread in place of the soiled one. He announced that he had no intention of allowing the defenders of the city to see him disturbed by anything that they might do.

His officers and guests, whether inspired or intimidated by his example, returned to their seats. The dinner proceeded. Within a few days Audenarde surrendered. Alexander waived his usual pillaging of captured cities for a thirty-thousand-crown dispensation in this case, perhaps as a gesture to his grandmother's memory, perhaps because he was as given to civil habits as to cold-bloodedness and plucky table manners.[407]

35. *Coups de grâce*

Three other events during his rule bear directly on the world in which Rubens had begun to find his way: the French Fury of 1583, the assassination of William of Orange in 1584, and what is known as the fall of Antwerp in 1584-85, the result of a fiercely contested naval blockade.

If mass murder had meant the end of an age, it had not meant the end of business. Other shocks were necessary to impress the meaning of the killings of 8,000 the city's inhabitants on those who remained, and to indicate to them that little could continue as before. Indeed, some of the richest commercial families, the Fuggers, for instance, who ransomed themselves and their mansion for 11,000 crowns at the height of the atrocities, tried afterwards to go on as they had, making money hand over fist through banking and shipping out of the port that still remained Europe's most valuable point of entry.[408] No one expected that a treacherous collaboration between arch-enemies, the Spaniards and Hollanders, might soon be tacitly agreed upon, or that it would be in the interests of both to bring Antwerp to its knees, applying coldish hands of strangulation to its throat: the river Schelde.

As late as 1584, to nearly everyone except Alexander the idea of any such manoeuvre would have seemed outlandish. Throughout the south, the Spanish Fury with its devastation had greatly improved the position

of the Orangist rebels. It had especially done so in the city itself. On the withdrawal of the disgraced soldiers, the Orangists managed to take over the municipal government, despite Antwerp's more or less equivalent numbers of Protestants and Catholics and their more or less equivalent wealth.[409] William's friend, Marnix van Aldegonde, who was a Calvinist theologian as well as the author in 1571 of the detailed denunciation of Alva's crimes in the Low Countries (he also wrote sonnets), became 'outer' mayor (Buitenburgemeester), in charge of the city's defences.[410]

The so-called 'French Fury', however, provided more than a hint of the troubles to come. French soldiers allied with the Orangists suddenly engaged in officially incited assaults and plundering straight across the Netherlands' fifteen southern provinces, seizing Dunkirk, Aalst, Ostend and other towns. They failed to take Bruges, though, and their attack on Antwerp on January 17, 1583, was routed. Over 1,500 of them, including some 250 officers, were killed, as against eighty Antwerpers.[411] This was a pittance by comparison to the lives lost during the Spanish Fury, but it suggested that not much in the way of outside help could be relied on in the event of more powerful assaults. Did it matter? Antwerp seemed to some to be reviving as a bulwark of riches and strength, as the best-protected city on the Continent, with its numerous militia, its ring of small forts, each equipped with cannon, and its home-grown weapons factories. Its real resource remained its harbour, with its grand funnel of a river leading into the world's seas and oceans. To most this seemed to render it impregnable, affording it an endless opportunity for resupply through the flow of mercantile exchange. Only Alexander viewed it as an opportunity.

He conceived a remarkable plan, one combining the cleverest engineering of the century with the weaknesses of his enemies – their mutual suspicions, religious rivalries and greeds – and putting each to use with stunning success. The idea was to throw a massive barrier bridge, some 2,400 feet in length, across a vulnerable spot along the river, cutting off all trade and effectively laying siege to the city without firing a shot.[412] At the same time, he realized that although relief operations would surely be mounted, the crippling of Antwerp might actually prove attractive to jealous Dutch merchants in major cities to the north, such as Amsterdam. Their ancient yearning for business parity might be appeased by the shipping that would be redirected their way. They might not object too much.

In this he was mistaken, because their objections at first turned out to be violent and formidable. In fact his plan might not have succeeded at all if William of Orange had not been assassinated on July 10, 1584.

William's death altered the deepest nature of the rebellion. It reinvigorated all the old antagonisms and fears. He alone had been able to inspire and negotiate with the various factions. He alone had

commanded sufficient popularity and confidence to transform the ancient kinship of the peoples of the Low Countries into national aspirations. The politician, warrior and prince, whose second wife had betrayed him, who had found happiness with the ex-nun who became his third wife, and whose son had been held prisoner for years now as a cruel but useless bargaining chip by Philip in Spain,[413] had always stirred emotions of tolerance and optimism in the hearts of his fellow citizens. An early attempt at assassination, in 1582, had left him wounded though capable of carrying on, but when he was shot to death in the stairwell of his house at Delft by a Calvinist fanatic, the obsessed Balthazar Gérard, anxious for a fifty-thousand-crown Spanish bounty on his head (and who was caught, tortured and executed[414]), cracks rapidly sabotaged the alliances between the north and south. An assassin's bullets became the catalyst for menacing disunity.

Throughout this period, Alexander made appropriate use of the services of two Italian engineers, Giambattista Piatti and Properazio Boracci, in designing his siege-barrier. Its completion, on February 25, 1585, saw the Schelde sealed shut by a floating blockade-roadway ten feet across, and supported along its 430-yard central section by thirty-two chained barges anchored to the river bottom. Each was equipped with two cannons, while earthwork parapets, also equipped with cannons, guarded both ends. The entire structure, incorporating scores of sunk pylons that supported its wings, bristled with pontoons bearing honed beams. These were intended to sink any hostile ships trying to ram their way through.[415]

Assaults on his war-engine materialised at once. They went on for months. Another Italian engineer, from Mantua, Federigo Gianibelli (*c.* 1530-88), hired by the Dutch, tried to destroy the terrible long lever with mines, drags and torpedoes: with 'porcupines', or wooden casks wrapped in steel spikes and carrying flammable material; with linked canvas sails drifting underwater into the pylons, where the current (it was hoped) would force them to collapse; and with a gunpowder-packed raft to be set off from shore as it hit the centre. All failed. Some were absurdities. The raft merely missed its target and went aground.[416]

Gianibelli tried again in April, 1585. This time he had the right idea, but the Dutch failed to take advantage of his shrewdness and this cost them everything. He launched four flat-bottomed barges straight at the bridge's weaker middle section. The prow of each was protected by a fourteen-inch-high wooden shield, and all four were designed to function as time bombs. At a signal from clockworks installed below deck, fires kept burning in the forward holds would ignite a mass of powder stuffed into the holds astern, expelling in all directions a lethal cargo of spikes, nails, chains and stones.

Three of the barges failed to detonate as planned, but the fourth worked perfectly. It exploded with a roar heard for miles around, blowing

away about 260 feet of the centre and killing 800 Spanish soldiers. Alexander himself, standing yards away, narrowly escaped death. He was shaken, but unhurt and certainly unbowed.[417]

From the Spanish point of view, however, all seemed lost. Their cause was saved when a relief army mobilised by the Dutch failed to arrive in time. Parma's engineers and his disciplined soldiers worked tirelessly to repair the gap. They managed to do so, and this indeed assured their victory. The bridge's restoration put an end to any practical hope of Antwerp's relief, and on August 17, 1585, the city's governing council, speaking for a population beaten into exhaustion and starvation by months of siege, capitulated, signing a treaty of surrender. In pride and empty majesty the duke rode with his army through the nearly deserted streets, among houses charred years before during the Spanish Fury.

At the Town Hall he demanded a remittance of one million florins to pay his men.[418] This was arranged by the despairing council magistrates, who perhaps guessed that the transfer of so much money marked the beginning of the end of the Beurs' financial dominance. The blockade continued, and was soon predictably enforced by the Dutch themselves, who had no desire to watch Antwerp make a comeback under the Spanish or to let it hinder what grew into a commercial boom in Amsterdam.[419] The business disaster assumed vast proportions. Money became scarce. Banking interests fled to the north. Industries moved out as well. Refugees sold or abandoned their homes, streaming into Holland and Zeeland, eventually by the tens of thousands. Their departure reduced the population from over 90,000 to under 50,000.[420] By this time too, the entire province of Brabant, along with Flanders, had fallen to Alexander's strategy of sieges. All of those territories that comprise modern Belgium were once more under Spanish rule.

36. The Family Returns to Antwerp

Succumbing perhaps to fatigue along with illness, Jan Rubens died on May 1, 1587.[421] The military catastrophes to the north did not deter Maria, and she made plans to return to her home city, where her family still owned property. She buried her husband in the Church of Saint Peter, where her children had long worshipped, placing over his grave a tombstone with a curious Latin epitaph. It asserted that the family had resided in Cologne for nineteen years, and added that 'his wife, to whom he presented seven children, and with whom he lived in harmony for twenty-six years, without giving her any reason for complaint, has caused this tomb to be erected, honouring her excellent and beloved husband'.[422] Peter Paul Rubens was then almost ten years old.

Much of the epitaph's message was untrue. The family had not lived in Cologne for nineteen years. Some of Maria's time with Jan was hardly happy. There is no mention of the years in Siegen, or other traumatic

problems. Entirely unmentioned is the fact that her children had an illegitimate royal half-sister living in Dresden.

On the other hand, these omissions were clearly a mask for love. They were also useful. Commentators have on occasion mingled wonder with amazement at Maria's fiddling with the facts, yet her propriety is entirely comprehensible: families do not normally wash their dirty linen on tombstones.[423] An epitaph is hardly the place to rehash a love affair with a distraught princess, or to remind others that one's husband may have spent a few squalid years in prison. Her tenderness is also clear. The words bespeak affection, loyalty and her practical sense. Indeed, she managed to secure from the Cologne Council a testament, essential in arranging her return to Antwerp, that she had 'usually kept house' (*consuetum domicilium*) for nineteen years in Cologne.[424] Actually, the epitaph simply took stock of some of Jan Rubens' better qualities at the end of his life, while encouraging his children.

The Council certificate was issued on June 27, 1588, and the family's return to Antwerp seems to have come in early 1589.[425] This was when Rubens was eleven, or some eight months after 'the supreme disaster' of Philip II's reign, the crushing defeat of his Spanish armada by unpredictable currents, nasty weather and a daring English fleet, thus marking Spain's first humiliation in the long, wrenching struggle for imperial supremacy in Europe and around the world. Philip's colossal blunder became Alexander of Parma's first loss as well. He had sailed with the armada in command of invasion troops whose unrealistic aim was to seize London (Federigo Gianibelli here exacted a bucket of revenge for failing to destroy Alexander's siege-bridge across the Schelde: after his failure, he took himself off to England, where he helped organize English resistance to the Spanish[426]).

Maria had little money, but through her former Alderman-husband and her own family she retained excellent social connections. With Philip, Blandina and Peter Paul, she moved into a family-owned house on the Meir, in one of the city's most elegant districts, though it was now going rather to seed. Within a year, or when he was sixteen, Philip had secured a position as secretary to the magistrate Jean Richardot in Brussels.[427] He had developed a passion for scholarship, and seemed to want to follow as a student of philosophy and law in his father's footsteps. Blandina left as well. In 1590 she married a Flemish nobleman, Simon du Parcq, who perhaps unwisely gambling on the city's revival, set about founding a trading company.[428] At a nearby school, Peter Paul continued the education begun with his father in Cologne.

Antwerp's schools were still plentiful, and crowded, including girls schools, such as the Lauwerboom (Laurel Tree), which had enrolled 464 pupils between 1576 and 1585, and was attended at one time by Catherine Plantin, a daughter of the publisher, though a majority of the city's girls were educated at home or in convents.[429] Languages and the

classics formed the heart of the curriculum for everyone at the academic schools (poor children received a minimal education, often simply learning their family's trade at home). A measure of these 'Latin' schools' linguistic emphasis is discernible in the example of Catherine Plantin herself. Though admittedly a startling exception, she was reading proofs for her father in five languages by the age of thirteen.[430] Arithmetic, geometry and rudimentary science, including geography, which tossed in bits about the customs of other cultures, were taught, especially in the schools run by Catholic Humanists. History was picked up through instruction in Christianity and the Greek and Roman classics, though in the case of more recent events, only in the streets through broadsheets and gossip. Religion and scripture saturated all types of education, as they did society itself.[431] Antwerp's traditional enthusiasm for learning and ideas, combined with spiritual training, had not abated, even if the number of children and adolescents began to ebb under the pressure of emigration.

Rubens attended the exclusive Papenschool, just behind Our Lady's Cathedral, on Melkmarkt (Milk Market) Street, a five-minute walk from his home. Its thirty boys were taught by the Humanist Rumoldus Verdonck (1541-1620).[432]

In a school administered with his wife, Verdonck's regimen was typically strict. Following the routine of schools throughout the Netherlands, classes began at seven or eight in the morning and ran till four in the afternoon. A break for lunch and further study, from eleven to two, allowed pupils to go home or to eat what they had brought with them. Classes commenced with everyone reciting a prayer. A psalm was sung. In schools affiliated with a church, such as Verdonck's, the first class was followed by attendance at morning mass.[433]

Learning was individual to the point of solitariness, with pupils called before their teacher to recite an assigned passage from, say, a classical author, and to answer his questions about it. These had as often to do with grammar and syntax as with sense and meaning, and if not answered properly, or if the answers were snidely or cheekily delivered, could elicit a caning. Corporal punishment was as familiar as memorisation. Snappish corrections went hand in hand with academic repetition. These methods are not much in use at enlightened schools now, and are usually denounced as smothering to creativity, but in Rubens' day the opposite view prevailed. Good thinking was seen as stimulated by repression, and repression itself as beneficial guidance.

There is little doubt that the system worked admirably for many, considering the steady stream of brilliant thinkers and artists in all fields that it produced, or that a culture heavily dependent on memory found its singular type of training valuable. Few people could count, as they can now, on credentials or printed documents to identify themselves to strangers or to help them make their way in the world, especially in

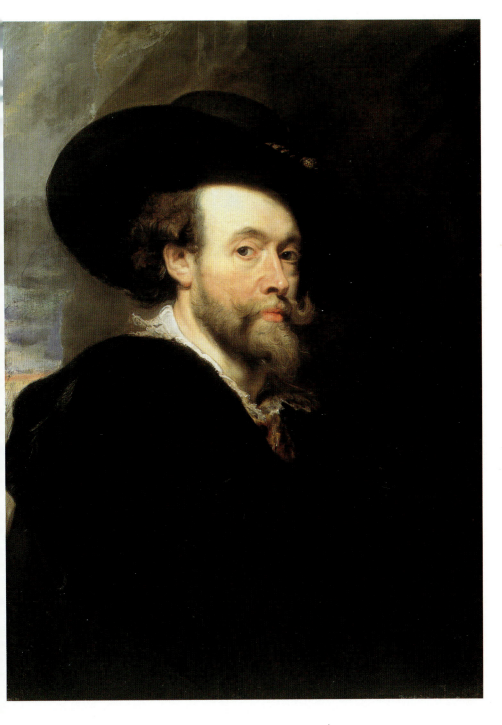

I. *Self-Portrait* (1623), Windsor Castle (see p. 10)

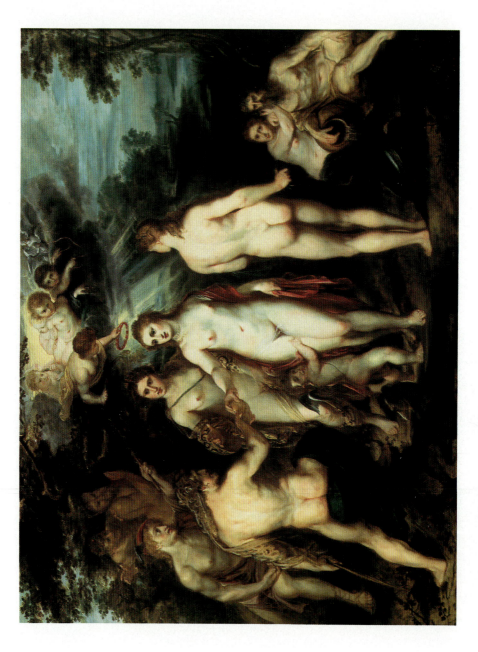

II. *The Judgement of Paris* (c. 1600), National Gallery, London (see p. 126)

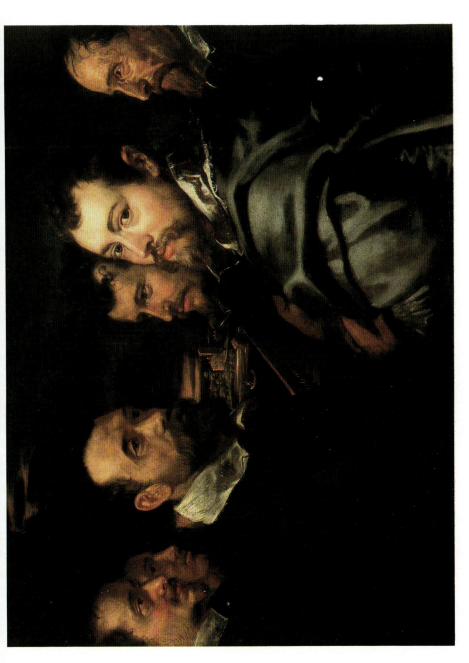

III. *Self-Portrait in a Circle of Friends*, Wallraf-Richartz Museum, Cologne (see p. 192)

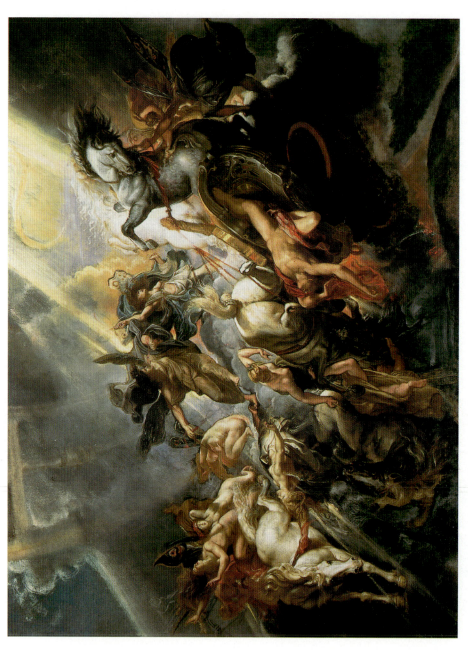

IV. *Fall of Phaëton*, National Gallery, Washington (see p. 201)

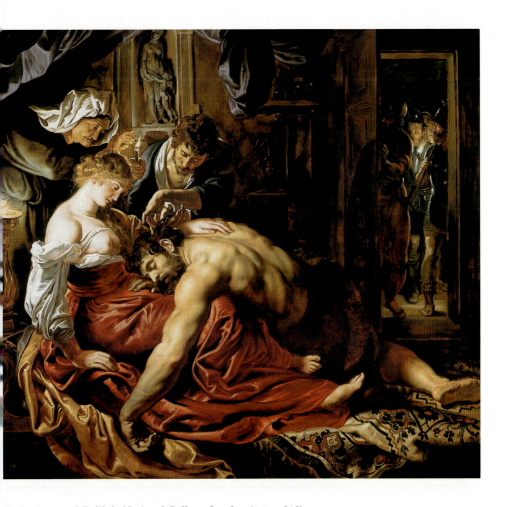

V. *Samson and Delilah*, National Gallery, London (see p. 219)

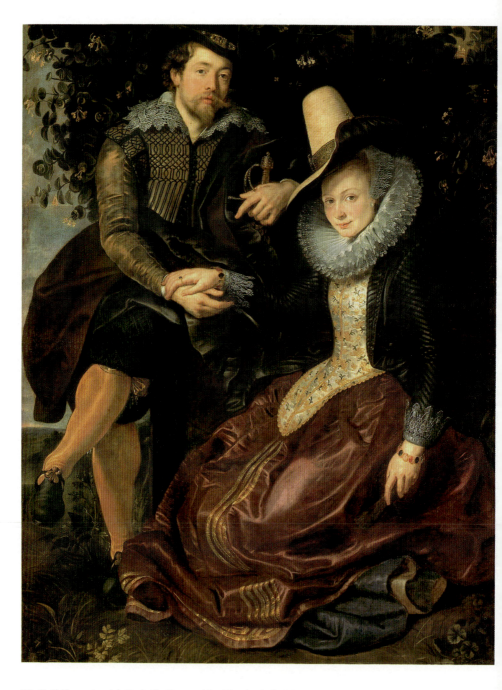

VI. *Self-Portrait with Isabella Brant*, Alte Pinakothek, Munich (see p. 219)

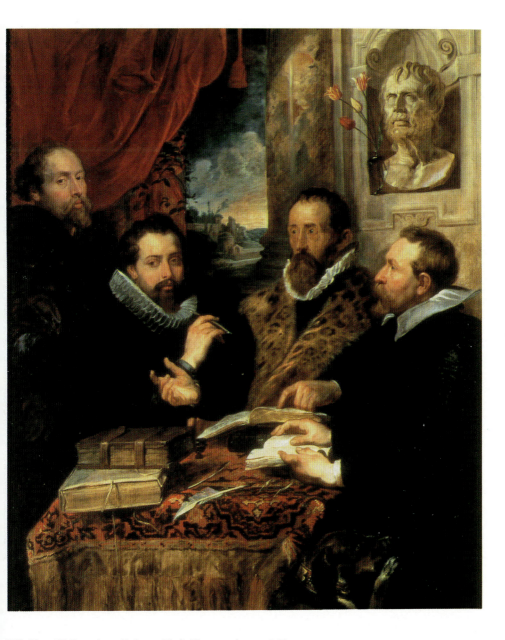

VII. *Four Philosophers*, Palazzo Pitti, Florence (see p. 219)

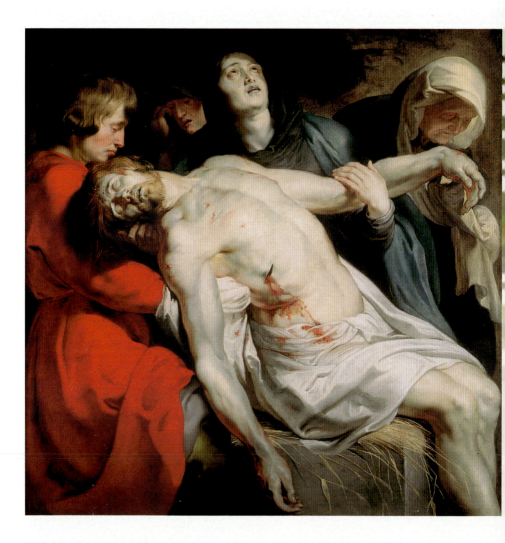

VIII. *The Entombment,* The J. Paul Getty Museum, Los Angeles (see p. 238)

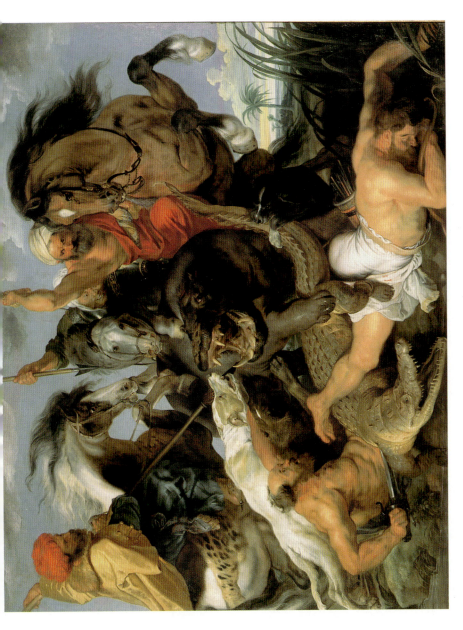

IX. *The Hippopotamus Hunt*, Alte Pinakothek, Munich (see p. 246) (see p. 246)

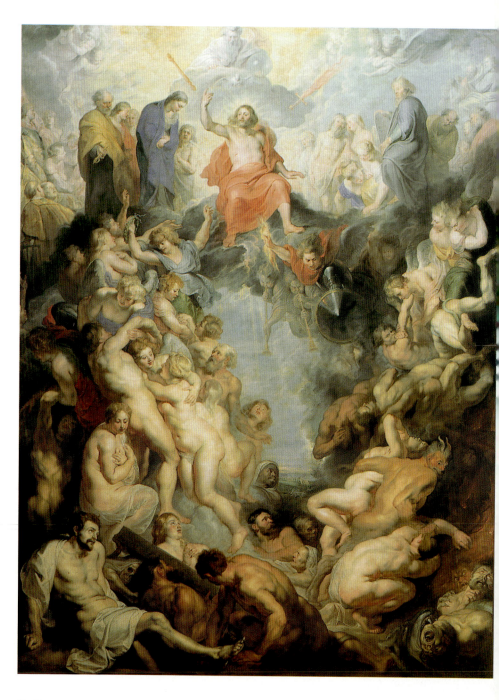

X. *The Last Judgement,* Alte Pinakothek, Munich (see p. 247)

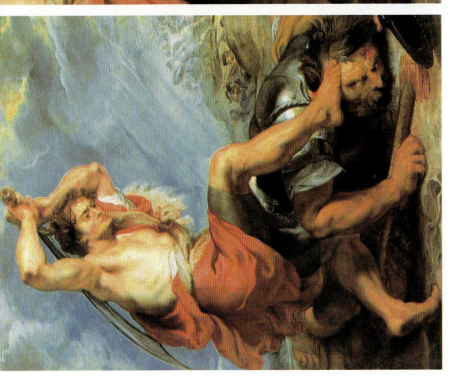

XI., XII. *David slaying Goliath* (and detail), The Norton Simon Museum, Los Angeles (see p. 301)

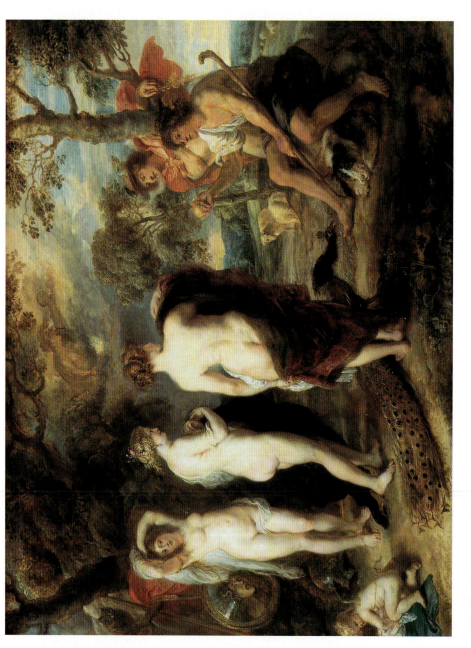

XIII. *The Judgement of Paris* (1632-35), National Gallery, London (see p. 329)

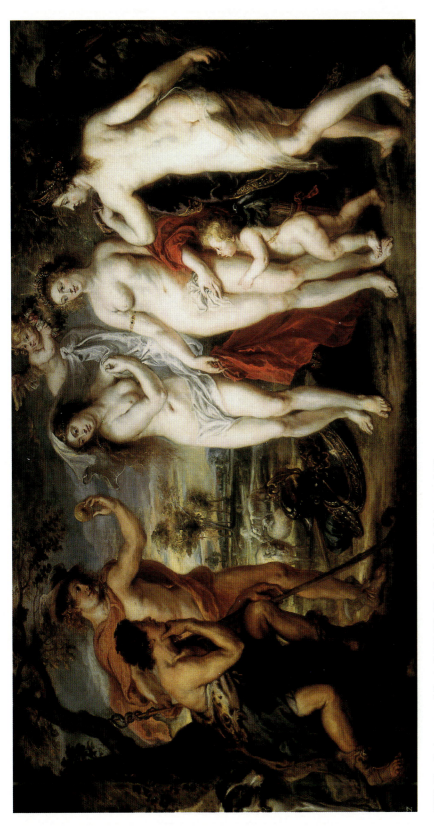

XIV. *The Judgement of Paris* (1638-39), The Prado, Madrid (see p. 340)

XV. *Forest at Dawn with a Deer Hunt*, The Metropolitan Museum of Art, New York (see p. 334)

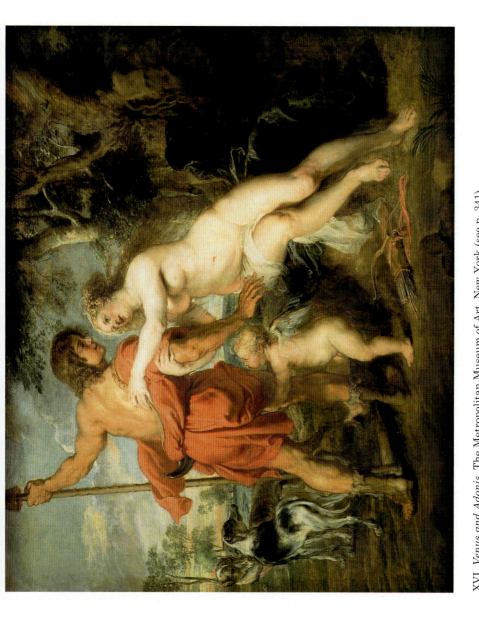

XVI. *Venus and Adonis*, The Metropolitan Museum of Art, New York (see p. 341)

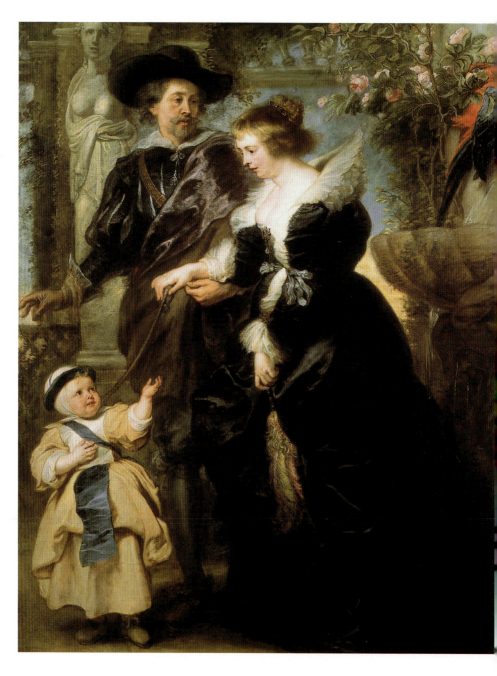

XVII. *Self-Portrait with Helena Fourment and Child,* The Metropolitan Museum of Art, New York (see p. 339)

foreign countries, though the printing press was slowly reorganising how ordinary business was handled. An ability to speak well, which meant a mastery of classical rhetoric, or the ancient arts of persuasion, and this if possible interlaced with memorised classical references, smoothed the way. Far from being regarded as pretentious, as is often the case these days, erudition indicated humility. Instead of alienating most people, it flattered them.

With Verdonck Rubens studied the standard Latin fare: Ovid's *Metamorphoses*, which he had probably also read with his father; the first four books of Virgil's *Aeneid* and his *Eclogues*; Horace's *Odes*; the histories of Livy, Pliny and Tacitus; Cicero's *de Amicitia* and his *Oratorio pro Archia poeta*; and possibly a Senecan tragedy or two.[434] He may have begun to learn French (modern languages were taught at the better schools). He also seems to have read Plutarch's *Education of Children* in Greek. There is no evidence that he knew Greek well. In fact in Catholic schools, and even then only among Catholic Humanists, learning Greek was a fairly newfangled thing. The problem is worth describing.

Protestant countries, such as England, had permitted and encouraged the teaching of ancient Greek only toward the end of the sixteenth century.[435] In Catholic districts and countries, or places of switching allegiances (such as Antwerp) it was often considered heretical. Ancient Greek meant Homer, Sophocles, Hesiod, Thucydites – or paganism. The study of Latin, while it included the equally pagan writers Cicero and Virgil, along with the unassailable Ovid and Horace, seemed to lead reassuringly into medieval Church theology. A revolt in educational circles against Church Latin, begun with philosophers such as Erasmus, had thus succeeded only in part. Latin itself continued to enjoy its traditional esteem as the passport into the international society of educated Europeans. All scholars wrote in Latin. Quite a few could speak it.

A better way to understand the position of Greek is to realize that Verdonck taught little Flemish. Instructional books existed for Flemish, which was just beginning to gain respect (as were German and French) as a literary language and subject worth studying in its own right, but straight across Europe, the vernacular, or vulgar (because popular) speech, still seemed irrelevant to what schools were intended to provide (Shakespeare never learned his English formally in school, for instance): a grasp of rhetoric as an instrument of divine and human truth.

The word 'truth' still retained its medieval flavour. One of its implications was old texts in classical languages, or texts that were ancient in a particularly Roman or biblical way. The older the right sort of text, the nearer somehow to God and Revelation and the more likely it was to be seen as 'true'. Even good penmanship, always stressed at Netherlands schools, had its divine aspect.[436] It reminded people of the understanding of God as Word. It therefore had a more than practical value, and was understood as an art.

One would nonetheless be foolish to imagine that all this school-room devotion to the past, to ancient authors, rote learning and ancient styles of rhetoric was accompanied by a poky solemnity, or that Rubens' four to five hours of homework six days per week (school was held on Saturdays too) were not also softened by having fun, good food – herring and beef especially – and striking up friendships.

Two of Christophe Plantin's grandchildren attended the same school as Rubens, one of whom at least became a close friend. This was Balthazar Moretus, who was three years older than he, the son of Jan Moretus, who had himself married one of Plantin's daughters and was now in charge of the publishing house – this producing, incidentally, some of the classical texts and grammars in use at Verdonck's school.[437] The other was Christophe Beys, who was four years his senior.[438] Beys had probably left school by the time Rubens arrived from Cologne (the usual school-leaving age was fourteen or fifteen), but he might easily have known Rubens anyway because through Balthazar Rubens soon became acquainted with the Plantin-Moretus family circle and with the publishing house itself.

Beys was a bit of a rebel at fourteen, or as he put it himself, 'refractory'. On February 21, 1587, for example, two years before Rubens' matriculation but well after Antwerp's surrender, he was ordered as a punishment by his grandfather to write up a Latin account of his day's work. Unwittingly, he supplied as good a description as one is likely to get of the life of an Antwerp schoolboy from a background similar to Rubens', mixing into his pained honesty a bit of his own griping.

Beys reports rising at six and right away rushing off to give a hug to his grandfather and grandmother. By seven he was at school, reciting his 'lesson in syntax'. By eight he was at mass, and the rest of his time was passed in a flurry of learning Cicero, parsing Latin phrases, lunch, more recitations and finally proof-reading on a forthcoming book in Latin, back at his grandfather's great house. It was this that apparently irritated him, and he refused to do it. He goes on: 'Before supper, my grandfather having made me go to him to repeat what I had heard preached, I did not wish to go or to repeat; and even when others desired me to ask pardon of grandfather, I was unwilling to answer. Finally I have showed myself, in the eyes of all, proud, stubborn and willful. After supper I have written my occupations for this day, and I have read them to grandfather.' He winds up with spiky glee: 'The end crowns the work.'[439]

37. Life as a Court Page

It is possible that Rubens left Verdonck's school because he had learned all that he had to teach. He was there less than two years. His leaving school at the age of thirteen, or a full year earlier than almost everybody

else, may have been the result of precocity. More likely it was the result of his prior preparation in the classics with his father and the Jesuits in Cologne, coupled with his family's pressing financial needs. By August, 1590, according to one of his mother's letters, he had at any rate already become self-supporting, taking a position as a page-boy with the princess Marguerite de Ligne-Arenberg, the widow of Philip, Count of Lalaing, probably in Audenarde.[440] For services rendered by her noble husband to the Spanish crown throughout the recent violence (he had died in 1583), Marguerite, who was wealthy in her own right, was allowed to maintain what amounted to a virtually independent court at her spectacular Castle Escornaix.[441] There she had a maze of galleries crammed with pictures.

The circumstances of the next eight or so months of Rubens' life remain something of a mystery: his reasons for going there, which can only be guessed at, and what he did, amid the traipsings about of colourful court costumes, the smattering of academic instruction that seems to have been provided to all of Marguerite's page-boys and routines that probably offered up nothing but a palatial dullness.

Maria had managed to bestow a dowry of 200 florins on Blandina when she married.[442] One reason for Rubens' move into the Lalaing court may have been to recoup this major expense by taking his upkeep off his mother's hands. The Lalaing arrangement no doubt looked promising in other ways as well, at least to her and perhaps initially to Rubens himself.

For one thing, it provided the perfect entrée into polite society. Politesse, then as now, was regarded as the key to political power (vulgarity as a clue to the fear of losing it), and while Rubens had heard a good deal about courtly etiquette from his father, he had never seen it in action. Maria no doubt wished to promote his future, perhaps as a diplomat, by inserting him into local court life, where he could also make the right connections. The Audenarde palace would serve as a finishing school for whatever he might decide to do. Behind these advantages lay two Renaissance ideals which Rubens certainly knew about, also from his father and from his classical studies. The first was that of the *vita activa*, or the principle that the intellectual, the educated man and the man of affairs ought to take part fully in the world, in its courts and politics. The second was the belief popularised by Petrarch two hundred years earlier, but still vastly influential, that fame and success were the results not simply of natural gifts or intelligence, but of *vertu*, or strength of character and excellence of morals.[443] A great many people everywhere, among them scientists such as Kepler and Galileo, subscribed to both ideals, and most people were convinced that courtly society was the arena in which to learn and perfect them.

In theory this may have made sense. In Rubens' case the reality of courtly wit, falsity and glee seems to have provoked his contempt,

squirminess, disconsolation and loathing. It is in fact hard at first to see how he benefited from his experience. None of his early biographers suggests that he did. He probably improved his French. He no doubt did some horseback riding. He enjoyed horseback riding.[444] He may have pored over some of the fine Italian engravings in the palace galleries. He may have spent hours in drawing and sketching and perhaps in copying them. He apparently sketched tombstones. He witnessed a good deal of pointless frivolity. There is no evidence that he disliked frivolity. On the other hand, he seems to have disliked pointlessness.

At the same time, it is clear that his experience at this court, abysmal though it was, turned out to be of great importance. It was now that he arrived at his decision to commit himself forever to art. Some months passed before he told his mother that he wished to be released from his courtly obligations, announcing to her his intention of becoming an apprentice painter. She bitterly objected. His request upset her dream of him as a gentleman, to her the highest social goal and one far less easily attained by an artist. He begged. She refused. She finally relented, but while her willingness to go along with him shows her compassion and empathy, it seems irrelevant to understanding his own state of mind. The key to this is that by the age of thirteen he had recognized himself as an artist in the making, and was prepared to insist on art as his destiny. Joachim Sandrart, the German art historian and artist himself, who met him years later, travelled with him and asked him about his artistic beginnings, describes this crucial moment in his career-to-be: 'Unable to resist his passionate yearning to paint, he at last obtained from his mother permission to devote his life to it entirely.'[445] His nephew, Philip, reports along similar lines that 'bored with life at court and drawn by his genius toward the study of painting, he begged his mother, now that the financial resources of his parents were exhausted by the wars, to place him under the instruction of ... a painter of Antwerp'.[446]

Rubens' insistence was surely based on work already done. It may already have been brilliant. No one, surely, decides to become a professional artist out of the blue. There must be evidence of talent, zeal, success, ambition and encouragement by others happy with what they have seen. If most of his early efforts, aside from his copies of Stimmer and Holbein, have now been lost or destroyed, it is only sensible to assume their existence as he left the Lalaing palace, returned home for a while and began to set about what soon became his grand business in the world.

38. The Apprentice Years

Rubens' life as an apprentice, spread over the next eight years, bumped along in an unusual way. He kept switching about from one teacher to another, dissatisfied, obviously frustrated, as if searching for something.

Each of the three artists with whom he worked could have taught him enough to qualify as a 'master' – they were all masters themselves – enabling him to join the painters guild as a landscapist or portraitist. It is clear, however, that qualifying as a young artist-master would not in and of itself suffice. Entering the community of Antwerp artists, who continued to thrive on small commissions in the midst of the city's decline, seems to have been tangential. Making a living was also not the point. He seems to have guessed from the start at some essential difference between himself and other artists, including other good ones, and to have determined to go his own way. From the beginning too, his artistic ambition, like his understanding of his abilities, seems to have been boundless.

This is not to suggest that his years as an apprentice were wasted, or that he could have nurtured his prodigiousness faster on his own: far from it. At thirteen Rubens seems already to have developed a talent not only for art but life, and for making use of his circumstances, even inauspicious ones, and of his relationships, even with second-rate teachers.

Nor were his teachers obviously second-rate. His first, Tobias Verhaecht, the landscapist, was twenty nine when Rubens came to live with him as his apprentice, probably taking him on because he was a distant relative. Verhaecht had married Susanna van Mockenborch, the grand-daughter of Jan de Landmetere, Jan Rubens' step-father, and was his mother's cousin.[447] It is likely that Rubens performed the sorts of chores for him that were normally assigned to apprentices: cleaning brushes, mopping up and sweeping out the studio, helping to mix colours (and in the process learning the magic, which seems to have interested him from the start, of blending flake white, genuine ultramarine, and the earth colours, such as terre verte and red ochre[448]) and filling in background figures for paintings that Verhaecht had sketched out in oils. Apprentices were expected to learn by copying, usually their master's sketches, often his copies of others' work and frequently his collection of the engraved copies of paintings by Italian Renaissance artists, if he had them. More was to be learned, it was believed, from copying the best art than from sketching live models. Whimsical invention, while not prohibited, was frowned on as useless from the viewpoint of improving one's technique.

Little of Verhaecht's work survives to show what he may have taught: a hunting scene that presents the Hapsburg emperor Maximilian I riding along a mountain path with his entourage (but this dates from a good deal later, in 1615; it is now in the Brussels Museum); a depiction of the Tower of Babel, something that he painted repeatedly, as did many artists (this at the Castle of Goosbeck in Brabant). Extant as well are engravings after his paintings on other popular themes: the Four Parts of the Day: Morning, Noon, Evening, Night, engraved by Egbert van Panderen; the Four Ages: Gold, Silver, Bronze, Iron, engraved by Jan

Collaert; the Four Elements: Earth, Air, Fire, Water, also engraved by Collaert; and Four Sea Pieces, engraved by Hendrik Pontius.[449]

Verhaecht was not an artist without accomplishments, though it is hard to see that any of them made much of an impression on Rubens. He favoured sharp contrasts and hard lines in his landscapes, approaches that his apprentice seems to have rejected without hesitation. Verhaecht's landscapes also have little of the panoramic daring of his predecessors in landscape art, such as Joachim Patinir, who influenced him. His pictures show an exacting and sometimes exciting management of details, along with an inferior understanding of how they can cooperate in the idea of the whole. The result is that his work stirs few emotions. The effects are dissipated. Admiration for his skill dwindles with doubts about its tepid employment.

Rubens stayed with him just briefly, and is not even recorded with the St Luke's Guild as one of his apprentices (often, however, to save costs, artists did not register their apprentices; Rubens' other teachers did not register him either).[450]

Each of his succeeding instructors was a 'Romanist', or artist deeply and cheerfully influenced by the Italian Renaissance achievement then sweeping the advanced ateliers of Europe, chiefly through engraved copies. For an apprentice, this meant studying Da Vinci, Michelangelo, Titian and Raphael at one remove and in black and white. It promoted learning by suggestion rather than imitation, although the copies were often good. It had its advantages in that it aroused curiosity and stimulated and one's powers of interpolation (what had been omitted that one might figure out and fill in?), as well as the obvious disadvantage of not seeing the originals, which were far away and in a real sense unknown.

Adam van Noort, Rubens' second teacher, made up somewhat for these defects through his artistic gifts, industriousness, popularity and ambition to earn lots of money. He soon attracted quite a few apprentices, though when Rubens joined him he was under thirty and at the start of his career.

Rubens spent four years with him, certainly improving his handling of figures and faces. These were Van Noort's specialities (another was producing occasional ink-and-wash sketches for Jesuitical books published by the Plantin-Moretus Press; these were engraved by others, though at least one of his original sketches survives, and were done at a date later than Rubens' apprenticeship; as with Verhaecht, few conclusions can be drawn about how he may have influenced his apprentice; the same applies to his series of paintings on wood panels, which indicate his debt to Italian Renaissance artists but were also done much too late to have affected Rubens; they may actually show influences running the other way, from Rubens himself to his teacher, years afterwards).[451]

With his third teacher, Otto van Veen, however, Rubens seemed to find the intellectual and artistic stimulation that he had been seeking. The

two quickly established a personal as well as artistic rapport. Van Veen, or Venius, as he often styled himself, latinizing his name in the affected manner of many of his fellow artists out to show off their learning and to lay claim to gentlemanly rank, had actually been to Italy. He had lived and worked there for five years. Enough is known about him, and sufficient numbers of his paintings and sketches have survived, to see more than the shadow of his character. As an accomplished portraitist, Humanist, Latinist, cosmopolitan, wit and raconteur, he may also have been Rubens' first competitor. Once word got out that Rubens had begun to outshine him, a friendly, or perhaps dry rivalry flickered between them.[452] By then, however, four years working together had zipped by, apparently in harmony, and Rubens in 1598 had qualified as a master himself, at twenty two, and joined the painters guild.[453]

Before that, Van Veen's breadth of interests, which inspired and matched Rubens' own, plus his intelligence, warmth, conviviality and undoubted abilities as a painter, managed to set just the right tone. He knew Spanish royalty and had painted royal portraits. He had good relations with Italian dukes and princes, and probably urged Rubens, who in all likelihood needed no urging by now, to go south himself to see Europe's beautiful, ancient, fabulous peninsula of art for himself, and to work there.

Like most Romanists, Van Veen believed that aesthetics and beauty could be reduced to exact rules of colour and proportion, a bizarre and awkward notion that Rubens never found to his precise taste. He may, however, have been struck by the fact that Van Veen had not only been attracted to Italy but returned to settle in Antwerp, that he had rejected many invitations from Brussels, Paris and Madrid to become a court painter, and that he preferred life in his native city, where conditions were looser and freer, whatever the general economic decline, and where he could follow his own star.

There is little question that by 1599 Rubens was on his way to following his star as well. He had found a place to live. He had set up a studio. He had enrolled at least one apprentice, Deodat del Monte, about whom nothing is known except that his father was a local goldsmith.[454]

He was definitely busy. Only three paintings by him are traceable to this period, before 1600, though it is clear that he must have produced many others. He gave a number of them to his mother, who thought them very fine and hung them in her home.[455] The three that he is most reliably known to have done at this time – a portrait, a biblical scene and a scene from Greek mythology – reveal an astonishing level of accomplishment. The boy who had been inspired by Holbein's fantasies of death and damnation had become a young man absorbed in exploring the nature of beauty and evil. These paintings also show that Eugene Delacroix was on the mark when he observed two and a half centuries later that 'Rubens was Rubens from the beginning'.[456] His 'Rubensian'

style, though by no means taken to what could be its loveliest and liveliest heights of 'gay vitality', shimmers unmistakably through each of them. Illuminating touches and intuitions of genius, of something mysteriously extra, instantly identifiable and magnificent, of a fire that might light the world and perhaps people's very souls, had begun to astonish his gathering admirers.

39. The First Three Masterpieces

His *Portrait of a Man* (21.6 x 14.6 cm, now in the Metropolitan Museum, New York), an oil-on-copper painting of a twenty-six-year-old geographer or architect, is signed and dated 1597, when he was still working with Van Veen. Conventional to the hilt in a late-sixteenth-century Flemish way, with the subject a thoughtful fellow holding up his designers square, dividers and pocket watch (a symbol of earthly *Vanitas*), each indicative of his profession, and showing him leaning slightly toward you over a wooden sill, it nonetheless swarms with strokes of novel softness.

At first, on looking at it, you are perhaps mildly shocked and puzzled. The face seems to emerge from an odd sort of twilight stamped with flickers of gold and silver. The man's features are only ordinary-interesting, with reserved, grey eyes that gaze away from you into the middle distance, close-cropped, dirty-blonde hair, a quibble of a dirty-blonde goatee, pale moustache and pale skin: a calmish person, you might guess, devoid of aggressiveness, sallow, distracted, self-absorbed and philosophical. He has not been flattered or much admired by his artist. A formal white ruff collar encircles his neck. He wears a black doublet dappled with gold and silver patterns that complement the twilight. He dandles a watch fob between his upraised fingers with a gingerliness that whispers of all sorts of contradictions: hesitation, strength, effeteness, curiosity, and even boredom and self-satisfaction.

Your shock and puzzlement, though, may have less to do with his character than with wondering about the otherworldly sheen of his face. It is a thrilling phenomenon. It alters him. It ennobles his expression. Strangely, this miraculous sheen fails to extend into the skin of his hands, which though beautifully modelled, appear merely pleasant and sensual in the way of whitish human flesh exposed to candle light. By contrast, in other words, his face glows with a saintly purity, with swatches of moonlight, sunlight, sea-foam light, flower-petal-yellow-and-white light and heaven. You realize quickly the reason for the difference between the face and hands: the face is lit from within as well as without by tricks of the painting, the flesh of it especially, while the hands are lit only from without.

The young professional's formal collar thus bisects his portrait. Above, all is dreaminess, holiness and miracles; below, all is earthiness, self-consciousness and ambition. This division, accomplished through a

mixing of techniques, an idea apparently new with Rubens, who has conceived his work along lines of rival yet blending dimensions, also seems a marvel of astuteness. It reproduces the arbitrariness of life itself. It imitates with the paradox that is a source of the mystery of grace the human yearning for spiritual transcendence amid materialism. The hands are busy with practical stuff (in a superb touch, even his finger-nails look dirty) and professional duties, while his face radiates a sublime sensitivity. The eeriness of his eyes, even the ghostly lushness of his cheeks and forehead, which you actually seem to see into, peering through his translucent skin, and this as if it were a sort of stained glass, register his natural double life and offer a glimpse into his hopes, conflicts and wishes.[457]

A similar division, or mingling of approaches, appears in the monumental *Adam and Eve in Paradise* (now at the Rubens House in Antwerp), though here with greater cunning and theatricality. This is an ambitious picture (180.3 x 158.8 cm.), and is a transformation of an engraving on the same conventional theme by Marcantonio Raimondi, after Raphael.[458]

Paradise in Rubens' version, by contrast to Raimondi's copy and Raphael's lost painting, has become a north-European forest. For the viewer, Eden seems just down the road. In the foreground, a hare sits placidly on a path. The path itself twists between sombre shrubs and trees. It winds (and winding paths are usually representative in medieval and Renaissance biblical depictions of perverted Reason and incipient evil) toward a lake where a crane and heron have posted themselves for a bit of fishing. The sky is pale opal shot with pink. The time is late afternoon, perhaps fivish. One might be anywhere in the neighbourhood of Antwerp itself, with everything local, familiar. Homey too, it seems, is the entire conception of Paradise, except for the two resplendent, youthful nudes in it, the man and woman, who stand facing each other, as if baffled by a dilemma, just behind the hare, and on opposite sides of the path and close to you, in the foreground. The shape of a monstrous snake wraps itself about a tree trunk against which the woman is leaning, and this just above her head with its undulation of blonde tresses.

Because of the mingling of strangeness with ordinariness, because of the surreal atmosphere, you perhaps cannot help but feel, as with his other painting, a tantalizing amazement. Again, the natural seems haunted by qualities of the supernatural. You are also aware (because of the title and the stock elements of the scene: the tree, the snake and the man and woman confronting each other) that despite the ordinariness of the background, a serious drama is in progress, that you have been thrust as a witness into a fearful moment before the birth of sin, of guilt and of all shabby-glorious human history. At this point, though, at the time selected by Rubens, an early biblical innocence prevails. The tree of the knowledge of good and evil, forbidden to the man and woman, looks

like any other tree, the snake like any other snake, if a trifle darker and larger. Neither tree nor snake has yet revealed its portentous secret.

Rubens' presentation of human flesh again assists mightily in producing your feeling of immanence. Adam gleams with a divine whiteness as he leans toward Eve. His hand and one finger seem to be raised in reproof. He appears to have caught Eve beside the tree and is worried that she is thinking of tasting its fruit. There is no hint that he is aware of the serpent. Eve may not know about it either. You cannot tell. Her hand rests on a branch next to it, a luminous trace of unearthly languor beside its scaly darkness, but she casts her eyes downward, avoiding Adam's, seductively, meditatively and serenely. One effect of her pose on the viewer is of an enticing yet sensual dread. We are held in an aching suspense.[459]

The macabre idea of dread as enticement is more thoroughly explored in his third painting, *The Judgement of Paris*(133.9 x 174.5cm., in the National Gallery, London; plate II), a far more daring work, presenting a whole group of figures and murkier clashes between them. In this picture the splicing of the divine-fleshly with a familiar-looking background seems aimed quite specifically at inquiring into the nature of beauty.

You begin with a smattering of conflicts. The story of the judgement of Paris is not simply about a choice between rival goddesses, or their mutual jealousy, envy and beauty. It is not even about beauty alone, or female beauty in three glorious manifestations. It is a tale both grotesque and bloody, and without exaggeration befouled beyond all others in the Greek mythological pantheon, even the incestuous, murderous tale of Oedipus. It is punctured by gloom, fatality, deceit, revenge and war. It hints at slaughter.

Simultaneously, the plot centres on beauty, the question of it, and female beauty especially, but this pushed for the sake of contrast straight into corruption and evil. The plot even toys with minor and risible themes of idiocy and naïveté, testaments to the Greek genius for illuminating complexities through irrelevancies, through light shifted against dark certainly, but with both bathed in a sort of psychotic twilight, when colours loosen and shift into seepings away among mists and blunderings.

To be sure, you are struck from the first by the beauty of the naked goddesses themselves: Hera, Aphrodite and Athena. The voluptuous light of their flesh pierces the centre of the large panel, lancing it, as might the swish of a fang. This light, as you come to realize, is a bitterness of passions balked by pride. Still, these are goddesses with supernatural powers, not mere women, and if their passions are balked, the consequences may well be thunderous. Each of them shines with immortality, or the right not only to vast amounts of time but also to divine lawlessness and rebelliousness. Understanding this, and mixing into it your happiness with the radiance of their bodies, and their decisiveness and

wiliness, you begin to guess that this eeriest of the three paintings is an experiment in reaching to the edges of culture and refinement, in moving to the bournes of delicacy, and then beyond them into the divine-irrational, into a species of rage that needs answer to no one and nothing, and that in the end cannot be thwarted.

Ironically, the key to seeing what is happening lies with Paris. It is to be found in his expression. He sits nervously on a boulder, contemplating the three goddesses at the moment when, having made his choice between them, he is handing the prize of a golden apple to Aphrodite. As he does so, he looks aghast. In a nervy twist, the focus of the scene rests on the zombie parting of his lips. It acts as an emotional sluice, becoming a guide to your reactions, without which everything would remain incomprehensible.

What is happening, though? On its face, the Paris story seems simple enough. Because of his personal beauty and strength, and also because he has had the wit to award Ares, disguised as a bull, the first prize in a bullfight, he has been appointed by Zeus as judge of a divine beauty contest, with the prize the golden apple that is actually the property of Discord. Paris himself does not know that he is the son of Priam, king of Troy, and of royal birth. He also knows nothing of the gloomy circumstances of his birth, that it was attended by prophecies of his bringing ruin to Troy. As a result, his father sought to get rid of him when he was born by condemning him to death, but, like Oedipus, he was rescued. He has been brought up amid idyllic mountains and pastures, and now thinks of himself as a mere cattleman who lives on Mount Gargarus. He is sceptical of his ability to arbitrate between divine beauties, but when Hermes urges him on, telling him that he need only use his native intelligence to do so, he feels idiotically flattered and agrees. The goddesses themselves, regarding him as a bit dull and easily manipulated, consent to accept his judgement.

At his invitation, each of them has disrobed (the nudity, as in *Adam and Eve in Paradise*, is hardly gratuitous), spoken to him privately and done her best to bribe him. Hera has promised that if she wins she will make him ruler of Asia. Athena confides that she will make him victorious in war. Aphrodite, however, bowls him over with her vow to make Helen his mistress. Helen is not simply the wife of King Menelaus, and so officially unavailable, but also the most beautiful woman in existence apart from Aphrodite herself, and thus, Paris assumes (but Aphrodite reassures him on this point), unlikely to find his rusticity attractive. His grave, moony lips seem to reflect his understanding that he can lard his newfound opportunism with sensual triumph, for he at once – and this is the dénouement depicted by Rubens – awards the apple to Aphrodite. The reactions of Hera and Athena to his decision are unmistakable, fierce and instantaneous, but where Ovid in his *Heroides* describes the two goddesses as merely furious that they have lost, and walking off together

127

to plan their vengeful destruction of Troy, Rubens concentrates on the appearance of Hera's glittery rage and Athena's implacable scorn.[460] She has turned her back on everyone, including us as we look on.

Beyond this trivial-seeming beauty contest, in other words, lies its consequence of mass murder. Rubens has allowed Paris to surmise, if not comprehend, some feeling for this. Also emphasised in Rubens' conception is the knowledge that the eye of the beholder has been corrupted, that Paris' judgement has been bought off. This does not of course mean (nor does the painting allow us to believe) that his judgement is worthless. He has yielded to Aphrodite's offer, after all, only because Helen is described as her equal in beauty. It is the divine beauty of the goddess herself that Paris craves and is willing to sell out for, and beauty itself that matters most to him – not power, not pomp, not military success, perhaps not the bliss of love. You realize that he is willing to risk the worst sort of divine wrath for the sake of beauty – and even, as readers of Homer, Lucan and Ovid must know, death itself. Rubens thus presents this quest for beauty as inextricably bound up in onerous perils – cheating, revenge, dissembling, treason and violence – and as worth it. (Interestingly, in thinking his way through the painting Rubens did not at first choose to show Paris bestowing the apple on Aphrodite at all; *pentimenti*, or alterations, on the panel indicate that he originally opted for a moment just prior to the height of the drama, taking his cue, as in his *Adam and Eve*, from an engraving by Marcantonio Raimondi after a painting by Raphael, but greatly elaborated and later drastically changed.[461])

Is corruption, therefore, as Rubens conceives of it, to be understood as an aspect of beauty? Is this his theme, along with the obvious delight that he takes in the female body? Is it the destiny of the beautiful to be impaled on circumstances whose cruelty spoils its purity and mars its perfection? Is beauty itself to be seen more as a quest than a fact, more as a process, perhaps as a degenerative and corrosive if infinitely seductive process, which the artist alone may illuminate, than a stasis? Does the supernatural quality of beauty, at least as Rubens reinvents it here, confirm a sort of glorious decay?

The painting provokes such questions. It also reveals Rubens' profound early interest in what may be termed any artist's grand theme: the nature of beauty itself, both in the world and in the universe beyond it. Even the landscape here, like the landscape of his *Adam and Eve*, shows his curiosity at work on this issue. In each of the paintings he recreates a recognizable afternoon in early summer, when the sun turns the new green of the leaves on far-off trees into a shower of silver coins, and the plains and hills that lie past them into oxidized copper umbrellas, before which shimmers a river or lake that is really the scoria of moulten maganese. Rubens' eye, like Ovid's in his *Metamorphoses*, seems drawn to the unending transfigurations of phenomena, and these especially as

they may be altered by light. Over and over, it is the moment of change, the process of moulting, that seems to command his attention, as if his understanding of his artist's role, like that of a good playwright or poet, is that one must indeed know one's story but never get ahead of it, never sacrifice its magical present. Perhaps the artist, as Newton later observed of the scientist (albeit a bit unrealistically), ought never to hypothesize. The tension between his artistic omniscience and the painted reality, the intractable present, may then be allowed to shiver with life, or the illusion of it, the present being forever the moment of change and revelation and on occasion apotheosis: Christ's agonised knowledge on the cross that he has been forsaken, combined with his intuition that he has not been abandoned: the vitality, the wonder, of pain, hope and consciousness: the inescapable, and beautiful, dimensions of human struggles.

All three paintings were produced against a social background that involved a new political mood and royal death. In the late 1590s, Antwerp languished amid the peace of neglect and blockade, Brussels amid the silence of nervousness. The Spanish army, fighting on feebly in the north, suffered continuous desertions due to near bankruptcy throughout Philip's imperial European holdings and his inability to pay his soldiers. In 1598, Philip himself died, praying in his bedroom beside his chapel in the gigantic Escorial amid the humiliation of military defeats and the filthier, pussier stages of the gout that had afflicted him for years.

Divine absolutism seemed to begin to die with him, the 'tyranny', as the Spanish political philosopher Pedro Augustin Morla wrote in 1599, that was 'invented by the flatterers of kings'.[462] In Spain at least, but not only in Spain, some fashion for constitutionalism seemed to be in the offing.[463] In the end Philip himself seemed to come around to this idea. In May, 1598, four months before he died, and in extreme pain, he signed a decree turning over the Netherlands portion of his empire to the Archduke Albert, the son of the Austrian Emperor Maximilian II, and to his own daughter Isabella, Albert's bride-to-be (though with the proviso that if their marriage proved childless, control of the Netherlands would once again revert to Spain).[464] Since 1596, Albert had actually served as Stadtholder, or governor-general, of the Spanish provinces – as Philip's by-no-means-powerless representative.[465] He had quickly acquired a reputation for kindness toward the population, but Philip's decree marked a step upward and forward. While it did not grant him or the southern provinces under his jurisdiction complete autonomy – neither he nor Isabella, or the Archdukes as they were called, had the right to make peace or war, and Spanish garrisons were to be permanently stationed in all the major towns and cities – his new quasi-independence amounted to a change from the arbitrary harshness and Spanish domination of previous administrators.

As a consequence, in December, 1599, a triumphal entrance into Antwerp was arranged for Albert and his wife. Otto van Veen was commissioned to paint allegorical figures of peace on two large canvases adorning the grandest of the ceremonial arches, the Arch of the Spanish, constructed for the occasion. This was also replete with flaming torches, statues and a balcony for musicians. Placed behind several other arches, it marked the new rulers' passage on horseback from the city gates into the Great Market Square at the Stadhuis where thousands hailed them. Rubens may have assisted his former teacher in designing or painting these canvases.[466] His work on them was thus perhaps his first public political act. He may also have helped with the canvases on other arches.

The following June discovered Albert, confident of his established popularity, busy settling scores with the Dutch, who imagined that the citizens of Flanders and Brabant would rise to help them throw out the Spanish army for good if they landed an army of 10,000 men on the beach at Nieuwpoort. They miscalculated, and no uprising occurred. Albert, riding at the head of his own detachments and supported by 3,000 returning Spanish mutineers, surprised the landing party, and while he did not succeed in routing them entirely, he wrecked their plans.[467] The attempt at invasion failed, and suffering heavy casualties, the embarrassed northern force retreated into Zeeland.

It had been led by a remarkable young commander, Prince Maurits of Nassau, the now thirty-one-year-old son of William of Orange and Anna von Saxon.[468] His audacity went unnoticed by at least one interested party, however, as by May 9, 1600, Rubens had left for Italy.

II

The Idea of Absolute Beauty

40. Journey to Venice

Antwerp was not a good place to think about beauty, death and evil, only perhaps to experience them. Vesuvius, nine-hundred miles to the south, though scalding bright in the summer sun, was better. Fifteen centuries after the fatal eruption that snuffed out Pompeii, with its glamorous imperial class of Romans, its ribbons of colonnaded villas and its acres of *trompe-l'oeil* paintings in black and gold of mythical heroes and sea-monsters, a faint odour of the smothered still sifted gloomily through the untouched soil.

Rome was perhaps best for the experience. Ruins excited the mind that wanted to be creative with decay, with vast, extinguished cultures. Ithaca was good for speculating on death too, or Athens. The Persephone-blessed cliffs, the crisp light like heavenly logic, the sea enfolding a jade-green menace of an Egyptian scarab, that sea-calm of a predatory beetle, all these hinted at ghastly opposites: chasms, mountains, darkness, lightning, abysses, cliffs, a tragic unfastening. The laughter there could be poisonous, vulgar, witty, free in the face of scooting plunges into blackness: Hades, the Christian Hell, divine and satanic monstrosities. The moulten, clear southern landscape had ever inveigled prophets and philosophers into the brilliant Western imperatives of tragedy and comedy, in literature, in painting and in grand sacrificial religions that offered the empathy of salvation. The skittish weather of London, its royal friskings, had managed this too, trumpeted along in the late sixteenth century by naval challenges, witchcraft and the ghostly Greek and Roman past.

Antwerp, on the other hand, was flat, placid, settled and half-miserable, no site for tragedy, hardly one for comedy. From the aesthetic viewpoint, it was flaccid. In 1600, its great ghosts seemed imported.

On May 8, Rubens received a passport-letter from the Burgomeister and the City Council, attesting to his good health and the fact that Antwerp was plague-free.[1] He probably set out for Italy on horseback, and was probably accompanied by his apprentice Deodat del Monte. While his dream of going south surely dated from his childhood and his

father's inspiration, its immediate catalyst may have been the publication of the first real travel guide to Italy, the *Itinerarium Italiae*, by François Schott (or Franciscus Scottus), officially in January, 1600, but actually some months earlier according to its license, by the Plantin Press run by Jan Moretus, the father of his close friend, Balthazar.[2]

Local guide books in Italian and Latin to Venice, Florence and Rome had been around since the late fifteenth century, but aside from Biondo da Forli's *Italia Illustrata* of 1474 and Fra Leandro Alberti's *Descrittione di tutta l'Italia* of 1550, both of which were sketchy despite their sweeping titles, there existed no single book to meet the increasing demands of tourists, businessmen and painters from abroad. Pietro Bertelli's *Theatrum urbium Italicarum* (Theatre of Italian Cities), published in the same year (1599) as Schott's book, went farther than most in whetting foreign appetites, with its collection of overviews of Italian cities, but Rubens would not have seen it before he left.[3]

All this haziness matters in terms of understanding his relations to Italy. The Italian collection of city states was both Europe's most famous beacon and unknown. It was the world's centre of education and mandarin and exotic. Despite a century of migrations by Netherlands painters, philosophers and lawyers-to-be, to the uninitiated it seemed hidden far away over the immense hump of the Alps. Beyond the Swiss lakes and the occasional troop of actors with dancing bears that one might expect to meet while descending among the northern hills of Lombardy,[4] the buried splendour of Roman history, as preserved in literary sprigs and fragments, was known to protrude mysteriously into the present in the shape of the grey bones of the Roman Forum, the dishevelled Coliseum, surviving triumphal arches, amphitheatres, aqueducts, incomprehensible temples and amputated statues – all of which, rediscovered, haunted the art of the Renaissance with spectral powers. From the standpoint of history as well as art, Italy remained the frontier of dreams, nightmares and civilization. To work and study there was to drench oneself in the storms and glories of the partly undeciphered past while gathering into oneself the energy of the Renaissance itself for the making of the future.

None of the extant guides captured this atmosphere of Italian bewitchment. Schott's, though lacking in the modern tourist's prerequisites of recommended inns, hotels and restaurants, and compiled from the reminiscences of a journey to Rome undertaken in 1574 by a sickly twenty-two-year-old German prince, Carl Friedrich, and his eloquent tutor, the noted archaeologist Stephanus Vinandus Pighius, sought to remedy this situation.[5] The first edition sold out within a year – another reason, apart from its timing, place of publication and publishing house, for thinking that Rubens read it.

Schott himself (1548-1622) was a prominent Antwerp lawyer and the

brother of André Schott (Andreas Schottus), a well-known Jesuit theologian and himself an author. François may or may not have travelled to Italy some years earlier. Borrowing heavily from various sources in addition to Pighius, he packed his fourteen-chapters with descriptions of sojourning from Venice to Milan, Bologna, Ferrara, Ravenna, Rome and Naples. Vesuvius put in an appearance, as did Tivoli, the Phlegraean Fields, a Roman Jubilee, Roman hills punctuated by ruined palaces, modern churches, the pope's household, good wines and the flooding of the Tiber. The Roman section was organized as a four-day sightseeing tour, listing ancient and Renaissance monuments and statues, the sacred as well as pagan and profane. Schott even included a list of other books to be read on Italy, both classical and modern, along with a brief account of the Vatican library. Despite the occasional dull patch and the haphazard structure, he provided the traveller with a solid sense of excitement, of what to expect and look for.[6]

It is not clear whether Rubens went south by way of Paris, where he could have stopped off only briefly, or along the 'Spanish Road', with a sharp deviation east, perhaps around the Alps. By June at the latest, riding at a leisurely pace, he had arrived in Venice, his first clear goal.[7] Here he stayed for a while, drinking in and studying the painting. Venice marked his first exposure to the masterpieces about which he had heard so much at home and poured over in engraved copies.

41. The 'Heavenly Shew upon the Water'

'When I came to the ... Lucie Fesina,' wrote Thomas Coryat a few years later (in 1608), 'I saw Venice, and not before, which yeeldeth the most glorious and heavenly shew upon the water that ever any mortal eye beheld, such a shew as did even ravish me both with delight and admiration. This Lucie Fesina is at the uttermost point and edge of the lande, being five miles on this side Venice. There the fresh and salt water would meete and be confounded together, were it not kept asunder by a sluce that is made for the same purpose, over which sluce the Barkes that go forth and backe betwixt Padua and Venice, are lifted up by a certaine crane. At this Lucia Fesina, I went out of my barke, and tooke a Gondola which brought me to Venice.'[8]

The town of dreams, a marbled fantasy propped on piles and pillars just above the swamps and sea, and built as a total work of art in defiance of tides, currents, erosion and waves, mirrored Antwerp, with the difference that it was not in its decline but its heyday. It was surely no coincidence that Rubens had fixed his journey so that it led him from his own 'Venice of the north' to Venice itself on his way to fulfilling his larger purpose: 'to view at first hand the most celebrated works of art, ancient and modern, in [Italy], and to form his art after these models'.[9] In Italy lay the source of everything aesthetically valuable to him. In Venice

particularly, at least at first, behind its bubbly fens and its decorated stone dykes, so lavish by comparison to the earthen ones that he knew at home, could be glimpsed humanity's artistic soul at its purest, most extravagant and most precarious. The squares, canals and scores of bridges were familiar, even as an intensification of his own experiences and ambitions.

On the other hand, the city was also a kaleidoscope of refinement, corruption, wealth and sensuality, the perfect laboratory for a young artist passionate about the beautiful. Coryat himself, though often critical of the foreign towns that he visited, seemed to see Venice as an abode recently cleared of its miraculous designing angels. He rhapsodised through dozens of pages about the Venice that Rubens also saw and wandered through, with its 120 waterside palaces, its thousands of stately pillars in Istrian marble, the 'pretty walke or open gallery' bedecking each palace and its 'pleasant little terrasse, that jutteth out from the main building', the 'incomparable' arch of the Rialto bridge that exceeded Trajan's in Rome, the delicacy of the masonry everywhere, the fascinating international population (with its 'Polonians, Slavonians, Persians, Grecians, Turks, Jewes, Christians of all the famousest regions of Christendome'[10]), Cardinal Bessarion's Library (actually Petrarch's, which he had donated to the city), the intricate new and old churches and its inexhaustible treasury of exquisite statues, busts and paintings by artists such as Titian and Tintoretto.[11]

It was also a carnival of risk, eccentricity, bawdiness, rambunctiousness and showoffishness, a theatre of the senses and spirituality, a Baroque wonderland made real. At any of the several seedy playhouses, one might see a comedy featuring women in the major parts, something virtually unknown in London and little known in Antwerp.[12] Looking up into the private boxes, one could take note of the famous courtesans of the day, double-masked for discretion, with twists of down or wool hiding their noses and cobwebby lawn-cotton sheathing their necks, short-cloaked in black taffeta. Esteemed for their learning, admired for their good taste as well as their promise of secret, expensive pleasures, they sat well above the men and were so well defended that anyone attempting to unmask them, especially a stranger, faced the prospect of being run through on the spot.[13]

The music at these performances might be uninspired, but that at the many concerts held in the houses of patrician Venetian families, as at the numerous parades and public festivals, was frequently superb, chattering, lilting and sniping away with treble violas, sackbuts and cornets. It might last through the night and into the next day, while your glance upward from the street yielded the shocking sight of a thief's head mounted as a warning on a steeple, or across the Piazza San Marco a couple of other criminals undergoing the slow, gushy dismemberment of the rope-hoists of the Venetian *strappado*.

II. The Idea of Absolute Beauty

The fashions of the young and slightly older women, too, were impossible to ignore in the suffocating heat of summer, when grapes, plums, apples, apricots, pears and musk melons burst out in swaths of colour at the numerous markets, when most men slept naked in their beds at night, and when mountebanks, disguised as doctors and jesters, and flipping their quack-medicines out of yellowy leather trunks on their portable stages, followed up some tuneful introduction with an harangue over an hour long, peppered with sensible and senseless references to old myths, before a credulous crowd suffering from scurvy, paralysis, acne, nausea and mere anxiety.[14] Wives (when allowed out by jealous husbands, who kept mistresses and visited the grander courtesans), widows and teenage girls wandered about in trailing white or black veils, many billowing to the ground. Their breasts were bared. Their backs were naked, often to their waists. Sometimes, though by no means frequently in the nimble heat that steamed off the canals, fens and marble, they covered their breasts and backs with strips of silk or translucent cotton. Nearly every woman was chaperoned by a man or another woman, to the enhancement of coquetry amid the denial of opportunity. Prostitutes strolled everywhere, though, tens of thousands of them in Venice and other nearby cities, as did knights in black damask gowns and red stockings, and gentlemen in costly doublets of lace and satin.[15]

Just beyond the lush traffic of the streets, in the quiet galleries of the Doge's palace with its new Council chamber, as well as in other palaces and churches, hung the paintings that Rubens had come to see. He was especially thrilled by those of Titian and Veronese. According to his nephew, he had the 'good fortune' to be put up by a nobleman of Mantua, a gentleman in the service of Vincenzo, the Duke of Mantua and Montferrat.[16] It is likely too that the young artist, who may have carried with him only such money as he had so far been able to earn from selling his paintings at home, plus pictures that he brought with him in the hope of showing them, finding a patron and securing employment, had been given a letter of introduction to this unknown man, possibly by the Archduke Albert himself, whose acquaintance he may have made through Otto van Veen after his work on the Spanish Arch for Albert's triumphal entrance.[17] Vincenzo was a first cousin of Albert's, and had visited him in Brussels the year before.

However the contact with Vincenzo came about, it was crucial. Rubens showed his paintings to Vincenzo's hospitable assistant. He in turn showed them to Vincenzo when he arrived in Venice in July to take part in a municipal festival. The Duke was impressed. He at once offered Rubens a position as one of his palace artists. By early October at the latest, after a few months in Venice, Rubens had moved to Mantua, or to one of the leading courts of Europe.[18] In a real sense, his artist's life was underway.

42. The City of Virgil, Mantegna and Giulio Romano

In the first year of the new century, the small principality of Mantua, situated on an island surrounded by marshes, lakes and the River Mincio and beyond them, loamy farmlands, remained the gleaming gem of Renaissance art, culture and gaudy dissipation that Isabella d'Este had first brought to a pitch of polish some seventy years earlier. Titian's portrait of her at sixty (now in the Kunsthistorisches Museum, Vienna), in which she had posed with a spotted boa and been made to look like a no-nonsense woman of twenty (or far more beautiful, she said, than she had been at that age[19]), still hung in Mantua's Palazzo Ducale. Her vast collection of paintings by Leonardo da Vinci, Lorenzo Costa, Perugino, Raphael and Mantegna brightened several of the palace's apartments, as did her piles of medals, vases, gold and silver medallions and copies of antique statuary from the Vatican, among them an Apollo Belvedere and two Laocoöns, and statues by the Greek paragon Praxiteles and Michelangelo.[20]

For the visitor, or latest resident artist, though, all this was by then only the beginning of the artistic wealth on offer in the isolated, continuously improved city. Her son, Federigo (1500-40), who had been made a duke by Charles V in recognition of his aid offered to imperial Spanish forces in northern Italy against the invading French, spent even more on art than his mother, and on music too, exhibiting an equal flair for seeking out the uniquely splendid in a time rife with masterpieces. With an income estimated at over 90,000 scudi, enabling him, for example, to hire 3,000 beaters for just one of the wild boar hunts that he staged for Charles when he stayed at the Mantuan court, Federigo could afford the expansion that he rapidly set in train.[21]

He became a patron of Titian, arranging commissions for him from Charles and coming to own over thirty of his paintings himself, among them a score of religious pictures and portraits (including a series of notional ones of the Roman emperors).[22] Titian's depiction of him at twenty nine reveals in the gleam of his eyes a mischievous personality, one far more enthusiastic about art and happiness than the blood and combat usual for a battle-inured duke, and a heart enamoured of luxury: in Titian's portrait his sword hangs indifferently by his side, half-hidden in folds of his velvet doublet, as he rests an appreciative hand on his fawning lap-dog. His imaginative self-indulgence may also be discerned in his most important success: recruiting Giulio Romano to Mantua as court artist and presiding architect in 1524. With a team of assistants, Giulio proceeded to redesign the already built and marvellous Palazzo del Tè (1525-35), just outside the city walls. Its Doric facade and interior courtyard, supplemented with friezes, pilasters and frescos of mythical figures (as in his *Psyche's Banquet*, c. 1530) was surpassed only by his lovely-frightening Sala dei Giganti (Chamber of the Giants) in the same

palace.[23] This was possibly the most astounding *trompe-l'oeil* achievement of the century. As you entered the relatively small room in which it flickered in flagrant reds, pinks and whites, the giants who had sought to overthrow the Olympian gods, and whose absurd threat to divine rule provoked their defeat, appeared above you, as they still do, on the ceiling and round about the walls, toppling to their deaths beneath the collapsing columns of their shattered porticos and buildings. Giulio's enclosed theatre of the monstrous seemed the more stunning for its ingenious compression, as if a powerful explosive had been detonated in a silvery glass jar.

Before his death in 1546, Giulio transformed Mantua with other delicious contributions. These included resetting the Duomo in Corinthian columns and a gilded ceiling and a daring redesign of the church of San Benedetto Po.[24] By the time Vincenzo became duke (reigning from 1587 to 1612), Giulio's painter and architect successors had turned the island-city into an aesthetic paradise that shone with the 120 Flemish pictures purchased by Federigo and portraits by the Antwerp master Antonis Mor, and that was 'marveilous strong, and walled round about with faire bricke walls, wherein there are eight gates, ... [so that it was] foure miles in compasse: the buildings both publique and private ... sumptuous and magnificent: [the] streets straite and very spacious. Also ... many stately Pallaces of a goodly height: ... most sweetly seated in respect of the marvailous sweete ayre thereof, the abundance of goodly meadows, pastures, vineyards, orchards, and gardens about it'.[25] Like Venice, Mantua had no shortage of its clowns and professional fools, though in this city of art and playfulness they cavorted in straw hats decorated with feathers and carried scythes.[26] It also fizzed with its throngs of prostitutes, who were invited to the frequent ducal parties, parades and masques, and with mountebanks, who were often arrested, tortured and hanged. Renaissance extravagance flourished alongside high taxes, murder, genuine piety and negligence.

Under Vincenzo, this ancient birthplace of the Roman poet Virgil, whose wisdom was carved everywhere into monuments, fountains and gateways, an indication of the civic pride taken in poetry itself, was more than keeping pace with its brilliant past. In his late thirties at the time Rubens met him, the duke was a corpulent, moustachioed, quasi-military man. He belonged to the Order of the Golden Fleece. He was a hedonist given to oblivious frivolity. His idea of going to war with Philip II against the Turks was to bring along almost as many musicians and singers as soldiers.[27]

He devoted his time to sex, love, archeology, antiquities and collecting paintings. He had a passion for ancient sarcophagi. He bought up Chinese vases. He imported Dutch tulips. His ambassador at Rome served as his purchasing agent for jewels and statues, selecting several items for him from the legacy of the famed Petrarchan scholar Cardinal

Pietro Bembo, among them an ancient Egyptian bronze tablet whose hieroglyphics were inscrutable but whose hints of a vanished, lustrous culture commanded growing attention among educated Europeans.[28] He persistently created combinations of the ancient with the modern, ordering the construction in the Palazzo Ducale of a new picture gallery, the Galleria della Mostra, to show off his ancient Greek, Roman and Egyptian acquisitions, and setting up a palatial gallery of portraits of beautiful women, purchasing Raphael's *Madonna della Perla* to be hung in it. A great many of the models for these portraits, which were produced by his court artists, ended up in bed with him, and it is likely that his artists also enjoyed their pleasures. He adored gratuitous exhibitionism, once arriving at a papal colloquy in Ferrara in 1598 with a retinue of 200 carriages and 400 horsemen.[29] He may in fact have at first liked Rubens, and felt no hesitation about indulging his wishes, as much for his personal charm as his artistic abilities. He no doubt guessed that his young Flemish acquaintance might prove useful to him in several ways, and that his training in courtly manners at Audenarde could come in handy for diplomatic missions. He at once began to trust Rubens and to cultivate his company when he travelled.

Throughout Vincenzo's city Rubens himself uncovered a feast for study and inspiration. Vincenzo's archaeological enthusiasm suited well with his own. The Duke's museum of ancient Greek and Roman artefacts fascinated him, and he began to work up a professional knowledge of how to date and identify them, learning techniques of comparative appraisal that were becoming something of a fad among intellectuals throughout Europe and that led into deciphering their political and religious meanings. He applied himself to understanding Giulio Romano's more dramatic achievements, especially those at the Palazzo del Tè and the Sala dei Giganti.[30] He seems to have been drawn from the start to those paintings of his predecessors that involved complex relations between great numbers of people, and even horses, lions and elephants, across large spaces and at decisive political and spiritual moments. From the outset he seemed to see the world as a place not so much of activity as action. It had bustle. It flexed. It moved. It was often violent. He was less interested in studying or copying portraits, or the sorts of paintings expected of court painters, as if doing so was a trivial exercise. He also showed little interest in medieval art (did it seem too static?), with the exception of the late medieval and early Renaissance art of Andrea Mantegna (1430-31-1506), who had himself been invited to become a court painter at Mantua in 1456 by the Gonzaga Marquis Ludovico III.[31]

One reason for Rubens' interest in Mantegna may have been that he was a synthesizer, combining in his paintings several ages and artistic fashions, along with techniques that seemed incompatible, and managing to do so with sublime ease. It is not clear, though it seems likely, that Rubens saw Mantegna's ceiling-and-room-wrapping series of paintings

(perhaps completed in 1474) showing the Mantuan court under Ludovico, in the Camera degli Sposi of the San Giorgio castle. Rubens certainly studied his other series, the nine canvases entitled *Triumph of Caesar*, installed at the San Sebastiano palace in 1506 (and now at Hampton Court; these were probably finished by 1495).[32]

Both offered up audacious innovations. They would naturally have aroused the intensest curiosity of a painter who was part of the Flemish light-exploring tradition, one of whose aims was the illumination, ever more accurately, of self-consciousness. In these two series, Mantegna combined elements of the medieval Gothic style with original uses of high and low vanishing points, as these had first been invented (but poorly understood) by Paolo Ucello (1396/7-1475), and the new fore-shortening techniques inspired by Brunelleschi (1377-1446).[33] The effect is a tense one of a crowding of light-sculpted, voluminous figures into constricted areas, and of a medieval, vertical pulling upwards toward Heaven, or at least into hints of the divine. In the Camera degli Sposi the antiquities of Rome – the ruined Coliseum treated as if restored, and the ancient pyramid of Caius Cestius – are in addition allowed to merge with a diorama of modern court life among the Gonzagas.[34] Discordant ages thus blend with diverse aesthetics. Paralleling this merging of incompatibles is another of Mantegna's novel tricks of perspective, one that was later imitated by Giulio Romano in the Sala dei Giganti: a seeming thrusting of the viewer into the drama of the paintings (an idea first suggested as one of any artist's loftiest goals by Alberti in his *De re aedificatoria*). On entering the room, the viewer finds himself turned into a silent participant in affairs of state, pomp, intimacy and celebration. Capping the whole thing off is the extraordinary *trompe-l'oeil* ceiling painting of a Pantheon-like dome thrown open onto bright blue skies. Balconies circling the vent at its top are crowded with pensive putti, while above them but peering down into the little theatre are a peacock and five young women. Three of them are looking not merely at the pageant below but at the spectator, who realizes that he or she has been spotted, and is being spied on, and who must feel tempted to return their amused glances.

Nobody knows whether Rubens made detailed copies of his own, or quick sketches in either pen and ink or chalk, of the Sposi paintings – he did some of paintings by Giulio Romano, and prided himself on acquiring a piece of decorative stucco (over a chimney) by him – but he definitely made a copy of at least one of Mantegna's *Triumph of Caesar* canvases.[35] This shows a procession of trumpeters, bulls and elephants, together with flaming tapers, and is a pulsating organism of colours, brimming with sweep and action. In his quest for stylistic perfection, Rubens may have guessed that many of these elements, if not the entire composition, might be deployed elsewhere in a painting that he would attempt later.

He was also impressed with Mantegna's exploration of still another

use of perspective throughout this series – though all these discoveries must have come about for him in some haste as by the beginning of October, 1600, or within a short time after his arrival, Vincenzo was whisking him off to Florence to attend a royal wedding. From canvas to canvas Mantegna's perspective shifts with extreme liberality. It alters to produce a sensation of motion, persuading the eye of waviness. The oddity of this is heightened by colours chosen less to distinguish and shape his figures – hautboys, charioteers, soldiers, elephants and musicians – than to establish an atmosphere of agility.[36] Mantegna had achieved an extraordinary success in capturing the transformations of phenomena amid a panoply of paint that seemed to mutate from second to second, or that refused stasis. This idea could be developed further.

43. The Wedding in Florence

At twenty seven, Marie de'Medici brought to her royal marriage to Henri IV, whom she had met only once at Lyon and who had instantly if a bit perfunctorily praised her as more beautiful than her portraits, qualities of caution, vigilance, modesty, submissiveness and refinement. These reasonably prepared her to become the wife of the King of France. She also had a staggering dowry. It had proved decisive in dissolving Henri's war debts, any doubts that he may have had about marrying her (such as whether to abandon his dissipated life), and forging an alliance with northern Italy against future Spanish imperial ambitions. She recognized that the king, who had been married before, was giving up, or seemed to be giving up, quite a bit for her sake – chiefly a couple of resentful mistresses. This may be why she accepted without qualm his proposal to wed her *in absentia*, or by proxy.[37] He would not attend the wedding, he said, not because he did not care about such niceties, as many imagined, but because preparations for his military campaign against Savoy, due to begin in August, needed to take precedence.[38] Marie scarcely demurred, and in fact maintained that for her too military interests came a close second in life, after love. As the king soon found out, however, she harboured in her well-bred body and mind a strength of character not easily to be trifled with, and the promise of sons to come who would guarantee Bourbon supremacy and French stability. On her wedding day in Florence she carried into the crowded church of Santa Maria dei Fiori the hopes of peace and religious toleration of quite a few European monarchs and millions of others. She represented powdery, smooth, happy politics. She was also the sister of Eleanora de'Medici, Vincenzo's betrothed (they were intended to be married in 1601).[39]

It is impossible to say whether Rubens was awestruck, inspired, overwhelmed, dazzled, smitten or simply bored with her wedding celebration, though boredom seems less than likely. He was certainly present at what was the first royal wedding of the new century.[40] Its festivities, including

a ball, concerts, an allegorical masque and a performance of a new type of music-drama, rumoured to be unusually fantastical, were arranged over ten days. Florence preened itself. It shone as perhaps never before. Vincenzo, who had brought the young artist along with him, arrived on about the second of October, and had no trouble in making sure that Rubens got to stand fairly close to the Queen herself (as people already called her) before the altar when she was 'led forward by the Auditor of the [Apostolic] Camera and Monsignor Malaspina into the presence of the Legate, together with the Grand Duke' for 'the usual benedictions of the ring'.[41]

It is likely that Rubens now made the acquaintance of the Grand Duke.[42] In any case, he was at the royal banquet and ball that night at the Salone del Dugento, mixing with French and Italian world-shakers and their advisers in seas of silk and redundancies of taffeta, gem-laced and pomaded hair, whispered liaisons, marvellous food, music and naughty griefs. As he recalled years later, he was struck by the beauty of the singing of a woman dressed as Iris, the goddess of purity and the rainbow (on which in the Roman myth she descends, bringing messages to mere mortals from the other gods), and the beauty of another woman, costumed as Minerva, who dined with her.[43]

The next day, October 6, with Vincenzo at the Palazzo Pitti, he perhaps attended a performance of *Euridice*, the musical extravaganza. Though there existed a few incomplete precedents for it, this was probably the world's first opera. It had lyrics by Ottavio Rinuccini (1562-1621) and music by Jacopo Peri (1561-1633).[44] Given Vincenzo's enthusiasm for all things musical and experimental, and his prominence, one may surmise that he did not miss it, or allow those accompanying him to miss it either. Its importance was great, and *Euridice* provided many fascinations. Its most intriguing feature, apart from its beauties, was its combining of all the arts, and of these with the sciences. The collaboration of poet, scholar (for research), composer, musicians, painters, architects (for scenery), historians (for the subject matter and themes) and court officials (for practical staging matters, financing and scheduling) reached beyond anything attempted in court masques. Its singing, and its acting requirements, were also more complex.[45] A path seemed suddenly to be lighted for artists everywhere. If they chose to travel it, they would find themselves becoming not simply the type of the ideal *homo universalis* of the Renaissance, but somehow more. They would be producing an art that would unify a wide variety of knowledge with music, theatre, social insight, politics and spiritual dimensions. A door was opening.

44. Copying as Innovation

During the days that he spent there, Rubens slipped off to see Florence itself, and especially the Michelangelos which had brought the city its

liveliest renown. This was his first intimate encounter with the great sculptor, and he used it to sketch copies of at least one of his early works. While doing so, he began to resolve in fresh ways the problem of the relations between sculpture and painting.

Artists had struggled exhaustively with this problem during the sixteenth century – was sculpture superior to painting? – and it may be fair to say that they have not had to do so since, or not with the same ardour. It has been described, misdescribed, fought over, clarified and virtually banished from recent aesthetic debates, but it was not passé then, as it could not have been in the shadow of Michelangelo's genius. Rubens had not yet established his own answers to the question, or had perhaps only guessed at them. They could be arrived at not through thinking or theorising, it seemed, but only through the experimentation involved in creative copying.

Copying, one comes to realize, was rarely understood by him as duplication. It was hardly cloning. It was never the draughtsman's plagiarism. It meant a special sort of imitation, or a precise dance around the original. This led into transformations of the original, often sweeping in scope, and into the projection into it of his own style.

The idea of this was actually nothing new. It had been one of the guiding principles of artists as well as writers and musicians throughout the Middle Ages and Renaissance. As a result, neither Rubens nor his medieval and Renaissance predecessors ever considered copying a mere learning exercise, which it may easily become now, or as just an efficient way to acquire the methods of the past so as to apply them in the present. It was one of the gateways to truth. In Keats' phrase, it was a magic casement. While connecting past with present, it provided nourishment for the eye and mind, without which the present could neither flourish, nor exist, nor make sense. It was also inevitably tangled up with problems of imagination and originality.

Just as educated medieval people across Europe had considered ancient biblical and other texts to be the path to ultimate truth, so they viewed imagination and originality, if unfettered and unsupported by the past, as forms of semi-lunacy. All good poets and other writers subscribed to this notion. Chaucer, for instance, had adapted many of the plots for his *Canterbury Tales*, if not his characterizations, which were often his own, from a sheaf of sources, as had Boccaccio for his *Decamerone*. Gower, Chaucer's friend and the author of the popular *Confessio amantis*, and Malory, their follower with his *Morte D'arthur* (printed by Caxton in 1485), had shuffled masses of previous tales into their new works with adaptive ease. The thirteenth-century Austrian poet Wolfram von Eschenbach had established the authority for his epic *Parzival* by citing and referring to a source-tale, as had the twelfth-century French Chrêtien de Troyes for his *Perceval*. It little mattered that the tale was never identified and may have been spurious. Straight into Rubens' day

the imitation, alteration and copying of stories, and most appropriately the copying of ancient stories, or the pretence of copying them, remained standard literary practice for the author aspiring, or pretending to aspire, to truth and vitality, much as it did for painters. Style rescued repetition from tedium. It was expected to provide the flashes of revelation which, far more than plot or contents, any audience craved.

On the other hand, the making up of stories for their own sake, or the exercising of one's imagination simply to astound people with novelties, a bit along the lines of the Mannerists, tended to raise eyebrows.[46] Educated readers remained convinced that purely original stories often sprang from private obsessions, egotism and the crazed frustrations of madness. They had failed to meet the cooler tests of antiquity for the sake of truth and had also not survived wrangles over quality and taste. They had not been winnowed by time. Even Shakespeare, Rubens' contemporary, while committing himself more and more to modern ideas of original story-telling (a sign that attitudes were changing), relied on ancient and legendary sources for most of his plays, including *Hamlet*. He was busy writing it in 1600, at just the time when Rubens was visiting Florence and copying Michelangelo.

Copying in any traditional sense was thus a kind of aesthetics kitchen for artists and writers. It was an opportunity to rustle up one's newer ideas, or variations on old ones. It was the ideal proving ground as well for any ambitious painter anxious to measure his powers against the debate over the possible superiority of sculpture to painting, and other technical puzzles.

Many artists had long believed sculpture to be superior because it entered the world. Carved stone or wood penetrated the physical realm of the spectator, while painting seemed restrained by flatness. In a sense Van Eyck's introduction of the new luminosity through turpentine had affected little, they thought, because painting could still not manage what they saw as this miracle of sculpture – its bursting through the limitations of plane surfaces. Painting could thus never overcome an intrinsic passivity, while stone was intrinsically active because it was three-dimensional and the viewer might peer or walk around it. In the hands of a master it could provide untold voluptuosities. The play of light, allowed complete freedom, could shift with the position of the uninhibited eye, making plausible adjustments. A statue might appear to breathe and to engage the viewer's soul as much as an encounter with another person – perhaps more so, since its rigid materials could also manage something denied to the living: it remained stationary, and fixed for observation, and yet reacted to the sun or among illuminating candles.

Many disagreed. The argument flared and persisted. In 1547, Benedetto Varchi, a respected if rather humdrum sixteenth-century Florentine historian and scholar and the author of a flowery essay on

Michelangelo's sonnets, solicited the aged sculptor's own ideas on the painting-versus-sculpture dispute (he also asked for the views of other artists, among them Benvenuto Cellini and Vasari).[47] Varchi himself proposed that the purpose of a work of art – its producing a noble or grand impression, say – rather than how it was made or what it was made of, ought to determine its superiority. He therefore pleaded the equivalence, or the potential equivalence, of painting to sculpture. Michelangelo's reply was conciliatory and evasive:

> I say that painting seems to me the better regarded the more it approaches [bas- or high-]relief, and relief the worse regarded the more it approaches painting; ... I used to think that sculpture acted as painting's lantern and that between the one and the other was the same difference as between the sun and the moon. Now ... [because] you say that, speaking philosophically, those things that have the same end are one and the same, I have changed my opinion and I say that *if greater judgement and difficulty, impediment and labour do not make for greater nobility* [italics added], painting and sculpture are the same thing; and, this being held to be so, no painter should make less of painting than of sculpture.[48]

On the surface, Michelangelo seemed here to go along with Varchi (years earlier, in a conversation with Francisco de Hollanda, he had argued that painting and sketching were indispensable to civilization[49]). Actually, though, he was merely changing the subject. He maintained that painting could be seen as a match for sculpture only if it required equal judgement, difficulty, impediment (or obstacles to be overcome) and hard work. His implication – and this from the artist whose hand had chiselled and released Moses from a block of uncut marble and painted the Sistine Chapel – is that painting requires less discretion and exertion. It is less complex and probably, therefore, the lesser art.

He left the painter an out, however, and it is likely that Rubens, who knew all about the painting-sculpture disagreement, whether he was acquainted with Michelangelo's position or not, seized on it intuitively, doing so at its most revealing point. Michelangelo had observed that the crossover between painting and sculpture, their intersection, is to be found in bas- or high-reliefs, and Rubens chose one of Michelangelo's own high-reliefs for copying, sketching it in pen and ink twice and from opposite angles.[50] Here was perhaps a chance to tackle the tricky problem – did painting really have the limitations that many would ascribe to it? – head-on.

The relief that he chose was the young Michelangelo's *The Battle of the Lapiths and Centaurs*, a small (84.45 x 90.53 cm.), unfinished, extraordinary work in marble, done precociously when he was in his late teens, or before 1492 (it is today in the Casa Buonarroti in Florence). Interestingly, it depicts a slew of struggles, a score of men and centaurs trying to kill each other, in a terrible, confusing tangle. Its ancient source

(as one might expect, it had one) is a Greek myth about a wedding feast gone grotesquely wrong (was Rubens drawn to this piece in part because of the royal wedding that he had recently attended, and its perilous politics which, if mismanaged, might lead to war?).

Ovid presents the Lapith-and-centaur battle in one of the goriest sections of his *Metamorphoses*, though the idea for Michelangelo's sculpture seems to have been given him not by the Roman poet but by Angelo Poliziano, the brilliant classicist and philologist, a tutor of Piero and Giovanni de'Medici – which need not imply that he himself did not at once rush off to read up on it in Ovid or in Virgil's *Aeneid* (Book VI).[51]

In the *Metamorphoses*, the theme is the defence of a beautiful woman, Hippodame, against attempted rape. Rubens, steeped in Ovid as he was, had no doubt read the story. Ovid presents it as circumscribed by the melancholy account of an actual rape, that of Caenis, 'the loveliest of all the girls in Thessaly', by Neptune. After taking his pleasure with her, the sea god remarkably feels guilty. He tells Caenis that he wishes to atone for his gruesome crime by granting her whatever she wants. She has only to ask. Devastated and furious, she begs to be turned into a man – or into someone who can 'never undergo such an injury again'. At once she finds herself transformed into Caenus, a Lapith warrior, and miraculously impervious to both swords and wounds.

The story proper now begins, and it provides the contents of Michelangelo's high-relief treatment of it in marble, and the challenge that Rubens accepted in making his two sketches of it. Eurytus, one of a loutish crowd of 'cloud-born' centaurs invited to Hippodame's wedding banquet by her fellow Lapiths, develops a wild sexual passion for her, seizing her and trying to drag her off. A bloody battle ensues as the Lapiths leap to her rescue and the half-man, half-horse and super-strong centaurs rush to assist Eurytus, who is killed, while the remaining centaurs try to kill every Lapith in sight. In Ovid's handling of it, the battle quickly turns into the sort of formulaic anarchy to be found in the descriptions of war in other ancient poems, such as the *Iliad*, in which denunciations and curses routinely boil over into pummellings, poundings, stranglings, eye-gougings and ghastly brain-spewings. The rescue of Hippodame, which is accomplished at once, thus yields to the poem's real subject, the battle itself, at the height of which Caenus reappears as a hero dispatching dozens of horsy centaurs to their deaths with vengeful glory. He (or she), however, is also killed. Unable to stab him because of his Neptune-protected skin, the centaurs tear up an entire forest and smother him with it. In a final moment of poignancy, Caenus' ghost, beautifully transformed into a bird with tawny wings the likes of which have never been seen before or since, is spotted flying out of the crush of tree trunks and soaring skyward. '

In his relief, Michelangelo, like Ovid, trains his sights on the violence, recreating it by raking his marble with a claw-chisel and shaping his

warriors with long lines and cross-hatchings, almost as if he were making a pen-and-ink drawing in stone, or painting with a brush. This, surely, is the crossover moment between painting and sculpture at which he hinted when he wrote to Varchi about painting as 'the better regarded the more it approaches relief'. In the case of Michelangelo's sculpture, painting actually becomes relief. He also uses his sculpture to explore not so much the original Greek myth as the state of mind of shock – that always lurking horror of life in which civilized harmony, as at a wedding, may without warning explode into shouts, threats, brawls and sexual outrage: an assault on anyone's sweetest expectations.

Michelangelo's masterpiece is a stilled pool of conflict bulking out of the stone. The marble bristles with torture and murder. Simultaneously, the battle is harmlessly stopped, as in mid-flight. The stopping is what makes bearable its brutality. His relief may be a three-dimensional sketch of slaughter, but it is managed with bloodless minerals. Their purity and cleanness, along with the 'cold pastoral' of art (to cite Keats again), assuage one's sense of grisliness. They allow one to experience the transmutation of morbidity into an anatomical study of unblemished beauty. Arms, haunches, legs, necks and the wrenched backs of men and centaurs alike turn into a deadly, magnificent ballet.

Rubens captures this scene, reversing it in a sense by transposing it onto sheets of paper. He then goes a step further. Indeed, the question arises whether his two versions of the *Battle of the Lapiths and Centaurs* (24 x 34.7 cm, now in the Boijmans-van Beuningen Museum, Rotterdam; fig. 2) are less copies of the Michelangelo than attempts to surpass it. In a departure that only sketching or painting could make possible, he punctuates Michelangelo's tortuous ballet by slipping against every figure, against every twitch of every muscle, an unusual dark section, a dusky reflection of each profile or an inked-in cone mimicking it. These resemble shadows but are actually instructions for looking, feeling and understanding.

At first glance, they look like shadows. They fall to the left and right of the combatants (depending on which of Rubens' sketches you are looking at), as might a chain of dominoes, and it has been suggested that he used candle light, first on one side, then on the other, to create his striking effect.[52] One rapidly realizes, though, that it is not simply his lighting that is unnatural but the shadowy sections themselves. They are too strong. They seem an impertinence. Unlike real shadows, Rubens' have purpose and friskiness. If real shadows are mere absences of light, often tinted by the objects that cast them, these act as if alive, and as if their function lies not so much in defining the figures as in clarifying their fight to the death – a different issue altogether – while conveying their mad energy.

The result is that his sketches are marvels of aliveness, as three-dimensional as Michelangelo's relief – more so in fact, as they seem

forever to keep moving. If they also have an element of crudity, this may be attributed to the unfinished work that is their source, and to the fact that Rubens clearly wanted to leave them that way, unpolished, rough-edged, like the battle itself, or a bit like rough-hewn life, promoting a power and realism on plane-surfaced paper that sculpture could rarely if ever match.

45. From Mantua to Rome

A flamboyance, even an indolence, mixed in with travel and artistic studies, permeated the months following his return to Mantua. The little capital and its duke seemed less and less to require his services, though he was put to work now and then, and paid, and made other copies, sometimes of ancient sculpture, and sent money home to his mother.[53]

It was probably during this time, the ten months or so that he spent there, while making excursions to nearby towns and cities on favourites from among the duke's more than one hundred horses, and studying the techniques of Titian, Raphael and Correggio, that he did two more lovely sketches in black and red chalk, of Vincenzo's children, the teen-age princes Francesco and Ferdinando, for a family painting to be finished later and commissioned by Vincenzo.[54] A clue to Rubens' wanderings about, and to how much he was missed back in Antwerp, shines through a remarkable letter sent to him by his brother Philip from Louvain on May 21, 1601. Philip was now twenty six, still in the service of the Brussels magistrate Jean Richardot, studying philosophy – especially Stoic philosophy and commentaries on it by the Flemish philosopher Justus Lipsius (1547-1606) – and planning with Richardot's brother Guillaume (Philip had become his tutor) to see Italy for himself.[55] Strongly resembling his artist-brother, though with cooler eyes more given to seriousness than Rubens' with their ironic sympathy, he was broad-shouldered, tall and softened by a moustache and goatee in their mutually rust hair.

Philip's letter, in Latin, is a blend of affection and youthful, academic posturing, written in a mock-tender style that Rubens would at once have found familiar. It would in no way have seemed standoffish, as long as one was aware of the feelings whispering through the educated brio:

> It has now been one year, my dear brother, since Italy took you away, one year that for me has been longer than that of Eudoxus, or than that
> *Whose length is owed to the calculation of Meton.*
> When you were here in our homeland, fate often kept us from being together and we rarely had the consolation of seeing each other. Still, the feeling of separation was greatly allevi-ated by the idea that we were living only a short distance from

147

each other, and that we could get together again quickly. Now that large spaces of country interpose themselves between us, my desire to be with you has only increased. I do not know what miserable defect of our mortal nature it is that pushes us toward that which is denied us, and which makes us prefer that which we cannot have. Today, in a burst of affection, my heart hurls itself toward you over the obstacles of countries, and passing above the highest mountaintops on the swiftest wings of thought, it comes to visit again him whom I love, but with a novel tenderness. Certain perfumes and odours, though a bit heavy in the head, are still agreeable and full of delights; certain dishes and seasonings seem to sting the palet and yet one finds them excellent: it is the same with our mental voyages: repeated contemplation of happiness, in which we rejoice, as of someone taken from us, has the effect on us of a dish in which sweetness mingles with bitterness. Ah, delicious memory of the time – too short, alas – that I spent in your company and that for me was a Golden Age! Though it seems already to be slipping far away, I recall it as best I can; I demand its return as my right. It is the rock of salvation that I cling to joyfully in the midst of this shipwreck. It is the dreamy medicine with which I find the strength to cheat my great sorrow. I speak to you thus, my brother, and have no fear in doing so, even though these reflections belong, so they say, to those who are insane or imbeciles; but those who believe that the human spirit can rob itself of all feeling simply reveal their harsh and cruel nature. Do not speak to me of that apathy that robs a man of his human quality, giving him one of iron or stone, and rendering him harder than that lacquered stone into which, according to the fable, Niobe was changed, though she at least covered herself in tears.

This is why we are happier in adopting the outlook of Aristotle and the divine Plato, those who did not chase all emotion from their human heart, but placed it at the service of the empire of reason. They imposed a check on it and restrained it. Does not Homer, that prince of intelligence and wisdom, transport us to a world where all breathes hope, fear, joy or sorrow? How often does one not seem to hear moans from deep in heaving breasts? How often, through a moist eye, does one not see tears streaming down cheeks? And with what men! Not only with those warriors triumphant over everything but themselves, but also with that illustrious king of Ithaca whom Homer puts forward as the type of sage for the centuries to come, whom he represents as having everywhere a divinity beside him, and Minerva as his adviser. More than once – I cite only this example – amid only the memory of his sufferings, his heart (and here let the words of the poet come to my aid)

... leaps in his breast

with such force that he admits himself conquered by grief and

comforts himself with tears and weeping. His poor, small home-
land was dearer to him than the fertile fields of the Phaeacians,
and he much preferred growing old in pain with Penelope and
those dear to him than finding repose in the company of a
goddess

And living out his days without old age and without end.

But my reflections run on. Why, then, this long apologia? It
is as if I have to defend the reason for this happy disposition of
my spirit to someone whom I regard as being much like me, or
rather like himself. I remember what you were. I do not ask you
to go on being the same. I affirm that you are always that. You
owe it to the law of nature that requires a particular concen-
tration in those who achieve harmony through some quality or
bond. You owe it to the social law that arranges the equivalent
return on that which one receives. If you owe anyone anything,
it is mine to repay it. Our affection demands to come first, with
no rivalry. It ought no more to suffer being shared

... than the throne or the Hymen.

Farewell, to you whom I miss![56]

Philip's phrases here seem to indicate as much respect for his
brother's gifts and intelligence as friendship and love: Rubens is referred
to, almost in awe, as one of those 'who achieve harmony'. Filtering
through the paragraphs too are hints of memories of long and longed-for
conversations about art, literature, philosophy and science (in his refer-
ences to the fifth-century-BC Greek astronomers Eudoxus and Meton,
who had sought to calculate the length of the solar year).

Within a little more than a year Philip had made up for the time lost
through their separation. By December 18 he was in Padua.[57] In June,
1602, together with a mutual friend and fellow philosophy student, Jan
Woverius, he met Rubens in Verona.[58] In the meantime, however,
Rubens' life had bounded into fresh opportunities and industriousness.
By mid-August, 1601, at the latest he had been sent to Rome, on a kind
of special assignment for Vincenzo. His sojourn lasted through much of
December, and with a possible interruption for a brief return to Mantua,
continued until April, 1602.[59]

No doubt he had long dreamed of visiting the 'great hub of the
universe', as Goethe described the ancient city some two hundred years
later (who, and what painter especially, had not?).[60] The actual occasion,
though, was Vincenzo's wanting him in Rome to copy paintings for the
Mantuan court while he rode on to Croatia via Gratz to take part in
battles against the invading Turks. The duke's letter of July 8, addressed
to the Roman Cardinal Alessandro Montalto, the pope's nephew,
requests protection for 'my Flemish painter' Peter Paul Rubens 'in all
that he may require for my service' – assuming apparently that Montalto
might supply him with permissions to enter sacred places, such as the

Vatican, to do his copy-work.[61] Montalto confirmed Rubens' arrival on August 15, in another letter, at the same time wishing Vincenzo battle-success in Croatia. The duke now set up an account for Rubens with his Roman agent, Lelio Arrigoni, who had in the past purchased gems, ancient bibelots and Egyptian shards for him, authorising the artist to be provided with money whenever he asked for it. A few days before September 14, according to a letter from Arrigoni to Annibale Chieppio, Vincenzo's secretary of state, Rubens made his first request, for fifty crowns, which was granted.[62]

46. The Roman Experience

Amid the ringing of bells – bells ringing through the hundreds of churches, bells ringing through the ancient pagan temples converted into churches, the big bells rung at the Vatican, the minuscule bells ringing on river barges to signal across the yellow morning mist, amid the market bells and school bells (to Rubens the ringing of church bells always remained in a sense the ringing of school bells), many chiming from scores of round, square and high towers – amid this music that was a heady jangle and reassurance, the Eternal City was both a modern creation and a ruin insinuating itself into the new century. Everywhere its past exposed a deathless vitality. If one had read Ovid, Tacitus and Livy, as he had, the ghosts of the pagan gods seemed to frolic in the streets as though alive, scowling and smirking even at the doors to Michelangelo's Sistine Chapel. Outside, Venus and Adonis ambled hand in hand, though now beside gaily frocked courtesans, perhaps pausing for a kiss on the Ponte Sant'Angelo. The emperors Tiberius, Augustus and Nero, in purple-togas, strolled among butchers and grocers near the broken Temple of Saturn. Psyche hid herself behind the wooden casks of vintners at the arches of Constantine's basilica. Eros tweaked the nose of a young Italian shepherd as he whistled his flock around the Claudian aqueduct. The whole city, a sonorous tumult amid its medieval and Renaissance art, sprawled, rose and rang among ancient and Renaissance splendours.

His personality, education, life and heritage had long been hastening towards this urban mixup of the ancient and modern, the Roman metropolis that had become a stew of anachronisms.[63] He had become a sort of arrow flying there. Rome was both target and axis. Here, after all, were everywhere on display the mightiest human efforts of past and present to resolve the contradictions of existence: the taunting paradoxes of death, love and salvation. Thrust into one's mind here too were the new impossibilities: of not investigating ancient puzzles, of not lifting sacred and profane curtains, of not establishing undreamt-of artistic, scientific and literary connections. Across twenty Roman centuries, amid filth, treason, prosperity, war, stunning architecture and sickness, a

formidable concentration of gifts and intelligence had been focused on clarifying the mystery of the beautiful through this lens of crowded piazzas, temples and palaces: a society of men and women who had been giving themselves over, many of them, to discovering new forms of beauty while speculating on its innermost nature.

Could the innermost nature of beauty be grasped at all? Could it be understood in a rational as opposed to a merely subjective way? If so, what would that mean in terms of one's art?

The works that he chose to copy and the artists whom he came to know imply his deep interest in these questions. Rome's artistic community was small. Caravaggio (born Michelangelo Merisi; 1573?-1610), who moved to the old capital in 1592, starting out poor and young (he was probably twenty) and knocking off hack portraits for a miserly art dealer at the rate of two or three per day at the beginning of his career, had become famous enough by the late 1590s to boast that he knew all the artists worth knowing there, and quite a few who were not (some dozens of artists were scattered among the narrower streets, most of them doomed to scrounge for a living all their lives and never to attract commissions).[64] Rome itself, with a population of under 110,000 in 1600, was less populous than Venice and less commercially important than Florence. This mattered not a whit to the city's magnetism, which rippled out of its antiquities, its Vatican, which made it the political as well as the religious brain of the Church, and the art of the Renaissance geniuses who ensured that it remained full of attractions decades after their deaths.

At the moment the painterly atmosphere buckled with rebelliousness. If its distant skies glittered with the pervasive light of Michelangelo's awesome chapel and its affirmation of the triumph of Reason over chaos, its nearer ones shone with the astonishing shadows devised by Caravaggio himself, as in his *Martyrdom of St Matthew* and his *Calling of St Matthew*, completed by July, 1600, for the Contarelli and Cerasi chapels of the church of Santa Maria del Popolo.[65] No one had ever seen shadows this wondrous strange. They transfigured the nature of light. No one had seen skin such as this sometime criminal (Caravaggio habitually got into fights and may have murdered a man[66]) was now busy inventing. His depiction of skin seemed less human, for all that it might be the skin of a street musician or fruit-seller, than divine or angelic. Out of a new blackness invading his canvases (no drawings by Caravaggio have survived to show how he worked) there surged an unearthly ecstasy reminiscent of the blessed in the Book of Revelation who 'washed their robes and made them white in the blood of the Lamb'.

Rubens took his time over these two chapels, and pored over Caravaggio's *Conversion of Saint Paul* (1600-1601) in the Cerasi chapel, with its vision of Paul overwhelmed and thrown to the ground by the power of a divine apparition on the road to Damascus while his horse

(whose pose is borrowed from Albrecht Dürer) waits beside him. The visitor from Mantua went off to study Michelangelo's *Crucifixion of St Peter* in the Paolina chapel in the Vatican, and compared it to Caravaggio's dramatic and frightening new version (1600-1601), also in the Cerasi chapel.[67]

Both works made solid impressions on him as images to be retained for future use (he seems to have had an extraordinary memory) – which is revealing because the paintings differ from each other, even in their similarities, as much as night from day. In each, Peter is shown upside down and already nailed to a massive wooden cross that is being lifted by sweaty Roman workers and soldiers. Caravaggio's Peter looks like Michelangelo's, a richly bearded man of sixty or so, balding and snapping with muscular vigour: his pullings about on the cross are the source of the drama of the scene. Here, though, all resemblance between them ends. Michelangelo's Peter is heaved into his martyrdom amid a crowd of scoffing onlookers. He ignores them, jerking his head over his shoulder to allow his eyes an admonishing encounter with you the viewer, and this swathed in a ghastly sternness that must inspire dread. Caravaggio, by contrast, avoids any suggestion of reproof. He eliminates the crowd and alters the angle. You find yourself standing uncomfortably below Peter's head and several feet away, yet pushed into an intimacy with him as if you were one of a number of unnoticed witnesses, craning up at his face. Peter gazes away from you, neither indifferently nor unpleasantly, but searching, beyond his agony, beyond the edge of the painting, for the altar in the chapel, which he regards with a mixture of calm and hope.[68]

Equally striking, if usual for Caravaggio because he resorts to it often, is that there is no background, or that the *scuro* setting, as opposed to some *chiaroscuro* one, consists of a silky blackness, the result, according to the seventeenth-century art-historian Giovanni Pietro Bellori, of his 'darkening the darks' ('ingagliadire gli oscuri'[69]). The workers trying to raise the cross (Caravaggio has also eliminated the Roman soldiers of Michelangelo's version), and Peter in torment, seem shot into a tender void. Perhaps because of the stark rendering of Peter's skin, the effect is one of bravery and misery.

Rubens studied this set of paintings, and much more. A signature energy seemed to be gathering in him. He sketched a fresco of a nude woman by Michelangelo in the Sistine Chapel. He made two rough copies of the Farnese statue of Hercules in the Vatican, dividing it into marked-off quarters to estimate its proportions (fig. 4).[70] He copied the ancient Greek statue of the doomed Laocoön in the Vatican as well – dashing off all four with a growing swiftness, care and panache. Bellori and two other late seventeenth-century art historians, Samuel van Hoogstraeten and Roger de Piles, agree, as have scholars ever since, that apart from doing work for his duke, Rubens must have had several goals in mind in making these and other copies: to amass a collection that might be useful

for paintings of his own, to pick up themes that he might expand on and to keep his memory green.[71] It may also be remembered that copying was always one of his methods of stylistic advancement. It was a way of measuring his sensibility against the styles of others, of honing it while altering and, perhaps incredibly in the case of Michelangelo, improving on others' work. A peculiar chase was in progress for him, it seems clear, a concentrated pursuit.

From a technical point of view, what was he after? In his copy of Michelangelo's *Ignudo*[72] he added Mannerist accents but softened them. Henrik Goltzius, whose engraving of the *Farnese Hercules* had caused a delighted stir among artists and the public in 1592, might have been pleased with his infusing bands of muscles into the arms and legs of Michelangelo's lounging woman, because they provide a wavy effect. He could just as well have been baffled, however, by the Flemish artist's smoothing away the rims of these muscles to render them seamless. Aspects of Mannerism were to be taken over, it seems, but not its methods *in toto*, and never at the expense of neglecting another consideration. The advantages gained by synthesizing various aesthetics, an idea reinforced by Mantegna's paintings in Mantua, were fresh in his mind.

A different intention apparently governed his sketch of *Laocoön* (in black chalk, 47.5 x 45.7 cm., today in the Biblioteca dell'Ambrosiana, Milan; fig. 5). Here, as with Michelangelo's relief copied in Florence, he headed off to the frontiers of violence in sculpture, this time ancient violence in ancient sculpture, but now digging more consciously into the psychology of violence. A further likely goal was his desire to improve his understanding of how to depict motion. If motion is always a type of violence, or at least a disturbance of stasis, and if life, because it requires motion, is itself a type of violence, his attraction is easily understood to this marble statue of the desperate priest who warned his fellow Trojans against the Greek gift of the wooden horse and who is here presented, along with his two small sons, at the moment when he is being strangled by sea serpents sent to kill him on orders from Athena. Rubens was drawn to aliveness. This meant motion, and beyond motion, drama, which at its simplest is only meaningful motion. Great violence, or motion at its most brazen, was an instructive avenue along which to explore aliveness with its secrets. As in his two sketches of the *Battle of Lapiths and Centaurs*, he now discovered an opportunity to test his powers to reveal grace under pressure, as Hemingway has put it more recently, or in this case, a morbid heroism.

He achieves a powerful impact in this sketch by bunching everything – the priest, his sons and the sea serpents – tighter than they appear in the statue, with the result that they seem constrained amid exaggerated shadows and muscles. The serpents emerge with a prickly thickness, with greater weight and appetite. Their ghoulish quality spills over into

Laocoön's struggle to extricate himself from their coils, raising his arm in an energetic gesture, while his face is torn by anguish. As Rubens reinvents him, he becomes a creature of overt conflict – should he, after all, have warned the Trojans of the Greek danger? was his self-sacrifice worth it? – and a giddy intensification of his tragedy.

Typically too, Rubens' lines here are not conceived as independent of each other. Each leads into the next. It makes the next necessary, much as in a good poem one line dictates the next, or as in a good novel the end of one chapter compels the beginning of another, or seems to. Flow, or fluency, is all. On the other hand, this issue of seeming necessity is crucial, in part because what it must actually mean is the illusion of necessity. Real necessity, it may be noted (because the question has everything to do with his developing strengths), exists no more in art than in history, or even in evolutionary biology. At most, it seems observable in retrospect, as when critics and philosophers proclaim that they have detected historical forces, fate or destiny amid some group of mundane patterns. The greatest deception of the universe may be its illusion of inevitability. There can, it may be suggested, be no more inevitable reason for the evolution of human beings later than insects rather than prior to them, or (superstitions and religious accounts aside) for the human race to have evolved at all. Napoleon's defeat at Waterloo is hardly the result of mechanical forces: he could just as easily have refused to fight, or the Prussian relief army under Blücher, marching to join up with Wellington to contribute to the rout of his armies, could have arrived an hour later, making a likely difference (from the English point of view) to the triumphant outcome. If elements of Napoleon's character and situation seemed to pull him one way instead of another, still compulsion was absent. At best, its presence cannot be proved. A madman might have been compelled to do what Napoleon did, but there is no evidence that he was mad. There is no proof that he was more than over-confident, and that he blundered. Art, however, unlike life but like most interpretations of it, demands what critics like to call unity, philosophers necessity, audiences coincidence and Aristotle plot. If anything seems inevitable in life and art, and inescapable to the human mind, it is illusion, with its capacities of distortion and also of revealing truths, including objective truths, or imperishable insights into the world. It is this paradoxical fact, the inescapable human dependence on illusion, that Rubens seems to have understood and set out to put to use.

In a deeper sense, to be sure, this seemed only appropriate. Court masques, such as *Le Paradis d'Amour*, staged nearly thirty years earlier, as well as holy masses, with their plethora of symbols, had long reflected a popular and educated conviction that illusion of the right sort was the gateway to divine or ultimate reality: indeed that illusion embodied that reality and was all that could be counted as real for human beings.

47. The New Aesthetic

He did not study anatomy.[73] Anatomy could not provide him with what he was after: the most effective ways to convey aliveness. Sketches of pebbly, dead limbs, flattened veins, extracted neurons, drained lymph nodes, trepanned brains and flapped-back faces were as irrelevant to his quest as they had been essential to Da Vinci's adventure into verisimilitude. Da Vinci's midnight autopsies on stolen corpses were not for him. Especially not for him was the vivisectionism of Vesalius (1514-64), which involved tying down a dog, slitting open its belly, extracting its beating heart and smothering its barking with a pillow, while delivering a lecture on its internal organs to a crowd of gawking medical students.[74] Vesalius' anatomical and skeletal engravings might prove valuable to clever but pedantic artists interested only in appearances. They might prove useful to surgeons. They had nothing to do with aliveness. They meant death or inertia. They could at best provide a crisp, though heartbreaking introduction to natural philosophy, as biology and the other sciences were then called.

A superior verisimilitude and naturalism, in any case, could be found aplenty in the work of his predecessors in Antwerp and the two northern Dutch provinces, who knew how to freeze forever a farm scene or a domestic one, how to recreate with instructive blandness and polish the interior of a tavern, or ice skaters on a January pond, even as with Pieter Bruegel the Elder to the point of suggesting the bluish chill of a bitter frost or the dampness in spring of a hearth as field hands lazed akimbo before hissing embers.

None of this contained the jewel.

To grasp the secrets of aliveness one needed to absorb not anatomy, or even life, but art, and specifically the shrewdness of those pious and extraordinary, as well as often decadent and sleazy, artists, mostly Italian, who had understood them to their depths. One also needed to abandon the idea of naturalism and concentrate on religion.

This may seem strange. To many it may seem incomprehensible. It is not. To trace the precise connections of his art into portions of the Catholic thought of his day, and then back into aliveness as he was coming to master it, one must consider the relations of his art to the iconoclasm that had swept across the Netherlands in the 1560s, and Catholic reactions to it. One must in addition plumb, as he did, the wells of sensual Jesuitical thought. Quite a few of the secrets of aliveness lay hidden in Jesuit fantasies and attitudes, unimaginable as this may seem now, and in the urgings especially of the Jesuit Religious to produce a new kind of art, and Rubens' own commitment, perhaps unconscious at first, to doing so.

At bottom there is nothing odd in this idea. Systems of belief which seem alien today have clearly stimulated artists, poets and musicians

into producing universally valued masterpieces. In the end, such systems may become irrelevant to the pleasures of most people, but an alive art, like accurate science, especially an art that is alive on several levels, including the spiritual, is perhaps the only form of human expression that may long survive its culture, continuing to thrill audiences in distant lands through time without end. The pagan world of Oedipus is closer in its psychology to the modern world than the Enlightenment world of Candide, though Candide's is more recent. Hamlet's debate with himself over his father's murder is more contemporary, in a painful way, than Ibsen's late nineteenth-century *Ghosts*, with its exhortations to do something about syphilis.

Rubens had long known that the north-European iconoclasm had left the Church and its artists with a chance to undermine, if not sabotage, the Reformation.[75] As a boy, he had been taught by Jesuits in Cologne. The progress of the Counter-Reformation had been guaranteed by the Council of Trent (1545-64). Since then, church buildings had been made more dramatic and open by eliminating their dividing Rood Screens and turning their naves into grand boulevards for the eyes of their congregations.[76] Other signs of Jesuit influence appeared in the stunning religious structures all around him in Rome. If the Franciscans had devoted energy and money to churches whose gorgeousness was intended to shame the simplicity of Protestant houses of worship, reassuring the faithful, winning converts and luring back those who had renounced Catholicism, the Jesuits far exceeded them in ambitiousness. Their college, the Collegio Romano, chiefly financed by Popes Pius IV and Gregory XII, was merely the most extravagant of their projects. It had cost an amazing 400,000 scudi.[77] They also owned numerous Roman churches, among them the Sant'Andrea al Quirinale, the San Vitale, the Sant'Apollinare, the Santa Maria dei Monti and the Santa Maria. The Jesuits were also trend-setters. Giacomo della Porta's design of the facade of the Santa Maria dei Monti, constructed in 1580, with its mix of classical lines, Corinthian pilasters and ornate scrollwork, had become a paradigm for many, mostly Jesuit buildings. It was understood to represent a Jesuit aesthetic that by 1601 was enticing artists and architects into what was becoming recognizable as the (unnamed) Baroque movement.[78]

Like the Order of Jesus itself, this aesthetic was a paradox. Despite the hermetic piety and scholarship of Jesuits straight across Europe, their intellectual daring led them into fierce conflicts over a slew of original, recently spawned ideas, including scientific ones, such as the heliocentric astronomy of Copernicus (Galileo, himself a Jesuit, had not done much to date beyond his unequal weight-dropping experiment from the Leaning Tower of Pisa, which at the time impressed none of his fellow professors; he had also invented a better compass, which he arranged to have manufactured and which sold well, making him a lot of money[79]). Probably as a result of this spirit of intellectual adventure, the Jesuits

supported art that was classical, modern, ethereal, savage and worldly. It seemed a contradiction, and was a good ploy as well as a sincere strategy – an exciting oxymoron. It led into sculpture and painting full of thrashed, suffering saints and other martyrs, who also seemed to float in the air, and putti who did the same, alongside aerial yet ordinary people who seemed weightless or celestial while appearing earthbound. Jesuit commissions streamed forth for an art that appealed to the senses, that promoted magnificence, though not luxury, and that sought to refresh, and even to hypnotize, spiritual hopes.[80]

Attracted to them on religious grounds and because their views led into posher illusions of aliveness than anyone had imagined, Rubens was also drawn to the paintings of the Carraccis, to Annibale's most of all.[81] Annibale's boldness seemed to overcome Caravaggio's limitations. Bellori observes that despite Caravaggio's having brought a healthy realism into painting, he had coarsened the divine with the commonplace. The feet of his pilgrims were filthy. His *Death of the Virgin* showed a swollen corpse. His *Supper at Emmaus* presented Christ without a beard. His innkeeper wore a cap. Bellori argues that the rebellious, antisocial painter who had come south from Milan (he often assaulted his opponents at tennis matches[82]) was more likely to besmirch the miraculous than reveal it. If the skin of his musicians and saints seemed angelic, still '[he] suppressed the dignity of art, ... [introducing] contempt for beautiful things, [with] the authority of antiquity and Raphael destroyed ... [amid] the imitation of ... [the] vulgar'.[83] Caravaggio relied too much on nature, on actual models and on private emotions, instead of sticking to the *maniera*, or accepted methods of painting sacred and profane subjects, with the result that he had moved 'away from art altogether ... [into] error and darkness'.[84]

The Carraccis, Bellori thought (did Rubens think so too?), dealt their cards from a more familiar, happier deck. Annibale (1560-1609) in particular seemed possessed of an exuberance that reflected his fascination with motion and action, or with aliveness. This contrasted with the frozen quality of Caravaggio's astonishing scenes, in which nobody seemed to move. Caravaggio (again according to Bellori) was satisfying 'a taste more for beauty than truth',[85] while Annibale, the brilliant cousin of Ludovico (1555-1619), who had set up an artists Accademia degli Incamminati (loosely, Academy of the Professionals) in Bologna, was 'restor[ing] beauty to the imitation of nature'.[86]

Caravaggio and Annibale were friends despite their differences. Caravaggio considered his rival one of the 'good' painters at work in Rome, or so he remarked at his trial for having libelled another artist, Giovanni Baglione, by writing smutty verses about his painting.[87] What Caravaggio meant by 'good' [valentuomine] is not clear, but Annibale had his own reservations about Caravaggio's style. He reportedly called it 'too natural'.[88] The airy muscularity and suppleness of Annibale's

figures, with each of them looking like a dancer dancing or getting set to dance, as in his vault frescoes at the Galleria Farnese (completed in 1600), were taking him down another path from Caravaggio's in any case. His influence on Rubens is noticeable at once, first in his decision to try out big sketches from now on, and second in his adaptation of Annibale's mingling of lightness with massiveness in large dramas.[89] Annibale's Hercules, for instance, seems both a giant and a powder-puff, a mountain of a man and a dandy: a spellbinding set of contraries. The sweep of his visions, some 270 feet in the Galleria Farnese, for example, rivals Michelangelo's.

Annibale's idea of beauty may also have proved alluring because it involved neither idealization nor falsification. He simply sought a different emphasis. Caravaggio's tawdriness and filth were to be omitted, and a more challenging aim was to replace them: that of letting oneself become the slave not to nature but to the beauty awaiting its release in nature.

Meanwhile aliveness itself, which at a minimum required the revelation of the beauty of natural creatures – their beauty of spirit, of the divine and of their bodies – was on the road to achieving an ironic triumph. As an ideal, it seemed to resolve religious mysteries. As promoted by the Jesuits and artists such as the Carraccis, it was finally and completely replacing the miraculous powers of the icons of the Middle Ages. As an aesthetic goal, it agreed with the inquisitive temperament of the moment. Its expanded naturalism, only centuries afterwards to be described as Baroque art, supported an active reverence which many would find irresistible.

48. The New Sensuality

None of this change in aesthetic fashions proceeded smoothly. It provoked endless arguments. By Rubens' day attacks on the new sensuality were commonplace. Even as long ago as 1545, Piero Aretino, an acquaintance of Michelangelo, had written him a letter severely critical of his Last Judgement. Aretino carped at what he called the arrogation of art over religion.[90] He was jealous. He was also ignorant of the altering relationship between art, religion and Christian societies, which Michelangelo had been among the first to understand and promote.

The new relationship had been developing for some decades by the time his patron, Pope Julius III, stood astounded and ecstatic beneath the completed Sistine Chapel ceiling, gasping in awe at its sensual depiction of the divine and human experience. He might, though, have witnessed something similar in an earlier woodcut, Dürer's *The Four Horsemen of the Apocalypse*, or in the *Crucifixion* of Matthias Grünewald (1480?-1528), which exposed perhaps for the first time to public view a thoroughly human and emaciated, bleeding and mouldering Christ. In their work, as in paintings by later artists such as Guido Reni (1575-

1642), himself influenced by Michelangelo and an influence on Rubens, traditional medieval relations of art to religion and society had been abandoned. Impulses both wilder and more moving, in fact more irrational, had begun to assert themselves.

The result was the debacle that led into the iconoclasm of Germany and the Netherlands. Medieval Christian art, apart from its miraculous iconic intention, had always served two quasi-official purposes: to popularize Christian beliefs, especially among the illiterate, and to illuminate biblical texts. Even the literate needed constant re-instruction. The agony of the Cross might be forgotten, along with the sizzling threat of damnation that awaited the sinner. Hell's fire might lose its terror. The abstractions of Romanesque and Gothic images were frightening precisely because they were alien to daily life. Strangeness propped up the faith that was based on hope and ignorance.

What Dürer, Grünewald, Michelangelo and their later Baroque successors began to demonstrate, however, was that art itself might become the gateway to Christian mysteries and salvation. It could expose the divine within the ordinary and social. It could even achieve an empirical, scientific aim. In the hands of a master, it might expose the truths of religion (or so it was imagined). The seamless blending of the naturalistic with the abstract – with the mind of God, with Heaven, Hell, Purgatory and the day of Judgement – could support Church theology far more persuasively than logic and metaphysics. This approach to spiritual experience was most voluptuously embodied in the religious paintings that Rubens almost immediately began to produce.

Aretino, like other critics of Michelangelo and the new movement in the arts, had actually misunderstood his age, which had begun to veer toward empiricism across the board. The new empirical-abstract method quickly flooded into other fields. A reinvention of art as an empirical demonstration of spiritual truths became fashionable only slightly earlier than empirical demonstrations did so in science, which was changing along similar lines. Copernicus had corrected a misunderstanding of the divine engine of stars and planets with heliocentricity. The real aim of Johannes Kepler (1571-1630) in discovering the elliptical orbits of the planets was to reveal God's signature in the heavens.[91] For them, as for Galileo and later Newton, science was to become the stepchild of a reinvigorated, chameleon Christianity.[92] The premise that the Word could be made flesh, in the person of Christ, had led into speculations on flesh itself. Nearly everyone was convinced that the physical laws discoverable in earthbound life could only reinforce Christian doctrine.

49. The First Roman Commission

Talent was little without connections. Rubens' brother Philip's relations with the Richardot family now led to his first commissioned work in

Rome, though this seems to have come about only after he had returned to Mantua, probably in mid-December, 1601.[93]

The reason was religion as well as ability. Albert, the Archduke of the Netherlands, had been cardinal, archbishop and Grand Inquisitor of Toledo at a time, years ago, long before his marriage, when a supposed relic of Christ's cross was entrusted to him. He in turn had donated it to the Roman church of Santa Croce in Gerusalemme. It had been stolen, and just recently had been recovered. To celebrate its return, and also to honour the church at which as a young man he had been made a cardinal, he decided to present an altarpiece to the church's smallish underground St Helena chapel. He wrote to his chargé d'affaires in Rome, the magistrate Jean Richardot, who had relocated there not much earlier, asking him to find a suitable artist, and stipulating that the price not run above 200 gold écus.[94]

Conveniently for the almost unknown Rubens, Richardot was the brother of Guillaume, with whom Philip was now touring Italy (the Richardots' father was president of Albert's cabinet in Antwerp). Richardot, like Albert himself, seems to have been mildly familiar with Rubens' work, perhaps by hearsay. He 'lost no time' in writing to Vincenzo Gonzaga, asking for the services of his 'young Flemish painter called Peter Paul, who [has] the reputation of being a man of merit in his art'.[95] As important as Rubens' merit was apparently Richardot's confidence, which he also communicated to Albert, that Rubens might not ask too much for the job, whose prestige quickly attracted the interest of other, better established painters with their ears to the ground, such as Guido Reni, but who now stood no chance of competing for it. What mattered to Vincenzo may have been a temporary lack of money (his wild living led him into frequent scroungings for cash; he was a bit of a spendthrift). He was happy enough to release his court artist to Richardot for a while – as religious convictions and growing esteem suddenly pushed Rubens' career ahead with his return to Rome in mid-January, 1602.[96]

For him, this was a superb opportunity. Not only might he present himself to a broad, serious audience, and one with large reserves of money, but also he might bring together his recently acquired knowledge and ideas in a set of three canvases. Above all, this commission might allow him to do what he could do best: welcome the achievements of the ancient and modern sculptors and painters whom he had been studying and copying within the ample mansion of his style.

He had already made more of these copies than are known today. He took his sketchbook everywhere, working as much in red and black chalk as in pen and ink.[97] He longed for copies with their stylistic pointers as historians after facts and chessplayers' gambits. Style itself, he appears to have thought, might gain a visceral fullness through assimilation. At the same time, a purely technical progression through and beyond what others had done was insufficient, in fact was next to nothing, if it was not

also suffused with passion and belief, or a system of values. Mere scattershot values could not do. This was because style always argued the importance of one thing over another, or a point of view. To be plausible, if not enchanting, a point of view had to be based in some logic of preferences.

It is a question whether for the first and maybe only time in his life he was now a bit intimidated by the eminence of his employers. He painted the central panel of the altarpiece, *St Helena with the True Cross* (252 x 189 cm.; today in the Hôpital de Petit-Paris, Grasse; fig. 6), with his familiar speed. It was finished by the end of January. The next two panels, however, *The Crowning with Thorns* (224 x 180 cm., also in Grasse; fig. 7) and *The Elevation of the Cross*, took months longer, till mid-April. He begged permission of Vincenzo to stay on in Rome, somewhat to the duke's irritation, though given the importance of this assignment, he could not very well refuse and order Rubens home, as was his right.[98] Still, one spots an odd stiffness in the execution of the two of the three paintings that have survived (the *Elevation of the Cross* was badly damaged in the eighteenth century), nonetheless combining with his characteristic texture, a pulsating animation. It is as if a clubby wish to please was causing him to leash in his daring and clarity.

Only the brightness, as the sensuous figure of Helena stands transfixed with happiness at the foot of the shining, original cross, her loosened tresses mulling over her shoulder to her waist while a crowd of putti swims in the air about her, salvages everything. This brightness is a sort of painted perfume, almost a heavenly madness, an insensible earthquake, for which no previous painting could ever prepare the eye. It is an inspiration. It is what you notice first and last, or would have in the snug chapel where it must have seemed to expand the space – its novelty particularly, which embarrassed Caravaggio's cynical shadows and trotted through the bitter darkness, as well as over the two candy-cane columns of the ancient temple of King Solomon that step out behind her: the sense of Helena's suffering, of her politesse, of a void and sun-lit space. It is a ravishing brightness, whose power emerges not simply from colour-contrasts but as a phenomenon in its own right, one that turns Helena's face into a rapturous silence and exultation. Its light grows in her uplifted eyes. One realizes that the former wife of Constantine I, who was divorced by him in 292, made Empress Dowager by him in 306 and baptised in 312, and who founded the basilicas on the Mount of Olives and at Bethlehem, must be looking at a miracle and that we have been invited to watch her experiencing it through her face that is a mirror of the sublime – or for some, one must not forget, the simply preposterous.

Here, certainly, is the challenge that Rubens took on in painting her, a problem irrelevant to non-believers but overwhelming to the devout: how to convey Helena's encounter with superhuman beauty. To do so, Rubens relied on indirection. As at the blinding climax of Dante's *Paradiso*, with

its unbearably bright vision of the divine, the miraculous moment is only semi-exposed. We do not quite see what she sees, yet we grasp as with an intense complicity her astonishment.

For this reason the design of the picture, or more aptly, its geometry, is of secondary importance. In fact, to concentrate on its composition as a set of interlocking triangles (though the prissier sort of viewer may prefer a reductionist approach of this sort) is to miss the gateway leading into the secrets of its effect. As long ago as 1898, in an exciting passage, Jacob Burckhardt zeroed in on the relative insignificance of geometry, or mere design, to Rubens' thinking generally, and most of all to his concerns as a practising artist: 'In Rubens' very great pictures of momentary action, what the spectator enjoys, at first unconsciously, is the combination of dramatic movement with a mysterious visual restlessness, and it is only later that he becomes aware that the separate elements cohere by a furtive symmetry, or even a mathematical figure. Rubens certainly never set to work with such a figure in mind, but it certainly entered of itself into his vision and *grew in his imagination along with the rest* [italics added].'[99]

The design, in Burckhardt's view – and it seems precisely appropriate – was never conceived apart from the human drama. Instead it was apprehended through the process of painting, and often in Rubens' other pictures through sketches later revised or discarded. To put this in terms of his personality: his commitment to harmony, as Philip had noted in his letter to him, or to a system of Christian values, or to cosmic justice, could hardly avoid the attractions of design, or geometry: triangles, cubes and parallelograms simply had to put in their appearance, albeit furtively, as his expertise in depicting passions remained his guide. The evidence of this is convincing although negative: nowhere in Rubens' preliminary sketches in oils (none survives for this painting, though he relied on Raphael's *St Cecelia*, in Bologna, for the shape and pose of his Helena figure) is there an abstract design that later becomes the basis of a finished canvas.

Design was thus a premise only, as geometry shaped the architecture of the universe, or so he and his contemporaries (such as Kepler and Galileo) imagined. Geometrical patterns were as intrinsic to any design that was not a mere mess as the fact that varnish glistened, or that the Word became flesh. There was also another reason for paying little attention to geometry as he painted: that he faced far more pressing and complex problems, each of which required delicacy, knowledge, tact, originality and shrewdness.

This becomes obvious in the second of the three paintings, *The Crowning with Thorns*, for which a set-up sketch in pen and brown ink still exists. Here the question was not so much how to position the figures as how to render understandable a theological and historical enigma: the relations between Christ and his torturers. In some ways

this problem resembled that resolved by Michelangelo in the Sistine Chapel when he came to depict Adam's relationship with God in the Garden of Eden, before the creation of Eve – and the solutions of the two painters were also similar: exquisite fears and yearnings, expressed through touching or nearly touching, were allowed to illuminate tantalizing unknowns.

If the extended fingers of Michelangelo's God and Adam are shown almost, but not quite, meeting across an expanse of sky, so the hand of one of Rubens' seven torturers rests like a riddle on Christ's shoulder, as seated and helpless, he yields to his bleak destiny. The resting hand is a psychological insight. It is a masterstroke. It points to an instant of doubt and guilty, public exposure among his tormentors – they are portrayed as halting in the midst of their ghastly business – before the crown of thorns is rammed on Christ's head. A Caravaggesque lantern above a slatternly scene which is set in a roomy dungeon, a lantern dropping darkness more than light, and Christ's powerful torso, which Rubens filched from the statue of the Apollo Belvedere in the Vatican, as he also swiped the tense positioning of Christ's legs from the Laocoön statue there, lay bare themes of struggle and vitality amid a glitter of surrender and stifled fury. The torturers are presented as trapped, each in his own private world, each in a cramped moment of self-absorbed rage. At the same time, their cruelty seems to crumple before the mockery of a strangely pliant light. Mere viciousness seems ridiculed by a quality of compassion, as if a holy smile were spreading across the night air and embarrassing their malevolence. These rival elements, which combine in an hypnotic jostling, manage to provoke what Burckhardt called, in referring to Rubens' religious paintings such as this one, 'the stirring within us of the profoundest mythological feeling',[100] a dimension of understanding that reaches beyond what words can express and the ordinary world.

What did Rubens himself believe, or even think, as he worked on this painting? Can his artistic and spiritual attitudes also be understood?

Paradoxically, a clue to them lies in a design. It is a small one, of a circle with a dot at its centre, that he contributed to the Friendship Book (*Album amicorum*) of the Antwerp commander, art collector and businessman Philips van Valckenisse (1557-1614), just before heading off to Italy, either in 1600 or slightly earlier (the approximate date is established by his signature, which is an early one). Above the circle, and his note on the same page to the effect that he, Rubens, the painter, was a friend of Van Valckenisse, he wrote, '*Medio Deus omnia campo*' (God is everything at the centre of a field). This phrase may provide a keyhole through which to examine his thoughts.

He had adapted it from an unfinished epic, *De Bello Civili* (On the Civil War), by the precocious ancient Roman poet Lucan, who died a suicide on Nero's orders at the age of twenty-six in 65 AD. Lucan himself had written, '*Medio posuit deus omnia campo*' (God has placed every-

thing at the centre of a field). In changing the wording, Rubens also changed Lucan's sense. He altered as well an idea of Plato's, implicit in Lucan's phrase, one that he may have come across in Cicero, in his *De Natura Deorum* (On the Nature of the Gods) and that he would have known about since childhood anyway: that the circle was God's elected field of perfection.[101] All this may have much to do with Rubens' approach to the picture, and to his religious paintings generally. It may spotlight a credo.

For Plato and the ancient world, as for St Anselm and the medieval world, and for the Renaissance too, the circle had always been understood as the most perfect of designs. It meant absolute beauty. It represented matchless proportion. It also represented celestial transcendence. This was the case, or so nearly all people thought, because the circle was the only design whose every point was equidistant from its centre – though why that oddity rendered it more perfect or beautiful than a design in which every point was unevenly distant from some fuzzy middle (or a design without a centre) – nobody thought to ask. Ancient and medieval astronomy was based on an assumption of symmetry. Astrology was a series of symmetrical or balanced animations. The nature of God, as St Anselm had argued in his *Proslogion* (1078), for instance, was the simplest thought that one could have, this being perhaps the most remarkable of his five famous attempts to prove God's existence.

Circles were certainly simpler than other geometrical figures. They were thought to be the blueprint of God's perfect universe because God would not have botched his creation.

Rubens' circle-dot drawing and inscription were thus intended in a real sense to graph the imagination of God, and his own spiritual beliefs. They reflected an extraordinary though not heretical view of how divine energy worked in the universe at large and in living creatures, including human beings. Their sense also verged on the mystical – which is surprising because Rubens' entire training with the Jesuits was anti-mystical. The deeper intent of the design was to account for the diversity of things in the midst of the boundless harmony of everything: if the circle represented perfect beauty, or absolute beauty, or God's plan of everything, its centre (or God) was also everywhere at all times, and its boundary (or God's hypothetical extent) was nowhere and beyond time, in eternity. Plotinus (204-70 AD), the last important philosopher of the ancient world, a neo-Platonist whose mysticism had deeply influenced Christian theologians from St Augustine on, had been among the first to articulate this idea, and also to equate it with eternal movement, or aliveness: 'All beings may be thought of as centres uniting at one central centre'; and 'we must think of [the 'Intellectual-Principle', which is 'one with the Intellectual Cosmos'] as a quiet, unwavering motion.'[102]

Plotinus had not himself described God's infinite numbers of moving

circles within one moving circle as without boundaries, but Renaissance philosophers such as Marsilio Ficino (1433-99) and authors such as Rabelais (1494?-1553) had helped to turn the concept into a widespread Christian conviction by Rubens' day. It implied that each person, and each soul, was a God-centre, a dot, so to speak, at the centre of an unbounded circle. By the early sixteenth century, this notion had become so trendy that it even invited satire, as in one of the Till Eulenspiegel stories (which Rubens probably read as a child). In the twenty-eighth Eulenspiegel tale, the smirking jester is challenged by a professor at the University of Prague to locate the centre of the world: "'It's right here," he replied. "I'm standing in exactly the centre of the world. And to see whether that's true, have it measured with a string. If I'm off by even a straw's length, I'll admit I'm wrong.'"[103]

Rubens himself, however, was being neither trite nor trendy in drawing his circle with its dot, which he managed with a compass. The inscription alone conveys his sincerity. Nor was he busy in some fiendish and romantic way in trying to tear apart and put on display God's brains, so to speak, as were some of his predecessors, such as Hieronymus Bosch and Matthias Grünewald, who confounded the sacred with the abnormal, decayed and misshapen as well as the graceful. By the age of twenty three in Antwerp, and by the age of twenty four in Rome, Rubens had come to regard rationality as more of a miracle than distortion. Balance was more entertaining than freakishness. Compassion revealed spiritual and physical truths more clearly than disease. His temperament, as exhibited in this painting and in his circle-and-dot vision of God, was taking him closer to the art of Shakespeare, with its infinite compassion even for mass murderers such as Macbeth, than, say, to Christopher Marlowe, whose brilliance resembled that of Blake's tiger stalking like a grand squad of flames through the forests of the universe, but which in the end rejected the company of others as equals, even other tigers.

What both Rubens' painting and his inscription in Van Valckenisse's friendship book announce is his belief in the presence of a mysterious divine spark in everyone, without exception. If he was serious about balance and rationality, the certainty that Christ's torturers were men like other men, and as deserving of empathy, had to be admitted and explored. They had to be shown as individuals with souls. If they were wicked, their wickedness lay in their choices, not in their genes or in some illness, mental or otherwise. The horror of their choices, illuminated by their sudden hesitation, and by his showing one of their hands resting on Christ's shoulder, had to be presented in an honest appraisal. The ghastliness of their purpose, and the final terror and spirituality of the painting itself, might thus turn out to be far more terrible, and also wonderful, than some caricature of these men, with its erasure of their responsibility for their acts. They were people, not symbols.

What this adds up to is that Rubens was by now creating an art

haunted not by darkness but by brightness, and no less tormented for its balance. Neurotic disturbances, or the sewers, musty chambers and eccentricities that figured in the paintings of other artists, were irrelevant. Holy brightness, and the light of the sun and the moon, could be as much a scold, a whip, a lesion and bout of suffering as mazes of despair and pessimism. The pleasure that he had discovered in motion, or aliveness, also required aliveness in him personally. It guaranteed his future commitment to taking life-long artistic and spiritual risks.

50. Excursions through Italy

The three canvases were well received. As late as 1610 in fact, his altar setting was described in terms of ecstatic praise by P.M. Felini in his guide to Rome.[104] Because there is nothing to suggest the opposite, it may be assumed that Rubens was paid. By April 20, 1602, at any rate, he was back in Mantua, arriving on the little island with its pompous palaces, towers and churches in time for a carnival.[105] It is unclear how he spent the next weeks, though it is likely that he worked for a while, even if it may have seemed more frivolity than work, on portraits for Vincenzo's gallery of beautiful women.

In doing so, he had at least one rival. Frans Pourbus the Younger (1569-1622), who also hailed from Antwerp, had been Vincenzo's official portrait painter since 1600, a post that he had assumed one month before Rubens' appointment to the Mantuan court.[106] The offspring of two generations of accomplished painters, his grandfather Pieter (d. *c.* 1583), who had also worked as a surveyor, and his father Frans, whose teacher had been Frans Floris and who 'excelled in painting animals from life',[107] Pourbus the Younger had fulfilled his father's unrealized dream of going to Italy. His father had been ready to go, and was even busy bidding his friends adieu, according to Carel van Mander, who knew him, when he changed his mind and gave up the idea for love, staying on to marry the daughter of Cornelis Floris, his teacher's brother. Pourbus the Elder had died in 1580, when his son was twelve, after a bizarre incident in which he inhaled some toxic air from a just-cleaned gutter.[108] His son, who seems to have been wiser and less passionate in his mode of living, and who was content to do the sort of genial work pleasing to his aristocratic patron and little else (his sitters are only rarely provided with so much as landscapes and backgrounds, not to mention dramatic situations), was now on his way to becoming one of Europe's most esteemed portrait artists.

There is no evidence of hostility between Pourbus and Rubens. They may have been friends. Professional conflicts were probably eased by their differing temperaments and ambitions. Still, Rubens seems quickly to have tired of this work (there was not much of it, and it remains unknown), as he often did of portrait painting, and possibly of his unde-

manding position at Vincenzo's court. Even the presence at the court of Claudio Monteverdi (1567-1643), the greatest composer of his day and the first to perfect the new opera form, who was working on his controversial madrigal books (his third, fourth and fifth were published between 1592 and 1607), with all the lively musical experience that his activity there implies, while his ambitious first opera *La favola d'Orfeo* lay in the future (it was not to be performed until February, 1607), failed to attract him.[109] It is as if life as well as art, the desire to be or become a man of the world somehow, to join in its political situations as a man of *vertu*, leading the *vita activa* along the lines of ideals known to him since childhood, was pulling at him in powerful ways.

His restlessness is evident in his early departure, no doubt spiced by his wish to meet up with his brother, though he may have devoted part of the next couple of months, before heading off to Verona, to one large and splendid painting, *Aeneas Preparing to Lead the Trojans into Exile* (146 x 227 cm., now in the Musée Nationale de Fontainbleu).[110] This is a panorama of exiles in flight – he seems frequently to have been intrigued by the problems of refugees, even legendary ones – in which the distant fires of burning Troy, dunked into darkness and gloom, on one side, give way to a Titian-bluish, hopeful sky and a dallying frigate, on the other, with Aeneas and his escaping followers huddled in between, and the whole serving up a dish of affectionate impressions of the *Aeneid* of Virgil, Mantua's poet of genius.

Probably riding northeast by way of Villafranca, he arrived in Verona in early July to see Philip, who had come over from Padua.[111] There he had got to know Nicolas-Claude Fabri de Peiresc (1580-1637), already by twenty two an accomplished scholar, historian, cartographer and bibliophile, a studious young man whose amateur's passion for science as well as art was mirrored in his friendship with Galileo. Peiresc was a wealthy aristocrat from Provence, fluent in Italian, Latin, Greek, Hebrew and Arabic.[112] He probably captivated Philip, who appears to have communicated his enthusiasm to his brother, as much for his infatuation with collecting *curiosa*, or exotic shells, Egyptian statuettes and the feather costumes of Peruvian Indians, as printed books and rare manuscripts (he was on his way to establishing one of the richest libraries in France, and notable fossil and coin collections). Philip himself was developing an interest in ancient Roman dress, and its political and social meanings. He was also working toward a Doctor of Law degree, planning to take it at the University of Rome, as had his father before him.[113]

Joining them in Verona was also Jan Woverius, himself a pupil of Justus Lipsius, Philip's philosopher-mentor in Louvain, and a friend of both brothers.[114]

After just over two years, their meeting – one can make an easy guess about it – must have been pleasant indeed. Their comradeship, coupled with their delight in each other's abilities, a passion suffusing Philip's

letters, ran strong and deep. In his own way Philip was as gifted, though less ambitious in the world-shaking sense. These facts argue that if either of them may be said to have been atoning unconsciously for the sins of their father and modelling himself on him, it was Philip. On the evidence, Rubens himself was not doing anything of the sort, or imitating anyone. If anything, he embodied a synthesis of both of their parents' values, enlightened by his luminous originality, in choices, gifts, attitudes, insights and independence. For both brothers too, a number of their qualities, such as their love of precision, their liking for money, their absorption in politics, their fascination with history and languages and their spirituality, as well as their personal neatness, loyalty, thoughtfulness, sensuality and boldness in taking calculated risks, reached back several generations and at least two centuries, into Maria Pypelinckx's merchant family and Jan Rubens' heritage of apothecaries and grocers, but with all of these traits now realigned and transfigured. The past was being replanted as a refined adventure in their new generation. Antique seeds of character were being nurtured, and the new shoots tended, by more sophisticated gardeners whose reserve matched their willingness to try out new ideas.

Rubens was back in Mantua by July 15.[115] Philip returned to Padua and then went on to Bologna, heading south after some weeks to Rome. At the same time, Rubens' artistic restlessness and what may be termed his worldly curiosity hardly abated. Perhaps biding his time, or unable to suppress his yen for some enchanting, fresh escape, especially an escape into a new fashioning of truth, he turned once again in his art to ancient Greek mythology, painting an enormous *Council of the Gods* (over 2 x 4 meters, now in Prague), in terms of sheer size and theatricality his most lavish fantasy and interpretation to date of the Greek myth-making mind.[116] To another artist, an undertaking of this magnitude (including the sheer physical strength and stamina that it required) might easily have seemed sufficient for half a career, or all of it. To him, accustomed as he was becoming to tackling complex and populous scenes with intricate poses and psychological clashes, it probably seemed a more casual affair, though no less intensely interesting because it was quickly done.

Its momentousness, which is by no means unaccompanied by humility, seizes you at once. The picture sprawls with colours and figures. At the same time, you cannot help noticing a stylistic advance, or at least an eagerness to resolve a new stylistic challenge. In this painting, as with so many of his religious inventions of a better, clearer world, you are consciously and cheerfully pulled up into the great natural verticals of the human imagination. Forced on you as never before is the fact that the imagination is a shooting up as well as rocketing down, that all imaginative acts defy gravity, and that the human heart must suffer, going deaf, dumb and blind, and sickening, sagging and shrivelling, if left stuck in so-called realistic circumstances, the

routines and cramped offices of the poor, glorious, all-too-human body. Your awareness of brilliant verticals is overpowering here, though the *Council* is actually a grand wall of paint and not a ceiling decoration. At the outset, your eyes are scooped up onto the peak of Mount Olympus. It is cloud-fretted, cloud-furnished, sun-tooled. The clouds, moreover, are carved out as huge chairs, couches, divans and a little bridge on which Zeus relaxes. This cloudy furniture is a set of lounging, perching and nestling places for Athena, Venus, Cupid, Mercury, Apollo, Poseidon, two-faced Janus (that spooky god of entrances and exits) and an additional score of supernatural beings, along with prancing horses, doves, a swan, a peacock and flitting putti. The gathering of the gods thus in many ways allegorises an inner council of the human mind, an assembly of personified instincts, passions and inclinations: an externalised display of everyday human struggles and wishes.

Rubens' attention, though, seems directed at a single divine rivalry, an old one between Athena and Venus, or between judiciousness and righteousness (or law leading into war and violence), on the one hand, and sensuality, beauty and wantonness, on the other. Almost isolated among the rest of the gods, Athena and Venus are shown standing up. They are confronting one another, debating their incompatible views of existence across the sunswept space atop Olympus. From his bridge, Zeus presides. At least he looks on, and seems disturbed, as the other gods laze about in an amused, unclothed languor coupled with a benign interest. Venus is winning. You can tell because the putti hovering over her head are about to crown it with rings of laurel leaves. Her triumph may actually represent a polite bow to Vincenzo.[117] It seems to acknowledge the duke's yearnings for luxury, love and pleasure as against the more predictable alternatives of battles and slaughter.

Certainly Athena's strident pleading – she wears an expensive gold-green dress and flings her arms forward – seems a frustrated exercise in contrast to Venus' shrug of mischievous glory. Rejoicing in her nakedness, she casts her arms wide apart, arching her back and thrusting out her breasts. Her face, framed by gold curls and tresses, floats skyward as a disk of sunlight. Whatever the painting's ultimate meaning, sensuality here clearly embarrasses and enrages, as well as humiliates, the simplicities of power.

51. Off to Spain

Ambition fiddled with nervousness in Vincenzo's mind. He worked incessantly at cementing his social and military alliances. To ignore them would be to invite invasion. The independence of his kingdom required protection from friendly foreign rulers and generals, especially those of Spain, Europe's if not the world's imperial master.

By February, 1603, at the latest, but probably somewhat earlier

considering the preparations involved, he had decided to resort to a new mixture of bribery, diplomacy and flattery in an effort to strengthen his relations with the hedonistic, devout Spanish king of the past five years, Philip III, and his advisers. His method was presents. Vincenzo had sent the twenty-five-year-old Philip presents before, as he had also sought to appease the pope by riding to meet him with an enormous entourage of knights and carriages, and as he had curried favour with the Hapsburg emperor, Rudolf II (1552-1612), by joining in his Croatian battles against the Turks, but this time he had an additional aim: to win appointment as admiral of the Spanish fleet, a position presently unoccupied and invaluable.

It is revealing that he chose Rubens to deliver his presents, entrusting an insignificant court painter with what amounted to an important quasi-diplomatic mission. While it was not unknown for artists to act as diplomats, because their discretion could be counted on and their powerlessness aroused little suspicion, and even for artists to engage in politics (as with Antonis Mor's begging Philip II to show mercy toward the Netherlanders, and with Lucas Cranach's plunging into the political life of Wittenberg), a more obvious choice for Vincenzo, if he wished to send an artist, would have been Frans Pourbus.[118] Far more than Rubens, Pourbus had been showered by the duke with commissions and public honours. He might also have chosen another artist, the well respected Pietro Facchetti, just now his agent in Rome. Not only was Facchetti a fine portrait painter but he was also the copyist whose renderings of Raphael figured among his presents to Philip.

Also revealing, and puzzling, is the route that Rubens was ordered to follow to deliver the Duke's gifts. Instead of proceeding directly to Genoa and there finding a ship to take him to Spain, he was ordered to travel in a more roundabout way, first to Bologna, then to Florence, then on to Pisa and then to Livorno, with its smaller harbour, where finding a suitable ship would probably prove difficult. The duke's insistence on his making this detour seems even odder if one considers the delicacy of the gifts themselves, and the greater chance of their being damaged on the rough roads over the Apennines and a much longer distance.

Vincenzo had actually decided to send an extraordinary collection of works of art and bibelots to the Spanish court, among them, and for the king himself, eleven ornate arquebuses, a rock-crystal vase serving as a perfume container (it was full) and, more astonishingly, a gilt coach with six bay-horses.[119] The horses, extraordinary in themselves, were to be pampered according to quite mad instructions, to wit, that Rubens was daily to arrange wine baths for them, a fantastic notion that rapidly became a source of irritation (as did the coach itself, which was transported on a specially built waggon, or derrick, drawn by oxen; its bumping and creaking along and, as things turned out, its eventually being abandoned because of its clumsiness, elicited gales of laughter from

the muleteers hauling the rest of the load). Nor was this all. For the Duke of Lerma, Philip's Prime Minister, there were sixteen wrapped and rolled-up copies of paintings by Raphael (Fachetti's contribution), as well as by Titian and other artists, and gold and silver vases. Two crystal vases were intended for Don Pedro Franqueza, Philip's Foreign Minister, along with valuable brocades. Another rock-crystal vase and two chandeliers were going to the Countess of Lemos.[120]

Everything considered, Vincenzo's choice of Rubens as his man for this expedition, which would have its own politically tricky aspects, looks puzzling indeed, and can only be explained by his having long before sized Rubens up as a capable organizer, as someone whose trustworthiness and negotiating skills complemented his artistic abilities. In the end, he may have been picked for his charm – and there was probably another reason. Vincenzo had likely opted for a serpentine route to Livorno so as to parade his gifts through a few major Italian cities on the way, and especially before the Grand Duke, who resided in Florence. There was capital to be made out of a bit of ducal strutting about, and perhaps by embarrassing the Grand Duke into sending the Spanish king some gifts of his own. Alone among Vincenzo's artists, therefore, Rubens, who had been to school in court manners at Audenarde, and who would know how to manage the Grand Duke because they had (probably) met at Marie de' Medici's wedding, was a solid choice, a person who could handle the diplomatic and practical problems as they might arise.

In retrospect, one can only be grateful that they arose immediately. They allow him to step forth today with new clarity. They lead to his surviving letters.

He set out for Bologna with ox-drivers, muleteers, waggons and the tedious derrick on March 5. By March 15 he had gotten only as far as Florence. So far, moreover, the journey had been appalling. Although back in a city that he knew as well as he knew Italian, or very well by now, and where two years before he had spent a profitable time sketching Michelangelo's *Battle of the Lapiths and Centaurs*, he felt that he might be moving into an unfamiliar, cosmopolitan bleakness, possibly because Vincenzo refused to tell him the real reason for the trip. Nothing seemed to go as planned, and even the weather was bad, with whippy rains and floods. He was also running out of money. The duke had not given him enough to pay or bribe everybody, especially the drivers and customs officials, who demanded to open all his packages. No doubt Vincenzo had misjudged the problems and costs involved in dealing with men, horses, oxen and his precious carriage. Perhaps Vincenzo had not really trusted him. The Grand Duke, to whom Rubens hoped to apply for assistance, turned out to be away in Livorno, his own destination. The time seemed ripe for complaints, and complain he did, in a letter of March 18, not to the duke, which would have seemed crude, but to Annibale Chieppio, his Secretary of State and his own friend in Mantua, who had arranged his

stipend when he went to Rome. Chieppio would make his chagrin known to the duke in any case.

In this letter, and for the first time (because all his earlier letters, which must have existed, have vanished or been destroyed[121]), one gets to listen to his lost voice, and what freshness, irony, sauciness, smartness and equanimity (for the most part) purr, grumble and babble through it: what life: a burliness too, beneath his conventional phrases of diplomatic politeness, a rawness, and always his care and thoughtfulness, the rapidity with which, as in his paintings, he spots the either-way twistings of people:

Most Illustrious Sir and Esteemed Patron:
First of all, in obedience to His Most Serene Highness [the duke], who ordered me expressly to report to him the progress of my journey from place to place, and second because a serious occurrence makes it necessary, I have resolved to bother you. I turn to you rather than to anyone else, for I have confidence in your kindness and courtesy; I know that in the vast sea of your many important affairs, you will not refuse to care for this poor little boat of mine, badly guided until now by the incompetent advice of I know not whom. I speak always with respect, and with the intention neither of blaming anyone nor of excusing myself, but in order to explain to His Most Serene Highness how he may suffer through the mistakes of others.

Well, I finally arrived in Florence on March 15 (not without the greatest expense, as I will tell you later, in transporting the baggage across the Alps – especially the little coach).... When [important Florentine merchants] heard of the undertaking, they were amazed; they almost crossed themselves in their astonishment at such a mistake, saying that we should have gone to Genoa to embark, instead of risking the roundabout route to Livorno without first being assured of a passage. And everyone asserts that I might perhaps wait there three or four months in vain, with the danger, even after such a delay, of being forced to go to Genoa in the end.

On the following day (to our good fortune) there arrived some Genoese merchants straight from Genoa. They told me that in that city there were galleys ready to sail, among them a ship loading for Alicante, which would remain in port for eight or ten days longer. And so, on the advice of the above-mentioned Florentines and the Genoese, I have decided to leave as soon as possible for Livorno. There I shall embark immediately for Genoa, where (God willing) I may arrive in time, as I hope to do by virtue of the guardian angel of our Prince [the duke]. I shall not fail to urge all possible haste, and indeed I should have departed already, if I were not delayed by the coach. It has not yet arrived, thanks to the oxen which are drawing the cart, for want of mules. And our derrick, especially constructed in Mantua and brought this far, has now to be left behind, to the derision of the muleteers, who say that it would exceed the maximum weight possible [on board ship], even without any other load. The coach alone, without the other seven pieces of luggage, cost forty ducatoons to transport from Bologna to Florence. And this price included all the concessions and assistance offered by [various] merchants, who were most friendly and helpful

to us. ... [In Ferrara] the Count Balthasar Langosco rendered the Duke a service by interceding for us with the Cardinal [Pope Clement VIII's Cardinal-Governor] for protection against the officiousness of the tax collectors who insisted upon opening our trunks. His Eminence condescended not only to guard us against their violence, but graciously surpassed our expectations by exempting us from all tolls and duties. And then in Bologna also (influenced, perhaps, by this good example) the collectors were content with an honest tip [probably a bribe]. I hope it will be the same in Florence, even though the Grand Duke is away in Livorno. It is no small thing to be exempt from the duty; for if this had to be paid (as I fear it will in Spain), the taxes would have cost more than the whole journey.... Already the expenses far exceed the narrow limits prescribed by the paltry ideas of the palace steward [in Mantua] and others. I will do what I can; the risk is my Lord the Duke's, and not mine. If he mistrusts me, he has given me a great deal of money; but if he trusts me, then he has given me very little. If the funds should fail (may I never have that experience), what a blow that would be to his reputation! But in giving me too much, there would surely be no risk, for I should always submit my accounts to censure, however severe. Does he think the surplus would not be returned, if he paid me in advance? What, then, is there to lose, unless interest and time?

But now I am making you lose time, with this long and tiresome letter of mine. I did not realize such an error, but carried away by my feeling, I am perhaps too free and impetuous in dealing with one of your rank. May your goodness pardon me, therefore, and your discretion make up for my defects. I pray, I beseech you to report to His Most Serene Highness what pleases you and seems necessary to my requirements. And if these complaints and troubles of mine do not perhaps deserve so much urgency and emphasis, I entrust myself completely to your wise judgement. Speak and act according to your inclination, and dispose of your servant, who bows to your patronage, humbly kissing your hands.[122]

His kissing of the hands is, to be sure, a purely literary exercise, as is his entire last paragraph and some of his other obsequious phrases. It would be a mistake to read into the preciosity of the language any preciosity of the writer. In Rubens' case – that of a man dirtying his fingers and sleeves with paint, chalk, oil and ink almost daily, as used to the smell and sweat of the stable as the fragrance of marble palaces, and interesting himself in the sheen and glamour of the skin of his frequent male and female models – any preciosity was mere irony, a mockery of this manner even as he used it, and as he waited for the much-delayed coach.

52. Spies and a Sea Voyage

Up to this point he had no idea that he was being spied on, with his every move watched by agents of the Grand Duke of Tuscany. When he found out, and as the knowledge was virtually served up to him in a spirit of smiling matter-of-factness, he at once reported his amazed resentment to

Chieppio. By this time (March 29), he had wheedled coach, men, horses and large packages through Florentine floods and storms ('I was detained in Florence for six days longer'[123]), reached Pisa ('taking ten days for such a short journey'[124]) and made contact with a ship captain from Hamburg willing to take him directly to Alicante from Livorno.

His first hint that he was under surveillance came soon after he reached Pisa, when 'through a Flemish gentleman in [the Grand Duke's] service',[125] actually Jan van der Neeson, the son of the City Secretary of Antwerp and a close friend of his brother,[126] he was asked to take one of the Duke's own palfreys to Cartegena as a present to someone there, along with the horses that he was already delivering to Philip III. Unaware till now that his presence in Pisa might have attracted the royal eye, he at once agreed, and even offered one of his grooms to care for it, guessing that the Grand Duke, whose powers were immense (including decisive ones over commercial transactions), was probably asking him to take the horse simply to keep him under observation ('the gentleman gave as an excuse [for asking him to take it] the expense of sending it any other way'[127]).

By March 29, however, while still in Pisa and having settled his embarkation plans with the German captain, who had gone ahead to Livorno, any doubts that he may have entertained about being constantly watched, and indeed that he had been spied on even before leaving Mantua, had been laid to rest:

> The Grand Duke summoned me today after dinner; and he spoke in the most friendly terms of His Most Serene Highness [Vincenzo] and Madame, our Duchess [Eleanora de'Medici]. And when he inquired somewhat curiously about my journey and other personal affairs of mine, this prince astonished me by showing how minutely he was informed in every detail as to the quantity and quality of the gifts destined for this person or that. He told me, moreover, not without gratifying my pride, who I was, my country, my profession and the rank which I held. I stood there like a dunce, suspecting some informer, or in truth the excellent system of reporters (not to say spies) in the very palace of our Prince. It could not be otherwise, for I have not specified my baggage, either at the customs or elsewhere.[128]

Embarrassment, or resentment, combine blithely with his droll egotism here, honestly confessed ('not without gratifying my pride'[129]). It was apparently flattering to receive even the suspicious attentions of so powerful a man. One might move up in the world, it seemed, simply by doing one's job – as long as one was dealing with intelligent people who had a similar turn of mind.

Less pleasant was the sea voyage itself and its aftermath. Both smacked of wretchedness plus adventure. There arose a question whether he had not simply been dispatched and abandoned.

April 2 found him in Livorno and writing to Chieppio from on board ship, probably a smallish three-masted barque, and awaiting favourable winds, whose rising might take a day or two. Provisions for a month, to be on the safe side, most likely the salt beef usual on voyages of any length, had been loaded. Money remained a problem. Rubens wrote (in Italian) that he had a little more than 100 ducats left of what Vincenzo's accountant had given him, and that to cover the 280 miles from Alicante to Madrid when he arrived (everyone in Mantua had wrongly assured him that the distance was much shorter), he was planning to meet the extra expenses out of his own money, or his pay as a court artist. One reason for his needing more was that 'to spare the poor horses' he imagined that he would be able to make only ten to fifteen miles per day.[130]

His irritation, however, as he waited for his ship to set sail, with 'all the crowd of busybodies and pseudo-experts [at Vincenzo's court] who [had] interfered in this undertaking' by denying him sufficient funds,[131] mounted steadily. Once more he insisted on his own scrupulousness, efficiency and good luck in finding a ship, and noted that Ferdinand, the Grand Duke, had actually decided to send along some gifts of his own, the already reported palfrey, for Don Juan de Vich, a captain in the Spanish army, and a 'table of very beautiful marble'.[132] It had perhaps occurred to him by now that the point of his diversionary journey was political, and that it centred on the Grand Duke himself. 'Otherwise,' he wrote laconically to Chieppio, 'I have nothing to add for now; the rest from Spain.'[133]

As it happened, his ship sailed within a day, arriving in Alicante toward the end of April ('(thank God) safe and sound, with the baggage, the horses and men'[134]), and he delivered the Grand Duke's horse to Don Juan de Vich's aide-de-camp. Though Rubens offers only the barest of clues, one may guess that the passage was pretty rough. It had taken seventeen days at a time when Spanish treasure ships, English privateers and Dutch merchantmen routinely crossed the Atlantic to the Caribbean in twenty eight.[135] There were probably spring squalls and noisy eruptions across the Mediterranean's usual emerald calm – dark mornings, afternoons and evenings, gales, swells and menacing lashings, upsets wild enough to remember, especially for future stormy paintings.

Nor was there any letup in these troubles once ashore. The band of ten men wound slowly toward Madrid, over horrid roads and amid torrential rains. In Alicante he was informed that the king had gone on to Valladolid, many miles to the north. He would have to go there too. One of the grooms became feverish.[136] Rubens stopped off in Madrid, perhaps to have the man tended by a doctor, though the doctors everywhere were notoriously bad.

Despite the weather and pressure to move on toward the absent king, art was never very far from his thoughts – not his own art and not the art of others. The tough circumstances may have sharpened his ache for painted beauty. In Madrid he was let into the royal palace, most likely for

no more than a few hours, but long enough to scan the paintings on display there and to reach some unhappy conclusions. Heading north again, he and his men and the rapidly worsening groom found themselves thrust onto the dark and rainswept plain that lifted heavenwards the block of the Escorial, indifferent though he may have been just then to the ghostly influence of Philip II imaginable about its steeple. Here he was also let in, and took time, though his men were exhausted, wet and annoyed (in a letter to Chieppio he speaks of 'daily rains and violent winds'[137]), to examine the royal art collection. As in Madrid, he was disappointed. Aside from the expected masterpieces by Titian, Raphael and other Italian Renaissance artists collected by previous Spanish monarchs ('which astonished me'[138]), he found himself wincing with scorn at the recent Spanish art. It was as if he had wandered into some *lumpen* provincial tavern instead of the palatial centre of the most powerful court in the world: 'As for the moderns, there is nothing of any worth.'[139] He was not one to make excuses, or to think of making them.

Resupplied with food, he and his group slipped out onto the roads again, and into the persisting high winds and rains, trailing north into the mountains, until on May 13 they reached Valladolid. Here too he discovered that the king was away. He had left with an entourage for Burgos on a hunting trip. Meeting him would be put off till he returned. Rubens had been twenty discouraging days in progress from Alicante.[140]

53. Disaster and Ghost-Painting

Convinced despite everything that all was well, and proud of having completed his journey with vases, horses and men intact, except for the feverish and by now desperately ill groom, he wrote to Vincenzo on May 17 in a cheerful mood: 'The horses [are] sleek and handsome, just as I took them from the stables of Your Most Serene Highness.'[141] He thanked Vincenzo for this assignment, expressed his regrets over his extra expenses and reported that the prized coach, now strapped onto a mule-drawn cart, together with the large package of paintings, was still to come, but that he had few fears that it would be damaged.[142]

To Chieppio he wrote in the same easier vein, stressing his personal contributions of money and hopes of repayment. He had been startled, he remarked, on getting into Valladolid, to find that Vincenzo's acting ambassador, Annibale Iberti, had not been told, so he said, about the expedition, and was surprised to have to assist him. There had been friction between the two, but it had been smoothed over. Rubens had even managed to secure a fast loan from one of Iberti's merchant friends (he had arrived in the city almost broke, without any money for food and new clothes, an absolute must in courtly circles). He remained optimistic about the safety of the rest of the baggage.[143]

About the coach, at least, he turned out to be right. The mule-cart

carrying it showed up a week later, and it seemed presentable. The paintings, though, were a disaster. Rubens had packed them himself in Mantua, in a way suitable for transporting delicate works of art – wrapped in double rolls of oil-cloth and stowed in a wooden chest coated with tin. None of these protective measures had worked. The damp, sharp winds and rain had seeped into all the linings. On opening the chest at Iberti's house on May 24, he found that the colours of many paintings had 'faded, swollen and flaked off'. The devastation of two of them was so complete that 'the only remedy is to scrape them off with a knife and lay them on anew'.[144]

His first reaction was horror: despite his best efforts, he had failed. 'Malicious fate,' he wrote to Chieppio, 'is jealous of my too great satisfaction; as usual, it does not fail to sprinkle in some bitterness, sometimes conceiving a way to cause damage which human precaution cannot foresee, still less suspect.'[145] Almost at once, however, and with some prodding from Iberti, he realized that 'malicious fate' might not have produced a total catastrophe, and that indeed it was offering him an irresistible chance. This was to restore the paintings himself. He might manage to do so before the king's return (his absence suddenly seemed a blessing in disguise). No one would be the wiser because he would handle the restoration almost invisibly, even if some might wonder at the freshness of the new paint, and gossip. This was a risk worth taking. There was a nice twist to his problem, too, one amounting to poetic justice. Vincenzo had not deigned to include any of his own paintings among those that he had sent to Philip. Ironically, every one of the restored works would now turn out in some definite way to be by him.

Perhaps in his dismay and enthusiasm he nearly neglected to mention, tossing in the news only as a postscript to Chieppio, that the ailing groom, Paul, who had been 'wasted and exhausted by a long, continuous fever', had died that day, just as the paintings arrived. He wrote that Paul had been 'provided with all the comforts of body and soul', or his last rites, and then apparently forgotten.[146]

There was a great deal to do, and Rubens set to work, urged on by Iberti, though not without arguments over whether local Spanish artists should help him. He had found nothing to admire in their abilities (or, as he carped, in 'the incredible incompetence and carelessness of the painters here'[147]). Besides, at this time of his life, and revealingly, he seems to have despised any form of collaboration ('I have always guarded against being confused with anyone, however great a man'[148]). Copying, at which he excelled, was one thing. Ghost-painting, a bit like ghostwriting because he would receive no credit for it, was acceptable in the circumstances, even if distasteful. The idea of allowing someone else to fiddle with his style, whose uniqueness he perfectly understood, was unthinkable ('[their] style is totally different from mine. God keep me from resembling them in any way'[149]). Indeed, he worried about 'being

disgraced ... by an inferior production unworthy of my reputation, which is not unknown here'[150] (though in this he exaggerated somewhat, because at first it was known only to Iberti). He fretted about his participation being exposed in work to which some inferior Spanish artist had added a few of his own amateurish accents.

His anxiety was misplaced. Iberti could be persuaded. Rubens was allowed to do all the work. It was not as much as he had at first thought, because the damage in most cases was not irreparable. The work went well.

He might better have worried about something else: Spanish politics. His position in Valladolid and at Philip's court, though he did not at once realize it, was vulnerable to sabotage by the very man assigned to help and protect him and who was pretending to do so. 'Doctor' Iberti, as the small, meticulous fellow styled himself, had started out as a secretary-agent in Madrid of the Duke of Mantua, but shortly afterwards began to describe himself as a nobleman, and still later made no objections to being taken for Vincenzo's official ambassador, even if his promotion remained unknown to his employer.[151] His machinations behind Rubens' back, which were driven by jealousy, stupidity and an exaggerated idea of his own importance, became threatening (at one point he accused Rubens of fraud), but idiotically contradicted themselves. In his reports to Vincenzo – he sent off nine, detailing Rubens' activities between May and August alone, with more later, and with Rubens himself apparently allowed to read a few of them – while seeming to praise him, he omitted his name, referring to him dismissively as 'the Fleming'.[152] Rubens probably bit his lip, saying nothing about his arrogance: in his own letters to Chieppio, he makes no mention of it.

At the same time, Iberti, who was anxious to ingratiate himself with those in power while nudging Rubens into the background, kept hounding him to restore the paintings as quickly as possible. As soon as they were done, though he told no one of his intentions, he planned to make the royal presentation himself. Over the days that followed, he led Rubens on, down a primrose path, even showing him a letter from Vincenzo 'expressly commanding' his own appearance before the king when the gifts were presented, but only at the last minute making sure that it did not take place. In the meantime he cultivated a tactful atmosphere. His pedantic manner induced a false sense of security. He tried to make helpful suggestions. At one point he proposed that Rubens mock up 'half a dozen little woodland subjects, the sort of thing in demand at galleries'.[153] Rubens declined his suggestion, probably because it seemed naïve and silly, but he had a lot to learn about the glitter, dark and conspiratorial atmosphere of life at this politically confused court, though for the moment he sweated away in ignorance.

The future developed unpredictably. As it turned out, two presentation ceremonies were advertised, of which the second had a decisive effect on

his future. The king returned on July 1. By then Rubens had finished his restorations. He had painted a new picture too, a small portrait, which he finished by July 6. He slotted it in unannounced with the rest.

Iberti's presentation of 'the little coach', at the first ceremony, took place on July 11. A posh crowd assembled. The 'ambassador' bowed and scraped his way through foppish protestations of admiration for His Majesty. Rubens was invited to join only the surrounding throng of courtiers. Iberti failed to point him out to the king, and as Rubens noted in a mildly annoyed letter to Vincenzo, 'I observed with pleasure the indications of approval which the King showed by gestures, nods and smiles', implying that he had been standing too far back to hear what the king may have said.[154]

With Chieppio he was more candid: '[Iberti] could have given me a place near His Majesty, to make him mute reverence. There was ample opportunity.' He went on: 'I say this not to complain, like a petty person, ambitious for a little flattery.... I only describe the event as it occurred.' In a sly dig of his own (he seems to have been learning fast), he suggested that his desire to meet Philip 'must have slipped [Iberti's] mind'.[155]

The paintings themselves were actually turned over only at the second ceremony, on July 13. The Duke of Lerma, the king's 'favourite', a man in whom an enormous amount of political power was concentrated and himself a lover and connoisseur of the arts (and whose wife had died on June 2), accepted them from Iberti and Rubens together. Perhaps because the Mantuan 'ambassador' foresaw some embarrassment if the true painter of most of the pictures was revealed and because he wished to shift any blame away from himself should that happen, he invited Rubens to participate up front. The result was startling, and while Rubens did nothing to implicate his rival, his mere presence, and how he acted, seem to have deflated Iberti's designs. In fact the meeting with Lerma altered Rubens' hitherto invisible position at the Spanish court. So important was it, and what resulted from it, that it may be said to have altered the history of art.

At first, the encounter with Lerma seemed innocuous enough. The duke regarded him, no doubt because Iberti said nothing to the contrary, as a mere deliveryman, as someone to be congratulated for having braved ferocious weather to bring a valuable collection of horses and paintings to his king. Lerma had no idea that Rubens was an artist himself, still less that he had already done major work in Rome. Lerma was also not sophisticated enough to tell the difference between originals by Raphael and Titian and good copies by someone else. Facchetti's second-rate renderings of Raphael's Creation and *Planets*, which had been more than restored by Rubens, were welcomed by him as the real thing (a portrait of Vincenzo by Frans Pourbus and another painting, *Hieronymus*, by Quentin Massys, were genuine enough, and unharmed). Neither Iberti nor Rubens let Lerma in on their secret:

I went to the Duke's and took part in the presentation. He showed great satisfaction at the fine quality and the number of the paintings, which (thanks to good retouching) had acquired a certain authority and appearance of antiquity from the very damage they had suffered.... They were, for the most part, accepted as originals, with no suspicion to the contrary, or effort on our part to have them taken as such. The King and Queen also saw and admired them, and many nobles and a few painters.[156]

The key moment, however, indicated by Rubens' phrase 'for the most part', came when his personal contribution was examined. This turned out to be a double portrait, done for the first time ever for such paintings in half-length, of the ancient Greek philosophers Democritus and Heraclitus. It was unavoidably shown as by Rubens, to Lerma's amazement and, one may surmise, Iberti's suppressed consternation. The disclosure that the deliveryman was himself an obviously thrilling artist led immediately – so profound was the impact of Rubens' minor but striking effort – to a request by Lerma that he be reassigned to the Spanish court (in fact Lerma told Iberti, repeating his idea on other occasions, that Rubens had surely been sent to Spain by Vincenzo for just that reason, as a type of gift to the king). Iberti declined this request – he had scant authority to accept it – but he said that he was willing (probably he found the proposition a relief, and a feather in his cap) to assign Rubens to Lerma temporarily, as his personal artist, throughout his time in Spain.[157]

It was certainly clear at any rate that his *Democritus and Heraclitus* (95.4 x 124.5 cm.; now in the collection of Barbara Piasecka Johnson in Princeton) could not have failed to impress anyone who enjoyed philosophical problems, even squabbles, as did Lerma, as well as superb draughtsmanship. The painting may have cast a surprising twinkle of rose and flaminess, emanating from its great cape (or Greek *himation*) worn and flaunted by Democritus, over the feebler golds, blues and pinks of the Spanish courtiers assembled at the Valladolid palace that day. What was remarkable too was that in a relatively short time, less than three weeks, and while restoring the paintings of others and redoing a couple of paintings entirely, Rubens had come up with a complex *inventione*, or new story idea, and polished it off in short order.

The painting's philosophical problem, or squabble, was entirely original as Rubens dealt with it, and would especially have seemed so in Spain, where debate-paintings of this type were unknown.[158] In it the two ancient Greek thinkers represent a popular conflict, that of optimism versus pessimism. What is unusual in Rubens' version is that the question whether the one is more realistic than the other is demonstrated as settled. Optimism seems to win. The world is invited to move on. Reason, possibly God's optimistic power of Reason, seems to triumph. The 'laughing' philosopher, Democritus, full-bearded, his satirical eyes jollying past you, is shown lounging beneath some trees, beside his clean-shaven (because historically speaking one-century-younger), 'weeping'

rival, Heraclitus, who clasps his hands in permanent commiseration across the European section of a globe that rests between them. If Heraclitus is not actually weeping, in conformity with the well-known Renaissance legend about him, he seems about to weep.[159]

Democritus brushes his gloom aside. He virtually ignores it. His reddish, sanguinary cape, reflecting a medieval colour-symbolism still in vogue in the Renaissance, also seems to refute it, as he smiles into eternity. Beyond his delicious good humour, and this Rubensian touch may have impressed the amiable Lerma, his casual domination of the little scene presses the spectator too into ignoring Heraclitus' pessimism. Neither philosopher – and Rubens' conception is probably at its most original in this detail – is shown as either happy or sad about anything in particular (it has been argued that Heraclitus is worried about the war still in progress in the Netherlands, but his pose seems too disinterested in specific geography, too generally directed at Europe, or at the globe itself, to credit this idea[160]). Each of the two philosophers illustrates an opposed view – but of the spectator's problems, not merely Europe's, and of life itself.

In addition, Democritus' titanic ease, together with the Italian-Renaissance refinement of his face, plus the hints of ancient Roman sculpture in Heraclitus' ponderous arms, hands and expression – Rubens' brilliant fusing of the recent with the ancient in their clashing personalities – embodies attitudes toward art and life popular among sixteenth-century Humanists.[161] Surely the picture mirrors Rubens' own attitudes, a possibility to be considered not because he painted it (he might have depicted some victory with which he did not sympathize), but because Democritus' candid optimism seems to sweep out of his own training in the classics, in Seneca, Ovid, Juvenal and the Stoics (which Philip was studying under Justus Lipsius). It sweeps out of his vigorous temperament. It seems a denial of the triumph of the tragic vision of things, though the creation of an artist who had studied tragedy, and known it in his own life. It offers an affirmation of serenity.

His meeting with Lerma that day may also have struck him as an augury of his own future. The stormy roads threading north across Spain had perhaps led into a new form of serenity for him too. A freedom to paint more or less as he pleased was on offer. This was to be a return gift of the duke, Spain's most influential politician, who seemed to appreciate that it was what he needed, and who wished to promote a matching of interests between his new-found artist's ambitions and his own imperial career.

54. The 'Poison Reason Drinks'

Spain had changed since the death of Philip II. Even ordinary people could feel it. On the political level, the drift toward constitutionalism,

which had set apart Philip's last years, had come to an end. Officially, his son ruled as he had himself, by divine right and with unquestioned authority, yet this appearance was deceptive. Philip III, though as religious as his father, had a wobbly, bacchanalian temperament. He seemed to take for granted a strength of command whose possible draining away had frightened the old king, even as his fear and his Christian beliefs drove ahead his most globe-challenging plans. Philip II had sought to augment his royal powers. He had no scruples about doing so, and never lacked for justifications based in respected Renaissance theories of kingship. His son seemed content to permit others to usurp his legitimate influence, and even his popularity, and too flaccid to resist.[162]

A system of favourites was becoming more masterful around him. It had its own shifting hierarchy (the office of the most important favourite, that of the duke, was termed the valimiento, or protection), and was by definition a network of influence-peddling. Some independence was retained by the State Council, a group of traditional ministers, but the favourite, if he had a forceful personality, could easily quash all whispers of dissent from those who had long urged the tax and banking reforms essential to reversing the slithery decline of Spanish resources.[163] The position of the king was a delicate one. He was becoming a subject in his own kingdom. There was no surprise here. As often if rulers adhere with less firmness to principles of governing than to some fascination with personal conflicts – as, for instance, with the emperor Diocletian (245-313), who accelerated the fall of Rome through sumptuosity and dividing the empire – their strengths may waffle, slide, lose respect and collapse.

Philip II had fretted over his son's docility. His older half-brother, Don Carlos, had apparently gone mad. Philip III was only twenty at his coronation. 'I am afraid,' the ailing king had told Don Cristobal de Moura, one of his most sympathetic ministers, 'that they will govern him,' a worry once expressed by his own father, Charles V, about him too in his untested youth.[164] By 'they' Philip meant not only the grandees, whom Charles V had brooded over, but also unprincipled smoothies among the new nobility (in addition to Lerma), who early on exercised a pernicious control over his devout, naïve, playgoing heir.

Philip III, who had been king himself for five years by now, had plenty of rationalizations for his negligent ineptitudes. This was not, for example, the worst time in history for his brand of hedonism laced with piety. The defeat of the Spanish armada by England in 1588 had inflicted a deep spiritual wound on the country itself.[165] The Spanish had seen the English war as a crusade against Protestantism. Spanish Catholics, expecting some sign of approval from God in their struggle, had been shaken by the English triumph. Despite the resurgence of the Spanish navy after its defeat, with the result that more ships were on the drawing boards these days than ever before, the ignorant as well as the educated seemed full of those nervous doubts that may ripen into frivolity or

mental ossification. A life of piety avoided some of the world's more baffling uncertainties.

This was also, as in England, a good time to be a theatre-goer. The most impressive theatre was that created by the son of an embroiderer, Felix Lope de Vega Carpio (1562-1635). Lope had spent a few years at the University of Alcalá, where Don Carlos had also been a student (and where he had thrown a woman down a staircase).

After giving up his university career, Lope had become a professional dramatist. While nearly all his talent was channelled into his 'monstrous' output of more than 2,000 much-adored plays, many of which have been lost, he also wrote good sonnets and prose (his *El Arcadia*, 1598, influenced Sidney and the modern German novel in the sixteenth century, with Grimmelshausen[166]). His productivity was incessant, competent, sometimes thrilling, if not as brilliant as his admirers liked to believe (it was often a predictable brew of the same conflicts), and energised by hysteria. Except when he was making love, asleep or bickering with someone, he wrote nonstop. Even while at sea with the Spanish Armada (in which he served as a sailor), he ground out more than a thousand lines of his *La hermosura de Angelica* (The Beauty of Angelica).[167] This imitated Ariosto's *Orlando furioso*.

Lope was in love with love, a frustrating if exhilarating obsession that required the cultivation of masses of women and sometimes the enactment of tempestuous bedroom dramas off stage. He was also in love with the Church. In his plays, bombast piles on sanctimoniousness, which then gives way to *commedia dell'arte* ribaldry. Jesting turns into clashes between peasants and nobles, usually over questions of honour. Many of his plays are organized around classical, Senecan ideas of drama, but these broken down into a patchwork of bewildering scenes (as Shakespeare and Ben Jonson were breaking them down in London) to guarantee entertainment. His chief aim, often achieved at a cost of emotional plausibility, was to make sure that under no circumstances the audience got bored.

As perfected by Lope, once his battle for this type of neo-classicism had been won by the end of the sixteenth century, the Spanish theatre also mirrored the fractures of Spanish society. A schism between rich and poor, accelerating in the 1590s, and especially after the death of Philip II, had drawn many of the often better educated noble families away from their bankrupt estates and into the loose, money-promising court life of Madrid and Valladolid. It had also forced impoverished peasants and small farmers off their skimpy holdings, usually indemnified to a nobleman, and into these same burgeoning cities. There they languished in worse conditions.[168]

The resulting urban collisions of classes provided the raw materials of good theatre, and also induced a contraction of agriculture. Great swaths of land now lay fallow. They burned into dust in the sun. Grain had to be

imported from northern Europe. Technology and science had sunk into oblivion. Meanwhile, the rich, who lived on borrowed funds, developed superb libraries, patronized musicians and invested, or borrowed more to invest, in superb tapestries. The rich and not-so-rich (but this in a Spain that, unlike the rest of Western Europe, had failed to nurture a balancing middle class) continued to support lavish households run by hundreds of underpaid and unpaid servants. These wretched persons remained in service, as does Don Quixote's servant, because they had nowhere else to go. They made do on feeble hopes of their luck changing.[169]

A step below everybody else, the huge majority of the poor, occasionally well-educated themselves at Spain's twenty-one universities, continued to opt for one of the three time-tested Spanish choices, the Church, the sea, or the army (Iglesia, o mar, o casa real).[170] For nearly all of them it was out of the question to obtain a sinecure at court, where thousands of opportunists, most of them tidied-up hangers-on jimmied into the royal spotlight by the grandees or other corrupt noblemen, crowded the plush corridors of power. One reason for Lope de Vega's popularity, apart from his genius, was that in spite of childhood poverty he had succeeded in besting this system of bribery mixed with religion. To many he seemed to have won in life as well as on the stage.

Fertile oases sprouted anyway across this national upheaval and melancholy. Among them were shipping and painting (regardless of the worthlessness of most of the artists to date, as noted by Rubens). Money clustered about both, though about neither as much as about the court and the Church, whose wealth was unsurpassed.[171] Around all four circulated an eerie, peculiarly Spanish, romantic mist, or brilliant fog. Its aura, spreading everywhere, influenced Rubens' relations with Lerma and what he found himself commissioned to do.

Lope de Vega had captured some of this bizarre atmosphere in his sonnet II, in which he refers to 'the falsities' of all the joys of his years gone by as a 'poison [that] reason drinks as a dazzling brew/Because that's what sheer thirst can make it do/Dressed in my sweet crystal fantasies' (veo que son sus falsas alegrías/veneno que en cristal la razón bebe/por quien el apetito se le atreve/vestido de mis dulces fantasías).[172] This was an atmosphere of poisonous dreams, flavoured with the perfume of a 'spiced amnesia' (hierbas del olvido), or of passions cultivated in spite of common sense and because they flew in the face of it. The brilliant fog was a hopeless stimulation.

Lope's exact contemporary, Miguel de Saavedra Cervantes (1547-1616), a soldier at the Battle of Lepanto, a prisoner of war in Algiers, a daredevil (and failed) escape-artist and an adventurer, exploded the appeal of this fog, really a type of glorious and vainglorious defiance, to devastating effect with his mines of ironic prose. It looked merely uproarious when described in terms of his down-at-heels nobleman-hero and fool, Don Quixote, who tries to revive the age of chivalry in a miscreant,

beauty-devoted era, and the absurd ambitions of his realistic, dreamy sidekick, Sancho Panza. Cervantes was at work on *Don Quixote* in 1603, when Rubens was in Valladolid, not too long after a ferocious outbreak of the plague in 1600. This had swept hundreds of thousands of his countrymen to their deaths – a horror that quite possibly reinforced the attractions of Spanish chivalric romanticism. Cervantes published Part I of his novel in 1604.[173] Its enthusiastic reception was a smile of identification. Millions of readers rediscovered a personal silliness in its delusionary pages. The nation in which masses of people seemed to inhabit obsolete mental environments – those of swash-buckling, knightly adventure stories – was apparently and interestingly prepared to laugh at itself. It was also prepared to keep on pampering its grandiosity.

Nowhere perhaps was the delirium of these attitudes more evident than among the otherwise practical Spanish sailors and soldiers. Spain still produced the world's most complicated and advanced engines, the warships of the Spanish navy.[174] From one point of view, its galleons, frigates, fire ships and barques, with their dozens of cannons, were funny, waddling half walnut shells. They bounced. They tipped. In a fair wind, with their scores of plump white sails properly aligned, they pelleted forward at good speed, slicing and cudgelling crests and waves with a more-than-walnut pride. From another point of view, these voluminous vessels, along with the hundreds of Spanish merchantmen that plied the Atlantic and Pacific routes (merchantmen of all countries carried cannon as well, in case of pirates) were the technological triumphs of their age. As such, they became the latest repository of the national dreaminess.

What the steam engine was to the nineteenth century, the internal combustion engine to the twentieth, or jet or rocket engines for that matter, the super-improved and constantly improving many-decked Spanish war and merchant ships were to the fifteenth and sixteenth centuries. Fantasies of exploration coiled about their ranged racks of pulleys, their organized tangles of ropes, their imposing helms with levers (newly invented) that bound them to their rudders.[175] Romance as well as greed worked their incessantly churning bilge pumps, lifted their astrolabes to the sky to establish changing latitudes, flipped over their sand-glasses for telling the time on deck and kept their powder dry in storms for the naval battles that erupted when the dark winds blew off and the bustly waves abated.

As chivalry sickened, the galleons and frigates got better. Spanish monetary ambitions had long been fixated on the New World with its silver mines. They remained focused on stashes of precious metals even when, as in the last few years, the deliveries began to slacken.[176] The imperial navy still struck terror across the seas with its manoeuvreable squadrons, as did the bright, winding columns of Spanish soldiers on

land – indeed more so than ever, while the manpower lasted. Despite setbacks in the Netherlands rebellion, the strictest codes of discipline, courage and honour, in Lope de Vega's sense of scorn for the slightest offence, encouraged Spanish armies to remain marvellously effective instruments of war.

The Spanish decline may thus be seen far less as a cracking up than a vast, long sigh. It was now in full swing. It was also inaudible, and invisible, not least because it was stoppered and concealed as far as most people were concerned by an astute, powerful rascal. This was the Valencian aristocrat Don Francisco de Sandoval y Rojas, Marquis of Denia (1553-1625), whom Philip III had named Duke of Lerma in 1599.[177]

55. The Revolutionary Portrait

Fifty years old when the twenty-six-year-old Rubens got to know him, Lerma was not only Philip III's favourite of favourites and Prime Minister but also one of the richest men in Spain. His income for the previous year (1602) alone had been 200,000 ducats, not bad for someone who had started out as an obscure member of the nobility and been fairly poor to begin with.[178]

Lerma had an amazing capacity to put people at their ease, especially the king. As a consequence he drew to himself an almost endless bombardment of gifts, most of them also from the king. Few people could have matched his talent for turning friendliness into high finance: 50,000 ducats in silver from the royal treasure fleet, 5,000 ducats' worth of the king's diamonds, several prosperous baronies with their villages, villagers and surrounding estates, 120,000 ducats from the jittery Marquis de Auñon, and the position of Comendador de Castilla, which itself paid 16,000 ducats per annum.[179]

His interest in his country's welfare always took second place to making money, enriching his family and holding onto his title of Valido, or as the position of favourite was also termed, Privado. His friendliness had its limits. After becoming duke, he arranged that his son-in-law was elected president of the Council of Castile, his uncle chosen Archbishop of Toledo and various acquaintances installed as ministers and military commanders. He himself quickly rose to become Spain's ranking cavalry officer.[180]

The only thing that he lacked when Rubens met him was some appropriate emblem of his success, and this Rubens was selected to provide in the form of a portrait whose novelty would astonish the world. It would also grant him aesthetic immortality. Propaganda, or a mere demonstration of power, which Lerma scarcely needed, was never to be the point of the portrait – and neither was it the point of most royal and ministerial portraits at the time. Behind them lay an enthusiastic revival of the

ancient Roman belief, popular among the *literati* during the sixteenth and seventeenth centuries, that art might confer deathlessness on those whom it depicted. Unease about Heaven induced a desire for an incarnation in oils. The more accurate and extravagant the likeness, moreover, the stronger the implication that the grave could not triumph over what some artist might achieve.Shakespeare's Ferdinand of Navarre, in his *Love's Labour's Lost* (*c.* 1595), remarks on this widespread conviction with a brashness that Lerma would surely have understood:

> Let fame, that all hunt after in their lives,
> Live register'd upon our brazen tombs,
> And then grace us in the disgrace of death;
> When, spite of cormorant devouring Time,
> Th'endeavour of this present breath may buy
> That honour which shall bate his scythe's keen edge,
> And make us heirs of all eternity.(I,i,1-6)

Lerma no doubt craved this type of honour, the sort that would make him an heir of eternity.

It is not known whether Rubens painted his famed *Duke of Lerma on Horseback* (289 x 205 cm., now in the Prado; fig. 8) before, during or after he finished a number of portraits of beautiful women that Vincenzo had told him to bring back from Spain for Mantua's gallery of beauties. Just now as well, or shortly afterwards, Rubens took on for Lerma himself, and completed, a series of twelve portraits of the apostles, plus a half-length Christ (now lost; the Twelve Apostles are in the Prado).[181] What is known is that within five days of meeting him Lerma asked Rubens to do his own portrait, and that, with interruptions, probably for these other jobs, it was completed by November 23.[182]

Lerma's reaction to it is also known, as is Rubens' ambition in painting it. In a letter to Chieppio of September 15, while his work on it was going ahead, he frankly announced his hope of producing 'a great equestrian portrait', so that 'the Duke is not less well served than His Majesty', a reference to the paintings that he had restored.[183] In a curious aside that may show a good deal about his state of mind, he remarked that he was eager to fulfil any orders that Vincenzo through Chieppio might want to place with him, giving as his reason the startling admission that 'I am deprived of every personal wish and interest; everything is transubstantiated into that of my patrons'.[184] While one might be tempted to regard this sort of talk as mere flummery, his odd use here of the religious term 'transubstantiation', along with the fact that he could have had no real motive in saying any of this to people with whom his relationship as a court painter was perfectly clear, leaps off the page. The word 'transubstantiation' makes sense only if one accepts that for the moment he felt truly 'deprived of every personal wish and interest' because his patron's desires had become his own, as the eucharistic bread

and wine were understood to become the body and soul of Christ – his own comparison – for the sake of divine salvation.

What did he mean? If one takes him at his word, and there is no reason not to do so, he could only have meant that he saw his yielding to their commands as a supreme joy – or that he was confessing to having the sort of mind whose acts of acquiescence, albeit in the right circumstances, could become actual gateways to personal victories. Obedience, again in the right circumstances, was thus not a constraint but a challenge. At the heart of the challenge, which might lead him to stretch his resources to their utmost, or further than his own merely personal desires could possibly have required, as he subsumed his ego in the desires of others, lay, as he apparently understood it, the opportunity to let life itself into his work: into masterpieces that would be as full of the world, or the passions and attitudes, the innermost feelings, of other people, as they would be devoid of any self-centred interests. Style was less an expression of the personal than a triumph over it.

Lerma turned out to be 'extremely pleased' with his portrait. Others were too, or so Iberti reported.[185] This is surprising as in an obvious sense the finished painting – which was far more revolutionary in design and impact than anyone at the Spanish court expected – actually belittles him. It makes him look foolish.

He probably did not notice. The way in which he appears foolish lies neither in some obvious embarrassment, nor in mockery, and certainly not in any snide manipulation by Rubens himself, though the mystery perhaps occurred to him as he painted (and found that he could do nothing about it, or did not wish to). It lies, amazingly, in the intimidating contrast between the unstartling duke and his magnificent horse.

To be clear: Lerma is realistically presented, more than decently so, and with no suggestion of absurdity. A well-formed, middle-aged businessman and military officer, with a bland, square face, he has close-cropped brown hair, a trimmed goatee, twirled mustachios and sombre, appealing dark eyes, though with some stiffness in them, an aloofness lapping at shivers of strength. He was never a weakling, but in his eyes there glimmers neither pomposity nor lordliness. Some have thought that his melancholy expression is connected to his wife's recent death. This seems doubtful (Iberti wrote to Vincenzo that 'it is generally rumoured that his grief is more simulated than genuine'[186]). His melancholy seems, on the contrary, perfectly natural to him, or a pose that he approved as appropriate to his position, an official emotion of a dour sort that Rubens found revealing if not important.

He is also wonderfully dressed. He looks the glass of Spanish military-parade fashion, with realms of gold all over: in his white ruff trimmed with gold and his shiny black chest plate checked with gold insignia. He wears gold-striped puff-breeches and cream-coloured stockings and boots – these picking up the gold of his ruff, chest armour and breeches and

flinging it back and forth: a mild-mannered, quite likely dangerous, expensive man on a horse.

Overhead, the sky drops a single blossom that is a gigantic, blackening cloud. Its petals blur into a smudge against remnants of meagre blue, and hover over hundreds of armoured, mounted men off in the distance, their lances erect as they canter in phalanxes toward a smoking, vague battlefield.

Riding at an angle toward us, Lerma pays no attention to them, or even to us. Perhaps reflecting on the fleeting prestige of war, which no longer impresses him except as colourful and horrible, or meditating on the palm and olive trees that signify victory and peace – peace even in the midst of battle – and that build up into dark masses of green foliage just behind him, framing him on his horse on a high hill, he looks askance, melancholy and stalwart.

It is now, or probably before taking all this in, that your eyes are drawn to his horse. It is a stunning being, whose presence requires an historical note. Rubens most likely got the idea for this military-political portrait of the mounted duke from two religious paintings, one by El Greco (1541-1614), *St Martin and the Beggar* (198.1 x 98.1 cm., now in the National Gallery, Washington, D.C.), and another by Il Pordenone (1483-1539), his own *St Martin* (S. Rocco, Venice). He may also have been influenced by Titian's *Charles V on Horseback* (today in the Prado), whose head and shoulders he hastily sketched when he saw the painting at the royal palace in Madrid on his journey north. He may have been inspired, too, by a line from the ancient Roman historian Pliny's *Natural History* (bk. XXXV, 96), in which he writes that the greatest painter of antiquity, Apelles (4th cent. BC), did a portrait of Antigonus, Alexander the Great's fiercest general, in battle armour and advancing on horseback.[187]

None of these sources has anything to compare with Rubens' huge, womanly prince of a horse, this flashing white stallion.

With its far too long – implausibly lengthened – silver mane, suggesting the loosened tresses of a sensual courtesan or wife at her toilette, with its tail's platinum lash like a galleon's wake, with its eyes a coruscation of sultriness, with its elegant withers, its curvy haunches, its thrust, flow and restraint that seem a compression of sun flares, this creature is less horse than a transubstantiation of light. The strength of the whole portrait, you realize, is established not by the comparatively feeble figure of the duke, but by this eerie animal.

The horse looms and floats towards you silently as a feminine-masculine dream of divine light-energy, as the eternal Spanish romance, but distilled through Flemish hands instructed by Italian art into its essence, which also contains eyes wrung with anguish: a residual plume of the earliest galactic explosion, or from a biblical point of view, the moment when God uttered light itself into existence.

The painting itself is a life-force energy showing a life-force animation, a horse to die for, or live for. Astride it, the duke himself subsides into a bauble, becoming a poor though marvellously painted gilt shadow.

56. Mantua, Friendships and Galileo

October 19 found Rubens in Ventosilla, at Lerma's country villa, to which he had been invited as a guest. Probably he completed his portrait there.[188]

The several weeks leading up to and after its unveiling remain a complete blank, though it seems that at some point he returned to the city that long ago had seen the first *auto-da-fé* involving Spanish executions, Valladolid, which at Lerma's request had a few years ago been designated the true Spanish capital, replacing Madrid. During those weeks he wrote one surviving, undated letter, to Chieppio, most likely in late November, perhaps at around the time when the portrait was exposed to public view and first admired. His letter makes it clear that he had suddenly gotten into a testy disagreement with Vincenzo over what to do next. The duke was requesting that he move on. Rubens also may have felt that his Spanish assignment was coming to an end.

Vincenzo wanted him in France. The clever court artist (for so the duke still seems to have thought of him) could there be put to work, as he had been in Spain, in chugging out yet another batch of portraits of beautiful women for his Mantuan gallery of beauties. As Rubens saw this issue, however, his patron's obsession with his gallery was blinding him (the ruler of 'my adopted country', as he affectionately termed the duke) to his own obviously superior abilities ('anyone can do [that sort of work],' he observed, going on to snipe that portrait painting of that particularly silly sort was 'unworthy of me', and that Vincenzo ought to 'employ me, at home or abroad, in works more appropriate to my talent'[189]).

No doubt he was influenced by the lavish congratulations pouring in at Valladolid. His confidence was growing, and with good reason. He could not, however, flatly refuse to go to France, which would have amounted to insulting the very nobleman who had helped him and taken him in when they first met in Venice, and who also had the power, if he chose, to wreck his career by telling others of any ingratitude (there was no inkling, it must be said, that Vincenzo would have done anything of the sort). Instead Rubens complained in his standard polite phrases, reminding Chieppio that he had always been 'willing to be my friendly intercessor before my Lord the Duke'.[190]

In the event, he did not go. Vicenzo seemed to relent. By February, 1604, he was on his way back to Mantua, on his second sea voyage, bringing with him an enhanced reputation (according to the reluctant Iberti[191]), plus a natural desire for more ambitious projects. On the eve of

his departure for Italy, Philip, who had received his doctoral degree in Rome in June 1603, wrote him a long poem in Latin elegaic metres. As poetry, in contrast to Philip's usually lucid prose, this quaint effort seems a baffled stream, one almost choking on its log-jam of classical allusions. It also overflows with fraternal affection, Philip's fears for his brother's life, his enjoyment of paradox and optimism, or with Democritus and his joshing outlook – but all picked over with the solemnity of the naïve graduate student (these are qualities that the modern reader needs to dig for, however, as a lot of this poem simply sounds over the top):

> To Peter Paul Rubens on board ship
> The mother of Achilles the Thessalonian was not as frightened as I now, when, exposed by a trick of Ulysses, he engaged in a cruel war for Menelaus' sake, rushing off to the ramparts of Ilium; Penelope, that epitome of Greek modesty, was less disturbed by the dangers faced by her beloved husband, whenever she heard the waves roaring at Cape Malis, or at the rocks of Caphareus and in the perilous Ionian Sea, than I now; ... for my heart is torn with anxiety for you my brother, who is worthier of love than the light of day – for you whom a small ship now carries across the Tuscan sea, and for you, who must miserably put all your trust in those fickle waters – now that the terrible power of the winds is let loose and the waves tumble under the influence of malicious stars. Oh, may the man who built the first ship and dared to set sail across the huge ocean eternally regret what he did. Since that day, we have become the toys of waves and winds, while a path to sudden death opens before us.... Oh, all you gods and goddesses inhabiting the shiny temples of the heavens, the earth, the sea ploughed by ships, and above all, you gods reigning over the Tyrrhenian Sea, grant him, if you can, your warm welcome, defending his vessel against the dreadful stars stirring up storms and the angry waves!

... and so on.[192] It is not clear whether Philip posted his poem before Rubens left or gave it to him after he arrived: the drippy though not unimaginative lines offer no facts, only feelings, combined with an honest outpouring of love and worry.

The two met up in Mantua, probably in March, and there now also took place, swept against their happiness on seeing each other after a lapse of some twenty months, another momentous meeting as well.[193] This encounter, it is safe to say, and no matter how astonishing any such declaration may seem, turned out to be of genuine importance to the history of ideas in the West, if not in the world. It amounted to a prophecy from the frontiers of thought, and in that sense has had repercussions that centuries later can still be noticed in human dreams of

truth, and behaviour too, even if so far they remain little understood. Actually a meeting of minds, as it fell out, this was Rubens' get-together with the greatest scientific genius of his day, Galileo Galilei (1564-1642).

Padua University's professor of mathematics was still not recognized as anyone too special. Vincenzo, who was as interested in science as in art and pleasure, had been drawn to him because of his invention of his 'geometric and military compass', which was not unlike the modern proportional dividers, and useful to engineers, on whose manufacture he continued to make a tidy sum.

Forty years old (a couple of months older than Shakespeare) and respected so far as much for his crusty ill-temper as his mathematical brilliance, though he had still not published any book or his world-changing discoveries in astronomy and physics, or even made them yet, Galileo came to know Vincenzo in Padua, discussed the principle of his compass with him and was twice invited to Mantua, in March and April of 1604, to negotiate terms for his appointment as Vincenzo's resident scientist.[194] These negotiations fell through. Galileo asked for 500 ducats a year, plus a house big enough to accommodate the woman with whom he was living, Marina Gamba, and their two young daughters. Vincenzo refused to budge above 400, and promised only a small house and a single servant.[195]

On one or both of his visits, however – and this much seems certain – Galileo met Rubens, Philip and two of Philip's friends, who had come to Mantua with him: Perez de Baron, the son of a Portuguese businessman living in Antwerp, and Guillaume Richardot, Philip's student and travelling companion in Italy.[196] Aside from the coincidence of the double dates, which place Rubens and Galileo on the same island and in the same palace at the same time,[197] and their having, as they would have realized, passions and interests in common (along these lines, it should be noted that Galileo was himself an amateur painter and the author of a treatise on colour, *De visu et coloribus*, now lost, but written before 1610[198]), the evidence for their meeting, and that they may even have gotten to know each other rather well, lies in Rubens' soon producing a painting of himself and Galileo together. This remarkable work includes Philip, his two chums and a stiffish-looking, effigy-like Justus Lipsius, the Stoic philosopher and Philip's mentor (he was De Baron's and Richardot's mentor too). At the moment, to be sure, Lipsius was living not in Mantua, but in Rome. Traditionally termed *Self-Portrait in a Circle of Friends* (77.5 x 101 cm., today in the Wallraf-Richartz Museum, Cologne; plate III) and finished either in 1604 or 1605, this painting also happens to contain Rubens' earliest-known portrait of himself.[199]

57. Stock-Taking in His Late Twenties

Though in some ways a mystery (when, exactly, and why, was it painted, who is in it and what does it mean? – puzzles that have only recently been

to some extent resolved), and brilliantly suggestive, Rubens' painting has always proved invaluable in at least one respect: in its providing a fascinating likeness of him at the age of about twenty seven.

He sets his scene indoors, probably in the ducal palace. With the exception of Rubens himself, the six friends appear to face each other by candle light before a balustrade that looks over what seems a sunset view of Mantua's Lago di Mezzo.[200] Bareheaded and alert, he glances toward you over his shoulder. A wolf's grey twist of cloak makes soft whorls about his neck and shoulders. He turns his head to look straight at or even a little past you, with an almost come-join-us expression. His eyes just miss making contact. Your first impression, however, is one of mildness, smooth-complexioned health, a touch of wintry red, wind-blown, on his cheeks, accents of restraint in his carefully groomed moustache and goatee and casualness. He lacks all pretension, and reveals himself as someone who probably enjoys the odd jest or two, perhaps even at his own expense. A trickle of a smile on his lips tells a great deal.

Whatever his conflicts, in other words, they are not concealed, even if they remain unexposed. Having seen him in action, you realize that his entire personality is implied by his tawny eyes with their silken burnish: his bulking, athletic body, his daily horseback riding, his quasi-abstemiousness,[201] his politeness, his distaste of vulgarity, his vanity about his receding hairline (should he comb his quiffs forward? – no, keep them flat), his delight in purposefulness, his piety sunk in curiosity about science and sacrilege, his calm amid his natural scepticism (perhaps a relic of his childhood), his wonderful memory that allows Roman poetry and Greek philosophy to spring nimbly to his lips (a legacy of his school years), his beatific visions, his enjoyment of holy and profane stories, his constant search for myths and legends of transfiguration, and always the practical artist's question, raised in this painting too: how can this or that aesthetic, psychological and emotional effect be achieved? – which is no doubt also the question of the politician or diplomat.

It is probably significant that he is not looking at Galileo, if only because the thoughtful scientist stands mutely at the centre of the group. All eyes but those of Rubens and Lipsius, who seems to gaze heavenward, are fixed on the Paduan professor.

Galileo himself, however, is looking at Rubens. We may never know why he is doing so, but it is worth making a guess, based on the rest of the painting, those depicted in it and what is known of their mutual enthusiasms. One idea, proposed by some amid the unending controversy over what is happening between these six men, to wit, that several colleagues who may not have been particularly well matched, with the exception of Philip's friends and the Rubens brothers, have simply been stuck together, pastiche-like and more or less pointlessly, flies in the face of everything known about how Rubens conceived his multi-figured paintings, which invariably depict dramatic actions.[202] In fact it seems

clear that this painting presents its own drama in progress. Even if
Lipsius never actually joined the others (he indeed has been stuck in),
and even if the group never got together in just this way and in just this
place, Rubens himself, in devising his own version of their relations, has
provided everyone with his own demanding role, as is indicated by the
direction of each man's eyes and his position. He has arranged them in a
little theatre of natural philosophy and argument with its own intense
atmosphere. The drama among them, which centres on Galileo and
shows Lipsius looking up as if seeking divine assistance, and seeming not
so artificial once you realize that he is doing so, is hard to miss, as is the
recognized interest of all of them in Stoicism, which may be their
common bond, and the battle then raging within Jesuit circles and
among educated people generally over Copernicanism, or more simply
put, over the question whether the Earth moves.

It was a momentous question. It was the scientific and religious
wrangle of the age. Copernicus had died too early to enjoy the scandal
provoked by his great book, *De revolutionibus orbium coelestium*. In fact
he had never so much as seen it published (in 1543).[203] He knew nothing
too of the pseudo-scientific attempts, sputtering away at the time when
Rubens painted this picture, to refute his proposition that the Earth
moves as the simplest way to understand the apparent irregularities of
planetary motions. Lipsius, himself an anti-Copernican, was implicated
in the debate. 'By common consent,' he had written, 'we believe that we
on Earth stand still, and we leave to the heavens their motions,' a
bizarrely anti-Stoic pronouncement coming from him, with its emphasis
on inertia instead of the Stoic idea of eternal movement, on stasis instead
of eternal Stoic advance and retreat, or rise and fall, or process.[204]

Beyond these aspects of Rubens' painting, however, one should prob-
ably not overlook its vista from the balustrade. This haunts its
background. It is an accurate though skewed rendering of the Ponte San
Giorgio reaching across the Lago di Mezzo, together with a hut on an
island.[205] Both appear as they were in Rubens' day, but the real point of
this miniaturized scene may, or may not, be its unearthly light.

It has lately been argued that the peculiar ashen, amber and salmon
pink of the sky may not be sunset light, as it seems to be, but flamy
shoots of the north-European aurora borealis.[206] Rubens may thus have
chosen to depict it as he has, if he has, because Galileo was then
attempting, briefly and unsuccessfully as it happened (it was an early
attempt) – to use this atmosphere-piercing phenomenon to demonstrate
that the Earth is not surrounded by an impenetrable sphere, as was
universally believed, but by permeable skies, and that the Earth indeed
moves. The odd illumination of the background may therefore amount to
a reference to one of Galileo's earliest astronomical investigations.[207] It
may even suggest Rubens' empathy with his work. To this it may be
added that Rubens was always meticulous in his research and attention

to pertinent detail, and that only rarely is anything introduced into his paintings simply for effect.

The hypothesis may of course be false. The strange light may be strange for some private reason, known only to the six 'friends' (the picture is rather private-seeming, and was certainly not done on commission). Beyond this possibility, in a larger sense the hypothesis may not matter. What counts, and has profound implications for the history of ideas, is the fascinating get-together itself between Rubens and Galileo, and that Rubens thought it important enough to record in oils. What should figure into any analysis as well is the divided state of science, or natural philosophy, at this time, and that of Stoicism, or the ancient philosophy of infinite change. As Rubens' life so far makes clear, science and Stoicism interested him deeply, as did all speculations that bore on arguments over aliveness.

Galileo wanted to show that the Earth moves because doing so would confirm Copernicanism. Rubens was captivated by motion itself, by its qualities and how to depict them. Though no one knows what the two may have said to each other, or what Philip and his friends may have contributed, no more suggestive meeting of minds can be imagined.

58. Rubens and the History of Ideas

The reason is that a momentous shift of intellectual attention among educated Western people had been in progress for three centuries by the time of his birth. It had taken several forms, though they were interconnected. Slowly and then more quickly, and then decisively during his late twenties, it started to change the world.

This shift amounted to a revolution in attitudes toward sensory experience. For millions of people, it began to cause an alteration in how they thought about reality. Since the fall of the Roman empire and the collapse of paganism, fundamental questions about reality had been understood as resolved. For Christians, Jews and, somewhat later, Moslems, reality had consisted quite simply in the creative mind of God. It was an abstraction. It was also far away. It was located in the Empyrean, or the abode of God, the fiery heaven beyond the nine spheres of the finite Ptolemaic System, which included the five known planets, plus the sun, the moon, the sphere of the stars, known as the *stellatum*, and the *primum mobile*, the outermost shimmering sphere of first causes.[208]

The physical universe, as everyone believed, had emanated from God's mind. It was false, deceptive and insignificant because temporary and subject to decay. Theologians regarded it as unreal. Where God's mind flamed outside of time, in eternity (the ancient Greek word 'empyrean' means 'of fire'), the sensory experiences of the physical universe and of ordinary human lives – much duller, frailer bubblings up – were illusions waiting to be blown into extinction. Only fools, it had been argued by

Church philosophers, might credit the information gathered by the five senses as a reliable guide to spiritual reality. The result was that medieval scientists dismissed most sense data. They favoured reason free of empirical observation. Logic allied with metaphysics illuminated medieval beliefs.

These crabbed views began to change at the start of the thirteenth century. A reaction against clerical methods, with sensory experience coming to be seen in a more positive light, as a key to a revised idea of what was ultimately real, and then for some as reality itself, began to spread across Europe.[209] This change was of supreme importance. It was also not to be the only shift in attitudes toward sensations. Since the Renaissance there have been others, a few of them growing into outright rebellions and revolutions. Each is crucial to understanding Rubens' age, his accomplishments and Rubens himself. Each opens a new window on his place in the long line of Western intellectual advances. The latest, for instance, commencing much more recently with Darwin in the nineteenth century and continuing into the present, shows that attitudes toward sense data since ancient Roman times may be described as having evolved through at least three influential stages. These consist of a first, or medieval, Ptolemaic stage, in which reality is regarded as a fixity or stasis, with sensory experience largely derided; a second stage, in which reality comes to be seen as pure motion or process, albeit often with a spiritual dimension; and a third stage, the post-Darwinian, in which observers begin to question their roles as observers and the problematic nature of sensory observation.[210]

This last stage has so far been characterized by immense progress, especially in the sciences. It has also been marked by uncertainties. Objectivity of observation is today denied by some and viewed with suspicion by nearly everyone else, even by those who remain convinced that it can be achieved and that absolutely true statements can be made, indeed that they are made all the time, about the universe and human turmoils and joys.[211]

Rubens was living through the second stage. He had begun to anticipate the third. This fact renders him prophetically modern, though paradoxically and frustratingly he is often seen as irrelevant to modernity. The reason for this is easily understood. Prejudices, chiefly aimed at religion and classical as well as religious allegory, continue to obscure a number of his insights. They becloud as well appraisals of his genius for analysing his world and for adventuring beyond what others had done. Because of this, the modern world itself, to which he was beginning to contribute some of its earliest flashings forth, in several ways appears murky and incomprehensible. Fanaticism continues to cripple intellectual progress.

It would on the other hand be a mistake to assume that these shifts from stage to stage in the history of sense data, or any other shifts in the history of ideas, result from dialectical necessity. Marx was wrong about

how this sort of thing may occur, or at least no evidence exists to show that he was right.[212] Important if not crucial roles in these changes, which are in fact shifts of attention from one type of phenomenon to another, or changes in intellectual fashions, are no doubt played by whimsy, curiosity, accident, serendipity, patience and jolly experimentation. From a psychological point of view, depression, gloom and a fiery desire to find out new truths, coupled with a defiance of the long accepted, are also valuable. So are errors, blunders, catastrophes, including natural disasters, and death. So is grief. So is the weather. The seductive concept of destiny is aptly ridiculed by the witty John Taylor: 'Things have their times, as oysters have their wool.'

None of this means that evolution does not occur, or that succeeding stages are not often superior to preceding ones. Their chief claim to superiority usually lies in their making more efficient use of previous knowledge. They are innovations, on occasion dramatic ones, and usually reactions against an exhausted style of belief: sure coin minted new more than fresh coin. Despite their glimmering appeal, though, there is no guarantee of progress. Reversions are possible. Atavistic states may reassert themselves, and often do so with an alarming, horrible welcome, as if people were growing weary of constant forward pressure, or sick of improvements, or petulant, or perverse. While the 'Dark Ages' were hardly as dark as was imagined by scholars in the nineteenth century, because medieval monks were kept busy salvaging the learning of the ancient Romans as they copied over ancient manuscripts, ordinary Europeans, afflicted by the spread of illiteracy after the fall of Rome, were on average far more ignorant than their ancestors. The world had slid backwards, as it may again.

What all this must mean is that artistic and scientific progress is in no sense predictable. It must also mean that progress is hard to spot. It may have been hard to spot at Mantua in 1604. What is amazing about Rubens' painting, apart from its sheer brilliance as art, is what Leibniz (1646-1716) was later to call apperception, or the state of mind in which one watches oneself solving a problem, or in a situation. Leibniz described apperception as the condition in which he was able to make a leap from struggling with a mathematical problem to solving it. It may not be too much of a leap to say that Rubens in this painting is doing precisely that. He may be inviting us, in some quasi-social sense, to join his company of friends, but he is also watching himself in their company through our eyes as he does so. It is his relaxed, self-conscious looking outwards, and implicitly inwards, that creates the unity of the composition.

59. The Second Stay in Rome

He may have rushed off to Rome at around this time to see a pickled hippopotamus.[213] He is likely to have done so, if one was on display. He

had an insatiable curiosity about large animals impossible to observe in Europe.[214] He no doubt imagined that they might figure in a painting. On the other hand, this story, though often retold, may be apocryphal.

By November, 1605, however, he had indeed returned to Rome to study the art that he missed on his first visit.[215] His stay, which he hoped would last for months at least, came about at his request and with Vincenzo's enthusiastic support. It was at his expense as well, though his payments were often inadequate or delayed. In a note of June 2, 1604, he had agreed to pay Rubens 400 ducats per year for as long as he might remain in the service of the Mantuan court.[216]

By December, 1605, Philip had joined him. The two decided to move in together. Philip himself had just come back from a visit to Flanders, to his old university at Louvain, and was working in Rome as librarian for the powerful Cardinal Ascano Colonna. With a couple of servants, they established themselves in a house on Via della Croce near the Piazza di Spagna.[217] Unlike their father, whose academic success in Italy had encouraged him to move back to Antwerp, a grand and prosperous city in those days, to try his hand at his own law practice and a political career, his two sons, perhaps because times had changed and Antwerp's glory seemed a faded thing, showed scant interest in going home at this point. Better chances were available in 'the queen of cities and mistress of the world' as Cervantes described Rome not many years later, remarking that 'just as one realizes the greatness and ferocity of the lion by its claws, so [one would] realize the greatness of Rome by its marble ruins, its statues, damaged or intact, its broken archways and ruined baths, its magnificent porticos and great amphitheatres, and by its famous and sacred river, which always fills its banks with water and blesses them with the countless relics of the bodies of martyrs which have been buried there; by its bridges, whose arches are like eyes looking at each other, and by its streets whose names alone make them superior to those of every other city in the world: the Via Appia, the Via Flaminia, the Via Julia and others like them'.[218]

Aside from this witchy glitter, there was another compelling reason to stay away. The war in the Netherlands, tottering about Antwerp and spilling back and forth into Flanders, Brabant and southern Holland, crunched ahead as earlier. Little reconstruction could begin while it continued. Public and private money went into hiring soldiers, manufacturing weapons and building defences. If many of the towns of the fifteen southern provinces under the rule of the Archduke Albert and his wife, the Archduchess Isabella – or under a much-weakened Spanish control – had lost up to one half to one third of their populations to emigration as tens of thousands sought to escape the constant raids, pillagings and slaughter, they had also seen the disappearance of their supporting agriculture. Farmers fled their fields for the insulation of walled-in but not much safer urban streets. The prices of foodstuffs shot up, along with

local taxes, which rose past endurance for the money-strapped middle class.[219] Capital vanished. English military assistance offered to the Protestant Dutch had also led to an almost separate war across the Netherlands, between England and Spain. This had freed the Dutch armies under Anna von Saxon's and William of Orange's son, Maurits, for a series of strategic thrusts that threatened Spanish rule in the south. In the spring of 1604, Prince Maurits seized Aardenburg. He then laid siege to Sluis, which surrendered to him in August. These victories were counterbalanced, however, by those of the Spanish general Ambrogio Spinola, who overwhelmed Ostend with superior forces on September 22. Both sides, suddenly exhausted, now agreed to a momentary halt. This was not a truce, though peace between England and Spain, meant to relieve their drained treasuries, was proclaimed in Antwerp on October 31.[220] Their treaty reduced the ongoing bloodshed, but in a more general sense the killings did not stop. Everyone assumed that any bargain achieved by the several opposed sides would soon collapse. It had done so in the past.

Aware of these unsettling developments through broadsides, letters from home (which may be presumed to have existed but are now lost), reports from friends and Philip himself, Rubens still scored a few striking successes, a few bright victories of his own, in Mantua, before moving on to Rome and his life there. On his way back from Spain, he had advanced his training by going back to Venice 'to examine at leisure', according to Roger de Piles, 'the beautiful things he had seen only in passing' a couple of years before, especially paintings by Titian and Veronese.[221]

He also returned to Mantua to find his patron a somewhat changed man. Vincenzo's mother had died on August 15, 1604. He had buried her in the Jesuit Church of the Trinity at the centre of the city, near the market place.[222] Affected by her death, his hedonism subsided into piety. He longed to make some consoling gesture that would honour the Jesuits as well as his family. For the first time, he asked Rubens to take on a major commission. This was his grandest in Italy so far, and involved three large canvases intended for the church where Vincenzo's mother was interred: a *Trinity adored by the Duke of Mantua and his family*, a *Baptism of Christ* and a *Transfiguration*.[223] The idea of the trinity – the other two pictures were intended for the walls on either side of it – had already been batted about between Rubens and Vincenzo when Rubens had made black and red chalk sketches of the duke's two eldest sons, probably in 1601. Now it was to be completed. Rubens was to be paid 1,300 ducats for it.[224]

The subsequent fate of this imposing achievement, finished over the next few months, is a testament to the pen's being mightier than the sword, or to art's being stronger than tyrants, though just barely. Nothing may be left of Napoleon's empire, or of his troops who invaded Mantua in 1797 and turned the church where the *Trinity* and other paintings were hung in 1605 into a barracks, treating this painting,

which they ripped into anti-clerical shreds as a target of their contempt and religious hatred, but a few sections of Rubens' majestic vision of Vincenzo's family nonetheless survived, saved by admirers. They have been reassembled. A vastly diminished version of it (190 x 250 cm.) can today be seen in the Palazzo Ducale, where it continues to glow, outshining the ferocity of those who would have destroyed it, a superb if stunted monument to scattered and lost beauty.[225]

No similar catastrophe befell the *Transfiguration* (417 x 576 cm., today in the Musée des Beaux Arts, Nancy) and the *Baptism* (482 x 605 cm., in the Koninklijk Museum voor Schone Kunsten, Antwerp; fig. 10). The latter in particular, though influenced by Michelangelo, Raphael and antique sculpture, reveals Rubens' unending stylistic thrusting forward into more sophisticated and refined handlings of motion.[226] In this painting, for instance, he has taken the great and spellbinding risk of dividing the dramatic action. The separated elements come together in a flimsy unity only because your eye reconciles them by an act of psychic self-deception, or so it seems, or because the mind craves and often invents relationships.

The problem is that the division or apparent schizophrenia of this picture is hardly alleviated by your knowing that the figures on either side of it are doing similar things, that Christ, wading in the River Jordan up to his mid-calves, as John the Baptist stands on the river bank and pours blessed water over his head, complements a number of other men undressing nearby and preparing to be baptised themselves. The two groups (above Christ's head is the Holy Ghost, hovering beside him angelic putti who carry his robe) are isolated from each other by a bulky tree trunk. The scene itself seems a mélange of divisions.

Both groups also seem divided by a light-versus-shadow contrast, an even greater risk. A bath of bluish, pinkish, whitish and reddish rays bespangles Christ and his assistants, while the men beyond the divisive tree make do with quilty shadows and patchy gleams. They are busying themselves amid a pious neglect. The fact that they are almost life-size, as are John the Baptist and Christ, further emphasizes this awkward split, or your sense of something wrong – and yet, mysteriously, confusingly, absolutely right.

For it is right – the conclusion is forced on you unwillingly and strangely – and it may be at this point, as you explore Rubens' divided theatre (one's sense of the theatrical as well as the holy here remains inescapable), that you realize that an enigmatic unity, a defiant harmony, is apparently asserting itself despite everything. This reveals itself not so much through the crisscrossing, flickering waves of light, or through the similar geometrical patterns of what both groups of men are doing, but through their complementary motions: their sympathetic forms of aliveness. A trembling reciprocity of movements echoes among them, as if a tone were being repeated by musical instruments.

II. The Idea of Absolute Beauty

Everyone is restless, blissfully so, amid this unknown sound. It echoes in a silence, in the sense that all heavenly music is the 'unheard music' of the soul, and consists of nothing but colour and shape. It also emanates from the intruding tree. The tree, you realize, unites as well as divides. Subtly, it conducts the instruments. It sways in stillness. Its shape mimics those gathered on both sides of it, even Christ as he moves in the transparent water, through which his ankles and feet can be glimpsed. The separate gatherings at the river are indeed bound together, and what your eye may have sensed the daring composition actually confirms, Plotinus-like – Rubens' dot-and-circle drawing springs to mind – within their stubborn separations.

His *Fall of Phaëton* (92 x 129 cm., in the National Gallery, Washington, D.C.; plate IV), which may also have been done in Mantua at around this time, finds him once more, and with even greater impudence, dismissing all conventionally static and symmetrical ideas of unity. He sacrifices simplistic notions of design to the same thrilling interplay of reciprocal movements, or to his intuitive grasp of the intrinsic aliveness of events.

This picture is a tumult of horses, Horae (the goddesses of the hours), Apollo's capsized chariot of fire, clouds and Phaëton himself – all toppling through a light-maddened sky into a consumptive dark. A terrifying myth is turned into an exhibition of vigour. The force of Chaos is interrupted by that of divine order. Something identical happens in the ancient Greek myth as well, which begins with Apollo rashly granting his son Phaëton a boon to prove to him that he is his true father (Phaëton is justifiably dubious). Apollo lets him choose whatever he pleases, and Phaëton, himself a bit rash, asks to drive his father's sun-chariot across the sky. Apollo, who has given his word, has no choice but to consent, though as Ovid tells the story (in *Metamorphoses*, II, and it is this version that Rubens would have known), he pleads with Phaëton to change his mind, warning him that he will be unable to handle the gigantic, romping horses pulling the chariot and that he will lose his way among the monsters of the constellations, who may devour him. Phaëton, whose conceit matches his innocence, insists on driving the chariot anyway, and life on Earth is nearly extinguished, with the universe shaken to its foundations, as he quickly loses control of his father's horses and careens across the heavens, and up and down, scorching mountains and valleys (and so creating the Libyan desert), annihilating cities, countries and whole populations, and frightening the Earth goddess herself. In desperation, she calls on Zeus to intervene, and it is precisely the moment after he has done so, launching one of his lightning bolts at Phaëton and killing him, that Rubens has chosen for his painting.

As with his sketches of Michelangelo's *Battle of Lapiths and Centaurs*, or his drawing of the *Laocoön*, the action is a compressed explosion, with ruddy, blue and gold energy made all the more nerve-wracking and powerful by a constraining blackness. Apollo's horses rear and plunge in

several directions (and the painting becomes in this sense a study of equine anatomy). The voluptuous Horae seem flung into half-seductive poses in the midst of the ransacking terror. A funnel of phosphorescence, emitted by the atom-bombish lightning bolt, looks like a holy, even Christian, beam of salvation-by-sacrifice as it slashes across this anarchy, opening up the dark of outer space and revealing Phaëton's death.[227]

It was amazing effects such as this that two of Rubens' friends in Rome, Caravaggio (his probable friend at least) and the brilliant German Adam Elsheimer (1578-1610), had for years been looking to create and eventually turning away from in their own work, lacking, it seems, Rubens' own new-found understanding of motion, or energy, and the methods that he was inventing to express it. Elsheimer, for whom Rubens felt real admiration and affection – they seem particularly to have enjoyed each other's company – was no doubt one of those, among his many contacts with painters and clerics in 'the queen of cities', whom he looked forward to seeing and spending time with, as he and Philip settled into their new life.[228]

60. Getting Rid of 'the Smell of the Stone'

It began with a mixture of the good, the bad and the very bad. The first few winter months were spent on research with Philip for a book on ancient Roman costumes, to be called *Electorum libri II*, that he was planning to write. Rubens contributed ideas and drew several toga designs to accompany Philip's text. These might later be converted into etchings, with publication of the whole thing – it was an ambitious, quasi-archaeological project – to follow by the Plantin-Moretus Press back in Antwerp.

It was probably at this good time too that he conceived and made sketches for an important essay of his own, *De imitatione statuorum* (On the Imitation of [ancient] Statues).[229] This he never finished, but even in its surviving fragment it reveals a great deal about his views to date of the old sculpture-painting conflict that he had first sought to resolve when he copied Michelangelo's *Battle of the Lapiths and Centaurs*. Sculpture in his essay, and by this he means ancient Roman and Greek sculpture, clearly takes a back seat to what painting can accomplish, though he sees the copying or imitation of it ('we of this erroneous age are so degenerate that we can produce nothing like [it]'[230]) as crucial to learning how to paint well ('a complete absorption' in ancient sculpting techniques is of utmost value 'in order to attain the highest perfection in painting'[231]).

He admits that for some painters the imitation, or sketching, of statues has proved poisonous to their development, though not to his own, but argues, while offering practical advice on how to set about it, that any such problems are the result of artists not having properly

understood the relations between these two forms of expression, and between both of them and nature: 'It is necessary to understand the antique, ... to be so thoroughly possessed of this knowledge that it may diffuse itself everywhere. Yet it must be judiciously applied, and so that it may not smell of the stone.'[232] To be successful, in other words, the painted result must be sculpture that has been thoroughly translated into painting.

How was this to be managed? He proposes that one must train oneself to observe the differences between sculpted figures and human bodies, or nature itself,

> above all the contrasts in shading, since the diaphanous quality of flesh, skin and cartilage do much to soften the shadows that are twice as sombre in most stone, and to diminish what would be the abrupt descent into darkness in statues. Remember, too, that there are areas of the body that change with movement and that may be either relaxed or contracted, because of the suppleness of the skin. These places are generally neglected by the common sculptor, but they should certainly be included, with moderation, in paintings.[233]

He adds that painting has an especial advantage over sculpture in its ability to recreate the everyday falls of light, when 'statues will appear entirely different from human flesh, for the glow of stone and its dramatic sheen will at least dazzle the eyes of the viewer, and may make the surface seem to stand in higher relief'.[234] This curious and stony artificiality, which painting may avoid, is inevitable even in the best statues.

Rubens' entire essay, according to Roger de Piles, who transcribed part of it (but whose copy of the original was destroyed in a fire in 1720), was obviously intended in many ways to be an artists manual. It contained illustrations of sample 'battles, storms, games, scenes of love, torture, various deaths and other similar passions, emotions and events, a large number of which are based on the Antique'.[235] It also indicates Rubens' passionate desire to advance his art, and the fortunes of artists generally, as much as himself: the natural yearning of his confident, ripening mind to clarify his own discoveries by giving them away to others. A sympathy for artists whose work he respected, even if it differed drastically from his own, and even if he felt himself out of sympathy with its intentions, as long as he could admire its quality and skill, shines through his kindly sentences.

This fact is also why one imagines that also during these months he saw and admired for the first time, as did other painters living in Rome, Caravaggio's just-finished, naturalistic masterpiece *Death of the Virgin* (*Transito della Madonna*, now in the Louvre), and heard with amazement of the scandal surrounding its rejection on grounds of vulgarity by the Fathers of the church of Santa Maria della Scala, for which it had been commissioned.[236] Certainly Rubens knew of Caravaggio's subse-

quent personal scandal, which put an end to his plans for reselling the painting elsewhere, and which caused him to flee the city. On May 28, a Sunday, he was attacked on the Via della Scrofa, near the Palazzo di Firenze, by Ranuccio da Terani in a dispute over a ten-scudi bet on a tennis match. The smallish, rheumy-eyed painter, his face already sword-scarred, was severely wounded. Da Terani was killed. Caravaggio apparently '[hid out] in the palace of Marchese Giustiniani, the protector of all virtuosi, who prized his works', until the following Wednesday, when he made his escape (he was never to return to Rome).[237] The genius who had given so much to 'the queen of cities' had exiled himself.

By late spring, Rubens was facing a serious problem of his own. He had contracted pleurisy. Disease, far more than today, was of course everybody's invisible companion, the sort of terror that he had seen often enough in his family as a child. On this occasion, however, he was lucky. He was treated and cured by a German doctor living in Rome, Johann Faber, whose broad artistic and intellectual interests had led to his home's becoming a meeting place for artists and students down from the north, or from Germany and the Netherlands. Grateful for Faber's timely assistance, Rubens painted his portrait, which is now lost, and also, in a witty gesture, presented him with a painting of a cock. On it he inscribed a humorous reference to the famous ancient Greek god of healing: 'To my Asclepius.' Faber got his joke at once, recalling that Socrates' last words had been that he owed a cock to Asclepius and that the traditional pagan sacrifice to Asclepius for a cure was a cock, though Socrates, a trifle more glumly, had no doubt meant that the cure for life is death. The friendly doctor observed that Rubens 'through jesting displays his erudition'.[238]

He had other sticky problems: a lack of money and his increasingly slithery relationship with Vincenzo. After an initial expression of happiness with his plan to study art in Rome, the duke perhaps imagined that he could manipulate him by dishing out and holding back his salary. As usual, Vincenzo did not have much money on hand, just now because of his enormous outlays for the impending wedding of his eldest son.[239] In a nervous letter of Rubens to Chieppio ('I should not know to whom to apply ... if not to you'), written on July 20, and oddly in Philip's hand, most likely because he himself was still too ill to write it, he pointed out that his salary was 'already in arrears for four months'. He begged his friend 'to incede for me before His Most Serene Highness'. His letter also contained a threat, a novel and canny move for him, to take his business to more appreciative clients if he was not properly paid, because 'then I can carry on my studies without having to turn elsewhere for resources – which would not be lacking for me in Rome'.[240]

Opportunities were indeed rapidly opening up for the still fairly obscure artist, whether healthy or not, to paint and above all to be paid, especially among the prelates of several churches then undergoing

expansion (as had been the case with the church of Santa Maria della Scala, for which Caravaggio had done his rejected *Death of Maria*). The quest of the Counter Reformation for an ideal new beauty, an absolute beauty, to supersede even the greatest art of the past, continued to pick up interest.

Vincenzo managed to send him 140 crowns. This was a trivial amount ('I could not furnish and suitably maintain a house with two servants [on it],' Rubens wrote[241]). Clearly disappointed, he had plunged by August into discussions with the Priests of the Oratory, or the Oratorian Fathers, of the Chiesa Nuova over something amazing, a prize competition for the altarpiece of this 'most celebrated and frequented church in Rome today, situated right in the middle of the city', as he described it. His contacts for these discussions and the prize ('the finest and most splendid opportunity in all Rome'[242]) may have come through Cardinal Bartolomeo Cesi, a friend of Justus Lipsius, or through Cesi's librarian, Jan de Hemelaer, Rubens' friend and a friend of Philip's. Even Cardinal Scipione Borghese, a nephew of Pope Paul V, and himself an extravagant patron of the arts as well as official 'Protector of Germany and the Netherlands', and so prepared to give a leg up to needy and qualified Flemish artists, may have recommended him. Borghese would have seen, as had many others and most significantly his assistant, Monsignor Giacomo Serra (who at once guaranteed 300 of the 450 scudi in prize money for the contest, but only as long as it went to Rubens), his three paintings in the church of Santa Croce in Gerusalemme, done during his first visit.[243] All these people would have known what he was capable of.

By this time too, Rubens seems to have become capable of something else, an appropriate slyness in his dealings with Vincenzo, who suddenly (in late November) decided that he ought to return to Mantua. On December 2, Rubens wrote to Chieppio that any quick return would now be 'impossible' because he was busy doing some 'important works which (to confess the true secret to you) I was forced to accept out of pure necessity'[244], or before Vincenzo knew anything about the contest for the Chiesa Nuova. In fact he had long since, perhaps as early as August, won the contest and signed a contract for the altarpiece. If he was not entirely forthcoming with Vincenzo, he was not lying, only fiddling understandably with the details of what he was up to. He was also a bit cagy about another matter. This had to do with the contest itself. He described it to Chieppio as having been won 'against the pretensions of all the leading painters of Rome'.[245] Actually, two of Rome's most outstanding artists were unable to compete in it, Caravaggio because he was on the run, off in Naples and heading for Malta, and Annibale Carracci because he had lapsed into a depression so profound that he could not paint at all.[246] On the other hand, Rubens' letter to Chieppio, like his letter of July, was written out by Philip.[247] His pleurisy had perhaps flared up again. Even as late as December he had still not wholly recovered.

61. Early Fame and a Journey to Genoa

His tremendous ambitions were finding a broad arena in which to assert themselves, one more spacious even than in Spain. In some ways he had begun to become a public man.

The altarpiece at the Chiesa Nuova, a new church because it had been built only in the 1590s (its facade was finished as late as 1605[248]), wanted his immediate attention. In doing it, he faced a thicket of requirements: to the Oratorian Fathers he had to submit several *disegni*, or preliminary sketches (a couple of these, in ink and oils, have survived). He also had to incorporate into it a small, third-rate but sacred fresco of the Virgin Mother from another church. The painting itself had to be finished by the following May.[249]

All this took time on the spot, and Vincenzo, who withdrew his demand that Rubens return to Mantua once he was apprised of the importance of the project, eventually gave him about six months, more than he asked for. By April, 1607, he had even sent Rubens another fifty crowns, not as much as he owed, but not entirely pathetic in his circumstances, as Rubens admitted.[250] Both men had begun to gamble on Rubens' career and success at this point, he no less than Vincenzo, because the 450 scudi in prize money was a slim sum for months of strenuous labour. Both clearly hoped that the prestige might compensate for the relative penury.

At the same time Rubens involved himself in another affair no less remarkable for what it reveals about his devotion to beauty and his generosity of spirit: the promotion and sale to Vincenzo of Caravaggio's *Death of Maria* for 350 gold crowns. This was clearly a picture for which he wanted to find a good home. Caravaggio himself, having disappeared (as far as anyone knew), would see none of the money (it went to the papal lawyer Laerzio Cherubini, who had commissioned it[251]). Many months ago by now, the Fathers of Santa Maria della Scala had found the painting vulgar because it departed from conventional representations of Mary's death, first, by showing her as young, barefoot, sexy and bloated in death, and second, by leaving out all traces of the supernatural. Giulio Mancini, Caravaggio's earliest biographer, suggests that actually the model for his Mary was a 'filthy prostitute' from the run-down section of Rome known as the Ortaccio.[252] None of this mattered to Rubens, who realized that the painting was one of Caravaggio's best. It also made no difference to him that it deviated sharply from the sort of sacred art that he was himself producing. He not only negotiated its sale, but supervised its wrapping and boxing, arranging for its shipping to Vincenzo on April 28, 1607.[253] If Rubens felt any twinges of jealousy about all this, they may have had to do with the duke's never having commissioned him to do a major picture himself for his palace galleries throughout the seven years that they had so far known each other.

Events nonetheless proceeded apace for him, and with a new momentum. They began to combine travel, portraiture of a revolutionary sort, yet again, and melancholy news from home. This last affected the pattern of his life.

Much of the great shift in his career, which was broadly in progress – he could perhaps sense it – such as Vincenzo's suddenly, just as he was finishing up his work on the altarpiece, inviting him to Spa, near Genoa, where he went to take the waters for his health in July 1607, was also the result of Rubens' personal charm and good conversation.[254] Artistic gifts were only part of his appeal. Gaspard Scioppius (Schoppe; 1576-1646), a rather stiff-necked scholar and theologian who met him in Rome at around this time, or maybe a year earlier, at the house of Johann Faber, seems to gush with the sort of admiration for him that, while typical of what others also said, is undiscriminating. Scioppius must be telling the truth, but one senses in his recollections of Rubens a prudish reticence. He seems unable to perceive, or even to tolerate, those revealing contradictions that alone can endow stick figures with life: 'Mr Rubens, a man in whom I would find it difficult to know what to praise most, his skill as a painter, an art in which, according to connoisseurs, he has reached perfection – if anybody can manage that today – or that fine judgement, which in him goes together with a special charm in conversation, or his knowledge of literature.'[255] One feels a frustrated need to inquire a bit further, into Rubens' dislikes, quirks and possible confusions.

He followed Vincenzo to Spa, and then went on, perhaps by himself, to Genoa. Odd though it seems in a life so tempted by opportunities and solid leads, he may simply have had nothing better to do. He had finished the altarpiece on time, and had to wait several months to install it. Giacomo Serra, who had helped in obtaining the contract, was away in Venice on a diplomatic mission, trying, successfully, to avert war between the papal armies and the old Republic. Rubens felt that it would be rude to have his painting publicly unveiled before Serra returned 'because of the affection which he has for me'.[256]

Equally pertinent was the fact that Philip had left Rome too, resigning his position as librarian in May and moving back to Antwerp.[257] He was responding to a report that their mother, Maria, was seriously ill. She was now seventy one, and had suffered from asthma for years. While Philip was surely going back to be with her, he may also have decided that the time had come to set up his own law practice, in a kind of imitation of his father. By July, at any rate, he had been granted his citizen's rights in Brabant, and was busy making and reestablishing contacts in high places, among them with the Archduke Albert in Brussels.[258] The question is why Rubens himself, who was as devoted to his mother as his brother, did not return too – to which the answer seems to be that the southern pull remained stronger. Whatever conflicts he may have felt

over his mother's illness, whatever terrors, paled before his drive to push ahead in his art, and in his unending exploration of Italy.

Genoa, for instance, at once presented him with good chances to examine a unique type of architecture and to produce some superb portraits. Genoese buildings differed from those of the rest of Italy in their lightness, their basis in urban planning, itself a novelty, and their adapting to the rival interests of the aristocracy and middle classes. With a population of about 70,000 and massive wealth concentrated in the shipping and banking families that had rescued Spain from financial collapse under Charles V and Philip II, it was currently enjoying Spanish naval protection and a housing boom. The Genoese love of lavish spending on altarpieces, palaces, fountains, tombs and tapestries was legendary. Charles V had once arrived for a state visit to find himself rowed ashore by velvet-clad oarsmen to a dock trimmed with gold cloth at a cost of 20,000 ducats. The Strada Nuova, planned by Galeazza Alessi (1512-72), provided ten equal-sized plots for newly constructed palaces.[259]

Walking about, Rubens made sketches of these palaces and less extravagant middle-class homes. The idea came to him to do a book on architecture, focusing especially on middle-class needs. A slim volume showing designs might benefit his fellow Antwerpers, whose losses during the revolts had been immense and who would one day wish to start a programme of reconstruction, perhaps according to modern, Genoese methods. He noted, for example, that the chief difference between the Genoese palace and the more practical, middle-class residence was that while each was shaped as a cube, often fronted with doric pilasters or columns, the nobility tipped into the centre of theirs an atrium with a fine garden. Less well-to-do people managed nicely enough with a central, high-ceilinged saloon. Elegance might be achieved at an affordable price.[260]

Before heading back to Rome and the unveiling of his altarpiece in September, he also found himself, perhaps through Vincenzo, commissioned to do a bunch of portraits of the local aristocracy, or (among others) the Grimaldis, the Spinolas and the Dorias, Genoa's leading families. Most of these pictures are lost. Among the survivors, a magnificent evocation of Veronica Spinola Doria (225 x 138 cm., today in the Staatliche Kunsthalle, Karlsruhe) at the age of twenty, is unusual, beyond showing her simmering Spanish-gowned beauty (most of the Genoese nobility affected Spanish fashions) and the characteristic energy that Rubens imparted to all his work, for its full-length interior presentation, a new portrait style that began to set a trend.[261] Modest revolutions might be effected by the merest of additions.

62. Rejection and a Summons Home

His visit to Genoa turned out to be thoroughly rewarding even if it was only a brisk footnote to a life that was constantly gaining in breadth.

None of his successes, though, prepared him for the 'strange thing' that took place on his return to Rome, the failure of his altarpiece (*St Gregory surrounded by other Saints*, 477 x 288 cm., now in the Musée des Beaux-Arts, Grenoble), a misery which he and the church Fathers spotted only after it was installed.[262]

It was in no sense an artistic failure. On the contrary, as Rubens understood, its conception and execution were worthy of him. In fact the painting may be said to mark yet another advance in his treatment of motion, with horizontal space now turned into a field of energy amid a striving for a new sort of freedom, the precise expression of that sparkling power – where ultimately does it come from in the far universe? – wrapped into the shapes of his depicted men and women. Energy fields are contained in each of them and yet unimpeded. These fields shimmer as personal powers of light. Near the centre, St Gregory stands surrounded by two martyrs and three other saints, Maurus, Papianus and Domitilla. As the imposing figure of Gregory, gorgeously costumed in a white robe fringed with gold, looks up to a niche in which the sacred fresco of the Virgin Mother has been positioned, he makes a sweeping gesture straight out of the picture and toward you, one requiring a complex foreshortening of his arm so that it seems to reach above your head. At the same time, and behind him in the background, a blue sky can be glimpsed through an arch. It spreads across the wide world. The effect is to create a wavering space-line between you and him and all the space beyond, or a thrilling communion. Rubens' style, and even his understanding of beauty, seemed to have attained a new fullness.

There could be no problem with so original and theatrical an idea. There was none with his treatment of it either. As Rubens wrote to Chieppio with pride, it 'turned out very well, to the extreme satisfaction of the Fathers and also (which rarely happens) of all the others who first saw it', and was also 'very beautiful because of the number, size and variety of the figures of old men, young men and ladies richly dressed [in it]' – except in one crucial respect: that it could not be seen.[263] The queer illumination of the apse, Rubens told Chieppio, rendered his bright figures on canvas virtually invisible. The church Fathers themselves, however, took the position that their sacred fresco was not prominently enough displayed.

In any event, his picture was rejected. Rubens himself withdrew it, wracked, it may be guessed, by amazement and alarm. This was by no means his only problem. With undaunted confidence, he at once agreed to make a variant copy of it, not on canvas but on slate, which would better gather and reflect the peculiar light. The Oratorian Fathers were happy enough to let him have another go at it, provided that he made new oil sketches, which he duly produced. In the meantime, and to avoid a complete fiasco with his previous months of effort, he put the first

altarpiece on public display ('crowds have seen it in Rome'[264]). He also attempted to sell it to Vincenzo. 'The picture,' he wrote to Chieppio, whom he asked to act as a middleman for him in February, 1608, and while working away at his new version, 'would surely hold its place in that gallery [in Mantua] which is filled by the competition and rivalry of many reputable men.'[265] From anyone else, he wrote, he would ask 800 crowns for it, but in Vincenzo's case would leave the price up to him. This shrewd strategy was the same as Benvenuto Cellini (1500-71) had often used (had Rubens perhaps heard of Cellini's approach to his papal patrons?), but in Vincenzo's case it did not pan out, either because any fair price was beyond the duke's means for the moment or for some other, never mentioned reason. Once again, the altarpiece was found wanting and turned down.

Vincenzo's rejection stung. Rubens had described selling his painting as a 'pressing matter', though he masked his unhappiness. To Chieppio he wrote that 'although my negotiation has not turned out well ... I am sure to find a good placement for [it] in Rome'.[266]

In fact this did not happen. Popularity often had little to do with profits. Over the next months he devoted himself to doing his copy, working, fascinatingly, in the church itself as people wandered around him, often painting behind a canvas screen, but equally often, as he told Chieppio, painting 'in public'. He had none of Michelangelo's passion for secrecy.[267] He also had none of Da Vinci's propensity for leaving projects incomplete.

The threat of incompleteness, in art, in life, however, seems often to have haunted him. It was matched by his fear of interruption. Interruptions, at least, could not be avoided. In August, 1608, Vincenzo received a letter about a 'family matter' concerning him. It was clearly about the worsening health of his mother, and came from the Archduke Albert in Brussels, probably at Philip's urging. It asked that Rubens now be allowed to return home.[268]

Vincenzo's reaction, considering that Rubens was off in Rome anyway, was astonishing. Not only did he refuse, which was his princely right, though Rubens was Albert's subject, but he couched his refusal in arrogant phrases that revealed a bit about his relations with his court painter (despite the failure to purchase his altarpiece) and Rubens' feelings about him, and about Italy as well. Vincenzo wrote of 'the entire satisfaction that his painter, like himself, found in the contract that united them. I cannot believe that he thinks of quitting my service, to which he shows himself so much attached. There can be no question of deferring to the wishes of his family, who have sought the assistance of the Archduke to recall him to his country. Quite otherwise is the desire of Peter Paul, who wants to stay as much as I desire to keep him'.[269]

A politer version of this letter was the one finally sent, but in the end Vincenzo's refusal made no difference. On October 28, Rubens himself

reported to Chieppio (the duke was now off in Flanders, of all places, gadding about with an entourage of thirty-three courtiers and ladies, and actually visiting the Archduke[270]) that his mother's condition (as he had just learned) was desperate. He announced that he was leaving to go to her, writing in haste ('mounting horse,' as he grimly noted), with apologies and making a promise to come back. At the same time, in a more self-congratulatory spirit, he noted that 'my work in Rome on the three great pictures for the Chiesa Nuova [he had actually produced three complementary paintings this time, two of them on slate, rather than a single copy] is finished, and, if I am not mistaken, is the least unsuccessful work by my hand'. He could not stay to see it unveiled, however – that much of a cheating interruption was tolerable – because 'haste spurs me on'.[271]

It did indeed, with the unexpectedness, one may surmise, of a guilty passion, and he rode north into that very morning – few people rode by night. He may have been accompanied by Deodat del Monte, the vaporous though wealthy (this much is known about him) apprentice with whom he had come south eight years earlier.[272] Before going, he packed up his scores of drawings and sketches, the harvest of his years of study, and his rejected altarpiece, arranging to have them sent after him by coach. Then, with his mind a cruel blend of the Italian beauty that he had seen and learned so much about, and anxieties about his mother, he headed off into the late autumn, toward his by now mysterious country over the mountains.

Beauty Human and Superhuman

Properly speaking, this book could in all honesty end here. By the age of thirty one, Rubens had made most of the discoveries about beauty that he was destined to make. What followed, their magnificent application in hundreds of paintings that continue to amaze art lovers everywhere, is from the viewpoint of his arriving at his understanding of beauty, thrilling – and almost secondary. His voyage through life was hardly over – in some ways it had just begun – but he had apparently realized much of the vision that, it seems from childhood, had been his driving force. A portrait of him from this angle may thus be deemed more or less complete, though in the ways of character, vigour and the full flowering of what he understood it must seem pale and inadequate. A biography based in his quest of beauty, however, ought not to slip into simple trot-tings after him as he moved from place to place, drooping into collecting the sort of trivia that have little to do with his vision, into mere diddling with the distractions that figure into any existence.

Yet to abandon him at this point, a crucial and exciting moment in his life, would hardly satisfy the curious. A feeling of deficiency would persist because there has been no complete and worked-out exhibition of what he discovered and how he applied it. What is more, his astonishing style, which lies at the heart of his vision, and of his idea of beauty itself, would seem a continuing enigma. This may be clarified by looking at the paint-ings that he now set about doing, together with important moments out of the years to come. Not everything is wanted. Nor is it available. Information is often missing. Valuable personal letters have been destroyed. On the other hand, one hardly expects a massing of irrelevan-cies – only an angling spotlight. Cast here and there, and with a consciousness of the insufficiency of its brightness, it may illuminate how he now began to deploy his ideas, and what he discovered about their power in the world as he did so.

63. Grief and New Beginnings

A forty-four-day horseback ride around the Alps (probably around them, or on the 'Spanish Road' taken by imperial armies, considering its

length) took him back to an Antwerp in which over the past eight years and with the exception of death, time had stood still. The streets were nearly deserted. Fire-blackened walls, untouched since the Spanish Fury of over three decades ago, could be seen everywhere. The isolated Gothic grace of a number of houses stood out against the silence of the great port. Divested of ships, it continued to languish before the well-established Dutch naval blockade, enforced a mile up the Schelde by cannon-bristling frigates.

In 1601, Maria had sold her parents' house on the Meir, where Rubens had lived with her during his brief school days. She had moved into another house on Kloosterstraat, one block over from the river.[1] To this he came, on December 11, riding to meet Philip and to make the discovery that his mother had died, in fact that she had died before he left Rome, on October 19.[2]

There are no surviving comments on his feelings. He had not seen his mother throughout his time in Italy. His sister, Blandina, had also died, on April 23, 1606.[3] The realization that only he and Philip now remained of a close-knit family that once numbered eight during the period of their German exile, and that his mother, who had offered him, as she had his father and all her children, unblemished affection, was gone forever, that she had been buried in the nearby Abbey of St Michael weeks before he arrived and that a door had hushed shut on his past, seems to have plunged him into a month of isolated grief. It also stimulated his characteristic way of calming his thoughts: a form of creative action.

At the Abbey, he ordered a new chapel built for her.[4] Over it he made plans to install his brilliant altarpiece-painting that had been rejected in Rome and Mantua and that he had unwittingly arranged to be sent north in the hope of selling it. It may have occurred to him that in winning the prize for the Chiesa Nuova he had inadvertently won a chance to paint a picture for his mother, and he may have appreciated the irony that in rejecting his masterpiece the Oratorian Fathers and Vincenzo had benefited her memory. Nothing was quite lost, only transfigured in meaning. His energetic dream of St Gregory had found a place in his own scheme of things.

There was another irony in that his mother immediately repaid him, so to speak, for his sacrifice of a canvas on which he needed to make money. Her will, drawn up on December 12, 1606, and notarized a month later, restored to him the 'beautiful' paintings, as she described them, that he had given her many years earlier, and that she had proudly hung in her two homes (where they had been seen by a local, admiring public).[5] Among them, though it is impossible to be certain, were a few of his apprentice canvases, not so far identified and perhaps lost, and others that he may have sent her from Italy.

Living together at Kloosterstraat for a while, as they had in Rome, but as never since their youth, the two Rubens brothers now set about estab-

lishing, indeed enjoying themselves in their damaged city. Rumours of a truce between the Dutch and Spanish fluttered in the wind, though battles continued to flare and fade just a few miles away. In 1604, the Dutch offensive in the south had been crippled by the peace treaty between England and Spain. This had opened the English Channel for the transport of Spanish troops straight into Flanders.[6] The Spanish commander Spinola's capture of Ostend, also in 1604, had brought a popular sense of relief to the fifteen southern provinces. Many Flemish hoped that under this capable officer, and banker too (he had a remarkable gift for raising money to hire troops), stability might be restored.[7] For most by now, stability was far more important than freedom. The atrocities committed on both sides had promoted a revulsion with war itself.

For him there was much to get used to again, drinking strong beer, for instance, instead of Italian wine, because there was little wine in the Netherlands, and the absence of hills, and the forests not far off, and the fat cows on the farms still operating, and the multitude of walled towns nearby. If one ate out, one commenced with small white and brown loafs of bread placed beside one's trencher. Beef and a slab of bacon were invariable appetizers. Dinner ended with butter. At least an hour and a half were spent on these meals, which seldom started before seven. Guests toasted each other constantly while dining, shaking hands every time. Often, though, a single big tankard of beer might last the drinker an hour or more.[8]

A brisk ride to the north (Rubens rode a bit every day, usually late in the afternoon, after he stopped painting[9]) brought one into the sight, across a river or lake, of the strings of the Dutch enemy's little forts, recently named redoubts, each crammed with fifty or more men and with a cannon or two. Here and there, the dykes had been knocked open and the land flooded.[10]

In the bricked, scorched city itself there were acquaintanceships to renew, perhaps with Otto van Veen, his former teacher, now fifty eight, with Balthasar Moretus, in charge of the Plantin publishing house (where Philip's book on Roman costume, with etchings by Cornelius Galle based on Rubens' drawings, had already come out, in 1608[11]), with the theologian Andreas Schott,[12] brother of François, whose own book on Italy he had probably read before going away, and with Philips van Valckenisse, the military man and art collector into whose friendship book he had once inscribed his dot-and-circle diagram of the divine. His brother, whose connections were solid everywhere, probably now introduced him to Nicolaas Rockox (1560-1640), though Rubens may have met him as early as 1599. Rockox, a Catholic humanist and art-and-coin collector, the descendant of a wealthy Spanish Marrano family that had settled in Antwerp in the sixteenth century, had been Buitenburgemeester (or outside Burgomeister) of the city since 1603. He

lived in a roomy, lavish house, Den Gulden Rinck (The Gold Ring), double-fronted with a spacious courtyard, on Keizerstraat, not far from the Great Market and the Stadhuis.[13]

Philip was doing extremely well. On January 20, 1609, or just over a month after Rubens' return, he was named one of Antwerp's municipal secretaries, or to the position once held by their father.[14] He had also fallen in love. Apparently a shy, uncertain type in contrast to his painter-brother, he had overcome his reticence enough to propose to Maria de Moy, who came from a rich family and was the daughter of another city secretary. On March 20 they were married, with Rubens acting as best man.[15] While Rubens himself had no plans to do the same so soon after the death of his mother, and certainly not unless he could find a woman as beautiful and intelligent, his mood had lifted. He reported on his new life to his friend Johann Faber in Rome (on April 10):

> Your kindness deserves a better correspondence from our side, and I should not know how to excuse such tardiness if the truth did not speak for itself. We have been so involved in the marriage of my brother that we have been unable to attend to anything but serving the ladies – he as bridegroom and I as best man. If you do not believe that such an affair is so intricate, have your friend, Signor Martellano, tell you his experience, and I am sure that you will then accept our excuses as legitimate. In short, my brother has been favoured by Venus, the Cupids, Juno and all the gods: there has fallen to his lot a mistress who is beautiful, learned, gracious, wealthy and well-born, and alone able to refute the entire Sixth Satire of Juvenal [whose wit leads to such ferocities as: 'Women, in judgement weak, in feeling strong/By every gust of passion borne along,/Act, in their fits, such crimes, that, to be just,/The least pernicious of their sins is lust'[16]]. It was a fortunate hour when he laid aside the scholar's gown and dedicated himself to the service of Cupid. I myself will not dare to follow him, for he has made such a good choice that it seems inimitable. And I should not like to have my sweetheart called ugly if she were inferior to his.[17]

In the same chatty vein, as between old friends, and a friend who had saved his life, he reflects on love, speaking now as a man of experience: 'I find by experience that such affairs should not be carried on coolly, but with great fervour. My brother has also proved this, for since my arrival he has changed his tactics, after pining for two years in vain [had Rubens, with a bit of suave prodding, snapped him out of his natural passivity?].'[18]

At once Rubens adds, reminded of his own unclear plans, that he is not at all sure if he should not stay in Antwerp. He hints that he has been introduced to the Archduke Albert and his wife, whom he may have met for the first time years earlier, during their festive 1600-entry into the city, but who would have known of him in any case through Philip, and through Jean Richardot, their representative in Rome and the son of the

president of their cabinet (who had arranged his first Roman commission). The Archduke and Archduchess had indeed met Rubens, apparently taking to him with warmth and admiration, and in March he began painting their portraits – something that, again, he only hints at to Faber, perhaps because he was unprepared to tell him that he might not be coming back[19]:

> I have not yet made up my mind whether to remain in my own country or to return forever to Rome, where I am invited on the most favourable terms. Here also they do not fail to make every effort to keep me, by every sort of compliment. The Archduke and the Most Serene Infanta [Isabella] have had letters written urging me to remain in their service. Their offers are very generous.

– which indeed they were: a court painter in Brussels might expect a salary of 500 florins per year.[20]

Court life, however, now as before at Audenarde and even in Mantua, held scant appeal for him ('I have little desire to become a courtier again'[21]), and none in comparison to the cosmopolitan life of Rome or the easy-going life among his friends in Antwerp itself. His enthusiasm for staying depended a lot on the rumours of peace turning into an actual peace, one that would last. He had high hopes: 'The peace, or rather, the truce for many years, will no doubt be ratified, and during this period it is believed that our country will flourish again. It is thought that by next week it will be proclaimed through all these provinces.'[22]

In fact it was. A treaty between Spain and the United Provinces, stipulating a complete cessation of hostilities for twelve years, was signed on April 9, 1609, or one day before Rubens wrote to Faber but unknown to him. It was ratified less than a week later, on April 14.[23]

The rest of the year amounted to a sailing into happy harbours, a reverse of the mournfulness with which it started off. On the personal side, he seems to have had no problem in discarding his resolution not to 'dare follow' his brother in love and marriage. Within six months of Philip's wedding he had fallen deeply enough in love himself to make up his mind to get married. His bride was Isabella Brant. Their wedding was held on October 5, and in the very church where his mother was buried.[24] Isabella was just eighteen. She was Maria de Moy's niece, so that in less than a year the brothers had married into the same family. To judge from Rubens' portraits of her, one of which he painted not long afterwards, he need not have worried about her not measuring up to Philip's wife. Isabella was ironic, stylish, blonde, affectionate and good-looking. Her education, something that mattered a lot to him, also left nothing to be desired. This may be inferred from the fact that her father, Jan Brant, was a lawyer and, like Philip, with whom he had gone to school, another of Antwerp's secretaries. A humanist with a passion for Julius Caesar –

his interest in the classics was typical and even trendy among educated professionals – he was a generous, thoughtful man, and also like Philip, an ex-student of Justus Lipsius. Conveniently, he owned a large house just down the street from Rubens.[25]

The grandish wedding probably resembled that of his parents – Philip's no doubt did – with hired carriages and the traditional feast that trundled out scores of hefty courses for dozens of guests. Money was available even in those war-stricken days. It would have come not only from Jan Brant and Philip but the groom himself. Two weeks before his wedding he had accepted an unusual, though not unheard of, appointment as court painter to the Archduke and Archduchess (years earlier, Otto van Veen had accepted an almost identical one). This allowed him to serve as an official artist, but *in absentia*, or while residing in Antwerp. Here was precisely the deal that he wanted. Its flexibility seemed to settle his decision to stay rather than go back to Italy, though it mingled with genuine regrets. He was able to enjoy the same privileges as other members of the royal household, but coupled with more or less complete freedom. Importantly, it gave him the right to 'teach his art to whomever he wished, without being subject to the regulations of the [painters] guild', such as annoying fees if he wished to enrol apprentices.[26] The Archduke and his wife, moreover, whose large portraits he had completed by August 8, were so pleased with his work that they presented him with a 300-gulden gold chain. Designed by the goldsmith Robert Staes in Brussels, it bore a medal stamped with their likenesses, a sign of their most esteemed official approval.[27] Temptations to stay had also poured in from other directions, in the form of offers for commissions, and, as early as June, through his friend Jan Bruegel, his induction at a ceremonial feast into Antwerp's Society of Romanists, whose membership consisted of artists from Brabant and Flanders who had studied in Italy.[28] By his wedding day, his conviction that from now on Antwerp was the right place for him must have seemed both wholesome and promising.

Philip may have had these achievements in mind (to Johann Faber he wrote that with the gift of the gold chain Albert and Isabella had 'bound [Rubens] with golden fetters'[29]), as well as wishing him joy, when on the night of Rubens' wedding feast he recited the customary poem, a Latin composition of his own, entitled 'Invocation to Hymen'. As might be expected from any product of this tradition, it was both solemn and silly:

> Broker of love divine, we invoke you on this night of my brother's great happiness, and call on you, his young wife, too.... Tomorrow you will say that tonight bore you off to a lovely awakening.... Hymen, the god, is already impatient to light your nuptial candle, to enter the homely temple of your marriage bed and Venus' arenas intended for tender exertions.[30]

A risible nonsense from a modern point of view, Philip's poem wound up with a placid image of Rubens' new wife rejoicing 'to see her womb

grow round' as she counted the days and weeks to come while waiting to give birth to a child (whether boy or girl is not mentioned) 'who resembles her husband'.

Panagyric absurdities such as this were sheer convention. The future nonetheless seemed auspicious. Within days the young couple had moved into Jan Brant's house. It was not only much larger than Rubens' mother's, and so more accommodating as well as familiar to Isabella, but also had space enough for a studio in which he could easily handle big paintings.[31]

64. 'The Hand of the Artist'

In addition to his portraits of the Archduke and his wife, he had already been at work on several of these, finishing them over the previous few months. A release of his style on a scale unprecedented in Italy, an expansiveness binding up his Italian and Spanish discoveries, driven by his hearty reception in Antwerp and no doubt spurred on by his prospect of marriage and setting up a home of his own, let loose a stream of *inventioni*.

This great bustle of activity, while typical of him, seems the more extraordinary because it was based on a delusion. Rubens and his Flemish patrons were convinced that the new Twelve Years Truce would save their city. It would reverse ongoing emigration and foster a return of established banking interests. It would restore trade. There was no evidence to support this idea. There could be none. As Rubens painted away, Antwerp's population continued to dwindle. The city's money supply kept dropping.[32] If the financing for a number of grandiose art projects was available through Church-endowed Jesuit societies and several well-off families, still he and his friends were swimming upstream against a stiff current.

Whether because his political analysis was faulty, or because he relied on pure faith, or because he did not care about being entirely sensible as he risked everything for the moment, no matter what, he pushed ahead with confidence. Among the pictures that he now completed was the first of his mature masterpieces, *Samson and Delilah* (185 x 205 cm., today in the National Gallery, London; plate V). This was commissioned by Nicolaas Rockox (as Rubens remarked, 'one of my first customers'[33]), and remains a spellbinding exhibition of his style in magnificent full bloom.

Along with three others that he also finished just now or within a year or so, *Self-Portrait with Isabella Brant*, *Four Philosophers* and *Descent from the Cross* (a subject that he seems to have felt repeatedly drawn to), this painting provides an opportunity to reflect on the issue of style as he was thinking about it, and beyond that, his attitudes toward beauty. Eugene Delacroix, who may have seen into his art better than almost anyone, if only because as a practising artist himself he cultivated

Rubens' influence on his own work, regarded both as problems in illusion.[34] If one grants that illusion is inescapable, how is one to put it to use? What are its varieties? What are its powers of truth?

In a note on Voltaire's satires, Delacroix remarks that 'in them you never have the sense of being present at actual events, such as you might get from reading the account of an eyewitness; you feel the hand of the artist – and you should feel it – just as you should see a frame round every picture'.[35] The frame, in the best styles (and there may be poor, broken or untrained styles – why not?), is to be sure the artist's hand. Like a picture frame, it does not so much distort as choose. It grasps, clasps, manipulates and presents. It clarifies. It persuades without overwhelming. Any good artist's hand, like anyone's fingerprints, is an original bridge as well. Across it stray in a ghostly animation – but again, only in the most pronounced, best instructed styles – the dreams, perceptions, knowledge, fears and harmonies of the artist's heart and mind, to be reanimated on the other side in paint with a personal, manual deftness.

The result, if all this works, is as Delacroix observes, not that 'you have a sense of being present at actual events', but that you realize that you are present at an altogether fresh aesthetic event. The chief difference between the two, and one of the sources of any fine painting's beauty, is that the aesthetic event possesses an unforced yet absorbing set of harmonized meanings, or precisely what is missing from ordinary events in ordinary lives, or for that matter in bad or incomprehensible art. It offers what people seem to crave and what most seem unable to do without, even if, as is often the case and like much of life, it turns out to be inapt or nonsensical. Values ought to be affirmed by the aesthetic experience as well, on occasion the sublime value of beauty.

In *Samson and Delilah*, the famous legend splayed about war, sex, strength, seduction, beauty and betrayal, and itself an effort to understand a bit of human history, is filtered through the Book of Judges (13-16), centuries of interpretation and finally Rubens' hand into a painting that Nicolaas Rockox planned to hang over his living room mantelpiece. A fiery night scene shows the voluptuous, meditative Delilah, who according to the Jewish historian Josephus Flavius (1st *c.*) was a whore paid by the Philistines, warlike enemies of the Jews, sprawling on a *chaise longue* while an exhausted, muscular Samson, Jewish judge, scholar and warrior, himself sprawls asleep across her lap. As he sleeps, her treachery and pleasure unfold before your eyes.

An old woman, probably Delilah's procuress, looks on as a Philistine barber bends over Samson's head. He is about to clip his 'seven locks of hair' with a scissors. Samson's hair proverbially holds the secret of his superhuman strength, which has enabled him to slay hundreds of Philistines with the lugubrious weapon of 'the jawbone of an ass'. Seduced by Delilah, and perhaps in love with her despite his suspicions

of her true, bleak purpose, to render him helpless, he has twice before lied to her when she questioned him about his secret. Tonight, though alerted by her previous attempts to entrap him, he has yielded. He has told her everything. No doubt she has reassured him. Perhaps he is simply weary. From a conventional Renaissance point of view, he has been blinded by passion.

In the background, crowding into a doorway, a group of four Philistine soldiers waits till the barber finishes his covert surgery to seize Samson and haul him off to prison (where he later has his eyes gouged out, with his physical blindness replacing his emotional and, from the usual contemporary viewpoint, moral blindness). A dim statue of Venus, accompanied by another conventionally blind figure, Cupid, stands in a niche in the rear wall.

The whole picture is tremendously alive, tense and surging, and when you ask why, you find yourself led into acknowledging several fairly self-evident reasons. These need to be stressed despite their simplicity. There are also several reasons that are more obscure.

The first is that you are immediately aware of being present at a staged theatrical event, a drama, in which a story is in progress. This is the case even if you do not know the story, or the drama, or the cosmic significance of theatre and story to Rubens and his acquaintances, who believed that the universe itself was a divine story, and that as a consequence everything and everyone in it were participants in both its smaller stories and its larger, universal one. Story here simply means a set of events threaded into a plot. They have a beginning, middle and end. As a result, they also produce meanings or appropriate ambiguities. The barber who is about to clip Samson's hair but who has not yet done so, the voyeuristic old woman, Delilah gazing at Samson asleep and the soldiers hovering beyond the door – all contribute to your feeling of a staged action and serve to create the scene's most important emotional ingredient: your sense of anticipation. Nothing is really at rest here, though Samson may be asleep, and you guess that a crucial moment among these events has been selected by the artist rather than some less interesting one, the moment when a transformation of its main characters is in progress.

Your eye may next wander back and forth between the soldiers and the figures clustered around the hero, speculating on their curious symmetrical presentation and connections. You may notice, though this detail is hardly self-evident and may tug at your mind only subliminally, that the two groups of heads seem to form out of their arranged faces two larger clock faces, with the angle of the candle flame at the centre of each announcing how late it is: just one in the morning, or well past midnight, long past the hour of any Cinderella-like rescue. This discreet hint of the time contributes to the tension.

A voluminous heat spreading among everyone, another subliminal

aspect, is overpowering. Half naked, Samson with his great Michelangelian back bared, and Delilah whose luscious breasts are exposed, may be lying near an open window. They seem smitten with sexual heat after sex, and the residual night-heat of the desert and sexual exhaustion. Mingling with the heat of their bodies is their luxuriant weightiness, a bodily weight and a weight of desires: a fleshy fullness of collapsed appetites.

An even more startling aspect may now make itself plain, one that you may have noticed and rejected, or merely taken for granted because it seems natural to most modern people, but that rendered the painting mildly revolutionary in Rubens' day, or especially alive, as it may in ours: the artist's profound sympathy for Delilah. In contrast to most depictions of her, including Titian's *Samson asleep in Delilah's lap*, which probably suggested the whole *inventione* to Rubens but which he altered, she appears not as some dull hired woman cool to the drama working itself out as she watches, but as physically and psychologically ravishing.[36]

She as much as he stirs your heart and mind. She as much as he looks heroic. The result is that the moral problem between the two springs into life. It becomes a valuable dimension of the painting's levels of aliveness. If a judgement is being passed on Samson's foolishness, it combines with a revelation of her emotional and intellectual power. Her calm eyes and mouth, discernible in profile only, affirm her complexity. They seem sheathed in paradoxical feelings that shift among each other as her mind switches between them: compassion, victory, sadness, satisfaction, glory taken in her female potency, which has proved more than a match for Samson's prowess, and most unexpected of all, a delectable sweetness. Her treachery is neither seen nor sensed. It slips beneath the shadows of her eyelashes for us as it has for him. It seems a ghostly accent amid her harem of tantalizing desires.

65. The Creation of Aliveness

So much, perhaps, for the painting's implications. Any inquiry into aliveness ought at least to suggest them, but there is much more. Rubens' attitudes toward a story such as this may also be found to some extent in paintings by Titian, Caravaggio and other artists. None of this painting's meanings, moreover, would be of the slightest interest if his style, 'the hand of the artist', did not cause his paint to live and breathe.

How does he manage it? How does he create the illusion of sensual vitality here as well as in the rest of his work? What are the sources of what looks like magic? These questions are trickier than they seem to be, if only because they turn out to be easier to answer than you might expect. One starts out looking for an unresolvable mystery, where there is only a series of brilliantly improvised techniques, with the deeper mystery of his Rubensian spirit, the spirit of his genius, stirring into the

picture from elsewhere, from religious and cultural attitudes, perhaps from the universe itself.

In a technical and practical sense, aliveness in art may always be understood as an illusion of motion. In sculpture this may be created by a slight exaggeration and twisting of the muscles and body, so that they appear to be doing two things at once, or straining from one position into another. Michelangelo's *Moses*, along with his other notable statues in marble, reveals this elastic approach, as it may be termed, in abundance: the moderately inflated thighs, pectorals and biceps, the controlled thrust of the limbs against their natural repose. Resistance to repose, even to the point of unnaturalness, is essential to producing the effect, even if, as with Samson sleeping, the figure's dominant mood is one of serenity.

In painting, an uncoaxed exaggeration and straining may produce the same illusion – it certainly arises in this painting – so that human figures or animals, inflated by gentle twistings (as with Samson's back muscles, for instance), appear to be in transition between static positions and never to be static themselves. The figures look alive in the sense that they are in fluent alteration, or metamorphosis. Significantly, they also seem to change before their own eyes and not merely before the viewer's.

This is because of an inward concentration peculiar to Rubens. It reinforces a crucial impression of self-awareness (with Delilah this is plain enough, but Samson's unconsciousness seems ironically to render him inwardly concentrated as well). Without this quality of self-awareness, or self-absorption in Samson's case, much of the illusion of aliveness would be dissipated. To preserve it, not only must the figures not look out at the viewer, or do so only when preoccupied with something else, but they must also almost never look into anyone else's eyes. Rubens' figures, as in this painting, may form a chain of looks and glances, with the one glancing at the other, but they seem to refuse to engage in any direct eye-to-eye contact that one can actually see. Trading glances is itself an illusion invented by the viewer, who imagines it, even as it heightens the viewer's sense of anticipation. In reality, his figures exist in a studied, theatrical isolation, a bit like that of a player delivering a soliloquy in one of Shakespeare's plays.

Other features of his style, some of them smuggled out of the work of previous artists and sculptors, but never employed with his consistency and coherence, gather into this glamour of the aliveness. Everyone in his paintings, for instance, is busy in the sense that every muscle is in use. In his portraits too, no one merely poses, or stands or sits for observation (often his portraits show people who seem in a hurry, or passing by on their way somewhere; in this painting, too, you sense that Delilah will soon be moving). This busy-work supplements another aspect, to wit, that his paintings almost invariably present populations or small groupings, by which is meant only that the figures are conceived as engaged in

activities with others (again, even his portraits present emotional nego-
tiations, usually indirect or implied, with the viewer). The universe
hinted at may on occasion terrify its inhabitants, as happens with the
Horae in his *Fall of Phaëton*, but it never abandons them to a deserted,
existentialist void: people are isolated, self-aware and self-absorbed amid
entertaining convivialities.

To be sure, at the heart of his style lies the treasure-vault of his lines
and colours. These show his powers of imagination at their most quixotic
and free, to such an extent that they often seem cyphers of heavenly
messages. About them it may at once be observed that Rubens' lines are
seldom single strokes or outlines: usually they are doublings and
triplings. Any actual outline strokes trace, retrace and wriggle beside
each other.[37] They complement each other, often with a smudgy rawness,
like a series of echoes. His colours, it may be added, like the colours of
nature, are impure in the same fading, smeary way. They are also colours
without names. This is to say that they are hardly the familiar colours of
nature. In fact they are generally unfamiliar. One may describe them as
blues, violets, pinks or flesh tones for want of better names – one prob-
ably must – but the truth is that they have never been seen before by
anyone, and herein lies a startling achievement: the illumination of the
world through a series of slight changes.

Nothing, for example, could be more absurd than the popular notion
that Rubens is the greatest painter of human flesh. It seems clear that he
never paints flesh, only a series of contrasts that seem to resemble it
because of their differences from their surroundings, in terms of texture,
hues, pliancy and placement. He paints fantasies of flesh, as he delivers
up fantasies of horses, lions, foxes and trees, or of Samson and Delilah.
The rare exceptions are a few flowers and sea shells.[38] What is amazing
is that nearly everyone believes the opposite. He has convinced the world
of a non-existent naturalism, where there is only a spectacular hint of it,
alongside his elaborate inventions.

On the other hand, he never departs so drastically from nature as to
offer up the grotesque or freakish in the fashion of the Mannerists.
Nature is not dismissed. It is not ignored. Instead it is modified by his
artist's eye (as Delacroix argues it should be), and by methods picked up
from others, but always amid the folds of the lucid, airy veil of these
synthesized approaches.[39] The result is a psychological invitation. As you
look, and make unconscious comparisons between his renderings of, say,
womanly flesh – Delilah's flesh, for instance – and the flesh of actual
women, his fantasy is forced upon your imagination with a power far
more compelling than if he were imitating nature accurately (thus saving
it from producing a photographic or chemical flatness). It is the viewer's
desire to reconcile Rubens' vision to memories of actual flesh that creates
an aesthetic sensation approximating hypnosis. With paintings such as
his *Samson and Delilah*, this may turn out to be more sensual than some

of one's own fantasies of love. Its strength surely marks the victory of a subtle psychologist.

Part of his success with this psychology is due to his having changed techniques once he got to Italy, and then flipped them back once he returned to Antwerp, producing a new mixture of his own from rival methods. Before going south he had worked more or less as other Flemish painters did, by laying on his canvases or wood panels a *primuersel*, or pale flesh colour, over which blandish tempera layers, called *dootverwe* (dead colour) established a sculpted voluminousness for figures that were later glazed over in oil and varnish. Italian painters had worked directly in oils on their priming, or *imprimatura*, which allowed the sketching out of their figures directly and simply in the paint itself, this making for a fancier delicacy, as opposed to the rougher charcoal sketching still favoured by the Flemish.[40]

Characteristic, too, especially after he came back, though in some ways present before he left, was his signature translucent glow, imparted to the whole surface, which created the impression both of peering at his figures through light-filled glass membranes and of discovering his figures themselves to be light-filled glass. This established their unearthly earthiness, or fleshly-heavenly scruffiness. In part it is traceable into his emergence from a tradition, itself stemming from the Van Eycks, of using – liberally employing – turpentine and essential oils and combining them with resinous oils.[41] A fresh opportunity to explore the properties of light, as well as an added intricacy of self-conscious facial expressions, came into his post-Italian pictures as he eliminated the *doodverf*, or the dead-colour-type of priming layers of his earliest works, and began to avoid whites entirely, except in the naturally lightest sections of his scenes (otherwise white turns out itself to be an illusion born of contrasts).[42] This glow shines deliciously through the burning reds of Delilah's robe, the shining blonde of her hair, across the gleaming shadows between the angling candle flames and Samson's and everyone else's light-softened skin.

Always and everywhere Rubens' massed purpose is to recreate the dapples, twists and thrusts of natural energy. It is mostly from this point of view that he imitates nature. The fading effect of his fantasized colours, as the one vanishes into the other and into his artificial, colour-excited shadows, heaps his canvases and panels with spreads of energy fields. The vaunted rawness of his lines, their unfinished quality, is itself a recreation of energy. His purposely blurred edges, his doublings of the rims of his outlines, with one edge slapped over another version of itself (as at the edges of Samson's resting arm or of Delilah's profile) are not so much signs of haste or ease, though after ceaseless training they came to him easily enough, as of his passion for purling into his pictures the discovered energies of every natural phenomenon, and his belief in energy as their designing power.

More can be noted about this method. The queer edges of his figures – an approach hinted at but never developed past a faint mistiness in the paintings of Titian, and ignored by Caravaggio, who prefers contrasts hemmed in by darkness to the illusion of motion – reveal a tendency discernible in Rubens' entire *oeuvre*. This is his anticipation, albeit unconsciously, of an invention that would not be forthcoming for another 250 years, that of sequential photography. His use of blurred lines looks forward to, and shows a precise interest in, the development of mechanical devices that might record the movements of people and animals, or movie cameras. The successive outline strokes and colour-blendings are themselves an early, brilliant realization of the cinematic.

While he may have developed his idea of showing several positions of the same limb or face or animal out of his own observations of actual limbs and shadows, and out of his interest, paralleling Galileo's, in motion itself, he may also have found an impetus for it in the work of the ancient Epicurean, quasi-empiricist poet-scientist Lucretius, whom he had read.[43] In Book II of Lucretius' *De rerum natura* (On the nature of things), the Roman poet describes what is today termed the experience of after-images:

> Replicas or insubstantial shapes of things are thrown off from the surface of objects. These we must denote as an outer skin or film, because each particular floating image wears the aspect and form of the object from whose body it has emanated.... We certainly see that many objects throw off matter in abundance, not only from their inmost depths ... but from their surfaces in the form of colour.... Since canvases [or the shadows of flags waving above a theatre, which Lucretius has in mind as an example] thus give off colour from their surface, all objects must give off filmy images as a result of spraying particles from their surfaces this way and that. Here then, already definitely established, we have indications of images, flying about everywhere, extremely fine in texture and individually invisible.[44]

It is these – these flying images everywhere – tossed off all objects, as off Samson's massive arm or Delilah's face, that Rubens has set out to catch, these images lingering in one's eye during motion. They lie at the heart of his aesthetics.

Beyond their own fascination, after-images made up of hazy lines are also extensions of sympathy. They embody feelings. As his colours and edges vanish into each other, they become a major source of the strength of his style. They produce his peculiarly Rubensian sense of harmony and a symphonic texture, and are enthralling in part precisely because they seem to remain such a rarity in life. One is astonished to find in his art, therefore, what one seldom if ever notices in the world, and which one may crave as a compensation for any private shabbiness and suffering.

Rubens himself, one may also surmise, was never, not since childhood,

content simply to endure hardships on their own terms. Instead he pressed himself into creating ceaseless transfigurations of pain, his own and that of his family, friends and others – it is his gift to himself, them and us – into impulses of energised grace, or the possibility of grace through transformation. The cynic may scoff at such an enterprise. Few can deny its impressiveness.

66. The Apprehension of Beauty

Or its beauty. In discussing this tricky word as it applies to him, one must distinguish between altering fashions and beauty itself – that sensual, supernatural experience of uplift and glory that one may on occasion welcome into one's ken, and that Shelley described in his 'Hymn to Intellectual Beauty' as 'The awful shadow of some unseen Power/[that] Floats though unseen among us'.

For a few lovers here and there, the moon may go out of fashion in the same way as long skirts and walrus moustaches. It may seem to lose its pale appeal. It may become a cliché. This would be an extreme case of a fashion change, but it may help to clarify the chameleon shiftiness of fashion itself. One may, after all, find the universe meaningless, as do certain modern thinkers, such as the existentialists.[45]

Do any such views affect the aesthetic perfections and possible meanings either of the universe or of life? Do they matter beyond those few, or even many, who may hold them? If they do not, it must still be asked whether the act of confusing one's attitudes, or one's fashionable beliefs of the moment, with vast and intricate phenomena over which one has no control is strictly avoidable. Even if this too is not, because attitudes are both fickle and mighty, it seems obvious enough that whatever one's feelings about the universe or life, in a general way, their wonderful, terrible energy, and their imperturbable harmony, their aesthetics or beauty, must continue as before. Emotional reactions to typhoons and sunsets are meteorologically meaningless.

One should probably also distinguish between reasonable uses of the word 'beauty' and familiar misuses of it. This issue is challenging on an everyday level. Many people are so accustomed to mixing up 'beauty' with 'pretty', 'pleasant', 'nice' and other terms of enthusiasm that they cannot conceive of the word as referring to a unique experience, and one for which we have no adequate alternative term. Others, aware of this difficulty, seek to resolve it by denying the existence of beauty itself, along the way rejecting the possibility of Shelley's shadowy 'unseen Power'. Objective beauty cannot exist. Its 'apprehension' is purely psychological. For them any 'perception' of beauty – and this would be by no means necessarily religious in nature (it was not so for Shelley), though it is probably akin to religious experiences, and may come close to the experience of the mystic – is a delusion.

Those who claim to have it are misguided or superstitious. At best they are foolish.

One suspects, however, that for most this type of objection cannot be accepted. It seems an evasion. It suggests only that those proposing it have not themselves seen, or allowed themselves to see, such transforming achievements as the Sistine Chapel or Rubens' most superb paintings. Their dismissal also remains unconvincing for another reason: few denunciatory efforts are quite as hopeless as trying to get people to deny what they know to exist. They have themselves experienced beauty as a unique awakening and transport of their souls, and that is that.

There is another, more troublesome category of difficulty in considering 'beauty', one not the same as those of fashion and misuse, though it is linked to them. This is that the mind often supplies imaginary additions to a work of art, and to others of life's happy experiences, changing them so as to render them even grander, or beautiful-seeming.

Beliefs of all sorts, particularly religious beliefs, may produce this effect (hence the frenetic attachment of many to icons, which are then perceived as divine energy incarnate, while to others they will appear as art only). Admiration can produce the effect as well, as can love or hate. One's stage of life will most likely alter one's attitudes. One's parents, perhaps perceived as gods by one as a child, and so as beautiful, may decline into ordinary human beings for one as an adult (or they may be seen as beautiful, but in a more human way). This act of transfiguration, which amounts to a psychological trick involving dreamy elaborations, and a fallacy of understanding, probably persuades millions that all beauty lies only in the eye of the beholder.

A greater dilemma, and a perhaps crucial one from the point of view of investigating Rubens' art, is that in principle each of these objections to 'beauty' is no doubt correct. In some sense, beauty is discoverable anywhere. Somehow, as with other experiences, it must indeed reside in the eye of the beholder. This must be true if only because of the aspect of beauty that consists in an aesthetic judgement. As an objection to beauty itself, though, it seems to stop short of considering significant aspects of the experience.

Few, in other words, would probably wish to reject outright the idea that beauty is a matter of perception. Arguments arise only when perception is taken as all-inclusive, with the assumption being made that nothing unique stimulates our sensation of it, or when people imagine that because the word 'beauty' is often wrongly or oddly used, the idea of beauty is just a matter of semantics.

To carry this a bit further: unless one is a solipsist, one is bound to admit that actual stimuli set in motion one's mental reactions leading to the belief that one is looking at, or hearing, tasting, smelling and touching, something that is intrinsically beautiful. This experience, when it occurs, is entirely persuasive. To those who have it, it seems clear

enough that beauty is an invited projection of a specific emotion onto a definite type of event outside oneself. The projection, one may realize, is often followed by its instantaneous confusion with the event, precisely because the power of the event is so great. We feel and think that a woman is beautiful, in other words, because she stimulates us to feel and think that this is true. She is also 'objectively' beautiful in the sense that her stimulation of our response is indubitable, though it may not always be so. She may have her unbeautiful days as well, a possibility that would not detract in the least from her intrinsic beauty on her beautiful ones.

What then (the nub of the matter, perhaps) is the general nature of these outside stimuli? Do their varieties have common themes, or motifs? Can they be identified?

Rubens most likely painted his *Self-Portrait with Isabella Brant* (174 x 132 cm., now in the Alte Pinakothek, Munich; plate VI) as a wedding picture in 1609.[46] Its beauty surely derives in part from our seeing an extremely up-to-date-looking married couple in a traditional pose amid age-old symbols of loyalty and promise, or amid Rubens' familiar scrambling of history with modernity. The theme is the newlyweds' harmony of public tenderness, plus, as one may notice, a pinch of salt, a dash of good humour. Rubens' entire notion of beauty, with all its elements, seems also to be present here, including what may be described as the pact for beauty, without which the experience itself, as we may come to see, would be unavailable.

Both Rubens and Isabella are wearing the latest expensive fashions: peaked, broad-brimmed, beribboned hats, his in jet black, a borrowing of a clerical colour (this style had come in not long before, in England and across much of Europe, and was the original source of the term 'jet set'[47]). He himself wears the latest flat lace collar (Antwerp's lace-making industry was declining, as were its other industries, but it remained active and innovative[48]). Isabella's es-shaped ruff is more old-fashioned if no less dashing, perhaps because of her vaguely flirtatious, ironic glance, which seems aimed at us. Her fleur-de-lis-patterned stomacher, in pink, white and green, sets off her chic, abbreviated jacket. Behind the painter and his wife, and around them, a honeysuckle bower glimmers among its creamy blossoms.[49]

All here is clearly symbols and sympathies, plus that extra quality, one that you must find it almost impossible to describe as anything but beauty. It lifts you out of the ordinariness of the world. It seems to extract you from any mortal context, while yet allowing you to remain earthy and earthly. It even seems for a few seconds a gift of the possibility of eternity.

This last purely mental event involves an aspect of the dramatic, though it is awakened by qualities of the painting, and seems important to any perception of beauty in it, as opposed to feeling that it is merely pretty, nice or pleasant. One may move on to suggest that where pretti-

ness involves an artificial or superficial perfection amid natural circumstances, beauty for Rubens, and others too, involves a natural straining toward perfection amid somehow dramatic circumstances. A pretty woman may exhibit a thoroughly realized symmetry of her features, but no more. Just because the symmetries are perfect, they will seem false. On the other hand, a beautiful woman – or Isabella as Rubens apparently regards her – will do nothing like this, but may instead reveal an aspect of strangeness, or even of disorder. It is precisely this oddity of her nature or appearance that will imply her belonging to a more than mortal order of things, not, to be sure, that of gods and goddesses, but of the energies of the universe itself. As Francis Bacon, Rubens' contemporary, remarked in this connection, 'There is no exquisite beauty without some strangeness in the proportion.'[50] The strangeness, or a sense of slight disorder, will be in part the result of an unusual awareness, whether her own or the artist's or both, that perfection, whether of a form or of desires, cannot actually be achieved. Efforts at it must always fall short, fail and change. Yet the straining toward it can produce a revelation of what seems to be the miraculous.

The reason, as the Stoics understood, is that the universe is not only in constant flux but is itself a flux. It consists of eternal cycles of expansion and contraction, or from a more modern point of view, of an apparently unending series of waves of intersecting energy fields.[51] A perfect circle or triangle may exist in the mind of Euclid, or of a high school student, but it cannot be found in an outside universe that yaws and pitches among endless alterations even while organized and reorganized among natural laws. The drama of change pulses through all events, though it is more obvious to us in some than in others. From this point of view, beauty merely awaits its discovery by us or someone else who might show it to us, such as an artist (and as it is everywhere, its discovery is indeed a matter of perception, or of the apprehension of the eye of the beholder).

Natural beauty, as Rubens seems to have understood it, therefore, is a process. It cannot be a stasis. It is always flowing. It reflects a ceremony of energy charmed by order, but this always a bit wavering and unruly. The process itself may be variously described: as Shelley's 'unseen Power', or as purely physical, or as God-given or God-inspired. It may be found in the most violent as well as the mildest of situations. For its observers it will seem forever to be stirring through its after-images.

67. The Pacts for Beauty

Among Rubens and his contemporaries, the shorthand of beauty was always a set of public and religious symbols. Like many artists, he may have read the 1551 edition of the *Emblematica* of Andrea Alciato (Alciatus; 1492-1550), the Italian humanist, jurist and friend of Thomas

III. Beauty Human and Superhuman

More and Erasmus, which prescribes the proper pose for married couples such as the one presented in his *Self-Portrait with Isabella Brant*.[52] The bride and groom, Alciato recommends, should be seated next to each other. The bride's right hand should rest devotedly on her husband's. Profuse vegetation, preferably flowers, as with honeysuckle in this painting, should be shown sprouting in the background. It should hint at their children to come and the fruitfulness of their married future.

As so often, Rubens has assimilated and altered a familiar formula. An air of playfulness as well as affection blows through this painting. In many ways it also marks a deliberate departure from the stodgy-feeling wedding pictures of earlier decades (as for instance, the dishonest, idealizing one of Anna von Saxon by Antonis Mor, or the crotchety diptych of Rubens' ancestors, Bartholomeus Rubens and Barbara Arents, by Jacob Claesz van Utrecht). If Isabella's right hand rests loyally, as it ought to, on his right hand, his left arm is crooking over a sword hilt. The blade, however, is nothing serious: a fencer's épée. His wife is not actually sitting but kneeling beside him, and perhaps because this could imply excessive adoration, she is placed a bit ahead of him. Her prominence may indicate his acknowledgement of her quasi-independence, or at least of his respect for her wishes.[53] It mingles with his artist's (and lover's?) enjoyment of her intelligence and ironic personality, which glistens in her eyes.

A lightness, combined with shades of wit in both their faces, a knowingness, a steadiness, seem to flicker across their appearing before us in this way. Rubens' hand has presented them as an enviable, ambitious couple, and as people going somewhere together. He also provides no suggestion that he is an artist. Perhaps in a picture that was to be kept at home, the very idea would have seemed superfluous. It might also have detracted from their pride in their mutual pact, or their marriage. It is this, their sacred promise to each other, that forms the unspoken public and secret basis of the beauty here, or of this story of their quest for happiness and aesthetic harmony, in which the painting itself amounts to an encapsulation of one chapter.

Here, then, may be the place to propose that one's discovery of beauty, even one's observing that a pair of eyes is beautiful rather than merely pretty, requires a pact, or profound alliance, however momentary. It is the pact that reveals and guarantees beauty's extra dimensions. As opposed to any mere agreement or deal, and like any other pact, it involves in some sense a complete yielding of oneself, and even an actual risk to one's life, even if only for a split second. It haunts about this painting too, even unconsciously, as we look at it. We sense, in other words, that the setting is organized and even dominated by that vital component, or motif, of any pact: harmonious, clear language. What is more, if their marriage vows represent one variety of the pact, the painting itself, with its legible symbols, amounts to another.[54]

At this point, it may even be useful to attempt a generalisation about pacts for beauty themselves. This is that, again as opposed to mere agreements or deals, they appear to come in at least one of three types: the sacred, or a pact involving one's soul, or most simply put, both parties' ethical choices, as here with Rubens and Isabella's holy vows; the political or social, or a pact involving the intellect or mind, as among those committed to mythical, legendary and utopian visions of history, or even to utopian social visions; and the physical, or a pact involving the body, as among people – often artists, scientists and lovers – who may seek out beauty, often at any cost, in the sensual. As one might expect, in practice reality fiddles about with each of these distinctions. The result is that all three types get mixed up with each other in actual situations as well as in art. This happens, for instance, in Rubens' symbol-studded, political portrait of the Duke of Lerma, which shuffles the Duke's royalist politics into the painting's quasi-religious pact with immortality. It happens in his *Self-Portrait in a Circle of Friends*, which presents Galileo and Justus Lipsius in the context of their tacit pacts with science and philosophy: that these will supply the visible world with those extra dimensions essential to seeing its beauty from a scientific or philosophical standpoint.

In Rubens' wedding picture, a restiveness wafts through the limbs of both man and woman. Neither is passive. Their heads and hats tilt toward each other. The hem of Isabella's burgundy dress falls across his left shoe. It pairs with her hand that rests on his. Their studied casualness implies their having stepped out of their busy lives for a moment, almost as if they were caught up in a home movie. You too, as you join them in this excerpt from their story, may feel swept out of your life, if only briefly, and offered what amounts to a moment of glorious timelessness – yet another motif of beauty and any experience of it.

Here, as well, may be the reason that there hovers about this scene an atmosphere that it may make sense to describe as angelic, for want of a better word and despite its limiting religious connotations, or an apprehension of extraordinary, celestial freedom. Freedom of this type – which may be understood as a major component of the beautiful – can be experienced only with a story that seems to have no end, that feels somehow infinite. As with Keats' Grecian urn, it may 'tease us out of thought,/As doth eternity'. It may also, and refreshingly, provide the liberating opposite of what can be termed the demonic, or the charisma of the ferocious, egotistical and obsessive. Angelic freedom must in fact erase psychological, spiritual and physical darkness, however briefly. It may even deliver one onto a plateau of contemplation. This painting itself, one may concede, is incompatible with egotism, and hints only at a process of liberating harmony.

All of which may suggest a final problem with beauty itself, to wit, that experiences of it, even while offering their elements of celestial freedom

and an harmonic process, may at bottom be evil. They may be seductive tricks. They may be corrupt. One may be ill-prepared for this possibility. It will probably startle one as might an ambush. Its anguish may redouble the dread of more mundane betrayals. On the other hand, distinguishing between beauty and evil, and grasping how insidiously they often blend with each other, has always been one of the dizzier challenges of life. In the first case, that of uncorrupted beauty, enthralling harmonies may prevail forever. The language of a pact, one at least of the major types, may resolve disturbing ambiguities.[55] In the second, angelic joys must give way to strains, unrelieved violence and quite likely to slaughter: to ugliness.

68. Studio Life

By 1612 Rubens was establishing himself as an esteemed artist in his home city. His fame was spreading. It was extending itself by leaps and bounds. He and Isabella had also become parents, on March 21, 1611, with the birth of a daughter, Clara Serena.[56] In a more melancholy vein, he had endured the bitter loss of two friends, the publisher Jan Moretus, father of his childhood school-friend, Balthasar, who had died on September 22, 1610, and of Adam Elsheimer, who had also died, in Rome on December 11, 1610, at the age of thirty two.[57] Even more dismal was the death of his brother Philip, on September 12, 1611.[58]

Philip, who was just thirty seven and who left behind his wife, who was eight-months pregnant, had died suddenly. He had been Rubens' closest confidant, keenest fan and counsellor ('Be firm and maintain your complete freedom,' Philip had advised him when he became court painter at Mantua, 'at a court where freedom is almost unknown: you have that right'[59]). An expensive funeral had been arranged, but Rubens may have wondered at the numerous deaths shadowing his successes since his return from Italy. On September 29, 1610, he and Isabella unveiled his Chiesa Nuova altarpiece for his mother at the now finished chapel dedicated to her in the Abbey of St Michael.[60]

To Johann Faber he wrote inconsolably about the death of Adam Elsheimer that 'after such a loss, our entire profession ought to clothe itself in mourning'.[61] Elsheimer had lived in Rome since 1600, and had proved as salubrious an influence on Rubens' ideas of drama and the role of landscape in theatrical paintings as a poor manager of his own affairs. He had been a set of contradictions: good-natured, hermetic, studious and lazy (Rubens gently accuses him of 'the sin of sloth'[62]). He had declined into poverty and been sent to debtors prison.[63] Rubens remarked that 'he has died in the flower of his studies', adding that 'I have never felt my heart more profoundly pierced by grief than at this news'.[64] Anger prickled in his threat that 'I shall never regard with a friendly eye those who have brought him to so miserable an end'.[65] He

acknowledged, however, that it was Elsheimer's own 'sloth' that had 'deprived the world of the most beautiful things [that he might have painted] ... [and that he] caused himself much misery, and finally, I believe, reduced himself to despair'.[66] He lamented that 'with his own hands he could have built up a great fortune and made himself respected by all the world'.[67]

One may guess that the phrase 'with his own hands' was no accident. Any artist, writer and composer (as well as almost anyone else) made his living or fortune with his hands. To Rubens, however, the painter's hands always seemed special: they could be regarded as eyes. '*Sed habet ocultas manus*' (but he has hands that see), a line from the ancient Roman playwright Plautus, was one of his preferred Latin mottoes.[68]

Throughout this time, working in his studio that he was arranging according to principles of mass but scrupulous production, and with commissions coming in regularly, his life had begun to pick up. A feeling of triumph and exhausting industry filled the air. Money could be made (in 1610-11, he earned over 3,400 gilders on his painting[69]). Young artists in search of apprenticeships applied to him in large numbers. There were too many of them, and he turned most away. To Jacob de Bie (Bije), an engraver, antiquarian, editor and secretary to the Duke of Aerschot, he wrote (on May 11, 1611) of his regret at having to reject the application of 'the young man whom you recommend. From all sides applications reach me. Some young men remain here [in Antwerp] with other masters, awaiting a vacancy in my studio. Among others, my friend and (as you know) patron, M. Rockox, has only with great difficulty obtained a place for a youth whom he himself brought up, and who, in the meantime, he was having trained by others. I can tell you truly, without any exaggeration, that I have had to refuse over one hundred, even some of my own relatives, or my wife's, and not without causing great displeasure among many of my friends'.[70]

Their displeasure was accompanied by envy, awe and hopes for the future. To those in the know, it seemed possible that a flourishing age in art, one beneficial to Antwerp itself, might be under way. Vast projects, involving talented younger and older artists, might redeem the decades-old malaise. The reason was that for nearly a century the better off Italian, Flemish, Dutch and German artists had run their studios as artists academies, as Rubens now began to do. Apprentices were trained by assisting qualified masters in their larger projects (in Antwerp this tradition had begun with Frans Floris[71]). The more gifted might later embark on projects of their own under their masters' direction. Specialisation was encouraged (Rubens was encouraging it) in depicting animals, flowers and landscapes. This was seen by the apprentices themselves, who may have realized that their inventive strengths might never rise to their masters' great heights, but who might excel at colours, details and filling in sketched-out compositions, as a gateway to earning

a good living. They might prosper, it seemed, no matter how second-rate their abilities.

Just now, too, the combination of the city's peculiar circumstances – its scores of churches standing about stripped of art forty years after the iconoclastic violence, the recent ceasefire and Jesuit money sifting in from Rome – began to lead to an avalanche of orders for devout paintings, an astonishing sixty for altarpieces by Rubens alone, to be done over the next few years.[72] Novice painters streamed forth, eager to take up almost any work in the arts in a city devoid of most other opportunities for educated people. On the other hand, a seventeenth-century north-European atelier, such as Rubens', never resembled a factory so much as a theatrical company – Shakespeare's, for example, with its writer-actors, players, dressers, musicians, boy actors-in-training, set-builders and makeup-and-prop people, collaborating on rapidly-turned-out plays for their audiences. An altarpiece was really a living painted theatre. It was animated by church music and meant to be seen by an audience of hundreds, if not thousands.

In the midst of this new spirit of enterprise, everyone continued to count on the safety net of peace, with the belief growing that it would hold. The failure of the Dutch to lift their blockade might in the end not matter too much, because Antwerp's former glory, visible in its fine houses that had survived the Spanish Fury, such as that of Nicolaas Rockox, might revive with a fresh impetus anyway as artists working with Rubens and other Antwerp masters made strong contributions to an age of money-making aesthetics that could prove triumphant.

Dreams along these lines, plus his desire to give his family a fine home, may have guided his purchase in November, 1610, of the big, old house with a fairly large garden on the Wapper canal.[73] He did not move in right away, but set about rebuilding or in fact reinventing it. He read up on architecture in books bought from the Moretus press while working on other projects.[74] From the moment when he acquired the property, his intention seems to have been to transform it into a sort of public wonder that would be even more than a home and a workplace, that would rival the most splendid artists' mansions of the past. Guido Reni's posh house in Rome, and Quentin Massy's two houses in Antwerp, The Ape and the St Quentin, with their swaths of putti and classical adornments – buildings converted into works of art for the display of aesthetic ideas – might be exceeded by a Counter-Reformation studio cum museum that would indeed be a home, but that would also set an example of the latest, often Italian aesthetic principles among his unaware northern friends. It might help to promote the city itself.

Rubens' many involvements may now have looked to his friends as if they were shooting off in odd directions. Actually, they revolved about a core of rationality and courage. Italy and Spain had not only enlightened but emboldened him. He seems to have realized that a chance to affect

civilized taste, to change the world, was unfolding, and this during a bellicose time in European history when, despite threats of war here and there, educated people remained convinced of the virtues of material progress and the values of the arts and sciences. Shakespeare was writing *The Tempest* and Galileo discovering mountains on the moon in 1611, as Rubens conceived some of his most beautiful painted meditations on philosophy, death and the human forms of divine energy – and as he began to expand his concept of beauty so that it came to resemble an actual democracy of aesthetics.

The nature of this new idea consisted in an appropriation of the complete range of human experience. It swept out of his insight that if the hand of the artist might 'see' beauty in everything, then its universality might be universally demonstrated. This could be managed, especially as a challenge to conventional attitudes towards beauty, by doing corpses as well as living bodies according to the principles of his enlivening style, in pictures capturing awkward, candid moments as well as instants of ease, and even in paintings of beautiful women who were big and fat as well as slender and more conventionally pretty. The world's idea of what was beautiful might be elaborated. The stimulation of ubiquity might be relished. A dead wolf or wounded boar as well as Venus might open one's eyes to the eternal process of the beautiful. A horse moving in a stable, or two farm hands dragging a cart, could reveal its richness as well as any emperor. Storms at sea might be made to disclose their miraculous energies as interestingly as rustic paradises – along with drunken gods, leering ones, or leering women, or contemptuous ones. Every subject was a temptation. In a literal as well as a religious sense, his taste was becoming more catholic.

His *Four Philosophers* (c. 1611, 167 x 143 cm., today in the Palazzo Pitti, Florence; plate VII) is conceived as a portrait of two dead men alongside two living ones. Another dead man, the philosopher Seneca, scans the heavens over their heads.[75] He appears as a marble bust, but looks alive even if subdued by a serene, or philosophical, agony. The painting seems to have been intended as a memorial to Rubens' brother Philip, and to Justus Lipsius, who had also died, in 1606, but what is startling is not that it shows the dead as they once were but that it lets them return, so to speak, from the grave as if alive, to join Rubens and their mutual friend, Jan Woverius, who had also studied with Lipsius.[76]

The drama of the red-, gold- and black-accented scene set in a small studio, or reading room, is thus one of life in concord with death. It centres on a beauty-inducing pact made with philosophy. Three of the four men have made life-long pacts with this speculative branch of knowledge as an instrument for discovering life's extra dimensions, such as truth, ethics and beauty itself, in an extra-clear way. Rubens may even have made his own pact with philosophy, given his enthusiasm for reading the Stoics, though his deepest pact, as always, lay with art, which

demanded almost everything (one is reminded of the young author Tonio Kröger's comment on his own tormented pact with art in Thomas Mann's eponymous novella that 'he who plucks one leaf from the tree of art must pay for it with his whole life'[77]).

As Rubens presents his brother and his two friends, and himself, books, possibly by Lipsius (his commentaries on Tacitus and Seneca) and by Philip himself, are piled on a table. The bearded Lipsius, a bit abstracted, seems to be discussing a passage from one of them, while the other men, but not Rubens, sit listening. Four tulips are set out in a vase on a shelf beside Seneca's bust, two open and two closed, symbols of the two living and two dead participants.[78] Rubens, who stands behind the other three and looks out at the viewer with his eyes just slipping past you, assumes a solemnity absent in his earlier self-portraits. It snuggles against his air of generosity. Neither the sheen of the oils, nor Philip's conjured-up vitality – Lipsius seems appropriately stiff, but then he always does – nor Lipsius' pet dog Mopsy nuzzling at Woverius' knee, nor Woverius' business-like élan, cancels out the eeriness of this encounter, or of yours with them, or the otherworldliness of these relations between the living and the dead – as the two spectral figures firm up before you with the force of vitality, conscience, affection, rejoicing and even guilt.

A different eeriness, one involving supernatural surrender and spiritual privation, transforms the altarpieces *Descent from the Cross* (centre panel, 1611-14; 420 x 310 cm., in the Cathedral of Our Lady, Antwerp) and *The Raising of the Cross* (centre panel, 1610-11; 462 x 341 cm.; entire triptych, 462 x 641 cm., in the same cathedral; figs 11, 9), which Rubens also in part or wholly finished at this time.[79] In both works, spiritual giants and misguided behemoths in human guise – where have these enormous, Mannerist figures come from in his mind? – seem to tread the earth. In the first, an overwhelming cosmic storm dies down as Christ's bleeding body is lowered, amid a milky cascade of sheets and flesh, to the three Marys waiting below. The striking figure of a man bending over the cross, with Christ's winding sheet caught between his teeth, is borrowed from a picture by Daniele da Volterra in SS. Trinità dei Monti, though the man is here endowed with a voluptuous power missing in the original.[80] In the second altarpiece, the universe seems to pour star-flushed, galactic muscles into the very arms and legs of huge Roman soldiers and workmen trying to raise a heaven-imploring Christ into his crucified horror.

Both altarpieces serve up a bustle of murder and prayer on a scale seen before only in the Sistine Chapel. Herculean forms and arrayed hurricanes of colour seem to scrawl the viewer's pact for his or her soul (if he or she is a believer, and a more transient one if he or she is not) into a dramatised legend that translates the original Christian drama into its essential energies. Titanic haste combines with patience. Unearthly tenacity fuses beauty, the angelic and evil in a strange yet proportional

way, so that beauty itself, ever threatened by cruelty, is seen to triumph only because the universe remains harmonic, no matter what its ghastly human stories.

Rubens' *The Entombment* (also *c.* 1612; 131 x 130.2 cm., now in The J. Paul Getty Museum, Los Angeles; plate VIII) carries his conviction of beauty's spookiness even further. This painting reaches past an old, barren frontier, that of a decadent movement in the arts during the latter half of the fourteenth century, following on outbreaks of the plague. Despair sinking into decadence had seen a vogue in glass-walled sarcophagi across parts of Europe. The glass walls allowed the visitor to some knightly tomb to compare an idealized marble effigy of its occupant, on the sarcophagus lid, with his mouldering body in the sarcophagus itself.[81] His decayed flesh served as a warning: life was a toy: it meant nothing except as a chance to opt for heaven, his idealized state, or a joyless place of eternal decay and torment, indicated by his rotting away before your eyes.

Christ's skin in Rubens' painting slips past this sort of cheap shock-effect into a deeper shock to traditional theology (although the painting received theological approval[82]). Deliciously coconut-white in death, the flesh of the sacrificed Son of God glitters with the pure and the macabre, with heaven and hell. It writhes in death, and awaits resurrection, but with what glorious or offended or eager spirit one cannot tell. His skin seems dead and alive and aching, and it is problematic, and this perhaps is the point, whether its frank sexuality implies the kingdom of the blessed or that dismal underworld reserved for those abandoned to the frustrations of sensual pleasures.

An indication of Rubens' relations with his public is the fact that his commissions for these pictures, *The Entombment* as well as his two altar-pieces, or 'widescreen' triptychs, came about through local political people who were his friends, church authorities known to him and, in the case of *The Raising of the Cross*, also through a friend, Cornelis van der Geest, who happened to be a dean of the Guild of Haberdashers, a tradesman who loved art and collected it.[83] At this stage of his career in Antwerp, leaving aside the Archduke Albert and his wife, royalty and lofty personages had nothing to do with setting him up in the world or making him well known.[84] He was in demand among his peers.

69. The 'Lover of Antiquities'

Could one remain interested in beauty and be indifferent to politics? For him, as opposed to some recent artists and writers, such as Oscar Wilde and Thomas Mann in their aestheticist periods (writers who found a conflict between the demands of art and those of politics, though both changed their minds[85]), the question was irrelevant. Propaganda, or the affirmation in art of political values, need not mar its complex beauty. As

he had long known, ethics had everything to do with style. In his own life too, he could no more ignore politics than relinquish his fascination with philosophy, or science, or buying up *curiosa*, which often connected art and politics and was an undying passion among the educated classes of Europe.

Curiosa, as his brother Philip had learned from his French bibliophile friend Nicolas de Peiresc in Padua, could mean almost anything, as long as they were strange, sometimes beautiful, pretty, or gaudy and informative of past cultures or nature (at some point Rubens purchased an Egyptian mummy, which he showed off to his daily visitors and dinner guests[86]). What qualified as curious, or exotic, depended, then as now, on when and where one lived. An ancient Greek coin might seem less stimulating to an ancient Greek than to a seventeenth-century Antwerper. The tooth of a tiger might arouse less excitement in the jungles of Southeast Asia than in Brabant, unless it was embedded in one's leg. Rubens quickly began to amass a collection of old coins, ancient statues (which on at least one occasion he purchased by the cartload), ivory statuettes and crystal vases, as well as other vases in agate and jasper and carved precious gems.[87]

At night, when he was alone and when he was not reading (as far as is known, he did not paint by candle light[88]), he liked looking at, examining and handling what he had bought. Many of these objects contributed details to his paintings. Many, it seems, gave him ideas for colour combinations (as in his extraordinary *Death of Hippolytus*, done around 1611, and now in The Fitzwilliam Museum, Cambridge, Eng., with its foreground of meticulously reproduced sea shells).

By 1618, he found himself living in an ideal place in which to enjoy his constantly changing collection. The city was quiet, without war, though ominous hints of a new conflict, a different, brasher and even more horrible one, had begun to emanate from Prague. His new house was finished.[89] He and his family – in addition to his daughter, he now had two sons, Albert, born in June, 1614 (and admiringly named after the humane duke and ruler of the Spanish Netherlands) and Nicolas (named after a Genoese banker friend), just born, on March 23 – had moved in.[90] Renovated and refashioned according to Rubens' wishes by 1616, the house was really a combination of two buildings, the older Gothic one, done in the traditional 'streaky bacon' style of Antwerp brickwork, and a new one, a mixture of ornate (or what is today termed Baroque) Italian arches, niches and pilasters, indented with tall windows (figs 14, 15). Both were yoked together by an ingenious passageway that looked out, at its back, onto a courtyard fenced at its far end by a grand and complexly carved stone portico, beyond which lay the garden.[91] The combination of these two building styles and structures was a bit like Nicolaas Rockox's double-fronted mansion, or another double-fronted one built over half a century earlier, that of Lucas Cranach, who had also been passionate about politics.

At its front, the house ambled into a small, sumptuous museum leading off a larger art gallery. The museum proper unfolded as a round, Pantheon-like chamber, or theatrical alcove, and was illuminated by sunlight through an opening at the centre of its domed roof (fig. 12). Marble busts, coins and the other exotic objects that were his delight were set out on semicircular shelves.[92] The art gallery was probably crammed, perhaps even floor to ceiling (in the manner of many practising artists), with paintings purchased from artist friends, from other artists whom he admired (possibly with Adam Elsheimer's work among them, though this is not clear[93]), samples of his own work and, it is likely, a globe or two and scientific instruments (perhaps *à la* Galileo's dividers).[94]

In trying to understand this apparent mishmash, it is crucial to remember that museums in the modern sense did not exist. Equally pertinent is the exploratory, adventurous temperament of his age, in which, from a European point of view, large quarters of the Earth remained unexplored and unknown but guessed or hinted at through reliable reports, worthless gossip and the often wild stories of returning sailors or captured specimens of humanity put on display themselves as curiosities: Africans and American 'Indians'. Atlases and the curvature-projecting maps of Mercator (Gerhard Kremer, 1512-94), himself a native of Antwerp, were a recent invention.[95] For most people, the universe appeared a divinely organized certainty, about which they believed that they knew a great deal, while the world in which they lived overflowed with alien mysteries. The vast majority, who still trusted in the Ptolemaic System and who were Christian, along with Jews and Moslems, felt confident of their cosmic location but not of their earthly companions. If science in the modern sense seemed episodic rather than progressive, because it was just lurching into its modern phase, an atmosphere of general unknowing and suspicion allowed all sorts of people, and especially accomplished artists, to regard themselves as swashbuckling explorers on the frontiers of discovery, or as amateur scientists themselves. The naturalist movement, made up of gentleman-farmer observers recording the migrations and habits of birds, for instance, had just begun to gain popularity.[96] Naturalist descriptions of plants and animals would lead, two centuries later, into daring speculations on human evolution and, in 1859, to Darwin's *Descent of Man*.[97]

To amass *curiosa*, therefore, as well as to paint, was to investigate and report on cosmic and natural forces as much as to train telescopes on Saturn's rings or to discover laws of motion. There was also, pleasantly enough from Rubens' point of view, money to be made in collecting and reselling. In many ways, painting and business remained what they had been for a long time by now, aspects of the same spreading about of the energies of beauty, for profit and delight – and possibly for nurturing useful political connections.

He plunged with clearheaded enthusiasm into buying and selling what he and others collected. The 'lover of antiquities',[98] as he termed himself, became a cheerful, diplomatic and tough bargainer. His remarkable letter to one of Europe's leading art connoisseurs, the English ambassador to the Hague, Sir Dudley Carleton (1573-1632), in which he proposes to swap a substantial group of his own paintings for 'all those antiquities in Your Excellency's house',[99] or some ninety ancient Greek and Roman statues, and to do so without having seen them, or even having seen a list of them, exposes a side of Rubens' personality that is polite, friendly, confident of his own worth as an artist and undaunted by Carleton's high rank and power (Carleton had seen several of his paintings, and was anxious to make the trade):

> Your Excellency may be assured that I shall put prices on my pictures, just as if I were negotiating to sell them for cash [the purpose of this was to match them up with the values of the statues]; and in this I beg you to rely upon the word of an honest man. I find that at present I have in the house the flower of my stock, particularly some pictures which I have kept for my own enjoyment; some I have even repurchased for more than I had sold them to others. But the whole shall be at the service of Your Excellency, because I like brief negotiations, where each party gives and receives his share at once. To tell the truth, I am so burdened with commissions, both public and private, that for some years to come I cannot commit myself. Nevertheless, in case we agree as I hope, I will not fail to finish as soon as possible all those pictures that are not yet entirely completed, even though named in the list here attached [*In margin*: The greater part are finished.] Those that are finished I would send immediately to Your Excellency. In short, if Your Excellency will resolve to place as much trust in me as I do in you, the matter is settled.[100]

It was settled, though not without a bit of crisp haggling over whether the pictures were authentically his. He himself was keenly aware that pictures smelling too much of the hand of the apprentice, that might be seen as lacking in his recognizable touch, were worth far less, and ought to be ('according to my custom, I have employed a man [Jan Wildens] competent in his field to finish the landscapes [or landscape backgrounds], solely to augment Your Excellency's enjoyment. But as for the rest, you may be sure that I have not permitted a living soul to lay a hand to them'[101]).

Value was determined by patience ('with the aid of the sun, if it shines bright and without wind (which raises dust and is injurious to freshly painted pictures), they will be ready to be rolled after five or six days of fine weather'[102]). The value of a painting could also never depend on excellence alone ('one evaluates pictures differently from tapestries,' he wrote to Carleton, who at one point in their negotiations asked him to throw in some tapestries along with the paintings that he was sending; 'the latter are purchased by measure' – but this at a time when marvel-

lous tapestries were by no means the rarities that they are today, and when ateliers in Brussels were producing them by the score – 'while [pictures] are valued according to their excellence, their subject and number of figures'[103]).

The bargaining for Carleton's statues turned out to be a formidable transaction on both sides. As Rubens knew, it was also not without its political implications. Carleton was a friend of the English monarch James I, who had knighted him.[104] The proposal for the deal had been cooked up by another trusted acquaintance of the king, George Gage, himself a Catholic, and a suave, debonair negotiator, who 'knew his way around the Antwerp studios' and who had been a frequent visitor to Rubens' studio, where he had gotten to know him and had seen him at work among his apprentices.[105] The benefits to Antwerp that might accrue from congenial relations with the powerful ruler of a country that had so recently supported the Dutch were not to be overlooked. Behind this trading of Rubens' art for *curiosa*, one might assume (as he seems to have assumed), lay the important theme of continued peace. It may have figured into his offering Carleton as many as nine pictures 'entirely by my hand', plus others done by 'my pupils' but with his own 'complete' retouching.[106]

Two of these must spark interest apart from their artistic loveliness. One, as he told Carleton, represented 'Sarah in the act of reproaching Hagar, who, pregnant, is leaving the house with an air of womanly dignity, at the intervention of the patriarch Abraham',[107] a painting that harked back to his own childhood copy of the same scene by Tobias Stimmer, perhaps done in Cologne during his family's refugee days. The potency of this drama had never left him.

The other was 'a picture of Achilles clothed as a woman', and 'although retouched by my hand', was by 'the best of my pupils'.[108] The pupil was Anthony van Dyck, who was just nineteen and who had been admitted as a 'free master' into the St Lucas Guild of artists on February 11, 1618.[109]

The house on the Wapper, in other words, was becoming a concentrated field of aesthetic and political energy itself, with its large, sunlit studio (measuring eight by ten metres and built into its new wing) now turning out paintings for export to influential courts abroad (fig. 13). There is also evidence that the studio may have seemed large enough to him to accommodate lions. To Carleton he announced that three of his paintings included in their exchange contained lions, tigers and leopards. He added that they were 'done from life'.[110] How and where he may have made contact with the tigers and leopards is not known, but a possibly true, possibly apocryphal story about his sketching and later painting lions, which figure beautifully into his *Daniel among the Lions* (now in the National Gallery, Washington, D.C.), has it that he invited a travelling lion-tamer to bring one of his trained beasts into the studio so that

he might sketch it. The animal wandered about placidly enough until Rubens tried to get it to pose for him, whereupon it fell into a bad mood, which frightened Rubens, and which a few days later led the humiliated lion into eating its owner.[111]

70. Jealousy, War and the Engraving Business

Perhaps because beauty implies both purity and corruption, it often provokes jealousy and violence. In 1621, the Twelve Years Truce between Spain and the United Provinces dwindled to an end. Not only was it not renewed, but its lapse was seen by the Spanish as an opportunity for their ingenious general Spinola to use his disciplined soldiers to inflict crippling damage on the Dutch. Even if Spanish hopes of retaking the provinces to the north had faded, still the Dutch might be stymied in their support of Protestants streaming together to participate in an even larger conflict, one that menaced Spanish and Hapsburg interests across Europe. This debacle, maturing into a conflagration, had begun in Prague and had been booming, brewing and crackling along since 1618. It would eventually be called the Thirty Years War.

Rubens had been born during the first stages of the Dutch Revolt. His early life had been shaped by military violence in his unseen homeland and close to his German home-in-exile. In Italy for eight years, and so far in Antwerp for over a dozen, he had known the pleasures of peace, though always under the threat of war. Now a ferocious war had indeed been kick-started (quite literally, with the famous defenestration of Catholic Hapsburg ministers by Protestants at Prague's royal castle on May 22, 1618), and in view of the gravity of the issues at stake and the tumult of the passions involved, there seemed little prospect that it would soon subside. The broken-up territories of Germany, long since divested of any semblance of centralised government, and with great swaths of torched farmlands as well as entire German duchies under the jurisdiction of foreign potentates, such as the King of Denmark, or under outright Spanish control, were deteriorating into a battlefield. Protestant versus Catholic animosities, distorted by sheer spite, were expressing themselves in monstrous acts of indiscriminate slaughter.[112]

Just to the north, even the weather during the ominous winter of 1624 seemed to rise in fury against the Dutch, though it made no difference to the battle-toughened Spanish troops under Spinola, who ignored it. Terrible cold and winds fierce enough to blow the roofs off houses were succeeded by a springtime bursting of the dykes, whose floods drove rural populations into the towns and cities.[113] In the late spring of 1624, unpaid units of the Dutch army mutinied at the strategic town of Breda, not far from the border of Brabant and some twenty-five miles northeast of Antwerp. Their act of treachery seemed to open other, human floodgates for a possible Spanish invasion of Holland. More distant cities, such as

Amsterdam and Utrecht, felt threatened. The danger was repelled, but not before Spinola, at the head of 11,000 picked men fresh from victories along the Palatine and in Germany, laid siege to Breda itself, forcing its inhabitants into conditions of near starvation.[114]

Efforts to negotiate a truce came to a halt with the death of the Dutch commander, the fifty-two-year-old popular Maurits of Nassau, on April 23, 1625. His younger brother, Frederick Henry, William of Orange's remaining son, himself over forty and according to the standards of the day a bit advanced in years to assume any major command, but who took over from him anyway, was unable to break the Spanish siege. His relief regiments proved too meagre. The promised English assistance, which might have reversed the situation, had been redirected elsewhere, into Germany, by James I, who thought that Protestant forces might be better deployed where the main action of the wider war was now surging forward. The result, on June 5, 1625, was that Breda surrendered to Spinola.[115]

This defeat offered the Spanish not only a military success, which they publicised on broadsheets throughout Europe, but also a chance to demonstrate their chivalric spirit, a virtue absent from most of their violent encounters with the Dutch. No doubt Spinola's character, which was praised by Rubens (who had also painted his portrait), was responsible for this display of Spanish gallantry. Affected by the defiance and courage of the Dutch defenders, Spinola greeted their commander as he stepped out of his lost fortress, and embraced him.[116]

All these events, combining theatres of blood and politics, blended in Rubens' life into a moment of change that seeks illumination. He seemed at this time to stand almost alone atop a gritty tor of personal and artistic achievement, while around him, as if bathed in ruined shadows, lay the ghosts and influences of some whom he had known, and who had mattered to him, whether as friends or as obstacles to his advancement, and others who had stroked and even pampered his progress, though he had not known them, but who had altered his life from afar. They had slipped away. They were being supplanted by others. The focus of his life had begun to shift. Among their forms gleaming in memory across his artistic successes lay confused episodes, some brilliant, others lucrative, some selfish, and one abashed by jealousy and mystery. If he had by now arrived at a quality of fame that led his admirers to compare him to the miracle-painter of ancient Greece, Apelles, doing so with conviction, he had also paid a price for their praise in his singular visionary isolation.[117] He paid it as Breda surrendered. It may have seemed negligible, because the Breda triumph was a Spanish victory of which he approved. In realism he may have felt that he could do nothing else.

The hedonistic Spanish king, Philip III, who had helped him twenty years earlier, had died on March 31, 1621, the Duke of Lerma just a few months ago. More staggeringly from the point of view of Brabant's future

and that of the southern provinces, the Archduke Albert had died on July 13, 1621, four years earlier.[118] With his death, and because his marriage to Isabella had been childless, control of the Spanish Netherlands had reverted, according to Philip II's wishes, to the new Spanish king, a frivolous teenager, Philip IV (1605-65), by now twenty, and his favourite, Gaspar de Guzmán, Count of Olivares (1587-1645).

Olivares, an ex-university official, was an administrator of intelligence and ferocious industry, whose incessant storm of memos, letters, pronouncements, declarations of policy, staff changes and orders to his king's commanders in the field – plus additional blizzards of documents dictated to a coachful of jumpy deputies who followed him about wherever he went, even on deer and wild boar hunts – drove four of his frazzled secretaries into their weary graves. As rugged and box-like of body as he was shrewd, Olivares brought the determination of a Sisyphus into his futile dream of saving Spanish supremacy. His obsession with power prompted one of his colleagues to remark, 'It is true that the [Spanish] ship is going down, but under other captains we should have perished much sooner.'[119]

Rubens had no wish to see it go down at all, not out of any great loyalty to the Spanish, and not (like his father) out of any great respect for kings or monarchies, though individual kings might win his esteem, but out of a passion, common to millions on either side of the spreading conflict, for peace and safety. It had needed no special acumen to imagine, even as early as the mid-teens of the new century, that Europe must be drifting toward the reef of an immense war. Even among the indifferent, if anyone was truly so, information about the latest skirmishes and peace conferences, or the royal marriages intended to cement alliances, as between Charles, the Prince of Wales, and Henrietta Maria, sister of Louis XIII, in May of 1625, had long been available in a novel way, through what may have been the world's first daily newspaper. It had begun publication under the direction of Abraham Verhoeven at number 6 Lombardenstraat (Vest) in Antwerp in 1605, a couple of streets over from Rubens' house on the Wapper.[120] Ordinary Antwerpers, not to mention someone such as he, with connections to the highest levels of government in Brussels, could watch with detached helplessness as the tide of a warlike passion everywhere began to rise. Then as now, one could have observed how much more convenient it was to justify violence than to waffle disagreements, how much easier to promote excuses for murder than to allay raging passions.

As a result, one's allegiance, like his, driven by family pride and religious anxiety and repulsed by the Europe-wide fragmentation, might have reached out with relative ease, as did his, to the Spanish empire, which more than local political institutions seemed able to provide stability. One's loyalty, though, like his, might easily have lain with one's own people, for him his fellow Flemish, whose sense of identity, or

'Flemishness', had in any case been developing for over two hundred years.[121] He had lived briefly in Spain. He had made the acquaintance of powerful Spaniards such as the Duke of Lerma, whose influence was now being erased. His true friendships, however, had been forged in Italy, his deepest ones in Antwerp.

It may therefore come as no surprise that many of his most ferocious pictures, as if they were auguries of war itself, sprang onto his canvases before the end of the Twelve Years Truce. He painted his astonishing hunting pictures, *The Lion Hunt* (249 x 377 cm., in the Alte Pinakothek, Munich) and *The Hippopotamus Hunt* (248 x 321 cm., also today in the Alte Pinakothek; plate IX) in 1621 and 1614-18, during the waning period of peace. Both deliver up a primordial violence. At the same time, they are bloodless. They show theatres of rampaging instincts, but skirt their nauseating actualities. They amaze one's sense of dread. As in his copy of Michelangelo's *Battle of Lapiths and Centaurs*, slaughter moults into a ballet of dancers-to-the-death – and yet not quite, for both pictures seem to leap beyond themselves into a new and frightening terrain, doing so in part because of a realistic touch often omitted from his other paintings: the open mouths of the men and animals that are here displayed. Despite the silence of art, both hunting scenes thunder with fright. They sound a horrid, general alarm as they re-echo with the tacit agonies of the wounded and dying, among the menacing snarls, snorts and hisses of a wolf, horses and a crocodile.

The Hippopotamus Hunt, if anything the more dramatic of the two because it hardly seems a hunt at all and shows the grotesque triumph of a hippopotamus over its human pursuers, stirs with the bellowing of a tusky-mouthed, awesome mammal, a force that sweats and charges visibly among us, and that is rendered even more startling because one expects – from those hippopotamuses that one may on rare occasions have seen (is this one a reincarnation of the pickled hippopotamus that Rubens possibly saw in Rome?) – a flotational calm, a vegetarian passivity. A hippopotamus is to be understood as a type of water-treading potato, one imagines, not a stampeding hill.

Something terrible and early in the history of the planet is released in this painting. A demonic force tramples humanity to death. The struggles of its hunters count for nothing. A couple of them will be lucky to escape with their lives. If we are shielded from the dreadful impact of their deaths by the absence of their blood, which seems reassuring, we are left to anticipate it. Our apprehension remains unaffected by the knowledge that Rubens took part of this *inventione* from old Roman sarcophagi, which depict lion hunts, but no hippopotamus hunts, and that the picture was commissioned by Prince Maximilian of Bavaria as one of four hunting scenes to be hung in his Castle Schleissheim, and even that this picture fits in with sixteenth-century attitudes toward hunting wild animals, which saw the hunter as heroically pitting himself

against sylvan barbarities of all sorts.[122] All this seems irrelevant. What Rubens has painted is a human defeat, and indeed the humiliation of the human species. The lack of blood, as in classical Greek tragedy, serves only to steer us away from bathos into a cool contemplation of a cruel spectacle, and enhances the tension.

The pre-war period of his art also spawned the sensual and frightening beauty of his most disturbing religious scenes of rescue and damnation. His *Last Judgement* (1616; 605 x 474 cm., in the Alte Pinakothek, Munich; plate X) and *The Fall of the Damned into Hell* (1618-1619; 289 x 226 cm., also in the Alte Pinakothek) coincide roughly with his series of hunting scenes (which after the *Lion Hunt* he apparently had no wish to repeat). In *The Last Judgement*, God, or the Ancient of Days, a glass-coloured humanoid shadow bathed in light, looms above the Holy Ghost and a Christ who beckons with one upraised hand to the saved, a remarkably fresh-looking bunch, to rise from their graves to join him, while with his other hand he presses down into darkness the doomed where they are lugged off by devils. The whole painting consists of a plush ring of tangled nude bodies, male and female, young and old, flying in space and a great shining, a pillowy doughnut of heaven- and hell-bound strangers mingling affection, fear and cordial sexuality. You notice, therefore, that it forms an unbounded circle, the divine circle that he had limned with a dividers years before: the design of God's mind, but now worked up into dozens of passionate men and women, as the divine One seems to oversee the universe.[123]

These two visions of salvation and damnation dovetail with a new and profitable business that he had by now established. This involved hiring accomplished engravers to produce copies of his paintings (Pieter Soutman's engraving is all that survives of another *Lion Hunt*, done for Maximilian, which was destroyed by a fire in 1870[124]). A purely commercial, if aesthetically exciting enterprise, and actually the usual route for artists wanting to earn as much money as possible from their paintings, it had been set in train by 1613.[125] By 1619, though, he began to supervise it with vigilance, seeking and obtaining, chiefly because of problems with plagiarists, his personal copyright protection, amounting to licensing, in the United Provinces (where Dudley Carleton's help proved crucial, as the Dutch parliamentarians were at first uninterested) and in Brussels and France.[126]

Throughout these years, into 1625, a novel haste, hopefulness and scepticism seemed to lay hold of him. His sharpening attitudes seemed accompanied by a refocusing of his personality. Brasher strengths, deeper dreads, more finely tuned forms of selfishness, kindness, suspiciousness and even love, all reflected in his letters, and banking against a steelier sarcasm, as if time were growing short – before what military or other catastrophe descended? – can be felt in his brisk, polite paragraphs. After October 25, 1623, this refocusing may have been hastened by the death

of his daughter, Clara Serena, who was just twelve.[127] Before that, and apart from the failing European political situation, it may have taken a shot of perverse vitamins from rivalries in his studio, leading into the alienation of several friends, a consequence, perhaps, of his success and inner isolation.

There is evidence, for example, that he fell out with his former teacher, Otto van Veen, a bare hint that he had trouble with the delicate, sultry and handsome Van Dyck, who may have relocated to England because he felt a bit crowded by Rubens' dominance in Antwerp, and strong if murky evidence of a violent attack on him, even a murderous assault, in April, 1622, by his most gifted engraver, Lucas Vorsterman (1595?-1675). The Van Veen difficulty surfaces in a letter in which Rubens asks his friend Pieter van Veen, the brother of Otto and living in Holland, to see whether he cannot get hold of a copy of a book on predestination that Otto had recently published. Why did he not simply ask his ex-teacher himself for a copy (Otto seems to have been living not far away at all, in Brussels)?[128] One senses that Rubens felt that he could not. A credible guess would be that he found it impossible. A suggestion that Van Veen was jealous may not be amiss. Jealousy had shown its tortured face before with Van Veen, at the end of Rubens' apprenticeship, and one can understand, forgive and gauge the heart of the older, good painter by it, a man who had made all the right career moves, including studying and nurturing his gifts in Italy, only to see the prize of art and fame borne off by his pupil. He perhaps never understood that the pupil who respects his teacher in some sense always remains a pupil, or that to be without his teacher's latest book might be as painful for him as his former teacher's desolation over his celebrity.

With Van Dyck, this situation may have been reversed. Rubens' relationship with him remains clouded by unknowns. Brimming with precocity and also the prickle of genius from his teacher, lifted onto an aesthetic Parnassus when he was twenty and already a guild member, and then fed on the manna and the artistic foods of the gods at Rubens' studio, Van Dyck seems at first to have admired Rubens, though whether their mutual enjoyment lasted more than a few years is a mystery. Their personalities were opposites. Where Van Dyck was a slim, blonde figure of impulse, romance and pleasure, a perpetual child and moon of whimsies, Rubens worshipped at the more serious shrines of calculation, intensity, steady passions and tough questions about history and truth. He invited Van Dyck to live with him, but this was not uncommon among masters and apprentices. They collaborated on several paintings and, in 1618, six cartoons (now lost) for a set of tapestries showing scenes from the life of Decius Mus, 'the Roman consul who sacrificed himself for the victory of the Roman people', as Rubens noted, a sizeable commission from Genoese merchants.[129] What is interesting is that from 1630 to 1632, or several years later, Van Dyck, who had given Rubens two of his

paintings, one of which was of Isabella Brant, before he left for England and Italy and then England again, where he lived and worked as a court painter for Charles I, took into his employ as an engraver the man who now attacked his teacher.[130]

Lucas Vorsterman was working as Rubens' engraver by 1618.He too had been precocious, producing his first engraving when he was twelve. When he and his wife, Anne Franckx, the sister of Antoine Franckx, also an engraver, had their first child, a boy, baptised in 1620, Rubens acted as godfather. At the time, relations between the determined-looking, big-handed Vorsterman and his employer seem to have been amicable.[131] Rubens assigned him various designs for engraved reproductions, among them his *Lot's flight from Sodom, The Battle of the Amazons, Descent from the Cross* and *St Francis receiving the Stigmata.* To Pieter van Veen, who was to handle the sales of these pictures in The Hague, Rubens wrote that he had found someone who lacked the egotism of 'great artists' and who, so he thought, would be happy enough working as an excellent copyist (he had reason for high hopes, as his engraving operation was just heating up): 'I should have preferred to have an engraver who was more expert in imitating his model, but it seemed a lesser evil to have the work done in my presence by a well-intentioned young man than by great artists according to their fancy' (his contempt for the vanity of 'great' artists is unconcealed).[132]

For a time, it seems, all went well. Vorsterman turned out an astonishing number of marvellous engravings based on Rubens' oil sketches. Even while doing so, however, he seems to have begun to veer off in a bizarre direction. This becomes plain if one considers two revealing portraits of him painted shortly afterwards by Van Dyck. Each shows a face full of arrogance, but that is not the point, which is that he had plainly set out to imitate Rubens' demeanour, his very look, even to the extent of wearing similar clothes and combing his hair and beard in the same way. A process of identification with his admired master had taken him over, flattered by their vaguish physical resemblance and coupled with Vorsterman's growing resentment at his own lack of recognition.[133]

The dank knottiness of their relationship seems to have sprung open in the summer of 1622, when two events, one unacceptable to Rubens, the other to Vorsterman, occurred in succession. In April, Rubens wrote to Pieter van Veen, who kept asking that more engravings be sent to him, apologising for any delay and hinting at a problem with Vorsterman. He was stalling, and had apparently come to regard his own work as more important than the originals. 'Unfortunately we have made almost nothing for a couple of years,' Rubens told Van Veen, 'due to the caprices of my engraver, who has let himself sink into a dead calm, so that I can no longer deal with him or come to an understanding with him. He contends that it is his engraving alone and his illustrious name that give these prints any value.'[134] A queer defensiveness enters into his protest

that 'to all this I can truthfully say that [my] designs are more finished than [his] prints, and done with more care. I can show these designs to anyone, for I still have them.'[135] In fact by 1621 Vorsterman had begun to sign the engravings with his own monogram. In July, 1622, he applied for and obtained his own copyright protection.[136]

By June, 1622, however, Rubens was already writing to Van Veen of 'the mental disorder of my engraver'. He again apologised for delays, adding that he had a *Battle of the Amazons* almost ready but that 'I cannot get it out of the hands of this fellow, though he was paid for the engraving three years ago'.[137]

Intolerable though all this may have seemed, still quite a bit of evidence on the other side indicates that Rubens drove Vorsterman mercilessly. The crisis between the two apparently came to a head when Rubens asked him to produce an engraving from his allegorical sketch of Charles de Longueval, Comte de Boucquoy, a well-liked artillery commander for the Spanish and later an officer in the army of the Austrian emperor. Longueval had been killed at Neuhäusel in 1621, in one of the battles of the new war. As was the custom, a memorial engraving was sought for speedy distribution to his friends and the public (Longueval had been killed only six weeks before Rubens received this request).[138] After what seemed an agony of months devoted to the hard, exacting work required to replicate Rubens' complex design in oils, Vorsterman came up with the picture. He also took his revenge. In secret, he scratched a record of his misery over the work into the plate itself. This took the form of a minuscule, amateurish verse that Rubens seems never to have noticed: 'This cost me, because of the bad verdict, much vexation,/Many nights of worry and great aggravation.'[139]

Whether he now staged his attack, which failed, or had done so earlier, as seems likely, perhaps storming at his employer with a weapon in his studio, is unknown. The word 'verdict' in Vorsterman's pathetic jingle may refer to a first attack (there may have been more) and to a court judgement brought against him for it. As early as April, in any case, Rubens' own friends had sought a writ of protection for him from the Spanish King's Privy Council, presumably against Vorsterman ('owing to the attacks of an insolent and, in the opinion of several people, disturbed individual'). This was turned down, but on April 29 it was granted by the Archduchess Isabella.[140]

An attack of some sort seems to have taken place. Throughout the summer of 1622, Rubens' acquaintances as far away as Paris heard rumours that he had been not only assaulted but murdered. Vorsterman soon left for England, but by 1630 he was back in Antwerp, and now at work for Van Dyck. Over the years that followed, his output of engravings continued as before. It was extensive. Indeed, he lived a long life. Strangely, however, after this incident he seems to have lost his touch. The quality of his work was less, and his flair seemed gone. A portrait of

him by Jan Lievens, which survives in an etching by Fans van den Wijngaerde, dating from decades later, with its lopsided face, preoccupied eyes and hair straggling off into dreamland – all this in a portrait? – shows a man who has not simply aged but been beaten or tortured into frightened submission.[141]

A darkness, accompanied by a universal effort at concealment, falls across this entire episode. One sees grief stirring in a dark, chilly room. Nights of struggle with the engraver's needle shift into days of shameful rebuke. Neurosis yields to vigour. Then the weather changes, and an envious gale whips over a headland, bringing with it an erratic blackness. Talent and egotism smash into the punctiliousness of genius. In the end, one seems forced, as in a nightmare, to peer into a vertigo at the centre of genius, itself a ghost of the everlasting, an after-image of doubt, a shimmering of perfection. A pit opens and shows a quiet churning at the centre of genius itself, a lost space like that in *The Fall of the Damned* or *The Last Judgement*, what Rubens understood so well, then closes under his lid of Stoic smoothness. Years before, he had ordered a few lines of Juvenal's tenth satire carved into the portico of his house, where its stone arch led into his garden: 'Leave it to the gods to give us what is becoming and useful to us; man is dearer to them than they are to themselves,' and 'we should pray for a sane mind in a healthy body, for a courageous spirit, not afraid of death, free of wrath and desiring nothing.'[142] As he wrote to his good friend Pierre Dupuy some time afterwards, though, he despaired of living up to the stoicism of these ideals: 'I have no pretensions of ever attaining a stoic equanimity.'[143]

He went back to work. He recouped his general calm. He recruited other engravers, among them Cornelis Galle, the Bolswert brothers and Paulus Pontius, none of whom seems to have given him any trouble. In that same year of 1622, he brought out the first volume of his long-projected *Palaces of Genoa*, with 72 plates, engraved by Nicolaes Ryckemans ('I have published a book on architecture, of the most beautiful palaces of Genoa,' he wrote to Pieter van Veen, 'about 70 folios, together with the plans, but I do not know whether this would please you'[144]). He began to involve himself in efforts to negotiate an extension of the Twelve Years Truce, though following the United Provinces' declaration of independence in March, 1621, and the successful Spanish siege of Breda, these were to prove useless.

After the Breda victory, he welcomed to his great house the Archduchess Isabella, by now a confiding friend and widow as well as mere governor of the southern Netherlands (as opposed to the ruler that she had been while Albert lived). She had returned a few days before from congratulating Spinola at his battlefield fortifications.[145] She posed for Rubens, in late June, 1625, in her widows weeds, her head shawled in black to indicate piety and mourning for her husband, who had died long ago. In this candid portrait, engraved copies of which soon circulated

among her loyal Flemish subjects, her eyes seem shy, huge and brave, and themselves full of a puzzling vertigo.

On occasion, he may have needed to remind himself of the splendid height, the tor, which he occupied, and how, three years before in Paris, he had reached it. The Paris experience had opened all remaining doors to him, including one that led to his contacts with Charles, the Prince of Wales, and to Charles' request, in 1623, for his self-portrait. He had painted it, with genuine reluctance, even as frantic manoeuvres, by the twenty-five-year-old former Cardinal Maffeo Barberini, who had just been elected Pope Urban VIII, and Germany's princes and electors, as well as James I, Philip IV, the Archduchess Isabella herself and the just-chosen Hapsburg Elector Maximilian, pushed ahead in a scrambled, futile attempt to shackle the monstrous European war.

IV

Kings, Queens, Ministers and the Angelic

71. Large Works and the Atmosphere of Creation

'I confess that I am, by natural instinct, better fitted to execute very large works than small curiosities,' Rubens had written to William Trumball, one of James I's agents in Brussels, on September 13, 1621. 'Everyone according to his gifts; my talent is such that no undertaking, however vast in scope or diversified in subject, has ever surpassed my courage.'[1]

He had been referring to the possibility, just broached to him, of doing paintings for the New Banqueting House at Whitehall Palace in London, but he might as well have been sizing up his career as it seemed to approach its zenith and his talent as he and the world were coming to understand it. It was a talent that embraced living multitudes on large canvases, but at no sacrifice of intimacy – or precisely what large-minded kings, queens and their ministers, or those who thought of themselves in that way, wanted: the world itself as it was and might be, neither trifles, nor mediocrity, nor stasis, nor paralysis: only sweeping, meaningful actions.

He had already tackled one such project. It had surely been intended to rival in scope and amazement Michelangelo's Sistine Chapel, and to put Antwerp on the map as an artistic competitor with Rome: the painting and installing at the Church of St Ignatius of no less than thirty nine canvases, for which he had signed the contract in March, 1620 (now called the Church of St Charles Borromeo, it was badly damaged by fire in 1718; all Rubens' work, with the exception of a smallish side-chapel, built to his design, was destroyed; some few oil sketches have survived[2]). It was a measure of his esteem and popularity that the Whitehall commission was offered to him, more or less, before the New Banqueting House was even finished. The brainstorm of England's, if not Europe's, finest architectural intelligence, Inigo Jones (1573-1652), and conceived along Palladian lines as a spacious theatrical arena with grandish windows and a balcony running round its lofty oblong, it would serve as throne room in which to receive arriving ambassadors, a feasting hall capable of accommodating court masques and a microcosm of new

English imperial power. It would replace a far smaller banqueting hall that had burned down in 1619.

Memory, which alone seems able to deal winning hands in poker games with time, and remains a source of time-defiant art, swirls swiftly backwards from 1625, and Breda, which lies four years in the future, and the hopeless-seeming battle situation, which also lies ahead, and his Vorsterman problem, which has just begun to surface, but is not yet more than a nuisance. Memory allows an intermission in the dance forward of events, and may allow him to stand out in starker relief. For Rubens, in September, 1621, at the age of forty four, the letter from Trumball, and his honest reply to it, had marked an ascendant moment in his life. A Danish doctor, Otto Sperling, personal physician to King Christian IV, had visited his studio in the April just past, and reported on what he saw there and Rubens' typical but remarkable way of working: 'We visited the quite famous and eminent painter Rubens, whom we found at work, while at the same time having someone read Tacitus to him, and dictating a letter. We kept silent, fearful of disturbing him, but he talked to us without interrupting his work, and while Tacitus was being read and the letter dictated, answered our questions, as if to give proof of his amazing abilities. Afterwards he told a servant to show us around his magnificent palace, and let us see his antiquities and Greek and Roman statues, of which he had a great many. We then looked into a large room without windows, but lit through an opening at the centre of the ceiling. There quite a few young painters had gathered, each busy on a different work, for which Rubens had provided a pencil drawing, highlighted in spots with colour. The young men reproduced these *modelli* in paint, and when they were done, Rubens added the final touches.'[3]

Though impressed, Sperling had waxed scornful over the money-making aspects of his operation ('this man, not content with amassing an immense fortune, ... has also had honours and expensive presents piled on him by kings and princes'[4]). Sperling seems to have had a prissy streak, and liked even less Rubens' stress on collaboration, or as he saw it, Rubens' exploitation of his apprentices, which he regarded as a cheat. He need not have worried. Most artists, and writers too, with the exception perhaps of lyric poets, still worked in collaboration: composers, architects and playwrights (the isolated novelist, despite Cervantes and Sidney, was not well known). The collaborative tradition had been a long one. Narrative poets, such as Chaucer, had performed in public and collaborated with, or borrowed from, earlier story-tellers to produce their work, doing so for the sake of 'truth' and entertainment. No one seriously interested in the arts could wonder at a painter's collaboration, even if many measured the quality of his work according to his contribution, as Shakespeare's plays too enjoyed a popularity based on his name. Nearly everyone would have been bemused by the modern idea of the cloistered artist, and baffled by the modern bohemian conception of the

artist cut off or alienated from his or her society. On the other hand, the notion of society itself, in the sense of powerful bureaucracies and nation states, did not exist either.

Rubens' collaboration with Jan Bruegel (who was called the Velvet Bruegel; 1567-1625), for instance, was already of many years' standing. They had met in Italy and become good friends. Bruegel's specialisation in painting exquisite flowers, gems, trees, sea shells, mountains and landscapes had led into several collaborative masterpieces, for which Rubens provided the human figures, such as *Madonna and Child surrounded by a Garland of Flowers* (1621; 85 x 65 cm., now in the Louvre). As early as 1612-13, Rubens had also painted a moving portrait-study of Jan's wife and two children, into which, probably somewhat later, he inserted Jan himself in his forties, wearing a tall black hat and a compassionate expression on a face that looks as worn as one of Antwerp's canvas-grey winter afternoons (124.5 x 94.6 cm., today in the Courtauld Institute Galleries, London).[5] The connection between the two men went further. Jan's father, Pieter, whom he had not known, was one of the many artists whose work Rubens had purchased for his gallery (among the others were Titian and Raphael). He may by this time have owned as many as twelve of Pieter Bruegel the Elder's paintings, including his *Flight into Egypt*. This painting, done some sixty years earlier, he seems to have found particularly intriguing, no doubt relishing its role in the invention of broad-perspective Flemish landscape art. For the past ten or more years, too, he had served as Jan Bruegel's *de facto* secretary. Jan's Italian was poor, though his patron was Cardinal Federigo Borromeo of Milan. Rubens translated many of his friend's letters into Italian for him, frequently signing his name as well.[6]

Another type of collaboration, one common enough even today, had long been deepening between Rubens and the Plantin-Moretus Press. This consisted in book illustration. Balthasar Moretus, who ran the press, was not only a friend, and one of his oldest, but also a powerful man in his own right. He lived in a nearby house almost as grand as Rubens', with a printing works on the premises that drummed out books to all Europe. Between them, they now seemed to divide their city. 'How fortunate is our city of Antwerp,' wrote Jan Woverius in 1620, 'to have as her leading citizens Rubens and Moretus! Foreigners will gaze at the houses of both, and tourists will admire them!'[7]

Shy, intellectual, intensely practical, Moretus was paralysed on the right side of his body in a curious repetition of his grandfather who had founded the publishing house after being crippled in a knife attack.[8] Balthasar had studied philosophy with Lipsius and learned book production with his first beer and herring slices. Over twenty years before, in a letter to Philip Rubens, one that his brother may not have seen, he had recalled knowing Rubens at school, adding that even then he had 'the kindest and most perfect character'.[9] With Rubens as his chief maker of title pages, Balthasar had introduced engravings into his books to replace

their clumsier woodcuts. Since 1609, apart from the slender batch of drawings produced for Philip's book on Roman costumes and a few others for a biography of St Ignatius of Loyola, Rubens had supplied him with pictures for a Roman missal and breviary, six illustrations for a book on optics by Franciscus Aguilonius (1613), the logo for the Plantin-Moretus Press itself (a dividers, appropriate to a house called The Golden Compasses) and dozens of title pages for other volumes.[10] These usually accorded with designs suggested by Moretus himself or their authors, but were often Rubens' own inspiration. The Jesuit poet Bernardus Bauhusius, fretting about the title page for a volume of his verse, wrote to Moretus in 1617, 'I know that Rubens, with his divine genius, will find something suitable for [it], suitable to my poetry, the order to which I belong, and to Piety.'[11]

In a sense, the drawing of title pages was little more than finding a public forum for his sketches. These sketches, however, were far more finished than anything merely dashed off. The thinking behind them could be as allegorically complex as any painting. Because they would not be translated into paintings, they also depended on a more delicate suggestiveness – of textures, of depth, of invisible but hinted-at colouration, of drama – than many paintings. One might present a good engraver, such as Cornelis Galle, with a precise recipe-sketch, so to speak, and then retouch the plate when it was almost ready, softening the lines and rounding them off with one's own stylistic harmonies. Rubens persisted in this work as an important sideline, in the beginning and for many years handling the engraving himself. There was not much money in it. Friendship apart, Moretus paid him about one quarter per title page what he paid his engravers (who worked longer): twenty florins for folios, twelve for quartos, eight for octavos and five for smaller sizes.[12]

He seems to have asked six months or sometimes less to come up with a design that satisfied him, doing his book work on holidays because the rest of his time was taken up with painting.[13] As an artist who had no wish to conceive of art apart from literature, or stories and language, and as one who had been brought up in happy proximity to print and the book trade through Moretus, he found it an important adjunct and diadem to his career.

Not many painters felt this way. Few had his breadth of interests. Van Dyck did no book illustrations. He collected no *curiosa*. He bought up quite a few paintings, at one time owning nineteen Titians. He felt nothing of Rubens' fascination with history, literature and science. His mind seems to have been more placid, his body more turbulent. He cultivated the dazzling and risky. His mistress in London, Margaret Lemon, a flirtatious beauty given to fits of jealousy over other beauties whom he painted, tried to bite off his thumb to keep him from painting them. While he resisted, there is no record that he minded.[14]

On occasion, instead of payment Rubens seems to have settled for

copies of books that he illustrated. His library may have contained as many as 300 volumes, on science, history, architecture, theology and the classics (a set of interests no doubt influenced by his father as well as his friends), an extraordinary number for those days, and suggestive of the possibility that he may have been one of the most widely read painters who ever lived.[15] Generally calm in his habits, efficient in the running of his theatre-company-like studio, he was scrupulous about his spiritual and reading life. His nephew Philip agreed with Otto Sperling when he noted that after attending first mass in the morning, Rubens 'applied himself to his work while a reader sat near him reading from Plutarch, Seneca or some other book so that his attention was fixed both upon his painting and the reading'.[16] Philip's observation is valuable for another reason as well. It implies that in listening to someone read while he painted Rubens may have sought to stimulate the mental state essential to doing his art itself, cultivating a trance-like, even hypnotic effect possibly induced by the combination of reading and painting, evoking another world of ecstatic liberation and ideas, in which words cleansed, prepared and soothed his mind.

72. The Medici Invitation

It was in this many-weathered atmosphere, therefore, that in November, 1621, he had received the most challenging and profitable invitation of his life. As a chance to help in the remodelling of one of Europe's most powerful palaces, it was not to be missed. If all the world was a stage, here would be his gateway to redesigning and influencing it. The Whitehall commission, after a brief hint or two, seems to have been dropped, at least for a while. On the other hand, the Queen Mother of France, Marie de' Medici, was suddenly asking him to decorate two of the longer galleries of her just-completed Palais du Luxembourg in Paris with two vast series of paintings.[17]

From the start, she apparently conceived of both series as the frankest sort of political propaganda, though as some would even today agree, in propaganda's best sense not only of self-promotion but humaneness. The first series was to glorify her own unhappy life, which had lately taken a turn for the better. Its theme would be her quest for peace. The second was to flatter the memory of her husband, Henri IV of France, dead and buried for over a decade by now, but whose bawdiness and indifference to her in life might be ignored for the sake of producing an impressive monarchy-serving legend. Whatever else an artist might choose to introduce into these paintings might be left up to him, as long as he respected her wishes and those of her advisers. Each series was to comprise twenty-four large-scale pictures. The artist was to complete the first within two years. His payment was to be 30,000 lire, with another 30,000 when he completed the second – or a small fortune.[18]

More than any other painter in Europe, Rubens had trained himself for a grand effort such as this. Not only was he skilled in the presentation of major fugues of themes and human figures, but he was also an experienced portrayer of the range of human contradictions. In hundreds of paintings he had already created a sprawling world of madcap drunks, camels poking into nativity scenes, the derring-do of exiled kings, the wrath of Achilles, the Roman rapists of the Sabines, gawking satyrs, imprisoned fathers suckling for sustenance at their daughters' breasts, Venus regarding herself in a glass, personified dogs and peacocks, dwarfs, oarsmen, Apostles, passionate autumnal valleys and everywhere on his masses of finely honed faces explosions of love, rage, delight, misery, happiness, indifference, saintliness, dreaminess and puzzlement. He had sifted onto canvases, oak panels and paper what already amounted to a global diorama of real and potential politics, where frowsiness begot seedy ambitions and adulation dished out bleakness. The Medici challenge would cap as well as extend his broad accomplishments.

He was also more than ready to meet on terms of mutual respect the French Queen whose nuptials he had attended some twenty years before in Florence. They had both travelled far since Marie's expensive wedding by proxy, though down diverging paths. His successes seemed a mirror-image of her disasters. Even her present prosperity might be an illusion. She had borne the trauma of the assassination of her royal and popular, if dissolute, husband, for instance, who had been stabbed to death in his carriage in Paris by a religious fanatic, one Ravaillac, in 1610. She had fainted when she saw Henri's bleeding body on a bed in a room full of men with swords drawn to protect her as next in line to the French throne (an arrangement worked out by the King only the day before he was killed).[19] She had also been expelled from her court by her own son, Louis XIII, who had forced her to flee Paris for Blois, but who in 1620 had been reconciled to her, albeit on his own terms, in the Treaty of Angers.[20] A corpulent, earnest, jowly woman at this point, she had endured a great deal, as was perhaps reflected in her somewhat naïve policy of trying to promote European peace through royal marriages, imagining that religious hatreds, and greed itself, could be softened by a colourful ceremony.

She had learned something about art as well, enough to grasp its political value, especially at a time of social instability and with the threat of war looming everywhere. Probably she had not followed the development of Rubens' career. His fame was such, however, that it would easily have been known to her, and he may have been recommended as the ideal artist for her project either by her sister, Eleanora de' Medici, wife of Vincenzo, the Duke of Mantua, or by her friend, the Archduchess Isabella, or by Nicolas de Peiresc, who had met Philip in Padua and had since risen to prominence as a scholar, bibliophile, amateur scientist and one of her closest advisers. Peiresc had himself gotten to know Rubens through a convivial exchange of letters between them when Rubens

applied for French copyright protection two years earlier and he had helped.[21] The two had kept up their correspondence ever since, and had unearthed a commonality of enthusiasms, for ancient coins and statues, precious stones, cameos and archeology, in which Rubens was becoming an expert. They were looking forward to meeting one another as Rubens accepted Marie's command-invitation and then made the four-day trip, probably by coach, to Paris. Even in the dead of winter in 1622, it seemed for him an adventurous moment.

73. 'The Theme is so Vast and so Magnificent'

The City of Lights, when he arrived in it, was as old as the Caesars and, with a population of over 300,000 (making it the largest city in Europe), still expanding. A tired but true adage had it that Paris had become '*non urbs, sed orbis*' (not a city but a world).[22] Ten miles in circumference, according to Thomas Coryat, who had stopped by in 1608, with fourteen massive gates thrust through its walls, it consisted of hummocks of white 'free-stone' houses and marble palaces, through which the Seine, criss-crossed by 'the bridge of exchange, where the Gold-smiths dwell, S. Michels bridge, and the bridge of birds, formerly called the millers bridge', and more 'white free-stone' bridges, including one at 'our Ladies street, in French la rue de nostre Dame', meandered beside mazes of unkempt streets that he found the 'dirtiest' and 'most stinking of all that ever I saw in any citie in my life'.[23]

Coryat enjoyed the numerous bookstalls in the Rue Jacob, the exquis-itely wrought stairs and roof at the Louvre (so 'richly gilt ... that a stranger upon first view thereof, would imagine it were either latten or beaten gold') and the long art gallery there, 'having in it many goodly pictures of some of the Kings and Queenes of France,' its ceiling deco-rated with 'the picture of God and the Angels, the Sunne, the Moone, the Starres, the Planets, and other Celestial signes'. He marvelled at walls two yards thick. He felt uplifted by the Parisian activity and haste, by the red and scarlet robes of the judges in the courts, by the prettiness, jewellery and coquetry of the finely dressed women, by the scores of gilt carriages and by the city's neat division into the University, the City proper (where the palaces shone in their whiteness) and the Town. He was pleased. He was not overwhelmed. The filth continued to appal him.[24]

Rubens was not overwhelmed either. He arrived in early January, and took lodgings on the Quay St Germain l'Auxerrois, hard by one of the bridges beloved of Coryat, the Pont Neuf. He had come by way of Brussels, where the Archduchess Isabella had entrusted him with two gifts for the French Queen, a small bitch and a necklace fashioned of twenty-four enamel disks.[25] He stayed on till mid-February, continuing the negotiations that had already been crepitating forward for months

over the pictures (what would they actually depict?). He met Peiresc, and they got on famously, becoming good friends. He seems nonetheless, as he put it somewhat later, already to have 'tired of this court', finding the in-fighting of ministers, and their 'methods', 'topsy-turvy'.[26]

Nonsense and crabbed spite could be endured for the sake of the project itself, however, which, as he also remarked (to Peiresc) not long afterwards, contained a theme 'so vast and magnificent' that he found it irresistible.[27] From the Queen's point of view, it was to show her personal triumph leading to political harmony. From his own, and this, it would appear, from the start, the ambition was predictably more sweeping. On the basis of his previous work, which she may by now have examined, his royal employer had perhaps sensed that he would produce something astonishing and new. Neither she nor anyone else, though, could have imagined what he planned to come up with: politics itself transformed by a pact for the sake of beauty and the divine.

Here at last was the chance to bring his understanding of aesthetics into an active political arena. Here was the moment in which to transfer the triumph of his art into the realm of human conduct. There was a question whether this could be done, but there was none about the opportunity, or about his interest in seizing it. He was being invited to improvise – there was no exact precedent for what was wanted – a set of historical paintings for a real court bristling with real power in the world, not merely to produce some ancient historical or mythical series, or a political portrait, no matter how brilliant, for an ambitious duke or king. The setting was suddenly far broader, the request, one might even say, more preposterous, the risks more delicate. If he accepted, a shabby, trite and simple-minded bit of political trivia, Marie's desire to affirm her revived importance to France, might be turned into a demonstration of the relations of history to beauty. History itself might be explored as a supernatural experience. It might be revealed as an art form of great importance. Applied to life as it was actually lived, it might show human beings forever facing dire choices between beauty, as a divine and harmonic energy working itself out through civilizations and the universe itself, and its opposite, the constricting power-manias of evil.

The immediate question, to be sure, was whether Marie's wishes could be handled adroitly enough to fit in with his ideas. To this problem, however, as well as others connected with doing the paintings, he brought what he usually had in abundance: his well-known tact. A good deal of Marie's life, which she in some yet unestablished way wanted him to represent, had been a disgrace. Much of it was an embarrassment. Some of it, while draped in trappings of elegance, exuded an odour of vulgarity. All this would have to be suppressed (hence the negotiations over what to include). Whole episodes would have to be transformed, either by allegory or by an invented lushness of contexts, to make them

acceptable. While in one sense this dilemma appeared to be one of dishonesty – how might he fabricate a tissue of lies about Marie's experiences – in another it only added fuel to his imaginative fires. In fact even had the raw data of her life been a model of perfection, he would have reshaped it. So-called 'realism', with no reshaping, or without some revelation of her life's invisible dimensions, would have betrayed all sense of truth by denying meaning. From his point of view, and that of his contemporaries, the universe, and anyone's life, were always more than the sum of their physical parts.

It is a testament to his tact that he achieved as much as he did. Marie's demons were fussiness and control. Artistic brilliance meant far less. Genius was irrelevant. At one point she had ordered the wooden floors of the Louvre twice replaced with Florentine tiles because the wood irritated her feet. All that had mattered to her in an Italian painting of her wedding was the accurate appearance of her dress.[28] She seems to have had a brain made quickly unsettled by opposition, and violent by frustration. She now offered Rubens a contract to do 'twenty-four pictures in which will be represented the very illustrious life and deeds of Madame the Queen', with 'all the stories which are written down and enumerated at length in writing in accord with the Queen's intention'. He agreed, and signed a memorandum specifying the stories (excepting five, to be named later, concerning her controversial son, the King) and noting 'that Rubens should entirely satisfy the Queen's intention', or not be paid.[29] If behind this imperiousness lay her unquestionable sorrow, her wish to revise her own history and perhaps some desire to get even with her son, the imperiousness itself, which was only another exhibition of her fussiness, may be seen as a source of her suffering. It might cause more.

Returning to Antwerp, Rubens set to work on preparatory oil sketches. At the same time, much in the manner of a modern theatre or film director concerned with authenticity, he dispatched a flurry of questions to Peiresc about details: Marie's birth sign (Taurus, but he ignored that), the colours of garters, shields, breeches, gowns and banners, the wording of inscriptions.[30] Special care had to be taken with any pictures representing Louis XIII, that he not be insulted lest a civil war break out or his outrage lead him once more into forcing his mother into exile. Peiresc advised a scheme of 'mystic figures [or personifications and emblematic devices, whose meanings were often incomprehensible] and ... full respect toward the son'.[31]

There were trickier problems. Rubens had been kept in the dark about the wall sizes and door locations of the still not quite finished galleries. These had to be established. Evidence of sabotage of the project soon emerged. Slanderous rumours began to circulate, concocted by rival French painters who had been passed over for the commission. In July, 1622, when reports first reached the French court that Vorsterman had

attacked him, these moulted into tales of brawls in his studio, wounds, stabbings and death. Scurrilous stories were repeated so often that Marie, worried that both project and painter had perhaps been lost, became alarmed and had to be calmed by Peiresc, who had already learned from Rubens that he was fine and at work.[32]

Indeed he was, with his customary speed, while marshalling for each canvas his knowledge of ancient and modern politics (though agreeing to do all the painting himself, he may have received a bit of background if not research assistance from others). He busied himself with little else ('I must finish the canvases,' he wrote to Frederik de Marselaer, Treasurer in Brussels, turning down for the moment an attractive project there, 'before I do any other work'[33]). The results were more than astounding. By May 24, 1623, or just ten months after signing his contract, he had completed nine of the twenty-four canvases, proceeding at what even for him must have amounted to a headlong pace.[34] Anxious to show the work so far done to the Queen, he made arrangements to take his finished paintings to Paris, then dithered over how to move them in safety ('they are drying and being sent by waggon (I myself following by [coach]')[35]). To a Parisian acquaintance, however, probably a friend of Peiresc's, with whom he stayed while in the French capital, he wrote in a somewhat livelier vein: 'I beg you to arrange to secure for me ... the two Capaio ladies of the Rue de Verbois, and also the little niece Louysa. For I intend to make three studies of Sirens in life size, and these three persons will be of infinitely great help to me, partly because of the wonderful expression of their faces, but even more by their superb black hair, which I find it difficult to obtain elsewhere, and also by their stature.'[36] Whether he ever used them and their exciting black hair as models remains a mystery (they have not been identified). His request provides a rare glimpse into his reliance on live models and how he evaluated them.

Marie returned to Paris on June 10, 1623, from Fontainebleu, where she had been vacationing, doing so expressly to see what he had accomplished. She was delighted. So was her chief adviser, the Abbé de St Ambroise (who actually tried to spirit away some of Rubens' sketches for his private collection). Delighted too was the young Cardinal Richelieu (Armand-Jean du Plessis; 1585-1642), who had been named cardinal only the year before and whose influence over the Queen seemed to grow by the day (Richelieu, it was said, 'could not weary of admiring' Rubens' pictures).[37]

He may have stayed on in Paris to retouch them. He perhaps supervised their storage under lock and key. Only a select few were to be permitted to see them before the whole series was finished and installed, a precaution taken to prevent the King from getting wind of what his mother was up to and perhaps intervening. By the end of June, Rubens was back in Antwerp.

74. Science and Art amid the Ruins

While he did little else during this strenuous time, on August 3 he managed to get off a letter to Peiresc, thanking him for sending along some ancient bacchanalian gems designed as rather sexy phalluses and vulvas ('they seem to me inestimable'), another of his enthusiasms ('I am extremely pleased with the *diva vulva* with the butterfly wings.... The reason for comparing the vulva to the snail I cannot imagine, unless perhaps because of the capacity of the shell, which is a receptacle both deep and capable of conforming to its tenant – or perhaps because the snail is a viscous and moist creature ... I tell you this freely between ourselves ... but the subject is very indecent'[38]). He also alluded to their mutual scientific interests. He reverted to an idea that had captivated the minds of educated people since the beginning of the century, and that had long held a special artistic fascination for him: that of perpetual motion.

He had forever been interested in motion. The idea of it lay at the centre of his art. It was the key to understanding space, mass, life, love, sex, bell-ringing, music generally and anything sensual. To create paintings that produced and reproduced it was to enter into the silent secret of the universe, a bit like praying, or contemplating salvation or meditating on grace. Within and beyond motion lay the sunnier secrets of light and energy, those divine flares for the sake of whose revelation, and for over two hundred years by now, Flemish and other artists had made pacts with their brushes, oils, turpentines, egg whites, chalks, canvases and cross-grained, glued panels, as well as the tendrils and tenacities of their very souls. If, as seemed probable, a Dutch scientist, who might or might not be a fraud, had come up with a machine that moved by itself by means of chemical reactions, and perpetually, his experiment, to which Rubens referred in his letter to Peiresc (it also seems clear that they had discussed this possibility before), was worth examining. Perpetual motion machines were an educated person's holy grail. In a sense, his own paintings were forms of perpetual-motion engines made of lines and colours that would go on changing forever, even as after-images for their viewers.

'I am glad you have received the design of the perpetual motion,' he wrote, reaching Peiresc at his estate in Provence, to which he had now retired. 'It is accurately done, and with the sincere intention of communicating the true secret to you.'[39]

Rubens well understood his friend. Peiresc had his own observatory. He had heard Galileo lecture in Padua. On reading about Galileo's telescope, in 1611, and learning that with it he had discovered moons circling Jupiter, he had built a telescope of his own, following the Paduan professor's description of how to do it (as Galileo himself had worked from a Dutch description), and seen Jupiter's moons for himself.[40] The

scientific hunt was on for the secret of perpetual motion, or understanding motion itself, and Peiresc wished to join in. He could not have known that Galileo had already solved this problem by inventing a new way of thinking about motion altogether. He had abandoned quasi-metaphysical pursuits of its 'secrets', and devised an empirical method that produced extraordinary results: an account in mathematical terms of how motion actually takes place in gravitational fields, or the laws governing moving objects. In establishing these laws, he had also founded modern physics, though the idea that he had done so might have astonished him.[41]

Rubens himself remained confident, at least for the moment, that the perpetual motion machine designed by Cornelis Drebbel, who had published an account of it, would work. 'If in Provence,' he urged Peiresc, 'you should try the experiment and it is not successful, I pledge to clear up all your doubts.'[42] As late as December, 1624, while winding up the last of his Medici paintings, he returned to the problem in another letter. By then he had ordered a working model of the machine and was sending it to Palamède de Fabri Valavez, Peiresc's brother, in Paris, to be forwarded to Peiresc in Provence: 'I have ... provided it with a special case, in which it is to operate according to instructions which I have already sent to M. de Peiresc, but which I will send once more to refresh his memory about how it ought to function.'[43]

Nothing came of it. Like myriad tantalising experiments along these lines, it proved worthless, though Rubens seems indeed to have sent his model. Drebbel's invention, it appears, consisted of little more than a glass tube. Its movements, or the risings and fallings of a liquid in the tube, depended on atmospheric pressure, but Pascal, who might have explained this phenomenon to them, telling them that Drebbel's machine was a type of primitive barometer, had only just been born, one year earlier, and would not make his own discoveries about barometers for decades.[44]

Far more exciting discoveries about motion were actually in progress in Rubens' studio. Nearly all his paintings for the Queen's gallery, the remainder of the first series, perhaps ranged in vast vertical pools of colour along his studio walls, or left out in his enclosed courtyard on bright winter's days, were drying ('it would be better to give me a little time to allow the colours to dry completely,' he wrote to Valavez on December 26, 'so the pictures can be rolled and packed without danger of spoiling anything'[45]). For the moment they remained hidden away – a concealed glory kept incognito even from his own city, a novel, possibly amazing secret amid Antwerp's continuing desolation.

About Antwerp's desolation there could still be few doubts. The neatened-up squalor glinted everywhere. All attempts at revival had failed. Even now, apart from its churches refreshed with Rubens' altarpieces, his own grand house and a few striking older buildings, the metropolis in

which he had chosen to live and work continued to deteriorate as before, amid leisurely neglect and barely changed since his return from Italy.

Fine mansions sat mute, left empty because their owners had moved north into the United Provinces, or to England, or France or Germany. The roads were deserted. A scarfed winter sun hobbled among the wretched alleys and pencilled in the gaunt cobblestones of the Great Market Square, where the triumphal entrances of monarchs and archdukes belonged to an alien past. In 1624, the Flemish historian Golnitzius noted that 'there remains only a great solitude; the shops are covered with dust and spider webs', and 'one never sees a merchant or a courier'.[46] He was inclined to attribute Antwerp's pernicious misery to renewed warfare between the United Provinces and Spain. As long ago as 1616, however, Dudley Carleton had reported that 'in the whole time we spent there I never set my eyes in the whole length of a street upon forty persons at once; I never met coach nor saw man on horseback; none of our company ... saw one penny-worth of ware in either shops or in streets bought or sold.... In many places grass grows in the streets, yet ... the buildings are all kept in perfect reparation. Their condition is much worse ... since the truce than it was before'.[47]

Antwerp was a kind of ghost-town. Everything lay in readiness for a new prosperity that had not come and that could not come, at least not now. In another sense, though, the purely human, this might not matter. Within the private chambers of his unusual home Rubens had been creating a series of paintings that, sent out into the broad world, might begin to improve human perceptions and hearts.

75. The Triumph of Political Theatre

Pressure mounted on him to finish quickly ('due to the brief time allowed for finishing the Queen Mother's pictures, and to other duties besides [possibly his involvement in attempts to renew the Twelve Years Truce, at the behest of Isabella], I am the most harassed man in the world'[48]). Marie wanted her gallery resplendent for the wedding of her daughter, Henrietta Maria, Louis XIII's sister, to Charles, the Prince of Wales, though these arrangements were later changed as with the death of Charles' father (James I died on April 6) he himself ascended the throne. Henrietta's wedding, by proxy – for the new king would await his bride in London – was scheduled for May 11, 1625.

There may have been no formal unveiling of Rubens' cycle. Perhaps the haste to install and retouch so many paintings ('I [have to] retouch the entire work, anyway, in its destined place'[49]), plus the politics involved, with Louis XIII himself invited to view the pictures afterwards, and to say who knew what, made formalities inadvisable.

After arriving in Paris for a two-month stay in March, 1625, Rubens in any case found himself busy with more than the cycle's installation. A

kind of secondary diplomatic and snooping career had begun for him. Acting as an agent for Isabella, which meant sizing up the chances for French assistance in promoting peace in the Netherlands, he had been asked to make discreet observations of the French court. As had happened before – with Antonis Mor at the court of Philip II, for instance – a painter who had access to royalty and state officials might serve as an unobtrusive diplomat and even spy.

The time for negotiations still seemed propitious. The siege of Breda was now underway. Maurits of Nassau was alive. Breda's surrender, which would spark the spread of a wider war in the north, was not yet to be thought of. There still seemed a realistic hope of lessening the military violence, or at least of directing influential European minds toward peace. Rubens, however, came quickly to doubt the sincerity of those whom he met (about one French agent, Fuquier, who approached him and others with peace proposals, he wrote to Isabella that 'he is a man of the worst reputation, accustomed to taking money by means of groundless claims', and about French attitudes he noted that 'it is a state maxim to keep the war in Flanders ever alive'[50]). While no stranger to the shabbiness and guile common to court life elsewhere, he concluded that he was wasting his time from a political point of view in a place 'where the truce is more abhorred than anything on earth'.[51] He begged the Archduchess, who might be worried about the exposure of his mission, lest it compromise her own good relations with the French Queen and her advisers, 'to have [my own] letter thrown into the fire'.[52] Like his father before him, he had begun to discover that pacts for peace and political beauty seemed to arouse more enthusiasm in art than in reality.

In his art, at least, they were stirring up a great deal of it. 'I am certain,' he wrote to Peiresc, 'that the Queen Mother is very well satisfied with my work, as she has many times told me so with her own lips.'[53] Others, such as Richelieu, Louis himself and even the French painters whose jealousy had inspired slanders against him, were satisfied as well. The satisfaction certainly continues. Transferred today from the Palais du Luxembourg, which houses the French Senat, to the Louvre, where the cycle has been reassembled as Marie originally saw it, his dramatisation of her life, this extraordinary biography, with its multiple acts in twenty-four scenes, what he had done at home, unfolds and moves before you as it did, as a blaze of colour that only with gradualness, as your eyes adjust to what seems a rebirth of heaven on earth, resolves itself into the various figures:

The cycle begins, as one could expect from a painter deeply committed to ideas of theatre, with what is also its end – with a parting or closing of crimson curtains. A full-length, over-life-size portrait of the Queen (24), today positioned above the far door in the reconstructed display room, shows her stepping forth humbly and regally between full-length, over-

life-size portraits of her parents, Francisco I de'Medici (1541-87) and Jeanne d'Autriche (1547-78), each of whom likewise steps out before bunched crimson curtains.

This sweep of crimson and often red material in curtains and sometimes drapes flares across the twenty-one other paintings. It rises and falls between them. Frequently it is complemented by carpets in scarlet. Thrown against its sunrise profusion of a vast wave undulating straight through Marie's world is another wave in gold, yet another in blue and one in ivory. Gold shimmers in the candelabras, the trim of soldiers' shields, the scabbards of their swords and sword handles and the coins and medals cascading from the hands of putti flitting about the heavens, or proffered by Marie and others to successful generals as rewards for their victories. Robes and capes, as well as chariots, podia and a boat, are gold too, not pure gold because Rubens always allows mixed and accented colours to mellow the ambitions of his modelling, but gold that amplifies the light of its colour-neighbour, usually ivory or blue. The range of the blue is broad, from the menacing, flannel-grey blue of the sea in *Louis XIII Comes of Age* (19 in the sequence) to the creamy, sun-lit gold-blue of the heavens in *The Exchange of Princesses at the Spanish Border* (16) and *The Return of the Mother to her Son* (23). The blue heavens, moreover, are unquestionably heavens and never simply skies. As in so many of Rubens' paintings, they are specialised expressions of the miraculous.

Glinting among the massive waves of crimson, gold and blue is a white wave of linen, of papers scattered about and the pages of open books. This is clearly a wave of illumination, milk, flesh, foam, pacts both kept and shredded and blessing. Its wreathing through the reds, golds and blues as a room-round stole, as a delicate yet Herculean ermine boa, wraps the whole work – for the Medici paintings form a single work as the Sistine Chapel presents a single story – in a utopian harmony. It is the harmony of human politics pervaded by the divine.

What is missing today for the viewer, to be sure, is the political bustle, the original audience of court officials, ministers, twitchy philosophical types, gossips, occasional musicians, wits, actors in the occasional court masque, messengers, ladies-in-waiting and secretaries. As with Rubens' numerous paintings designed for specific places and today in museums – his altarpieces or his hunting scenes plumping out the mansions and castles of noblemen – the display of Marie de' Medici's history in this newish hall has about it a whiff of rescue from a lost past, of extrication from life, a dryness.

This is only for an instant. Then one is gathered into the magnificent theatre of struggle that Rubens has invented, its glossings over truths and its truth.

From the start, you are aware of its great and eloquent silence. In so large a series, occupying so large a space, your sense of pictorial silence cannot perhaps be avoided. Here, though, it seems a feature of his idea,

a quality of the plot of the paintings themselves, one that he has thought through and put to use: as if the silence of colours and forms were endowed with a special sort of speech, the capacity to give utterance to the nature of awe.

This is not to say that noise is nowhere enunciated, only that the suggestion, one of great power, of a unique silence suffusing every scene, especially those involving violence, dominates the drama you are watching (what Picasso with misguided, hostile prescience called 'journalism, historical film'), and that it is emphasised by the few hints of sound: waves slapping at a ship's prow (in *Louis XIII Comes of Age*), the playing of a viola da gamba (in *The Education of the Princess*, 5), the snarl of a lion (in *The Marriage consummated in Lyons*, 9), the far-off blare of horns (in *The Coronation in Saint Denis*, 12, and *The Felicity of the Regency*, 17), a cry of agony (in *The Council of the Gods*, 14), a single note blown on a conch shell (in *The Exchange of the Princesses at the Spanish Border*), and a psychotic, baffled roar from the monster of Ignorance (in *The Return of the Mother to her Son*) as it is flung into darkness by an avenging angel at the end – or not quite at the end: the paintings indeed shape a cycle, and at the end you are brought back to the beginning: the over-life-size and silent portrait of Marie triumphant. All hints of noise are subsumed in the silent, muffling waves, tidal waves really, of colour – the reds, blues, golds, ivories and whites – that sweep across the action, and that wash away these minor slappings, gurglings, musical notes, roars and cries as so much trivia beside their immense cosmic laws, consigning them to oblivion. It is the presence of these master waves behind and running through everything, and pumping all into a quiet, fluid harmony – a bit like the intrepid laws of motion discovered by Galileo – that helps to produce one's impression of eloquent awe itself.

At the same time, this very emotion, like any form of cowed happiness, of reverence complicated by sensations, is restless, to use Burckhardt's phrase, and this in the midst of its silence. This is because you are conscious of being plunged into a drama – as Mantegna created a feeling of participation for his viewers with his large Camera degli Sposi and *Triumph of Caesar* series, which Rubens had seen and admired in Mantua years ago. You realize that the Medici cycle is a quiet court masque swivelling about you. You may also come to see what is less obvious and more interesting, that it precisely resembles in dramatic style and movement the plays of Rubens' brilliant contemporary, Shakespeare (who had died nine years earlier), and for whom, as for Rubens himself, all the world was a stage, with all the men and women on it merely players.

Both Rubens and Shakespeare are the creators of what may be called the theatre of fantastical persuasion. In this type of drama every scene, almost without exception, offers up wild and implausible images whose

intention is to persuade someone to do something that he or she may or may not want to do. Othello woos and wins Desdemona, for instance, with his fabulous tales of anthropophagi, who carried their heads beneath their shoulders. Mercutio persuades Romeo to attend the ball where he will meet Juliet by describing the fairy Queen Mab and her magical kingdom. In Rubens' *Presentation of her Portrait to Henri IV* (6), Henri is shown as besotted with a princess, Marie de'Medici, whom he has never met, and enchanted with the idea of marrying her because of her fanciful likeness in a portrait, an image as fantastical as those of anthropophagi and Queen Mab: it bears scant resemblance to the Queen-to-be, and Henri never fell in love with her. The scenes of this type of theatre take on countless protean forms, as in the comparable plays of Marlowe, Ben Jonson, Kyd and Webster. If Hamlet is roused to action by a ghost, and Henry V's troops are goaded into fighting the French by his quick poetic sketch of them as old veterans looking back with pride on their future St-Crispian victory, so here Marie consents to her education at the knees of giant gods and goddesses, and persuades her son (in *Louis XIII comes of Age*) to share with her the captaincy of the French ship of state – something that, again, she never did – while both pose in the prow of a miniature, allegorical ship of state oared through choppy waves by a crew of sensual, hard-working Amazons (3.94 x 2.95 m.; fig. 16).

Everywhere in drama of this sort problems with the mundane are resolved by the power of unearthly imaginings. Action is the premise and guiding virtue. Persuasion is the goal. It is shown as coming about through mythology. Always the fantastical, or a visual invention, prods the various characters into making choices. Marie is shown escorted into a temple of safety by Mercury, who brandishes a caduceus wrapped in writhing snakes (*The Queen opts for Security*, 21). Mercury, again, proffers her an olive branch to convince her to accept peace negotiations with her son in *The Negotiations at Angoulême* (20).In *The Regent Militant: The Victory at Jülich* (15), the Queen, above whom soars a winged Victory offering her the crown in battle, rides forth on a horse reminiscent of the light-shot stallion in Rubens' portrait of the Duke of Lerma – and this in a scene whose method of persuasion is violence permeated by a dreamy myth (3.94 x 2.95 m.; fig. 17). To be sure, Rubens' commitment to fantastical and persuasive theatre harks back to his early *Judgement of Paris*, in which Athena, Juno and Venus try to bribe the egotistical shepherd-hero with dreamy promises of power, conquest and beauty. By comparison, the Chorus at the beginning of Shakespeare's *Henry V* wishes for

> a muse of fire,
> That would ascend the brightest heaven of invention,
> A kingdom for a stage, princes to act,
> And monarchs to behold the swelling scene!

Then should the warlike Harry, like himself,
Assume the port of Mars, and at his heels,
Leash'd in like hounds, should famine, sword and fire
Crouch for employment,

and this is precisely what Shakespeare's plays and Rubens' Medici cycle provide: the torments of human flesh relieved and soothed by unearthly panaceas (whose meanings may also, a genuine risk, be evil). Ordinary people, or actors, as Shakespeare's Chorus puts it, thus become 'cyphers to this great accompt', or the drama. Actors divide 'into a thousand parts'. They work on your own 'imaginary forces', and you, as viewer-participant, make 'imaginary puissance'.[54] The politics presented in this sort of theatre are to be saved or damned by the powers of imagination.

'I believe I've written you,' Rubens told Peiresc, in one of his two surviving discussions of the Medici cycle, affirming the role in it of fantastical, persuasive theatre, 'that a picture representing "The Departure of the Queen from Paris" has been removed [because it would have offended the King], and in its place I have painted an entirely new one, representing "The Felicity of Her Regency" [rather amazingly, the new painting was done at top speed after he arrived in Paris]. This shows the flowering of the kingdom of France, with the revival of the sciences and the arts through the liberality and the splendour of Her Majesty, who sits upon a shining throne and holds a scale in her hands, keeping the world in equilibrium by her prudence and equity.' Intended to persuade Marie herself, as well as Louis XIII and others, of her unthreatening nobility, this strangest of the paintings seems inflated and fraught with a glory that is almost too much to bear (3.94 x 2.95 m.; fig. 18). As flattering to the Queen as it is jammed with delightful nudes, a study of motion straining against stasis for the perfection of the political state, it shows the fantastical as capable of moulting into a glorious disease, a type of shining ulceration. Rubens was aware of the unreality here: 'This subject, which does not specifically touch upon the *raison d'état* of this reign, or apply to any individual, has evoked much pleasure.'[55] Even if overblown, however, and reaching the limits of what your mind can accept (always a problem with this sort of drama), it still fitted in with his larger theme: 'I believe that if the other subjects [too] had been entrusted entirely to us, they would have passed, as far as the Court is concerned, without any scandal or murmur.'[56]

His grand theme, riding the waves of his colours, and hinted at in this picture, is human imbalance and corruption transformed by an extraordinary pact for beauty as a process in actual politics. This is made clear at the end (before we begin again) in *The Return of the Mother to her Son* (23), when we witness the banishment of the frightening monster of Ignorance.

In optimism and confidence, this climactic pact moves beyond peace.

It moves through evil into a triumph over competing greeds. Marie's life is shown as achieving meaning because it is danced through stages of assassination, exile and return by the hands of an artist whose paintings are an earthly arrangement of divine energies. History is thus shown to be a supernatural art that explores the relations of the natural allegories of the human mind – dreams and nightmares – to what people do in the world. In Rubens' cycle one sees myth and allegory pouring into their world, taking on crazed, evil and angelic forms and influencing what happens there. History, as the cycle presents it, is not merely facts, or verifiable facts. Neither is it simply allegory. Instead, a theatre of fantastical persuasion combines with facts, nightmares, dreams and allegory – as it did for the ancient Greeks and Romans, and as it may do for us, though most of us may be unaware of the unconscious magic that weaves new spells through our lives.

Bumblings and a messy accident accompanied the wedding of Henrietta Maria and Charles I by proxy in May, 1625, and the first recorded public viewing of Rubens' cycle. He wrote to Peiresc that just prior to the royal wedding Louis XIII 'did me the honour of coming to see our Gallery', where the Abbé St Ambroise managed to avoid all controversy and offence to the King by serving 'as the interpreter [of the paintings and their allegorical senses], changing or concealing [their] true meaning with great skill'.[57]

He missed out on the Abbé's performance. Fitting him for a new boot, a shoemaker so wrenched his ankle that 'he almost crippled my foot' ('I remained in bed for ten days, and even now, although I can mount a horse, I still feel the effects of it keenly'[58]). At the wedding itself, a balcony on which he was standing beside Peiresc's brother, Valavez, along with the guests of the English ambassador, suddenly fell apart, hurling Valavez and others onto the floor. Valavez was left with a nasty bruise. Rubens avoided injury by stepping back just in time: 'To my horror [he wrote to Peiresc], I saw your brother, who was just beside me, fall with others. I myself was standing on the edge of the adjoining scaffolding, which remained safe ... I had hardly time to draw my foot from the collapsing scaffolding and set it on the floor that stood firm. And from here there was no possibility for anyone to descend without falling. Therefore I was unable, at this moment, to see your brother, whether he was injured or not. I was obliged to remain there in this anxiety until the end of the ceremony. And then, slipping away as quickly as possible, I found him at his home with a wound in his forehead. I was terribly distressed.'[59]

Perhaps equally distressing was that he had not been paid, and that despite praise all round, nobody wanted to discuss payment. Richelieu, who had now risen to being French prime minister, at the age of forty one, a radiant, shadowy person, immaculately dressed, lanky, haughty

and literary (with an amused lack of candour, he insisted that he preferred 'writing verses' to running France), seemed happy enough with Rubens' paintings (he ordered one of his portraits for himself) but suspicious of their implied hostility to his new ally, Louis XIII.[60] He felt an especial disdain of Rubens' pro-peace politics. At the moment he was more interested in war. Its purpose would be to eliminate Spanish-Hapsburg influence in Germany and the Palatinate, setting France free for independence of action across Europe – a policy that he had no problem in describing as defensive. For his own part, Rubens guessed that as a result Richelieu might oppose his doing the next series of paintings, those centering on Henri IV, though he had already submitted his plans: 'I believe there will not fail to be difficulties over the subjects for the other gallery, which ought to be easy and free from scruples.'[61]

As on his previous visits, he was also finding himself 'tired of this court'. His major and unspoken reason, apart from his problems with Richelieu, was the general French indifference to the violence whipping in and out of the Netherlands (Richelieu was right to wonder about his politics on this score). A passion for seeing the war stopped was becoming paramount with him. It was the source of his rueful, sarcastic remark to Peiresc that 'unless [those at the French court] give me prompt satisfaction, comparable to the punctuality I have shown in the service of the Queen Mother, it may be (this is said in confidence, *entre nous*) that I will not readily return'.[62]

He longed for his family and friends: 'Time passes, and I find myself far from home, to my great disadvantage.'[63] A cloud of frustration impinged on his pride in having finished his great work. It was only relieved by one superb contact that he made just after the wedding, with George Villiers, the Duke of Buckingham, who had been dispatched by Charles I to escort his new bride back to London.

Buckingham shared his frustration. An extraordinary personality, often maligned yet able and intelligent, once the favourite, indeed the 'sweet child and wife' of James I (for so James had still called him in 1624, in the midst of an illness that augured his death, adding, 'Grant that ye may ever be a comfort to your dear dad and husband'[64]), dazzlingly handsome, obscenely rich, eelishly clever, flamboyantly loyal, the nearly thirty-three-year-old Duke had always appealed to Charles as well. After James' funeral on May 7 – following hard on Buckingham's sincere tears and his participation in the funeral procession, to which he wore a black robe and hood and led a horse clad in a black velvet cape studded with silver and pearls – he found himself named the new King's representative at Paris, where his duties consisted not only in collecting Charles' wife but also in bargaining with Richelieu over a possible alliance, or at least an *entente*, between their countries.[65]

In the latter he had been sorely disappointed. Unlike Rubens, whose overtures to Richelieu were greeted by silence, Buckingham was received

by the prime minister and had spent hours discussing the Spanish problem with him, and that of the Protestant Huguenots, which had assumed insurrectionist proportions at the port-city of La Rochelle. Despite his best efforts, however, and here his treatment matched Rubens', he had gotten nowhere. Richelieu had listened. He had expressed sympathy. His manners had been perfect. He had also indicated that his passions lay elsewhere. What these passions might be was unknown – some French arrangement with Spain? war itself? – and guessing at them had vaguely alarmed 'the best made man in the world', as a female member of Anne of Austria's house described the Duke: he had arrived in Paris in a white suit encrusted with diamonds; even his deerstalker hunting cap quickly set a trend among Parisian dandies.[66]

He concealed his worries. He handled himself with aplomb. His manners were perhaps more perfect than Richelieu's. He went shopping. He purchased a barber for £100, contracting with his master to send him to England. He bought rare plants for the gardens at his New Hall and Burley houses. As a shrewd art collector, whose only genuine rival in England was Thomas Howard, the Earl of Arundel, Buckingham knew Rubens' work, admired his paintings at the Palais du Luxemburg, and met him. James I's erstwhile favourite swiftly offered Rubens a 500-pound commission to do an equestrian portrait of himself.[67] The two men probably talked politics as well. They had common political interests, and Buckingham may even have suggested that at some point, perhaps in the not-too-distant future, Rubens might visit England.

76. The English Experiment

By 1629, when Rubens was fifty two, with his fame a happy noise among the ateliers and palaces of Europe, England had long since slipped into a maritime ebullience. The defeat of the Spanish Armada forty-one years earlier had led publicans and politicians, kings' minions and kings, as well as one intrepid queen, to turn their faces away from their centuries-long scalded ambitions on the battlefields of France and the rest of Europe – excepting the occasional expeditionary force dispatched into the Netherlands and Germany – and to train ambitious eyes, along with those of English merchants, manufacturers, investors, explorers, pirates and visionary navy men, across the Atlantic and Pacific oceans to the treasures lying just beyond their beaches.

The English Channel and wide waterways of the world suddenly seemed, as they had a bit earlier to the Spanish and the Dutch, broad avenues and lovers lanes, inviting adventurers, the English moneyed classes and their sailors into boundless profits among Indian tea plantations, Burmese teak stands, Canadian furs, American timber, Siamese rice paddies, Chinese porcelain factories, Egyptian cotton fields and even – though this came only later – galleysful of horrified African slaves. In

distant jungles, on deserts left pathless by apocalyptic winds, in strange ports and amid forests ghostly with millennia-old djinns, stout new English heroes might score unheralded English victories or meet memorable ends with phrases of the King James Bible and Virgil caressing their lips. Not only the quest for plunder, but also the noble genius of ancient Rome and Athens might be redeemed by their sallies into the planet's heathen and rough places.

New York was still Nieuw Amsterdam, and a mere three years old, a minute settlement of several thousand persons and some dozens of houses bounded by cleared farmland and thinnish woods at the tip of Manhattan, where it mixes the Hudson with the East River (as it is now called) to form their vast tidal-basin harbour, when in early June Rubens was rowed down the Thames through the heart of London to Greenwich. He had had been one day crossing from Dunkirk to Dover, aboard the new English man-o'-war Adventure, bristling with scores of cannon and soldierly protections. This largest type of ship of the English navy had been sent to bring him over at the invitation of the English King.[68] His business on Shakespeare's 'sceptr'd isle' was diplomacy and peace. He travelled with the approval of Philip IV of Spain, the acquiescence of his ever-scribbling minister Olivares and the sanction of the Archduchess Isabella. After a number of false starts, Rubens had come a long way in the world of international negotiations. Among the ranking political and military leaders of several countries, it was already a settled issue that his abilities as a diplomat were as formidable as his gifts as an artist, though these were now to be put to the test – as in a larger way would be his quest for beauty in the political world.[69]

If London, with a population of 200,000, was smaller than Paris, still the sight of it from his small boat, and the feel of its raciness, which he had barely tasted the day before, as Charles had summoned him to Greenwich for discussions the next morning, held a majesty, perfume and spikiness to be found in no other city of the world. The tawny span of London Bridge, its seventeen massive arches caked and iced on top with shops and houses, lay placidly before him. From across the water bubbled the announcement horn at The Globe, where *Hamlet* was perhaps to be put on that afternoon. One may also have heard a gloomy snarl or two, coupled with the cheers of the crowd, from the nearby Bear Garden. Ahead stretched a cream-coloured banner of white sails on the water, amid sunlight, foggy bits and patches of mist, where trading and naval ships creaked and piped among trawlers, barges, skiffs and private sloops. Off to starboard and far beyond Blackfriars, then a fashionable district with fine waterfront houses, rose the quadruple spires of old St Paul's cathedral, like some enormous rook on a Renaissance chessboard.[70]

Cooking smoke, even in the warm weather, looped and lolled above the thousands of four-storied houses that pebbled among the ribs and joints

of streets and haphazard knuckles of alleys between the cathedral and where he sat. Along the length of the port-river, but also rushing into its squares and alleys, one felt the new imperial breeze. It swam in and out. It meant commerce and imagination taking flight on wings of language. Its freshness might have reminded him of his own city with its blockaded river, as a tinge of regret for its grand past paled his cheeks.

Any sadness would not have been only political. He had arrived at his prominence in diplomacy through tragedy. Isabella Brant, his wife of seventeen years, had died on June 20, 1626, probably of plague (he himself refers to an outbreak of plague at around this time, noting that, together with his family, he had fled his home because of it[71]). While her death followed by just over a year, in January, 1625, that of his dear friend Jan Bruegel, who had died shortly after appointing him guardian of his children, and had come soon after the loss of his own daughter, Clara Serena, Isabella's death had wrenched him to the quick. 'You do well to remind me of the necessity of Fate,' he had written in response to a letter of condolence from Pierre Dupuy, in Paris. To Dupuy (1582-1651), who with his brother Jacques, was the French Royal Librarian, and a friend of both Peiresc brothers, Rubens unburdened his heart of an unfamiliar fatalism, together with an appreciation of his wife and his own resilience:

[Fate] does not comply with our passions, and ... as an expression of the Supreme Power, is not obliged to render us an account of its actions. It has absolute dominion over all things, and we have only to serve and obey. There is nothing to do, in my opinion, but to make this servitude more honourable and less painful by submitting willingly; but at present such a duty seems neither easy, nor even possible. You are very prudent in commending me to Time, and I hope this will do for me what Reason ought to do. For I have no pretensions about ever attaining a stoic equanimity; I do not believe that human feelings so closely in accord with their object are unbecoming to man's nature, or that one can be equally indifferent to all things in this world. ... Truly I have lost an excellent companion, whom one could love – indeed had to love, with good reason – as having none of the faults of her sex. She had no capricious moods, and no feminine weakness, but was all goodness and honesty. And because of her virtues, she was loved during her lifetime, and mourned by all at her death.

Such a loss seems to me worthy of deep feeling, and since the true remedy for all ills is Forgetfulness, daughter of Time, I must look to her for help. But I find it very hard to separate grief for this loss from the memory of a person whom I must love and cherish as long as I live. I should think a journey would be advisable.[72]

The best medicine was indeed a journey, or as it turned out, many journeys. Though conscious that *'mecum peregrinabor et me ipsum circumferam* (I shall travel with myself, and shall carry myself about

with me)', he had plunged with bleak enthusiasm, yet by no means neglecting his painting, into his diplomatic efforts. In fact these had commenced as long ago as 1623, when the Archduchess Isabella had begun to allot him ten florins per month for what was then sporadic work as her agent.[73]

By 1629 the real challenge, that of using his fame, tact and influence to help put a stop to the war, had become formidable. It was on a track to becoming unmanageable, even if he still had no special reason to suspect that he had entered a dark, confident world of chicanery and treachery. At the heart of the problem, as far as he and his fellow Flemish were concerned, lay Spanish dreams of triumph. One might cherish the religion of the Spanish king, yet abhor his policy running back to the reigns of Charles V and Philip II: that of weakening Protestantism in the United Provinces, of returning them to Spanish rule and of militarising the fifteen southern provinces, including Antwerp, as a base from which to do so. Little had changed for the government at Madrid since Don Juan's death in a pigeon coop and Alexander of Parma's construction of his blockade bridge across the Schelde. A nightmarish hallucination from the start, Spanish ambitions were now complicated by the German wars spilling over into the Netherlands, by opportunistic French alliances with the Dutch, which enraged Philip IV and Olivares, by the wavering involvement of Protestant England on the side of the Dutch (and also the Huguenots at La Rochelle), which enraged them as well, and by Spanish-French conflicts further south, in Italy, which centred around Rubens' old stamping ground of Mantua.[74] Soldiers were mustering and finding themselves used for terrible purposes everywhere, while Spanish difficulties were in turn worsened by the steady decline of the country itself as a world power. The wreck of Spanish finances, and the increasing shortage of trained, native-born soldiers, were understood by some in Madrid but seldom discussed – the fact that everybody was presently witnessing the thrashings about of an expiring giant.

To touch even one twig of this delicate European house of unbalanced branches was to threaten all the others. The slightest disturbance could start the house itself teetering toward collapse – or crashing into the shambles of even wider, if not total war. The repercussions of peace overtures might thus not be peace but slaughter. A truce concluded in one place might mean the release of demons in another. Diplomatic sophistication, a type of delicacy familiar to him from childhood, was increasingly embarrassed by cunning. On the other hand, cunning was helpless in the face of panic. The panic was well-disguised. It appeared at political meetings clad in jaunty costumes and conciliatory phrases.

Rubens had been sent to England only after plenary sessions in Madrid, where he had spent six of the past nine months.[75] Their point, befuddled by behind-the-scenes manipulations among Olivares and his nervous colleagues, was peace between the Spanish and English (whose

1. *Right: Till Eulenspiegel in a Cartful of Earth* (1515 edition, Strassburg) (see p. 89)

2. *Below: The Battle of the Lapiths and Centaurs,* Boijmans van Beuningen Museum, Rotterdam (see p. 146)

3. *Bottom*: *Summer.* Windsor Castle (see p. 335)

4. *Two copies of the Farnese Hercules*, Courtauld Institute Galleries, London (see p. 152)

5. *Laocoön*, Biblioteca Ambrosiana, Milan (see p. 152)

7. *The Crowning with Thorns*, Chapel of the Hôpital de Petit-Paris, Grasse. (see p. 161)

6. *St Helena with the True Cross*, Chapel of the Hôpital de Petit-Paris, Grasse (see p. 161)

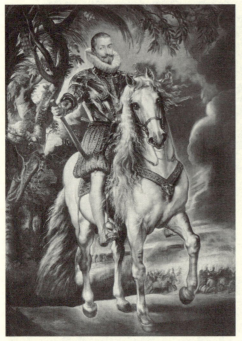

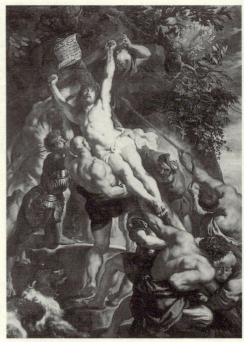

8. *The Duke of Lerma on Horseback,* The Prado, Madrid (see p. 187)

9. *The Raising of the Cross,* Cathedral of Our Lady, Antwerp (see p. 237)

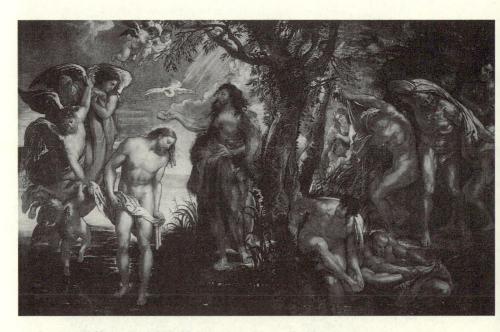

10. *Baptism of Christ,* Koninklijk Museum voor Schone Kunsten, Antwerp (see p. 199)

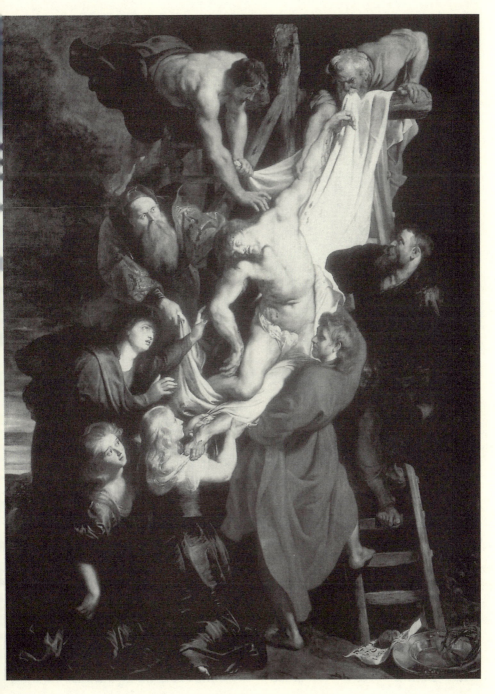

11. *Descent from the Cross,* Cathedral of Our Lady, Antwerp (see p. 219)

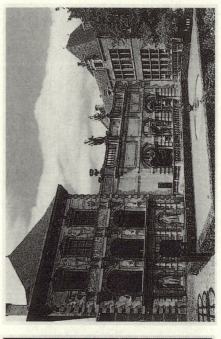

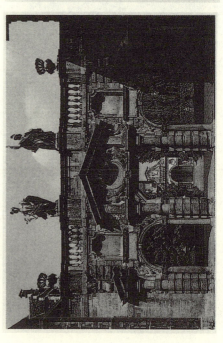

12-15. The Rubens House (modern restoration). Clockwise from upper left: gallery and Pantheon-room, studio, portico and studio facade from the rear, portico with view of garden pavilion (see p. 239)

18. *The Felicity of the Regency*, Louvre, Paris (see p. 268)

17. *The Regent Militant: the Victory of Jülich*, Louvre, Paris (see p. 269)

16. *Louis XIII Comes of Age*, Louvre, Paris (see p. 267)

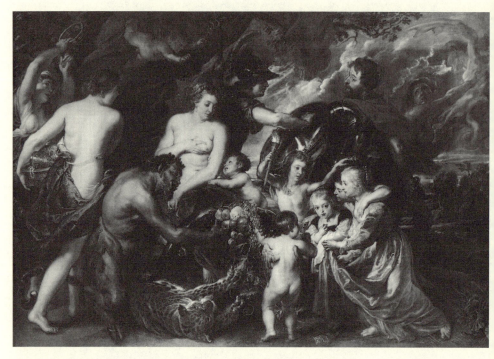

19. *Peace and War,* National Gallery, London (see p. 289)

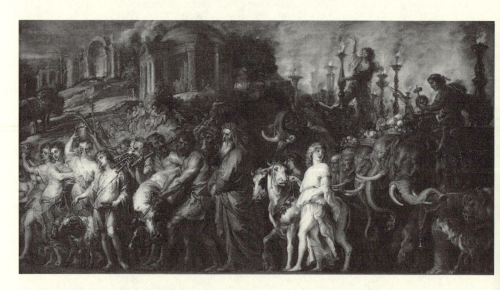

20. *Roman Triumph,* National Gallery, London (see p. 301)

1. *Top right: Albert and Nicolas Rubens,* Fürstliche Sammlung, Vaduz (see p. 307)

2. *Bottom left: Portrait of a Young Girl,* Albertina Museum, Vienna (see p. 308)

3. *Bottom right: Helena Fourment,* Courtauld Institute Galleries, London (see p. 312)

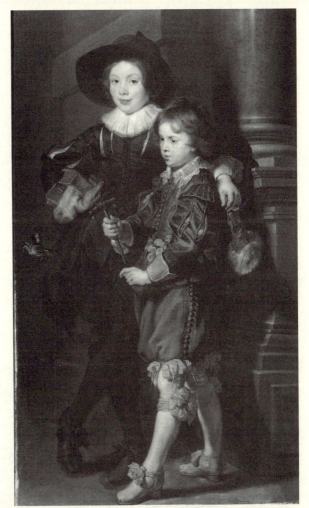

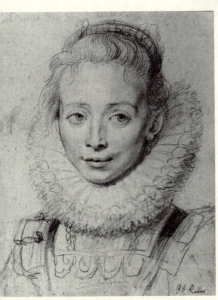

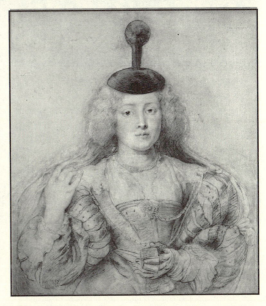

24. *Henry IV at the Battle of Ivry,* Uffizi Palace, Florence (see p. 309)

25. *Self-Portrait with Helena Fourment and Nicolas Rubens,* Alte Pinakothek, Munich (see p. 312)

26. *Minerva impaling Ignorance with a Spear,* New Banqueting House, Whitehall (see p. 320)

27. *Hercules beating down Envy,* New Banqueting House, Whitehall (see p. 320)

28. *The Garden of Love,* The Prado, Madrid (see p. 322)

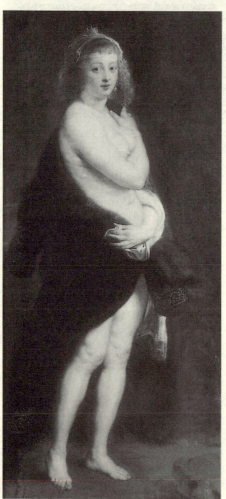

29. *Het Pelsken* (The Little Fur), Kunsthistorisches Museum, Vienna (see p. 323)

30. *Kermesse*, Louvre, Paris (see p. 323)

O VTINAM, PARTIS TERRAQVE MARIQVE TRIVMPHIS,
BELLIGERI CLVDAS, PRINCEPS, PENETRALIA IANI!
MARSQVE FERVS, SEPTEM IAM PÆNE DECENNIA BELGAS

QVI PREMIT, HARPYÆQVE TRVCES, LVCTVSQVE, FVRORQVE,
HINC PROCVL AD THRACES ABEANT, SCYTHICOSQVE RECESSVS
PAXQVE OPTATA DIV, POPVLOS ATQVE ARVA REVISAT! C. Gius.

31. *Temple of Janus* (Theodore van Thulden after Rubens), in Pompa Introitus (Antwerp, 1641; see p. 328)

32. *An Autumn Landscape with a View of Het Steen in the Early Morning,* National Gallery, London (see p. 333)

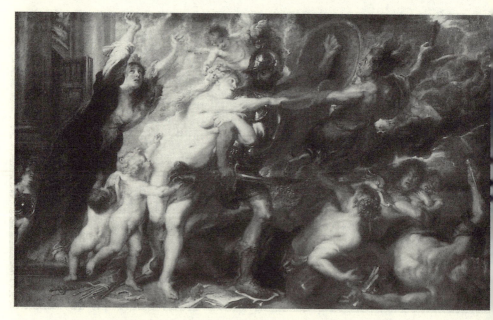

33. *Horrors of War,* Palazzo Pitti, Florence (see p. 338)

4. *Top right: Letter from Rubens to Balthazar Gerbier,* the British Library (see p. 346)

5. *Bottom left: Self-Portrait sketch,* Royal Library, Windsor Castle (see p. 347)

6. *Bottom right: Self-Portrait,* Kunsthistorisches Museum, Vienna (see p. 347)

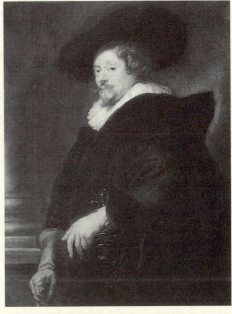

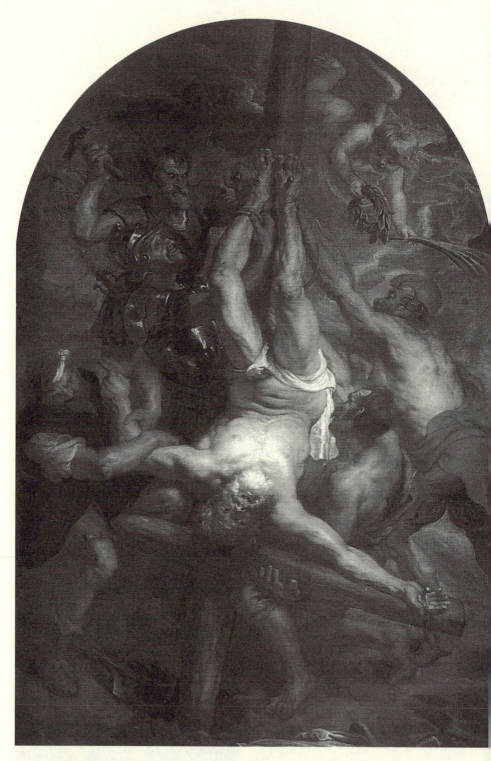

37. *The Crucifixion of St Peter,* Peterskirche, Cologne (see p. 348)

king still regarded the Spanish-held Palatinate as his private fiefdom). If his upcoming talks were successful, they might relieve the Netherlands and Antwerp of the pressures of war. Even getting the possibility of these talks moving, though, had taken years, as may be anticipated when bad cases of the jitters are supervised by the commanders of armies and navies and when a venerable culture is forced into making concessions.

For Rubens, the whole business had begun in Paris. At Charles I's proxy wedding he had met not only Buckingham but also his remarkable if slippery Master of Horse, Balthasar Gerbier (1592-1667).[76] Gerbier had worked for the Duke since 1618. He may have been the first to let Rubens know of Buckingham's (or in effect Charles') interest in peace with Spain. Gerbier was winning, tough and shifty, a mediocre artist and spy whose rare brilliance seemed suited to periods of muddy struggle. He seemed to gain an unwonted lustre as others descended into disillusion and hysteria. In settled times his polish might seem flimsier.

A Netherlander by birth, he had started out as a painter and engraver. He had produced a portrait of Prince Maurits of Nassau (Anna von Saxon's son) that impressed the English Duke, who hired him to decorate his houses and purchase paintings for him abroad. The flavour of Gerbier's personality, its wheedling and exuberance, appears in remarks to the Duke on purchasing for him a Danae by Tintoretto, that it contained 'a naked figure, the most beautiful, that flint as cold as ice might fall in love with it', and that Inigo Jones on seeing it 'almost threw himself on his knees in front of it'.[77] His chemistry of unctuousness and excitement made for self-congratulatory rhapsodies: 'Sometimes when I am contemplating the treasure of rarities which Your Excellency has in so short a time amassed [due in large part to his own efforts], I cannot but feel astonishment in the midst of my joy; for out of all the amateurs and princes and kings there is not one who has collected in forty years as many pictures as Your Excellency has collected in five'.[78] This was true, and the Duke's collection now included masterpieces by Titian, Bassano and Tintoretto, yet in Gerbier's manner the glitter often failed to outshine the grime, the charm – as when, in Rubens' phrase, he managed to 'keep Buckingham in good humour' – the candid profiteering.[79]

With Gerbier as middleman between himself and Buckingham, Rubens found his life after Isabella's death swept up into rounds of promising, mousy meetings, each as secret as sin, in Holland, Germany, Calais, Dunkirk and Brussels, into waiting for him at secluded inns where he neglected to appear, into exchanges of clumsily encoded messages (in which numbers replaced the names of easily identified people, such as the King of Spain) and into repeated offerings and withdrawals of the lure of the sought-after peace talks.[80] Aware that this was nonsense, Rubens went on greeting his transplanted countryman with friendliness and compassion. He bided his time. He pursued his leads. He

avoided pouring out on Gerbier's head the vinegar with which he had assailed the Duke himself in 1625, and his changeable views on war with Spain: 'The Secretaries of Spain and Flanders, resident in England, have been recalled [he wrote to Valavez], and I have no doubt that war will follow. And indeed, when I consider the caprice and arrogance of Buckingham, I pity that young King [Charles I], who, through false counsel, is needlessly throwing himself and his kingdom into such an extremity. For anyone can start a war, when he wishes, but he cannot so easily end it.'[81]

What did he believe about his political world as he trolled these chartless waters? What did he think in private about the kings and ministers whom he knew, and the political chances of the rest of humanity?

Clues may be located in his attitudes toward a failed rebellion, duelling and war itself. A letter to Pierre Dupuy in May, 1628, written from Antwerp just prior to his leaving for London, reveals him as entertaining broad humanitarian sympathies. These were far in advance of the convictions of most of his contemporaries. They mocked the condescension of most noblemen. He seems to have been persuaded that government ought to be a process of change rather than a set of rigid or even aristocratic institutions. Most strikingly, he shows himself as passionate about 'oaths and pacts'. These alone, if honoured, might alleviate the savagery of tyrannies. His political views complement the democracy, or universality, of his aesthetics, with its commitment to beauty as a rhythm of transformation and energy.

His letter describes an attempt by a daring businessman, Vacchero, to incite an uprising a few months earlier in Genoa. Vacchero's intent had been to force the Genoese nobility to grant ordinary citizens a voice in the city's government. He had received modest support from the Duke of Savoy, Louis XIII's younger brother, but the rebellion was betrayed and crushed. Vacchero himself had been executed.[82] Rubens' unrestrained anger over all this shines through sentences that seem to echo conversations among his friends, and even with his now-dead wife (clearly with Dupuy he felt on safe ground in speaking out as he did):

The Genoa conspiracy was terrible.... The discontent of those people is certainly justified, as many Genoese gentlemen of the most moderate opinions have confessed to me, and it will never come to an end except by the transformation or the ruin of that republic. The nobility has, in fact, assumed a tyrannical domination, contrary to the oaths and pacts which were solemnly sworn in the late agreements between the nobles and the people, and concluded after long and terrible struggles. The conditions were that each year a certain number of the most qualified citizens should be admitted to the nobility; by this means the people would participate in the administration of all the public offices. But they have been cheated out of this benefit by a wicked plot on the part of the nobles, who never gave the necessary number of votes or ballots to these candidates. The

result is that for many years not a single one of them has been elected, while the people remain completely excluded from all honours and participation in the government, deprived of the fruits of such a dearly won peace.[83]

He also tosses in some observations on the corruption of power:

It is to be noted that the new nobles, who had been chosen from the people by virtue of the agreement with the old nobility, are the most obstinate in excluding from this dignity men of their former caste. They hope that in time their nobility will mature, enabling them to pass as nobles of long standing (who consider themselves of higher rank and do not like to associate with the others); thus they do not want their number to increase, lest their new authority be weakened by the participation of many of their equals.[84]

While his democratic sentiments seem clear enough in spots like these, none of what he says should be taken as indicating that he would have supported universal suffrage in any modern sense. The very idea was unknown to him. To the vast majority of his friends, and even to him, actual popular elections would have seemed shocking: a threat to a sensible control of mobs and mere pluralities, and even to sanity. Nor can it be assumed that he would have subscribed to democratic revolutions elsewhere, and especially, one may surmise, had the level of education not been as high as in Genoa. He lived during a time – a very long one, it seems, for it continues even now – of transition from absolutism into democratic thinking. Clever minds in several countries were groping toward the notion of political freedoms, but only amid hesitations and doubts. In the United Provinces, where the principle of perpetual change through a rather limited franchise was best established, and in England, where it was known among the Puritans, the radicals of their day (no matter how drab their clothes and funny their immense black hats), people continued to believe that only a just monarch might best serve the interests of his people. Only he would redistribute the wealth of the nobles and others in his kingdom while avoiding the instability of mob rule. This conviction accounts for Rubens' lamenting the frequent bankruptcy of Christian kings: 'The riches of the world are distributed in the hands of private individuals, and ... this is the cause of the public poverty'[85] (he was himself a rich private individual at this point, but his views should not be understood as a precocious espousal of socialism).

Nor was he a pacifist, despite his passion for peace. Nor was he opposed to sensible-seeming wars. If he found barbaric the French practice of settling questions of honour through duels, his distaste in no way coloured his approval of the French siege of La Rochelle or his admiration of the Marquis Ambrosio Spinola, who had assisted the French

commanders there with strategy. About duelling, an ancient French aristocratic privilege, Rubens could be caustic:

> This mania of the French really ought to be suppressed [in fact it was outlawed by Richelieu in an edict of 1626, though without success, as French noblemen kept on stabbing each other to death with abandon], for it seems to me to be the curse of that kingdom, and will exterminate the very flower of the French nobility. Here we fight a foreign foe [he was at the time staying at an inn at Laeken, just outside Brussels, perhaps to escape the outbreak of the plague that later killed his wife[86]], and the bravest is he who conducts himself most valiantly in the service of his King. Otherwise we live in peace, and if anyone oversteps the bounds of moderation, he is banished from the Court and shunned by everyone. For our Most Serene Infanta and also the Marquis [Spinola] wish to render all private quarrels dishonourable and destestable. Those who think to gain fame in this way are excluded from all military offices and honours, and this seems to me the true remedy, since all these exaggerated passions are caused by mere ambition and a false love of glory.[87]

A true glory, as he saw it, lay with those handling the siege of La Rochelle. Rubens admired battle courage – indeed his plans for the second series of Medici paintings called for depictions of Henri IV leading his triumphant cavalry into several bloody collisions of horses and men. Like most of those who had a classical education, and many nobles who pretended to the influence of the Roman epics of Virgil and Lucan, he also appreciated, as a matter of course and culture, the daring and heroism of his enemies. This issue was put to the test with Buckingham himself, whose dashing equestrian portrait in profile, with the Duke mounted on a prancing steed that surges past you as his scarlet cape blooms like a ball of fire behind him, Rubens had painted in 1625.[88]

In July, 1626, shortly after Isabella's death, Buckingham had offered him an astonishing 100,000 florins for virtually his entire sumptuous collection of antiquities and *curiosa*.[89] While one of the Duke's motives was no doubt to enhance his own collection by adding to it all the statues that Rubens had purchased from Dudley Carleton, plus a mass of carved antique gems and thirteen paintings by Rubens himself, another – and probably the chief motive of both men – was to buttress their amicable relations. Rubens wanted liquid cash for his new career as negotiator, which required a definite poshness and financial independence (he bought up five houses in Antwerp with some of the 84,000 florins that came his way, after deductions for the agent, Michel le Blon, and various expenses).[90] On Buckingham's side, however, the most compelling reason may also have been to place on sounder terms, with a munificent deal, the amity between their two countries. This was to acquire a crucial importance after his disastrous and momentous expedition, launched some eleven months later, to relieve the

Protestants at La Rochelle. The friend turned foe might still be regarded as a friend.

On June 27, 1627, Buckingham had set sail from Portsmouth in command of an English fleet of one hundred ships, including forty man-o'-wars, and carrying seven regiments, or over 7,000 regular and pressed troops (the latter 'poor rogues and beggars', 'such creatures that I am ashamed to describe them', according to Sir George Blundell, the expedition's sergeant-major).[91] Buckingham's goal was to land on the Ile de Ré, fight his way through the French lines and resupply the city's starving inhabitants and soldiers. True to form, he had travelled with an orchestra, 'musical instruments of every kind, bedding, coaches, horses for tilting and other hindrances to warfare', among them fifty-pounds-worth of books. Elegantly dressed, his musicians were to provide concerts at sea and after the struggles to come. The Duke himself often sported 'an immense collar and magnificent plume of feathers in his hat'. He brought along as chaplains the poet Robert Herrick and George Donne, the son of John, then Dean of St Paul's.[92]

The enterprise turned into a fiasco, though to Buckingham it offered a showcase for his bravura talents and courage. When Richelieu learned that he had landed at the Ile de Ré on July 10, and that England's foppish-seeming art-collector and kingly favourite, with whom he had spent hours in polite conversation at the proxy wedding of Charles I, had invaded France, he at once tore his beard. He also speeded up the arrival of a royal army, 20,000 strong, on its way to reinforce his troops just outside the city. Initial skirmishes on the Ile de Ré favoured the English. A ferocious battle that erupted once the much larger French force arrived, however, after sending ahead of them onto the island a determined contingent of 4,000 men commanded by the professional Henri Schomberg, under cover of darkness and as a hurricane broke over the narrow beaches, went the other way.[93]

Decimated by disease and dysentery, the English regiments were much reduced by the time the French landed. Few reinforcements had been sent over. The prestige of Charles I, not to mention Buckingham himself, rode on a successful outcome. The English ability to project power onto the Continent was at stake, and all Europe was watching. Rubens, speculating in mid-October on Buckingham's brave gamble (for the skirmishing stretched out over three months), while scarcely supporting it, noted that 'he seems to me, by his own audacity, to be reduced to the necessity of conquering or dying gloriously. If he should survive defeat, he would be nothing but the sport of fortune and the laughing-stock of his enemies'.[94]

His observation proved dismally prophetic. Begging money to pay his men (even his wife Kate was asked for a loan), with his supplies unreplenished, though a contingent of Irish were finally slipped into his trenches by late summer, Buckingham was unable to cope with

Schomberg's manoeuvres in the dark on September 27, and the subsequent waves of attacks and counterattacks. His last, brash assault, in late October, on the citadel guarding La Rochelle proved suicidal: the English scaling-ladders were too short, and the soldiers got stranded near the top of the fortress walls, where they were pelted to death by the French defenders throwing stones, boulders and logs. Shortly afterwards, the English battle-in-retreat, a seesawing affair, rattled across the beaches. More than forty officers were killed, along with 500 men and a far greater number drowned, as escaping units fought their way back to their ships. By then, upwards of 5,000 of the original invading party had been slaughtered or had died of disease, and Buckingham's disgrace on returning, coupled with the shaking of Charles' reputation, looked perilous for their futures. A relief squadron, dispatched the following year to atone for the defeat, failed when its commander, Denbigh, turned back at the first hint of the appearance of Spanish warships.[95] While preparing to lead yet another expedition himself some months later, Buckingham received the *coup de grâce*. He was assassinated at the Greyhound Inn at Portsmouth, on August 22, 1628, by an enraged Puritan wielding a knife, John Felton, who later repented of his deed ('It was abhorrent,' he said, in tones of self-reproach, crying out, 'I have much dishonoured God in it') as he was hanged at Tyburn.[96]

The art of politics clearly required as much courage as trying to paint after Michelangelo. It ran serious risks, and those daring to assume them, such as Buckingham, in contrast to dabblers such as Gerbier, earned Rubens' esteem. So did the French, whose amazing new blockade of La Rochelle – a superbly engineered dyke built of sunk boats and pilings by the architects Clémant Metézeau and Jean Thiriot – Rubens visited in late October, 1628, on his way back to Spain before going on to England by way of Brussels. 'I did make one small detour on my way here,' he wrote to Peiresc from Madrid, 'and saw the siege of La Rochelle, which seems to me a spectacle worthy of all admiration.'[97] The city finally surrendered on October 27, and its loss, and the death of Buckingham, the remarkable nobleman whom he had painted and who had enriched him by buying up his collection of antiquities, played no small part in making appropriate his diplomatic mission on board the Adventure to see Charles I.

77. The Artist Meets the King

'He made me believe that nothing but good intentions and sincerity have been in his heart,' wrote James Hay, the Earl of Carlisle, about Rubens to Buckingham in May, 1627, 'which on my soul I think is trew, because in other things I find him a reall man' – remarks that he quickly salted with irony – 'and as well affectet to the King of England's service as the King of Spain can deseyer.'[98]

IV. Kings, Queens, Ministers and the Angelic

In the deepest sense, the graceful, twenty-nine-year-old King, who welcomed Rubens to his green parks and palace at Greenwich in June, 1629, could have desired no more in his emissary, not in his tact, not in his art, not in his peaceful intentions. Presiding over a nation as clever as that of his father and Elizabeth before him, Charles had sought to concentrate his influence on England's growing cultural supremacy. His belief in the divine right of kings, and his descent into what his enemies viewed as a grim, personal and autocratic rule, were balanced, according to his friends, by his compassion and his amateur's devotion to the arts – to poetry and theatre, especially the court-masque theatre of Ben Jonson and Inigo Jones, as well as to music and painting.[99] In the latter area, his attractive Catholic wife, Henrietta Maria, who liked dancing in court masques as well as gambolling with monkeys, dogs and dwarfs, made her own contribution, putting on display in her chapel at Somerset House paintings by Correggio, Andrea del Sarto, Leonardo and Veronese. These were shipped over from Rome by Cardinal Francesco Barberini.[100] They stirred resentment. Her display of so many Catholic masterpieces raised suspicions of papal influence among Charles' subjects, the vast majority of whom felt bitterly anti-Catholic.

The genius of English culture had filtered into many fields, but shone with special brilliance through its ancient and modern literature, and with matchless dazzle through its poetry – that microscope of any people's articulateness and ability to negotiate pacts for its future, and this at a time when German, French, Italian and Flemish were themselves making rapid gains in expressiveness. If Ben Jonson was housebound at the moment because of a stroke (he was visited in bed by his poet-friends, the 'Tribe of Ben', but not, it seems, by Rubens),[101] John Donne (1572-1631), who as young Jack had caught his 'falling star', and who was born to see 'things invisible', was thrilling congregations at London's greatest cathedral. There he preached a sensual, neo-Platonic and Christian vision of the body and soul that Rubens would surely have commended for its delicacy and extravagance, in a style that today would be called Baroque: 'We are so composed that if abundance or glory scorch and melt us, we have our earthly cave, our bodies, to go into by consideration and cool ourselves; and if we be frozen, and contracted with lower and dark fortunes, we have within us a torch, a soul, lighter and warmer than any without; we are therefore our own umbrellas and our suns.'[102]

Thomas Hobbes (1588-1679) was off touring the Continent. He had just published his *Thucydides*, one of the foremost translations of the age, but was not yet known as a political theorist. Henry Wotten (1568-1639), himself a poet, diplomat and friend of John Donne, had five years earlier, in 1624, brought out his *Elements of Architecture*, an adaptation of Vitruvius. This had begun to influence the exciting Palladian revolution in building styles then underway (a phenomenon chiefly shaped by the Italian fantasies of Inigo Jones). The witty Cavalier poets around the

King – Suckling, Davenant and Carew – received royal patronage. So did 88 royal musicians.[103] John Milton, who had been expelled from Cambridge for insubordination, attracted no financial aid, but at twenty one had managed to return to his college there, Christ's Church, where he was completing his B.A. and finishing his first major poem, 'On the Morning of Christ's Nativity'. This masterpiece seemed to sweep both past and future before it with its refreshed evocation of the Ptolemaic System and its nine spheres, a theme no less sensual, spiritual and Baroque than Donne's sermons in its focus on energy, motion, celestial music and beauty as a process:

> Ring out ye crystal spheres,
> Once bless our human ears
> (If ye have power to touch our senses so)
> And let your silver chime
> Move in melodious time;
> And let the base of heav'n's deep organ blow,
> And with your ninefold harmony
> Make up full consort to th'angelic symphony.[104]

Milton's idea of time as melodious, and in fact the musical English atmosphere when Rubens' arrived – as long as you did not glimpse the darker currents of Puritan hatred and acrimony flowing fiercely beneath its surface – would have seemed congenial to his enthusiasms and beliefs.

Despite this coincidence of tastes, however, and Rubens' love of travel and seeing new countries, and no doubt because he was feeling a trace older ('to see so many varied countries and courts, in so short a time,' he told Peiresc, 'would have been more fitting and useful to me in my youth... my body would have been stronger, to endure the hardships of travel'[105]), he had made plans for only a brief visit. He had brought with him an agreement signed by Philip IV. It stipulated a temporary cessation of hostilities without any Spanish concessions. Rubens seems to have looked forward, perhaps a bit naïvely, to having Charles countersign this document, and then going home. He had arranged to stay with Gerbier and his family, probably at their home in Westminster (Gerbier in fact soon submitted a bill to Charles for the cost of his board).[106]

This was not to be. The English outward show was deceptive. Rancour as well as envy and beauty streaked the political atmosphere from top to bottom. The King himself seemed as intractable as welcoming. Where Puritan and even moderate opinion in England found Charles' expensive patronage of the arts, and most of all his court masques, mere 'Pomp and glory, if not vanity', or a bit later, in 1633, in the words of William Prynne, a lawyer-pamphleteer who had his ears chopped off for denouncing these royal shows, 'a badge of lewd lascivious women and strumpets', Charles found Philip's proposal of a mere truce mildly insulting.[107] Philip had failed to deal with English claims to the

Palatinate, or more precisely, with those of the King's brother-in-law, Frederick, whose control of this jurisdiction that formed a corridor between the Netherlands and Italy – the 'Spanish road' – had been seized by the Spanish at the start of the new (Thirty Years) war.

At Charles' first meetings with Rubens, on June 6, 7 and 25, when they 'talked a long time alone', the King suggested a compromise on the Palatinate and also on another problem, whether Spain would at last recognize England's ally, the United Provinces.[108] He seemed amicable and pliant. Quite suddenly, though, and to Rubens' amazement after hours spent in bargaining and sounding each other out, he announced that the question of a peace treaty, which was what he wanted rather than a truce, would be turned over to his ministers. He appeared to lose all interest in the matter.

'I am very apprehensive as to the instability of the English temperament,' Rubens at once reported to Olivares. 'Rarely, in fact, do these people persist in a resolution, but change from hour to hour, and always from bad to worse.'[109] He had run into an eccentricity that others had also detected in their King, to wit, that political negotiations bored him – or that only the arts and his young wife excited him. As a result, he often left the approach as well as the finer points of even war-provoking issues to underlings, who represented squabbling factions and seldom agreed. Rubens noted that Charles' quirk whereby he mixed a clear grasp of a problem with a sporadic indifference to solving it could prove an obstacle to peace: 'Whereas in other courts negotiations begin with the ministers and finish with the royal word and signature,' he told Olivares, 'here they begin with the King and end with the ministers.'[110] He foresaw delays. He was also becoming impatient ('I have ... written to the Most Serene Infanta [Isabella], begging her to grant me permission to return home'[111]). It seemed evident that behind the King's joy in meeting him, the artist whose self-portrait he owned and whose pictures adorned his gallery – behind his royal, fine, yet diffuse and pale features, so suggestive of his liberal charm – lay a paralysing reserve. It bottled up his sprightliness in rigidity. It might hint at a mental intransigence that could provoke violence. On the other hand, Rubens found Charles 'determined and resolute'.

78. Securing the Pact for Peace

The days now swept into weeks and then months as Rubens stayed on, enlivened by diplomatic thrusts and parries among the competing interests at court, points gained and lost in his manoeuvrings to secure a treaty, salubrious visits to the art collections at the great houses nearby, a discouraging encounter with Cornelis Drebbel of perpetual-motion fame, an eventual diplomatic success, an academic award at Cambridge (was Milton in the audience?), a knighthood bestowed on him by the King

and, throughout it all, his painting and the promise of a grand commission, finally, that of doing a fantastical set of canvases for the vast ceiling of the New Banqueting House at Whitehall Palace.

At the same time, the England that he saw was not the England that he had expected, a rustic land ignorant of art because far from Italy, to which he forever longed to return: 'In this island I find none of the crudeness which one might expect from a place so remote from Italian elegance. And I must admit that when it comes to fine pictures by the hands of first-class masters, I have never seen such a large number in one place as in the royal palace and in the gallery of the late Duke of Buckingham.'[112] He enjoyed the English, and the novel experience of being in a country untouched by wars of invasion: 'This island ... seems to me to be a spectacle worthy of the interest of every gentleman, not only for the beauty of the countryside and the charm of the nation; not only for the splendour of the outward culture, which seems to be extreme, as of a people rich and happy in the lap of peace, but also for the incredible quantity of excellent pictures, statues, and ancient [Greek and Roman] inscriptions [always one of his passions] which are to be found at this Court.'[113]

These delights aside (Sir Francis Cottington, who was soon to become Charles' Chancellor of the Exchequer, had written in a letter appended to his passport, 'The King is well satisfied, not only because of Rubens' mission, but because he wishes to know a person of such merit'[114]), he had arrived at Charles' court under a threat, of which he was daily, agonizingly aware. England had become the hypotenuse of a French-Spanish-English right triangle of power. Both France and Spain were in hot pursuit of a determining alliance, or treaty – it made little practical difference which – with the English King. The country securing it first would in effect find its military ambitions guaranteed, not only against its rival but also straight across western Europe. On the other hand, from Rubens' and the Archduchess Isabella's point of view, any English-French treaty must at all costs be avoided and sabotaged. It would fail to neutralize Spain in the Netherlands. It would amount to a licence for the Spanish to prosecute the war against the United Provinces as they wished, or with the most vicious abandon. For Antwerp, it could mean complete ruin.

Precisely such a pact had just been signed, however, though it had not been ratified, on April 24, before Rubens left Madrid.[115] A repellent shadow thus fell across his meetings with Charles, the likelihood that his mission might prove worse than useless if he failed to persuade the King to switch sides and to align his government in a new, peaceful relationship with Spain, or that if he alienated English affections and esteem, more lives might actually be lost on the muddy battlefields of Brabant and Flanders than if he had not come at all: more land flooded, crops destroyed and unpaid soldiers allowed to wreak their will in the streets of towns and villages.

These were hardly abstract issues. They emboldened rape, starvation and murder. As always at the turning points in the lives of great and established peoples, they depended for their resolution not on the pressures of social forces but on the personalities and predilections of a few isolated men and women who by accidents of genes, birth, native brilliance, altruism, idiocy, selfishness, powdery disdain, intelligence and kindness – all the twists of the human psyche and its ancient, unconscious myths – found themselves hurrying along the corridors of palaces in a few capitals divided by land and sea, while the destinies of millions hung on their sighs, words, frowns, doffings of plumed hats, abilities to amuse and well-mannered tact. It had not taken Philip IV in Spain long to recognize in Rubens, whom he had at first dismissed as a 'mere' painter (before meeting him), the qualities of discretion and confidence – Rubens' brand of practical optimism – that would be ideal for this mission, if it could be handled at all.[116]

Could it be handled? Charles was appreciative of being courted by the suitors of both sides of the triangle of which his government had now come to form the decisive joining link, and while there is no hint of deception in his behaviour, he was anxious to secure for himself and his country the best possible terms. The French, whose ambassador, the Marquis de Châteauneuf, arrived in July, but who (in a gesture of royal indifference?) was greeted only by twenty carriages, 'most of them empty', were as eager to see their treaty with England ratified as was Rubens to see it set aside.[117] Shadier diplomatic players also involved themselves. As they did so, 'the public squares and streets of London' were rife with gossip.[118]

Writing many and lengthy reports to Olivares in his usual fluent Italian (Spanish seems never to have felt comfortable enough to him), Rubens charted the shoals through which he was attempting to steer a passage: 'There are in this Court several factions. The first, which is headed by the Earl of Carlisle, wants peace with Spain and war with France; the second is much larger and wants peace with all. To tell the truth, I believe that the Lord Treasurer [Cottington] is of this opinion, and the Earl of Holland also. The third is the worst; it wants war with Spain and an offensive league with France against her.'[119] Simultaneously, news was pouring in of terrifying battles and surrenders in Italy and Germany that could easily affect the outcome of his efforts and his own future. The violence of the larger war, which had begun as a fairly well-defined conflict between Catholics and Protestants, now started to pummel both sides into seeking bizarre alliances with former enemies, for the sake of survival and to satisfy imperial ambitions. Natural-seeming pacts between Catholics, as between Protestants, were also pulling apart. Religious objectives were yielding to those of conquest for its own sake, and slaughter for the sake of revenge.

The idyllic island of Mantua – to cite the most important instance –

whose Duke was now French, had become one focus-point of this momentous shift, Augsburg in Germany another. Vincenzo II, the effete successor to Rubens' former patron, Vincenzo I, had already robbed his glorious republic of much of its splendour before his death in 1627, by selling off to Charles I almost all of his magnificent collection of paintings for the amazing sum of 18,280 pounds sterling.[120] Pictures by Caravaggio, Tintoretto, Titian, Guido Reni and other artists were packed up and shipped to England in 1628, with Mantegna's *Roman Triumph* tossed into the bargain in 1629, in a deal that appalled Rubens, who looked back on his years spent among the island's gem-like palaces with affection and regret ('This sale displeases me so much that I feel like exclaiming, in the person of the Genius of the state: *Migremus hinc!* [Let's abandon this place!]'[121]). With its old artistic majesty in tatters, Mantua had now also been abandoned to the crueller fate of a siege. To the horror of Pope Urban VIII, a ferrety, nervous man who lived in dread of Spanish spies in the Vatican and who had feared the invasion of Italy by Spanish or Austrian troops, Philip IV had laid claim to the republic itself, chiefly to drive out the French. A Spanish army had surrounded the nearby fortress of Casale and Mantua itself. This was a dangerous act that might set Spain and France on a collision course toward a much wider war, pitting one Catholic state against another.[122]

There was certainly no issue of beauty in these stratagems, but only of degrees of ugliness, as there was none in the surrender of the free city of Augsburg to the Hapsburg Emperor Ferdinand II in August, 1629. Ferdinand's takeover of the oldest shrine of Lutheranism with imperial regiments, during which not a shot was fired, exposed the feebleness of resistance in Germany.[123] It also represented the willingness of noblemen eager for war to disregard any remaining rules of civilized conduct. Because Augsburg's fall could be expected to incite Protestant military reactions by outside powers, such as Sweden, it might signal the start of a Continental, German-centred conflagration.

Both of these affairs drew massive publicity, not only in the thousands of illustrated broadsheets and newspapers printed in such cities as Antwerp and Paris, where *La Mércure* offered long if – according to Rubens – unreliable analyses,[124] but also among the influential group of over 20,000 students working toward law degrees at the Hapsburg Empire's universities. Law students exercised an influence on popular opinion far beyond their numbers, and these future political leaders of their scores of duchies were treated to a constant stream of position papers on military events affecting Italy and Germany, in *Denkschriften* issued at Germany's hundreds of printing houses.[125] In London, where 837 presses were active between 1553 and 1640 alone, scores of advice-giving pundits responded as well to the developing disasters across the Channel.[126]

In this half-mad situation, as Rubens understood, achieving the diplo-

matic breakthrough that he sought would be like pulling a rabbit out of a hat. Doing so would require not only his considerable skills but also the assistance of others able to look beyond petty ambitions. On the one hand, as he had written to Jacques Dupuy a year earlier, 'today the interests of the entire world are closely linked together', a fact that ought to promote restraint. On the other, 'the states are governed by men without experience and incapable of following the counsel of others'. He thought often about Antwerp's twilit quagmire, 'midway between peace and war, ... feeling all the hardships and violence resulting from war, without reaping any of the benefits of peace'.[127] Walking the unthreatened, vivacious streets of London, he ached for his city across the water that was 'going step by step to ruin, and liv[ing] only upon its savings, ... [with] not the slightest bit of trade to support it'.[128] He worried about his son Albert, now twelve and learning Greek and Latin at school, whom he seems to have asked his old friend Jan Casper Gevaerts (1593-1666), a lawyer, classicist and Clerk of Antwerp, to look after in his absence: 'I beg you to take my little Albert, my other self, not into your sanctuary but into your study. I love this boy, and it is to you, the best of my friends and high priest of the Muses [Gevaerts was an expert on Marcus Aurelius] that I commend him, so that you, along with my father-in-law and brother Brant [Isabella's brother], may care for him, whether I live or die.'[129] Only his tested and reliable strategy of realizing personal goals through obedience to his royal masters, his method of attaining the success that he wanted through his capacity for personal surrender, might prove useful. His commitment to democracy in aesthetics and quasi-democracy in politics, with pacts at the centres of both, might enable him to achieve happy results.

They began to emerge, amid a flurry of aspersions cast on his trustworthiness by the French and further delays, but the slowness of their development encouraged him – in fact invited him – to get back to his painting, and to produce one work in particular, his *Peace and War*, that cast a brutal illumination over the risks that he and others were taking.

Charles, he had come to realize, together with the dominant faction at his court, had been in earnest about signing a treaty with Spain. Rubens' reassuring arguments now began to smoothe the way. They proved irresistible. By July the issue seemed as good as settled. The outstanding problem was an exchange of ambassadors, but this longed-for simplifying of the situation led him for the second time to guess that he might soon go home.

It – yet again – was not to be. The actual naming of the English and Spanish ambassadors, and their dispatch to their posts, remained essential if the whole project was to succeed: the presence on the spot of the men authorised to approve the final wording of the text, thereby allaying everybody's residual suspicions. In the meantime, renewed violence, especially attacks on rival ports and shipping, which could be ruinous to

everything so far achieved, might flare up. To deal with this threat, and because the selection and sending of the ambassadors seemed forever delayed amid bickering, Rubens was once more asked by Isabella to stay on. He had no authority to sign the agreement himself, but before leaving Madrid he had been designated Secretary of the Privy Council of the Netherlands by Philip (who also sealed their personal pact by presenting him with diamond-studded ring).[130] This title supplied him with sufficient cachet while he continued to tarry at the English court.

79. A Previous Engagement

It had never been in his nature to lounge about. In Spain as well he had been forced to sit like patience on a monument while ministers oiled and set in motion the wheels of stately planning after Buckingham's shocking death: it was his death that had reawakened Spanish doubts about English sincerity in seeking a treaty: it had been through Rubens, and with Rubens as his unofficial representative, that Buckingham had been angling for such a treaty when he was killed.[131]

Waiting in Madrid in those days, as the Spanish took months to make up their minds, he had spent his time rediscovering old aesthetic delights and doing much new painting. Not for him, as on his rough sea voyage to the Iberian peninsula twenty-five years earlier, the overseeing of six bewildered horses and a delicate gilt coach, plus a mass of paintings on their way to ruin amid storms and rains on bad roads and with a sickly groom about to die. Not for him either the piddling betrayals of Vincenzo's 'ambassador'. In 1628, though he had ridden through France discreetly and fast ('for the King of Spain, my Lord, had commanded me to come posthaste'), he travelled as a renowned artist and diplomat bound on important business at the nerve-centre of European imperialism.[132] As an honoured guest he had gone out to inspect the sea blockade at La Rochelle ('the dyke is indeed a regal piece of work, and my satisfaction was all the greater since M. de Marsillacq, the superintendent of operations, let me see and enjoy it in detail'[133]). In Madrid, he had found that even the quality of the royal vanity had improved. Unlike his negligent, unforceful predecessor, the young Philip IV was refined and took 'an extreme pleasure in painting'. He had also installed Rubens in an apartment at his palace not far from that occupied by another artist, the twenty-nine-year-old Diego Velásquez, with whom he had previously corresponded and whom he quickly befriended, but it was not for these reasons alone that he saw Philip – chatting a bit with him every day – as 'endowed with excellent qualities'.[134]

Rubens still had scant regard for the Spanish, who struck him as spiteful and, with the exception of Velásquez, poor painters. 'The King alone arouses my sympathy,' he told Peiresc. 'He is endowed by nature with all the gifts of body and spirit, for in my daily intercourse with him

I have learned to know him thoroughly. And he would surely be capable of governing under any conditions, were it not that he mistrusts himself and defers too much to others.'[135]

While he waited, he had concentrated on his art: 'Here I keep to painting, as I do everywhere, and already I have done the equestrian portrait of His Majesty [this was destroyed in a fire at the Escorial in 1734], to his great pleasure and satisfaction.'[136] He did an amazing amount of other work as well, much of it now lost, including at least three additional portraits of Philip (a striking sketch of him, probably from life, survives), and members of the royal family, whose pictures Isabella had asked him to bring back to Antwerp.

In the company of Velásquez – slender and dark in his youth, bushy-haired, arrogant and warm-hearted – he had made at least one excursion to the Escorial, in November, 1628. The two men had managed a hard climb on horseback into the Sierra Nevada mountains overlooking Philip II's fantasy of art and power. Rubens did a sketch of the scene (only copies of it are now extant, by Pieter Verhulst). Curiously, and perhaps revelatory of Rubens' political thinking at the time, it shows a nearby monastery as a trivial jumble of roofs crouching in the distance. The impressive house is overawed by dismissive peaks, a towering splash of white clouds and in the foreground a large, tilting cross.[137] Though Rubens had done landscapes before, this sketch may have been his first in which a massive human achievement seems cowed as if by destiny, by aloof natural forces, and shrunk to childish dimensions, to a doll's house.

Even more revealing of his wish to mix aesthetics with politics (in work that he decided to do on his own) were his paintings after Titian. With Velásquez he had explored the Titian-rich galleries at the Escorial itself. In Madrid he had studied and then set about copying, or more accurately, imitating, the Titians in the royal palace. Their dominance of Spanish art harked back to the golden decades of Charles V and Philip II, the king whose soldiers, priests and merchants had been the first to establish colonies on four continents.

For Rubens, Titian had always been a primary influence. From his pioneer days in Venice and his slapdash stopovers in Madrid and at the Escorial in 1603, he had poured himself into gleaning as much from him as from Michelangelo. Titian's effect on his style, however, is tricky to estimate and easy to overestimate. It is unlikely, for instance, that Rubens adapted his own smudgy-edged handling of human figures, animals, plants and objects from him. On the other hand, Rubens' confidence in his own technique, which emerges in his earliest work, probably received a boost of confirmation through his discovery that Titian had hit on a similar method. There was little question but that he had, or that it had provoked controversy, as when Francisco de Vargas, Charles V's ambassador to Venice, asked him why he painted 'with rough brush

strokes, almost like smudges [borrones]'. Titian had replied that he did so because after Michelangelo, Raphael, Correggio and Parmigianino it became essential 'to embark on a new route that would make me renowned in some way, as they were for those who followed them'.[138] To Rubens, Titian's agitated yet precise brushwork, coupled with his fine draughtsmanship, marvellous colour sense and large scenes full of figures – his taking on stories brimming with the dramatic – would have been enough of a magnet, but there was more: his delight in the male and female body and sheer flesh, his devoutness and his passion for mythology (though he was by no means as well read as Rubens in this or any area). Titian's comparative restraint may even have seemed a provocation. His *borrones*, or almost careless smudges, failed to push their possibilities to the limit. He seemed content to leave a mist about the edges of his figures, only hinting at motion. A more flamboyant wildness with richer smudging might reproduce the flow, design and grandeur of energy itself.

Whether he felt provoked or not, Rubens' enthusiasm for copying or recasting many of Titian's masterpieces, among them his *poesie*, as he called his pictures based on myths, reawakened during his second visit to Spain. It took wing. Francisco Pacheco, Velásquez's father-in-law, his first teacher (though he was a mediocre painter himself) and an art historian, reports that Rubens 'copied every work by Titian owned by the King, namely, the two bathing scenes, Europa, Adonis and Venus, Venus and Cupid, Adam and Eve and others'.[139] Of these, the most memorable is his *Rape of Europa* (181 x 200 cm., now in the Prado) after Titian's *Europa* (178.7 x 202.5 cm., in the Isabella Stewart Gardner Museum, Boston), and this not least for its altering the tone, or political sense, of a picture that Titian had conceived as flattering to Philip II, for whom it was painted.

The bizarre Greek myth involving Europa, on which both artists relied (for Rubens knew it too), is a paradox of abduction and victory, and by implication of the imperial uses of sexual violence. Titian had taken some liberties with the versions of the story by Ovid and the ancient Alexandrian writer Achilles Tatius, whose novel containing it, *Leucippe and Clitophon*, came out in an Italian translation in 1560, when he was doing his picture.[140] In both versions, Zeus assumes the form of a peaceful-seeming bull, whose hide, 'white as untrodden snow', mesmerizes the lovely daughter of the king of Sidon, Europa, as she plays with her friends on a Mediterranean beach. Afraid at first of the strange animal, she approaches it, as Zeus wishes her to. She yields to the bull's gentleness. He kisses her hands. He flaunts his muscular, dewlapped beauty. Then he frolicks. He rolls about. He stretches his whiteness on the sand. She strokes his breast. She gathers flowers and wraps his horns in garlands. His horns are small, but they are 'like the work of an artist' and 'more polished than any jewel'. She mounts him, and he eases his

way into the sea. He churns in the water, and bears her off, now terrified but helpless, over the waves to Crete. There he 'lays aside' his disguise and reveals himself – not merely as the lusty divinity 'whose nod shakes the universe', but as divine lust, which as both Ovid and Tatius make plain, is wickedly triumphant.[141]

In doing his picture, Titian was influenced by contemporary Hapsburg propaganda, and what he produced has entirely different undertones. As he reinvents the drama, Zeus is (by implication) Philip II. It was Philip's triumph as an empire-builder, his bearing of Europe off to the New World, that his picture was meant to celebrate, an imperial victory of sensuality, guile and omnipotence over innocence. Titian thus softens the cruelty and irony. Relying more on Tatius than Ovid, he stresses Zeus' invitation and Europa's surrender. In a shrewd stroke of reinterpretation, he chooses to paint the massive god-bull out at sea, showing (as in Tatius' account) Europa lying akimbo on his back, her legs tossing, her scarf ballooning like a sail in the wind. In Titian's light-hearted recap, fish cavort in the foam. Europa's friends wave to her in useless alarm from the shore. A couple of winged putti, or *amori*, flutter overhead. Everything – the sky, her scarf, her body, the sea itself, Zeus as divine bull – seems bathed in a fruity, red-orange haze, like that of a boudoir, a brothel or a chandelier-lit throne room. As Titian sees it all, any savagery is folded into mere nervousness, into froth.

Rubens reverts to a gloomier view of what happens here, mostly but not only by changing Titian's colour-scheme. Reproducing with great exactitude the contents of the earlier painting – Europa sprawls across the swimming bull in his copy as in the original, and even the tense arches of her feet writhe at the same emergency angles – he drops Titian's Martian unearthiness, his atmosphere that seems a heap of vitamin flames, for a set of surprising – and scowling – blues. The scarlet sky turns umbrageous. The white bull, flecked with rouge shadows, darkens as its muscles nudge forward with more menacing power through the sea. Putti and fish slither out of a pouchy blackness. The steep mountains, far across the water, leap into relief. The sea looks less like a sheet of glass than a blue-black void.

The result is a swapping of one sort of story for another. The actors may be the same, and they may be caught up in the same plot, but their worlds differ, as does the energy, the now bitter fate, that stamps their destiny.

A crucial change appears in Rubens' treatment of Europa's head. It is flung back, as Titian's picture, but more so, with the result that her face, reaching beyond the shadow of her arm, can be better seen. It mirrors the tragic mood that Rubens has introduced. It blanches. Her eyes gaze about. You realize that Rubens has in fact extended to her expression a generosity of despair wholly lacking in Titian's fine but ultimately less engaging achievement.

80. A Marriage of Politics and Art

Rubens' wait in London now paralleled in many ways his long months in Spain, which he had put to such brilliant use. If the reason was the same – the slowness of ministers, the dreads of kings and the fidgettings of those staking their futures on an English-Spanish treaty – he directed his art along similar lines too, and found that a few not unwelcome public satisfactions came his way. He sensed that his time spent in the English capital might be worth it, and that his diplomatic-artistic life was rising to a crescendo, though whether it would be a happy one remained a question.

He had indeed expected to stay in England 'for a little while', as he wrote to Peiresc in August, 1629, 'in spite of my desire to breathe once more the air of my own home'.[142] He discovered unusual stimulations. He viewed the pampered luxury of life at Charles' court as an opportunity for bribery, even if he did nothing about it: 'All the leading nobles live on a sumptuous scale [he reported to Olivares] and spend money lavishly, and are hopelessly in debt. Among these, in the first place, are the Earl of Carlisle [whom he thought guilty of war-profiteering] and the Earl of Holland, who, by their fine table, maintain their following and their position among the nobility, since splendour and liberality are of primary consideration at this Court. I do not speak of the many other lords and ministers who ... have inadequate revenues to support their rank, and are forced to provide for their needs as best they can. That is why public and private interests are sold here for ready money.'[143]

He examined a vast collection of ancient Greek, Roman, Italian and Turkish statues and inscriptions ('I confess that I have never seen anything in the world more rare') of another nobleman who had no financial worries, Thomas Howard, the Earl of Arundel. At Philip's court, Rubens had discovered little interest in ancient beauty and none in archeology.[144]

William Boswell, a poet, secretary to Dudley Carleton and antiquarian, caught his Epicurean ear with a promise to let him read obscene passages hitherto omitted ('perhaps from modesty or prudishness') from *The Secret History* of Procopius. The sixth-century historian-statesman and erstwhile friend of Justinian I had spiced his horrifying account of his Emperor's mass murders in Libya and Italy with descriptions of 'the debauchery of Theodora', his wife and queen, whom he had picked up in a dance hall in Cairo after watching her perform naked.[145]

Somewhere during these months too, while out walking in London, Rubens saw hurrying past the Dutch physicist Drebbel, now living there, and met him, a cloaked, bulky figure. His perpetual motion machine had failed, and he had become an object of pity and ridicule ('I do not recall ever having seen a physiognomy more extraordinary than his: something remarkable, I do not know what, emanates from the ragged man').

Rubens felt ashamed of making fun of the poseur-inventor, who had also claimed – falsely – to have invented the microscope. As before, however, Rubens retained his interest in perpetual motion.[146]

He rose early, as was his habit. He went to pray in the private chapel at the house of Lorenzo Barozzi, envoy of the Duke of Savoy, his closest friend among the foreign diplomats at Charles' court. While being ferried to Greenwich with Barozzi one morning to see the King, he nearly drowned when their boat capsized. A priest drowned who was travelling with them. Rubens was pulled to safety, only barely, by the oarsman.[147]

As in Spain, with the exchange of ambassadors still stymied amid confusions, he painted. He did so even when news arrived that his eldest son Albert had fallen ill. He decided not to go home – that he could not, or not yet, considering what depended on his mission.[148]

His mission itself had begun to jostle his outlook, at least with respect to his belief in lasting peace, though this tormenting change may have been germinating for some time. His portrait of Van Dyck (today next to his self-portrait in Windsor Castle), and finished in 1627-28, before he crossed the Channel, with its accent of dismay, a striking difference from Van Dyck's assured expression in his own self-portraits, seems to set the mood for his artistic work in London.[149] He plunged into doing a fair amount of it – not as much as in Spain: what with diplomatic demands, there was less time – going ahead without commissions, or simply because various themes appealed to him. His portraits in particular seem to catch his subjects in tenser negotiations with the viewer, or with some secret future, than his earlier ones (among the exceptions are his *Self-Portrait in a Circle of Friends* and his wedding picture with Isabella Brant). The change had little to do with his growth as an artist – a too convenient idea for which there exists no evidence – and far more to do with his deepening political pessimism. His portrait of the Earl of Arundel (67 x 54 cm., in the National Gallery, London), even if unfinished, and his preparatory sketch for it, show a bust-length storm of a man in his forties moving briskly along, draped in a fur mantle and wearing his St George medal of the Order of the Garter. His hair seems to dowse the dark. His face and averted eyes are full of noble determination, if not anger. By contrast, a melancholy kindness flickers across the eyes of Rubens' sketch-portrait (which seems to have served as the basis of two different paintings) of the elderly, white-bearded Theodore Turquet de Mayerne, royal physician since 1611, a chemist and the author of a treatise on painting (Rubens provided him with tips on mixing colours).[150] His *St George and the Dragon* (153 x 226 cm., now in the Royal Collection) offers up a more familiar, ethereal aura. It shows Charles and Henrietta Maria in profile at a distance. The Thames Valley, a bit changed, spreads out in the background. This was the only occasion when Rubens painted any likeness of the King, or, for that matter, an English landscape.[151]

He painted the Gerbier family, with whom he was living – Balthasar's wife and three children – more than once. In fact, he inserted them into what must be regarded as one of the most brazen of his pictures (not simply those completed during his English months, which soon spilled over into 1630), his *Peace and War* (203.5 x 298 cm, now in the National Gallery, London; fig. 19).

This masterpiece is a vivid and cinematic depiction of torment, slaughter and serenity. It brings together, as in a film, quite new intuitions about great violence and great justice. It also seems suggestive of something else: his growing disenchantment with the possibility of workable pacts for peace. The drama here seems to race ahead of world events into terror.

81. The Fantasy of Peace and War

On the surface, there was no reason for terror. Despite the signing of a memorandum of understanding between England and France in September, 1629, Charles' efforts to conclude his treaty with Spain progressed, if with glacial slowness. Rubens in any case had finished this painting when he went to Cambridge on October 3 to receive an honorary Master of Arts degree, the highest then bestowed on an artist.[152] By then, Cottington had been named Charles' ambassador to the Spanish court, though he had not left for Madrid, and Don Carlos Coloma his opposite number, though he had not set out for England. On December 21, the peace process inched forward a bit further when Cottington departed for Dover and his ship. New Year's Day saw the exchange of ambassadors at last in place. Wranglings over wording, however, slogged on through February. Throughout the preceding months the danger had persisted, quashed by Rubens' coaxing, that negotiations might still be broken off (would the Spanish send an ambassador? were they luring an English emissary to Madrid only as a delaying tactic in prolonging the war?). As late as November, 1629, Rubens, immersed by now in disillusionment, and long after doing his *Peace and War*, complained to Olivares: 'I consider this delay at the present juncture as so unfortunate that I curse the hour when I came to this kingdom.'[153] As late as December, after he had presented the picture to Charles as a token of his esteem (and possibly to convey a more pointed political message), he begged to be allowed to go, this time for private reasons and because the apprentices essential to his business were abandoning his studio: 'I cannot postpone my departure any longer without great disadvantage to my domestic affairs, which are going to ruin by my long absence of eighteen months [actually only fifteen at the time], and can be restored to order only by my presence.'[154] The artist-diplomat enchanted with motion, energy and beauty had begun to find the inertia unbearable.

There can thus be no doubt that he greeted the issuing of his return

passport on February 10, 1630, with a sigh of relief (the treaty had still not been signed). His sigh seems to have echoed through the palaces at Greenwich and Whitehall – not over his departure but in gratitude for his contribution, by now recognized everywhere, to ending, or helping to end, the English-Spanish bloodshed. Perhaps in response to *Peace and War*, Charles at this point may have taken him to see his New Banqueting House at Whitehall Palace. The King at any rate had finally decided to ask Rubens, whom he admired without any of his customary reservations – and whose new painting now hung in the royal gallery – to do a series of ceiling pictures as ambitious as his Medici series in Paris.

The Whitehall series was intended to commemorate the union of England and Scotland under Charles' father, James I, or a pact for peace and amity very different from that which Rubens had been trying to arrange in London. As he discussed the commission, he may have met Inigo Jones, in a get-together between painter and architect as happy for his ideas of aesthetics as his meeting with Galileo had been for his ideas of motion (Jones may also have supplied the ceiling-area measurements for the new paintings). Rubens may even have made oil sketches on the spot for Charles' approval (several perhaps done on the spot have survived).[155]

On March 3, 1630, at Whitehall Palace itself, Charles knighted him – thus conferring on his (by now) friend from Brabant the supreme English, and European, honour – a few days before Rubens climbed aboard his coach for Dover and his return to Antwerp.[156] He did make one last-minute effort, which was unauthorised, to arrange yet another truce, on March 5, between the United Provinces and the Southern Netherlands. He paid a sudden visit on Albert Joachimi, the Dutch ambassador to London, then seventy years old and a cautious if stubborn but experienced diplomat himself. According to Dudley Carleton, Rubens told him that 'the States might make peace if they would, and therby bring quiett and rest after long warre to all the seventeen Provinces'.[157] In this desperate push for a peace pact affecting his own country, he failed, perhaps confirming afresh his disbelief in the possibility of agreements between peoples animated by religious hatreds instead of minimal tolerance. Joachimi was adamant that 'there was but one way [to make peace, and that was] ... by chasing the Spanyards from thence'.[158]

Rubens' *Peace and War* (also called *Minerva protects Pax from Mars*), though painted a few months earlier, seems to capture the toxic mood, the ambivalence, of these sometimes successful, sometimes frustrating situations and trials. It is among the strangest of his canvases, so bewildering that at first your mind has trouble taking it in. The eye flips back and forth among its fifteen figures, including a squatting satyr and a playful leopard cub rolling on its back. All of them seem to advance and recede before you, most while barely moving, a couple while thrashing

about. They crowd a stage sashed in red at its edges. The stage-rear area opens onto a vista of storms and mountains plunged into miles-away blackness.

The effect is one of mesmerising confusion. You realize that the source of the confusion lies in the picture's inexplicable-seeming psychotic split, or schism, between its lopped-off theatres of peace and war. You seem to be looking at something impossible – clashing spurts of murderousness, a volcanic eruption of rage – that cannot be ignored, and that yet goes unnoticed by nearly everyone, and this in a large and mysterious drama.

In the foreground, all is tranquil. A glorious nude goddess, who may be Pax but who is more easily identified with the Venus who appears as a goddess of conciliation in Rubens' other political allegories (as in his *Death of Henri IV and the Proclamation of the Regency* (13) in his Medici series), and who may represent a merging of love with peace, is seated behind the satyr, who offers pomegranates, pears and grapes from a cornucopia to three elegantly dressed, hesitant children.[159] The leopard sprawls at his feet. Venus squeezes milk from one of her breasts into the mouth of an infant, who may be the god of wealth. Of the two putti present, one is ogling the children, the other swooping down from above. He bears a laurel crown for Venus and a caduceus, whose writhing snakes suggest anarchy. Nearby, two half-nude women, or perhaps bacchantes, are dancing, one rattling a tambourine.

Just behind Venus, or Pax, and the others, Minerva has entered into a dreadful combat with Mars. The idea of these two gods fighting seems odd because the ancient world saw Mars and Venus as lovers. Here, however, the god of war appears as a Fury-like madman. He wields a sword while a genuine Fury, a female Underworld fiend, flees in terror as Minerva hurls herself at him to prevent his attack on Venus and the children. Minerva is steel-helmeted and tough-looking. She carries a spear. Storms prickle with lightning above their struggle, in which Mars has turned both evil and crazed.

This division between peace and war is wholly without anticipation in Rubens' previous work. It is nothing like the separation between scenes and figures in his *Baptism of Christ*, for instance, done many years earlier and during his Mantuan days. There, a unity of composition, between Christ wading and other men waiting to be baptised on the far side of a tree, issues from the tree itself, which seems to draw all the figures into a natural and spiritual harmony. No such aesthetic union develops here. It also seems plain that the division is not one of composition but of psychology. It is the result of incompatible states of mind, of rival forms of energy and motion: those of serenity, on the one hand, and of depravity, on the other. An additional sign of the picture's immediate meaning may also not have been lost on Charles. This was that the children in the foreground were Gerbier's children, and that his wife had probably posed for the figure of Venus, or Pax.[160] All were Netherlanders,

as was the artist himself, who though respected for his peace efforts, was about to return to his war-battered home-city.

As he took his leave, Rubens worried as much about the religious impulse in men and women, its capacity to create beauty and violence, as about war itself. This conflict, too, seems to explode across his quasi-mythical painting, and its display of the undisturbed, marvellous energy of beauty, as behind it thrashes the dreadful force of evil, which has a seductive beauty of its own. 'It is evident,' Rubens had written to Pierre Dupuy months before finishing the picture, 'that religion exerts a stronger influence upon the human mind than any other motive.'[161] At best, his remark was meant to convey a sceptical melancholy.

He had achieved a good deal in London, yet all remained unsettled. A peace treaty had been drawn up, but it remained unsigned. Kings and commanders kept vacillating between opportunities and fears, perhaps most of all fears of peace, that great unknown, like freedom.

V

Rubens and Sensuality

82. Toward a New Optics

A dark, masculine smell of judgement, of sex as aggression, the odour of
imminent slaughter sweating through the nape of an enormous neck and
head left dazed yet pinging with terror on a battlefield, its giant eyes
trussed with expectations of the beheading sword now starting its down-
ward swing. The sword begins to sweep through sweet blue air, the light,
mad fragrance of heaven above.

The background is unreal, a blur of bluish soldiers, Israelites, hurtling
en masse toward a routed Philistine army in ancient biblical times,
except that the year is 1630 and David is slaying the giant Goliath a few
months after Rubens returned to Antwerp via Brussels, on April 6. He
had painted this powerful, gruesome scene before, for the ceiling of the
Jesuit Church in Antwerp. As he did so again (*David slaying Goliath*,
122.23 x 99.06 cm, today in the Norton Simon Museum, Los Angeles;
plate XI), and with terrifying new power, he may have had in mind
Titian's Cain in his *Cain slaying Abel* at the Santo Spirito in Isola, in
Venice, or a design by Raphael in the Vatican Loggie, or even his own
Christ in his *Christ scourged* at St Paul's Church, also in Antwerp, all of
which influenced him. More significantly, he may have been thinking of
a similar Goliath from the Palazzo del Tè in Mantua.[1]

Mantua had fallen to the French on July 22. The news reached Rubens
at his home only in August: 'We have received very bad news from Italy
[he told the ever-sympathetic Peiresc], that ... the city of Mantua was
taken by assault by the Imperial troops, with the death of the greater
part of the population. This grieves me deeply, for I served the House of
Gonzaga for many years, and enjoyed a delightful residence in that
country in my youth. *Sic erat fatis* [So it was fated].'[2]

It is unclear whether his David and Goliath was done on commission,
or simply because he wished to do it, as with so much of his work. This
was the case with another Mantua-inspired painting that he did at
around the same time, or in England when it arrived there in 1629 as
part of the shipment of Mantuan art sold to Charles, his copy of
Mantegna's *Roman Triumph* (86.8 x 163.9 cm, now in the National

Gallery, London; fig. 20). Both militaristic pictures, with each harking back to the Italian glory city of his youth and by implication to Rubens' anxiety about its siege and sacking, are remarkable for their humanizing of bloody-mindedness and dreams of victory, their reduction of nationalistic fantasies of domination to ordinary size. Rubens' *Triumph* in fact shrinks the dimensions of Mantegna's large painting, with its floating lines of perspective that had first caught his eye when he wandered through Vincenzo's San Sebastiano palace.[3]

Rubens made other alterations to Mantegna's picture as well, inserting them with casual confidence. He placed a red-gowned priestly figure at the centre of the crowd of soldiers, sacrificial heifers, animal handlers, citizens, admiring women and a troop of surly elephants – one of them pointing its trunk straight out of the picture plane, in a lovely gesture of foreshortening – that moves past you, against a setting of temples and flaming torches. The priest acts as a gyroscope of calm. His coolness undermines the triumphalism. In addition, Rubens' muscular, thrilling animation of the figures, especially of the animals (as opposed to the deadening sterility of Mantegna's animals, no matter how lively his ideas of perspective), transforms what was conceived as an egotistical ceremony into a carnival. Grandiosity slides into the grand.

Goliath in the companion picture (as it may be understood) is also no cartoonish monster, some dullish superman (Orazio Gentileschi, court painter to Charles, depicts him as both), but just a big man. His shaggy face, full of malice and amazement, with hints of shattered contempt in his eyes, elicits the fear and pity of biblical tragedy. You identify with his human conflicts. David, the poet-warrior and author of the psalms, is presented as his near match in size and strength. He places a single pressing, dancer's foot on the giant's great head as he begins the swing of his fearful sword.

Most exciting is a novel vagueness introduced into both paintings, but with special power into *David slaying Goliath*. No effort is made to render the background – its vanilla-and-lemon-streaked blue sky, the rushing bluish outline-ghosts of soldiers – with the same close-up conciseness that we get with the two death-obsessed combatants in the foreground. Pieter Bruegel would have done so, one imagines, as would Titian, Da Vinci and even Michelangelo (Caravaggio would probably have eliminated the all traces of background). Pride in an implausible accuracy of details, no matter how distant – pleasure taken in a perfectly delineated if leagues-off boat, battle or castle on a hilltop – is exchanged for a dynamic interest in optics (as if Rubens had made a new optical discovery): in how the eye works and how it adapts to varying situations.

Energy, as Rubens handles it here, perhaps developing the approach out of his earlier understanding of after-images, not only governs the details spotted by the eye but controls visual interest. Close up, it resolves itself into specific people doing particular things. Far off, it slips

into a display of crisscrossing visible streams of pure motion – into what seems a lack of focus but is in reality a manifestation of the elasticity of vision, the ability of the optic nerve and the brain to perceive energy itself as it turns more and more into its unrefined form at increasing distances.

Rubens thus paints the sky, and the far-off soldiers, as wavy Niagras of transfiguration. They are not, nor does he allow them to appear, as merely unfocused, or fuzzy, as in a still-photograph. They become vibrations of colour and design. Close up, the same phenomenon of transfiguration is taken into account as energy shifts in and out of itself and seems to change with your eye skipping from detail to detail. Goliath's brooding, vindictive face, for instance, may for a moment become your centre of attention, which may then light on his nose, his lips, the wound inflicted on his forehead by the stone from David's sling, which has felled him, and David's toes curling over his brow. Each is rendered as both solid flesh and energy, which means that with each readjustment of attention it springs into something definite or slips into wavering clues to it. The result is that you are never presented with any optical strains on belief, but only with the sources of phenomena and the phenomena themselves, even among the smallest whorls and folds of the two major figures' hairs and limbs.

All of this enhances the drama. An energised sky pulses around the judgemental face of David. The action emerges with greater vigour. This fact may be clarified by a close-up of Goliath's face [plate XII]. Both here and in the picture as a whole you find your eye taking in not an instant extracted from the execution but successive seconds of it. These repeat themselves, and may, as your eye readjusts, be run both forwards and backwards. You become a constant witness to the metamorphosis of flesh into energy, and vice versa, and to the eternal beauty – no matter how appalling the circumstances – of this most universal of physical processes.

83. Mission Cancelled and a Second Marriage

To get on with such work he had come home to his two sons, a few servants, a single apprentice-caretaker and, with Isabella long dead, an echoing desolation. A wifely absence seemed to drain the opulent splendour of his house, the accumulation of his fifteen years' residence there.

Apart from his artist's studio, the furnishings of his many rooms seem to have resembled those of his married but childless friend, Nicolaas Rockox, with seven-doored cupboards ornamented in carved lion's heads and inlaid woodwork, a marble mantelpiece with oak cornices and a carved frieze, oak beams adorned with painted acanthus leaves, walls hung in gold-stamped leather, a pendulum clock with astrological designs, walnut chairs, four- and twelve-branched brass chandeliers, fur-

lined wardrobes, Ming-dynasty porcelain, copper footwarmers meant to be taken full of hot coals to church (for no churches were heated), stone kitchen jugs, an ebony art cabinet overpainted with biblical animals, a chimney piece wrapped in velvet Spanish valance, boxwood and ebony crucifixes, pewterware, Persian carpets and many paintings (among them Rubens' own *Samson and Delilah*).[4] In his own house, in addition to his many paintings and copies of work by Raphael, Tintoretto and those of Titian that he had done in Spain, there were masterpieces by Van Dyck, Jan and Pieter Bruegel, Adam Elsheimer, Veronese, Paul Brill, Dürer, Jan van Eyck, Bronzino, Antonis Mor, Sebastian Franx, Frans Snyders and Jordaens.

All this dazzling, unattended emptiness still wanted, or so he felt, the woman's touch. It lacked its former vivacity, those evenings when, having finished his painting for the day and taken his horseback ride, he came home to write letters to Peiresc, the Dupuy brothers and his other correspondents in France, Holland, Spain and England and to sit down to a convivial dinner with his wife, children, friends and perhaps Rockox himself.

Rubens had gone over to England with Hendrick Brant, Isabella's brother.[5] He too had been eager to get back to Antwerp, as Rubens wrote to Gevaerts, but not only because he missed his job as City Clerk: 'My brother-in-law is losing his patience at having to leave all the work to his colleagues for so long, and it also distresses him to be so long deprived of the society of the girls of Antwerp. Probably in the meantime they will all have been snatched away from him.'[6]

He missed them himself. He had always been a strongly sexual man – as witness his unending delight in painting nude women and love scenes. Once on familiar territory again, he wasted little time in making up for his lack of female companionship.

He settled into his studio, took up his archeological studies, seemed to drop out of politics for a while, though he kept himself well informed, and began to call on a young woman whom he had known since she was a child, Helena Fourment, the daughter (along with her ten brothers and sisters) of Daniel Fourment, a well-off Antwerp merchant and tapestry dealer. Rubens had known Helena's father for many years and had designed tapestries for him.[7]

Despite a pudgy face, Helena sported a surge of blonde curls, sultry eyes, two becoming dimples and a small mouth. Everyone considered her a beauty. Her breeding, education, good temper and independent wealth seemed commendable, as did her unpretentiousness. If he wooed, won and even married her, she might make none of the demands of more sophisticated women that he pursue court life, with all of its vapid excitements. She might be happy to pose for Europe's most esteemed artist and might find his messy studio and his paint-stained hands no impediments to an harmonious life. She might support him in any struggles to come.

Despite her youth and his age (she was an astonishing sixteen; he was approaching fifty three), there existed in Brabant, as in the whole of Europe, none of the modern world's prejudices against alliances between very young women and middle-aged men, though Chaucer had voiced conventional suspicions of the dangers in his 'Merchant's Tale' ('it is an heigh corgage/Of any man that stapen is in age/To take a young wif'[8]).

As Rubens visited Helena and painted, he amused himself with writing to Peiresc about an ancient tripod found in a Roman temple of Neptune ('according to my accustomed temerity, I shall not fail to state my own views on this subject'). Peiresc had sent him a drawing of it, and Rubens offered a detailed estimate of its possible function, concluding with his customary clarity that 'this bronze tripod of yours ... is one of those which was used to burn incense at the sacrifices. The hole in the middle served as an air hole to make the coals burn better'. He invited his son Albert, the same age as Helena, to translate some ancient passages that Peiresc had enclosed, noting with pride that 'the passages by Ancient authors have been added by my son Albert, who is seriously engaged in the study of Antiquities'. An inkling of his keenest interest at the moment, though, may be found in his next remark: 'I find those [ancient] nuptial rings [sketches of them had also been sent to him] the nicest – so beautifully inscribed that Venus herself, with all her Graces, could do no better. These are worth a treasure, indeed they are inestimable.'[9]

Nearby, as he scribbled away and reestablished himself at home, the war frazzled on. The Spanish position was deteriorating.

After some initial successes against the Dutch under his friend the Marquis Spinola, who had just died of illness, broken-hearted and with his hopes of peace and victory dashed at the siege of Casale near Mantua on September 25, the royal army in Brabant and Flanders had stumbled from one defeat to another. Frederick Henry, Prince Maurits' brother, had acquired an immense popularity among his troops and the Dutch as he seized major towns such as Wesel and 's Hertogenbosch. Spanish bankruptcy exacerbated problems of poor command and loose discipline. At Breda, where unpaid soldiers ran about in rags and without ammunition, the threat of mutiny looked as dangerous to Madrid as had the Dutch mutiny five years before. During the past winter, sentries had starved or frozen to death at their posts.[10]

Dissension was rife across the Southern Netherlands. The Archduchess Isabella came under criticism. She pawned her jewellery to raise money for victualling her troops, who were deserting in droves. The amount raised proved insufficient to retain them, as did the taxes that she levied on everyone, including Rubens, who had still not been repaid for his expensive trips on her behalf to Spain and England.[11]

Relief seemed to smile from on high with the signing of the Spanish-English peace treaty on November 15, 1630, and its proclamation one

month later. Its final implementation brought great joy to Rubens, as did receiving his diploma for his English knighthood, sent to him by Charles in December.[12] Perhaps, after all, his disillusionment had been premature. Perhaps peace in a broader sense, among the various warring nations of Europe, could be achieved despite the usual aristocratic and ministerial intransigence. His financial position improved somewhat too, this making for a domestic sort of happiness, when on November 27 he managed to arrange the sale of Hubert Goltzius' numismatica, an impressive collection of ancient coins, for 4,920 florins.[13]

Philip IV now sought to embark on a shift in strategy. In late 1630, he asked Rubens to go back to England. The King's idea was that the Fleming would this time go as Isabella's ambassador – a rare honour – replacing the able Spanish commander Don Carlos Coloma, his present emissary, who would return to Brussels to take charge (as he had done before) of the collapsing Spanish army. The King wrote with enthusiasm to the Archduchess about his plans: 'Rubens is highly regarded at the Court of England, and very capable of negotiating all sorts of affairs.'[14] On this occasion, however, his optimism was ill-conceived. After more than seven years of diplomatic service and unselfish devotion to the cause of peace, Rubens rejected his offer. What is more eyebrow-raising, though it illuminates Isabella's sympathetic nature, is that she offered him her support. In replying to Philip, her nephew as well as king, she noted that she could not send Rubens 'because I did not find him willing [except for a few days] to accept this mission.'[15] She had taken his new reasons to heart.

After so long an absence, his desire to spend time with his sons played its role in his refusal to go, as did his pleasure in remaining at home and devoting himself to his painting full time, especially his second Medici series (he had started on it as early as 1628), that focusing on the life of Henri IV ('I ... have made considerable progress on some of the largest and most important pieces, like the 'Triumph of the King', for the rear of the gallery'[16]).

Most important, though, was a great change in his personal life. On December 4, with his ex-father-in-law and friend Jan Brant presiding as an alderman of Antwerp, Rubens signed a marriage contract with Helena Fourment.[17] The two must have laid their plans well in advance, as their wedding took place, to the accompaniment of a marriage poem, a lavish bestowal of gifts by Rubens on his bride and expensive festivities, just two days later.

84. New Life, New Beauty

If Isabella had been his companion, Helena had become his centre of adoration. Isabella had helped him shape his life. Helena began to change it.

V. Rubens and Sensuality

Rubens had told Caspar Gevaerts while still in London, 'I should be happier over our peace or truce [between Spain and England] than anything else in the world. Best of all, I should like to go home and remain there all my life.'[18] He now fulfilled his wish, and with Helena, began to attain much more. To Jan Woverius, his friend from childhood who had met up with him and his brother Philip in Verona during the salad days of his youth, he wrote with glee, 'I find myself most contented in the conjugal state [this one month after his wedding], as well as in the general happiness over the peace with England.' If he let slip a flash of anger over still not having been paid for his diplomatic outlays (he felt 'an insufferable affront' over this, and added, 'I am so disgusted with the Court that I do not intend to go for some time to Brussels'[19]), he revelled in the new mixture of sensuality and love, with a devout licence to spend his hours basking in both, that he might now enjoy.

Gevaerts in his wedding poem, which to Rubens may have banged a bit awkwardly against Philip's poem on his wedding of twenty-two years earlier – the style of lumbering classical allusion was the same – compared his friend's Helena with 'Helen of Greece'. Such absurdities were of course the standard fare (Helena, Gevaerts said, 'far' outshone Helen), as was his exclaiming that Rubens' Helena, like Venus, must have stepped golden-haired from the sea (no matter how uncomfortable this damp image might have made Helena feel during her fifty-course wedding feast). Conventional, too, were Gevaert's praises of her 'spotless simplicity, her innocence [always a risky term] and her modesty'.[20]

In Gevaert's defence, it should be noted that the frequent result of this old-fashioned puffery was a paradox. If the extravagance was a game, its silliness reinforced passion, at least by contrast. Shakespeare had mocked the Petrarcan convention while appreciating its power to sabotage 'the world's false subtleties': 'And yet, by Heaven, I think my love as rare/As any she belied with false compare.'

False comparisons had never been to Rubens' taste, though he might put up with them in his own wedding poem. To judge from the sensuality with which he at once began to sketch and paint his new wife, Shakespeare's frankness seems to have been more his cup of tea.

Absolute candour, at any rate, shines through his delicate depictions of her in paintings for which she soon began to pose – as Hagar in the desert (his familiar exile figure), or Bathsheba, or an unidentified siren, saint or vixen – each of which blends in an exciting way close psychological insights with undistorted appreciations of her charms. From the start, Helena seems to have been sheer woman to him – not Venus, not goddess, though he asked her to play both roles. Long before he met her, he had done as much for others in his family. In sketches and paintings of Isabella as she grew older, and in the remarkable painting *Albert and Nicolas Rubens* (c. 1625, 158 x 92 cm.; in the Sammlungen des Fürsten von Liechtenstein, Vaduz; fig. 21), completed when his sons were twelve

and eight and just before their mother died, as in the sketch of his daughter Clara Serena (if in fact it is of her; *c.* 1623, 35 x 28.3 cm., in the Albertina collections, Vienna; fig. 22), with its 'gay vitality', he had seized on his wife and children's mischief, wistfulness, sorrow and pride – on their undistorted humanity – while avoiding suppressions of their idiosyncrasies.[21] If he had perfectionist ideals among his models, whether members of his family or not, they clustered around his quest for 'gay vitality' itself. In his lost essay on painting and sculpture, cited by Roger de Piles, he had grumbled that these days 'we see so many paunch-bellies, weak and pitiful legs and arms'. He liked athletic types for their sheer vim: 'The arms, legs, neck, shoulders, and whatever else works in the body, are assisted by exercises, nourished with juice drawn into them by heat and ... increase both in strength and size.' Best of all, he relished 'the arms of prize fighters, the legs of dancers and almost the whole body of watermen'.[22]

It was no wonder that he felt mesmerised by Helena. Her sexy, playful, dead-serious vitality flourished amid any natural imperfections. It seemed to erase them. Rubens had no compunction at all about showing her big bones. He exposed her bulky knees. He refrained from chiselling into an idealised Italian fantasy the roundness of her face.[23] He dandled her eccentricities. He explored her versatility. In one painting after the other, she could be coaxed as quickly from naïve innocent into know-it-all flirt as into mature young woman, imperial mistress and petite yet wholesome housewife. An early sketch, perhaps intended as a finished work of art rather than as a preparatory piece for a painting (*Helena Fourment*, 1630-32, 61.2 x 55 cm., in the Courtauld Institute Galleries; fig. 23), shows her slipping off her translucent mantle, or heuke, from the cylindrical pompom of her cap and her shoulders with one hand, while in the other holding a prayer book. Done in black chalk, with traces of red chalk at her lips, cheeks and forehead, it seems to catch her just coming back from church. Her face and eyes, though, limned with Rubens' typical and unceasing attention to personal contradictions, are all sensual dreams.

It is also interesting – or maybe not (so much is unknown, even with a good deal of information) – that he never painted a wedding picture of himself with Helena, or even a wedding portrait of her alone. A single portrait, *Helena Fourment* (1630-31, 160 x 134 cm., in the Alte Pinakothek, Munich), has been seen as one, though aside from its official-seeming formality, with Helena in a splendid gown, leaning forward in a chair, her face like a hot rum punch afloat in a gold goblet (her energy seems irrepressible here too), there is no proof of any connection to her actual wedding.[24]

What is clearer is that for several years, starting well before his marriage and his trips to Spain and England, his art itself had been moving into a greater sensuality than hitherto – with this including

sprawling fields of violence as well as love, as if he was forming some pact with sensuality itself. This began to overshadow, though not eclipse, his earlier pacts for spiritual and political beauty. Age and maturity seemed to induce a fresh emphasis. Helena's glorious entry into his life can perhaps be understood as a signal of a more general aesthetic change.

War could be sensual too, after all, at least as he conceived of it. Not only his *Peace and War*, but also several of the huge battle paintings that he intended as parts of his new Medici series, blaze and pulse with the dreads, triumphs, lunacy, barbarism and griefs of military slaughter – and all on a scale never seen before, either in his, or perhaps anyone's, art. His six titanic Henri pictures, each of them left unfinished and two of them lost, but whose contents can be surmised on the basis of his contract for 'all the battles of the deceased Henri the Great',[25] mirror in reverse the sensuality of his paintings of Helena, and others of his new sketches and paintings.

In *Henri IV at the Battle of Ivry* (367 x 693 cm., in the Uffizi Palace; fig. 24), unlike his other two battle pictures that have survived among those that he worked through varying stages for the series (*Henri IV's triumphal Entry into Paris* is in the Uffizi; the remaining battle pictures were completed by co-workers and so cannot fairly be estimated along these lines), the unfinished quality of what is a colossal sketch in oils of clashing armies presents you with a unique moment: that when energy writ large resolves itself into flesh and blood, into horses, swords, lances, writhing skies, stabbings and corpses. A smudgy rawness exposes the transformation. The splays of paint extol the art of creation. In a brilliant yet crude experiment, for so in its unfinished state the picture may be regarded, the crazed lights of an unheralded Impressionism fuse with the decadent nobility of Romanticism, though neither movement in the arts had yet been born. The painting thus becomes a prophecy of uninhibited treatments of energy as yet unformed. As a sketch, it also becomes a lens. It magnifies and explores the process of the invention of beauty. No figure is perfectly resolved. No object is quite clear. Nothing is static. Only the spectacle of design unfolding into colour can be glimpsed, as a voluptuous geometry turns into life, with the ghostly energy behind it hinting at a divine intelligence.

Beyond this, the very conception of war here abounds in a new realism. It presents in horrifying ways the sensual attractiveness of martial destruction, but stripped of heroic foolishness. In the lower right-hand corner, an anonymous hand lifts the last shred of clothing from a dead soldier. The lower left-hand corner shows a man slamming head first onto the ground as his horse topples beneath him. The foreground centre shovels up a gaping corpse, its head upside down, with a horse crushed by other horses sinking onto its chest. The rest of the lower section is a study in men's straining dark feet and equine pumping legs. Above the feet and legs, as two battle horses rear against a background

of grey clouds and the armed spirits of war, masses of soldiers go at each other with swords, daggers and their bare hands. In the midst of this fracas, Henri himself, mounted on a bay horse, armoured and charging, but rendered less like the Hercules with which the propaganda of the day identified him than an ordinary, if powerful man, leads his assault. Little blood is visible throughout, despite the lethal violence – not none, as in Rubens' *Hippopotamus Hunt* – but viewers of the battlescape, who can in any event imagine all the blood they want, may find themselves stirred by a fearful realization which the nausea of blood and gore would obscure: that the whole scene, so representative as Rubens painted it of real battles pouring back and forth across Germany and flooding into his own neighbourhood of Antwerp, is as sensually exciting as his portraits of his new wife.

85. Promoting War

Quite a few people found Marie de'Medici unbearable. She demanded endless small attentions. She travelled, as befitted a queen, with dozens of servants and ladies-in-waiting, who made their own demands, as well as requiring food and lodging. She was often moody. She disapproved of nearly everything.

In Paris, she disapproved most of Cardinal Richelieu, whose influence on her son Louis XIII she deplored and against whom she had intrigued for years. The conflicts between these three would-be-rulers of France came to a head in February, 1631, when she publicly humiliated the King by forcing him to kneel at her feet and when, after a day of filial jitters, he summoned Richelieu into his presence, granted him full state powers and forced his mother once again to flee the capital.[26]

Her flight, or in fact banishment, was not without its Machiavellian compensations. Detained with her retinue under house arrest at a castle in Compiègne, she plotted her return. In doing so she received the assistance of the King's brother Gaston, the Duke of Orléans, whose hatred of the witty Cardinal vied in ferocity with her own.

A series of embarrassing blunders led on July 18, 1631, to her escape, and to her flight into the Southern Netherlands. There she proclaimed her arrival and sought protection from her old friend, the Archduchess Isabella.[27]

None of the Queen's more unpleasant qualities affected Rubens, who remained grateful to her for commissioning his Medici series, whom he viewed as the rightful French Queen, whose peace policies across Europe he supported and whose enemy, Richelieu, had now become his own: with Marie in exile, he could scarcely hope to see his commission for the Henri IV paintings honoured, a stunning if not insulting setback. All might be redeemed, however, if she could be restored in Paris – by force, as seemed likely. This indeed might be managed if the Duke of Orléans succeeded in

fomenting a rebellion, and especially if the Spanish, who had no love for Richelieu, could be induced to supply money enough to hire sufficient soldiers and cavalry. Spanish money would bolster as well the mood of a score of disaffected French nobles who longed to participate in an uprising, or so Rubens was convinced, but whose eagerness for battle was prone to flag.[28]

It thus mattered little that the Archduchess wished to welcome Maria to the Spanish Netherlands warmly, but not so warmly as to provoke the French. Rubens had come to believe that he himself had leverage with the Spanish ample to counterbalance any provocation: on July 16, Philip, following the lead of Charles in England, had knighted him for his services to the Spanish crown.[29] Through Brussels, the King had also arranged (by March 24) a repayment of his diplomatic expenses, or 12,374 florins.[30] He accordingly set off, on Isabella's orders and accompanying the Spanish ambassador to the Southern Netherlands, the Marquis d'Aytona, to greet Marie at Mons. He arrived at the end of July.[31] While staying there for a few days and talking over with her the question of the rebellion and their mutual dislike of Richelieu, he penned the longest, wildest, most notorious letter of his life, at least among those that have survived. It was addressed to Olivares in Madrid. It advocated war.

Apart from observing that all interesting people, and some who are not, harbour fascinating paradoxes, one is hard put to know what to make of this piece of hypocrisy, which was in any case spurned by the Privy Council in Madrid when Olivares presented it. Few were seduced by its casuistry, or its attempt to draw the Spanish into a conflict which they could ill afford, either financially or militarily (one minister described it as packed with 'absurdities and Italian verbosity'[32]), yet the letter itself exhibits a side of Rubens' personality seldom open to view.

It seems likely that he interrupted his work on the Whitehall paintings as well as on several intimate family pictures to ride to Mons and while writing his war-letter. The paradox that it illuminates becomes all the more interesting for this interruption: his new paintings were devoted to peace.

To his credit, he admitted the strangeness of what he was about: 'I have never [before] worked for war, as Your Excellency can confirm, but have always tried, insofar as I have been able, to procure peace everywhere.' On the other hand, the present situation required exceptional measures: 'Surely we have in our time a clear example of how much evil can be done by a favourite [Richelieu] who is motivated more by personal ambition than regard for public welfare and the service of his King ... and how a good prince, badly advised, can be induced to violate the obligations of nature toward his mother and his own blood.'[33]

All this was well enough, but one may surmise that it was not so much the duties of son to mother that moved Rubens as a more personal

motive: his nasty sense of betrayal surrounding the Henri IV commission ('I certainly consider all I have done as labour entirely wasted'[34]). At the same time, his motives were pure ('if I saw that the Queen Mother or Monsieur [the Duke of Orléans] were aiming to cause a break between the two crowns [Spain and France], I should withdraw from this affair'[35]). The nefarious Richelieu had become his target, not a wider war (though as he knew, 'Anyone can start a war when he wishes, but he cannot so easily end it'[36]). Suspicions of his possibly tortured feelings about the whole enterprise are also aroused by the sheer complexity of his argument. In familiar Machiavellian style, he moves from exhortation to threats (if the Duke of Orléans 'is not able to subsist with our help, he will be forced to throw himself into the arms of the Hollanders'). He even paraphrases Machiavelli (the 'soul' of the undertaking 'is secrecy and prompt execution'). He slips in his price (an exorbitant 300,000 gold crowns), offers a sly comparison with amounts already pledged by others and winds up with flattery ('the decisiveness which is the peculiar virtue of Your Excellency', 'the heroic nature of Your Excellency').[37] In the end he may have felt happy enough that this proposal came to nought, relieved by the refusal of the Spanish to involve themselves in an adventure whose wisdom he may have doubted (a small army later assembled by the Duke of Orléans was routed by Richelieu's forces at Castelnaudary on September 1, 1632). At any rate, he expressed no dismay when the Queen Mother now proceeded in relative calm to Brussels and thence to Antwerp, securing six-weeks' lodgings with her retinue at the Abbey of St Michael, where his *St Gregory surrounded by Other Saints* hung in the chapel dedicated to his own mother, and from which she had but a short walk to his studio to pay him visits. If she continued to lay her plots, pawning her jewels to raise money for troops, and if his sympathy for her continued to burn bright, still he seems not to have involved himself to any great extent in further scheming on her behalf.[38]

At his studio she may have seen his unfinished Henri IV paintings as well as the first of his nine canvases for the Whitehall commission, for which Charles had offered him £3,000 (or £180,000 in today's money).[39] She may have gazed upon a portrait of Helena, *Portrait of Helena Fourment* (96 x 69 cm., in the Alte Pinakothek, Munich), which shows her off in a plumed black-felt hat and low-cut, black-and-gold dress, each plumped out with a red bow – as a sort of elegant, half-smirking gypsy – and an amazing family portrait of unusual intimacy, done at about this time, *Self-Portrait with Helena Fourment and Nicolas Rubens* (97 x 131 cm., in the Alte Pinakothek; fig. 25).

No other picture by Rubens conveys so perfectly the impression of an earthly paradise of domestic love, of a garden just outside Eden where married lovers and the child of one of them seem to realize their every mortal wish. His brush here celebrates a dream of innocence. Just behind their house, Rubens, Helena and his son Nicolas, who was about thir-

teen, can be seen strolling along a path leading to the ornate, columned pavilion at the end of it. A dog, symbolic of loyalty, scampers beside them. A peacock, sacred to Juno, goddess of marriage (though she was often traduced by Zeus), spreads its golden-eyed tail before them, to their left. A servant-woman, standing close to the peacock, nods deferentially. If Marie, whose own marriage had scarcely been a paradise, saw this picture, she may also have been struck by an extraordinary element in it that plays but a small role in Rubens' long-ago wedding portrait with Isabella (the only picture of them together). This is the tumbling mass of trees, plants, shrubs, fruit and flowers that rises around and behind the three central figures and that showers and bathes them in a lushness, a profound sensuality, of groomed and civilized nature.

Most of the canvas is taken up with this heaped-about flora – with blooms, leaves, downy sprigs, buds, stilting branches, grass and vines – and the effusion is unending. Behind the family stands a shut gate leading into an enclosed, smaller garden. This was perhaps Rubens' evocation of the medieval *hortus conclusus*, or symbolic Garden of Eden, from which Adam and Eve were expelled and left to wander over the tougher garden of the Earth, whose lushness lasts only through summer. The paradise of mortals was but for a season.

Everything in the picture shines with ravishing innocence. Helena, standing at the centre, even looks a trace girlish (she was perhaps eighteen) in a puffed-sleeved white frock and straw hat. Nicolas, clad in red, walks self-consciously behind her. Rubens himself, in a wonderful specimen of his rare self-portraiture, seems a man much changed from his appearance in his earlier portrait with Isabella and in his self-portrait done for Charles I. In his mid-fifties by now, still sporting his black felt hat, and peering toward you over Helena's shoulder, he brims with curiosity and energy, but seems graced with reserve. If he looks more aware of his importance in the world and to it, he also seems sceptical. A shadow of paternalism, rinsed with irony, blends into lights of humour and affection brushing his face – all this in an atmosphere of post-lapsarian dreams of purity, or what he may have imagined could be saved of them.

86. Beauty, Evil and the Whitehall Pictures

His diplomatic career did not so much end as drift into pointlessness and fade away. More and more, he seemed willing to shrug and resign himself to victories of the forces of corruption, to betrayals of the best human impulses and to the miasma of outright evil, as if his trust had been shaken, though he rejected the dark options of cynicism. At the same time, a sensual rebirth and vigour, or his pact with sensuality, began to renew him.

As long ago as 1625, he had told Peiresc's brother Valavez that 'in

public affairs I am the most dispassionate man in the world, except where property and person are concerned. I mean ... that I regard the whole world as my country, and I believe that I should be welcome everywhere'.[40] It was a feeling that he clung to all his life. His welcome, however, was not always easy to come by. Often it was cool. On several occasions in 1631, he travelled to Holland on the orders of the Archduchess, trying in vain to arrange some sort of peace with the Dutch, who were planning to extend the war in the south. The military situation continued to swarm with disasters, at least from the Spanish point of view, and as late as November, Rubens was pulling in 500 florins as Isabella's secret agent.[41] In December, he made a frustrating trip to Bergen op Zoom, and thence to the Hague, seeming to vanish for nine days (to avoid arousing the jealousy of nobles in the south, who wished to go themselves), meeting with Frederick Henry, the Prince of Orange, and seeking the promise of a truce. Gerbier, who had now become Charles I's emissary in Brussels, and who had dined with his wife and Rubens and Helena at their house in Antwerp on August 23, reported that 'Sir Peter Rubens is gon on Sunday last, the 14th of this month, with a trumpetter towardes Bergen op Zom, with ful power to give ye fatal stroke to Mars, and life to this State & the Empire'.[42] Pierre Dupuy, however, soon received a letter from Hugo Grotius (1583-1645), the famous Dutch legal philosopher, to the effect that Rubens' mission had failed: 'Our good friend M. Rubens, as you will have heard, has accomplished nothing; having been sent back by the Prince of Orange almost as soon as he had arrived.'[43]

His failure, on a stay that lasted three days in the Dutch capital, should not necessarily be understood as meaning that the two men (who, as Balthasar Moretus noted, liked each other) had nothing besides the war to discuss, or that even if Rubens' reception was cool, it was cold.[44] They may have taken up the fact, if they had not done so earlier, that their families' lives had crisscrossed with a good deal of drama in the past, that Frederick's father, William the Silent, had once imprisoned Rubens' own father for having an affair with his second wife – the alcoholic German princess who had perished so many years ago now in a castle at Meissen. It is hard to imagine that Rubens and Frederick, and his dead half-brother Prince Maurits, Anna von Saxon's son, whom Rubens had known well – worldly men all three – refrained from taking stock at some point in their long acquaintanceship of their shared tragic history.

Not that doing so helped, or that their knowledge of miseries past influenced the course of terrors on the way. The tragedy of Anna von Saxon was just an overture whose gloom they probably appreciated. It may even have set a tone for them for the wicked bloodshed now unravelling across the European landscape as the Thirty Years War began at last to turn into total war, as the spectre of an empirical evil – a colossal

destructiveness undertaken for its own sake and no longer for any rational reason, a slaughterousness that had become a charismatic force like a hurricane or an earthquake – began to materialise and beat against everyone's best hopes.

Some of the military events of 1631 and the following year, which Rubens knew about, brought home this fact. Given his sharp historical sense, he surely also saw their connections to his own life and to his career as an artist.

The sacking and burning of Maagdeburg by troops under the command of the Catholic generals Jean t'Sarclaes Tilly (1599-1632) and Gottfried Heinrich Pappenheim (d. 1632) on May 20, 1631, for instance, were hardly typical of the atrocious behaviour of commanders and armies on all sides. No levelling of so large a town, coupled with the shooting or incineration of 25,000 of its 30,000 inhabitants, could be anything but unique. What was frightening, however, was that neither Tilly nor Pappenheim, nor anyone, could establish the cause of the fire that broke out after weary, starving, drunk, undisciplined and loutish Imperial soldiers seized the city. Neither general had any interest in seeing the one place that they had looked to and taken to feed their armies, that they desperately needed, reduced to ashes, so that the carts bearing the masses of bodies to the nearby river formed lines fourteen days long and the mounds of the dead almost stoppered the cleansing currents. It was the sense in which organized violence kept getting out of hand, rose into chaos, turned on its inventors and swept everyone away that Maagdeburg's destruction became an omen of what began to occur elsewhere.[45]

European-wide reactions to the Magdeburg catastrophe were also taken as omens. The slaughter begot strange alliances. By May 31, the Swedish King Gustaphus Adolphus, at the head of invading Protestant armies in eastern Germany, had reached a military agreement with the United Provinces. Its purpose was to relaunch the war in Brabant and Flanders.[46] Averting this threat had been Rubens' objective. When he could not do so, and as he foresaw the violence about to be let loose, he understood, as did many, that the character of the war itself had changed ('the public evils frighten me,' he had written to Jan Woverius, and to Peiresc he expressed outright dread: 'I hope that His Holiness and the King of England, but above all the Lord God, will intervene to quench a blaze which (not put out at the beginning) is now capable of spreading throughout Europe and devastating it'[47]). The German Elector John George's remark that he no longer had any idea what the war was about, or the sense of it, could be discarded in favour of the grim recognition that the war was now simply about itself.[48] Its purpose was its perpetuation, in the manner of a government bureaucracy or civil service. Dishonesty had replaced policy, betrayal diplomacy and mass murder lapsing social institutions.

It was in this sense too that, as Rubens realized, the opposite of a heavenly beauty – an extending evil, a secular sort of ghastliness that might even be analysed as a specific type of human behaviour – was beginning to dominate the minds of millions across the Continent. If treaties were everywhere scrapped or ignored, or replaced by others that were ignored, their language itself, one had to admit, in contrast to the lucidity and simplicity of the language of pacts for beauty, was meaningless. The language of politics, and not simply the language of peace, was breaking down.

One might – and Rubens understood this too – trace the linguistic part of the emerging debacle into religious wrangles over biblical language, now in progress for over a century. The advent of biblical translation, and especially of Luther's translation of the Bible into easy-to-read German, played its role here, as did that of William Tyndale into the masterful English of the King James version, published in 1611, and a slew of other biblical translations, including those into Dutch and Swedish. The sacred speech that most people could not understand, that had been unfathomable Latin or the sounds of incomprehensible celestial music, or that worshippers cherished in obedient blindness in their churches, had altered, inspired and aroused them when they began to read it in the privacy of their homes.

Industrial developments also contributed to the breakdown, and one in particular. Basking in the glory of the printing press, which scattered knowledge along with nonsense everywhere, biblical translations and religious disputes had helped to alter the attitudes of millions toward their countries and rulers. One could not blame translation itself for this – no more absurd idea could be imagined – but all the same, it had added an explosive mixture to the social and political fragmentation that Rubens was now witnessing, the loosening of ancient unions.

Evil itself flourished amid fragmentation. Only in an atmosphere of social crackup and isolation could destructiveness for its own sake, or a military mayhem coupled with a wish to take some sort of harsh revenge on reality itself, envenom the air. Only amid disunity could evil secrete its toxicity – abetted by still other elements that promoted its growth and that, like fragmentation, could be named: an unnatural momentum within political and military events, rather like the momentum of nightmares, producing a feeling of universal helplessness; an aura of inevitability, like the terror of Doomsday; repetitiousness; unquenchable appetites; orgies of violence; and charisma, often centring about the violence and often sparked by mesmerizing generals and royal and religious leaders. Secular evil required a world of its own, created by these ingredients acting in tandem, plus a spray of iciness, of mercilessness. If the experience of beauty lifted one out of all mortal contexts, evil drowned one in spreading vengeance. Where beauty induced a feeling of timelessness, evil supplied an imprisoning haste. If evil thrived, like

316

beauty, on pacts for the souls, minds and bodies of those giving themselves over to it, their intent was to eliminate harmony and freedom. Attractive and beautiful-seeming pacts for evil – for their false beauty and meaningless language remained the greatest source of its dismal energy – required an abandonment of ethics, and soon a handing over of one's mind and body into slavery.[49]

There was more to evil: he understood that as well. As a unique and modern form of behaviour, it included a rather new murder-provoking ingredient best described as a novel form of hatred. Rubens may have had it in mind when he wrote to Peiresc about 'the dangers to which the suspicions and malice of this century expose us'. He may also have been thinking of the last third of the previous century, of the iconoclasms (with their own linguistic collapse), the burnings of heretics, the flight of his family into Germany and the fact that Philip II's war in the Netherlands, drumming away for over sixty years by 1632 (excluding the Twelve Years Truce), had moulted into the last Christian crusade.[50] It was a crusade extending itself across the mountains and plains and into the cities of Europe itself. The Spanish Fury, with its expression of religious hatred, had been one symptom of a hateful tidal wave that now found its outlet in battle after battle, in siege after siege, as in the Battle of Breitfeld in September, 1631 (the first Protestant victory, signalling the breakup of Hapsburg supremacy in the west), or in a comment of Sir Thomas Roe, journeying through Bavaria some four years earlier: 'I hear nothing but lamentations nor see any variety but of dead bodies.'[51]

Rubens realized that the history of his own art mingled with past and present passions of all sorts, and with this unusual hatred as well. His attitudes toward the world, and toward art, could be traced deep into thickets of Roman paganism, Roman decadence, Christian revulsion with Roman decadence, heresy directed at the subsequent decadence of the Church itself, violent reactions of the Church to all forms of heresy, as expressed by the Inquisition, and continuing acts of defiance, leading into the Counter-Reformation – in other words, into the morbid vacillations of religious history prior to his birth and just after it.

Each of these vacillations had fostered the sort of long-lasting group disdain that was now becoming fashionable. Each succoured cultural arrogance. The vacillations themselves could be seen as a bleak seesaw of vengeance, tilting up and down and only occasionally arriving at moments of equilibrium.

Surprising as it may now seem, and little studied by historians and psychologists, the propellant force beneath these tiltings had been – and remained, as he also seems to have realized – the human sense of filth, or so it may be termed. A cultivated sense of filth may in fact be said to have influenced the religious and much of the military history of the spacious period from the last centuries of the Roman empire into the seventeenth century and into his own lifetime. The collapse of ancient

Roman restraints had allowed the growth of a new and powerful emotional fashion. The ancient Greeks, and the Romans themselves, had regarded their enemies as human beings. Medieval Europeans tended more and more to see them as altogether subhuman.

To make a distinction: the sense of filth must lie a dungeon-level or two below that of disgust (which Roman historians such as Suetonius, who knew nothing of the filth-sense, had nurtured in abundance). Disgust by definition refers to a revulsion caused by bad or abused taste. Behaviour and ideas may be disgusting. Furniture may be disgusting. So may a glass of stale milk. This is not the same, however, as finding them filthy. When one describes an idea or object as filthy, one means that it has been so infested with an alien and nauseating presence as to become infectious and potentially lethal. Certainly it must be viewed as disease-causing and threatening. A disgusting chair is dangerous only to one's aesthetic sense. A filthy chair may necessitate a shower for the person who sits in it, and in extreme cases a visit to a doctor.[52]

The feeling of filth was to be associated with the phenomenon of demonization accompanying the evil that he saw and feared. At its core lay descriptions of enemies as vermin rather than people (anti-semitism and the citing of Moslems as infidels during the medieval crusades had established precedents for it), and the transformation in the popular mind of heretics, dissidents and those with an ethnicity different from one's own into imaginary but convincing Bosch-like fiends and infections.[53] Some basis for the development of the fashion in filth leading into demonization was also to be found in the belief in befouled devils and witches, which remained widespread across Europe, even if actual witch-burnings were infrequent (a not unusual exception was Bamberg, where 600 people, most of them women, were burned for witchcraft between 1628 and 1633 alone).[54] All of this made the prospect of peace more difficult. One might with ease be brought into a peace conference with a human enemy. Against rats, fiends and the plague one would fight to the death, and any means of doing so would be acceptable.

And yet there were finer possibilities.

If you today enter the New Banqueting House at Whitehall Palace, you find yourself looking at the paintings that Rubens was also finishing at just this time – and you stroll into a room that seems the white immaculate brain of heaven. The place itself ravishes your mind with peace. Rubens had been there. He knew its dimensions. He knew its bareness and gold trim and the deep embrasures of its two rows of windows, those double rows of natural lighting that could be converted into celestial softness by hundreds of candles for evening receptions and parties. He knew the significance to his ceiling pictures, finished by 1634,[55] of its vast brown floor and the balconies running along two of its sides, high up. He did not come back. He did his nine paintings at home, in his Antwerp

studio, inventing hundreds of acute and foreshortened angles, each necessary to *trompe-l'oeil* art, through an act of brilliant visualisation. For him, an awareness of the dimensions was enough.

His great theme was the political energy of peace leading into beauty. This may seem peculiar today, because it anticipates a society able to think *en masse* beyond the merely social, and capable of concentrating on the eternal for the sake of internal harmony. It may seem foolish. On the other hand, the fact that while he was failing to arrange a truce with the Prince of Orange he was perfecting one of the most ambitious visions of peace ever seen on canvas, or anywhere, remains a paradox typical of his life and his personality.

Because the size, proportions and height of the banqueting hall make it impossible to take in the floor and ceiling all at once – a shrewd piece of planning by Inigo Jones – you discover yourself now, as you would have found yourself then, caught between rival appeals: that of being swathed in daylight, but earthbound, or on looking up, of being lifted and lofted away from the Earth into a boundless space. It is here that Rubens sited his utopian political drama – in flight, amid a drawing up of your eye, and even of body and soul, into a reality of contemplation, of angelic freedom: in a unique world that refuted the fragmented world of evil.

The perspectives of the nine paintings whirl about you, as they have for centuries. There is no single proper position – Charles I's throne at the far end, say – from which to take in your astonishment. The whirling, or circling about your head, is also essential to the idea. Inigo Jones may have discussed the contents of these paintings with Rubens: Jones' inset ceiling casements, consisting of five ovals, four squares and twelve rectangles (when all are counted in), in a real sense determined the sizes of the pictures. Charles himself surely discussed with him the work that he had commissioned, not only because of his interest in any art bearing on his father's reign and therefore on his own, but also because he admired Rubens personally. It is reasonable to assume (though no records have survived) that two artists such as Jones and Rubens, with deep interests in architecture and proportion (Rubens remained the author of a monumental study of Genoese palaces), would have discussed the proportions of Jones' banqueting room itself, and their meaning and possible bearing on Rubens' *inventioni*.

Inigo Jones had been influenced by Palladian ideals. These he also developed through Vetruvius and Alberti from Plato's description in his *Timaeus* of what were imagined as the dimensions of the architecture of the heavens and the human soul. Jones had thus created an arrangement of two adjacent cubes, 55 feet high by 55 feet broad and 110 feet long, or a room in which height plus breadth equalled length. The concept was based on one of Plato's ideal geometrical figures, the square.[56] Rubens may have felt more than intrigued by the fact that his paintings celebrating the union of England and Scotland would be displayed in a room

that consisted of united cubes. Its proportions affirmed his own theme of unity.

You may sense Jones' architectural combination as you walk in. At once, however, on looking up and finding yourself swept into Rubens' great theatre, you become conscious of gigantic motion.

The massive heavenward thrust of action in the central panels – the two square ones at either end, plus the great oval between them – complements a downward ramming of action in the four oval paintings at each of the four corners: *Reason holding a Bridle above Intemperate Discord*, *Abundance triumphing over Avarice* (over the throne), *Minerva impaling Ignorance with a Spear* (fig. 26) and *Hercules beating down Envy* (fig. 27) (over the entrance). The violence in these spots resembles a set of solid tent pegs pinning into place the sky-bound sails of *The Union of the Crowns* (over the entrance), *The Peaceful Reign of James I, or the Benefits of his Government* (over the throne) and the oval painting *Apotheosis of James I* (in the centre). As a result, the powerful effect, unconsciously produced before you begin to make out the figures in the various pictures and what they are up to, is of an up-and-down swaying, or of the tilting of an immense but beautiful seesaw, and this, as the contents become clearer, of history vis-à-vis the present, and of the light-filled universe that shines beyond both.

Unlike his Medici cycle, which presents a false biography turned into fantasy and allegory, Rubens' Whitehall paintings set out to explore a national dream still in progress. Based on a political fact, the joining of Scotland to England in 1604 with the accession of James VI of Scotland as James I of England to form Great Britain, they depict a new direction for England and Scotland, and its potentials. Rubens' altertness to history may also have led him to find his initial inspiration in Veronese's *Triumph of Venice*, an early baroque masterpiece commissioned to replace the paintings in Venice's Great Council Chamber after fire gutted the old one in 1577, or in the year of his own birth. One of the first allegories of the Counter-Reformation would now be distilled by him into its grandest achievement.[57]

His pictures themselves present a fantastical theatre of persuasion directed at the viewer for the sake of harmony and the improvement of civilization. Allegory and myth illuminate a process of both civic and personal development. The violence with which Hercules batters Envy (shown as a muscular young man) into submission, or with which Minerva stabs Ignorance (a writhing woman) to death, must forever be repeated in oneself and one's society, as must the struggle of the goddess of Reason to restrain the bucking male figure of Intemperate Discord, or that of the goddess of Abundance, haloed by sunlight, to dominate the vicious hag of Avarice – by planting herself victoriously above her. The unending whirl of perspectives thus becomes, and was designed to be, an externalisation of mental processes mixing intimacy with politics: those of your inner life and of your nation.

At the same time, the neighbouring canvases explore another unending process, that of social union. They do so in a novel way, by elevating love into a political principle. James I (above the entrance) here presides over the crowning of the god of love, a very young Cupid escorted by Minerva, while female personifications of England and Scotland bestow twin coronets on his head. Simultaneously, Cupid tramples on obsolete and burning weapons of war. The idea that only love can create a lasting social compact supplements that of an arranged English-Scottish marriage of cultures. The same conviction also floods the square picture at the far end of the room, in which two goddesses, Peace and Plenty, are shown embracing as James urges them together. His throne appears before Solomonic columns, betokening his wisdom.

A wild gossamer haze, a tangerine and pineapple richness, enlivens the colouration of these scenes. The same hues also bluff your eye toward the triumphant centre, with its painting showing the *Apotheosis of James I*. Like the square paintings, it is an apotheosis that brims with warm tints but is devoid of Christian symbolism (the sole exception is a small cross topping James' mace). Pagan and allegorical figures swarm about the over-life-size King. Cherubim relieve him of his orb and crown. Minerva soars protectively overhead. Assisted by Justice, a nimble blonde, he ascends among a crowd of trumpeting cherubim through a heavenly dazzle – a ceremony of salvation that hints at his role as head of the Church of England but that remains intellectual and amorous. The picture embodies James' royal vision, which was also that of his son, of the king himself as the incarnation of spirituality, of the perfect union of church and state, of absolute monarchy and of the divine right of kings: 'The State of monarchy [James had written] is the supremest thing upon earth. For kings are not only God's Lieutenants upon earth and sit upon God's throne, but even by God himself they are called gods.'[58] The modern viewer may confuse these sentiments with distasteful egotism. In fact they are impersonal, an affirmation of the hierarchical structure of divine justice in a universe understood as consisting of hierarchies – or despite the discoveries of Copernicus and Kepler, which were only beginning to gain acceptance, of the old Ptolemaic universe, in which fairness might be rare but in which divine justice was guaranteed.

As if to confirm the love-governed process of justice in all nine of Rubens' pictures, two long side panels (13 x 3 m.) show groups of putti, or *genii*, playing with rams, wolves and lions – an ultimate victory of justice and reason, along with divine love, but this time over animal ferocity.

87. Festivals of Love

Though Rubens had completed his pictures by August, 1634, no call (as Gerbier put it) came from London for their shipment. They remained

rolled up in his studio.[59] In the meantime, he abandoned his diplomatic
work altogether, even if through 1633 he continued to visit the court at
Brussels, to consult with the Archduchess on political and military
matters, including the rebuilding of dykes, and to come to Gerbier's
defence when calumnies were hurled at his head ('I take to my charge,
the first time I come to Bruxelles, to try the Infanta [Isabella] her pulse
on the calumnies laid on you'[60]). Whatever Gerbier's shortcomings,
Rubens felt strong loyalties to him as a friend, as he seems to have felt to
all his friends.

A novel frivolity had also begun to slip into many of his drawings and
paintings. In fact it had been bubbling beneath the surface for some time.
Helena figured everywhere in his work at this point, but so did games of
love and sex for their own sake, games generally, nonsense and ordinary
human pleasures, such as picnicking, hunting, drinking, cooking,
arguing, embracing, skipping about and looking at flowers.
Simultaneously, his drawings began to gain in sensitivity and refinement.
Often he seemed to devote as much attention to their details as to those
of the paintings – as if a muscular, precise, juicy flow of freedom had
opened up for him, revealing sluices of drawing potentials that he had
slighted, and as if he was realizing afresh that the one could be as satis-
fying, as propitious as the other.[61] Throughout the past two years, and
into the next months of the early 1630s that soon turned into years
themselves, his letters affirm a sense of having come home. He was redis-
covering old Flemish and rich human roots in Antwerp with his family
(Helena gave birth to their first child, Clara Johanna, on January 18,
1632, and their second, Frans, on July 12, 1633[62]). He felt refreshed by a
plummy desire to make the best of all good and bad things in ways that
had previously not occurred to him, to wish only to live in happiness with
those around him amid a new inner peace – despite the killings, darkness
and violence besetting Flanders and Brabant – and to let his newly
discovered sensuous light shine and rummage through his artist's hand.

No less than seven extraordinary sketches survive for his *The Garden
of Love* (1632-34; 198 x 283 cm., today in the Prado; fig. 28), each a
jumbly test tube for the final picture (the title itself may be a misnomer;
the painting has often been called *Conversation à la mode* and *Een
Conversatie van Joffers* (Conversation among young women)). The
finished work retains chunks of these sketches, such as three women
dodging a water 'surprise', or a concealed garden spray, while a young
couple watches them, the sort of scene that Rubens might have witnessed
in Mirimola near Mantua, though here the fountain, with Venus astride
a dolphin, is too far away to reach them. Allegorical accents – turtle
doves, a torch, a yoke – suggest marriage. More interesting, in fact star-
tling, is that no recognizable text forms the basis either of the painting
or the drawings, no written pact for beauty or anything else. You instead
catch hints of a medieval love-garden tradition, borrowed perhaps from

the *Roman de la Rose*, and flirtatious quests for love among the five men and eleven women whom you join at a garden party. Their playful search for spontaneous pacts of their own creates the drama.

Even more interesting is that Helena herself appears here at least three times, and this as the party itself blossoms into a blue, gold and cream-coloured wave of delightful silk dresses. On the left, a young cavalier escorts her in. She seems reluctant if curious, and is jostled forward by an impertinent cupid. At the centre, she shows up in a gold dress, sitting down and regarding the viewer. To the right, she shows up again, in the same blue dress as at first. She is now chatting with a woman seated on a staircase. Her multiple appearances seem not simply flattering to her, or convenient to Rubens, who presumably could have used her as his model whenever he liked, but part of a strategy. Is she to be understood as exploring various roles for herself in the Garden of Love – while a cinematic treatment of her, showing her progress, unrolls before us? Is the picture in some sense an exploration of a personal triumph? If the garden party is itself a fantasy, or piece of wishful thinking, one remains impressed not merely with its sensuality but – and here is perhaps its most startling feature from the point of view of what Rubens usually depicts – its social plausibility.[63]

A similar intimacy, plausibility and spontaneous pact-seeking haunt about his delectable *Het Pelsken* (The Little Fur, apparently his own title), done at around this time (oil on panel, 176 x 83 cm., in the Kunsthistorisches Museum, Vienna; fig. 29). Often referred to as a picture in which Helena poses as Venus, though there is little evidence of any Venus-connection, it shows a scantily draped-in-fur, full-length Helena just coming from her bath (not going towards it – she would want to be caught afterwards, not before). She embraces herself and coaxes her gleaming breasts up a bit beneath a hot yet shy glance that sweeps just past you, or far more likely, just past Rubens (this must have been a private portrait, reserved for the two of them and maybe their friends).[64] Rubens' adoration shines through her slight awkwardness. His artist's hand does not hesitate to admire her ankles, thighs and knees despite their funny thickness (which was no more fashionable in his day than it may be now). He ushers her into real time and the real world, rather than dispatching her to some imaginary mythical epoch, as with one foot raised she moves past you toward her bedroom or boudoir.

A flamboyance of real time sweeps through his famous *Kermesse* (Country Festival, 1630-35; oil on panel, 149 x 261 cm, in the Louvre; possibly done for his own amusement as well; fig. 30), a painting that is an atlas of sensual freedom. Every possible pleasure, or so it seems, vaults before you here, and only murder and larceny go thankfully missing from what is a quasi-journalistic exposure of a jamboree splurging with over sixty peasants, plus a couple of dogs, a pig and a duck, all on a tear in the countryside in autumn and probably not far

from Antwerp. If the scene owes a bit to depictions of kermessen by Pieter Bruegel and David Teniers (1582-1649), it differs from them in its crazed energy – everyone is alive and moving, as opposed to being trapped in stiff poses – and also its lack of meaning, unless by stretching the word 'meaning', you wish to force freedom and sheer fun into pompous absurdities (thus Pieter Bruegel, who ever plays the moralist, satirizing his peasants, deadening and erasing their wildness). Rubens tackled these rustic bacchanals more than once, though never with this amicable indulgence, as in his *Dance of (Italian) Peasants* (which may have been painted a bit earlier; now in the Prado).

Much of your sense of the animal freedom in *Kermesse* emerges from something aesthetically amazing that at first looks like a blunder: its lopsidedness. A heap of people on one side swims into a twisting snake of dancers in the middle, who swarm against spreading fields, hills and far-off church spires. The fields and sky predominate (it is possible that they were painted by Cornelis Saftleven), and because of the imbalance, you are tempted to imagine that Rubens' artistic restraint or control has been abandoned. The oddity persists. An absence of restraint, or his insistence on all sorts of lopsidedness, including an aesthetic one, is emphasized by your realization that the landscape itself is hardly idyllic. The picture presents no conventional pastoral dreamland for lovers and other pleasure-seekers – Marlowe's delicious but false 'valleys, groves, hills and fields' where 'shepherd swains shall dance and sing' – but resembles far more Raleigh's time-smitten grey countryside 'where flowers do fade and wanton fields/To wayward winter reckoning yields'. Traces of dying summer colours patter against broken trees, weeds, a blowy sky and a ramshackle farmhouse with a dangling shutter. There are no flowers.

None of it matters. Something about the doggedness of the intrepid light, its way of getting in everywhere despite the autumn bleakness – Rubens' command of light as persuasion – holds you. Amid the greyness and winding down, the eruption of scores of peasants into a spree suddenly looks urgent, determined, sympathetic, unpolitical, desperate and perfectly comprehensible. As usual, Rubens has captured what may be termed a classical state of mind, or in this case a recognizable emotional emergency, as when miserable circumstances provoke intensity. Nor would it be correct to assume that he had changed, that the artist who attended mass every morning had now stopped doing so, or that he had not always enjoyed this sort of Flemish peasant free-for-all, the sort of debauch that had led the Spanish bastard prince Don Juan to describe Flanders as a place of 'wineskins' and 'scoundrels', and to recoil in prudish disgust.[65]

Rubens' artistic focus had simply moved closer to a neglected aspect of his experience. The perpetual motion of spiritual and political yearnings had surrendered to that of instinctual demands. His understanding of

the democracy of beauty, of the process of its balanced energy, had never had any trouble with peasants, as here, romping and kissing, or suckling their babies, or vomiting, shouting, singing to the music of shawm and flute, hugging, flirting, drinking, fondling, bickering and plunking into orgies. From his point of view, as long as the fragmentation and violence of evil were excluded, there were no limits to human magnificence. It could as easily reveal itself in mad releases as restraints. The pleasure-grabbing in *Kermesse* thus puts itself forward as worth any price, including degradation. Moral judgement vanishes. Evil disappears. There emerges only an escape from the rough conditions of life. The peasant idea is to manage it with impunity.

As always, Rubens regarded 'the whole world as [his] country', welcoming the fascination of the variety of passions. His point remained clarity. His goal was freedom. He intimated as much to Peiresc in 1635, when he told him about Helena:

> I made up my mind to marry again, since I was not yet inclined to live the abstinent life of the celibate, thinking that, if we must give the first place to continence, *fruimur licita voluptate cum gratiarum actione* [we may enjoy licit pleasures with thankfulness]. I have taken a young wife of honest but middle-class family, although everyone tried to persuade me to make a Court marriage. But I feared *commune illud nobilitatis malum superbiam praesartim in illo sexu* [pride, that inherent vice of the nobility, particularly in that sex], and that is why I chose one who would not blush to see me take my brushes in hand. And to tell the truth, it would have been hard for me to exchange the priceless treasures of liberty for the embraces of an old woman.[66]

A quest for freedom had also led him out of his diplomatic work. His resignation in 1632, before Isabella, who had ever supported him and who had come to rely on his political judgement, was nervous-making:

> When I found myself in that labyrinth [of diplomatic and secret governmental work], beset night and day by a succession of urgent duties; away from home for nine months [in England], and obliged to be present continually at Court; having reached the height of favour with the Most Serene Infanta ... and with the first ministers of the King [of Spain]; and having given every satisfaction to the parties abroad, I made the decision to force myself to cut this golden knot of ambition, in order to recover my liberty.... I seized the occasion of a short, secret journey to throw myself at Her Highness' feet and beg, as the sole reward for so many efforts, exemption from such assignments and permission to serve her in my own home. This favour I obtained with more difficulty than any other she ever granted me.... Since that time ... I am leading a quiet life with my wife and children, and have no pretension in the world other than to live in peace.[67]

This was all very well, and yet it was not quite true, as he quickly

admitted. For him, peace remained work. Invention itself created freedom. Soon after his retirement from his diplomatic activities, he had found himself hounded ('I have time neither to live nor to write'[68]) by one of the most ambitious projects of his career, that of creating a vast set of decorations for Antwerp's celebration of the 'joyous entry' of a political and military leader whom he had met once on his last trip to Spain.

This was the just-appointed new Spanish ruler of the Southern Netherlands, the Cardinal Infante Ferdinand, the twenty-six-year-old soldier-brother of Philip IV. On the occasion of his assuming power in Brussels, the chief magistrates of Antwerp had invited him, as was customary, to enter their city – still an utterly run-down and half-wrecked place – in the splendid, traditional, ceremonial way.[69]

88. Ferdinand's Joyous Entry

To Rubens, the amazing performance-project suddenly on tap was a staggering opportunity, even for someone trained in dealing with big chances. Conveniently, it dovetailed with his latest passion for detailed sketching in chalk, ink and oils (on which, to save time, a finished painting might simply be imposed). It also called on his special skills in allegories, such as he had been doing for the Plantin-Moretus Press over many years (though now on a much larger scale). It fitted in nicely with his undying passion for promoting Antwerp's recovery.

After accepting the assignment ('the magistrates of this city have laid upon my shoulders the entire burden of this festival'[70]), he at once started designing on short order (the entry was originally scheduled for January, 1635, but because of bad weather was postponed until April) dozens of pictures and the plans for four triumphal arches (the most elaborate had painted wings extending 100 feet on each side; an additional arch was later included) and four stages for allegorized plays, each to be situated along Ferdinand's projected two-hour progress through the streets.[71] No doubt his work brought to mind the triumphal arch that he had painted thirty-six years ago with Otto van Veen for the joyous entry of Archduke Albert and his wife, though now his involvement as head-of-project required much more: in addition to doing his own painting, he was to supervise other artists, along with crews of stone carvers, carpenters and masons. To achieve the effects that he wanted, he began to excavate his by-this-point professional knowledge of Italian Renaissance *trionfi* under the Medicis and Borgias, Petrarcan poetry describing ancient Roman triumphs and Albrecht Dürer's designs for Charles V's entry into Antwerp back in 1520.

A solid wave of sadness, if not despair, lay behind it all. Ferdinand was an expert commander of men (at the age of twenty he had begged his kingly brother to 'rid me of these cardinal's robes, that I may go to war'[72]). His troops seemed for the moment to be turning back the tide of

Dutch advances in the south. On the other hand, he had taken up his position on November 4, 1634, at a dire moment: that following the unexpected death in 1633 of the Archduchess Isabella. Her piety and quest for peace had sent thousands into mourning in palaces straight across Europe. For Rubens her death was a tragedy. A link to his past, and to his dream of ending the war, had been broken ('may she rest in glory,' he wrote to Peiresc[73]), and his own future, even as court painter *in absentia*, seemed uncertain.

Nonetheless, there remained the challenge of transforming his bedraggled city itself into some sort of glory. Isabella's death, combined with Ferdinand's energy, presented him with a paradox. He might actually profit from the general grief, doing so by turning Antwerp's desolation into theatre. The ruins of seventy years could be used to coax the new governor into offering municipal assistance. If Rubens handled the project well, a new pact between ruler and ruled for the sake of a happier future, one based on his insights into beauty, might even be worked into his pictures, arches and stages (the Netherlands tradition for joyous entries had always tolerated political propaganda, an idea dating back to their former independence[74]). As he therefore plunged into making Antwerp over into an artistic display for a brief while (had not Palladio done the same for Venice to honour Henri of Navarre in 1574?), he looked forward to wringing elements of hope out of despair, to inscribing his countrymen's misery in a grand show that might embarrass Spanish inertia. At the age of fifty seven, he had abandoned none of his ideals.

In fact his designs for Ferdinand's entry proved to be every bit the success that he wanted them to be (the prince proclaimed his delight, congratulating him in person), even if they failed in their mission of securing imperial relief. Through several intense months Rubens produced superb and often enormous if detailed oil and chalk sketches of gods, goddesses, ships, the blockaded and silted-up River Schelde, Antwerp's deserted harbour, Isabella herself in her heyday, Philip IV and the conquering figure of Ferdinand (he had helped to win the crucial Battle of Nördlingen over the Swedes for the Hapsburg cause in September, 1634, sending a signal to the Dutch that when he took over in Brussels he might prove a match for Frederick Henry[75]). Rubens' imagination seemed as copious as ever, and many artists and craftsmen signed on to work with him. Jordaens, Jan Cossier and Cornelis de Vos filled out sketches for his major pictures. Arches of carved stone were assembled. The sculptor Hans van Mildert translated into stone as well his sketch for the statue of Good Hope for the Stage of Welcome (this was the first of the stages to be seen by Ferdinand as he was ferried the short unblockaded distance up the Schelde into Antwerp on April 16, amid a flotilla of 100 ships). Management of the technical aspects fell to Gevaerts, who advised on

classical references; Rockox, who organized the payments; Rubens himself; and Philips van Valckenisse (the son of Rubens' old friend), who raised money. Their budget was limited, and the cost, 36,000 florins, extravagant. Bills were paid through contributions and a tax on beer. Rubens himself earned 5,000 florins.[76]

In the end, Ferdinand enjoyed the two nights of fireworks accompanying his celebration as much as Rubens' panorama of drama and art: a man of civilized but limited sensitivity, he radiated a bloodthirsty dullness. He was no fool, however, and quickly renewed Rubens' appointment as court painter in Brussels, also recommending him to Philip IV for a new, even more extraordinary commission: doing over eighty paintings to decorate the Spanish King's Torre de la Parada hunting lodge just outside Madrid.[77] Ferdinand may even have taken to heart the political appeal of some of Rubens' joyous-entry pictures, while ignoring their call for help (his contempt for the people whom he had been sent to rule was made clear a short time later when after noting their dancing and drinking at a kermesse, he remarked, 'The people here live like animals'[78]).

Rubens' pictures themselves, finished mostly by others, turned out to be fantastical extravagances in size, diversity and themes, a necessity if they were to persuade and enchant crowds outdoors and mix with hours of music. In making them, he had been at the height of his powers (to Peiresc he wrote that 'I believe you would not be displeased at the invention and variety of subjects, the novelty of the designs and the fitness of their application'[79]). He had hopes that his aesthetic triumph, turning Antwerp's shabby streets into a wonderland of colours, battles, holy images and pagan gods, but that was soon torn down, though bits and pieces were later taken to Brussels and a few major paintings and oil sketches have survived to this day, would be preserved in a book of engravings – he was nothing if not a man of books – 'adorned with the beautiful inscriptions and verses of our friend Gevaerts'.[80]

This indeed happened when Gevaerts published a small memento volume of the entry late in 1635, but for the moment Rubens rejoiced in the grateful reception accorded, for example, his *Quos Ego (The Crossing of the Cardinal Infante from Barcelona to Genoa* (326 x 384 cm., today in the Staadliche Kunstsammlung, Dresden)), based on an unpleasant sea voyage during which Ferdinand had almost drowned, with storm-shattered ships and a ferocious, ancient god of the sea summoning up rains and winds amid a wilderness of waves (a trip similar to Rubens' own sea voyage of years ago). He took a more cunning pleasure in one of the last of the settings that Ferdinand visited, the *Temple of Janus*, a grotesque evocation of the Fury of war (whose evil is unmistakable even in Theodor van Thulden's toned-down engraving, fig. 31) as it bursts forth into the world – and into the Netherlands – accompanied by a personification of the plague and soldiers tearing out children's hair while two women

struggle in vain to shut the temple doors on the warrior ghastliness of their modern history.

Rubens himself missed out on all the fun. He had done his best, but he remained at home. He had created for Antwerp a splendour to match his great series of paintings for Marie de'Medici in Paris and Charles I in London – an illuminating transformation of politics into art and both into the energy of beauty – but these at a terrible cost in exhaustion and physical agony. On learning that he had taken ill, Ferdinand presented his respects at his house, where he lay in bed, stricken with gout. This was not his first attack of 'the gentleman's sickness', as it was then called, because doctors believed that only noblemen contracted the well-known and devastating inflammatory ailment of the joints, particularly of the feet and hands, that was the result of the flow 'of matter from the body's vitals to the extremities' and an excess of uric acid. His affliction had actually begun in October, 1626, or about nine years earlier, during his negotiations with Buckingham over the sale of his *curiosa*. By now the episodes were coming on regularly, and he had experienced a particularly vicious one while doing the designs for the entry. He had kept going, though at last the pain had proved too much and had left him incapacitated. On the other hand, the chance to make his appeal to the new government and to a large public had been too interesting to miss.[81]

89. The second Golden Apple

Somewhere during this time, either just before producing his entry pictures or just after, he returned to a subject that had been among his first ever as an artist: the judgement of Paris, or the question of beauty.

To be sure, he returned to many subjects. Most were religious, as with his altarpieces, a few secular, as with his hunting scenes. Given his enthusiasm for the ancient world, though, and his myriad copies of ancient statues and myth-centred paintings, it is surprising how seldom he returned to the same ancient Greek myths. He painted the fall of Phaëton twice (the second time for Philip IV, as part of the Torre de la Parada commission, which he now accepted) and at least twice the abduction of Ganymede by Zeus. These, however, were more or less exceptions. He seems also to have avoided redoing the same dramatic moment from the same myth, again with a few exceptions, among them his Phaëton, in which the second version, a picture of tremendous energy, concentrates more on the actual fall of the hero than does his first, and this judgement scene between Paris, Mercury, Venus (Aphrodite), Juno (Hera) and Minerva (Athena).

It is thus more than suggestive that he revisited the Paris myth at all (*The Judgement of Paris*, 144.8 x 193.7 cm., in the National Gallery, London; plate XIII), and that he chose to do so at the height of his career, or some thirty-five years after first wrestling with it. His return seems in

fact a gateway to his latest thoughts about beauty. It especially seems so as you consider the perfect match between his life-long passions and the story's themes: its focus on beauty itself, its subplot of corruption and its link to the Trojan War, that triumphant Greek conflict understood in his day as marking the start of European history in the sense of European supremacy, and yet in Homer's epic poems bruised with violence, irrationality, tragedy, evil and bitter as well as compassionate meddlings of the gods.

The discrepancy between the two paintings amounts to a revelation. It too seems to underline his apparent wish to have another go at a myth that he found personally important: this mysterious tale of beauty unveiled, of beauty estimated, in which he may have seen himself and many of his ideas about the world reflected as in a glass. His recent marriage may also have spurred his wish to return to the story – the fact that his friend Gevaerts in his wedding poem had compared Helena to Venus, even though Rubens now abstained from using her as his model.[82]

As to the paintings' outward differences: Rubens' early work is far more crowded with mythical figures and gods than his new one, more plumped out with skin and flesh – streams, flares and moonlight braids of bodies. This difference has nothing to do with some acquired conservatism. His new painting's uninhibited sensuality simply seems to require fewer divine accomplices: no sea god, for instance, or prominent putti descending on Venus with a laurel crown through a blaze of stagy light – fewer special effects. In addition, the landscape of his earlier picture, while meandering into an attractive spread of trees and water, fails to compete with the sensual power of the background in his later one, which is only a hilltop.

Amid these changes, which may become clear at a glance, you may discover a more significant one: the superficial bustling about of the figures in the first painting, as opposed to the confident billows of motion, the grace of the dance of the goddesses, in the second. A mobile stiffness in the first, coupled with the rigid expressions of Juno and Venus as they approach Paris, and the aloofness of Minerva, who turns her bedroom-back on them all, and any viewer too – the posiness of everyone – give way in his new work to a divine relaxation of giantesses. Petulance and anxiety yield to sheer enjoyment, and this despite the hissing of Juno's peacock at Paris' unimpressed dog. Minerva shows off her body to us rather than to Paris. Juno, though we cannot see her face, looks at ease. Venus points to herself, but with some hesitation. She seems puzzled, as if surprised that Paris may have chosen her to receive the prize of Discord's golden apple.

These differences contribute to the fascination of the telling change in the drama itself: that while Paris awards the apple to Venus in Rubens' earlier painting, he does not do so in the new one, or seems only about to do so. The outcome of the momentous beauty-and-bribery contest, with

all of its disastrous implications for Troy, Greece and Europe over the next thirty centuries, has been omitted.

In Rubens' new painting, it is the process of judgement that counts and not the result. This picture, like Keats' famous ode, in which the painted lovers will never kiss, 'though winning near the goal', and in which love will forever keep its freshness, and never fade, concentrates on exploring a moment of hesitation. It examines the power of art to control and preserve it. The temptations of choice – their motion and energy – are allowed to run on without end, while the triumph of Venus is merely hinted at, and will never take place at all.

90. Living out of Town

In mid-autumn, the countryside near Antwerp was a vast hermaphrodite. Sprawling toward the Schelde and the North Sea in pan-sexual indolence, it flamed for miles with seductive roses, clematis, yser and fields of bright yellow rape. Dandelions, their thick stems topped by fox-grey globes of seeds, assented to the shakings out of stiff sea-breezes. Anemones preened themselves by twilight. Lilies matched the moon in its creamy splendour. At dawn, goldfinches, kingfishers and magpies browsed and scurried among blackberry bushes, chrysanthemums, achillea and aretum. The soft, undulating land lounged in a gold-green haze by mid-morning, with the light shifting into a burnished gold by late afternoon, and by sunset into a pastel satisfaction of mixed gold, sepia and the colder fires of diamonds.

The season itself seemed to beckon to him.

In November, 1635, shortly after Charles I requested that his Whitehall pictures be sent over to London (he had still not paid for them) and they were taken on October 8 by waggon to Dunkirk for shipment across the Channel, Rubens and his family moved into a small, rural, medieval castle, Het Steen (The Rock or Stone).[83] Well out in the country, it was a twenty-minute walk from the minuscule village of Elewijt, a bit south of Mechelen, about thirty kilometres from Waterloo and on the way to Brussels. The old castle, which had ample grounds but could do with expansion and improvement, was a two-hour leisurely carriage or horseback ride from Antwerp. It perched at the edge of a wood and was half wrapped round by a stream, the Baerebeek. Rubens had bought it, together with its ancient title of Lord of Steen, back in May for 93,000 guilders from Jean de Cools, Seigneur de Corbais, who had himself owned it for thirteen years.[84] Rubens planned to use it as a retreat and summer home. The castle was close enough to his mansion in Antwerp for him to manage the journey back and forth without trouble.

It was not his first castle. There had been a series of them, all subsequently sold. He had bought up the mortgage on Ter Leeven near Assenede in April, 1627, purchased outright the Castle van Urssle in

331

Eekeren in May, 1627, and picked up another mortgage on a third castle in Wilryck, also in May, 1627.[85] He plainly and unamazingly enjoyed his castles, though the one at Eekeren suffered flooding from a nearby burst dyke and several Dutch raids and had to be abandoned. Het Steen pleased him greatly, and he set about adding outbuildings, including a stable, and buying up the surrounding acres.[86]

At the same time, he began to devote himself to landscape painting with greater determination than ever. He did so not at the expense of his other work – his dozens of Torre de la Parada oil sketches on mythical subjects, for instance, including his second *Fall of Phaëton* – but in tandem with it. His speed of execution, what Bellori called his *furia del penello* (frenzy of the brush), allowed him to add to his old interests without ignoring them.[87]

One of his old interests was perpetual motion. It was surely no accident that he returned to it as he began to devote much of his energy to paintings and sketches showing the movements of carts, trees, cows, waterfalls, clouds, milkmaids, farmers, deer, sunrises and huntsmen (thus of an apparently self-propelled clock he wrote to Peiresc in December, 1634, 'I think you will find this machine worthy of an Archimedes or an Architas, and that you will laugh at the "perpetual motion" of Drebbel, which he was never able to set into regular movement. You need not doubt the authenticity of the thing (the mystery consists in a certain attraction and magnetic power); I have talked it over with men of ingenuity who have seen and operated it with ease, and have the greatest admiration for it'[88]). That he always followed his nose for motion – for depicting and seeking to understand it – springs out at you afresh in his passions for both clocks and landscapes.

Certainly his artistic shift at this point, never a complete one, but a change in emphasis from painting scenes dominated by people to scenes governed by the forces and creatures of nature – by flights of birds, erosion, earth, flowers, sudden chills and winter snow – and these always illuminated by sunlight or moonlight, or utterly natural lighting, turned into a novel adventure. It required new submissions. Powers greater than his own, and especially the powers of light, over which in outdoor settings he could exercise little control, began to alter his perceptions. Precious colour-combinations from his past – blues and golds, for instance – were abandoned. Light itself was revisited. Its windings and moods, its unpredictability and calm as it dashed, smarted, vaporised into a thousand hues, blistered, paled, rhapsodised, mourned, eviscerated fens and wounds and lingered, reddening, after a storm – as it slid through wilder metamorphoses than even Ovid had guessed at – were rechannelled, trapped and let loose again on unbounded, and in a real sense unframed and unlimited, wood panels, paper and canvas.

Doing landscapes, however, presented practical problems. There were few customers. There were fewer commissions. Feeble public eagerness

had as yet developed for them, and their apparent lack of drama caused them to seem insignificant (had not he himself employed Jan Wildens as a mere background specialist?). Another problem was that there existed little in the way of a landscape tradition. Aside from the brilliant examples by his long-dead friend Adam Elsheimer, and Pieter Bruegel's marvellous yet unrealistic (because frozen-in-time) paintings of harvest fields and snow-bound villages, the idea of doing nature in the raw had awakened only a contemptuous enthusiasm among most artists, though their neglect might prove an invitation.[89]

Rubens seems to have been undismayed. Throughout his life he had painted more or less as he wished and what he wished, even for the nobles who had sought to dictate the contents of his pictures (though never his style). After moving into Het Steen, he went ahead as usual, following his instincts, and without knowing it inventing a tradition, or what would become one for many generations of artists, while sharpening his powers of observation.

He was tracking light and motion to their sources. To Peiresc he wrote a year later, and his comment is revealing of how his mind looked out at the world, always and remarkably giving precedence to form over colour: 'The strong impressions which visible objects make upon your eyes seem to me more curious with regard to the lines and contours of forms than to the colours.'[90] The right colours themselves, he added, were not to be found in the prismatic displays of rainbows but in 'the proper colours' of the objects themselves, to which he might also have added that in his case they were modified by the blending softness of his style. The question was where such ideas would now lead him.

Perhaps by November, 1635, but certainly within a year of settling for months at a time in the country, they led him into painting an early morning picture of Het Steen itself (*An Autumn Landscape with a View of Het Steen in the Early Morning*, 1635-36; 131.2 x 229.2 cm., in the National Gallery, London; fig. 32), in which a man can be seen out birding with a gun in the foreground (a family of unsuspecting partridges is preening itself, just beyond the branches and flowers to your right), while a cart drawn by two horses, a farmer riding on one of them, and a pretty woman, perhaps his wife, sitting with a calf and a barrel in the cart itself, heads past you along a flooded dirt road. A kingfisher swoops. Two magpies skim the sky. Patchy clouds and alabaster-blue heavens take up the whole top third of the picture, and a great stretch of landscape, unbuttoning into achillea and aretum, in bloom before you, rushes out to meet them, quite a few miles away. Informal avenues of trees, ever diminishing, step out to meet the heavens too, across fields and meadows running to the horizon, just before which the spires of Mechelen can be made out like jagged, small bristles. Close in, the tawny rut of a stream slopes across several fields. It angles down before Ruben's castle, beyond a stand of white birch on your left.

It is a small, pretty castle – not a castle at all, really, more an elegant stone mansion, unless you take into account a detached stone tower (since torn down) a few feet to the north of it, which is crenellated, like a rook. Two women and a man – the man vaguely resembles Rubens himself – are out for a stroll in front, not far from the stone moat-bridge, but too far off to be seen with any clarity, though if you walk past the place today, you will recognize almost everything else. Despite some alterations in the eighteenth and nineteenth centuries, the facade has kept much of its seventeenth-century appearance, including its stepped-brick pediments, and in back its outer gallery on the first floor, with its fluted columns in Renaissance style, stonework tracery underneath. On the roof is a more recent black-slated steeple, at the rear an old Gothic doorway and a walled-in gallery for promenades. A modern gravelled area, also at the rear, unrolls into lawns, hedges and a forest, bits of which Rubens might still know.

The reach of his morning picture is thus immense. Its sweep retains, or he has borrowed for it, the horizon-curving vastness of the landscapes of Joachim Patinir, first unveiled before an amazed public over fifty years before his birth. Rubens' painted oak panel – actually a quilt of twenty-one oak pieces glued together[91] – seems to breathe with the familiar cosiness of his warm style, however, which Patinir knew nothing about: his way of establishing an intense intimacy across enormous spaces, so that you feel no alienation or coldness, even if everyone here is wearing a jacket and the air is brisk with a late autumn chill.

His painting brims with a robust, leonine flow, plus a wonderful, dying inflammation of greens and yellows, of energy rising into contemplation. A novel atmosphere of peace, though not quite serenity, gathers through everything, a hearty quality different from the symphony of reconciliation of his Whitehall pictures, or the marital bliss of his self-portrait with Helena and his son Nicolas. This new peace feels rough-hewn, and governed not by human but by natural laws.

A similar fascination with the laws of nature, if combined with accents both frightening and morbid, steeps through his marvellous landscape *A Forest at Dawn with a Deer Hunt* (also c. 1635; 61.6 x 90.2 cm., today in the Metropolitan Museum of Art, New York; plate XV), in which you may not notice at first that a deer hunt is in progress at all. A forest clearing, with lanky, youthful trees scattered about it, seems to float in a pond of shadows, of murky ripples, the last velvet-black vestiges of night, as inserted through a crook in the arm of a tree to your left, the first beam of sunlight, too bright for your eyes to bear but compressed into a spotlight by a tricky curl of the bough itself, forced and shaped into a kind of light-demon, flings itself with illuminating tenderness across the forest floor. Wherever it lands and spreads, splaying here and there, the earth and the leaves are transformed into a yellowy softness. Demon fingers of light conjure up isles and rills of yellow splendour, and set afire

with a harmless long blaze an alley straight across the whole clearing. Only as you begin to refocus your eyes through its magic do you spot the three deer, or see that they are trying desperately to escape, bounding off into the last dark places – or notice the hunter in hot pursuit with his pack of baying hounds.

The brightness nearly conceals the terror. It wraps the impending death of the deer in a voluptuosity. Doom and struggle seem swathed in a perverse miracle of camouflage.

What is astounding in both pictures is thus an exposure of Rubens' eagerness to meet nature untamed, undomesticated, or on its own terms, to explore a shadowy no-man's land between civilization and the wild and to show people invading it, crossing a bourne into the unknown. An important shift was underway for him. Soon after his arrival at Het Steen, he began to take on the new challenge of depicting nature unrestrained. At the same time, he avoided any usual reduction of natural phenomena to allegorical, literary and spiritual meanings. This alone seems remarkable, considering his training. To be sure, the viewer may feel tempted to read allegories into his landscapes anyway, to see his morning drama before Het Steen, for instance, as a country idyll, a sort of Eden, when there is no real evidence that it is idyllic (the hunter looks as if he is having a tough time of it; the partridges are about to be shot; the sky is pleasant but scarcely perfect – little of which implies that several of the people present are not enjoying themselves).[92]

A theme far grander than idyllic allegories had attracted his infinitely fertile concentration: that of the age-old conflict between civilization and nature itself – and the question whether a satisfactory pact for beauty, or a symbiosis, could be worked out between them. In some of his new, optimistic farming scenes, such as *Landscape with a Rainbow* (c. 1636; 135.5 x 233.5 cm., in the Wallace Collection, London), he suggests that it can, as he does in his much earlier 'season' pictures, such as *Summer* (c. 1618; fig. 3). These last, though, remain grounded in a literary convention popular among Italian poets since the thirteenth century, which involved composing sonnets on the seasons and days of the week, or an artificial, if engaging, refashioning of nature according to the pieties of medieval religious books of the hours.

Rubens' new landscapes lack such stunting premises. They have no messages. Often they intimate the ambiguities of gigantic powers beyond human understanding. His *Landscape with a Waggon at Sunset* (49.5 x 55.7 cm., in the Boijmans van Beuningen Museum, Rotterdam) and his *Waggon fording a Stream* (47 x 70 cm., in the National Gallery, London), each dating from his time at his castle, and his sketches of trees and country lanes also done during this relaxed period, or in his late fifties, show him embarking on a firmness and freshness of naturalistic investigation that resembles the scientific naturalism then becoming fashionable, and in which he had long been interested. His open-mind-

edness emerges in vigorous landscapes with an enthusiasm as unimpeded as nature itself, and as an achievement that other artists and his admirers in Antwerp began to find thrilling, and hard to avoid wanting to imitate.

91. 'The Unfortunate Europe'

'I have a horror of courts,' Rubens confided to Peiresc in March, 1636. He had not cared to go to England with his Whitehall pictures to oversee their installation, though he had retouched them before sending them off. 'I sent my work to England in the hands of someone else. It has now been put in place, and my friends write that his Majesty is completely satisfied with it.'[93]

He had still not been paid, but he had few worries ('my friends in that Court sustain me with good hopes, always assuring me that the King will treat me in a manner worthy of himself and me'[94]). Freedom from courtly entanglements, especially while the war dragged on and blossomed into frustrating misery everywhere, mattered more to him than prompt payment: 'I should have gone there in person, to settle things well. But I tell you this only the better to assure you of my desire for peace of mind and my determination to avoid, as far as it depends upon me, every disturbance and intrigue.'[95] He kept his focus on his art and family (his son Albert, who was now twenty two, had followed in his footsteps, and those of his grandfather whom he had never met, but whose interests in law and the classics matched up with his own, by travelling to Italy for a year, to Rubens' great joy, starting in late 1634[96]). Even a new legal squabble in France, which Peiresc tried to settle, over his right to the royalties from engravings based on his paintings, ceased to irritate him as in the past ('I am by nature and inclination a peaceful man, the sworn enemy to disputes, lawsuits and quarrels, both legal and private' – and this even though, as he noted, 'I abhor chicanery like the plague'[97]).

He had no lack of new commissions, if not for landscapes. He farmed out quite a few of the Torre de la Parada paintings to Frans Snyders (who was put to work on sixty of them), and to Borrekens, Symons, and Gowy, artists who for the first time he encouraged to sign their work. This may have been a gesture of self-protection. His generosity (he seldom signed his own pictures) may have been disguised vanity, the result of his dread that their efforts, often second-rate, might be confused with work by him.[98] Nonetheless, he produced over fifty oil sketches for the series, nearly all of them illustrations of dramatic moments selected from Ovid's *Metamorphoses*. For a number, he also came up with the finished paintings.[99]

Nor was there any abatement in his anxiety about the war. Through 1635 and 1636, battles between the Dutch and Spanish slapped back and forth, like a robotic dragon's tail, first into Brabant, then into Holland –

forced there by the driving successes of Ferdinand's armies. Ferdinand's glory portended his own relief: 'Instead of having 60,000 of the enemy in the heart of Brabant,' he noted in the summer of 1635, 'we are now, with an equal number of men, in control of the country.'[100] He lamented the bitter cost of this brand of glory, or 'the butchery which the peasants have everywhere inflicted upon isolated detachments [of the Dutch], and also . . . the dysentery and plague which have taken the majority of them.'[101]

On the other hand, as he realized, in the ever-worsening international conflict all victories were deceptions. By early 1636, broadsheets, newspapers and the reports of refugees had made it clear that throughout much of Germany civilization had collapsed entirely. Large towns – Bayreuth, Eichstätt and Fürth, along with hundreds of villages – had been burned to the ground by marauding commanders. Up to ninety percent of their citizens became wandering fugitives, themselves turning to robbery, plunder and murder just to survive. In Strassburg, just south of Antwerp, thousands of unpaid soldiers starved and froze to death in the snow-bound streets. In German districts to the east, food shortages led to riots (though the Jesuits managed to rescue and feed the children). In Strassburg, 30,000 soldiers seeking sanctuary were evicted by the impoverished inhabitants, only to die in fights among themselves and amid wild blizzards. In Alsace, citizens robbed the gallows for food. They cooked their dogs. Some ate rats. In Calw, a priest spotted a starving woman feeding off a dead horse surrounded by dogs and ravens.[102]

Modern anti-war poetry and anti-war painting were apparently invented during these frightful years. The precocious German playwright Andreas Gryphius, born in 1616, the year of Shakespeare's death, was now in his early twenties and producing such poems as his alexandrine sonnet 'Lament for his Fatherland' ('Tränen des Vaterlandes'), possibly the first poem to excoriate war itself (Gryphius here takes no particular side), with its striking vividness, its Baroque richness of detail and its grim apprehension of the secular and empirical evil racing through his country:

Right now we're not just wholly, but more than wholly, in hell.
The crazy mass of people, the raging battle horn,
The sword greased with blood, the thundering royal gun
Have eaten up all our sweat and toil and war matériel.

The towers loom through embers, the church sounds its own death knell,
The government waits in dread, the strong are chopped right down,
The women have been assaulted, and everywhere we turn
Are flames, plague and death, piercing heart, and spirit as well.

The trenches and city streets run daily with fresh blood.
It's three times six years here since our river's lazy tide –
Now almost stopped up with corpses – followed its casual rolls.

But I still haven't noted the thing that's fouler by far than death,
Far worse than the plague and embers and famine across the earth:
That so many have also seen plundered the treasure of their souls.[103]

In Antwerp too in late 1637, Rubens was finishing a new painting commissioned for the Medici Gallery in Florence. It remains if not his most violent and scornful, then his most eerie and shocking painting to deal with war: *Horrors of War* (206 x 342 cm., today in the Galleria Pitti, Florence; fig. 33). Perhaps no depiction of battle, including his earlier *Peace and War*, approaches the power that he here achieved in depicting the geyser of hysteria unleashed by human carnage, that ghastly paradox of officially sponsored slaughter in which psychosis is accepted as normality, disease as health and evil itself as a monstrous virtue.

Rubens sent the painting off to Italy in February, 1638, amid worries that it might be stolen or destroyed ('I hope that the roads in Germany since the capture of Hannau and the defeat of the Duke of Weimar, will be cleared of all dangerous obstacles'[104]), addressing its packing case to his artist-friend Justus Sustermans, then living in Florence, who had acted as his middleman for the commission. To Sustermans, on March 12, 1638, he also wrote an explanatory letter. He told his friend that the picture had in fact been sent (after three weeks, it had still not arrived), that he had been paid and then – and what comes next is almost without precedent among his letters and so offers invaluable insights into how he thought about details in his paintings – that it depicts something terrible, the victory of Mars over his lover Venus as he pulls away from her and sets about wreaking havoc in the world:

The principal figure is Mars, who has left open the temple of Janus (which in time of peace, according to Roman custom, remained closed) and rushes forth with shield and blood-stained sword, threatening the people with great disaster. He pays little heed to Venus, his mistress, who, accompanied by Amors and Cupid, strives with caresses and embraces to hold him. From the other side, Mars is dragged forward by the Fury Alekto, with a torch in her hand. Nearby are monsters personifying Pestilence and Famine, those inseparable partners of War. There is also a mother with a child in her arms, indicating that fecundity, procreation and charity are thwarted by War, which corrupts and destroys everything. In addition, one sees an architect thrown on his back with his instruments in his hand, to show that that which in time of peace is constructed for use and ornamentation of the City, is hurled to the ground by force of arms and falls to ruin. I believe, if I remember rightly, that you will find on the ground under the feet of Mars a book as well as a drawing on paper, to imply that he treads underfoot all the arts and letters. There ought also to be a bundle of darts or arrows, with the band which held them together undone; these when bound form the symbol of Concord. Beside them is the caduceus and an olive branch, attributes of Peace; these also are cast aside. That grief-stricken woman clothed in black, with torn veil, robbed of all her jewels and other ornaments, is the unfortunate Europe who, for

so many years now, has suffered plunder, outrage and misery, which are so injurious to everyone.[105]

From his point of view – letting Sustermans know how to view and understand his painting – these sentences glow with a fine descriptive brilliance. They also indicate his apparently usual care and research. In other respects, though, his ideas here may be misunderstood and his personality misconstrued. The supporter of the blockade at La Rochelle, the advocate of Ferdinand's victories over the Dutch, the artist who had painted *Peace and War*, as well as this painting – Rubens himself – both loathed war and regarded it as a necessary evil (his attitudes no doubt resembled those of many 'pressed' soldiers). He was also no partisan of an as yet inconceivable European union. Powerful nationalistic and folk feelings, held in high esteem everywhere at just this time, were gaining strength from Ireland to Amsterdam, and in London, Paris, Madrid, Rome, Oslo, Helsinki, Leipzig, Warsaw and Moscow.[106] Rubens himself felt passionately Flemish. If he mourned a Europe bereft and battered by the war now in progress, he would not have approved the idea of a Europe without national boundaries, many of which would be settled only ten years later, in 1648, in treaties to be signed at Osnabrück and Münster.[107]

He remained a man of stoic and on occasion bellicose contradictions. They in turn, and the friction that they sparked, continued to stoke the fires of his inspiration.

92. Painting Beauty Bare

'He was tall and well formed,' Bellori wrote of him, 'with a pleasing complexion and temperament, a commanding presence too, and generous, elegant in his manners and of dignified mien. He usually wore a gold chain and often rode about the city on his horse, as did other knights and the nobility, and through his very appearance sought to show that to be called a painter in Flanders was a thing incomparably magnificent.'[108]

He had ridden about a bit less in the past few years because of his recurrent attacks of gout, which tended to lay him up for weeks at a time ('the gout very often prevents my wielding either pen or brush – and taking up its usual residence, so to speak, in my right hand, hinders me especially from making drawings on a small scale'[109]). Still, he had broad resources of energy. He called on them in the midst of his pain, and kept doing large canvases, a number of which trained sharp lights on his unending inquiries into intimacy, pacts and beauty, but with a new intensity – and a fresh sense of humour too.

His *Self-portrait with Helena Fourment and Child* (1638-39, 203.8 x 158.1 cm., now in the Metropolitan Museum of Art, New York; plate XVII)

is a fascinating reprise of his earlier self-portrait with Helena, though this time the child is one of their own, Peter Paul, who was born on March 1, 1637, and who here toddles out in a leashed harness, taking a stroll with his parents, probably in their Antwerp garden (yet another child, their third, Isabella Helena, had been born on May 12, 1635).[110] The picture thus presents many of the same ingredients as their earlier paradisal double portrait, but in an eight-years-on flash-forward. Paradise has all at once snapped into deeper maturity. Rubens has put on some weight as well. Traces of his diseased struggle, around his eyes, melt into his pride and happiness with his wife and son. Helena, no longer girlish, brims with thoughtfulness. Where masses of vegetation set the tone for the earlier picture, Rubens and Helena, this time depicted as life-size, dominate the scene. Everything seems in serene slow-motion amid pale blues and greens and a dusting of gold across their clothes, as Rubens leads the way. Their happiness no longer springs from Edenesque innocence but from trust. It gleams through a single detail which seems to turn into the painting's marvellous open secret and which rests like a fulcrum at its centre: their touching hands. Rubens has doffed one of his knightly gloves to support Helena's right hand on his palm-upwards left one, a sign of protection, even as hers on his turns into a gesture of acceptance. Their touching hands re-commemorate their marriage, while his gloved hand points into their future. Trust is to be seen not as a stasis but as a process of energy and beauty, of sensuality elaborated by tests of years and collaboration.

In 1638 too, and for perhaps the fourth time, Rubens made yet another return to his familiar judgement-of-Paris story, once again changing his approach to it. In this version, without question his most radical, the old conflicts between beauty and evil are allowed a fresh and surprising resolution that seems to cheat corruption of its hoary success.

Philip IV had ordered the painting by early 1638, though Rubens himself may have suggested it as a complement to his Torre de la Parada series, just finished and sent on to Madrid, where the king had developed an insatiable appetite for his work and continued to shower him with new commissions for his twenty-odd-room hunting lodge.[111] By June, the Cardinal Infante was making inquiries and trips from Brussels to Antwerp to check on his progress. Suddenly, for long stretches, there seemed to be none at all, or very little. The truth – a bitter plight for him – was that his gout was now often making it impossible for him to lift a brush. Philip nonetheless refused to be put off (his insistence sounds like incomprehensible cruelty until one realizes how important this painting had become to Rubens himself), despite Ferdinand's report that he was bed-ridden and incapable.

He got better, worsened, improved and worsened again, refusing to let illness hold him back, managing to paint in spurts. Remarkably in these trying circumstances, over the next many months he not only finished

the new *Judgement of Paris* but also invented and completed another painting, his extraordinary *Venus and Adonis* (196.85 x 241.93 cm., today in the Metropolitan Museum of Art, New York; plate XVI). The two have a good deal in common, and his *Venus and Adonis* may even be seen as a pendant to the new Paris picture.[112] In each, Venus appears as the same healer of passions and incarnation of beauty, peace and love as in his Medici series, *Peace and War* and *Horrors of War*.

In the *Adonis* she plays the hapless role of spectator to the death of her lover. As she implores the unimaginative but strong and handsome Greek hero Adonis to give up hunting big game because he may be killed, and as her eyes beseech him to stay with her, he looks askance. Love and beauty bewilder him. They cannot rule him. Sensual delight matters less than proving himself through slaughter. Supernatural passions seem uninteresting. Besides, his dogs are waiting. Venus realizes – and her mournful seductiveness dissolves into agony – that her powers, or those of beauty itself, will not prevail over the fevers of his hunter's soul, that his doom is a certainty.

Rubens' chooses to depict Adonis' farewell (as the previous *Judgement* depicts Paris' moment of hesitation). A vivid, glowing, tawny and red atmosphere turns into an instant of perpetual motion that approaches death but never runs into it. As in Rubens' earlier *Judgement of Paris*, he avoids the outcome of the story, in which Adonis is gored to death by a vicious wild boar, while Venus, who finds his body 'still writhing in its own blood', is moved to sprinkle it with sweet nectar, transforming it into a magnificent anemone. In Rubens' picture, Adonis' terrible miscalculation is allowed a wrenching moment of magnetism, which glimmers through his nervousness.[113]

Rubens' new *Judgement of Paris* (oil on panel, 199 x 379 cm., in the Prado; plate XIV), though also presenting a beneficent Venus, marks a drastic departure from Adonis' unwitting preparation for death. It switches the problem of grim choices around and redirects the viewer's attention from the hunter to the hunted, or in this case to beauty itself. The nature of Paris' problem – should he prefer one goddess, or one sort of beauty, to another, and which one, and why? – becomes secondary to the question of beauty's protean shapes and guises, to the unending, democratic ways in which beauty may show up everywhere. From still another point of view, the painting amounts as well to a spectacular jest.

There could be no question that Rubens attached immense importance to his (final) version of the story, and that some of his slowness in completing it was due as much to deciding how to handle it as to physical incapacity. In October, 1638, Ferdinand told Philip that he was doing everything he could 'to see that Rubens makes up for lost time. God only knows how I regret the delay, considering Your Majesty's desire that it be done quickly.'[114] Five months later, in February, 1639, he sent a more welcome report, announcing that the picture was finished and that 'it is

without question the best picture Rubens ever painted'. With his usual squeamish myopia, however, an attitude peculiar in a military man, he griped that 'the goddesses are too naked; but it was impossible to get the painter to change this, as he insisted that it was essential to bringing out the beauty of his painting'.[115] In fact the goddesses' nudity is total, in contrast to their semi-clothed state in Rubens' earlier judgement-versions, and while (just as he said) divine nakedness is essential to his new intention, or to this painting's beauty, it was only one of a number of remarkable changes that he introduced.

From the start here, you are struck by enthralling novelties. Where in the other treatments Paris holds the prized golden apple, Mercury does so now. While he seems about to offer it to one of the three goddesses, he shows no interest in giving it up. Instead, he seems spellbound by the apple's radiance. Nor is it clear on which goddess, presumably with Paris' approval, he might bestow it. Paris, on the other hand, looks baffled and thoughtful. He has not made up his mind. He may not do so – or may be unable to decide. He sits stroking his chin and gazing at Juno, Minerva and Venus, lost in mysterious contemplation.

This mood of Paris seems completely to have escaped Ferdinand. It is quite different from his apprehensiveness in Rubens' first judgement-painting, or his self-absorption in the second – far cooler, like some late-blooming, delicate, white aster, and, like the mood of the painting itself, far richer, with that peculiar richness of twilight that is richer than afternoons, or that of autumn, which is sweeter than the prosperity of summer. Ferdinand seems to have ignored Paris' intellectuality and sensuality, here qualities unique to him, which are also reflected in the glistening white of the goddesses' skin – itself a complexion worlds away from their darker tones in Rubens' earlier versions. Had Ferdinand noticed these details, he might have realized as well that, allowing for the varying falls of the light, the colouration of the three goddesses is in fact identical. He might then have noticed that all three are actually the same woman.

Ferdinand had no trouble recognizing that Venus was Helena: 'The Venus standing in the middle greatly resembles [Rubens'] wife,' he wrote to Philip, 'who is undoubtedly the most beautiful woman [in Antwerp].'[116] To compare the three goddesses, however, seems not to have occurred to him: their exact duplications of height from the one to the other, the identical shapes of their knees, the matching lengths of their toes and the matching thicknesses of their ankles, thighs, buttocks, breasts, necks, eyes, mouths and faces. He was probably fooled, as Paris is not – that surely is why he sits immersed in his odd reverie – by the slight differences between their hair styles (that usual foil to identification).

He may have been frightened by the repetitions of these physical qualities, or found their implications not to his taste: the idea that in

turning Helena into three goddesses Rubens was not merely flattering his wife or complimenting her or making love to her in some original and public way, but also showing the folly of the ancient Greek beauty contest itself, and the madness of the war and vengeful history that it had inspired. Rubens had at least once before used Helena three times in a painting, in his *Garden of Love*, but now the suggestion was (and is) far more insolent: that the harbingers of war and justice cannot be distinguished from the messenger of beauty, love and peace. Paris himself realizes that there is no choosing between them. Rubens' sly hint, moreover, directed at the viewer, is that the prize of Helen of Troy, promised to Paris by Venus, is his already: she is Helena, or Venus herself – and she is also (though Paris cannot know it) the painter's wife. The divine beauty of three goddesses, all dancing before us as Helena, has become a torment of recognition, and the paralysing illusions that may accompany it.

93. The Chance to Do 'Something Extraordinary'

He knew that he would probably not recover. Few did. He treasured his time spent at Het Steen with his wife and young children, and his often disease-interrupted correspondence – no longer, sadly, with Peiresc, who had died in 1637, and whom he had never met again after their two brief encounters in the French capital during his Medici painting days – but with Francis Junius, an admired historian of ancient Greek and Roman art, Gerbier and others who sought to interest him in commissions.[117] He saw much of Rockox ('a fine man who is acquainted with antiquities ... an excellent administrator, whose integrity in all matters is legendary'[118]) and his oldest friend Balthasar Moretus, from whom he kept buying books.[119]

He continued to collect paintings and *curiosa*: 'I have never failed,' he had remarked to Peiresc in one of his last letters to him, 'to observe and study antiquities, both in public and in private collections, or missed a chance to acquire certain objects of curiosity by purchase.'[120] His Antwerp house had years ago triumphed over its depletion through his sale to the Duke of Buckingham. At the time, he had not only retained some precious stones and jewels ('I ... kept for myself some of the rarest gems and most exquisite medals from the sale'[121]), but hung onto his Egyptian mummy (of a man, from the Ptolomaic period). He had also acquired a number of fine Flemish statues, most of them copies of ancient Roman ones, a few ivory statuettes and over 300 superb paintings, a great many of them his own, a large number by Italian and Flemish masters. They flooded his gallery and pantheon-room which served (as did the houses of other gentlemen, ladies and lords across Europe) not only as a temple of personal artistic inspiration, but also as a quasi-public viewing space, the forerunner of the modern museum,

frequented by artists, visiting kings, such as the King of Poland, and interested citizens from Antwerp and elsewhere.[122]

He helped old friends, such as Marie de'Medici. She had been granted a brief respite and haven in Amsterdam after leaving Flanders, but once there her complaints about unsatisfactory treatment had led the Dutch to ask her to pack her bags and move on. In September, 1638, she accepted an invitation from her daughter and son-in-law, Charles I. By 1640 she was in London, but Rubens, who anticipated that her stay among the English might also lead to unpleasantness – her disastrous moods left her with few enthusiasts – had made available to her his parents' modest house in Cologne, at number ten Sternengasse, where he had spent part of his childhood and which he had inherited. It was expected that with a severely cropped retinue she would soon embark for Germany.[123]

In February, 1638, he received his last payment from Charles for his Whitehall paintings (Marie had long since paid for her Medici cycle). In February, 1640, Philip IV paid him for the Torre de la Parada series – 10,500 florins.[124]

He kept working. In June, 1637, he responded to a mystifying request from George Geldorp, a German artist and member of Antwerp's Saint Lucas Guild, who was then living in London, for an altarpiece centering on the life of Saint Peter. Geldorp's letter was a muddle. Rubens failed at first to understand that he was acting as an intermediary for a wealthy German financier and art collector, Eberhard Jabach, who wished to present a new altarpiece to Cologne's Church of Saint Peter. When he realized what was wanted, he was surprised, thrilled and moved. The painting would be installed in his own boyhood church, where he had worshipped with his family and where his father was buried.[125]

He recalled his time there with pleasure: 'I have great affection for the city of Cologne, because it was there that I was brought up until the tenth year of my life. And I have often had the wish to see it again, after so long.'[126] He never wrote to Jabach himself, but to Geldorp he suggested that while the war ('the perils of our times') and his other artistic responsibilities would now keep him from visiting the city, he would be happy to take on the job if he was sent the proper measurements. He would want time, however, or so he said, a good deal of it by his usual fast standards for a single picture ('I must have a year and a half, in order to be able to serve your friend with care and convenience'[127]). As for his choice of what to depict, it was apt and revealing, as if a peculiar purpose had seized hold of him: 'If I might choose or wish for a subject according to my taste, relating to St Peter, it would be his crucifixion, with his feet uppermost. It seems to me that that would enable me to do something extraordinary.'[128] The extraordinary, whatever he might mean by it, was desirable, and everything was agreed. He made a start on the picture right away, but it is a question whether he did not light on the idea of St Peter's upside-down crucifixion for a few

private as well as religious reasons: that it would make an oblique reference to the topsyturvydom of his own life as a child in exile in Cologne, and to the appalling topsyturvydom especially of his father's life, that of the former Alderman of Antwerp, who had died there as an exile. He surely understood that he now had an opportunity to honour his father with a memorial picture, as he had honoured his mother with his *St Gregory surrounded by Other Saints* in St Michael's Abbey in Antwerp. In both cases, though separated by decades, a commemorative chance had come his way through no act of his own, but as if a circle was completing itself through a series of blind but appropriate choices.

There is no question that he considered the picture important ('the subject of this picture attracts me more than all the others I have on hand'[129]). By April, 1638, in fact, or eight months later, he was writing to Geldorp to ask that he not be rushed, probably at this point because of his recurrent attacks of gout: 'I should not like to be pressed to finish it, but ask that this be left to my discretion and convenience, in order to be able to do it with pleasure.'[130]

The timing of the commission, arriving in the midst of his physical decline, also no doubt struck him as significant. It is fair to assume that he even took it as a sign of the shape of his life, of a gathering symmetry. No other painter, musician or poet, except Shakespeare, his contemporary, was ever as sensitive as he to existence as a series of rhythms, balances and contrasts, what Delacroix later called 'the astounding relief of his figures, that is to say their astonishing vitality', or that as the most brilliant painter of the world-as-stage, he knew that timing, or theatrical coincidence, was all, that the deepest human assumption was that the universe was punctual. All science depended on it, and as he understood so well, everyone, whether consciously or not, relied on exact regularities, of the sun, of waves in the sea, of heartbeats, even of death. One could on occasion afford to be late because one knew that the universe was on time, and this with a miraculous if often melancholy perfection. People inhabited a tremendous clock – a sort of perpetual motion machine – and were the mice who ran up it. The clock's punctuality, moreover, was no fantasy.

He kept uncovering noumenous pleasures of mind, body and his rebounding if besieged energy during what he began to understand as his last months (to François Duquesnoy (1594-1642), a well known Flemish sculptor living in Rome, who sent him casts of two putti, he wrote on April 17, 1640, of being 'detained' by age and gout, but that he had a hope of seeing Flanders 'resplendent with your illustrious works. May this be fulfilled before I close my eyes forever'[131]).

For Lucas Fayd'herbe he wrote a letter of recommendation. Engaged to be married on May 1, 1640, Fayd'herbe (1617-1697) was a sculptor from Mechelen who was planning to relocate to Germany. He had done a

number of exquisite ivory carvings after Rubens' sketch-designs, and for three years had worked with him as his sole recorded pupil. The friendship between the two was close, and Fayd'herbe had often been left in charge of his Antwerp studio when Rubens and his family went to Het Steen. The young apprentice, whom Rubens described in his letter as 'very praiseworthy' and having made 'great progress in his art', was entrusted with sending oil sketches on to him for work that he was doing ('I have urgent need of a panel on which there are three heads in life-size, painted by my own hand, namely: one of a furious soldier with a black cap on his head, one of a man crying, and one laughing'[132]) and safeguarding his other sketches before travelling out to the castle himself for a stay, bringing bottles of wine for everyone: 'We think it strange,' Rubens had prodded him in August, 1638, 'that we hear nothing about the bottles of Ay wine; that we brought with us is all gone. ... Take good care, when you leave, that everything is well locked up, and that no originals remain upstairs in the studio, or any sketches. Also remind William the gardener that he is to send us some Rosile pears as soon as they are ripe, and figs when there are some, or any other delicacy from the garden.'[133] Fayd'herbe accommodated himself to the cheerful cosiness of Rubens' domestic life, and kept finding a warm welcome.

By early 1640, while struggling to paint during his periods of remission, he was receiving more or less constant medical attention from Antwerp's specialist Dr Lazarus Marcquis (1605-47), the author of a book on the plague, *Volcomen tractaet van de peste* (Complete Treatise on the Plague (1634)). Marcquis' treatment would have been standard and possibly pain-relieving, but in the absence of knowledge that the causes of gout, if left unchecked, might lead to kidney failure, useless and even hazardous. Rubens had received the same treatment for 'a violent tertian fever' at the hands of a less skilful physician, back in October, 1626 ('purges, bloodletting, and similar remedies often more grave than the illness itself'[134]). Marcquis was a Jew who had fled persecution in Spain, as was his assistant, the doctor Antonio Spinoza, whose connection to the great philosopher, if it exists, is unknown.[135]

In April, 1640, Rubens found himself happy to receive an invitation from his old friend and spying-days chum, Gerbier. It seemed to carry him, as on a magic carpet of memory, back to the Escorial and his ride with Velásquez into the Sierra Nevada mountains in 1628. Gerbier asked that Rubens forward to him a painting by Pieter Verhulst based on the sketch that he had made there (the painting, which Rubens thought shoddy, was intended for Charles I). In the midst of his physical torment he recalled the wonderful, long-ago expedition, with his old freshness (fig. 34), and his own sketch:

> The mountain, which is called La Sierra de S Juan en Malagon, is very high and steep, and very difficult to climb and descend, so that we had the

clouds far below us, while the sky above remained very clear and serene. There is, at the summit, a great wooden cross, which is easily seen from Madrid, and nearby a little church dedicated to St John, which could not be represented in the picture, for it was behind our backs; in it lives a hermit who is seen here with his mule. I need scarcely say that below is the superb building of St Lawrence in Escorial, with the village and its avenues of trees, the Fresneda and its two ponds, and the road to Madrid appearing above, near the horizon. The mountain covered with clouds is called La Sierra Tocada, because it almost always has a kind of veil around its top. There is a tower and house on one side; I do not remember their names particularly, but I know the King used to go hunting there occasionally.... I forgot to say that at the summit we found *forze venayson*, as you see in the picture. [*Note in another hand, in English*: He means deare, wich is called venson when putt incrust.][136]

On May 9, he was still joking with Lucas Fayd'herbe about an ivory statue that he had put off completing because of his recent wedding ('there is no hurry about the little ivory child,' Rubens told him; 'you now have other child-work of greater importance on hand'[137]). Over the next two weeks he seemed to recover somewhat, but by May 27 it was clear that his resilience was failing. With characteristic practicality, he summoned a lawyer and drew up a new will. In it he made equal provisions for his wife and children, with the exception that Helena was given the contents of their Antwerp house, half-ownership in Het Steen, his jewellery (including his gold chain, a gift of Charles I, which he had worn as he rode about Antwerp) and his nude portrait of her, *Het Pelsken*. He also stipulated that if any of his sons wished to pursue a career as an artist, or any of his daughters married an artist, he (or she) might lay claim to his drawings (none of them did, and these were later scattered by sales starting in 1657; among them was a fascinating sketch of himself (fig. 35) that seems a diagnosis of the effects on his face of his illness, done perhaps in 1638; it may have served as a preliminary sketch for his *Self-Portrait with Helena*). He also specified that his collection of paintings was to be sold, no doubt to provide money for his family.[138]

He was asked (by whom is not known) whether after he died he would permit the construction of a chapel in his name. 'With his natural modesty' replied that he would if this was desired, and that one of his most recent and opulent paintings, his *Madonna and Child* (211 x 195 cm.), might be placed in it.[139] In the last warm days of May he perhaps still retained the portentous yet challenging appearance of his last painted self-portrait (1639; 109.5 x 85 cm., now in the Kunsthistorisches Museum, Vienna; fig. 36). In it his face is drawn and serious. One searches in vain for a twinkle in his eyes and yet understands that it is there.

On May 31, 1640, Gerbier wrote to Charles I from Brussels, 'Sr Peter Rubens is deadly sick. The Physicians of this Towne being sent unto him

for to try their best skill on him.' They had been sent by Ferdinand to assist Drs Marquis and Spinoza, but arrived too late. Within hours, Gerbier was forced to add a postscript: 'Since I finisht this letter neewes is come of Sr Pieter Rubens death.'[140] He had in fact died the day before, a Wednesday, and Gerbier wrote to Inigo Jones that his death had been caused by 'a defraction which fell on his heart'.[141]

Over the weeks that followed, hundreds of masses in Rubens' honour were offered up in Antwerp, Elewijt and Brussels. His funeral cortege was bedecked with 'sixty tapers, crosses of red satin and the music of the Church of Our Lady'. Scores of orphaned boys, to whose refuge he had contributed money, accompanied his bier, as did his family, friends and Antwerp's officialdom. His body was interred in the Fourment tomb in the St Jacob's Church, where his parents had been married, until its transfer several years later to its present location in the small new chapel that had been built for him in the same church. His *Madonna and Child* was installed there, and above it a marble statue, *The Virgin*, carved by Lucas Fayd'herbe. Gevaerts contributed the epitaph: 'Peter Paul Rubens, Knight [and] Lord of Steen, who, among the other gifts by which he marvellously excelled in the knowledge of ancient history and all other useful and elegant arts, deserved also to be called the Apelles, not only of his own age but of all time, and made himself a pathway to the friendship of kings and princes.'[142]

By then, the sale of his extraordinary collection had begun in earnest. Gerbier's postscript to Charles, despite its note of heartfelt regret, was not without its usual touch of opportunism ('many fine things will be sold in his auction'), and he alerted Arundel and Inigo Jones along the same lines. An inventory of Rubens' paintings and other works of art was launched on June 8, 1640, and published on July 14.[143] It included 314 paintings by others and scores of his own, quite a few of which were bought by Philip IV. Helena herself paid the estate for several, including the *Conversation à la mode*. Not long afterwards she found herself in litigation with her stepsons Albert and Nicolas over Het Steen. All was not peace between the members of Rubens' family after his death, and the liberal dissemination of his artistic legacy to an admiring and often unaware world was underway.

Not listed in the inventory, and in fact discovered in his studio only after his death, was his *Crucifixion of Saint Peter* (310 x 170 cm.; fig. 37). His (apparently) last painting, begun in late 1637, and about which he felt certain that it would be 'one of the best pieces that has ever left my hands', or so he told George Geldorp, he brought close to completion toward the very end.[144] Eberhard Jabach, who had commissioned it, had himself died by then, but Joris Deschamps, acting on behalf of his family, paid 1,200 guilders for it in 1641, and it was sent to Cologne, where it was installed as the altarpiece in 1642. Rubens' return to the church and city

of his childhood, and his parting gesture to his father, turned out to be posthumous.[145]

It was a dazzling return, a moving gesture – 'something extraordinary', as he had anticipated. He had taken the old legend, according to which Peter asked to be crucified upside down because he felt unworthy of Christ's crucifixion right side up, and transformed it into a monument to redemptive beauty. A tremendous optimism is filched from horror. A light is distilled from pain. A pact with the everlasting overwhelms the toils of sadism in a scene that, as far as is known, Rubens had never painted before, though it owes much in the way of pose and suggestion to upside-down crucifixions of Peter by Michelangelo, Guido Reni and Caravaggio, which he had seen in Rome, and his own *Death of Seneca* (1611), from which (in a final bow to Stoicism?) he seems to have borrowed Peter's head.[146]

If you are lucky, you may get to see the picture for the first time, through a stroke of kindness, during Lent, when all the paintings in the church are covered, but when it may be possible to persuade your guide and a workman to lift the prophylactic sheet to let you look under it. A glimpse of Peter in these circumstances will be enough to show you why Van Dyck stayed in London until Rubens died, and then rushed back to Antwerp in a selfish but futile attempt to replace him as the city's leading painter, on October 18, 1640, only to die himself in the following year. Peter's face, with its life-size, up-ended, blood-filled whiteness, seems to lean straight into you if you see the picture in this way, offering the plea of its agonised beauty, and the beauty of its capsized body stretched along the tall cross, to which his feet have been nailed, and the fierce beauty of the ugly workmen and Roman soldiers hoisting him up and installing the cross in its cold hole in the earth – with all this muscular motion sweeping aside your mere wonder and reforming it as a claustral joy, a sense of torn peace that is still peace, a perception of grand, angelic freedom.

Even the bright flesh of Peter's chest, as in Rubens' depiction of Christ's body in his *Entombment*, implies a holiness of death as it prepares to release Peter's battered soul from its earthly case. For the unbeliever too this whiteness may cause death to look like an illumination in which personal pain defies the temptation of senselessness for an affirmation of harmony. The flesh of Peter's chest has become a sun that recognizes neither eclypse nor night.

His face and head in fact seem the purification of a belief. Their incandescence seems to cleanse decay of its force and to deprive time of its ubiquity. Yet his face is sharp and igneous, with flinty, feeling eyes, lights of his wavering eagerness to be away, to be gone.

It is actually hard not to see this painting, as its kangaroo shadows leap in the background and beneath the five torturers' feet, as an expression of a double and even a triple cleansing. From the Roman point of

view, a religious threat is being eliminated through an execution. From the Christian, an earthly corruption is being shed through the sacrifice of the saint's human body for the sake of salvation. For Rubens, there may have been as well a serene victory over his past, one that could be provided only by art, his art, as it was cleansed and rinsed by the pervasive energy of his act of creation, and by the power of creation itself.

VI

Apotheosis

Beauty and Physics

You glance through a window in a modern city, say London, on a grey winter afternoon. Across the street are two stepped-brick pediments over embrasures. The pediments themselves stick up over a gabled house. Above them, a sheet of gorse-grey cloud shoots past, borne on wind that you cannot feel in your apartment with the window shut. You know it is there, though, an invisible trick of energy, propelling condensation through the sky.

The pediments are in motion too, though you cannot see it. Your eyes lack the requisite molecular vision. They cannot make out bricks as tangles of radio waves, or embrasures as patterns of electrons and atomic particles rotating through minute yet infinite space, recombining and somersaulting through force-fields. To the human eye, they seem stationary. At most, when you look away and then back at them, they fill your mind for a split-second with after-images, clues to the fact that, like the sheet of wind, they are brimming with changes.

On anyone's face this phenomenon is easier to notice – that nothing is static. Even at its calmest, a face shifts through trickles of passions. Feelings affect the shapes of the eyes, the lifts of the lips. Cheeks contract among excitements released or suppressed. The chemistry of the skin is busy. It reacts to weather, to indoor temperatures, to metabolism. An invisible flame plays with existence.

One's memory is formed of interesting streams of after-images, some recent, many older. A few – who knows? – may reach back into eras before one's birth, into prehistoric times, and before that into early instants of creation itself, even into the first appearances of dimension, the development of geometry in the natural world and, amid brazen flashes, even earlier epochs: into adventures horrifyingly, gratifyingly previous: into when?

Rubens' heritage is not merely scores of masterpieces but a major portion of the grand river of Western thought itself, to which he contributed and which divides into rival rivers with his appearance. He did not create this division, though he helped to stimulate it. With others,

such as Galileo and Shakespeare, he stands at the division point, and where one is today is what he points to, through his paintings and in his life.

The division is one between those consumed with reality as energy, motion, process and change and those interested in it as stasis. Both approaches are estimable. In his lifetime, as he was aware, painting began to split along these lines, between paintings that sought to create and recreate motion and those that did not, with the same division entering science and philosophy through the work of such thinkers about motion as Galileo and Descartes.[1] Among Rubens' fellow artists, brilliant primitives (as they may be termed with no derogation) such as Pieter Bruegel the Elder and Caravaggio, sought to reinvigorate a venerable idea of stasis with wonderful still-photograph-like paintings, whose modernity of subject matter concealed their conservatism, or essential continuity with the stasis-devoted medieval past. Bruegel and Caravaggio seized the moment. They fixed it forever. Time was made to stop. In their paintings, it remains stopped. Their influence leads at length into still-photography, still-lifes and even modernism, which goes so far as to promote the elimination of perspective.

An impulse more raw, sensual and cinematographic surfaces with Rubens. Even its spirituality is rawer and more sensual. Because his paintings lack Caravaggio's enthusiasm for filth and slumming, and own to little of Bruegel's concentration on middle-class routines, because they reach into history, mythology and royalty as well as candid fleshliness – because their contents may therefore seem to modern eyes conservative politically – one may mistake the accuracy of his insights into the aesthetics of reality for the defence of a *status quo*, or of kings, queens, obsolete political ambitions and even, absurdly, obesity. The truth is different. Because his aesthetics of motion take in everything, because of his sublime range, he shows himself to be by far the more democratically minded of the three: his energised understanding of beauty reaches among all things and all sorts of people, even among kings and queens, and among the obese as well as those hardier and leaner. Rubens is without prejudices, even if he is ever alert to the possibility that beauty may mingle with an empirical evil.

Through his life and his work there also flows another, shrewder current, though it too forms part of the long Western tradition of seeing the universe as movement and cycle. This current stretches back at least to the Stoics and then forward into his immediate, light-exploring artist-predecessors in Antwerp and Italy. Still later, and fascinatingly, it ripples through the insights of modern scientists, particularly those of Newton and Einstein. One errs if one thinks of either as an atheist, or sees their discoveries as materialistically one-dimensional. On the contrary, it was their deep spiritual convictions – Galileo's as well as Newton's and Einstein's – and their intuitions of a divine and harmonic omnipresence,

that formed the premise of their elucidating physical harmonies and laws, or what Einstein has described as the 'marvellous feeling of realizing the uniformity of complex phenomena'.[2]

Nor is it an exaggeration or a wild surmise to notice that Rubens' magical-seeming style is reborn several centuries later as Einstein's discovery of the exact relations, the quantifiable ones, between mass, the speed of light and energy. The passionate interest of both men in these relations is identical, as are their conclusions, even if they are expressed in quite different ways. The basis of their thinking is not simply that the physical universe is an aesthetic phenomenon – many artists have believed in its fundamental aesthetics – but that it is a physical, spiritual and aesthetic process, one incorporating unending transformations, and that to represent these transformations, whether in painting or mathematics, is to lay bare its truth, or the ultimate facts about it, and to expose its ultimate beauty. The physical universe, whose music Einstein exposed as energy manifesting itself through curved space-time, is thus to be seen as a set of stories that are physical and potentially spiritual. As in Rubens' paintings, it contains plots, or laws that supply its events with beginnings, middles and ends. It offers up no straight lines and no pure colours, but boundless and hypnotic shadings-off, which themselves shade off *ad infinitum*, and then renew themselves. Rubens was born into and perfected a manner of painting that, without his knowing it, corresponded to Einstein's unveiling of the fact that all mass has energy, as all energy carries mass.[3]

Not all painters moved, or could move, in this direction. Few understood how to do so, even among those whom Rubens profoundly affected, such as Nicolas Poussin (1594-1665). Rubens was the first painter to manage this lifting forward with more or less complete self-knowledge (Shakespeare, it may be said, managed it as well, with his theatre of fantastical persuasion, or dramas of continuous transformation induced by poetry). Rembrandt, who was thirty four when Rubens died, bestrode a widening chasm between those who wished to reveal motion and those who sought to freeze individual moments, thoroughly aware of the choice before him, yet in the end opting more often for stasis and brilliant darkness. Rembrandt's approach to his art is thus more reticent, even traditional, if nonetheless enthralling. Caught up in his passion for the varieties of night, he took fewer great risks, all the while his older contemporary was adventuring ahead, into the last minute of his life, exploring the relations of light to mass, and of both to the hidden raptures and shapings of energy.

Notes

Abbreviations

CR M. Rooses, C. Ruelens, *Correspondance de Rubens et documents epistolaires concernant sa vie et ses oeuvres*. 6 vols. Antwerp: 1887-1909.
CRB *Corpus Rubenianum Ludwig Burchard*. Brussels, London, New York: 1968.
Magurn R.S. Magurn trans., *The Letters of Peter Paul Rubens*. Cambridge, Mass.: 1955.
R:*Oeuvre* M. Rooses, *L'Oeuvre de Rubens*. 5 vols. Antwerp: 1886-92.
Lind:*Vita* L.R. Lind, 'The Latin Life of Peter Paul Rubens by his Nephew Philip A Translation', *Art Quarterly* IX. Detroit: 1946; pp. 37-44.

Introduction and I

1. E.H. Gombrich, *The Story of Art* (rpt. London, 1995), p. 400.

2. Even now no complete *catalogue raisonné* exists, though the massive scholarly undertaking known as the *CRB*, in progress for decades and involving the publication of twenty-seven sections (some multi-volumed), of which fifteen have so far appeared, has gone far to establishing one. A major problem, apart from the vastness of Rubens' production, is that previously lost paintings are sometimes found. Another is that some are on occasion re-attributed. Still another (to be taken up later) is that the contributions of Rubens' assistants often throw the tricky question of authenticity into doubt (as will be seen, this was an issue in Rubens' own day). Similar problems arise with Rubens' hundreds, and perhaps thousands, of drawings (on this issue, cf. the important discussion of quantity, authenticity and dating by Julius Held, *Rubens: Selected Drawings* (rev. ed. Oxford, 1986), pp. 9-15). On the figure of 3,000 paintings, of which approxi-mately half are certainly by Rubens alone, cf. among others Emma Micheletti, *Rubens: The life and work of the artist* (Firmin O'Sullivan trans.) (rpt. London, 1984), p. 12.

3. Eric Newton, *European Painting and Sculpture* (3rd ed. London, 1945), p. 95. The phrase 'Prince of Painters' is actually a borrowing from the account of one of Rubens' first biographers, Roger de Piles, in his 'Abrégé de la vie de Rubens', in *Conversations sur la connaissance de la peinture* (Paris, 1677; rpt., Geneva, 1970).

4. Yves Bonnefoy, 'Byzantium' (John T. Naughton trans.), in Richard Stammelman ed., *The Lure and the Truth of Painting: Selected Essays on Art* (Chicago, 1995), p. 23, though Bonnefoy's remark should be weighed against his admiration of Rubens' influencing the sensuality of Baudelaire's poetry. On this issue cf. Bonnefoy's 'Baudelaire contre Rubens', in *Le nuage rouge* (Paris, 1977), pp. 9-80.

5. Herbert Read, *The Meaning of Art* (rev. ed. London, 1968), pp. 144, 145, 146.

6. Pierre Assouline, *L'Homme de l'art* (Paris, 1989), p. 335.

7. Clement Greenberg, *The Collected Essays and Criticism* (4 vols.): *Modernism with a Vengeance, 1957-1969* (vol. 3), John O'Brian ed. (Chicago, 1993), p. 92.

8. Lind, *Vita*. This is actually not the first, though it is the most complete in the sense of treating Rubens' entire life, despite its brevity, and so may be considered the earliest true biography. As early as 1642, Giovanni Baglione (1571-1644) had published an important account of Rubens in his *La Vita de' Pittori, Scultori, Architetti ed Intagliatori dal Pontificato di Gregorio XIII del 1572. fino a' tempidi Papa Urbano VIII nel 1642.* In 1672, or some four years prior to the writing of these Latin reminiscences of Rubens' nephew (which were adapted by Roger de Piles and appeared in print only in 1677 (see n. 3, above)), the art historian Giovanni Pietro Bellori (1615-1696) published his own useful account of Rubens in his *Vite dei Pittori, Scultori ed Architetti*. While both of these and some of the subsequent biographies are cited in the Bibliography, a list more or less complete to 1990 is to be found in Nora De Poorter, Guido Jansen, Jeroen Giltaij eds, *Rubens en zijn tijd*; *Rubens and his Age* (Rotterdam, 1990), pp. 168-174.

9. Christopher White, *Peter Paul Rubens* (New Haven, 1987); Marie-Anne Lescourret, *Rubens: A Double Life*, Elfreda Powell abridged trans. from the French (1990) (London, 1993); Otto von Simson, *Peter Paul Rubens (1577-1640): Humanist, Maler und Diplomat* (Mainz, 1996).

10. Cf. 'Publications by Julius S. Held', in Anne W. Lowenthal, David Rosand, John Walsh Jr eds, *Rubens and his Circle: Studies by Julius S. Held* (Princeton, 1982), to be extensively cited here.

11. Considered in (for example) Eileen Reeves, *Painting the Heavens: Art and Science in the Age of Galileo* (Princeton, 1997), pp. 68-76; to be cited, along with other evidence, below.

12. That Descartes was concerned to maintain the unity of mind, body and God, rather than to advocate their division in nature, as is often incorrectly supposed, is demonstrated by Charles Coulton Gillespie in *The Edge of Objectivity* (Princeton, 1960), pp. 84-95.

13. The reliance of Ptolomaic solar-based astronomy on logic and metaphysical assumptions, as opposed to empirical inference and hypotheses, is more fully taken up in sections 56-58, below.

14. Walter Pater, *Studies in the History of the Renaissance* (London, 1873), p. vii; Pater adds ('Conclusion', p. 207), 'To regard all things and principles of things as inconsistent modes or fashions has more and more become the tendency of modern thought.'

15. David Hume, 'The Sceptic', in *Essays Moral, Political and Literary* (rpt. Oxford, 1971), p. 166. Cf. as well David Hume (Ernest Mossner ed.), *A Treatise of Human Nature* (London, New York, 1969), which contains such remarks as 'beauty is nothing but a form', '[it] cannot be defined' (p. 350) and '[beauty] is merely a passion or impression in the soul' (p. 352).

16. George Santayana, *The Sense of Beauty, Being the Outline of Aesthetic Theory* (rpt. from 1896 ed., New York, 1955), p. 164. Cf. also pp. 31-33 for similar assertions.

17. The similarities between Rubens' and Einstein's conceptions of energy will frequently be taken up below, and especially (though only in light of evidence) in V. Apotheosis: Beauty and Physics.

18. Lind: *Vita*, p. 38.

19. Magurn, pp. 101-102.

20. Cf. Lind: *Vita*, p. 41, and Bellori, 'Vita di P.P. Rubens', in *Le Vite de' Pittori*, p. 300.

21. Geoffrey Parker, *The Dutch Revolt* (rev. ed. London, 1990), p. 263f.

22. Oil on panel, 117.5 x 85 cm., today in the Herzog Anton-Ulrich Museum, Brunswick.

23. C.V. Wedgwood, *The Thirty Years War* (rpt. London, 1953), p. 156.

24. Wedgwood, 157.

25. That this was Rubens' own view of himself is made clear at many points in his letters, such as that of January 10, 1625: 'I regard the whole world as my country, and I believe that I should be welcome everywhere' (Magurn, p. 102).

26. See, for example, Claudia Landwehr, *Peter Paul Rubens: Gemälde und Grafiken* (Münster, 1995), p.13, where it is claimed that psychological self-examination (of the sort to be found in Rembrandt's self-portraits) is largely sacrificed to Rubens' presentation of himself as a gentleman of rank.

27. Cf. the study by Wilhelm Pinder, *Rembrandt's Selbstbildnesse* (Königstein im Taunus, 1956), in which his evolution as self-psychologist and artist is viewed as charted through his more than a score of self-portraits.

28. Magurn, p. 455.

29. For accounts of wanderers on roads during this and prior as well as subsequent periods, cf. Reinhold August Dorwart, *The Prussian Welfare State before 1740* (Cambridge, Mass., 1971), pp. 94-100; Paul Oppenheimer, *Till Eulenspiegel: His Adventures* (Oxford, 1995), xviii-xx; and Arthur F. Kinney ed., *Rogues, Vagabonds, and Sturdy Beggars: A New Gallery of Tudor and Early Stuart Rogue Literature* (Boston, 1990). Cf. also John J. Murray, *Antwerp in the Age of Plantin and Bruegel* (Norman, 1970), p. 6.

30. Murray, pp. 3-5.

31. *Ibid.*, p. 6.

32. *Ibid.*, pp. 58-63.

33. Herman van der Wee, *Growth of the Antwerp Market and the European Economy: fourteenth-sixteenth centuries*, vol. I (The Hague, 1963), pp. 188, 378-80; also Murray, pp. 59-60.

34. Van der Wee, p. 188.

35. Murray, p. 7.

36. Parker, pp. 20, 21.

37. *Ibid.*, p. 21.

38. Murray, p. 11.

39. *Ibid.*, pp. 12-13.

40. Van der Wee, p. 289; Parker, p. 27

41. Parker, pp. 27-28.

42. William Martin Conway trans., Alfred Warner intro., *The Writings of Albrecht Dürer* (New York, 1958), p. 113.

43. Parker, pp. 27-28; Van der Wee, pp. 364-65.

44. Dürer, pp. 99-100.

45. Ludovico Guicciardini, *Description de tous les Pays-Bas* (Antwerp, 1567; 2nd ed., Antwerp 1582; trans. London, 1953), pp. 48-57 for complete account; cited in Murray, p. 4.

46. Cited in Parker, p. 27.

47. Murray, pp. 22, 23.

48. Derek Blyth, *Flemish Cities Explored: Bruge, Ghent, Antwerp, Mechelen, Leuven & Ostend*, 3rd ed. (London, 1998), p. 183; Antony Mason, *Brussels, Bruges, Ghent, Antwerp* (London, 1998), p. 356.

49. Dürer, p. 100.

50. Parker, p. 26.

51. George Haven Putnam, *Books and their Makers during the Middle Ages*, 2 vols (New York, 1896-97), vol. 2, p. 285.

52. Douglas C. McMurtrie, *The Book: The Story of Printing and Bookmaking* (New York, 1943), p. 360; Murray, p. 74; Putnam, p. 257.

53. Colin Clair, *A History of European Printing* (London, New York, 1976), p. 197; Murray, p. 74; Putnam, p. 257.

54. Murray, p. 72.

55. Murray, p. 75.

56. W.M. Conway trans., *The Writings of Albrecht Dürer* (London, 1958), p. 172.

57. Putnam, pp. 263-64, 266, 268f, 275.

58. Clair, p. 200; Putnam, p. 259.

59. Cited in Murray, pp. 3-4.

60. Murray, p. 74.

61. Murray, pp. 78-79; McMurtrie, p. 364; Clair, pp. 197-98.

62. Murray, pp. 82-83; Clair, *ibid.*; Putnam, pp. 272-73.

63. Murray, pp. 83-84.

64. Putnam, p. 278.

65. Murray, p. 84; Putnam, p. 276f.

66. Murray, p. 86; Parker, p. 26; Putnam, p. 265.

67. Parker, p. 26; Putnam, pp. 279-80.

68. McMurtrie, p. 362; Putnam, pp. 279-80.

69. Parker, p. 36.

70. Parker, p. 37.

71. *Ibid.*

72. Murray, p. 78; Putnam, p. 266.

73. Putnam, pp. 263-64.

74. Putnam, p. 260, 263.

75. McMurtrie, p. 362; Putnam, p. 263.

76. Frank Percival Price, *The Carillon* (Oxford, 1933), pp. 7-8.

77. Price, p. 9.

78. Price, p. 17.

79. Parker, p. 27.

80. Price, pp. 12-13.

81. Price, p. 15f.

82. Price, pp. 9-10.

83. *Ibid.*

84. Price, pp. 13-14.

85. Murray, pp. 150-51.

86. Murray, p. 150.

87. Murray, p. 151. One of the harpsichords of the famed instrument-maker Johannes Ruckers, dated 1612, can still be seen in Fenton House, Hampstead (London).

88. Murray, p. 146.

89. *Ibid.*; cf. also Johannes Koepp, *Untersuchungen über das Antwerpener Liederbuch vom Jahre 1544* (Antwerp, 1928?).

90. C.S. Lewis, *The Discarded Image* (Cambridge, 1965), p. 214; on 'reading' the text of the universe, pp. 1-12.

91. Erwin Panofsky, *Early Netherlandish Painting: Its Origins and Character* (Cambridge, Mass., 1958), pp. 180-81.

92. *Ibid.*

93. Cited by Panofsky, *ibid.*, from *Le opere di Giorgio Vasari* (Florence, 1878-1906), vol. II, p. 565f. Vasari speaks of Van Eyck's search for 'a kind of medium that would dry in the shade without his placing his pictures in the sun', and of this as leading to his discovery of varnish, which all painters 'had long wished for'. It 'set the colour afire' and 'blended better than tempera'. Carel van Mander (see note 98, below) argues (p. 437 n. 3) that oil painting was known as early as the thirteenth century.

94. As cited in Robert Goldwater, Marco Treves eds, *Artists on Art, from the 14th to the 20th Century* (London, 1976), p. 116. Cf. also Panofsky, p. 181.

95. Goldwater, p. 117.

96. Cf. the discussion of Patinir in Christopher Brown, *Making and Meaning: Rubens's Landscapes* (London, 1996), pp. 13-15; and by Max Friedländer in *From Van Eyck to Bruegel* (London, 1965), pp. 76-84.

97. Brown, p. 14.

98. Constant van de Wall trans. and intro., Carel van Mander, *Dutch and Flemish Painters. Translation from the Schilderboek* (New York, 1936), p. 418.

99. Goldwater, p. 68; also cited in George Bull, *Michelangelo: A Biography* (London, 1996), p. 276.

100. Goldwater, p. 117; Van Mander, p. 31.

101. Larry Silver, *The Paintings of Quinten Massys*, with Catalogue Raisonné (Montclair, 1984), p. 7.

102. Geoffrey Parker, *Europe in Crisis: 1598-1648* (London, 1990), pp. 22-23.

103. As cited in Richard Woodfield ed., *The Essential Gombrich: Selected Writings on Art and Culture* (London, 1996), p. 400.

104. Goldwater, p. 114; cf. also J.A. Gere, *Taddeo Zuccaro: His Development Studied in his Drawings* (London, 1969), p. 60f, in which

Mannerism is taken up as a type of emphasis or fashion.

105. Walter L. Strauss, *Hendrik Goltzius, 1588-1617: The Complete Engravings and Woodcuts,* 2 vols (New York, 1977), pp. 562-63. Cf. discussion of Goltzius and Hercules in Eckhard Schaar, Holger Broeker, *Zeichnungen und Graphik des niederländischen Mannerismus* (Stuttgart, 1992).

106. Van Mander, p. 61.

107. Silver, p. 3.

108. Dürer, p. 97.

109. Silver, p. 5.

110. Max J. Friedländer, *Antonis Mor and his Contemporaries* (Heinz Norden trans.) (Brussels, 1975), pp. 64-65.

111. *Ibid.*

112. Curt Glaser, *Lukas Cranach* (Leipzig, 1923), pp. 128-29.

113. Van Mander, pp. 154-55. Cf. also F. Grossmann, *Pieter Bruegel: Complete Edition of the Paintings* (London, 1973).

114. Van Mander, p. 154.

115. *Ibid.*

116. Murray, p. 110.

117. *Ibid.*

118. This is the thesis of Paul Oppenheimer, *The Birth of the Modern Mind: Self, Consciousness and the Invention of the Sonnet* (Oxford, 1989). See especially, p. 3f, and p. 171-190.

119. On the first sonnets as poems consisting of single stanzas, cf. Oppenheimer, p. 177f.

120. See the citation of Walter Mönch, *Das Sonett, Gestalt und Geschichte* (Heidelberg, 1955) (pp. 82-83) in Oppenheimer, p. 178.

121. *Ibid.*

122. Cf. Oppenheimer, pp. 11-12, 34-35.

123. See Goethe's sonnet 'Mächtiges überrashen' ('Ein Strom entauscht umwölken Felsensaale (Out of a cloud-enveloped chamber of rocks)) and Wordsworth's sonnet 'Nuns fret not in their Convent's narrow room'.

124. Oppenheimer, pp. 187-90.

125. Oppenheimer, pp. 35-39.

126. John R. Spencer ed. and trans., Leon Battista Alberti, *On Painting,* pp. 90-91.

127. Spencer, Alberti, p. 15.

128. Spencer, Alberti, p. 91. Spencer observes that *istoria* as used by Alberti 'cannot be limited solely to narrative and historical painting' (p. 13), but involves drama and emotion (p. 23f). For Alberti's discussion of different sorts of light rays (which he compares to stalks), from 'extreme' and 'median' to 'centric', and which behave differently and affect the eyes in various ways, cf. p. 46. For his discussion of the movements of animate and inanimate beings, cf. p. 80f.

129. C.S. Lewis, p. 186; quadrivium, pp. 196-97.

130. Murray, p. 151.

131. *Ibid.*

132. Cf. Gilbert Highet, *The Classical Tradition: Greek and Roman Influences on Western Literature* (Oxford, 1976), pp. 57-62.

133. Cf. H.R. Fairclough trans., Horace, *Satires and Epistles* (London, 1978); also discussion in V.G. Kiernan, *Horace: Poetics and Politics* (London, 1999), p. 157f.

134. Geoffrey Shepherd ed., Sidney, *An Apology for Poetry* (Manchester, 1973); cf. also C.S. Lewis, *Poetry and Prose in the Sixteenth Century* (rpt. Oxford, 1997), pp. 343-47.

135. Michelangelo (as cited by Bull, p. 282) quoted approvingly from Horace's *De arte poetica*: 'Pictoribus atque poetis/Quidlibet audendi semper fuit aequa potestis/Scrimus et hanc veniam petimusque damusque vicissim' (Poets and painters have always shared a like power of daring anything – we know that, and between us we both seek and grant that license in turn).

136. M. Nijhoff ed., *P.C. Hooft's Nederlandse Historiën in het Kort* (Amsterdam, Brussels, 1947).

137. F. Jos van den Branden ed.,

Anna Bijns, haar leven, hare werken, haar tijd, 1493-1575 (Antwerp, 1911), p. 151. Cf. also Dr W.L. van Helfen ed., *Anna Bijns, Refereinen* (Rotterdam, 1875), and Murray, p. 110.

138. Reinder P. Meijer, *Literature of the Low Countries* (London, 1978), p. 80.

139. Murray, p. 110; Meijer, pp. 84-89; Theodore Weavers, *Poetry of the Netherlands in its European Context, 1170-1930* (London, 1960), pp. 116-47, 224-234; and Dr W.A.P. Smit ed., *Jan van der Noot, Bosken in het Theater* (Amsterdam, 1953), which contains examples of his sonnets and sonnet translations.

140. Wedgwood, p. 270; Michael Roberts trans., Nils Ahnlund, *Gustav Adolf the Great*, (Princeton, 1940) pp. 110, 112.

141. Parker, *Dutch Revolt*, p. 131.

142. *Ibid.*, p. 26.

143. *Ibid.*, pp. 23, 249-50, 235.

144. On the development of these from the medieval tournament, cf. Roy Strong, *Art and Power: Renaissance Festivals, 1450-1650* (rpt. London, 1995), pp. 16-19; also John Lothrop Motley, *The Rise of the Dutch Republic*, 3 vols, (rpt. London, 1930), I, p. 65f.

145. Oppenheimer, *Sonnet*, pp. 16-17.

146. Motley, *ibid.*

147. John Adington Symonds, *Shakespeare's Predecessors in the English Drama* (London, 1884), p. 322f; L. Collison-Morley, *The Story of the Borgias* (London, 1932), p. 127 (based on Thuasne ed., Johannes Burchard, *Diarium sive verum urbanarum comentarii, 1483-1506*, 3 vols (Paris, 1883)).

148. Symonds, *ibid.*; Collison-Morley, pp. 165, 166.

149. Symonds, *ibid.*; Collison-Morley, p. 125f.

150. Symonds, p. 332.

151. Symonds, p. 333.

152. Strong, p. 44.

153. Monsignore Bembo, *Il Petrarca* (Venice, 1573).

154. Rudolf Wittkower, *Architectural Principles in the Age of Humanism* (rpt. New York, 1971), pp. 88-89.

155. Symonds, p. 332.

156. Strong, p. 154f.

157. Symonds, p. 331.

158. Strong, pp. 154-55.

159. Mary Hollingsworth, *Patronage in Sixteenth Century Italy* (London, 1996), p. 315f; Strong, pp. 111-13.

160. *Ibid.*, pp. 11, 16, 17; Symonds, p. 321.

161. Murray, p. 108.

162. Alfred Lück, *Siegerland und Nederland*, 2nd ed. (Siegen, 1981), pp. 53-54.

163. Parker, *Dutch Revolt*, pp. 58-60.

164. Motley, II, p. 318f.

165. *Ibid.*; Parker, *Dutch Revolt*, p. 138.

166. Parker, *Dutch Revolt*, p. 51; Motley, I, pp. 220, 222f; Lück, p. 55.

167. Parker, *ibid.*; Motley, I, p. 271f.

168. Motley, *ibid.*

169. Motley, *ibid.*; Lück, *ibid.*

170. Motley, *ibid.*; Parker, *ibid.*

171. Simon Watson Taylor trans., Paul Zumthor, *Daily Life in Rembrandt's Holland* (Stanford, 1994), p. 128.

172. Louis van Keymeulen trans., Max Rooses, *Rubens: sa vie et ses oeuvres*, ltd ed. (Paris, 1898?), p. 2. Cf. also J. Smit and Victor van Grimberghen, *Historische Levensbeschryving van P.P. Rubens* (Antwerp, 1840), p. 359f.

173. Zumthor, p. 128.

174. *Ibid.*, pp. 130-132.

175. Rooses, *Vie*, pp. 1-2; cf. also chapter on Rubens' life in Floris Prims, Maurits Sabbe, Victor de Meyere, A.J.J. Delen, Paul Pambotte, *Rubens en zijne Eeuw* (Brussels, 1927).

176. Rooses, *ibid.*; F. Baudouin, *Rubens* (Antwerp, Paris, 1977), p. 23.

177. Baudouin, pp. 26-27; Prims, Floris Prims *et al*, biographical chapter.

178. Baudouin, p. 23.

179. Baudouin, pp. 23-24.

180. Baudouin, p. 26; F. Verachter, *Généalogie de Pierre-Paul Rubens et de sa famille* (Antwerp, 1840), p. 10, 32, 33.

181. Baudouin, p. 23.

182. *Ibid.*, p. 26.

183. Elizabeth Lee trans., Émile Michel, *Rubens: His Life, his Work, and his Time*, 2 vols (London, New York, 1899), p. 3; Rooses, *Vie*, p. 2; P. Génard, 'De nalatenschap van P.P. Rubens', Antwerpsch Archievenblad I) (1865), p. 112f.

184. John Tomes, *Belgium and Luxembourg* (London, 1989), pp. 284, 288; Murray, p. 98; Blyth, pp. 240-45.

185. *Ibid.*

186. On first auto da fé, Motley, I, p. 196; Parker, *Dutch Revolt*, pp. 36-37, places this in Brussels in 1523.

187. Lind, *Vita*, p. 37.

188. Rooses, *Vie*, p. 2; Lind, *Vita*, p. 37; P. Génard, *P.P. Rubens: aanteekeningen over den grooten meester en zijne bloedverwanten* (Antwerp, 1877), pp. 113-23.

189. Lind, *ibid.*; Rooses, *ibid.*; Génard, p. 121.

190. Cf. Anthony Howard's discussion of the Great Reform Bill of 1832, in 'Rivals who were the chalk and cheese of politics', *The Times*, Wed., 13 Aug. 1997, p. 9.

191. Hans Gerhard Evers, *Peter Paul Rubens* (Munich, 1942), pp. 11-12; Rooses, *Vie*, p. 4.

192. Murray, pp. 105-107.

193. Murray, p. 106; Floris Prims *et al*, *Rubens en zijne Eeuw*, pp. 192-93.

194. Floris Prims *et al*, *ibid.*, p. 192.

195. *Ibid.*, pp. 192-93.

196. Alastair Duke, 'The Netherlands', in Andrew Pettegree ed., *The early Reformation in Europe* (Cambridge, Eng., 1992), p. 142; cf. also Martin van Gelderen, *The Dutch Revolt* (Cambridge, Eng., 1993), p. 24; Murray, p. 36.

197. Van Gelderen, pp. 30-31.

198. *Ibid.*

199. Stephen Ozment, *The Age of Reform, 1250-1550: An Intellectual and Religious History of Late Medieval and Reformation Europe* (New Haven, 1980), p. 282.

200. Cited in Ozment, p. 282-83.

201. Ozment, p. 282.

202. Ozment, p. 283.

203. Ozment, p. 284.

204. *Ibid.*

205. Ozment, p. 284f.

206. Duke, 'The Netherlands', p. 148.

207. *Ibid.*

208. *Ibid.*, p. 150-51.

209. Rooses, *Vie*, p. 3; Michel, p. 6; Génard, p. 121.

210. Michel, p. 6.

211. *Ibid.*

212. Cf. account in Parker, *Dutch Revolt*, pp. 74-80; Motley, I, p. 458f.

213. *Ibid.*

214. Parker, *Dutch Revolt*, p. 79.

215. Parker, p. 78.

216. Cf. Helen E. Evans, William D. Wixom eds, *Glory of Byzantium: Art and Culture of the middle Byzantine era AD 843-1261* (New York, 1998), whose first chapter contains an illuminating discussion along these lines; Robin Cormack, *Painting the Soul: Icons, death masks, and shrouds* (London, 1997); and Eamon Duffy's review of the latter, 'Byzantium endures', *Times Literary Supplement*, Jan. 30, 1998, p. 20.

217. Émile Michel, p. 6.

218. Parker, *Dutch Revolt*, p. 84f.

219. Parker, *ibid.*, p. 41; Henry Kamen, *Philip of Spain* (New Haven, 1997), pp. 218-19 (a contrary view); on his habits, such as punctuating negotiations with sex by sallying forth in disguise to hunt up whores, cf. Motley, I, p. 133. Parker's contention in his *The Grand Strategy of Philip II* (New Haven, 1998), pp. 4-10, that Philip pursued imperial conquest and empire in the large sense in no way contradicts the more traditional emphasis on other

aspects of his mind and character presented here. Indeed, there is no contradiction. Nor is Parker's remark (p. 403) that Motley's account of Philip 'is a picture to be discarded' to be taken literally: distortions are certainly to be found within it, together with invaluable reconstructions from contemporary reports, all of which suggests that judiciousness rather than blanket rejection is the proper course to follow.

220. Kamen, p. 189.

221. Motley, I, 167f.; Parker, *Dutch Revolt*, pp. 38, 41; Kamen, pp. 68-69.

222. Mary Cable ed., *El Escorial* (New York, 1971), p. 139-42.

223. *Ibid.*

224. *Ibid.*

225. *Ibid.*

226. Motley, I, 167f.

227. Kamen, p. 90.

228. Motley, II, p. 194f; Parker, *Dutch Revolt*, p. 111-12.

229. Motley, II, pp. 193-95.

230. Murray, pp. 79-80.

231. Motley, II, pp. 83-88; Parker, *Dutch Revolt*, pp. 89-92.

232. Motley, I, p. 167.

233. Motley, II, pp. 83-88; Kamen, p. 27.

234. Parker, *Dutch Revolt*, pp. 19-20, 23-30; J. Jacquet ed., *Fêtes et cérémonies au temps de Charles-Quint* (Paris, 1960), pp. 297-342, which describes in detail Philip's reception in the Netherlands.

235. Motley, I, p. 133.

236. Nijhoff, Hooft's Nederlandse Historiën, pp. 34-52; Kamen, p. 78, relying on an English account, places the storm after Philip's arrival at Laredo.

237. Motley, I, 134f; Kamen, p. 78 (though, despite several contemporary reports, he is sceptical that Philip made this remark). On Philip's religious fanaticism, however, cf. Parker, *Grand Strategy*, pp. 104-108.

238. Harold Child trans., Max Rooses, *Rubens*, 2 vols (London, 1904), pp. 4-5; Evers, p. 12; J.F.M.

Michel, *Histoire de la vie de P.P. Rubens* (Brussels, 1771), pp. 10-12, cites in full Jan Rubens' certificate from the Antwerp Council, praising his work as an Alderman and asking that he be well treated wherever he might go.

239. Motley, II, p. 74; Parker, *Dutch Revolt*, p. 71, 99; Lück, p. 57.

240. Motley, II, p. 88f; Parker, *Dutch Revolt*, pp. 83-85, 88-90, 101-104.

241. Motley, II, p. 110f; Parker, *Dutch Revolt*, p. 85, 106.

242. Motley, II, 110f; Parker, *ibid.*, p. 106.

243. Motley, II, pp. 146-47.

244. *Ibid.*; Parker, p. 106.

245. Motley, p. 83f; Parker, p. 89.

246. Lück, pp. 57-58; Parker, p. 105f.

247. Parker, pp. 108.

248. *Ibid.*, p. 107.

249. *Ibid.*, p. 108.

250. *Ibid.*, pp. 83, 84, 85-86, 100, 287 n. 1.

251. Motley, II, p. 197; Michel, p. 6; Rooses, *Rubens*, p. 4; Parker, pp. 106, 293 n. 30.

252. Michel, pp. 6-7; Rooses, p. 4; Evers, p. 12.

253. Van Gelderen, *Dutch Revolt*, pp. 24, 30-31.

254. *Ibid.*, pp. 58-59.

255. Motley, II, pp. 229-30.

256. Motley, I, p. 408f; Parker, *Dutch Revolt*, pp. 69, 74.

257. Evers, p. 12; Hago Holborn, *A History of Modern Germany: The Reformation* (rpt. Princeton, 1982), p. 278f.

258. Dürer, p. 107.

259. *Ibid.*

260. T. Coryat, *Coryat's Crudities*, 2 vols (London, 1611; rpt., Glasgow, New York, 1905), vol. 2, p. 313.

261. *Ibid.*

262. *Ibid.*

263. Coryat, vol. 2, pp. 334-35, 348.

264. Holborn, p. 278f.

265. Evers, p. 13

266. William Noël Sainsbury, *Original unpublished papers illustrative of the Life of Sir Peter Paul Rubens* (London, 1859), facing p. 1f (a listing that supplies incorrect birth and death dates for Jan Rubens, as noted earlier and below); cf. also Evers, p. 483 n. 17; cf. also Smit and Grimberghen, *Historische Levenbeschryving*, pp. 5-6.

267. Horst Kaestner, 'Peter Paul Rubens' Eltern in Köln und Siegen', *Heimatland: Beilage zur Siegener Zeitung* (Siegen, 1927), Nr. 7, p. 98.

268. Hans Kruse, 'Wilhelm von Oranien und Anna von Sachsen: Eine fürstliche Ehetragödie des 16. Jahrhunderts', *Nassauische Annalen, Jahrbuch des Vereins für Nassauische Altertumskünde und Geschichtsforschung* (1934), 54, p. 59f.

269. Kruse, *ibid.*; Kaestner, p. 98; Evers, p. 12; Motley, II, p. 480f, 482 notes.

270. Kaestner, p. 98; Kruse, *ibid.*; Evers, 12.

271. Kaestner, *ibid.*; Kruse, *ibid.*

272. Kruse, p. 112; Evers, p. 13.

273. Kruse, p. 77; Evers, p. 13

274. Kruse, p. 111; Evers, p. 14.

275. Kruse, p. 79; Evers, p. 14.

276. Kruse, *ibid.*; Evers, *ibid.*

277. Kaestner, p. 99; Rooses, *Rubens*, p. 6.

278. R.C. Bakhuizen van den Brink, *Het Huwelijk van Willem van Oranje met Anna van Saxon* (Amsterdam, 1853; rpt. The Hague, 1939): O. Dambre, *Marginalia bij Maria Pypelinckx' Troostbrieven* (Antwerp, 1940), p. 497; also cited in Evers, pp. 15-16; Rooses, *Rubens*, pp. 8-10.

279. R.C. Bakhuizen van den Brink, *Les Rubens à Siegen* (La Haye, 1861), p. 14; also cited in Evers, p. 17.

280. Kaestner, p. 99.

281. Bakhuizen, p. 48; cited (in German) in Evers, pp. 18-19.

282. Motley, II, p. 480f; cf. Lück, pp. 67-75, for a description of his activities; cf. also Evers, pp. 11-12.

283. Kaestner, p. 99; Lück, p. 76;

Rooses, *Rubens*, p. 11; Evers, p. 19.

284. Rooses, *Rubens*, p. 11; Evers, p. 19; Kaestner, p. 99.

285. Lück, p. 75; Evers, p. 13; Kruse, p. 135; K. Wolf, 'Christine von Dietz', *Siegerland* (Siegen, 1938), nr. 20, p. 104.

286. Motley, II, 480, 484.

287. Motley, p. 484 (cited from Augustus Böttiger, (1836), pp. 169-73); Evers, p. 15; Kaestner, p. 100; Kruse, p. 94f.

288. Motley, *ibid.*; Kruse, *ibid.*

289. Evers, p. 19-20; Kaestner, p. 100.

290. Kaestner, *ibid.*

291. Evers, *ibid.*

292. Evers, *ibid.*; Kaestner, *ibid.*; Génard, pp. 140-249.

293. Motley, II, pp. 496, 499f; III, pp. 4-14; Parker, *Dutch Revolt*, pp. 216-18.

294. Compare with the nearly identical translation in M.A. Screech trans., Michel de Montaigne, 'On the Cannibals', The Complete Essays (London, 1987), p. 233.

295. *Ibid.*

296. Motley, I, p. 115f.

297. Lück, p. 14.

298. Lück, 'Die Anteil der Siegerländer Eisenindustrie an der nassauischen Wirtschaft und am Freiheitskampf der Niederlande', pp. 61-66.

299. Rooses, *Rubens*, p. 11, has Bourgstrasse, though the address cited here is only tentatively more likely.

300. Evers, p. 20; Rooses, *Life*, pp. 15-17, which summarizes the early controversy over the date and place (in Siegen or Cologne?) of Rubens' birth, now regarded as settled.

301. Kruse, p. 100; Evers, p. 20.

302. Kruse, *ibid.*; Evers, p. 19; Rooses, *Life*, p. 11.

303. Hollingsworth, pp. 164-65.

304. *Ibid.*, pp. 165-66; cf. also Wolfgangz Wolters, 'Der Programmentwurf zur Dekoration des Dogenpalastes Dezember 1577', in *Mitteilungen des Kunsthistorischen*

Instituts in Florenz, 12 (1965-66), pp. 271-318, and especially pp. 303-318.

305. Evers, p. 20; Rooses, *Life*, p. 12.

306. Kruse, p. 100; Rooses, *Life*, p. 14; Sainsbury, p. 1f.

307. Evers, *ibid*.

308. Schmidt the Elder (1535-1592) – his eponymous son was also a composer – wrote motets for organ as well as secular songs (cf. entry in Barry Jones ed, *Hutchinson Concise Dictionary of Music* (London, 1998)).

309. G. Hirth ed., *Neue Künstliche Figuren Biblischer Historien* (rpt. Basel, 1923). On the use of Guarin's book by Rubens as a school of artistic instruction ('eine Lehrschule'), cf. the remarks of Joachim Sandrart (who knew him and spoke with him in 1627 about this period) in A.R. Peltzer ed. *Sandrart's Academie der Bau-, Bild- und Malerey-Künste* (rpt. Munich, 1925), p. 106.

310. On Hagar, and also on echoes of this sketch in his later work, cf. Hans Gerhard Evers, 'Rubens und Tobias Stimmer', in *Rubens und sein Werk: Neue Forschungen* (Brussels, 1944), pp. 95-96; on 'improving' on artists whose work he copied, cf. Simson, p. 434, and also pp. 34-35.

311. Evers, *ibid*., speculates that the copies may date from Rubens' time in Cologne, and argues the same in his *Rubens*, p. 24 (Rubens' use of the word 'Jugend' in his comments to Sandrart, while somewhat ambiguous, seems to support this possibility).

312. On two early drawings by Rubens after Holbein's *Totentanz*, cf. Julius Held, *Selected Drawings* p. 64. Held adds, 'It is anybody's guess at what age Rubens drew them,' and 'I see no reason why one cannot put them to the years 1591-92, when Rubens was entering the studio of his first teacher at the age of fourteen,' though these remarks also leave open the question whether they were not made even earlier. Thus of Rubens'

copies of Tobias Stimmer Held observes that 'the question remains of how far back one is entitled to go' in dating them, and finds himself unwilling to push the date back much before 1597 only because of the 'fully developed hand' of Rubens' inscription on the same sheet (which may have been added later) and the fact that two prints copied by Rubens from Goltzius on this sheet are dated 1597 (though these copies too may have been subsequent additions). What is important in all these early drawings, as both Held and Simson agree, is Rubens' already emergent personality, or style, his desire to depict 'figures in agitation' (Held, p. 66). On the copies from Stimmer Held notes that their purpose 'was the study of the greatest possible variety of bodily motions'. These are today in the J. Pierpont Morgan Library, New York.

313. Cf. Held, p. 64; Simson, p. 34; J.Q. van Regteren Altena ed., *Peter Paul Rubens tekeningen naar Hans Holbeins Dodendans* (facsimile, Amsterdam, 1977); and Held, 'Thoughts on Rubens' Beginnings', in *The Ringling Museum of Art Journal* (Sarasota, Fla., 1983), pp. 14-35.

314. Paul Oppenheimer trans., *Till Eulenspiegel: His Adventures* (Oxford, 1995), pp. xiii-xiv, xxii-xxiii.

315. The earliest Flemish edition (1520-30) is probably *Ulenspiegel. Van ulespieghels leuen en schimpelijcke wercke, wonderlijcke avontueren die hi hadde, etc.* (modern facsimile by M. van Hoochstreten; note by M. Nijhoff). This was followed by a number of other editions also published in Anwerp straight through the sixteenth century. Cf. the incomplete but useful listing in K.R.H. Mackenzie trans., *Master Tyll Owlglass: His Marvellous Adventures and Rare Conceits* (London, 1923), pp. 284-303.

316. *Eulenspiegel*, p. 50.

317. Such carts, with the angle not always reversed, appear, for instance,

in *Summer* (*ca.* 1618, 143 x 223 cm.,
London, The Royal Collection), *A
Waggon Fording a Stream* (*ca.* 1635,
47 x 70.3 cm., National Gallery,
London) and *Landscape with a Cart
crossing a Ford: La Charette
Embourbée (ca.* 1620, 86 x 126.5 cm.,
The State Hermitage Museum, St
Petersburg).

318. *Eulenspiegel*, p. xxviii.
319. Cf., for example, Christopher
White, *Rubens*, p. 6; on the popularity
of the Eulenspiegel stories and the
likelihood that Rubens read them see
also Erik Larsen, *P.P. Rubens, with a
complete Catalogue of his works in
America* (Antwerp, 1952), p. 35, and
Murray, p. 112.
320. *Eulenspiegel*, p. xix.
321. *Ibid.*, p. xxii.
322. Lind, *Vita*, p. 37, 44 n 7;
Rooses, p. 29.
323. Génard, p. 222.
324. Rooses, *Life*, pp. 12-13; Evers,
Rubens, p. 20.
325. Evers, *ibid.*; Kaestner, p. 100;
Sainsbury, p. 1.
326. Evers, *ibid.*; Kaestner, *ibid.*;
Génard, p. 223.
327. Sainsbury, facing p. 1; Evers,
ibid., p. 483, n 17.
328. Parker, *Dutch Revolt*, p. 195-
96; Evers, *Rubens*, pp. 20-21.
329. Evers, *ibid.*
330. Evers, *ibid.*, p. 21; Rooses, *Life*,
p. 13.
331. Cited by Evers, *ibid.*, pp. 21-
22.
332. Evers, *ibid.*, p. 22.
333. Rooses, *Life*, p. 27
334. Parker, *Dutch Revolt*, p. 195,
200-201; Motley, II, pp. 472-79.
335. Motley, I, 338f, III, p. 5f;
Parker, *ibid.*, pp. 32-34, 335.
336. Motley, II, p. 331; Parker, *ibid.*,
pp. 138, 135, 140, 189.
337. Motley, II, p. 332; Parker, *ibid.*
338. Motley, II, p. 333; Parker, pp.
140-42.
339. Motley, *ibid.*
340. *Ibid.*

341. *Ibid.*
342. *Ibid.*; Parker, *ibid.*, p. 141.
343. G. Velderman ed., *Bloemlezing
uit Hooft's Historiën (Bibliotheek van
Nederlandse Klassieken)* (Doetinchem,
1881), 1, pp. 17-22; Parker, *ibid.*, pp.
140-42; Motley, II, p. 334f.
344. Parker, *ibid.*, pp. 191-92;
Motley, III, p. 8f.
345. Motley, *ibid.*; Parker, p. 149,
176.
346. Parker, *ibid.*, p. 200-202;
Parker, *Europe in Crisis*, 1598-1648
(London, 1990), pp. 50-51.
347. Parker, *ibid.*; Motley, II, 7f;
Holborn, 278f.
348. Motley, II, p. 14f; Parker,
Dutch Revolt, p. 168, 173f.
349. Motley, *ibid.*; Parker, *ibid.*, p.
173f.
350. *Ibid.*
351. *Ibid.*
352. *Ibid.*
353. *Ibid.*
354. *Ibid.*
355. *Ibid.*
356. *Ibid.*
357. Parker, *ibid.*, pp. 159-60.
358. Cited in Parker, *ibid.*, p. 161.
359. *Ibid.*
360. Parker, *ibid.*, p. 169.
361. Cited in Motley, III, p. 76.
362. Motley, III, p. 62; Parker, *ibid.*,
pp. 176-77.
363. Motley, III, p. 62f.
364. Noted in Motley, III, p. 65.
365. Parker, *ibid.*, p. 178.
366. Parker, *ibid.*, p. 56.
367. M. Nijhoff, *P.C. Hooft*, p. 195f.
368. Nijhoff, *ibid.*; Parker, *ibid.*, p.
178; Motley, III, p. 33f.
369. Nijhoff, *ibid.*; Motley, *ibid.*
370. *Ibid.*
371. *Ibid.*
372. Motley, *ibid.*, p. 101f; Parker,
ibid., pp. 180-81.
373. Parker, *ibid.*, p. 181; Motley,
III, p. 103.
374. Velderman, *Hooft's Historiën*,
pp. 60-62; Motley, *ibid.*
375. Motley, *ibid.*, p. 104.

376. Motley, *ibid.*
377. Parker, *ibid.*, pp. 182-83.
378. Motley, *ibid.*
379. Motley, *ibid.*, pp. 104, 110; Parker, *ibid.*
380. Van Mander, p. 424.
381. *Ibid.*
382. Jervis Wegg, *The Decline of Antwerp under Philip of Spain* (London, 1924), pp. 216-17.
383. Friedländer, *From Van Eyck to Bruegel*, p. 136, pl. 290.
384. Van Mander, p. 155.
385. Wolfgang Stechow, *Pieter Bruegel the Elder* (London, 1990), p. 85.
386. Stechow, pp. 18, 21; on Ortelius, cf. Murray, pp. 128-30, and especially the exhibition catalogue, *The Illustration of Books Published by the Moretuses* (Antwerp, 1997), pp. 138-39. On Ortelius' relations with Bruegel, cf. the summary in Hessel Miedema ed. *Karel van Mander: The Lives of the Illustrious Netherlandish and German Painters*, 4 vols, (Doornspijls, 1996), vol. III, p. 253 n. 20. Miedema (vol. III, p. 252 n. 10) takes note of the recent debate over whether Bruegel was himself a peasant, citing his 'elitist aloofness' and in effect rejecting the idea. On the likelihood that Rubens and Ortelius later knew each other, cf. Paul Huvenne, *The Rubens House, Antwerpen* (Antwerp, 1996), p. 32.
387. Carel Van Mander, pp. 182-85.
388. *Ibid.*
389. *Ibid.*, p. 289.
390. Miedema, *Karel van Mander*, vol. I, p. 295 (folio).
391. Carel van Mander, pp. 182-85.
392. *Ibid.*
393. *Ibid.*, p. 404.
394. *Ibid.*, p. 405.
395. Miedema, *Karel van Mander*, vol. I, p. 295 (folio).
396. Carel van Mander, p. 151.
397. *Ibid.*, p. 405.
398. Parker, *Dutch Revolt*, p. 193; Motley, III, p. 242f.
399. Motley, *ibid.*
400. Motley, III, p. 245f.
401. *Ibid.*
402. Motley, III, p. 254; Parker, *Dutch Revolt*, p. 193.
403. Parker, *ibid.*, pp. 200-204; Motley, *ibid.*, p. 255f.
404. Parker, *ibid.*, p. 208; Motley, *ibid.*, p. 258.
405. Parker, *ibid.*; Motley, III, p. 399.
406. Cited by Motley, *ibid.*
407. *Ibid.*
408. Murray, p. 40.
409. Parker, *ibid.*, p. 203.
410. Murray, p. 111; Parker, *ibid.*, p. 144.
411. Velderman, *Hooft's Historiën*, pp. 73-82; Murray, p. 42.
412. Parker, *ibid.*, p. 412; Vezio Melegari, *The Great Military Sieges* (London, 1972), p. 142-43.
413. Motley, III, p. 447.
414. Parker, *ibid.*, p. 207; Murray, p. 42; Motley, *ibid.*
415. Melegari, *ibid.*; C.E.H.J. Verhoef, *De Val van Antwerpen* in 1585 (Antwerp, 1985), pp. 16-19.
416. Melegari, *ibid.*
417. Melegari, *ibid.*; Parker, *ibid.*, p. 215.
418. Melegari, *ibid.*; Parker, *ibid.*
419. Parker, *ibid.*, pp. 215-16; Murray, p. 42.
420. Parker, *ibid.*, pp. 250-51; Parker, *Europe in Crisis*, p. 136.
421. Rooses, *Life*, p. 13; Evers (in what seems a confusion) has June 27, p. 22; Sainsbury has March 27 (facing p. 1). J.F.M. Michel, *Histoire de la vie de P.P. Rubens*, p. 17, attributes his death to 'une violente maladie'.
422. J.F.M. Michel, pp. 17-18 (correctly cited in Latin).
423. Rooses, *Life*, pp. 14-15, for example, suggests that 'the Rubens family always systematically avoided mentioning their residence at Siegen and the circumstance which caused it'; cf. also Simson, p. 30.

424. J.F.M. Michel, *ibid.*

425. Rooses, *Life*, p. 13.

426. Parma supplied some 25,000 troops for Philip's invasion army, extracting them from his Netherlands forces (S.T. Bindoff, *Tudor England* (rpt. London, 1962), p. 272).

427. *CR*, vol. I, p. 3

428. Rooses, *Life*, p. 14.

429. Murray, p. 99.

430. *Ibid.*

431. *Ibid.*, p. 101; cf. also Zumthor, *Daily Life*, p. 79f, 91f (it should be noted that between the southern and northern Netherlands, even well into the next century, few dramatic cultural distinctions can be said to have existed; even fewer of the inhabitants seem to have recognized any).

432. *Ibid.*, p. 100; cf. also the letter of Balthasar Moretus to Philip Rubens, *CR*, vol. I, p. 1.

433. Zumthor, *Daily Life*, p. 106.

434. Rooses, 'Petrus-Paulus en Balthasar Moretus, I,' *Rubens Bulletin*, I, (1882), p. 207f; Rooses, *Life*, p. 28f.

435. F.W.M. Draper, *Four Centuries of Merchant Taylors' School: 1561-1961* (Oxford, 1962), p. 8. On an English educational approach comparable to Rubens', cf. pp. 4-5. John Colat, the founder of St Paul's School, gave a sermon in 1512, advocating for the first time the teaching of 'heretical Greek' (pp. 7-8).

436. Zumthor, *Daily Life*, p. 107; on the study of Latin and French, cf. pp. 108-111.

437. Murray, p. 101.

438. *Ibid.*, p. 99.

439. *Ibid.*, p. 100.

440. *CR*, vol. I, p. 3.

441. *Ibid.*; Evers, p. 24.

442. *CR*, *ibid.*; Rooses, *Life*, p. 28; Génard, pp. 374, 376.

443. Thus, for example, Brian Vickers notes that the Renaissance 'rhetorical tradition carried with it an ideal of the *vir civilis*, trained in eloquence and able to take part in public discussions, serving the State in some form of active life, as a politician, counsellor, secretary, or teacher' ('Tis the Goddesse of Rhetorick,' *Times Literary Supplement*, August 16, 1996, p. 27 [review of Quentin Skinner, *Reason and Rhetoric in the Philosophy of Hobbes* (Cambridge, Eng., 1996)]). Along the same lines, Rubens' contemporary Francis Bacon (1560-1626) observes that 'men in *great place* are thrice *Servants*: Servants of the Soveraigne or State; Servants of Fame; and Servants of Businesse. ... Merit, and good Works, is the end of Man's Motion' (W. Aldis Wright ed., *Bacon's Essays* (London, 1868), pp. 39-40).

444. Roger de Piles, *Conversations* 'Abrégé de la vie de Rubens', in *Dissertations sur les Ouvrages des plus fameaux Peintres* (1681), p. 30; Piles, (1677), pp. 213-15.

445. Cited in Émile Michel, *Rubens, sa vie*, p. 27.

446. Lind, *Vita*, pp. 37-38.

447. Sainsbury, pp. 2-3; Rooses, *Life*, p. 31.

448. Larsen, pp. 203-11; Zumthor, p. 196.

449. Rooses, *Life*, p. 40.

450. *Ibid.*

451. Rooses, *ibid.*, pp. 42-43; cf. also *Illustration of Books Published by the Moretuses*, pp. 90-91. Between 1587 and 1627 Van Noort had 33 pupils, including Jordaens, and died owning eight houses.

452. Lind, *Vita*, p. 38; and *Books Published by the Moretuses*, pp. 131-32.

453. Evers, p. 26; Simson, pp. 31-32 (who puts his age (incorrectly) at 21); Huvenne, p. 42.

454. Evers, *ibid.*; on August 19, 1628, Rubens attested that Deodat del Monte had boarded and lodged with him, while serving his apprenticeship, before 1600 (Rooses, *Life*, p. 31, though he gives the date as August 6; cf. Magurn, p. 227).

455. Génard, p. 373.

456. Hubert Wellington ed., Lucy

Norton trans., *The Journals of Eugene Delacroix*, (3rd ed. London, 1995), p. 413.

457. Simson, p. 33, notes that the pose here, with the right hand resting on a sill, harks back to old-Netherlandish painting styles.

458. *Ibid.*

459. Christopher White, p. 8, traces influences of Otto van Veen in this painting.

460. The figure of Athena is adapted from Gian Giacomo Caraglio's copper engraving after Rosso Fiorentino's *Juno* (19.6 x 10.8 cm., today in the Berlin-Dahlem museum) (White, p. 9).

461. Simson, p. 34.

462. Cited in Kamen, p. 319.

463. *Ibid.*; Parker, *Dutch Revolt*, p. 233.

464. Parker, *ibid.*, pp. 232-34.

465. *Ibid.*

466. Evers, p. 26 (though he erroneously dates this at 1598).

467. Parker, *Dutch Revolt*, p. 234.

468. *Ibid.*, pp. 234-35.

II

1. Evers, p. 26; Lind, *Vita*, p. 38.

2. E.S. De Beer, 'François Schott's', *Itinerario D'Italia*, in *The Library: A Quarterly Review of Bibliography*, (London, 1942) Fourth Series, vol. XXIII, No. 2, 3, p. 63; cf. also *Books Published by the Moretuses*, p. 17.

3. De Beer, *ibid.*, pp. 58-59.

4. Edward Chaney, 'The Grand Tour and the Evolution of the Travel Book', in Andrew Wilton, Ilaria Bignamini eds, *Grand Tour: The Lure of Italy in the Eighteenth Century* (London, 1996), p. 102 (see also p. 75, on Schott).

5. De Beer, *ibid.*, p. 58; cf. also *Books Published by the Moretuses*, p. 104.

6. De Beer, *ibid.*, pp. 61-63; André Schott was himself apparently one of Rubens' friends (to be taken up later).

7. Evers, *Neue Forschungen*, p. 12.

8. Coryat, II, p. 300.

9. Lind, *Vita*, p. 38.

10. Coryat, *ibid.*, pp. 307, 308, 318.

11. *Ibid.*, pp. 342, 344

12. *Ibid.*, pp. 386-87.

13. *Ibid.*, p. 387.

14. *Ibid.*, pp. 388, 390, 392, 395, 413, 409.

15. *Ibid.*, pp. 397, 399, 413.

16. Lind, *Vita*, p. 38 (while it is not clear precisely how Rubens met Vincenzo, the Latin strongly implies the interpretation offered here).

17. This seems a distinct possibility. Simson (pp. 36-37) inclines to the belief that Vincenzo was initially more impressed with Rubens' diplomatic abilities.

18. Evers, *Neue Forschungen*, p. 12; Vincenzo is placed in Venice from 15 to 22 July, 1600 (*CR*, I, p. 54); Michael Jaffé, *Rubens and Italy* (Oxford, 1977), maintains (p. 9) that by October at the latest Rubens had entered the Duke's service.

19. Hollingsworth, p. 291.

20. *Ibid.*, pp. 290-91.

21. *Ibid.*, p. 292.

22. *Ibid.*, pp. 303-304.

23. *Ibid.*, p. 295-97; Simson, p. 37.

24. *Ibid.*

25. Coryat, II, p. 264

26. *Ibid.*, p. 266.

27. Hollingsworth, p. 303.

28. *Ibid.*, p. 303-304; *CR*, I, pp. 55-58.

29. Hollingsworth, p. 303.

30. Simson, p. 37; Jaffé, p. 7f.

31. Susan Madocks Lister trans., Ettore Camesasca, *Mantegna* (Milan, 1992), p. 36f.

32. *Ibid.*, 59f; Jeffrey M. Muller, *Rubens: The Artist as Collector* (Princeton, 1989), p. 15.

33. Camesasca, p. 62.

34. *Ibid.*, pp. 48-49.

35. C. White, p. 12; Simson, p. 281; *CR*, I, p. 55.

36. Camesasca, p. 62.

37. Jaffé, p. 10; Ronald Forsyth

Millen, Robert Erich Wolf, *Heroic Deeds and Mystic Figures: A New Reading of Rubens' Life of Maria de'Medici* (Princeton, 1989), p. 55; Simson, p. 37.

38. Parker, *Dutch Revolt*, p. 235.

39. Hollingsworth, p. 302.

40. Millen and Wolf, *Heroic Deeds*, dispute this (p. 55). Considerable evidence, including a letter from Nicolas de Peiresc to Rubens, cited below, n. 43, indicates that he was. On the wedding itself, cf. Piero Marchi, 'Le feste fiorentine per la nozze di Maria de'Medici nell'anno 1600', in Mina Gregori ed., *Rubens e Firenze* (Florence, 1983), pp. 85-101.

41. Cited in Millen and Wolf, *ibid.*, p. 54.

42. This would have seemed appropriate in the circumstances, and is supported by Rubens' presence at the royal banquet and his invitation to meet the Grand Duke at a later date (to be cited).

43. Letter in *CR*, III, p. 57. Cf. Jaffé, p. 10.

44. Robert Oresko, 'Culture in the Age of Baroque and Rococo', in George Holmes ed., *Oxford History of Italy* (Oxford, 1997), p. 139f.

45. *Ibid.*

46. Cf. Lewis, *Discarded Image*, p. 209.

47. George Bull, *Michelangelo*, pp. 343-44.

48. *Ibid.*

49. *Ibid.*, p. 274f.

50. Bull, *ibid.*, pp. 20-21.

51. Mary M. Innes trans., Ovid, *Metamorphoses* (London, 1968), pp. 273-82.

52. Simson, p. 38.

53. Cf. Jaffé, p. 10.

54. Held, *Drawings*, pp. 53, 68-69; Christopher White, p. 31; and a contrasting view in *CRB* XIX, Frances Huemer, *Portraits I*, (London, 1977) pp. 28-33.

55. *CR*, I, pp. 9-10.

56. *Ibid.*, pp. 7-8 [translation from Latin into French].

57. Evers, *Neue Forschungen*, p. 14; Jaffé, p. 10. In a letter to his brother of December 13, 1601, Philip writes: 'Quid tibi de hac urbe videatur, ceterisque Italiae quas lustravisti iam plurimas volupte sit ex te audire' (I long to hear your impression of this city [Padua] and of those others in Italy, so many of which you have already sampled) (Ch. Ruelens, M. Rooses eds, *Codex Diplomaticus Rubenianus*, 6 vols (Antwerp, 1887-1909), I, #VII).

58. Probably late June. Cf. Evers, *Neue Forschungen*, p. 16.

59. Evers, *ibid.*, pp. 14, 16.

60. *Italienische Reise*, entry for November 1, 1786.

61. *CR*, I, p. 28.

62. *Ibid.*, pp. 29, 59.

63. On Rome as a model of the modern anachronistic city, cf. Paul Oppenheimer, 'Goethe and Modernism: The Dream of Anachronism in Goethe's *Roman Elegies*', *Arion*, Spring-Summer, 1998, pp. 81-100.

64. Alfred Noir, *Caravaggio* (New York, 1989), p. 11.

65. Howard Hibbard, *Caravaggio* (New York, 1983), pp. 91f, 118f, 138f.

66. *Ibid.*, pp. 88.

67. Noir, *ibid.*, p. 86.

68. Hibbard, *ibid.*, p. 132f.

69. *Ibid.*, p. 69.

70. He scribbled a note on the sheet on which he made these copies, which itself was no doubt torn out of his lost sketch-book, to the effect that the body of Hercules divides neatly into the sorts of squares, triangles and cubes that would have been familiar to him from Pythagorean geometry and the *Timeus* of Plato (cf. Simson, p. 54). The proportions of the human body, in other words, were identical with those of the mansion of heaven and the shape of the human soul, as Plato describes them. They were also the same ratios as those used by Palladio

and Michelangelo in their designs of Renaissance rooms and buildings, and that appear in the structure of the sonnet (cf. Wittkower, *Architectural Principles*, p. 104, and Oppenheimer, *Modern Mind*, pp. 189-90). There is ample evidence too that Rubens devoted a great deal of time to absorbing and assimilating Dürer's theories of proportion at this point, working them out in copies after Raphael. Cf. Justus Müller Hofstede, '"Ut Pictura Poesis": Rubens und die humanistische Kunsttheorie', in *Gentse Bijdragen tot de Kunstgeschiedenis* (Ghent, 1976-78), XXIV, pp. 171-89. On Rubens' copies after ancient Roman sculpture, cf. Marjon van der Meulen, 'Rubens and the Antique Sculpture Collections in Rome', *ibid.*, pp. 146-58.

71. Cf. on this question for instance, Julius Held, 'Copies made by Rubens', *Selected Drawings*, pp. 42-48, and Marjon van der Meulen, 'Observations on Rubens' Drawings after the Antique', in *The Ringling Museum of Art Journal* (Sarasota, Fla., 1983), pp. 36-51. On Rubens' sketch of Laocoön cited here, and others that he did of the same figure, cf. Held, *ibid.*, pp. 178-79. Held dates these to 1605-08, while Christopher White puts them during this earlier period, as does Simson.

72. *C.* 1601-2, 38.9 x 27.8 cm., in red chalk and red wash, today in the National Gallery, London.

73. Cf. Jeffrey M. Muller, 'Rubens' Anatomy Book', in *Rubens Cantoor: een verzameling tekeningen ontstaan in Rubens' atelier* (Antwerp, 1993), pp. 78-107.

74. On the other hand, Muller finds it incorrect to suppose that Rubens' presentation of muscles and anatomical alterations in his 'anatomical' studies is merely whimsical. His (later) *Flayed Head of an Old Man*, a sketch now at Chatsworth, in the Devonshire Collection, 'analyses the deeper facial muscles exactly according to Vesalius' system of classification' (p. 85). Rubens' 'pen and ink study is [nonetheless] his own imaginary dissection in which he imposed his knowledge from Vesalius to see below the skin of an ancient Roman portrait bust thought to be of the Emperor Galba and of which he made a straightforward study in red chalk, now in the Rubens House' (*ibid.*). Muller writes that 'Vesalius' tables of muscles are idealised and posed to resemble ancient sculptures' (p. 86); and 'although ... the drawings demonstrate considerable knowledge of anatomy, ... the violent movements, oblique viewpoints and numerous inaccuracies make it unlikely that Rubens drew any of his studies directly from a cadaver' (p. 87). Muller argues (p. 88) that Rubens relied on Vesalius' advice to artists that they should seek any reasonable imaginary method for joining bones and limbs in anatomical studies, and that this led him to pose his figures virtually as he pleased, or according to a conscious mix of the natural and the invented. Rubens' lost *Anatomy Book*, one may surmise, provided similar examples for students, or was meant to do so.

75. Hago Holborn, p. 278f.

76. *Ibid.*, p. 270f.

77. Mary Hollingsworth, pp. 133-34.

78. *Ibid.*

79. Stillman Drake trans. and intro., *Discoveries and Opinions of Galileo* (New York, 1957), pp. 15-16.

80. Mary Hollingsworth, p. 132.

81. Simson, pp. 40, 41, 45, 52.

82. Hibbard, pp. 88, 206.

83. *Ibid.*, p. 67; also his reprint of Bellori's 'Vita', p. 371.

84. *Ibid.*, pp. 371-72.

85. *Ibid.*

86. *Ibid.*

87. *Ibid.*, p. 160f.

88. *Ibid.*, p. 161.

89. Julius Held, *Drawings*, p. 52.

90. George Bull, *Michelangelo*, pp. 296-97.

91. Cf. Kepler's *Te Deum*, as cited in Charles Coulton Gillespie, *The Edge of Objectivity*, p. 39: 'Has not God Himself waited six thousand years for someone to contemplate His work with understanding?'

92. Cf. Gillespie, *ibid.*: 'Neither Copernicus nor Kepler ever broke with the medieval or the baroque in their mathematicism. Their cosmos was built according to a geometrical structure, as a cathedral may be which is embellished with gargoyles and figures of saints.'

93. Evers, *Neue Forschungen*, p. 14.

94. *CR*, I, 8 June, 1601.

95. Evers, *Peter Paul Rubens*, p. 27; *CR*, I, 25 January, 1602 (p. 43).

96. Evers, *Neue Forschungen*, p. 16.

97. Held, *Drawings*, pp. 27-30.

98. Evers, *ibid.*; Simson, p. 57.

99. H. Gerson ed., Mary Hottinger trans., Jacob Burckhardt, *Recollections of Rubens* (London, 1950), pp. 65-66.

100. *Ibid.*, p. 77.

101. Cf. Jeffrey Muller, 'Rubens' Divine Circle', in *The Ringling Museum of Art Journal* (Sarasota, Fla., 1983), pp. 220-225.

102. Stephen MacKenna, B.S. Page trans., Plotinus, *On the One and Good: Being the Treatises of the Sixth Ennead* (London, 1930), v, p. 129; vi, 5,5; and Stephen MacKenna trans., John Dillon intro., Plotinus, *The Enneads* (London, 1991), p. 541.

103. Oppenheimer, *Eulenspiegel*, p. 57.

104. *Trattato nuovo* (Roma, 1610), cited by H. Vlieghe, *Saints* (*CRB* VIII Brussels 1972-3), II, p. 61.

105. Evers, *Neue Forschungen*, p. 16.

106. *CR*, I, p. 58.

107. Carel van Mander, pp. 258-60.

108. *Ibid.*

109. Hans F. Redlich, 'Monteverdi', in Eric Bloom ed., *Grove's Dictionary of Music and Musicians*, 5th ed., vol. V (London, 1954), pp. 841-44.

110. Simson, pp. 63-64.

111. Evers, *Neue Forschungen*, p. 16.

112. *Ibid.*, p. 17; cf. also Frances West Gravit, *The Peiresc Papers* (Ann Arbor, 1950), pp. 1-3.

113. Cf. Jeffrey M. Muller, *Rubens: Artist as Collector*, p. 8; Cecilia Rizza, *Peiresc e Italia* (Turin, 1965), pp. 80-81, 102, 190.

114. Evers, *Neue Forschungen*, p. 16.

115. *Ibid.*

116. Simson (p. 64f) accepts this date.

117. *Ibid.*, p. 65; cf. also J. Neumann, 'Aus den Jugendjahren von Peter Paul Rubens. Eine Versammlung der Olympischen Götter', in *Jahrbuch des Kunsthistorischen Instituts der Universität Graz* (1968), III-IV, p. 73f.

118. *CR*, I, p. 58; Magurn, pp. 21, 434.

119. Lind, *Vita*, p. 38; Magurn, pp. 21, 24

120. Magurn, *ibid.*; Simson, p. 66.

121. Of the roughly 8,000 letters that Rubens may be assumed to have written, 250 have survived. Cf. Magurn, p. 2.

122. *Ibid.*, pp. 24-26

123. *Ibid.*, p. 26.

124. *Ibid.*

125. *Ibid.*, p. 27.

126. *Ibid.*, p. 433.

127. *Ibid.*, p. 27.

128. *Ibid.*

129. As the Grand Duke was Vincenzo's uncle, it may be assumed that this remark also had its political side.

130. Magurn, p. 28.

131. *Ibid.*

132. *Ibid.*, p. 29.

133. *Ibid.*

134. *Ibid.*, p. 30.

135. Cf. the illustrative map giving journey times (pp. 5-6) in J.H. Elliott, *Imperial Spain: 1469-1716* (London, 1990).

136. Magurn, p. 30.

137. *Ibid.*, p. 31.

138. *Ibid.*, p. 33.
139. *Ibid.*
140. *Ibid.*, p. 30.
141. *Ibid.*
142. *Ibid.*
143. *Ibid.*, p. 31.
144. *Ibid.*, pp. 32-33.
145. *Ibid.*, p. 32.
146. *Ibid.*, p. 34.
147. *Ibid.*, p. 33.
148. *Ibid.*
149. *Ibid.*
150. *Ibid.*
151. *CR*, I, p. 80; Simson, p. 69.
152. Evers, *Neue Forschungen*, p. 19, provides a list of Iberti's reports.
153. *CR*, I, pp. 139-42; cited also in *CRB*, XIII, Elizabeth McGrath, *1: Subjects from History* (London, 1997), 2 vols., vol. II, p. 53.
154. Magurn, p. 34.
155. *Ibid.*, p. 35.
156. *Ibid.*, p. 36.
157. *Ibid.*, pp. 434 n. 1, 435.
158. McGrath, *Subjects from History*, II, pp. 53-54.
159. Cf. complementary discussion in McGrath, *ibid.*, p. 55f, and vol. I, p. 103.
160. Cf. Simson, p. 70.
161. *Ibid.*
162. Cf. for example, John Lynch, *A History of Spain: The Hispanic World in Crisis and Change, 1598-1700* (Oxford, 1992), pp. 22-23.
163. *Ibid.*
164. Elliott, *Imperial Spain*, p. 301.
165. Lynch, *History*, pp. 22-23.
166. Cf. on Lope Melveena McKendrick, *Theatre in Spain, 1490-1700* (Cambridge, 1989), pp. 84-139.
167. *Ibid.*
168. On the economic changes in Spain since 1590, cf. Elliott, *Imperial Spain*, pp. 285-320; also W. Borah, *New Spain's Century of Depression* (Berkeley, 1951) and B. Benassar, *Valladolid au siècle d'or* (Paris, 1967).
169. Elliott, *ibid.*
170. *Ibid.*; also Parker, *Europe in Crisis*, p. 301.
171. Elliott, *ibid.*; Lynch, *History*, pp. 22-23.
172. Cf. Paul Oppenheimer, *Modern Mind*, pp. 142-43, 167, 'Soneto II'.
173. Cf. Franciso Rico ed., Miguel de Cervantes Saavedela, *Don Quijote de la Mancha*, 2 vols (Barcelona, 1998), Introduction, and B.W. Ife, 'Another sally for the knight: Perspectivism and printer's devils: The first critical edition of *Don* Quijoxte', *Times Literary Supplement*, October 9, 1998, p. 15.
174. Cf. Carla Robin Phillips trans., Pablo E. Pérez-Mallaína, *Spain's Men of the Sea: Daily Life on the Indies Fleets in the Sixteenth Century* (Baltimore, 1998), p. 63f.
175. *Ibid.*
176. Hollingsworth, *Patronage*, p. 215.
177. *Ibid.*, p. 301.
178. *Ibid.*; Parker, *Europe in Crisis*, pp. 57, 148.
179. Elliott, *ibid.*; Parker, *ibid.*
180. Elliott, *ibid.*; Parker, *ibid.*
181. Magurn, p. 435.
182. *Ibid.* The painting was long lost to the public. It was discovered in the Lerma family collection only in the twentieth century, and was initially removed to the Convento de los Frailes Capuchines in Madrid.
183. *Ibid.*, p. 37.
184. *Ibid.*
185. *Ibid.*, p. 435.
186. *CR*, I, p. 59 (to the Duke of Mantua, July 6, 1603).
187. Cf. Held, *Drawings*, pp. 76-77; and Huemer, *Portraits* I, pp. 21-23.
188. Evers, *Neue Forschungen*, p. 19; Huemer, *ibid.*, p. 135.
189. Magurn, p. 38.
190. *Ibid.*
191. Iberti to the Duke of Mantua, November 23, 1603 (Evers, *ibid.*); Huemer, *ibid.* The date of his departure is unknown.
192. *CR*, I, pp. 236-38. Ch. Ruelens (*ibid.*, p. 240) thinks that this poem was written at the time of Philip's

departure from Italy for the Low Countries (he later returned); this conjecture seems to make less sense than that proposed here, which is agreed by Evers, *Neue Forschungen*, p. 19, and Simson, p. 74.

193. On dates, cf. Evers, *ibid.*, pp. 16, 19.

194. *CR*, I, pp. 248-49; Stillman Drake, *Galileo*, pp. 15-16; Eileen Reeves, *Painting the Heavens*, p. 72.

195. *CR*, I, p. 249.

196. Cf. the tentative but sensible identification by Christopher White, p. 26, and especially Eileen Reeves, *ibid.*, p. 69.

197. *CR*, I, pp. 249-50.

198. Eileen Reeves, pp. 25, 114-18.

199. Simson (p. 61f) opts for the widest possible range of dates, between 1600 and 1608; Christopher White (p. 26) inclines to 'this period of brotherly reunion', which could conceivably, though implausibly, push the date for the picture back as far as 1602. Reeves favours the dates cited here, which coincide with, or fall somewhat after, Galileo's visits to Mantua. On the question of Rubens meeting Galileo, Ch. Ruelens observes that 'il est certain qu'il y fut au moins deux fois pendant que Ruebens y était lui-même: ils doivent s'être rencontrés au palais', and that there existed 'traces de rapports entre ces deux hommes si dignes de se connaître' (*CR*, I, p. 250). On the identification of Galileo, cf. Reeves, *ibid.*, pp. 70-76, and Frances Huemer, 'Rubens and Galileo 1604: Nature, Art, and Poetry', in *Wallraf-Richartz Jahrbuch*, 44 (Cologne, 1983), pp. 175-96.

200. The realism of the Mantuan setting has long been accepted (cf., for instance, Simson, pp. 61-62).

201. Roger de Piles, *Dissertation*, p. 30.

202. Curiously, Burckhardt, in *Recollections of Rubens* (pp. 72-74), stands almost alone among all who have ever written about Rubens in arguing that his paintings are not theatrical, though for him this results from their infrequent depiction of sounds and conversation. Even Burckhardt, however, concludes that Rubens presents 'magnificent stage scene[s]' which have 'not the remotest hint of theatricality', or (as he in fact seems to have meant by this term) bombast.

203. Galileo himself was a rather late convert to Copernicus, never mentioning 'his preference for the Copernican astronomy until he was over thirty years of age, and then remain[ing] silent about it for another decade' (Stillman Drake, *Galileo* (Oxford, 1980), p. 3).

204. Justus Lipsius, *Physiologia Stoicorum* (Antwerp, 1610), pp. 121-22; also cited in Eileen Reeves, *Painting the Heavens*, p. 73.

205. Cf. Frances Huemer, *Portraits I*, p. 165.

206. Eileen Reeves, *ibid.*, pp. 71-72.

207. Eileen Reeves, *ibid.*, p. 72f.

208. Cf. Stillman Drake, *Galileo*, pp. 10-13 for one useful summary of this change in beliefs.

209. Cf. Stillman Drake, *ibid.*

210. *Ibid.*

211. While the literature on the questions of truth, objectivity and fairness is vast, it may not be out of place to refer the reader to dismissals of deconstructionism on logical grounds in Paul Oppenheimer, *Evil and the Demonic: A New Theory of Monstrous Behaviour* (London, New York, 1996), pp. 158, 202 n. 37, 203 n. 45; and, by the same author, 'Does Time Exist?', in *The Literary Review* (U.S.), vol. 33, 3, Spring, 1990, pp. 388-93.

212. Bertrand Russell's criticism of Marx on this issue remains apposite. He notes that all of Marx's claims for a dialectical progression of history are too narrowly confined to the earth and purely human history – too indifferent to the cosmos in which they also take place – to make any sense, and adds,

'There goes with this limitation to terrestrial affairs a readiness to believe in progress as a universal law. This readiness characterized the nineteenth century, and existed in Marx as much as in his contemporaries' (*The History of Western Philosophy* (rpt. London, 1999), p. 753; cf. also p. 750f).

213. A. Balis, 'Hippopotamus Rubenii: een hoofdtstukje uit de geschiedenis van de zoölogie', in *Feestbundel bij de opening van het Kolveniershof en het Rubenianum* (Antwerp, 1981), pp. 127-42. Cf. also Paul Huvenne, 'Over Rubens' Cantoor, Panneels en de Kopenhaagse Cantoortekeningen/On Rubens' Cantoor, Panneels and the Copenhagen Cantoor drawings', in *Rubens Cantoor*, p. 21.

214. Paul Huvenne, *ibid*.

215. Evers, *Neue Forschungen*, p. 22.

216. *CR*, I, p. 242.

217. Cited in Simson, p. 87, Christopher White, p. 33.

218. C.A. Jones trans., *Cervantes: Exemplary Stories* (London, 1972), p. 125.

219. Parker, *Dutch Revolt*, pp. 254-55.

220. Evers, *Neue Forschungen*, p. 20; Parker, *ibid*., pp. 236-37.

221. Roger de Piles, *Dissertation*, p. 8.

222. E. Michel, *Rubens*, I, p. 94; Huemer, *Portraits* I, p. 26; Simson, p. 80.

223. Cf. complementary discussions in Huemer, *Portraits* I, pp. 26-33, and, of the preparatory drawings, in Held, *Drawings*, pp. 68-69.

224. Cited in Simson, p. 80.

225. Cf. somewhat conflicting discussions of this history in Huemer, p. 27 n. 14, and Simson, pp. 81-82.

226. On influences here, cf. Held, *Drawings*, pp. 77-78; Christopher White, pp. 32-33; and Yolande Morel, 'Baptism of Christ', in *P.P. Rubens: Catalogue: Paintings Oil Sketches,*

Royal Museum of Fine Arts (Antwerp, 1990), pp. 24-25.

227. Cf. Simson, pp. 86-87, who notes that 'what distinguishes [Rubens'] approach from comparable depictions is the unprecedented concentration of the entire action on a single dramatic moment'.

228. Cf. Heinrich Weizsäcker, *Adam Elsheimer, der Maler von Frankfurt* (Berlin, 1936), I, p. 82f.

229. The brief remains of this essay, which may itself have been written some years later, were first transcribed by Roger de Piles and included in his *Cours de peinture par principes* (Paris, 1708), p. 139-48. Cf. also Jeffrey M. Muller, 'Rubens' Theory and Practice of the Imitation of Art', in *Art Bulletin*, 64 (1982), p. 229-47.

230. De Piles, *Cours de peinture* (Eng, translation, 1743), pp. 86-92.

231. *Ibid*.

232. *Ibid*.

233. De Piles, *Cours de peintures*, as cited in Eileen Reeves, *Painting the Heavens*, p. 69, where an association is made between these ideas and the possible artistic-scientific interests of Rubens and Galileo.

234. *Ibid*.

235. De Piles, *Dissertation*, p. 36.

236. Howard Hibbard, *Caravaggio*, p. 198f.

237. *Ibid*., p. 206 n.

238. R:*Oeuvre*, IV, no. 154.

239. Magurn, p. 436.

240. *Ibid*., p. 38.

241. *Ibid*., p. 39.

242. *Ibid*.

243. *Ibid*., pp. 22, 436. On background, cf. J. Müller Hofstede, 'Rubens's First Bozzetto for Sta. Maria in Vallicella', *Burlington Magazine*, CVI (London, 1964), pp. 442-51, and Hofstede, 'Zu Rubens zweitem Altarwerk für Sta. Maria in Vallicella', *Nederlands Kunsthistorisch Jaarboek*, XVII, (The Hague, 1966), pp. 1-78; also Simson, pp. 89-90.

244. Magurn, p. 39.

245. *Ibid.*
246. Hibbard, *Caravaggio*, p. 209.
247. Magurn, p. 436.
248. Hollingsworth, *Patronage*, pp. 133-34; Simson, p. 91.
249. Hofstede, 'Zu Rubens zweitem Altarwerk', pp. 1-78; Simson, pp. 92-93.
250. Magurn, p. 40.
251. Hibbard, *Caravaggio*, p. 200f.
252. *Ibid.*, p. 202.
253. Magurn, p. 436; Hollingsworth, *ibid.*, p. 303; Evers, *Neue Forschungen*, p. 27.
254. Evers, *ibid.*, p. 26.
255. *CR*, II, p. 4; cited in Magurn, p. 12.
256. *Ibid.*, p. 41.
257. Evers, *Neue Forschungen*, p. 26.
258. *Ibid.*
259. Hollingsworth, *Patronage*, pp. 235-37.
260. Even at this point, before publishing his book, it seems clear that he was thinking about producing some work 'for the public good' that would 'provide a service to the many rather than to a few', as he later wrote, or designs of buildings that do not surpass 'a gentleman's private means' (*CR*, II, p. 422).
261. While, as Frances Huemer points out (in *Portraits I*, p. 38), the full-length seated interior portrait was known in North Italy, it was unfamiliar either in Spain or the Netherlands. Cf. also Christopher White, p. 47.
262. Cf. Rubens' letter 17 in Magurn, pp. 42-43.
263. *Ibid.*, p. 43.
264. *Ibid.*
265. *Ibid.*
266. *Ibid.*, p. 44.
267. *Ibid.*, p. 46. The contrast between Michelangelo and Rubens on the question of secrecy, or at least intense privacy, is revealing of their differing temperaments. Paolo Giovio, a medical doctor who became a bishop and who wrote a collection of brief lives of the famous in his day, noted of Michelangelo in his forties: 'Even though he was besought by princes he would never undertake to teach anyone or even allow [anyone] to stand watching him at work.' Giovio adds that Michelangelo constantly hid his work until it was finished, and in an aside that may not be an irrelevance, observes, 'His domestic habits were incredibly squalid.' (Bull, *Michelangelo*, p. 171.)
268. Magurn, p. 438.
269. Cited in E. Michel, *Rubens*, I, p. 114.
270. Magurn, *ibid.*
271. Magurn, p. 46.
272. Evers, *Neue Forschungen*, p. 28.

III

1. Evers, *Neue Forschungen*, p. 14.
2. *Ibid.*, p. 28.
3. *Ibid.*, p. 24.
4. This coincided with his receiving a part-payment of 300 scudi for his new copy of the Chiesa Nuova altarpiece (Evers, *ibid.*, pp. 28).
5. *Ibid.*, p. 24; Génard, *Aanteekeningen*, p. 377. Rubens' altarpiece was installed in the new St Michael chapel only in 1610 (Evers, *ibid.*, p. 32).
6. Parker, *Dutch Revolt*, pp. 236-37.
7. *Ibid.*, p. 236.
8. Coryat, I, p. 360.
9. Roger de Piles, *Conversations*, pp. 213-15.
10. Coryat, I, pp. 263-64; Parker, *Dutch Revolt*, p. 237.
11. Entitled *Electorum libri II in quibus antiqui ritus, emendationes, censurae. Eiusdem ad Iustum Lipsium*, this was Philip's series of descriptions of ancient Roman customs, including styles of dress and their meanings. Bound in leather, with red-sprinkled edges, the book contains four double-leaf engravings of Roman statues,

another engraving of the head of a Roman priest in relief and still another showing pagan priestly headgear – all from drawings by Rubens and done while he was in Rome. The book winds up with an elegy by Philip to Justus Lipsius, who had died in 1606. It was issued in an edition of 1,000 copies. Cf. *Books Published by the Moretuses*, pp. 107-108.

12. Schott was a Jesuit and himself the editor of the *Annales romanorum* (1599-1615), by S.V. Pighius, as well as a friend (cf. Elizabeth McGrath, 1:Subjects from History, I, p. 66, and *CR*, III, pp. 433-37).

13. Rockox had been ennobled during the Joyous Entry of the Archduke Albert and the Archduchess Isabella in 1599 'for having staunchly defended the Faith, the Church, Justice, and championed the cause of widows and orphans' (Stichting Nicholaas Rockox, *The Rockox House* (Antwerp, 1979), p. 4).

14. Evers, *Neue Forschung*, p. 30.

15. *Ibid.*; Magurn, p. 438.

16. William Gifford trans., Juvenal, 'The Women', in Francis R.B. Godolphin ed., *The Latin Poets* (New York, 1949), p. 551.

17. Magurn, p. 52.

18. *Ibid.*

19. Evers, *Neue Forschung*, p. 31.

20. Magurn, p. 52.

21. *Ibid.*

22. *Ibid.*, pp. 52-53.

23. Evers, *Neue Forschungen*, p. 30; Parker, *Dutch Revolt*, p. 239.

24. Evers, *ibid.*

25. Lind, *Vita*, pp. 38-39; Magurn, p. 49, 438; Génard, *Aanteekeningen*, p. 409f; Simson, p. 127.

26. Magurn, p. 409.

27. Evers, *Neue Forschungen*, pp. 30-31.

28. *Ibid.*, p. 30.

29. Lind, *Vita*, p. 38.

30. Génard, *Aanteekeningen*, p. 409; *CR*, II, p. 22f.

31. Cf. Lind, *Vita*, p. 39; Paul Huvenne, *The Rubens House*, pp. 3-4.

32. Parker, *Dutch Revolt*, pp. 253-55.

33. Letter of May 11, 1610, literal translation, as cited in P. S. Falla trans., R.-A. D'Hulst and M. Vandenven, *CRB* III, *Rubens*; *The Old Testament* (London, 1989), p. 107f.

34. Delacroix argues that style, illusion and effect are inseparable and that the introduction of 'odd names' and inconsistent 'foreign customs' into a work, such as one finds in the novels of Walter Scott, for instance, reduces the whole to a 'romantic fable and this destroys the illusion' (*Journal*, p. 219). He maintains that 'the true painter is one whose imagination speaks before everything else' (*ibid.*, p. 209).

35. Delacroix, *ibid.*, p. 219.

36. Cf. the complementary discussion in D'Hulst, *Old Testament*, pp. 107-115; also Christopher Brown, *Landscapes*, pp. 97, 98.

37. To this it may be added that, as Held points out, 'Rubens rarely left the first thin sketch without making changes. Generally he continued drawing on top of it, developing some figures or groups more thoroughly, repeating certain sections, trying out alternatives ... Rubens never hesitated to draw into and over figures which he had outlined before. Some of his drawings are in multiple layers' (*Drawings*, p. 27).

38. As in his *Death of Hippolytus* (c. 1611, 50.2 x 70.8 cm., in The Fitzwilliam Museum, Cambridge (Eng.), in which a slew of naturalistically coloured sea shells appears in the foreground. Rubens' lions, on the other hand, always appear at least vaguely personified.

39. Delacroix writes, 'Rubens is carried away by his inspiration, and allows himself exaggerations in keeping with the idea, but they are always founded on nature' (*Journal*, p. 312).

40. Cf. Erik Larsen, *P.P. Rubens*, p. 203-11.

41. *Ibid.*

42. *Ibid.*

43. Cf. for instance, Millen and Wolf, *Heroic Deeds*, pp. 32, 81.

44. R.E. Latham trans., *Lucretius, The Nature of the Universe* (rpt. London, 1959), pp. 131-32.

45. Not all of them, to be sure. Both Kierkegaard and Dostoyevski, who were Christian (the latter a Christian mystic), hardly found the universe meaningless in the sense of a Georg Büchner or an Albert Camus.

46. Simson, p. 114.

47. Cf., for instance, Shakespeare's sonnet 127: 'In the old age black was not counted fair,/Or if it were, it bore not beauty's name,/But now is black beauty's successive heir', and the discussion in Katherine Duncan-Jones, *Shakespeare's Sonnets* (London, 1997), p. 368.

48. Cf. *De andere Kant van Carolus. Kanttentoonstelling in de Sint-Carolus Borromeuskerk, Conscienceplein Antwerpen* (Antwerp, 1996), pp. 10-11.

49. In fact the painting has traditionally been known as *Self-portrait with Isabella Brant in a Honeysuckle Bower*.

50. W. Aldis Wright, *Bacon's Essays*, pp. 176-77. Bacon is dismissive of those painters who 'would make a Personnage by Geometricall Proportions' alone, arguing that beauty cannot be produced 'by Rule'. Most interestingly, he adds that 'the Principall Part of *Beauty*, is decent Motion'. Along similar lines, Delacroix proposes that the sensation of beauty in art is easiest activated by 'gigantic works, objects whose very disproportion constitutes an element of beauty' (*Journal*, p. 270).

51. The Stoics believed in a universe permeated by divine, deterministic energy, on the one hand, the *pneuma*, or breath, or even wind, which preserves the forms of things, and, on the other, a limited form of free will. Cf. for instance Terence Irwin,

Classical Thought (Oxford, 1989), pp. 168-184.

52. Alciati's book, first published in 1531, had run through many editions by 1600. Cf. G. Duplessis, *Les Emblèmes d'Alciati* (Paris, 1884), and Simson, pp. 114-17.

53. Cf. the complementary suggestion in Simson, *ibid.*

54. The idea of wedding pictures as witnessing and affirming marriage contracts, or pacts, is traditional, though its manner of expression is here modified by Rubens.

55. By way of contrast, Dr Faustus, in Marlowe's eponymous play (1592?; first published in quarto, 1604), requests of Mephistophilis a pact that will 'resolve me of all ambiguities' (Sc. 1, l. 80), but whose meaning is unambiguously evil.

56. Evers, *Neue Forschungen*, p. 34.

57. *Ibid.*, p. 32.

58. *Ibid.*, p. 34.

59. *CR*, I, p. 60.

60. Evers, *Neue Forschungen*, p. 32.

61. Magurn, p. 53.

62. *Ibid.*, p. 54.

63. *Ibid.*, p. 439.

64. *Ibid.*, p. 54.

65. *Ibid.*

66. *Ibid.*

67. *Ibid.*

68. Plautus, *Asinaria*, I.3.50: *semper oculatae nostrae sunt manus: credunt quod vident* (cited in Magurn, p. 270).

69. Evers, *Neue Forschungen*, pp. 32-34.

70. Magurn, p. 55.

71. Cf. Murray, p. 158.

72. Many of these were produced in collaboration with assistants (though with Rubens himself providing the final, definitive touches), and many were sent to churches abroad. Altarpieces in Antwerp itself were often paid for through collections taken up among congregations (cf. F. Prims *et al*, *Rubens en zijne Eeuw*, p. 18).

73. He paid 8,960 carolusguilders for it (cf. Evers, *Neue Forschungen*, p. 32).

74. On Vitruvius' *De architectura*, purchased from Moretus in 1615, which influenced various aspects of his new design-ideas, cf. Jeffrey M. Muller, *Rubens: Artist as Collector*, pp. 23, 30; see also Christopher White, p. 62, to whose comments it may be added that parts of the construction continued past 1617.

75. Actually a false bust of Seneca, though this was unknown to him. Esteeming it as a genuine replica of the philosopher's head, he had brought it back to Antwerp from Italy. Cf. Elizabeth McGrath, 1:Subjects from History, II, p. 286.

76. McGrath, *ibid.*

77. H.T. Lowe-Porter, Thomas Mann, *Death in Venice and Seven Other Stories* (rpt. New York, 1954), p. 106.

78. On the importance of books to this painting, cf. the comments by Held, *Drawings*, p. 62, and, *ibid.*, 'Rubens and the Book', in *Rubens and his Circle*, p. 167; also the complementary discussion of it in Simson, pp. 155-56.

79. Roger D'Hulst, Frans Baudouin, Willem Aerts, Jos Van Den Nieuwenhuizen, Madeleine Manderyck, Nicole Goetghebeur, Regine Guislain-Wittermann, *L'erection de la croix: Pierre Paul Rubens* (Brussels, 1992), pp. 30-31.

80. *Ibid.*

81. Cf. Paul Binski, *Medieval Death: Ritual and Representation* (London, 1996) on so-called 'transi tombs', which 'gained in popularity' after the fourteenth century (pp. 139-52).

82. Alfred Michiels, *Rubens et l'école d'Anvers* (Paris, 1854), p. 113.

83. Jeffrey M. Muller, *Rubens: Artist as Collector*, pp. 56, 65; Held, *Drawings*, pp. 35, 42, 43.

84. Cf. Held, 'Artis Pictoriae Amator: An Antwerp Art Patron and

his Collection', in *Drawings*, pp. 35-64 (and especially pp. 54-56); also Christopher White, p. 86.

85. Mann's early aestheticism, though mocked in his own 'Death in Venice' (1911), is well known, as is his rejection of it with the rise to power of the Nazis, and especially in his *Doctor Faustus* (1947), in which the passivity of both artist and bystander in the face of the Holocaust is indicted as complicity in evil. Wilde's parallel shift is less widely understood. A purely ethical stance, arguably devoid of politics, in *The Picture of Dorian Gray* is a far cry from the mix of ethics with politics in 'The Ballad of Reading Gaol' (1898), with its grim presentation of capital punishment, and the harsh and politically potent depiction of prison life that haunts about the personal revelations of *De Profundis* (1897). Wilde's blending of politics and art was anticipated by his 'The Soul of Man under Socialism', which contains such statements as 'the form of government that is most suitable to the artist is no government at all'.

86. Magurn, pp. 100, 102.

87. Cf., for example, Jeffrey M. Muller, *Rubens: Artist as Collector*, p. 11; Magurn, pp. 59, 441; Sandrart, *Teutsche Academie* (orig. ed. Nuremberg, 1675-79), II, p. 292.

88. An exception seems to have been his sketching of Michelangelo's *Battle of Lapiths and Centaurs*.

89. On November 11, 1616, he had signed a contract with 'a joiner' for the monumental staircase in the house, which was to be decorated with sculptures by Hans van Mildert. This was by now completed (Paul Huvenne, *The Rubens House*, p. 42). The 'Pantheon' section was probably finished by 1618 (Jeffrey M. Muller, *Rubens: Artist as Collector*, p. 77).

90. Evers, *Neue Forschungen*, pp. 40, 48.

91. Cf. the discussion of the classical and Renaissance heritage behind

Rubens' design in Jeffrey M. Muller, *Rubens: Artist as Collector*, pp. 26-34.

92. *Ibid.*, pp. 38-42.

93. *Ibid.*, pp. 101, 102.

94. Sandrart, *Teutsche Academie*, II, p. 293; Roger de Piles, *Dissertation*, pp. 12-14.

95. Murray, pp. 126-27.

96. Its growth was greatly stimulated by Francis Bacon's urging that a comprehensive 'collection of data about the natural world' be set up which, once analysed, would yield knowledge of all natural laws (cf. Paul Foster ed., Gilbert White, *The Natural History of Selborne* (London, 1993), p. xiif).

97. Foster, *ibid.*, observes that naturalists such as Gilbert White (1720-93), whose *Natural History of Selborne* (1789) contributed to European-wide speculations about evolution in the late eighteenth century, was himself influenced by the work of Carl Linnaeus (specifically, his *Systema Naturae*, 10th edn, 1758) and Bacon. On this aspect of the development of evolutionary biology, cf. also Lewis Pyenson, Susan Sheets-Pyenson, *Servants of Nature: A History of Scientific Institutions, Enterprises and Sensibilities* (London, 1999), pp. 251-53.

98. Magurn, p. 59.

99. *Ibid.*, p. 60.

100. *Ibid.*

101. *Ibid.*, p. 65.

102. *Ibid.*

103. *Ibid.*, p. 67.

104. *Ibid.*, p. 441.

105. Cf. Susan Barnes, 'Van Dyck and George Gage', in David Howarth ed., *Art and Patronage in the Caroline Courts* (Cambridge, Eng., 1993), pp. 3-4.

106. Magurn, pp. 60, 61.

107. Magurn, p. 65.

108. *Ibid.*, p. 61.

109. *Ibid.*, p. 442; Evers, *Neue Forschungen*, p. 48.

110. Magurn, pp. 60-61.

111. Alfred Michiels, *Rubens et l'école d'Anvers*, pp. 188-90.

112. Wedgwood, pp. 32-34; Parker, *The Thirty Years' War*, pp. 14-24.

113. Wedgwood, p. 200; Parker, *ibid.*, pp. 70, 95.

114. Wedgwood, *ibid.*; Parker, *ibid.* Melegari, *Great Military Sieges*, pp. 144-45.

115. Wedgwood, pp. 201-202; Parker, p. 95.

116. Wedgwood, *ibid.*; Melegari, *ibid.*, p. 145.

117. Such praise had already begun to pour in by 1609, from the classicist Daniel Heinsius, professor at the University of Leiden (cf. Simson, p. 108). Despite its seeming flippancy, it often seems to have been sincerely meant.

118. Evers, *Neue Forschungen*, p. 54.

119. Parker, *Europe in Crisis*, p. 233.

120. Murray, pp. 112-13.

121. One indication of this development is that Jan van de Werve of Antwerp had published *Trescor der Diutsche tale* (Treasury of the Dutch [or Flemish] Language) as early as 1553 (Murray, p. 102f).

122. Cf. Simson, p. 25.

123. George Bull, *Michelangelo*, observes (in what is surely a complement to Rubens ideas) that 'also fundamental to Michelangelo's practice and understanding of art was *intelletto*: the God-given, mental faculty of discerning beauty. The motto accompanying his symbol of three linked circles was "Leven al cielo nostro intelletto" – "they raise our intellect to heaven"' (p. 341).

124. Magurn, p. 441.

125. Julius Held, 'Rubens and Vorsterman', *Rubens and his Circle*, p. 115.

126. Magurn, pp. 50-51.

127. Evers, *Neue Forschungen*, p. 58.

128. The situation with Rubens was

ambiguous. In 1611, Van Veen lost out in a competition with his former pupil to paint *The Assumption and Coronation of the Virgin* for the high altar in Antwerp's cathedral. He later moved to Brussels to direct the mint. When asked about his view of Rubens in 1628, though, Van Veen is recorded as calling him the 'Apelles of the Universe' (cf. F.M. Haberditzl, 'Die Lehrer des Rubens', *Jahrbuch des kunsthistorischen Sammlungen in Wien*, XXVII (1908), p. 191).

129. Magurn, p. 66.
130. Magurn, p. 447.
131. Held, *Rubens and his Circle*, p. 115
132. Magurn, p. 69.
133. Held, *ibid.*, p. 122.
134. Magurn, p. 87.
135. *Ibid.*
136. Held, *ibid.*, p. 115.
137. Magurn, p. 88.
138. Held, *ibid.*, p. 121.
139. *Ibid.*, pp. 120-21.
140. Magurn, p. 447.
141. Held, *ibid.*, reproduced as pl. X6.
142. Paul Huvenne, *The Rubens House*, p. 21. It is worth noting that the inscription appeared directly over the garden entrance and that it was supported by two relief statues of satyrs (cf. Elizabeth McGrath, 1:Subjects from History, I, text illustration 38).
143. Magurn, p. 136.
144. *Ibid.*, p. 88. Volume one, *Palazzi Antichi*, was soon succeeded by volume two, *Palazzi Moderni*, with 67 plates.
145. Magurn, p. 111.

IV

1. Magurn, p. 77.
2. As well as a very few in chalk. Cf., for instance , that of St Gregory Nazianzanus (411 x 476 mm., now in the Fogg Art Museum, Cambridge,

Mass.); discussed in Held, *Drawings*, pp. 125-26.
3. *CR*, II, p. 156; Max Rooses, 'De vreemde reizigers Rubens of zijn huis bezoekende', *Rubens-Bulletijn* 5 (1910), p. 222.
4. *CR, ibid.*
5. Cf. Simson, p. 204.
6. Magurn, pp. 447-48.
7. *CR*, II, p. 254; Paul Huvenne, *The Rubens House*, p. 4.
8. *Books Published by the Moretuses*, p. 20.
9. *CR*, I, p. 1 (November 3, 1600).
10. *Books Published by the Moretuses*, pp. 22, 81f. Rubens' six detailed and precise illustrations, plus the title page, for Aguilonius' *Opticorum libri sex philosophis iuxta ac mathematicis utiles* strongly suggest that his interest in optics was no casual affair. Not only was the author an acquaintance who sought him out for the work, but the book itself was a virtual compendium of the optical knowledge of its day, with sections on the anatomy of the eye and optical experiments. It was later superceded by the discoveries of Kepler. (Cf. *Books Published by the Moretuses*, pp. 137-38.)
11. Cited in Held, 'Rubens and the Book', *Rubens and his Circle*, pp. 170-71.
12. *Ibid.*, p. 168.
13. *Ibid.*
14. Oliver Millar, *Van Dyck in England* (London, 1982), p. 112.
15. Held, *Rubens and his Circle*, p. 167. On Rubens accepting copies of books in exchange for his title pages, it may be noted that he owned a Vasari and probably a copy of Carel van Mander's *Lives of the Artists*, and that by 1610 he had started to relearn, or improve, his knowledge of ancient Greek. He was a buyer (and barterer) of the latest editions in areas that particularly interested him, such as theology, archeology and politics. An invoice-listing of books sent him by the

Plantin Moretus Press from 1613 onwards shows that he owned (among many other books) Occio's *Numismatica* (1579), Caraffa's history of Naples (1572), Giovio's lives of famous men (1575-77), Aldrovandi's *Ornithologia* (1599-1603), Gesner's *Serpentibus* (1587) and Rosinus' *Antiquitates romanae* (1611). Aldrovandi's books on various types of animals, among them fish and insects, may have played a role in his inventing his hunting scenes. Giovio's lives of famous men clearly influenced his portraits for Balthasar Moretus. (Cf. Elizabeth McGrath, 1:Subjects from History, I, pp. 56–59, 61, 65f.)

16. Lind, *Vita*, p. 41.

17. While the first surviving reference to this project appears in a letter of Peiresc to Rubens of December 23, 1621 (*CR*, III, 323: 'I later learned that the purpose of your [upcoming] journey is that the Queen Mother wishes you to adorn her new palace with paintings by your hand'), it is clear that some negotiations had already taken place. Cf. also Simson, p. 229.

18. Evers, *Neue Forschungen*, p. 56.

19. Millen and Wolf, *Heroic Deeds and Mystic Figures*, pp. 122-23.

20. *Ibid.*, p. 17.

21. Magurn, p. 83.

22. Philip Benedict ed., *Cities and Social Change in Early Modern France* (New York, 1992), pp. 24, 69.

23. Coryat, I, 170, 171.

24. Coryat, I, p. 173, 171, 174. The divisions of the city were noted not only by Coryat but, as early as 1576, by Jean Bodin (cf. Robert Descimon, 'Paris on the eve of Saint Bartholomew: taxation, privilege, and social geography', in Benedict, *Cities and Social Change*, p. 70f).

25. Evers, *Neue Forschungen*, p. 56.

26. Magurn, p. 110.

27. *Ibid.*

28. Millen and Wolf, *Heroic Deeds and Mystic Figures*, p. 9 n.

29. *Ibid.*, p. 8; cf. Max Rooses, 'Les contrats passés entre Rubens et Marie de Médici concernant les deux galeries du Luxembourg', *Rubens-Bulletijn* 5 (1910), pp. 216-20.

30. Millen and Wolf, *Heroic Deeds and Mystic Figures*, p. 34.

31. *CR*, III, 23-24

32. *CR*, III, p. 13; Held, *Rubens and his Circle*, p. 117.

33. Magurn, p. 89.

34. *Ibid.*, p. 448.

35. *Ibid.*, p. 89.

36. *Ibid.*, p. 90.

37. *Ibid.*, p. 81.

38. *Ibid.*, p. 91.

39. *Ibid.*

40. In England, Thomas Harriot also imitated Galileo, though without knowing it (he was mapping the moon by August 5, 1609, before Galileo's serious moon-studies got off the ground, so to speak). Both Harriot and Peiresc 'observed Jupiter's satellites as soon as they heard of Galileo's observation' (John North, *The Norton History of Astronomy and Cosmology* (New York, 1994), p. 330).

41. Galileo's chief contribution to physics, arguably greater even than his discovery of his laws of motion, lay in his dismissal of metaphyical definitions as necessary to understanding nature. Motion, for instance, could be described with powerful accuracy by mathematics, whether agreed definitions of it existed or not. Cf. Paul Oppenheimer, 'Does Time Exist?' (*The Literary Review* (U.S.), and the account of Galileo's battle with the Aristotelians in Stillman Drake, *Galileo*, pp. 81-92.

42. Magurn, p. 91.

43. *Ibid.*, p. 97.

44. *Ibid.*, p. 449.

45. *Ibid.*, p. 99.

46. *CR*, II, p. 113.

47. Sainsbury, *Original unpublished papers*, p. 11.

48. Magurn, p. 101.

49. *Ibid.*

50. *Ibid.*, p. 104.
51. *Ibid.*, p. 105.
52. *Ibid.*, p. 107.
53. *Ibid.*, p. 109.
54. Prologue, ls 17, 18, 25.
55. Magurn, p. 109.
56. *Ibid.*
57. *Ibid.*
58. *Ibid.*
59. *Ibid.*, pp. 107-108.
60. Wedgwood, *Thirty Years War*, p. 188; Magurn, p. 99.
61. *Ibid.*, p. 109.
62. *Ibid.*, p. 110.
63. *Ibid.*
64. Cited in Roger Lockyer, *Buckingham: The Life and Political Career of George Villiers, First Duke of Buckingham, 1592-1628* (London, 1981), p. 233.
65. *Ibid.*, p. 235.
66. *Ibid.*, p. 236.
67. *Ibid.*, p. 239.
68. According to the report of the Adventure's Captain Meunes, he embarked on June 3, 1629, and arrived in Dover that evening. He would have proceeded overland by coach to London. Cf. *CR*, V, pp. 54-55, 56.
69. Lind, *Vita*, pp. 41-42.
70. As, for example, in the contemporaneous painting *Old London Bridge* (1630) of Claude de Jongh (d. 1663), in Kenwood House (London).
71. Magurn, pp. 119-20.
72. *Ibid.*, pp. 135-36.
73. Evers, *Neue Forschungen*, p. 58.
74. Parker, *Thirty Years War*, pp. 106-109, 113-14. Wedgwood, p. 249f.
75. Evers, *Neue Forschungen*, pp. 68, 70.
76. Magurn, p. 460; Sainsbury, *Original unpublished papers*, p. 316f.
77. *Ibid.*, p. 162; Roger Lockyer, *Buckingham*, pp. 214.
78. *Ibid.*, p. 409.
79. Magurn, p. 203.
80. *Ibid.*, pp. 109-10, 473, 162-64; Evers, *Neue Forschungen*, p. 66. Philip IV himself took a dim view of these maneuvres, writing to the

Archduchess of his at least initial contempt for Rubens and his possibility of success: 'I am distressed indeed at your involving a mere painter in affairs of this magnitude' (Cf. *CR*, IV, p. 82-84).
81. Magurn, p. 123.
82. *Ibid.*, p. 486.
83. *Ibid.*, p. 265.
84. *Ibid.*
85. *Ibid.*, pp. 176-77.
86. *Ibid.*, pp. 119-20.
87. *Ibid.*, p. 122.
88. Once in Osterley Park, property of the Earl of Jersey; destroyed in a fire, though an oil sketch has survived (Huemer, Portraits I, p. 17).
89. The negotiations began somewhat earlier and were completed between November, 1626 and January 4, 1627 (Jeffrey M. Muller, *Rubens: Artist as Collector*, p. 78; Evers, *Neue Forschungen*, p. 64). Cf. also, Roger Lockyer, *Buckingham*, p. 357; Magurn, pp. 182, 473.
90. Jeffrey M. Muller, *ibid.*
91. Roger Lockyer, *Buckingham*, p. 374.
92. Lockyer, *ibid.*, p. 371f; Vezio Melegari, *Great Military Sieges*, pp. 146-49.
93. Lockyer, *ibid.*, p. 380; Melegari, *ibid.*, p. 146.
94. Magurn, p. 208.
95. Lockyer, *ibid.*, pp. 389-401; Melegari, *ibid.*, pp. 148-49.
96. Lockyer, *ibid.*, p. 459.
97. Magurn, p. 293.
98. *CR*, IV, p. 220.
99. Cf. Judith Hook, *The Baroque Age in England* (London, 1976), p. 33f.
100. *Ibid.*; Lockyer, *Buckingham*, pp. 243, 251-52, 295-96, 465-66.
101. Cf. Margaret Drabble ed., *The Oxford Companion to English Literature* (Oxford, 1998), p. 516.
102. Edmund Gosse, *The Life and Letters of John Donne*, (London, 1899), I, p. 219 (also cited in Judith Hook, *Baroque Age*, p. 117).
103. Judith Hook, *ibid.*, p. 35.

104. John Leonard ed., *John Milton, The Complete Poems* (London, 1998), Hymn XIII, p. 5.

105. Magurn, p. 320.

106. Sainsbury, *Original unpublished papers*, pp. xix, 144-45.

107. Hook, *Baroque Age*, p. 38.

108. Magurn, p. 299.

109. *Ibid.*, p. 301.

110. *Ibid.*

111. *Ibid.*

112. *Ibid.*, p. 322.

113. *Ibid.*, p. 320.

114. *CR*, V, p. 42.

115. Evers, *Neue Forschungen*, p. 70; Parker, *Thirty Years' War*, p. 108.

116. *CR*, IV, pp. 82-84.

117. Magurn, p. 309.

118. *Ibid.*, p. 313.

119. *Ibid.*, p. 304.

120. *Ibid.*, p. 487.

121. *Ibid.*, p. 269.

122. Parker, *Thirty Years' War*, pp. 106-109; Wedgwood, pp. 235-36.

123. Parker, *ibid.*, pp. 97-98; Wedgwood, *ibid.*, pp. 245-46.

124. Rubens was grateful to Pierre Dupuy for sending him the French *Mércure*, an annual summarizing newsworthy events (Magurn, pp. 190, 196). His views of most news reports, however, are probably better conveyed by his comment (repeated in various ways in several of his letters) that 'we know nothing definite here' (Magurn, p. 197).

125. Parker, *Thirty Years' War*, p. 110.

126. Edward Arber ed., *A List of 837 London Publishers, 1553-1640*, The English Scholar's Library (London, 1895).

127. Magurn, pp. 277, 279.

128. *Ibid.*

129. *Ibid.*, p. 295.

130. *Ibid.*, pp. 285-86; Evers, *Neue Forschungen*, p. 70.

131. Magurn, pp. 283-84; Roger Lockyer, *Buckingham*, pp. 449-51. On the suspicions of the papal nuncio Giovanni Battisti Pamphili that Rubens was a secret emissary of Buckingham, dispatched to Spain to propose a treaty with the English, cf. *CR*, IV, pp. 455: 'It is accepted that Buckingham's great friend has come to propose a treaty between the two crowns.'

132. Magurn, p. 291.

133. *Ibid.*

134. *Ibid.*, p. 292; also Antonio Palomino, *Biografías* (Madrid, 1724), in *Velásquez Homenaje* (Madrid, 1960), pp. 41, 42 (cited in Frances Huemer, Portraits I p. 63). By this time Velásquez had been a court painter for five years.

135. Magurn, p. 295.

136. *Ibid.*, p. 291.

137. Now at Longford Castle. Cf. Jeffrey M. Muller, *Rubens: Artist as Collector*, p. 119.

138. A. Pérez, 'Epistolario', in *Biblioteca de Autores Españoles* (Madrid, 1856), no. 71, 1:519 (also cited in Manuela B. Mena Marqués, 'Titian, Rubens, and Spain', in Hilliard T. Goldfarb, David Freedberg, Manuela B Mena Marqués, *Titian and Rubens: Power, Politics and Style* (Boston, 1998), pp. 73, 74).

139. F.J. Sánchez Cánton ed., *Arte de la pintura*, 2 vols (Madrid, 1956), I, p. 153.

140. Cf. Hilliard T. Goldfarb, 'Titian: *Colore & Ingegno* in the Service of Power', in *Titian and Rubens*, p. 15.

141. Mary M. Innes trans., *Metamorphoses of Ovid*, pp. 72-73.

142. Magurn, p. 321.

143. *Ibid.*, p. 314.

144. *Ibid.*, p. 320-21.

145. *Ibid.*, p. 322. On Procopius, cf. also Paul Oppenheimer, *Evil and the Demonic*, pp. 73-75, 78, 190.

146. *Ibid.*, pp. 322-23.

147. Sainsbury, *Original unpublished papers*, letter cxiv, p. 133.

148. Evers, *Neue Forschungen*, p. 70 (Sept., 1629); Magurn, p. 337.

149. Cf. Frances Huemer, Portraits I, p. 93.

150. *Ibid.*, pp. 93-94, 178-80; Jeffrey M. Muller, *Rubens: Artist as Collector*, pp. 61, 115; Roger Lockyer, *Buckingham*, p. 196; Hugh Trevor-Roper, 'Mayerne and his Manuscript', in David Howarth, *Art and Patronage*, pp. 268-293.

151. Joseph Mead, scholar and contemporary, noted in 1630 (*CR*, V, pp. 287-88) that this picture was painted 'in honour of England' and that Rubens sent it 'home to Flanders to remain there as a monument of his abode and employment here'. Cf. also Christopher White, pp. 226-27.

152. Sainsbury, *Original unpublished papers*, p. 138. Evers, *Neue Forschungen*, p. 70.

153. Magurn, p. 352.

154. *Ibid.*, p. 353.

155. Julius Held, 'Rubens' Glynde Sketch and the Installation of the Whitehall Ceiling', in *Rubens and his Circle*, pp. 126-137.

156. Evers, *Neue Forschungen*, p. 72.

157. Cited in Magurn, p. 357.

158. *Ibid.*

159. On Venus as 'the divinity of peace in all Rubens' political allegories', cf. Simson, p. 312.

160. Cf. Frances Huemer, *Portraits I*, p. 98 n.; also R. Baumstark, 'Ikonographische Studien zu Rubens Kriegs- und Friedensallegorien', in *Aachener Kunstblätter*, XLV (Aachen, 1974), pp. 125-234, and A. Hughes, 'Naming the unnameable: an iconographical problem in Rubens' "Peace and War" ', in *The Burlington Magazine*, CXXII (1980), pp. 157-65.

161. Magurn, p. 261.

V

1. Cf. Julius Held, *Drawings*, p. 95; also R.-A. D'Hulst, *Rubens: The Old Testament*, pp. 126-28.

2. Magurn, p. 367.

3. Ettore Camesasca, *Mantegna*, p. 62; Jeffrey M. Muller, *Rubens: Artist as Collector*, pp. 15-16, 144.

4. K. Vanderhoeght, *The Rockox House* pp. 19-48. Cf. as well Frans Snyders' painting *Carstiaen Luyckx* (Still Life Banquet Scene), c. 1650, with its display of a silver gilt pronk goblet, its Seville oranges, its silver puntschotel (cake tray), its spoons with lion finials and its nautilus shells. Snyders lived next door to Rockox and collaborated with Rubens from 1610 on (he died in 1657) (Cf. Peter Sutton ed., *The Age of Rubens* (New York, 1993), pp. 549-50.)

5. Magurn, p. 295.

6. *Ibid*, p. 350.

7. *Ibid*, pp. 64, 442, 504. One of Helena's brothers had also married Isabella Brant's sister, Clara, in 1619 (Evers, *Neue Forschungen*, p. 50).

8. Maurice Hussey ed., Geoffrey Chaucer, *The Merchant's Prologue and Tale* (13th rpt. Cambridge, Eng., 1996), ls 301-303.

9. Magurn, pp. 366-67.

10. Wedgwood, *Thirty Years War*, p. 248.

11. *Ibid*; Parker, *Thirty Years' War*, p. 107.

12. *CR*, V, pp. 347-48; Evers, *Neue Forschungen*, p. 72.

13. *Ibid.*

14. *CR*, V, 374.

15. Magurn, p. 358.

16. *Ibid*, p. 369.

17. Evers, *Neue Forschungen*, p. 72.

18. Magurn, p. 350.

19. *Ibid*, p. 371.

20. *CR*, V, pp. 344-46.

21. On the question whether this is in fact a drawing of Clara Serena, cf. Held, *Drawings*, pp. 132-33.

22. Roger de Piles, *Cours de peinture par principes* (Eng. trans.), pp. 91-92.

23. Cf. Simson, p. 344.

24. Cf. Held, *Drawings*, p. 148.

25. *Rubens-Bulletijn*, V (Brussels, 1910), p. 216f.

26. Parker, *Europe in Crisis*, p. 205; Wedgwood, p. 308.

27. Evers, *Neue Froschungen*, p. 74; Millen and Wolf, *Heroic Deeds*, p. 18.

28. Magurn, p. 359.

29. Evers, *Neue Forschungen*, p. 74.

30. Evers, *ibid*; Magurn, p. 498.

31. Evers, *ibid*.

32. Louis Prosper Gachard, *Histoire politique et diplomatique de Pierre-Paul Rubens* (Brussels, 1877), p. 226.

33. Magurn, pp. 374-75.

34. *Ibid*, p. 372.

35. *Ibid*, p. 375.

36. *Ibid*, p. 123.

37. *Ibid*, p. 380.

38. Evers, *Neue Forschungen*, p. 74. Rubens (*ibid*) was lending her money on her jewelry as late as October, 1631. On Marie's visiting Rubens' house and studio, cf. Jean Puget de la Serre, *Histoire curieuse de tout ce qui c'est passé a l'entree de la Reyne Mere du Roy Treschristien dans les villes des Pays Bas* (Antwerp, 1632), p. 68 (also cited in Jeffrey M. Muller, *Rubens: Artist as Collector*, p. 65).

39. Magurn, p. 506; Evers, *Neue Forschungen*, pp. 86, 88.

40. *Ibid*, p. 102.

41. Evers, *ibid*, p. 74.

42. Evers, *ibid*; Magurn, p. 360.

43. *Ibid*.

44. *Ibid*.

45. Vezio Melegari, *Great Military Sieges*, pp. 150-51; Wedgwood, pp. 286-91.

46. Wedgwood, p. 291; Parker, *Thirty Years' War*, pp. 125-29.

47. Magurn, pp. 370, 400-401.

48. Parker, *Thirty Years' War*, pp. 125-32; Wedgwood, pp. 255-56.

49. Cf. Paul Oppenheimer, 'The World of Evil: A Theory', in *Evil and the Demonic*, pp. 1-11, for a more detailed discussion of these aspects of evil as a peculiar type of behaviour limited to specific circumstances.

50. Wedgwood, p. 303. On the question of linguistic collapse in evil environments, cf. Oppenheimer, *ibid*, pp. 147-55.

51. Cited in Wedgwood, p. 256. On

charismatic violence and its relations to empirical evil, cf. Oppenheimer, *ibid*, pp. 66-85.

52. For early modern observations suggestive of the relations of filth, vermin, revulsion and group hatreds, cf. Motley, *Rise of the Dutch Republic*, I, pp. 293, 436.

53. On demonization, cf. Oppenheimer, *Evil and the Demonic*, pp. 95-101.

54. Parker, *Europe in Crisis*, p. 298.

55. Magurn, p. 506; Evers, *Neue Forschungen*, p. 81.

56. Lionel March, *Architectonics of Humanism: Essays on Number in Architecture* (Chichester, 1998), pp. 115, 246; Ann Saunders, *The Art and Architecture of London* (2nd ed. rpt. London, 1996), pp. 114-18.

57. Julius Held, 'Rubens' Glynde Sketch and the Installation of the Whitehall Ceiling', in *Rubens and his Circle*, pp. 126-37: p. 134; cf. also Held, *Drawings*, pp. 25, 128.

58. Simon Thurley, Susanne Groom, Susan Jenkins, The *Banqueting House, Whitehall Palace* (London, 1997), p. 35; Christopher White, p. 253. On the controversial question whether it is Cupid who is crowned (rather than Charles I as an infant) and the theme of love and marriage in the paintings, cf. Björn Fredlund, 'The Iconography of the Union of England and Scotland', in *Gentse Bijdragen tot de Kunstgeschiedenis*, XXIV (Ghent, 1976-78), pp. 43-50.

59. Magurn, p. 506.

60. *Ibid*, p. 388.

61. On the change in Rubens' drawings, cf. Held, *Drawings*, p. 59-61.

62. Evers, *Neue Forschungen*, pp. 76, 78.

63. Cf. discussion of the sketch for this painting in Held, *Drawings*, pp. 59-60, 150-51; and complementary discussion of the painting in Simson, 437-41.

64. Held, 'Rubens' *Het Pelsken*', in

Rubens and his Circle, pp. 106-13, asserts the Venus-connection here, as does Christopher White (p. 243). It is rejected by Simson as 'going too far' in the circumstances of the scene itself (pp. 347-48).

65. Motley, III, p. 104. On the *Kermesse,* cf. Svetlana Alpers, 'Painting in Flemish: The Peasant Kermis', in *The Making of Rubens* (New Haven, 1995), pp. 5-64.

66. Magurn, p. 393.

67. *Ibid,* p. 392.

68. *Ibid,* p. 393.

69. *Ibid,* p. 504.

70. *Ibid,* p. 393.

71. Cf. Irmengard von Roeder-Baumbach, 'De triomfbogen van 1635 (Rubens)', pp. 64-76, and Hans Gerhard Evers, 'De Weg gevolgd door de Blijde Inkomsten langs de Straten te Antwerpen', pp. 117-75, in Irmengard von Roeder-Baumbach, *Versieringen bij Blijde Inkomsten* (Antwerp, 1943).

72. Cited in Max Rooses, *Rubens* (London, 1904), p. 556.

73. Magurn, p. 392.

74. Parker, *Dutch Revolt,* pp. 34, 39; Roy Strong, *Art and Power,* pp. 48-49.

75. Wedgwood, pp. 369-81; Parker, *Thirty Years' War,* pp. 140-41.

76. Simson, p. 446; cf. also *CRB XVI,* J.R. Martin, *The Decorations for the Pompa Introitus Ferdinandi* (Brussels, London, 1972), pp. 19-22, 23-34, 35.

77. The first commissions for this began to arrive in April, 1636. Cf. Evers, *Neue Forschungen,* p. 84; Simson, p. 475; also *CRB IX,* Svetlana Alpers, *The Decoration of the Torre de la Parada* (Brussels, London, 1971), pp. 21, 30.

78. *CR, IV,* p. 237.

79. Magurn, p. 393. The engraver Theodor van Thulden published an outsize, extravagant volume, containing all the designs and encomia for Ferdinand's entry, the *Pompa Introitus Honori Serenissimi Principis*

Ferdinandi Austriaci Hispaniarum Infantis, in 1641.

80. Magurn, p. 393.

81. Evers, *Neue Forschungen,* p. 82; Magurn, pp. 399, 147.

82. It should also be noted that two other (previous) versions of the Paris story survive as well, one a rough sketch for his first, pre-Italian painting (or so it has been identified by Michael Jaffé; cf. Wolfgang Prohaska, '1. Das Urteil des Paris', in Klaus Demus, Günther Heinz, Wolfgang Prohaska, Karl Schütz, Anna Maria Schwartzenberg, *Peter Paul Rubens, 1577-1640: Ausstellung zur 400. Wiederkehr seines Geburtstags* (Vienna, 1977), Kunsthistorisches Museum, p. 49), and the other a painting done in *c.* 1625 and now in the Gemäldegalerie in Dresden. This last strongly resembles the painting that he now set about doing, and may even be seen as a preparation for it. The most significant discrepancy, which, as will be seen, scarcely affects its meaning, is that in the Dresden painting (as opposed to the second London version), Paris holds the precious apple on his lap. Cf. John Goodman trans., Hubert Damisch, *The Judgment of Paris* (Chicago, 1996), pp. 272-73.

83. Génard, *Aanteekeningen,* p. 32. Evers, *Neue Forschungen,* p. 82.

84. *Ibid,* p. 80; Rooses, *Rubens* (Eng. trans. 1904), p. 571.

85. Evers, *Neue Forschungen,* p. 66.

86. These purchases continued over several years. Cf. Evers, *Neue Forschungen,* pp. 88, 92. A number of Rubens' additions to the house survive to this day.

87. Cited and commented on in Held, *Drawings,* p. 26.

88. Magurn, p. 394.

89. Cf. Christopher Brown, *Rubens' Landscapes,* pp. 105-109.

90. Magurn, p. 401.

91. Cf. Christopher Brown, *ibid,* p. 119; also p. 96.

92. Cf. by way of contrast, Chrisopher White, p. 285.
93. Magurn, p. 402.
94. *Ibid.*
95. Magurn, p. 403.
96. Evers, *Neue Forschungen*, p. 80.
97. Magurn, pp. 398, 400.
98. Simson, p. 476; Svetlana Alpers, *Torre de la Parada*, p. 34-35.
99. Simson, p. 475-87.
100. Magurn, p. 400.
101. *Ibid.*
102. Wedgwood, pp. 411-12.
103. German text with discussion in Paul Oppenheimer, *Modern Mind*, pp. 86-87, 159-60.
104. Magurn, p. 408.
105. *Ibid*, pp. 408-409.
106. Wedgwood, pp. 381-86.
107. Parker, *Thirty Years' War*, pp. 173-86.
108. Bellori, *Vite* (1672), Parte prima, p. 300.
109. Magurn, p. 411.
110. Evers, *Neue Forschungen*, pp. 86, 82.
111. Evers, *ibid*, pp. 88-89; Christopher White, 'Rubens and Old Age', *Allen Memorial Art Museum Bulletin*, XXXV (Oberlin, 1978), pp. 40-56.
112. Both involve golden apples. In the Venus and Adonis story recounted by Ovid (*Metamorphoses*, X), Venus tells Adonis that she had once assisted Hippomenes in obtaining his beloved Atalanta by distracting and hindering her with three golden apples (Mary M. Innes trans., pp. 242-45). Rubens also did at least two other versions of the same scene, though each shows Venus embracing Adonis (and is thus quite different from this one), in *c.* 1609, with the one today in the Kunstmuseum, Düsseldorf, and the other in The Hermitage, St Petersburg (cf. Maria Varshavskaya, Xenia Yegorova, *Peter Paul Rubens: The Pride of Life* (St Petersburg, Bournemouth, 1995), pp. 42-43).
113. Ovid, *Metamorphoses*, p. 244.

114. *CR*, VI, p. 227.
115. *Ibid*, p. 228.
116. *Ibid.*
117. Evers, *Neue Forschungen*, p. 86; Magurn, pp. 406-408.
118. *Ibid*, p. 112 (see note to phrasing for variants, p. 457).
119. Evers, *Neue Forschungen*, pp. 87, 93.
120. Magurn, p. 394.
121. *Ibid.*
122. Bellori, *Vite*, p. 245.
123. Evers, *Neue Forschungen*, p. 88; Millen and Wolf, *Heroic Deeds*, p. 19; Mariana Hanstein, *Peter Paul Rubens' Kreuzigung Petri: Ein Bild aus der Peterskirche zu Köln* (Köln, 1996), p. 2.
124. Evers, *ibid*, pp. 88, 92.
125. Magurn, p. 406.
126. *Ibid.*
127. *Ibid.*
128. *Ibid.*
129. *Ibid*, p. 410.
130. *Ibid.*
131. *Ibid*, pp. 413-14.
132. *Ibid*, p. 410.
133. *Ibid*, p. 411.
134. Elise Chandler trans., Frans Baudouin, *Peter Paul Rubens* (New York, 1977), p. 273; Magurn, p. 422.
135. Baudouin, *ibid.*
136. Magurn, p. 414.
137. *Ibid*, p. 415.
138. Evers, *Neue Forschungen*, p. 92; on his will, cf. P. Génard, 'Het laatsste testament van P.P. Rubens', in *Rubens-Bulletijn*, 4 (1890), p. 125f.; on the self-portrait sketch, cf. Held, *Drawings*, p. 61.
139. P. Génard, 'De nalatenschap van Rubens', in *Antwerpsch Archievenblad*, I (Antwerp, 1865), p. 168.
140. Sainsbury, *Original unpublished papers*, pp. 228, 229.
141. *Ibid*, p. 230.
142. Rooses, *Rubens* (Eng. trans. 1904), p. 620; epitaph: *ibid*, p. 629.
143. For a republication of the inventory, cf. Jeffrey M. Muller,

Rubens: Artist as Collector, pp. 91-146; for inventories of other paintings and items owned by Rubens, cf. *ibid*, pp. 147-55. Muller cites numerous errors in the frequently re-issued French versions of the *Specification*, as the inventory was termed, though a *Catalogue des Tableaux, dessins, sculptures et autres objets rares, Lesquels ont été trouvés à la Mortuaire du fameux Peintre, Le Chev. P.P. Rubens, l'an 1640, Orné de son Portrait*, dated 1797 and in the possession of the author, is apparently error-free. It should also be added that Helena was pregnant at the time of Rubens' death. His last child, Constantina Albertina, was born on Feb. 3, 1641 (Sainsbury, *Original unpublished papers*, facing p. 1).

144. Magurn, p. 410.

145. Mariana Hanstein, *Kreuzigung Petri*, pp. 26, 37-39.

146. *Ibid*, pp. 28-36; Simson, p. 497.

VI

1. Cf. Stillman Drake, *Galileo*, pp. 10-11, where after noting that Galileo and Descartes 'laid waste' Aristotelian natural philosophy between 1605 and 1644, Drake observes: 'Aristotle's physics offered material, formal, efficient and final or purposive causes of every kind of change in nature. Galileo's physics dealt with local motion', an approach that Descartes rejected 'because it had not started with an investigation of the causes of motion and heaviness.'

2. Cited in Ewald Osers trans., Albrecht Föling, *Albert Einstein* (Harmondsworth, 1997), p. 207. On the principle of space-time relativity as known to Galileo and Newton, cf. pp. 156-57. On the issue of Einstein's conviction of a divine and harmonic omnipresence, cf. Banesch Hoffmann, 'Albert Einstein', in *Year Book XXI. The Jewish Question and Antisemitism*, Publications of the Leo Baeck Institute (London, 1976), pp. 279-88: esp. p. 280, in which Hoffmann recalls from conversations with Einstein that 'when evaluating a scientific theory, his own or others', Einstein would ask himself this question: "If I were God, would I have made the Universe that way?"'

3. Cf. Banesh Hoffmann, *ibid*, p. 283. Hoffmann (himself a physicist) writes (p. 282): 'One comes to recognise a hallmark that characterises Einstein's science: its aesthetic nature.'

Select Bibliography

Rubens may be the most written-about artist who ever lived. Prosper Arents' bibliography of articles, books and other references to him (see below) runs to over six hundred pages, and since its publication in 1940, the field has broadened considerably and cheerfully. The listing here, which is by no means exhaustive, is thus limited to items that I have cited or otherwise used in a direct way, or that in a few cases may lead the reader into complementary research. [Note: *CRB*=Corpus Rubenianum Ludwig Burchard.]

Adler, Wolfgang. *CRB*. XVII. *Landscape: I*. P.S. Falla trans. New York: 1982.
Ahnlund, Nils. *Gustav Adolf the Great*. Michael Ruberts trans. Princeton: 1940.
Alberti, Leon Battista. *On Painting*. John R. Spencer ed. and trans. rev. ed. New Haven: 1966.
Alpers, Svetlana. *The Making of Rubens*. New Haven: 1995.
——. *CRB*. IX. *The Decoration of the Torre de la Parada*. Brussels: 1971.
Altena, J.Q. van Regteren ed. *Peter Paul Rubens tekeningen naar Hans Holbeins Dodendans*. Facsimile. Amsterdam: 1977.
Arber, Edward ed. *A List of 837 London Publishers, 1553-1640*. The English Scholar's Library. London: 1895.
Arents, Prosper. *Geschriften van en over Rubens*. Antwerp: 1940.
——. 'De bibliotheek van Pieter Pauwel Rubens.' *Cultureel Tijdschrift van de Provincie Antwerpen*. I (1961): p. 145f.
Assouline, Pierre. *L'Homme de l'art*. Paris: 1989.
Bacon, Francis. W. Aldis Wright ed. *Bacon's Essays*. London: 1868.
Baglione, Giovanni. *La Vita de' Pittori, Scultori, Architetti ed Intagliatori dal Pontifico di Gregorio XIII del 1572. fino a' tempidi Papa Urbano VIII nel 1642*. Rome: 1642.
Balis, A. 'Hippopotamus Rubenii: een hoofdtstukje uit de geschiedenis van de zoölogie.' *Feestbundel bij de opening van het Kolveniershof en het Rubenianum*. Antwerp: 1981. Pp. 127-42.
Barnes, Susan. 'Van Dyck and George Gage.' Cf. under David Howarth ed. *Art and Patronage in the Caroline Courts: Essays in honour of Sir Oliver Millar*. Cambridge, Eng.: 1993. Pp. 1–11.
Baudouin, Frans. *Rubens*. Antwerp, Paris, New York: 1977.
Baumstark, R. 'Ikonographische Studien zu Rubens Kriegs- und Friedensallegorien.' *Aachener Kunstblätter*. XLV (Aachen, 1974): pp. 125-234.
Beer, E.S. De. 'François Schott's *Itinerario D'Italia*.' *The Library: A Quarterly Review of Bibliography*. Fourth Series, vol. XXIII, no. 2, 3 (London, 1942): pp. 1-63f.

Bellori, Giovanni Pietro. *Vite dei Pittori, Scultori ed Architetti*. Rome: 1672.

Benassar, B. *Valladolid au siècle d'or*. Paris: 1967.

Benedict, Philip ed. *Cities and Social Change in Early Modern France*. New York: 1992.

Bijns, Anna. Dr W.L. van Helfen ed. *Anna Bijns, Refereinen*. Rotterdam: 1875.

Bindoff, S.T. *Tudor England*. rpt. London: 1962.

Binski, Paul. *Medieval Death: Ritual and Representation*. London: 1996.

Blyth, Derek. *Flemish Cities Explored: Bruge, Ghent, Antwerp, Mechelen, Leuven & Ostend*. 3rd ed. London: 1998.

Bonnefoy, Yves. 'Byzantium.' Richard Stammelman ed. *The Lure and Truth of Painting: Selected Essays on Art*. John T. Naughton trans. Chicago: 1995. Pp. 19-24.

———. 'Baudelaire contre Rubens.' *Le nuage rouge*. Paris: 1977. Pp. 9-80.

Borah, W. *New Spain's Century of Depression*. Berkeley: 1951.

Branden, F. Jos van den ed. *Anna Bijns, haar Leven, hare Werken, haar Tijd, 1493-1575*. Antwerp: 1911.

———. *Geschiedenis der Antwerpsche schilderschool*. 2 vols. Antwerp: 1883.

Brink, R.C. Bakhuizen van den. *Het Huwelijk van Willem van Orange met Anna van Saxon (Amsterdam: 1853; rpt. The Hague: 1939)*: O. Dambre. *Marginalia bij Maria Pypelinckx' Troostbrieven*. Antwerp: 1940.

Brown, Christopher. *Making and Meaning: Rubens's Landscapes*. London: 1996.

Bull, George. *Michelangelo: A Biography*. London: 1996.

Burckhardt, Jacob. *Recollections of Rubens*. Mary Hottinger trans. London: 1950.

Cable, Mary ed. *El Escorial*. New York: 1971.

Camesasca, Ettore. *Mantegna*. Susan Madocks Lister trans. Milan: 1992.

Canton, F.J. Sanchez. *Arte de la pintura*. 2 vols. Madrid: 1956.

Catalogue des Tableaux, Dessins, Sculptures et autres objets rares, Lesquels ont été trouvés a› la Mortuaire du fameux Peintre, Le Chev. P.P. Rubens, l'an 1640, Orné de son Portrait (1797). 16-page pamphlet.

Cervantes. Miguel de Cervantes Saavedela. Franciso Rico ed. *Don Quijote de la Mancha*. 2 vols. Barcelona: 1998.

———. *Exemplary Stories*. C.A. Jones trans. London: 1972.

Chaney, Edward. 'The Grand Tour and the Evolution of the Travel Book.' *Grand Tour: The Lure of Italy in the Eighteenth Century*. Andrew Wilton, Ilaria Bignamini eds. London: 1996.

Chaucer, Geoffrey. *The Merchant's Prologue and Tale*. Maurice Hussey ed. 13th rpt. Cambridge, Eng.: 1996.

Clair, Colin. *A History of European Painting*. London, New York: 1976.

Clark, Kenneth. *Feminine Beauty*. New York: 1980.

Conscienceplein Antwerpen: De andere Kant van Carolus. Kanttentoonstelling in de Sint-Carolus Borromeuskerk. Antwerp: 1996.

Cormack, Robin. *Painting the Soul: Icons, death masks, and shrouds*. London: 1997.

Coryat, T. *Coryat's Crudities*. 2 vols. London: 1611. rpt. Glasgow, New York: 1905.

D'Hulst, Roger and Frans Baudouin, Willem Aerts, Jos Van Den Nieuwenhuizen, Madeleine Manderyck, Nicole Goetghebeur, Regine Guislain-Wittermann. *L'erection de la croix: Pierre Paul Rubens*. Brussels: 1992.

Damisch, Hubert. *The Judgement of Paris*. John Goodman trans. Chicago: 1996.

Daston, Lorraine and Katharine Park. *Wonders and the Order of Nature, 1150-1750*. New York: 1998.

Select Bibliography

Delacroix, Eugene. *The Journals of Eugene Delacroix*. Hubert Wellington ed. Lucy Norton trans. 3rd ed. London: 1995.

Descimon, Robert. 'Paris on the eve of Saint Bartholomew: taxation, privilege, and social geography.' Cf. Philip Benedict, above. P. 70f.

Dorwart, Reinhold August. *The Prussian Welfare State before 1740*. Cambridge, Mass.: 1971.

Douxchamps, Herve and Philippe du Bois de Ryckholt, Georges de Haveskercke, Bernard Nolf eds. *Rubens et ses descendants*. Brussels: 1977.

Downes, Kerry. *Rubens*. London: 1980.

Drabble, Margaret ed. *The Oxford Companion to English Literature*. Oxford: 1998.

Drake, Stillman. *Discoveries and Opinions of Galileo*. New York: 1957.

——. *Galileo*. Oxford: 1980.

Draper, F.W.M. *Four Centuries of Merchant Taylors' School: 1561-1961*. Oxford: 1962.

Duke, Alastair. 'The Netherlands.' Andrew Pettegree ed. *The early Reformation in Europe*. Cambridge, Eng.: 1992.

Duplessis, G. *Les Emblêmes d'Alciati*. Paris: 1884.

Dürer, Albrecht. *The Writings of Albrecht Dürer*. Alfred Warner intro. W.M. Conway trans. New York: 1958.

Elliott, J.H. *Imperial Spain: 1469-1716*. London: 1990.

Evans, Helen E. and William D. Wixom eds. *Glory of Byzantium: Art and Culture of the middle Byzantine era AD 843-1261*. New York: 1998.

Evers, Hans Gerhard. *Peter Paul Rubens*. Munich: 1942.

——. *Rubens und sein Werk: Neue Forschungen*. Brussels: 1944.

——. 'De Weg gevolgd door de Blijde Inkomsten langs de Straten te Antwerpen.' Irmengard von Roeder-Baumbach ed. and auth. *Versieringen bij Blijde Inkomsten*. Antwerp: 1943. Pp. 117-75.

Favaro, Antonio. *Galileo Galilei e lo studio di Padova*. II. Florence: 1883.

Finaldi, Gabriele and Michael Kitson. *Discovering the Italian Baroque: The Denis Mahon collection*. London: 1997.

Föling, Albrecht. *Albert Einstein*. Ewald Osers trans. Harmondsworth: 1997.

Fredlund, Björn. 'The Iconography of the Union of England and Scotland.' *Gentse Bijdragen tot de Kunstgeschiedenis*. XXIV (Ghent: 1976-78). Pp. 43-50.

Friedländer, Max. *From Van Eyck to Bruegel*. London: 1965.

——. *Antonis Mor and his Contemporaries*. Heinz Norden trans. Brussels: 1975.

Gachard, Louis Prosper. *Histoire politique et diplomatique de Pierre-Paul Rubens*. Brussels: 1877.

Gaukroger, Stephen. *Descartes: An intellectual biography*. Oxford: 1996.

Gelderen, Martin van. *The Dutch Revolt*. Cambridge, Eng.: 1993.

Génard, P. *P.P. Rubens: aanteekeningen over den grooten meester en zijne bloedverwanten*. Antwerp: 1877.

——. 'De nalatenschap van P.P. Rubens.' *Antwerpsch Archievenblad*. I (Antwerp: 1865).

Gere, J.A. *Taddeo Zuccaro: His Development Studied in his Drawings*. London: 1969.

Gillespie, Charles Coulton. *The Edge of Objectivity: An Essay on the History of Scientific Ideas*. Princeton: 1960.

Glaser, Curt. *Lukas Cranach*. Leipzig: 1923.

Glen, Thomas L. *Rubens and the Counter-Reformation: Studies in his Religious Paintings between 1609 and 1620.* New York: 1977.

Godolphin, Francis R.B. ed. *The Latin Poets.* New York: 1949.

Goldfarb, Hilliard T. 'Titian: *Colore & Ingegno* in the Service of Power.' Hilliard T. Goldfarb, David Freedberg, Manuela B. Mena Marqués. *Titian and Rubens: Power, Politics and Style.* Boston: 1998. Pp. 1-27.

Goldwater, Robert and Marco Treves eds. *Artists on Art, from the 14th to the 20th Century.* London: 1976.

Gombrich, E.H. *The Essential Gombrich.* Richard Woodfield ed. London: 1996.

——. *The Story of Art.* rpt. London: 1995.

Gosse, Edmund. *The Life and Letters of John Donne.* 2 vols. London: 1899.

Grafton, Anthony. 'Portrait of Justus Lipsius.' *American Scholar.* 56:3 (1987). Pp. 382-90.

Gravit, Frances West. *The Peiresc Papers.* Ann Arbor: 1950.

Greenberg, Clement. *The Collected Essays and Criticism.* 4 vols. John O'Brien ed. Chicago: 1993.

Grossman, F. *Pieter Bruegel: Complete Edition of the Paintings.* London: 1973.

Guicciardini, Ludovico. *Description de tous les Pays-Bas.* Antwerp: 1567; 2nd ed. Antwerp: 1582. Trans.: *The Description of the Low Countries and of the Provinces thereof.* London: 1953.

Haberditzl, F.M. 'Die Lehrer des Rubens.' *Jahrbuch des kunsthistorischen Sammlungen in Wien.* XXVII (1908). Pt 1.

Hanstein, Mariana. *Peter Paul Rubens' Kreuzigung Petri: Ein Bild aus der Peterskirche zu Köln.* Köln: 1996.

Held, Julius. *Rubens and his Circle: Studies by Julius S. Held.* David Rosand, John Walsh Jr eds. Princeton: 1982.

——. *Rubens: Selected Drawings.* rev. ed. Oxford: 1986.

——. *The Oil Sketches of Peter Paul Rubens.* 2 vols. Princeton: 1980.

——. *Rubens in America: Catalogue of Paintings and Drawings by Rubens in American Collections.* Jan-Albert Goris intro. New York: 1947.

——. 'Thoughts on Rubens' Beginnings.' *The Ringling Museum of Art Journal* (Sarasota, Florida: 1983). Pp. 14-35.

Hibbard, Howard. *Caravaggio.* New York: 1983.

Highet, Gilbert. *The Classical Tradition: Greek and Roman Influences on Western Literature.* Oxford: 1976.

Hirth, G. ed. *Neue Künstliche Figuren Biblischer Historien.* rpt. Basel: 1923.

Hoffmann, Banesch. 'Albert Einstein.' *Year Book XXI. The Jewish Question and Antisemitism.* Publications of the Leo Baeck Institute. London: 1976. Pp. 279-88.

Hofstede, Justus Muller. '"Ut Pictura Poesis": Rubens und die humanistische Kunsttheorie.' *Gentse Bijdragen tot de Kunstgeschiedenis.* XXIV (Ghent, 1976-78). Pp. 171-89.

——. 'Rubens's First Bozzetto for Sta. Maria in Vallicella.' *Burlington Magazine.* CVI (London: 1964). Pp. 442-51.

Holborn, Hago. *A History of Modern Germany: The Reformation.* rpt. Princeton: 1982.

Hollingsworth, Mary. *Patronage in Sixteenth Century Italy.* London: 1996.

Hooft, P.C. *P.C. Hooft's Nederlandse Historien in het Kort.* M. Nijhoff ed. Amsterdam, Brussels: 1947.

Select Bibliography

Hook, Judith. *The Baroque Age in England*. London: 1976.

Horace. *Satires and Epistles*. H.R. Fairclough trans. London: 1978.

Howard, Anthony. 'Rivals who were the chalk and cheese of politics.' [On the Great Reform Bill of 1832.] *The Times* (Wed., August 13, 1997). P. 9.

Howarth, David ed. *Art and Patronage in the Caroline Courts*. Cambridge, Eng.: 1993.

Huemer, Frances. *CRB XIX. Portraits I*. London: 1977.

——. 'Rubens and Galileo 1604: Nature, Art and Poetry.' *Wallraf-Richartz Jahrbuch*, 44 (Cologne, 1983). Pp. 175-96.

Hughes, A. 'Naming the unnameable: an iconographical problem in Rubens' "Peace and War."' *The Burlington Magazine*, CXXII (1980). Pp. 157-65.

Hume, David. 'The Sceptic.' *Essays Moral, Political and Literary*. rpt. Oxford: 1971.

——. *A Treatise of Human Nature*. Ernest Mossner ed. London, New York: 1969.

Huvenne, Paul. *The Rubens House, Antwerpen*. Antwerp: 1996.

——. 'Over Rubens' Cantoor, Panneels en de Kopenhaagse Cantoortekeningen/On Rubens' Cantoor, Panneels and the Copenhagen Cantoor.' Cf. under Hans Nieuwdorp ed. *Rubens Cantoor*. Pp. 16-37.

Ife, B.W. 'Another sally for the knight: Perspectivism and printer's devils: The first critical edition of *Don Quijoxte*.' *Times Literary Supplement* (Oct. 9, 1998). P. 15.

Imhof, D. ed. *The Illustration of Books Published by the Moretuses*. Antwerp: 1997.

Irwin, Terrence. *Classical Thought*. Oxford: 1989.

Jacquet, J. *Fêtes et cérémonies au temps de Charles-Quint*. Paris: 1960.

Jaffé, Michael. *Rubens and Italy*. Oxford: 1977.

Jones, Barry ed. *Hutchinson Concise Dictionary of Music*. London: 1998.

Kaestner, Horst. 'Peter Paul Rubens' Eltern in Köln und Siegen.' *Heimatland: Beilage zur Siegener Zeitung*, 7 (Siegen: 1927). Pp. 97-100.

Kamen, Henry. *Philip of Spain*. New Haven: 1997.

Kiernan, V.G. *Horace: Poetics and Politics*. London: 1999.

Kinney, Arthur F. ed. *Rogues, Vagabonds, and Sturdy Beggars: A New Gallery of Tudor and Early Stuart Rogue Literature*. Boston: 1990.

Koepp, Johannes. *Untersuchungen über das Antwerpener Liederbuch vom Jahre 1544*. Antwerp: 1928(?).

Kruse, Hans. 'Wilhelm von Oranien und Anna von Sachsen: Eine fürstliche Ehetragödie des 16. Jahrhunderts.' *Nassauische Annalen: Jahrbuch des Vereins für Nassauische Altertumskünde und Geschichtsforschung*, 54 (1934).

Landwehr, Claudia. *Peter Paul Rubens: Gemälde und Grafiken. Münster: 1995*.

Larsen, Eric. *P.P. Rubens, with a complete Catalogue of his Works in America*. Antwerp: 1952.

——. 'The Metaphysical Foundations of the Rubens Landscape.' *The Ringling Museum of Art Journal* (Sarasota, Florida: 1983). Pp. 220-25.

Lescourret, Marie-Anne. *Rubens: A Double Life*. Elfreda Powell abridged trans. (from 1990 ed.). London: 1993.

Levis, Howard C. *Nicolaus Claudius Fabricus, Lord of Peiresc, called Peireskius*. London: 1916.

Lewis, C.S. *The Discarded Image*. Cambridge, Eng.: 1965.

Lind, L.R. 'The Latin Life of Peter Paul Rubens by his Nephew Philip A Translation.' *Art Quarterly*, IX (Detroit: 1946). Pp. 37-44.

Linley, David. *Court Masques.* Oxford: 1996.

Lipsius, Justus. *Physiologia Stoicorum.* Antwerp: 1610.

Lockyer, Roger. *Buckingham: The Life and Political Career of George Villiers, First Duke of Buckingham, 1592-1628.* London: 1981.

Longueville, Thomas. *Policy and Paint, or Some Incidents in the lives of Dudley Carleton and Peter Paul Rubens.* London: 1913.

Lück, Alfred. *Siegerland und Nederland.* 2nd ed. Siegen: 1981.

Lucretius. *The Nature of the Universe.* R.E. Latham trans. rpt. London: 1959.

Lugt, Frits. 'Notes sur Rubens.' *Gazette des beaux-arts,* 67 (1925). P. 179f.

Lynch, John. *A History of Spain: The Hispanic World in Crisis and Change: 1598-1700.* Oxford: 1992.

MacKenzie, K.R.H. ed. and trans. *Master Tyll Owlglass: His Marvellous Adventures and Rare Conceits.* London: 1923.

Magurn, R.S. trans. *The Letters of Peter Paul Rubens.* Cambridge, Mass.: 1955.

Mander, Carel van. *Dutch and Flemish Painters. Translation from the Schilderboek.* Constant van de Wall trans. New York: 1936.

Mann, Thomas. *Death in Venice and Other Stories.* H.T. Lowe-Porter trans. rpt. New York: 1954.

March, Lionel. *Architectonics of Humanism: Essays on Number in Architecture.* Chichester: 1998.

Marchi, Piero. 'Le feste fiorentine per la nozze di Maria de'Medici nell'anno 1600.' Mina Gregori ed. *Rubens e Firenze.* Florence: 1983.

Marius, Richard. 'The Peasant's Rebellion.' *Martin Luther: The Christian between God and Death.* Cambridge, Mass.: 1999. Pp. 414-35.

Marqués, Manuela B. Mena. 'Titian, Rubens, and Spain.' Cf. under Hilliard T. Goldfarb. Pp. 69-94.

Martin, John Rupert. *CRB XVI The Decorations for the Pompa Introitus Ferdinandi.* Brussels, London: 1972.

—— ed. *Rubens before 1620.* Princeton: 1972.

Mason, Anthony. *Brussels, Bruges, Ghent, Antwerp.* London: 1998.

McGrath, Elizabeth. *CRB XIII 1:Subjects from History.* 2 vols. London: 1997.

McKendrick, Melveena. *Theatre in Spain, 1490-1700.* Cambridge, Eng.: 1989.

McMurtrie, Douglas C. *The Book: The Story of Printing and Bookmaking.* New York: 1943.

Meijer, Reinder P. *Literature of the Low Countries.* London: 1978.

Melegari, Vezio. *The Great Military Sieges.* London: 1972.

Meulen, Marjon van der. 'Rubens and the Antique Sculpture Collections in Rome.' *Gentse Bijdragen tot de Kunstgeschiedenis,* XXIV (Ghent, 1976-78). Pp. 146-58.

——. 'Observations on Rubens' Drawings after the Antique.' *The Ringling Museum of Art Journal* (Sarasota, Florida, 1983). Pp. 36-51.

Michel, Émile. *Rubens: His Life, his Work, and his Time.* 2 vols. Elizabeth Lee trans. London, New York: 1899.

Michel, J.F.M. *Histoire de la vie de P.P. Rubens.* Brussels: 1771.

Micheletti, Emma. *Rubens: The life and work of the artist.* Firmin O'Sullivan trans. rpt. London: 1984.

Michiels, Alfred. *Rubens et l'école d'Anvers.* Paris: 1854.

Miedema, Hessel ed. *Karel van Mander: The Lives of the Illustrious Netherlandish and German Painters.* 4 vols. Doornspijls: 1996.

Select Bibliography

Millar, Oliver. *Van Dyck in England*. London: 1982.

Millen, Robert Forsyth and Robert Erich Wolf. *Heroic Deeds and Mystic Figures: A New Reading of Rubens' Life of Maria de'Medici*. Princeton: 1989.

Milton, John. *The Complete Poems*. John Leonard ed. London: 1998.

Mönch, Walter. *Das Sonett, Gestalt und Geschichte*. Heidelberg: 1955.

Montaigne, Michel de. *The Complete Essays*. M.A. Screech trans. London: 1987.

Morel, Yolande. 'Baptism of Christ.' *P.P. Rubens: Catalogue: Paintings—Oil Sketches*. Royal Museum of Fine Arts. Antwerp: 1990.

Motley, John Lothrop. *The Rise of the Dutch Republic*. 3 vols. rpt. London: 1930.

Muller, Jeffrey. 'Rubens' Anatomy Book.' Cf. under Hans Nieuwdorp. Pp. 78–107.

——. *Rubens: The Artist as Collector*. Princeton: 1989.

——. 'Rubens' Divine Circle.' *The Ringling Museum of Art Journal* (Sarasota, Florida, 1983). Pp. 220–25.

——. 'Rubens' Theory and Practice of the Imitation of Art.' *Art Bulletin*, 64 (1982). Pp. 229–47.

Murray, John J. *Antwerp in the Age of Plantin and Bruegel*. Norman: 1970.

Neumann, J. 'Aus den Jugendjahren von Peter Paul Rubens. Eine Versammlung der Olympischen Götter.' *Jahrbuch des Kunsthistorischen Instituts der Universität Graz*, III–IV (1968). P. 73f.

Newton, Eric. *European Painting and Sculpture*. 3rd ed. London: 1945.

Nieuwdorp, Hans ed. *Rubens Cantoor: een verzameling tekeningen ontstaan in Rubens'atelier*. Antwerp/Rubenshuis: 15 mei tot 27 juni 1993.

Noir, Afred. *Caravaggio*. New York: 1983.

North, John. *The Norton History of Astronomy and Cosmology*. New York: 1994.

Oppenheimer, Paul. *Till Eulenspiegel: His Adventures*. New York: 2001.

——. 'Goethe and Modernism: The Dream of Anachronism in Goethe's *Roman Elegies*.' *Arion* (Spring–Summer, 1998). Pp. 81–100.

——. *The Birth of the Modern Mind: Self, Consciousness and the Invention of the Sonnet*. Oxford: 1989.

——. *Evil and the Demonic: A New Theory of Monstrous Behaviour*. London, New York: 1996.

——. 'Does Time Exist?' *The Literary Review* (U.S.), vol. 33, 3 (Spring, 1990). Pp. 388–93.

Oresko, Robert. 'Culture in the Age of Baroque and Rococo.' George Holmes ed. *Oxford History of Italy*. Oxford: 1997. P. 139f.

Ovid. *Metamorphoses*. Mary M. Innes trans. London: 1968.

Ozment, Stephen. *The Age of Reform: 1250–1550: An Intellectual and Religious History of Later Medieval and Reformation Europe*. New Haven: 1980.

Palomino, Antonio. *Biografias* (Madrid: 1724). *Velásquez Homenaje*. Madrid: 1960.

Panofsky, Erwin. *Early Netherlandish Painting: Its Origins and Character*. Cambridge, Mass.: 1958.

Parker, Geoffrey. *Europe in Crisis, 1598–1648*. London: 1990.

——. *The Dutch Revolt*. rev. ed. London: 1990.

Pérez-Mallaína, Pablo E. *Spain's Men of the Sea: Daily Life on the Indies Fleets in the Sixteenth Century*. Baltimore: 1998.

Petrarca. *Il Petrarca*. [Pocket-size, with woodcuts and dictionary of rhymes.] Monsignore Bembo ed. Venice: 1573.

Piles, Roger de. *Conversations sur la connaissance de la peinture*. 1677. rpt. Geneva: 1970.

——. *Dissertation sur les ouvrages des plus fameux peintures*. Paris: 1681.

——. *Cours de peinture par principes*. Paris: 1708.

Pinder, William. *Rembrandt's Selbstbildnesse*. Königstein im Taunus: 1956.

Plotinus. *On the One and Good: Being the Treatises of the Sixth Ennead*. Stephen MacKenna, B.S. Page trans. London: 1930.

——. *The Enneads*. Stephen MacKenna trans., John Dillon intro. London: 1991.

Poorter, Nora De and Guido Jansen, Jeroen Giltaij eds. *Rubens en zijn tijd*; *Rubens and his age. Rotterdam: 1990.*

Porter, Roy and G.S. Rousseau. *Gout: The Patrician Malady*. New Haven: 1998.

Price, Frank Percival. *The Carillon*. Oxford: 1933.

Prims, Floris and Maurits Sabbe, Victor de Meyere, A.J.J. Delen, Paul Pambotte. *Rubens en zijne Eeuw*. Brussels: 1927.

Prohaska, Wolfgang. '1. Das Urteil des Paris.' Klaus Demus, Günther Heinz, Wolfgang Prohaska, Karl Schütz, Anna Maria Schwartzenberg eds. *Peter Paul Rubens, 1577-1640: Ausstellung zur 400. Wiederkehr seines Geburtstags*. Vienna: 1977. P. 49.

Putnam, George Haven. *Books and their Makers during the Middle Ages*. 2 vols. New York: 1896-97.

Pyenson, Lewis and Susan Sheets-Pyenson. *Servants of Nature: A History of Scientific Institutions, Enterprises and Sensibilities*. London: 1999.

Redlich, Hans F. 'Monteverdi.' Eric Bloom ed. *Grove's Dictionary of Music and Musicians*. 5th ed. V. London: 1954. Pp. 841-44.

Read, Herbert. *The Meaning of Art*. rev. ed. London: 1968.

Reeves, Eileen. *Painting the Heavens: Art and Science in the Age of Galileo*. Princeton: 1997.

Rizza, Cecilia. *Peiresc e Italia*. Turin: 1965.

Roeder-Baumbach, Irmengard von. 'Die triombogen van 1635 (Rubens).' *Versieringen bij Blijde Inkomsten*. Antwerp: 1943. Pp. 64-76.

Rooses, Max and Charles Ruelens. *Correspondance de Rubens et documents epistolaires concernant sa vie et ses oeuvres*. 6 vols. Antwerp: 188—1909.

——. *L'Oeuvre de Rubens*. 5 vols. Antwerp: 1886-92.

——. *Rubens: sa vie et ses oeuvres*. ltd ed. Paris: 1898 (?).

——. *Rubens*. 2 vols. Harold Child trans. London: 1904.

——. 'De vreemde reizigers Rubens of zijn huis bezoekende.' *Rubens-Bulletijn*, 5 (1910).

——. *Oud-Anterpen. Le vieil Anvers*. Brussels: 1894.

——. *Art in Flanders*. London: 1914.

——. 'Les contrats passés entre Rubens et Marie de Médici concernant les deux galeries du Luxembourg.' *Rubens-Bulletijn*, 5 (1910). Pp. 216-20.

Rubens, Philip. *Electorum libri II in quibus antiqui ritus, emendationes, censurae, Eiusdem ad Iustum Lipsium*. Antwerp: 1608.

Rudolf, Anthony trans. *Balzac: Gillette, or The Unknown Masterpiece*. London: 1999.

Ruelens, Charles and Max Rooses eds. *Codex Diplomaticus Rubenianus*. 6 vols. Cf. also under Max Rooses, *Correspondance*. Antwerp: 1887-1909.

Russell, Bertrand. *The History of Western Philosophy*. rpt. London: 1999.

Sainsbury, William Noël. *Original unpublished papers illustrative of the Life of Sir Peter Paul Rubens*. London: 1859.

Sandrart, Joachim. *Academie der Bau-, Bild- und Malery-Künste*. rpt. Munich: 1925.

——. *Teutsche Academie*. 2 vols. Orig. ed. Nuremberg: 1675-79.

Select Bibliography

Santayana, George. *The Sense of Beauty, Being the Outline of Aesthetic Theory.* 1896. rpt. New York: 1955.

Saunders, Ann. *The Art and Architecture of London.* 2nd ed. rpt. London: 1996.

Schaar, Eckhard and Holger Broeker. *Zeichnungen und Graphik des niederländischen Mannerismus.* Stuttgart: 1992.

Serre, Jean Puget de la. *Histoire curieuse de tout ce qui c'est passé a l'entree de la Reyne Mere du Roy Trechristien dans les villes des Pays Bas.* Antwerp: 1632.

Shakespeare, William. *Shakespeare's Sonnets.* Katherine Duncan-Jones ed. London: 1997.

Sidney, Sir Philip. *An Aplogy for Poetry.* Geoffrey Shepherd ed. Manchester: 1973.

Silver, Larry. *The Paintings of Quinten Massys, with Catalogue Raisonné.* Montclair: 1984.

Simson, Otto von. *Peter Paul Rubens (1577-1640): Humanist, Maler und Diplomat.* Mainz: 1996.

Smit, J. and Victor van Grimberghen. *Historische lebensbeschryving van P.P. Rubens.* Antwerp: 1840.

Smid, Dr. W.A.P. auth. and ed. *Jan van der Noot, he Bosken in het Theatre.* Amsterdam: 1953.

Stechow, Wolfgang. *Pieter Bruegel the Elder.* London: 1990.

——. *Rubens and the Classical Tradition.* Cambridge, Mass.: 1968.

Stone, Lawrence. *The Crisis of the Aristocracy: 1558-1641.* Oxford: 1965.

Strauss, Walter L. *Hendrik Golzius, 1588-1617: The Complete Engravings and Woodcuts.* 2 vols. New York: 1977.

Strien, Kees van. *Touring the Low Countries: Accounts of British travellers, 1660-1720.* Amsterdam: 1998.

Strong, Roy. *Britannia triumphans: Inigo Jones, Rubens and Whitehall Palace.* London: 1980.

——. *Art and Power: Renaissance Festivals, 1450-1650.* rpt. London: 1995.

Sutton, Peter ed. *The Age of Rubens.* New York: 1993.

Symonds, John Addington. *Shakespeare's Predecessors in the English Drama.* London: 1884.

Thicknesse, Philip. *A Year's Journey through the Pais Bas; or, Austrian Netherlands.* 2nd ed. London: 1786.

Thulden, Theodor van. *Pompa Introitus Honori Serenissimi Principis Ferdinandi Austriaci Hispaniarum Infantis.* Antwerp: 1641.

Thurley, Simon and Susanne Groom, Susan Jenkins. *The Banqueting House, Whitehall Palace.* London: 1997.

Tomes, John. *Belgium and Luxembourg.* London: 1989.

Trevor-Roper, Hugh. 'Mayerne and his Manuscript.' Cf. under David Howarth. Pp. 268-93.

Vanderhoeght, K. *The Rockox House.* Antwerp: 1979.

Varshavshaya, Maria and Xenia Yegorova. *Peter Paul Rubens: The Pride of Life.* St Petersburg, Bournemouth: 1995.

Velderman, G. ed. *Bloemlezing uit Hooft's Historiën.* Doetinchem: 1881.

Verachter, F. *Généalogie de Pierre-Paul Rubens et sa familie.* Antwerp: 1840.

Vergara, Lisa. *Rubens and the Poetics of Landscape.* New Haven: 1982.

Verhoef, C.E.H.J. *De Val van Antwerpen in 1585.* Antwerp: 1985.

Vickers, Brian. "'Tis the Goddesse of Rhetorick.' *Times Literary Supplement* (August 16, 1996). P. 27.

Vlieghe, H. *CRB*. VIII. *Saints*. 2 vols. Brussels: 1972-73.

Walls, Peter. *Music in the English Courtly Masque, 1604-40*. Oxford: 1996.

Walpole, H. and G. Vertue. J. Dallaway, R.N. Warnum eds. *Anecdotes of Painting in England; Also a Catalogue of Engravers*. London: 1862.

Weavers, Theodore. *Poetry of the Netherlands in its European Context, 1170-1930*. London: 1960.

Wedgwood, C.V. *The Thirty Years War*. rpt. London: 1953.

——. *The Political Career of Peter Paul Rubens*. London: 1975.

Wegg, Jervis. *The Decline of Antwerp under Philip of Spain*. London: 1924.

Weizsäcker, Heinrich. *Adam Elsheimer, der Maler von Frankfurt*. 2 vols. Berlin: 1936.

White, Christopher. *Peter Paul Rubens: Man and Artist*. New Haven: 1987.

——. 'Rubens and Old Age.' *Allen Memorial Art Museum Bulletin*, XXXV (Oberlin, 1978). Pp. 40-56.

White, Gilbert. Paul Foster ed. *The Natural History of Selborne*. London: 1993.

Wilenski, R.H. *Flemish Painters, 1400-1800*. 2 vols. London: 1960.

Wilson, Derek. *Hans Holbein: Portrait of an unknown man*. London: 1997.

Wittkower, Rudolf. *Architectural Principles in the Age of Humanism*. rpt. New York: 1971.

Wolf, K. 'Christine von Dietz.' *Siegerland*, 20 (Siegen, 1938).

Wolters, Wolfgang. 'Der Programmentwurf zur Dekoration des Dogenpalastes Dezember 1577.' *Mitteilungen des Kunsthistorischen Instituts in Florenz*, 12 (1965-66). Pp. 217-318.

Zumthor, Paul. *Daily Life in Rembrandt's Holland*. Samuel Watson Taylor trans. Stanford: 1994.

Index

Index